PATRONAGE

Power & Agency in Medieval Art

THE INDEX OF CHRISTIAN ART

Occasional Papers · XV

PATRONAGE

Power & Agency in
Medieval Art

Edited by

COLUM HOURIHANE

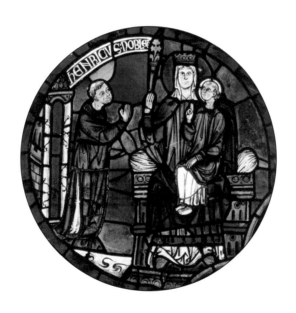

INDEX OF CHRISTIAN ART

DEPARTMENT OF ART & ARCHÆOLOGY

PRINCETON UNIVERSITY

in association with

PENN STATE UNIVERSITY PRESS

MM·XIII

CONTENTS

PREFACE *by Colum Hourihane* ix

FOREWORD *by Elizabeth Carson Pastan* xi

NOTES ON THE CONTRIBUTORS xiii

INTRODUCTION *by Colum Hourihane* xix

JILL CASKEY
Medieval Patronage & Its Potentialities 3

JULIAN LUXFORD
The Construction of English Monastic Patronage 31

ELIZABETH CARSON PASTAN
Imagined Patronage: The Bayeux Embroidery & Its Interpretive History 54

SHEILA BONDE & CLARK MAINES
The Heart of the Matter: Valois Patronage of the Charterhouse at Bourgfontaine 77

CLAUDINE LAUTIER
The Canons of Chartres: Their Patronage and Representation in the Stained Glass of the Cathedral 99

ANNE DERBES
Patronage, Gender & Generation in Late Medieval Italy: Fina Buzzacarini and the Baptistery of Padua 119

BENJAMIN ZWEIG
Picturing the Fallen King: Royal Patronage & the Image of Saul's Suicide 151

NIGEL MORGAN
What are they Saying? Patrons & Their Text Scrolls in Fifteenth-Century English Art 175

ROBIN CORMACK
'Faceless Icons': The Problems of Patronage in Byzantine Art 194

CORINE SCHLEIF
Seeking Patronage: Patrons & Matrons in Language, Art, and Historiography 206

ADELAIDE BENNETT
Issues of Female Patronage: French Books of Hours, 1220–1320 233

STEPHEN PERKINSON
Portraits & Their Patrons: Reconsidering Agency in Late Medieval Art 257

LUCY FREEMAN SANDLER
The Bohun Women & Manuscript Patronage in Fourteenth-Century England 275

ADEN KUMLER
The Patron-Function 297

GENERAL INDEX 323

INDEX OF MANUSCRIPTS 333

PREFACE

IT GIVES ME great pleasure to present the proceedings from a conference on patronage and medieval art that was organized by the Index of Christian Art in Princeton University to celebrate the ninety-fifth anniversary of its foundation. Over the last few years, the Index has played an active role on the conference circuit by organizing events that focus on topical matters in medieval art, and our efforts to look at the role of patronage last year paid major dividends. We attempted to define the various roles and possible functions of the patron over two very exciting days. We discussed all the terms used to refer to those responsible for or associated with the creation of works of art, and made efforts to understand and separate out the possible functions of owner, artist, patron, commissioner, and user. Even though we usually set out at the start of our conferences with lofty ideals to provide definitive answers for all of our subjects, we usually end up short of that goal! This event was different, however, and I must admit to being particularly pleased with the progress we made. This series of studies really did make a lot of progress in working towards resolution for some large-scale issues in the role of patronage. It is always rewarding to see the Index playing such an active role in the field of medieval studies.

The subject for this conference was given to us by Elizabeth Carson Pastan who approached me several years ago to see if we would be interested in discussing the theme. I was impressed by her eagerness to deal with the topic and by her approach to the subject. Although there were some obvious omissions in the speaker list, we worked closely in getting some of the most eminent scholars in the field to speak at the event. It was pleasurable to see them in the audience and leading the discussions at the end of these talks. My sincere thanks go to Elizabeth not only for all her work leading up to the event but also for her quiet and considerate behind-the-scenes prompting of speakers to ensure that these papers now appear before you. She has been a pleasure to work with. Not only did she help organize the event, but she also pre-sented a wonderful paper at the conference, which is also included in this volume.

The aim of the conference was to look at the many aspects of the topic—from papal to ecclesiastical patronage, to female to courtly, to secular to royal, as well as to the different functions of artist, architect, donor, user, and so forth, and to see how they overlapped, if indeed they did. If anything was to be learned from these studies, it was clear that one cap does not fit all heads and we have to see each case as distinct. Our efforts to apply one solution or definition to the role of the patron does not work.

With two exceptions, all of the speakers at the conference decided to publish their papers and my thanks go to them. It was with a certain amount of difficulty that they met deadlines, but we got there in the end! Their papers are uniformly focused and all dealt with the subjects that they were asked to present. Even though they looked at various aspects of patronage, they all overlap nicely, and taken together they present a comprehensive picture of the subject. True to the aims of the Index, we looked at as many media as was possible—from metalwork to architecture to manuscripts to panel paintings, stretching from Byzantium to thirteenth-century England. We had individual case studies and high-level papers on the general theory of patronage. Of course, we could not deal with every aspect of the subject and if there are omissions, then the fault is mine.

A number of people who worked behind the scenes must be acknowledged, and from the outset I should like to thank everybody who contributed towards making it a memorable event. The moderators for the two days were Madeline Caviness, Patrick Geary, and Elizabeth Carson Pastan, and they have my profound thanks. I wish to thank the Council of the Humanities in Princeton University for their continued support in the running of these conferences. All of my colleagues in the Index gave of their resources and expertise not only in helping at the event but also in the editing of these essays. These are Fiona Barrett, Adelaide Bennett, John Blazejewski, Judith Golden,

Jon Niola, Beatrice Radden Keefe, Jessica Savage, and Henry Schilb. Michelle Horgan from the Conference and Events Service in Princeton University assisted in many ways.

We have worked with Mark Argetsinger in copy-editing and designing these Index volumes for the last seven or eight years and his work continues to impress and amaze me. He weaves a magic spell with a lot of hard work over a bundle of loose papers and image files and makes volumes such as this appear, as if effortlessly. I am indebted to him for all his help and guidance.

<div style="text-align: right">

Colum Hourihane
Director
Index of Christian Art

</div>

FOREWORD

WHAT MEDIEVALIST hasn't felt a twinge of source envy in reading about the several hundred documents detailing the artistic commissions in Michael Baxandall's *Painting & Experience in Fifteenth Century Florence?*[1] A guiding notion behind this conference was to have medievalists speak about the nature and texture of their findings on patronage, thus allowing examples from the Middle Ages to inform a conversation often dominated by a later paradigm.

Within Baxandall's study of fifteenth-century Florence, three strategies that are promising for medievalists may nonetheless be discerned. The first is Baxandall's precision of language, which led him to set aside the term "patron" because he felt that it carried too many overtones from other situations. Instead he called his particular subjects "clients," whom he defined as the "active, determining and not necessarily benevolent agent[s] in the transaction of which the painting is the result"—powerful Florentines who aimed to control the artist as they allotted funds in ways that affected the character of the painting, withholding them if they were not satisfied.[2] Following his lead, medievalists need to construct a purpose-built language that speaks more clearly to the scenarios we seek to describe. Is the putative patron truly the author of the iconographic program, or an impresario with a vision that others fulfilled,[3] or one whom the work honors?[4] Is it possible, as Herbert Kessler has argued in the case of the *Vivian Bible*, that

the so-called patron was little involved in the iconographic program?[5] In the eponymous Carolingian manuscript, despite the appearance of Count Vivian in both a dedication miniature and poem, Kessler persuasively demonstrated that the count, a military hero who was made lay abbot in compensation for his services, left the complexities of its iconographic program to others.

Baxandall also made a second important point in reference to patronage, in noting that certain media, such as the large fresco cycles of fifteenth-century Florence, might require a more complex process than the singular engagement of the client that he highlighted for panel painting.[6] Indeed, recent analyses of the necessarily collaborative medium of medieval stained glass windows have demonstrated that the assumption based on norms derived from panel painting of one master craftsman overseeing one window requires substantial modification in view of the evidence that teams of craftsmen with recognizably different styles worked together across multiple windows.[7] In a glazing cycle requiring hundreds of windows, a collaborative approach makes inherent sense, both in the glaziers' execution of so many windows simultaneously and in the chapter's oversight of the iconographic program, as both Jane Welch Williams and Colette Mahnes-Deremble have examined from different perspectives.[8]

A third area were medievalists have much to con-

1. M. Baxandall, *Painting and Experience in Fifteenth Century Italy: A Primer in the Social History of Pictorial Style* (Oxford, 1972), 5.

2. *Ibid.*, 1.

3. As P. Kidson, "Panofsky, Suger and St. Denis," *Journal of the Warburg and Courtauld Institutes* 50 (1987), 1–17, argues was the case for Abbot Suger's role in the rebuilding of the abbey church of Saint-Denis.

4. See E. C. Pastan and S. D. White, "Problematizing Patronage: Odo of Bayeux and the Bayeux Tapestry," in *New Approaches to the Bayeux Tapestry*, ed. M. K. Foys, K. E. Overbey, and D. Terkla (Woodbridge, 2009), 1–24.

5. H. L. Kessler, "A Lay Abbot as Patron: Count Vivian and

the First Bible of Charles the Bald," in *Committenti e Produzione Artistico-Letteraria nell'Alto Medioevo Occidentale (4–10 April 1991)*, Settimane di Studio del Centro Italiano di Studi sull'Alto Medioevo, 39 (Spoleto, 1992), 647–679.

6. Baxandall, *Painting and Experience*, 21–22.

7. M. W. Cothren, "Suger's Stained Glass Masters and their Workshop at Saint-Denis," in *Paris, Center of Artistic Enlightenment*, ed. G. Mauner *et al.*, Papers in Art History from Penn State University, 4 (University Park, Pa., 1988), 46–75, esp. 51–54; and C. Lautier, "Les peintres-verriers des bas-côtés de la nef de Chartres au début du xiiiᵉ siècle," *Bulletin Monumental*, 148 (1990), 7–45.

8. C. Mahnes-Deremble, *Les vitraux narratifs de la cathédrale*

tribute is in the evaluation of visual evidence, which Baxandall always sought to square with the documentary materials he adduced.[9] There may be fewer surviving medieval contracts and, quite possibly, there were fewer medieval commissions in writing that spelled out the terms by which the work of art would be undertaken. But even in those cases where a contract portrays a certain ideal in written form, medievalists have been fearless in thinking around the document and between the lines.[10] Here again, studies of stained glass provide a salutary example, as the comparison of the glazing contracts for Antonio of Pisa and his colleagues at Florence Cathedral with the late fourteenth-century stained glass windows there demonstrates. This collaborative study, overseen by Claudine Lautier and Dany Sandron, showed that even within a system where panel painters provided the cartoons, and where contracts spelled out the obligatory indebtedness of the glass maker to the panel painter's cartoon, the glass painter could nonetheless make a significant impact on the outcome of the windows through color choices, paint handling, glass cutting, lead placement, and border designs.[11] Scholars more given to the primacy of the written contract might have been put off, but the French team, informed by Antonio of Pisa's own treatise on glass making, insisted on the visual evidence offered by Antonio's extant window in the nave of Florence Cathedral.[12]

These three themes—the definition and refinement of what exactly is meant by the term patron in a given scenario, an appreciation for collaborative endeavor and attention to media and programs that require it, and finally an insistence on visual evidence, not just in the absence of written documentation but sometimes in spite of it—hardly offer an exhaustive account of the issues implicated in this conference on medieval patronage. Nonetheless, they begin to set out the content that was refined and developed in the course of the conference, as the papers within attest.

My gratitude to Colum Hourihane and his entire staff at the Index of Christian Art at Princeton University is boundless. Indeed, the excellence of the contributors was matched only by the kindness and solicitude of our hosts. I particularly appreciate Colum's tact and inclusiveness, coupled with his advocacy of the highest intellectual standards. In all the right ways, and in only the best ways, he resembles one of Baxandall's exacting patron-clients in bringing about conferences and publications of great caliber and lasting importance.

ELIZABETH CARSON PASTAN
Emory University
April 2013

de Chartres: étude iconographique (Paris, 1993), and the review by A. A. Jordan in *Speculum* 72 (1997), 524–526; and J. W. Williams, *Bread, Wine & Money: The Windows of the Trades at Chartres Cathedral* (Chicago, Ill., 1993).

9. Baxandall, *Painting and Experience*, esp. 109–153.

10. P. Buc, *The Dangers of Ritual: Between Early Medieval Texts and Social Scientific Theory* (Princeton, N.J., 2001).

11. C. Lautier and D. Sandron, eds., *Antoine de Pise: L'art du vitrail vers 1400*, Corpus Vitrearum France, Études, 8 (Paris, 2008), and the review by E. C. Pastan in *Speculum* 85 (2010), 986–988. Also R. K. Burnam, "The Glazing of Siena Cathedral's *fenestra rotunda magna*: Preliminary Observations from a Production Standpoint," in *The Four Modes of Seeing: Approaches to Medieval Imagery in Honor of Madeline Harrison Caviness*, ed. E. S. Lane, E. C. Pastan, and E. Shortell (Oxford, 2009), 13–29.

12. This is an approach that Hartmut Scholz has also pursued with not dissimilar results for glass paintings from Nuremberg in the circle of Albrecht Dürer. See H. Scholz, *Entwurf und Ausführung: Werkstattpraxis in der Nürnberger Glasmalerei der Dürerzeit* (Berlin, 1991).

NOTES ON THE CONTRIBUTORS

ADELAIDE BENNETT is a research scholar in the Index of Christian Art and a board member for the journal *Studies in Iconography*. She studied under Robert Branner at Columbia University where she received her Ph.D. She has published widely in the area of manuscript illumination and is presently compiling a catalogue of French Books of Hours from 1200 to 1320. She has contributed to past Index publications, including most recently the eighty-fifth anniversary volume *Insights & Interpretations: Studies in Celebration of the Eighty-fifth Anniversary of the Index of Christian Art* (2002). Amongst her studies are "Making Literate Lay Women Visible: Text and Image in French and Flemish Books of Hours, 1220–1320," in *Thresholds of Medieval Visual Culture: Liminal Spaces*, edited by Elina Gertsman and Jill Stevenson (2012); "Devotional Literacy of a Noblewoman in a Book of Hours of ca. 1300 in Cambrai," in *Manuscripts in Transition: Recycling Manuscripts, Texts, and Images*, Proceedings of the International Congress held in Brussels (5–9 November 2002), edited by Brigitte Dekeyzer and Jan van der Stock (2005).

SHEILA BONDE is Professor in the Department of Archaeology and the History of Art and Architecture at Brown University. She received her B.A. from Cornell University in 1975 and her A.M. and Ph.D. degrees from Harvard in 1976 and 1982, respectively. She taught at Reed College before going to Brown and has served as a visiting professor at the Université Paris I (Sorbonne). She has excavated in England, France, and Israel, and currently directs the MonArch excavation and research project in northern France at the Augustinian abbey of Saint-Jean-des-Vignes in Soissons, the Carthusian house at Bourgfontaine, and the Cistercian monastery at Notre-Dame d'Ourscamp. Her research combines archaeology, architectural history, spatial analysis, and digital humanities. Amongst her many publications are *Re-Presenting the Past: Archaeology through Image & Text*, co-edited with Stephen Houston (2011); *Saint-Jean-des-Vignes: Approaches to its Architecture, Archaeology, and History*, with Clark Maines, Biblioteca Victorina, XV (2003); *Soissons: L'abbaye Saint-Jean-des-Vignes*, Archéologie en Picardie, 23 (2002); *Glimpses of Grandeur: Courtly Arts of the Later Islamic Empires*, with Aimée Froom (1999); *Fortress-Church: Architecture, Religion & Conflict in Twelfth-Century Languedoc* (1994); and *Architectural Technology up to the Scientific Revolution: New Methods and Interpretations*, co-authored with Lynn Courtenay, Clark Maines, Robert Mark, and Elwin Robison (1993). She is currently working on *The Medieval Charterhouse at Bourgfontaine*, co-authored with Clark Maines, accepted for publication as a separate volume of the Analecta Carthusiana series (forthcoming).

JILL CASKEY is Associate Professor in the Department of Art History at the University of Toronto. She received her A.B. from Bryn Mawr College and her Masters and Ph.D. from Yale University. A medievalist, she has received several awards and honors, including a Fulbright Full Grant at the University of Naples (1991–1992), a Samuel H. Kress Predoctoral Fellowship at the American Academy in Rome (1992–1994), and a Getty Post-doctoral Fellowship in Art History (1999–2000). Her scholarly interests include the art and architecture of medieval southern Italy and the concept of "global" medieval art, together with multiculturalism. She has published in the field of patronage especially with regard to southern Italy and Sicily from *c.* 1050 to 1350. She is currently looking at the patronage of major cult and pilgrimage sites in southern Italy around 1300. She is the author of *Art & Patronage in the Medieval Mediterranean: Merchant Culture in the Region of Amalfi* (2004), and has edited *Confronting the Borders of Medieval Art*, with Adam S. Cohen and Linda Safran (2011). Amongst her recent articles are "The Look of Liturgy: Identity and *ars sacra* in Southern Italy," in *Ritual & Space in the Middle Ages*,

Proceedings of the Harlaxton Symposium 2009, edited by Frances Andrews (2011); "Stuccoes from the Early Norman Period in Sicily: Fabrication, Figuration, and Integration," *Medieval Encounters* 17 (2011); and "Whodunnit? Patronage, the Canon, and the Problematics of Agency in Romanesque and Gothic Art," in *A Companion to Medieval Art: Romanesque & Gothic in Northern Europe*, edited by Conrad Rudolph (2006).

ROBIN CORMACK is Emeritus Professor in the History of Art at the Courtauld Institute of Art, University of London, and associate in Classics in the Faculty of Classics at the University of Cambridge. He received his B.A. (Literae Humaniores) from the University of Oxford (1961), an Academic Diploma in the History of Art from the University of London (1964), a Masters from the University of Oxford (1965), and a Ph.D. from the University of London (1968) for a study entitled "Monumental Painting and Mosaic in Thessaloniki in the Ninth Century," which was supervised by Professor H. Buchthal and Professor C. Mango. He became a Fellow of the Society of Antiquaries in 1975. Throughout his distinguished career he has been Deputy Director of the Courtauld Institute of Art (1999–2002), Acting Director for the Spring term in 2001, and Honorary Professor in the History of Classical Art at the University of Nottingham (2005–2008). Best known for his many publications, he has also been the driving force behind some of the major exhibitions on Byzantine art in recent times, including *From Byzantium to El Greco*, Royal Academy (1987, consultant); *After Byzantium* (1996, consultant and curator); *Russian Icons*, Virginia Museum of Fine Art, Richmond (1997, consultant); *The Art of Holy Russia: Icons from Moscow 1400–1660*, Royal Academy (1998, consultant); *Mother of God*, Benaki Museum (2000, member of the Scientific Committee); *Sinai, Byzantium, Russia* at the Courtauld (2000–2001, curator). He was co-curator of the major Byzantine exhibition in the Royal Academy in 2008–2009: *Byzantium 330–1453*. Amongst his many publications are *Writing in Gold: Byzantine Society and its Icons* (1985); *The Byzantine Eye: Collected Studies in Art and Patronage* (1989); *Painting the Soul: Icons, Death Masks, Shrouds* (1997); *Byzantine Art* (2000); and *Byzantium 330–1453*, edited with Maria Vassilaki (2009).

ANNE DERBES is Professor of Art History and Co-director of the Honors Program at Hood College. She received her B.A. from Vanderbilt University (1969), her Masters from the same university in 1971, and her Ph.D. from the University of Virginia in 1980 for a dissertation entitled "Byzantine Art and the Dugento: Iconographic Sources of the Passion Scenes in Italian Painted Crosses." She was the Forsyth Lecturer for the International Center of Medieval Art in 2012. She is currently working on *Gender & Generation in Late Medieval Padua: Fina Buzzacarini and the Fresco Program of Padua's Baptistery* and *The Moral Topography of Hell in the Arena Chapel*, with Mark Sandona. Amongst her many publications are *Picturing the Passion in Late Medieval Italy: Narrative Painting, Franciscan Ideologies, and the Levant*, with Mark Sandona (2004), and *The Usurer's Heart: Giotto, Enrico Scrovegni, and the Arena Chapel in Padua*, with Mark Sandona (2008).

LUCY FREEMAN SANDLER received her Ph.D. from the Institute of Fine Arts, New York University, in 1964. She joined the faculty of New York University the same year as assistant professor, before becoming full professor in 1975. She became the Helen Gould Sheppard Professor of Art History Emerita in 2003. She has served on the boards of and as an advisor to a number of learned organizations, amongst which are the Medieval Academy of North America, the International Center of Medieval Art, the Medieval Manuscripts Society, and the American Council of Learned Societies. She is a Fellow of the Society of Antiquaries of London and a Fellow of the Medieval Academy of America. Her many publications include *Gothic Manuscripts, 1285–1385*, A Survey of Manuscripts Illuminated in the British Isles, V (1986); *The Lichtenthal Psalter and the Patronage of the Bohun Family* (2004); and *The Splendor of the Word: Medieval and Renaissance Illuminated Manuscripts at The New York Public Library*, co-edited with J. J G. Alexander and James H. Marrow (2005).

ADEN KUMLER has been Assistant Professor of Art History at the College at the University of Chicago since 2007. She received her B.A. from the University of Chicago (1996), her Masters from the Centre for Medieval Studies, University of Toronto (2000), her Ph.D. from Harvard University (2007), and her L.M.S. (Licentiate in Mediaeval Studies), Pontifical Institute of Mediaeval Studies, Toronto (2012). She is editor of the Online Census of Graduate Programs in Medieval Art, was a member of the Electronics Committee at the International Center of Medieval Art (2008–2012), and was Chair of the Graduate Student Committee of the Medieval Academy of America (2003–2004). She was Elected Fellow of the Wissenschaftskolleg zu Berlin (2014–2015) and was Guest Professor of the EIKONES Research Project, University of Basel, Switzerland (2012–2013). Amongst her many publications are *Translating Truth: Ambitious Images and Religious Knowledge in Late Medieval France & England* (2011); "Translating ma dame de Saint-Pol: The Privilege and Predicament of the Devotee in Paris, BnF, MS naf 4338," in *Translating the Middle Ages*, edited by Karen Fresco and Charles Wright (2012); "The Multiplication of the Species: Eucharistic Morphology in the Middle Ages," *RES: Anthropology and Aesthetics* 59/60 (2011). She is co-editor (with Christopher Lakey) of the recently published special issue of *Gesta* (2013), "*Res et significatio*: The Material Sense of Things in the Middle Ages."

CLAUDINE LAUTIER is now a corresponding member of the Centre André Chastel after being a CNRS researcher in charge of a team whose task was to examine stained glass. She was responsible for the restoration of all the stained glass windows from Chartres Cathedral. She was vice-president of the International Corpus Vitrearum (to 2012), and is a member of the French Committee of the Corpus Vitrearum. Her main interests include the history of stained glass, with a particular focus on that of Chartres Cathedral, as well as the techniques used by stained glass artists. She has also researched and published on Gothic architecture. Amongst her many publications are *Île-de-France, Gothique*, co-authored with Maryse Bideault (1987–1988); *Les vitraux de la cathédrale de Chartres: Reliques et images*, special issue of the *Bulletin monumental* 161 (2003); *Les vitraux du chœur de la Cathédrale de Troyes (XIIIᵉ siècle)*, by Elisabeth C. Pastan and Sylvie Balcon, with the assistance of Claudine Lautier (2006); and *Antoine de Pise: l'art du vitrail vers 1400*, by Claudine Lautier and Dany Sandron (2008).

JULIAN LUXFORD is Senior Lecturer in Art History at the University of St. Andrews School of Art History, where he has been since 2004. He received his B.A. in 1997 from La Trobe University (Melbourne) and his Doctor of Philosophy for a study entitled "The Patronage of Benedictine Art and Architecture in the West of England during the Later Middle Ages (1300–1540)" in 2002 from the University of Cambridge (King's College). He has been Senior Research Fellow at the Paul Mellon Centre for British Art since 2012. He is editor of the *Journal of the British Archaeological Association* (2008–present), as well as a Council Member of the British Archaeological Association. Amongst his many current research projects are a Corpus of Scottish Medieval Parish Churches (dioceses of St. Andrews and Brechin), which is an AHRC-funded project to survey the fabric and documentary evidence for approximately 250 medieval churches in these dioceses. He is also undertaking two monographs—one on drawings in British medieval manuscripts and the second on the Carthusians in the Middle Ages—which will be published as part of Boydell Press's Monastic Orders series. Amongst his most recent articles are "Luxury and Locality in a Late Medieval Book of Hours from South-West England," *Antiquaries Journal* 93 (2013); "King Arthur's Tomb at Glastonbury: The Relocation of 1368 in Context," *Arthurian Literature* 29 (2012); "The Great Gate of St Augustine's Abbey: Architecture and Context," in *Canterbury: Art and Architecture after 1220*, edited by A. Bovey, British Archaeological Association Conference Transactions, 25 (2012). He is the author of *The Art and Architecture of English Benedictine Monasteries, 1300–1540: A Patronage History* (2005).

CLARK MAINES is the Kenan Professor of the Humanities, Professor of Art History, Professor of Environmental Studies, Professor in the Archaeology

Program, and Professor of Medieval Studies at Wesleyan University. He received his B.A. from Bucknell University (1968), his M.A. from The Pennsylvania State University (1972), and his Ph.D. from the same university in 1979 for a study entitled "The Western Portal of Saint-Loup-de-Naud (Seine-et-Marne)." He is co-founder and co-director of the Wesleyan–Brown Archaeology Project at the Cistercian Monastery of Notre-Dame d'Ourscamp (2003–present), as well as founder and co-director of the Wesleyan–Brown Archaeology Project at the Augustinian Abbey of Saint-Jean-des-Vignes, Soissons (1982–present). He was also director of the Saint-Loup-de-Naud Architectural Survey (1992–1993) and co-director of the Bourgfontaine Architectural Survey Project (2004–present). He was editor for *Gesta* (2007–2010) and co-editor of the *Old World Archaeology Newsletter* from 1990 to 2001. Amongst his many publications are *Saint-Jean-des-Vignes in Soissons: Approaches to its Architecture, Archaeology, and History*, Biblioteca Victorina, xv, co-authored with S. Bonde, E. Boyden, and K. Jackson-Lualdi (2003); *Architectural Technology up to the Scientific Revolution: The Art and Structure of Large-Scale Buildings*, co-authored with S. Bonde, L. Courtenay, R. Mark, and E. Robison (1993); *The Western Portal of Saint-Loup-de-Naud* (1979); and *Making Thoughts, Making Pictures, Making Memories*, a special issue in honor of Mary J. Carruthers, *Gesta* 48/2 (2010).

NIGEL MORGAN is currently Emeritus Honorary Professor of the History of Art at the University of Cambridge. He received his B.A. from the University of Cambridge (1964), his Masters from the same university in 1968, and his Ph.D. from the Courtauld Institute of Art in 1988 for a study entitled "Early Gothic Manuscript Illumination in England, 1190–1285." Throughout his distinguished career he has taught at a number of colleges, including the School of Fine Art, University of East Anglia (1968–1976), Westfield College, University of London (1976–1982), La Trobe University (1991–1997), University of Oslo (1989–1990, 1997–2005), and New York University (2005). He was a Visiting Fellow at the J. Paul Getty Museum in 1990 and at All Souls College, Oxford, in 1996. He was also director of the Index of

Christian Art in Princeton University for five years (1982–1987). His many monographs include *Medieval Art in East Anglia, 1300–1520*, with P. Lasko, Exhibition Catalogue, Castle Museum, Norwich (1973); *The Golden Age of English Manuscript Painting, 1200–1500*, co-authored with R. Marks (1981); *Early Gothic Manuscripts, 1190–1250*, Survey of Manuscripts Illuminated in the British Isles, iv, Part 1 (1982); and *Early Gothic Manuscripts, 1250–1285*, Survey of Manuscripts Illuminated in the British Isles, iv, Part 2, (1988); *The Douce Apocalypse* (2006); *Illuminating the End of Time: The Getty Apocalypse Manuscript* (2012); and *English Monastic Litanies of the Saints after 1100*, Vol. 1, Henry Bradshaw Society, CXIX (2012).

ELIZABETH CARSON PASTAN is Associate Professor in the Department of Art History at Emory University. She received her B.A. in English and Art History from Smith College in 1977 and her Ph.D. from Brown University in 1986 for a study entitled "The Early Stained Glass of Troyes Cathedral, *c.* 1200–40." In her distinguished career she has taught at Brown University, Boston College, Rhode Island School of Design, Wellesley College, Indiana University, and Emory University. She is President of the American Corpus Vitrearum and has sat on the board of many organizations, including the International Center of Medieval Art (2007–2010), and as *membre associé* of the Corpus Vitrearum, Comité français. She is currently working on a study entitled *Picturing the Norman Conquest: The Bayeux Embroidery & the Abbey of St. Augustine's, Canterbury*, in conjunction with Stephen D. White, for publication in 2014. Amongst her most recent articles are "J. Pierpont Morgan and the Collecting of the Twelfth-Century Stained-Glass Panels from Troyes," *Collections of Stained Glass and their Histories*, edited by Tim Ayers, Brigitte Kurmann-Schwarz, Claudine Lautier, and Hartmut Scholz (2012); and "A Feast for the Eyes: Representing Odo in the Bayeux Embroidery," in *The Haskins Society Journal: Studies in Medieval History* 22 (2010). She also has several edited volumes to her credit, including *Edouard Manet and the 'Execution of Maximilian,'* Exhibition Catalogue (1981); *The Four Modes of Seeing: Approaches to Medieval Art in Honor of Madeline*

Harrison Caviness, with Evelyn Staudinger Lane and Ellen Shortell (2009); *Les vitraux du chœur de la cathédrale de Troyes (XIIIᵉ siècle)*, with Sylvie Balcon, Corpus Vitrearum France, ii (2012).

STEPHEN PERKINSON is Associate Professor in the Department of Art History at Bowdoin College. He received his B.A. from Colgate University (1989), and his Ph.D. from Northwestern for a study entitled "Portraire, Contrefaire, and Engin: The Prehistory of Portraiture in Late Medieval France" (1998). Prior to teaching at Bowdoin, which he joined in 2008, he was Assistant Professor of Art History at the University of Denver, School of Art and Art History (2002–2008), and Assistant Professor of Art History at Skidmore College (1999–2002). Amongst his recent publications are "Likeness," in *Medieval Art History Today: Critical Terms*, special issue of *Studies in Iconography* 33 (2012); "'As they learn it by sight of images': Alabasters and Religious Devotion in Late Medieval England," in *Object of Devotion: Medieval English Alabaster Sculpture from the Victoria and Albert Museum*, edited by Paul Williamson and Fergus Cannan (2010). He is currently finishing "The Making of 'Mynding Signes': Copying, Convention, and Creativity in Late Medieval English Alabasters," which will be published in *Alabaster Sculpture in Late Medieval England: New Directions in Scholarship* [working title], edited by Jessica Brantley and Stephen Perkinson. His monograph *The Likeness of the King: A Prehistory of Portraiture in Late Medieval France* (2009) won the 2009 Morris D. Forkosch Prize for Best First Book in Intellectual History, awarded by the *Journal of the History of Ideas*.

CORINE SCHLEIF is Professor of Art History in the Herberger Institute for Design and the Arts at Arizona State University. She first studied at Washington University in St. Louis, from which she received her Masters (1980), and subsequently at the Universität Bamberg in Germany, from which she received her Doctorate in Philosophy (1986). Her research and publications examine art within several contexts as she uncovers the various social functions that precipitate its manufacture, as well as the ideological nego-

tiations that accompany it through its ever-changing meanings. She has consistently pointed to the interplay of various media, beginning with her first articles on pictorial and written sources promoting Saint Deocarus. Recently, she has drawn attention to visual and tactile agencies. Since 1998, her research and publications have focused on feminist issues, especially the roles of artists' wives in art history and historiography, as well as the more general role of women from the gendered placement of donors and saints. Her interests in archival sources, postmodern theory, women's agency, cultures of gift-giving, and multisensory experience all come together in her most recent research, including the study *Katerina's Windows: Donation and Devotion, Art and Music, as Heard and Seen in the Writings of a Birgittine Nun*, co-authored with Volker Schier (2009). Amongst her many publications are *Donatio et memoria: Stifter, Stiftungen und Motivationen an Beispielen aus der Lorenzkirche in Nürnberg* (1990); "Kneeling on the Threshold: Donors Negotiating Realms Betwixt and Between," in *Thresholds of Medieval Visual Culture: Liminal Spaces*, edited by Elina Gertsman and Jill Stevenson (2012).

BENJAMIN ZWEIG is a doctoral candidate in the Department of History of Art and Architecture at Boston University (expected 2013). He received his B.F.A. in Art History and Painting at Massachusetts College of Art in 2005 and his M.A. from the Department of Art and Art History at Tufts University in 2007. He received a Graduate Research Abroad Fellowship from Boston University in 2011 as well as the President's Grant from the Society for the Advancement of Scandinavian Study in Boston University in 2011. He had a Fulbright Fellowship at Uppsala University from 2007 to 2008 and was a Teaching Fellow in Art History at Boston University from 2010–2011. Amongst his research interests are representation of suicide in medieval art; representations of emotions in pre-Modern Europe; art history and neuroscience; medieval art and science; iconoclasm; historiography of medieval art; hermeneutics and epistemology; subjectivity; medieval Scandinavian art and architecture; and medieval art and culture on film.

INTRODUCTION

WHEN Elizabeth Pastan first approached me with the idea of organizing a conference on the subject of patronage, I was interested but also a little reticent. My reluctance came from the fact that I rather sadly wondered what else could be considered that had not already been said. It was not until I looked at some of the recent bibliography on the topic that I realized what a huge interest existed and how considerable a need there was to revisit the topic. This was what led us to spend two days looking at the topic from as many angles as we could: from royal to secular, from female to ecclesiastical; in as many media as we could consider, from architecture to metalwork; in a sweep of locales, from the eastern realms of Europe to its western shores; and ranging over the entire medieval period. At the conference, we had some general, high-level studies of the subject interspersed with specific case studies. Nothing prepared us for the complexity of the topic! It was clear after the first few papers that our wishes to apply one neat, watertight definition to the whole issue would not suffice and we were going to have to deal with every case individually. If there was overlap, then it was a blessing, but it was not something we expected. In the past, studies on patronage have revolved around works for which we have solid, documented evidence, be it a specific date, person, artist's involvement, or comment, and we have then attempted to build and extend from those data into broader pictures involving related works and processes. We have built up pictures and attempted to understand the processes by which works were made using what are clearly less-than-firm foundations.

Wikipedia defines patronage as "the support, encouragement, privilege, or financial aid that an organization or individual bestows to another." It goes on to say, "In the history of art, arts patronage refers to the support that kings or popes have provided to musicians, painters, and sculptors." This simple, rather unsatisfactory statement is loaded in itself, and does not do justice to the complexity of a term that has recently gained widespread currency, in part due to our wishes to understand the parameters of the individuals, institutions, and processes involved. Traditionally, we have tried to apply what we know from some of the better-known patrons to those works for which we don't have information, and, of course, this can paint a misleading picture. The role of the patron has also been confused at times with that of user, or artist, or maker, and it is clear that patronage may not encompass any of these elements. Just who was responsible for the idea, the program, the finance, and the making may all be invested in a single person or, as well, in many. We use terms with abandon and interchangeably when they may not shoulder the burden.

Over the two days of the conference we used terms such as *considerateur*, *décideur*, *auctor*, *patronus*, patron, instigator, donor, founder, promulgator, commissioner, creator, benefactor, real patron, supposed patron, imagined patron, beneficiary, and user to refer to some of those involved in the patronage process! We have assumed that such roles included the process of commissioning, designing, paying, and using the finished works. We have subtly blurred and at times merged the role of creator or designer with that of donor or patron, and we have not worked out how far one person's role blends with that of another. We are too reliant on the long-held tripartite equation of there being a patron who has both the idea and finances to create, an advisor whose involvement is to suggest an intellectual schema, and a maker or artist who actually transfers those ideas into reality. As Holly Flora has pointed out, this is a Renaissance model that we have not questioned until recently.* Wherever possible, we have always attempted to look at each work of art from its genesis, and that, of course, can involve a person or institution whose

* H. Flora, "Patronage," in *Medieval Art History Today: Critical Terms*, ed. Nina Rowe, special issue of *Studies in Iconography* 33 (2012), pp. 207–218.

idea it was, who may have had involvement in its design and making, who may have paid for it, and who may eventually have used it or given it to somebody who did. It is a question that has always been to the fore—for whom or why was the work made and what was that person's (or persons') input? The role of the artist is one that has remained undefined around the edges and may not have been consistent or uniform in meaning, but it is also a role on which we have tried to impose one definition or meaning. It is also clear that these various roles may have been shared.

It seemed obvious after two days of focused papers that the key to understanding the whole concept of patronage was firstly to realize that a variety of contexts and situations existed that prevent one definition from being imposed. Situations differed from country to medium to individual. Patronage for stained glass is vastly different from that of a manuscript. In our wishes to understand works, we have held on to the belief that we will understand it better by knowing who made it and for whom was it made. It has become an all-consuming quest at times and in some instances has obliterated a better understanding of the works themselves. Some of these papers, such as those by Jill Caskey, Aden Kumler, and Stephen Perkinson, look at personal as well as collective agency and highlight how patronage is in many ways a continuous, organic process—but it is also a process that may not incorporate everything. The traditional models are questioned and some new innovative perspectives are discussed. Many of the papers point out that the concept of salvation lies at the core of patronage and the belief that by doing good on this earth the patron will benefit in the next world. One paper looks at patronage from the perspectives of the artwork's pre- and post-natal linkages. Another study looks at the tactics of patronage and the performative nature of the subject. Many of the studies highlight the two-way process of its benefits—how it suits both the benefactor as well as the recipient. The baseline, after two intense days of focusing on the subject, was that every work should speak for itself. Looking at patronage and trying to make the work fit into our own pre-defined categories may lead us astray.

The opening paper at this event was given by Jill Caskey, who has studied the subject for a number of years and who gives us here a magisterial survey of patronage from the Late Antique to the late medieval period. Part historiography and part case study, it looks at the roles and processes involved with a particularly insightful emphasis on agency. For her it is the "proactive engagement through which a person or people affected works of art in ways distinct from the nitty-gritty of facture." Agency is a word that sits uncomfortably with most art historians and may need to be abandoned, and yet here we are using it in the title of this volume! Why don't we simply use the term process? Borrowed from the social sciences, agency conveys a multitude with a lack of precision that is terrifying. As an interpretative tool, it lacks application to the processes of patronage and should be abandoned. Jill highlights the diversity of practices involved and repeatedly points out the collaborative nature of patronage. The essay is a mine of useful insights, and I particularly liked her section on how the medieval language of patronage as found in inscriptions and other works can inform us. She points out its inconsistencies, its ambiguities and the fact that it also challenges our own linguistic abilities. Jill ends on an optimistic note with the expectation that new studies on patronage in the arts will profit from our realization that new methodologies and frames of reference will yield benefits.

Jill's ending is taken up and reiterated by the second paper in the collection, written by Julian Luxford, another scholar who has published extensively on the subject. Even though he has undertaken considerable research in the field of English monastic patronage, he proposes new areas for exploration in the field. He argues for an opening up of our approaches to the concept of English patronage and modestly states that they may not look innovative to the reader but that the benefits will be. He argues that the conceptual possibilities and utility of patronage are under used, and even though he states that he is going to avoid defining the term, he goes some distance towards doing it. I know that his focus on "internal" patronage will pay dividends in the future—in fact, he beautifully demonstrates that within his essay. He

looks at the concepts of largesse and devotion and shows the nuances of patronage, its "priorities, balance and rhythms," before showing how it can indeed provide a lot for us in the line of a broader view than has hitherto been only glimpsed. He unites material development with patronage and shows the benefits for both parties before briefly outlining further possibilities in the realm of socio-economic patronage and the roles of imagination and affect in the placement of commissions and gifts.

All of the speakers were asked from the outset to place their subjects in a broader historiographical context, and no one had a greater task than Elizabeth Pastan who decided to examine the Bayeux Embroidery for her subject, and no one could have provided us with a more interesting and insightful paper. She argues that assumptions about its patronage have led to its mischaracterization as a Norman secular undertaking. Despite a number of recent studies on its complexity as a narrative, the textile is still routinely framed as a straightforward victory monument attesting to its putative patron's greatness. Scholars have established a strong case for its manufacture at St. Augustine's, Canterbury, without giving sufficient consideration to the authorial role played by the monks there, whose skill and originality is well attested in such works as the Old English Hexateuch, and whose point of view better suits the perspective on the Norman Conquest in the hanging's complex pictorial narrative. Although we have no contemporaneous information about the textile in the first four centuries of its existence, both its materials and the earliest extant reference to it in the fifteenth-century inventory of Bayeux Cathedral suggest the plausibility of an ecclesiastical setting. In a beautifully rounded study, Elizabeth examines all the evidence and convincingly points to it being made at St. Augustine's, the result of collaborative and monastic patronage.

To confirm that every case and every building is different, one has to go no further than the detailed case study of the patronage of the Charterhouse at Bourgfontaine to see how complex the situation can be. Sheila Bonde and Clark Maines have disentangled the complex history and reasons behind this monastery, which was established between 1323 and 1325

by Charles, Count of Valois. Upon his death in 1325 the task fell to his son Philip, who completed it. Philip later became the first Valois King of France, which, of course, brings the establishment into a different realm. Both Charles' and Philip's bodies were divided upon death and interred at different foundations, but Philip's heart was to remain at Bourgfontaine. Their encyclopedic study deals with multiple patronage from both a noble and royal household. Sheila and Clark detail the involvement of the community and, using skilled detective work, they disentangle who did what and when. They show how the benefits of corporate patronage evolved and were two sided. In a skilled analysis, the two authors detail how a network of Papal, monastic, and royal relationships enabled the Valois to legitimatize their rule and presence and how the Carthusians also extended their network.

The construction of Chartres Cathedral must have entailed huge planning and massive expenses. It was clearly not undertaken in one phase, despite the remarkable continuity that the building exhibits. Despite the wealth of information that we have and the enormous amount of work that has been undertaken, we are still a long way off from being able to paint a complete picture. Renowned for its architecture, sculpture, and stained glass, the next case study in this collection looks at one subset of the remarkable assemblage of glass that dates to the start of the thirteenth century. Written by Claudine Lautier—a scholar who has devoted much of her life to the study of the glass of this building—it looks at the windows that were given by the canons of the cathedral. She paints a detailed and comprehensive picture of the works of these figures, whom she calls donor-canons. Some of these canons are brought out of anonymity through inscriptions, while others are known by name but are still unidentified, and a third set are known only from their images in glass. Claudine's task here has been to identify and catalogue them and she acknowledges that she does not know whether the windows were given by individuals or by the chapter. Patronage is not a neutral act and it usually involves current or topical issues to which the worshipper and donor can relate. Chartres is no exception, and Claudine shows how issues such as transubstantia-

tion, which had been discussed in the fourth Lateran Council of 1215, influenced the iconographical program of these windows.

The first of our essays on female patronage is by Anne Derbes who looked at Fina Buzzacarini and the Baptistery of trecento Padua. Anne's study attempts to understand the agency involved in female patronage and to understand just how much control a woman had in the final work. Was the act simply a symbol of status or did she have an active participatory role in such munificence? As Anne points out, it is a hugely complex issue involving roles and rules and regulations that could and might be overstepped if a woman were of such a status that enabled her to do so. It is a subject that is slowly revealing its secrets and we are beginning to see that the role of the woman was far more powerful than has hitherto been suspected or known. Once we can understand the role of the woman as a patron, it might be possible to better understand her general status in society and to see how autonomous or subservient she was in other areas. It is clearly going to be a picture that will evolve over time and studies such as Anne's will certainly add significantly to a bigger picture being painted. The Baptistery in Padua Cathedral was converted into a family mausoleum in the 1370s at the behest of Fina Buzzacarini, the consort of the ruling lord of Padua, Francesco da Cararra, from whom she was estranged. Anne paints a deft picture of how much Fina, an able and wealthy woman, may have accomplished in selecting frescoes that were personal and salvational. It may have been her independent strength that enabled her to undertake so pertinent and personal a program, but it is clear that it was also answering a need, at the end of her life, for salvation, while at the same time providing a framework for her son. Anne sees the program as Fina's will and legacy.

Another essay to look at gender is provided by Adelaide Bennett, who very sensibly warns us against the perils of reading too much into female imagery. There is a tendency for us to go too far in interpreting female images and gendered texts in many books. In a survey of French Books of Hours from 1220 to 1320, Adelaide looks at a number of examples that show the woman in prayer or reading. No one knows these manuscripts better than Adelaide, having spent most of her academic life studying these personal prayer books and their patronage. She encompasses issues of usership, readership, and ownership and looks at these works to see if patronage can be disentangled from what we traditionally believe the word encompasses. Surveying the gendered texts and images that show that the works were made for a woman, Adelaide questions the ability of the woman to act as patron for these works. Would these women have had the finances or power to determine what they wanted represented? She justly argues that ownership or use of these books did not necessarily mean that they were either commissioned or paid for by the woman who is shown as using them in the miniatures. The visual and textual programs may have reflected the concerns of the woman, but that does not necessarily mean that they were patrons. These would seem to point to the noblewoman being an indirect patron—one who knew what she wanted regarding prayers, text, and imagery, but who may have acquiesced to the hierarchical role of the male as the person who could actually pay for and commission such works in the first place. The woman was, as such, an indirect patron whose needs were met in these devotional works and who may have determined what she wanted represented, but who acted through the male as the person who could commission them.

Although not primarily concerned with female patronage, Corine Schleif's article has some insightful comments on gendered benefaction. In a particularly detailed study, she asks us to envisage what the medieval person thought of art before it became art. Our definition of works of art is, after all, a modern practice—works of art were not viewed as such when they were made. She asks the question "Were women patrons?" And, like both Anne and Adelaide elsewhere in this volume, she does not give a conclusive answer. She notes that it is an ubiquitous term and argues for looking at gendered patronage through different strategies. Much of her study is devoted to terminology and how we need to evaluate what words were used to described the benefactor. It is clear that artisans could be called donors, as indeed were sponsors and producers, so we have to be cautions in our use

of words. She rightly argues that every case is different and warns against imposing general judgments. Visual and textual evidence alone is not satisfactory and we need to go into complex history to fully understand what agency meant. This is beautifully demonstrated in a case study on the collegiate foundation at Nordhausen, wherein she shows how cautiously we have to tread to reach an understanding.

The final paper on female patronage looks at the acts of two members of the Bohun family and sees how they differed. Lucy Freeman Sandler has been one of our biggest supporters in the Index and no conference on patronage would be complete without her input. Similarly, no one can speak more authoritatively on the Bohun family than Lucy, and here she looks at two contrasting aspects or agencies of female patronage centering on Joan Fitzalan, the matriarch of the family, who actually commissioned the devotional books, Mary de Bohun who received these books, and Eleanor de Bohun, who was both a commissioner and a recipient and whose patronage also extended to her heirs. These two sides of female patronage have different strategies and needs—one is active, focused on the commission of books and the conception and execution of their pictorial programs, the other is passive, focused on the recipients and their reading and viewing experiences. It's a fine study that, like a number of others in this volume, makes us aware of the need to abandon our pre-conceived ideas and to look beyond the known. We have to see patronage as a multi-stepped process or agency involving commissioning, conceiving, executing, receiving, and bequeathing.

The Index, as always, attempts to act as patron in promoting and encouraging young scholarship, and this volume is no exception. Some months before this conference, the Index was visited by a young doctoral scholar from Boston University who was undertaking research on the subject of suicides in medieval art and was working on the relationship of subject and patron. He was questioning why the subject of suicide, and that of King Saul's in particular, was favored by certain iconographical programs. Examining three case studies, this essay looks at the reverse of patron and theme and goes from theme to patron, attempt-

ing to develop an understanding as to why this motif was used. In a nicely paced essay, Benjamin Zweig goes from the Carolingian to the Capetians and looks at works created under the patronage of Blanche of Castile and Louis IX. Ben sets his framework as that of Beat Brenk's patron-*donateur* to patron-*concepteur,* which he extends to include patron-*récepteur.* It was a theological subject that played an important role used with intent by a selected group—the royals—to convey a message. It may be, as Ben advises us, a *unicum,* but it repeats a message found elsewhere in this volume: that patronage usually has an ulterior motive. It is nearly always a process that is designed to bring benefits where possible. Even nowadays the patronage by a wealthy benefactor of a library or particular room is usually linked to the stipulation that it be called after the person who gave the funds to pay for it.

Sometimes it is possible to find clues as to the patron's intentions within the works themselves, and it is that subject on which one of my predecessors in the Index of Christian Art, Nigel Morgan, writes in this volume. Even though Nigel hopes that this is a subject that somebody will tackle in the future, his work shows just what can be accomplished. Nigel's subject is what he calls text scrolls (he says that with more research it might be possible to re-label them as speech scrolls), which are held by figures, usually kneeling, in English stained glass, brasses, and manuscripts. In an erudite essay he shows us some unknown as well as some familiar works, all of which receive his inimitable scholarly eye. He advises us that context and location are determinants in evaluating these and shows how some can be interpreted as private while others are public. They represent the direct intervention of the patrons and are perhaps even more important than the representations of the figures themselves, in that they speak directly to us through these scrolls. While many are simple prayers for the soul, others are more direct and personal.

The Index of Christian Art has always attempted to be as inclusive as is possible, and this volume is no exception. The Index covers all periods and areas of medieval art and not just that of the western world. Our lone Byzantinist to speak at this event was Robin

Cormack, who gave a precise and comprehensive historiographical evaluation of his predecessors who have dealt with the subject in Byzantium. Robin starts his essay with a question as to the value of the subject, if it gives us nothing more than an unidentified name lost to time. His survey starts with Hagia Sophia and encompasses images of the patron in religious paintings and mosaics, excluding secular art and other media. He probes, as many other authors in this volume do, the nature of patronage: who gave what and how far did their influence go? It is clear that in Byzantium the theme differs from that of the western world and that a much closer relationship existed between the donor and work. Even though his essays ends, as it started, with a question, it is clear that it is a subject that will pay dividends with future research.

Although agency is referred to frequently throughout these essays and is dealt with in detail by nearly all authors, it really is the focus of the opening and last few essays, those by Jill Caskey, Stephen Perkinson, and Aden Kumler. Royal patronage and that of the French King Charles V is the subject of Stephen Perkinson's study. It centers on the frontispiece image of Charles found in the Vaudetar Bible. We are now accustomed to seeing frontispiece images in many modern books, but we rarely question their role and why they are there. Not so with Steve! In a beautifully paced essay, he looks at the agency behind this miniature and, seeing how four individual characters may have been involved in its creation, he examines the role each one played and why they became involved in the first place. Just who was the patron or patrons in this complex scenario: the king, who had promised monetary support for the project, or Jean de Vaudetar, who was the subject of the king's largesse but who also employed others to actually work on creating the book (which in itself makes him a patron perforce)? Can we call Raoulet d'Orléans, the scribe, who interjected his own versified praise of Charles into the project, a patron, or is it the artist Jean de Bruges who served as *pictor regis* and who undertook the making of the image? Four characters are examined, all of whom were involved in the creation of this image and all of whom could justifiably be called a patron in their own right.

Agency again lies at the core of Aden Kumler's essay and she starts by warning us of the dangers of conflating or substituting agency and artistic intention, be it that of the artist, patron, or user. She is the first to state that her essay here is a speculative and experimental consideration of what might be at stake in the *inventio patroni* or *matronae* practiced in art-historical interpretation of medieval works of art. In a modest and understated manner, she looks at the power of patronage as a historio-cultural and epistemic function from the dual perspective of it working within medieval art but also within our twenty-first century interpretative schema in viewing the past. She looks at patrons as the effects instead of the cause of works of art. It's an insightful essay that adopts a new vantage point for us to look at the subject. It's an essay that makes us aware of the pitfalls of seeing too much while at the same time taking a more reasoned approach and distant stance to the subject.

Our understanding of patronage has been greatly expanded and enriched by the fine studies in this volume. None of the authors have come to the same conclusion and this highlights the variety of possible meanings to the term. In fact, the single characteristic emphasized by all authors is the complexity and variety of meaning carried by the term patronage.

PATRONAGE

Power & Agency in Medieval Art

JILL CASKEY

Medieval Patronage & Its Potentialities

ALTHOUGH the *Vita Constantini* poses many problems of interpretation, Constantine's purported letter to Macarius, Bishop of Jerusalem, and related chapters in Eusebius's biography provide illustrative benchmarks for the study of medieval patronage. The emperor's letter of 325 or 326[1] outlines his ambitions for what would become the Church of the Holy Sepulchre:

> I have no greater care than how I may best adorn with a splendid structure that sacred spot, which, under Divine direction, I have disencumbered ... of the heavy weight of foul idol worship.... It will be well ... for your sagacity to make such arrangements and provision of all things needful for the work, that not only the church itself as a whole may surpass all others whatsoever in beauty, but that the details of the building may be of such a kind that the fairest structures in any city of the empire may be excelled by this.[2]

Constantine's letter and Eusebius's text are, on one hand, fully immersed in imperial rhetoric and the visual cues of ancient Rome. Indeed, Constantine's list of aesthetic desiderata, from precious marble columns to the gold-paneled ceiling, could be describing such majestic imperial ensembles as the Forum of Trajan. But the text is Janus-faced, and its language, themes, and imagery also anticipate what ultimately became conventional in medieval accounts of artistic production. While the majority of medieval works of art possess little of the evidence that accrued around the

Holy Sepulchre—that is, there is typically little to no detailed documentation about founders, donors, patrons, artists, builders, or first users—the *Vita Constantini* frames salient issues concerning patronage in the Middle Ages.

First, miraculous events inspire and justify an ambitious artistic initiative. In Jerusalem, the discovery of the tomb of Christ and the continuation of "newer wonders every day" surpass "every natural capacity of human thought," according to the emperor.[3] Second, Constantine is characterized repeatedly as exceptionally pious, both implicated in the recovery of the tomb and worthy of presiding over its holy power. Constantine's patronage thus assimilates ancient practices of imperial munificence into the new arena of Christian piety. This elision between piety and patronage becomes a dominant motif in later centuries, a paradigm that is expressed in such disparate works as the ivory cross of Ferdinand I and Sancha for San Isidoro in León (*c.* 1063) and Philip the Bold's foundation of the Chartreuse de Champmol near Dijon (1377). Throughout the Middle Ages, such artistic commissions, both large and small, derived in part from anxiety over salvation, to be sure. But for the wealthiest members of medieval society, largesse on a grand scale also articulated one's social station in life and was an essential responsibility of that social station. And, perhaps most critically, it remained an exceptionally powerful yet nimble ideological tool.

In addition to illuminating the miracles and motives

Many thanks to Colum Hourihane and Elizabeth Pastan for their invitation to participate at the conference, and to the speakers and attendants for their insights and encouragement; to Adam Cohen, Robert Couzin, Alexander Harper, Christine Kralik, and Amy Miller, who shared their thoughts on an earlier presentation of this material; and to Esther Kim for her bibliographic assistance. This article is dedicated to Sally and Jack.

1. *Eusebius of Caesarea, Life of Constantine*, trans. by A. Cameron and S. G. Hall, Clarendon Ancient History Series (Oxford, 1999), 283–284.

2. *A Select Library of Nicene and Post-Nicene Fathers of the Christian Church*, 2nd series, vol. 1, *Eusebius: Church History, Life of Constantine the Great and Oration in Praise of Constantine*, ed. by P. Schaff and H. Wace (Oxford, 1890), 528. Recent and less fluid translation in *Eusebius, Life of Constantine* (as in note 1), 134. See also T. Barnes, *Constantine and Eusebius* (Cambridge, Mass., 1981), 248–250.

3. *Eusebius, Life of Constantine* (as in note 1), 134.

behind the construction of the Holy Sepulchre, the Letter to Macarius and related chapters in the *Vita Constantini* make another obvious yet significant point: that building a major foundation required marshaling, coordinating, and managing an immense quantity of human, material, and economic resources. Suitably lavish materials had to be located, no matter what challenges they posed; God would prevail and provide if the project were worthy, as many medieval sources also claim. In other words, Constantine declared his goals and then delegated the work to a complex, hierarchical structure to realize them.[4] This scenario raises a fundamental question about artistic patronage: given the large cast of characters involved in the creation of the Holy Sepulchre, what does it mean to designate Constantine as its patron? What is gained by doing so? What is lost?

As the *Vita Constantini* suggests, the collaborative nature of artistic production during Late Antiquity and the Middle Ages places the question of agency at the heart of patronage studies. At this juncture, I define agency simply as the proactive engagement through which a person or people affected works of art in ways distinct from the nitty-gritty of facture. The methods used and questions posed to uncover this effect vary, taking into account (among other things) whether the object of study is a great church, a prayer book, or a gold brooch. Across divergent scales and media, historians often have envisioned a triadic configuration of agency in which a patron provided money, a theological advisor developed iconography, and an artist utilized specific forms and styles to realize the others' ideas.[5] This triad can illuminate the genesis of centuries-old works of art, but it also invites mechanistic over-simplification, as discussed below.

Before sketching out some of the problems and potentials of patronage as a line of inquiry, I must issue a caveat. The complex cultural dynamics that gave rise to one thousand years of art and architecture do not lend themselves to a unifying definition or theory of patronage. As Holly Flora recently noted, "there is … no term that equally conveniently and accurately describes the personalities and processes involved in artistic commissions."[6] Related words, including instigator, donor, matron, founder, promulgator, impresario, and their rough equivalents in other languages, may express more specific roles or nuanced meanings than those implied by the broad "patron." Many such terms, however, have prompted equivocation or do not extend readily beyond unique circumstances. Patronage is "probably never completely simple and straightforward," as John Mitchell recently wrote.[7]

Mindful of such problems, I seek to emphasize the diversity of medieval practices and scenarios while highlighting salient themes in the literature. Part case study and part historiographic essay, this article begins by considering the ways in which patronage studies have derived from and altered traditional art history and its practice. Second, it examines how patronage has been described and located within the process of artistic production. Third, it analyzes the medieval language of patronage in inscriptions on works of art. Because agency is a term laden with theoretical claims in anthropology, sociology, philosophy, psychology, and other disciplines, the last part of the paper asks how ideas developed in such fields might help build bridges between patronage studies and other subjects within and outside of the history of art.

Woven throughout this essay are references to a variety of works of art. Recurrent among them are the bronze doors of Monte Sant'Angelo, a town located on the Gargano Peninsula, the "spur" on the east coast of Italy's "boot" (Fig. 1).[8] Dated by inscription to 1076, the doors mark the entrance to the cave where St. Michael first appeared in the West around

4. Krautheimer is, as usual, illuminating here. R. Krautheimer, "The Constantinian Basilica," *DOP* 21 (1967), 139–140.

5. Historiographic discussion of these themes in J. Caskey, "Whodunnit? Patronage, the Canon, and the Problematics of Agency in Romanesque and Gothic Art," in *A Companion to Medieval Art: Romanesque and Gothic in Northern Europe*, ed. by C. Rudolph (Malden, Mass.; Oxford, 2006), 193–212.

6. H. Flora, "Patronage," *Studies in Iconography* 33 (2012), 209.

7. J. Mitchell, "Who's the Boss? Patterns of Patronage at San Vincenzo al Volturno in the Ninth Century," in *Medioevo: I committenti*, Atti del Convegno internazionale di studi, Parma 2010, ed. A. C. Quintavalle (Milan, 2011), 43–55.

8. This brief essay cannot offer a comprehensive treatment of the doors. Salient literature includes: É. Bertaux, *L'art dans*

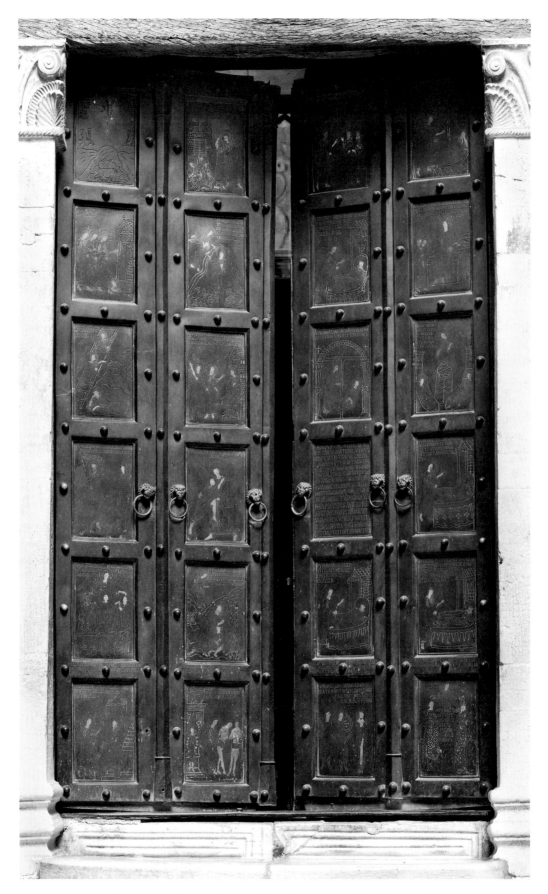

FIGURE 1. Bronze doors of the Sanctuary of St. Michael, Monte Sant'Angelo, Italy, 1076 (photo: Beppe Gernone).

the year 500 and indicated he wished to be worshipped there.[9] The miraculous events attributed to the archangel's presence transformed the cave into the preeminent pilgrimage site in southern Italy—at least until the advent of the Normans and the translation of St. Nicholas's relics from Myra to Bari in 1087, that is. The marble portal and bronze doors helped systematize the cavernous spaces, which, in Ado of Vienne's evocative words, define a sacred *domus angulosa* not built by human hands.[10]

The doors at Monte Sant'Angelo illuminate the problems and potentials of patronage, for indications of their genesis proliferate across their highly worked surface. They belong to a corpus of eight Byzantine bronze doors commissioned by Italians and installed in Italy within fifty-odd years.[11] The doors consist of small cast pieces, including panels with incised inscriptions and figural imagery rendered in colored niello-like inlay and silver.[12] They bear inscriptions referring to patrons, artists, dates, and place of manufacture—generally, Constantinople. At Monte Sant'Angelo, the name of Pantaleone, the presumed "patron," appears two times. As discussed below, some scholars have identified this figure as Pantaleone de Maurone Comite, who commissioned the first and third sets of bronze doors in the corpus, those of the Cathedral of Amalfi (*c.* 1061) and San Paolo fuori le Mura in Rome (1070) (Figs. 2 and 3). The second set, made for the new abbey church of Montecassino, names his father, Mauro (1066). Thus, the first four in a series of eight Byzantine doors in Italy have been associated with one family; this clan included wealthy merchants and prominent diplomats with deep roots in Amalfi and distinguished careers in Constantinople, Antioch, and Jerusalem.[13] This study considers Pantaleone's possible roles in the creation of the doors at Monte Sant'Angelo and how his impact upon them has been and could be conceptualized.

STUDIES OF PATRONAGE, PAST & PRESENT

As an alternative to such traditional projects in the history of art as the study of iconography or style, patronage has had a long-standing and symbiotic relationship with the discipline's canon of monuments

l'Italie méridionale (Paris, 1904), 401–437; A. Thiery, "Le bronze et l'ivoire," in *L'art dans l'Italie méridionale: Aggiornamento dell'opera di Émile Bertaux*, ed. by A. Prandi, (Rome, 1978), 5: 627–631; G. Matthiae, *Le porte bronzee bizantine in Italia* (Rome, 1971); specialized studies are noted below.

9. Recent studies of the site include J. C. Arnold, "Arcadia Becomes Jerusalem: Angelic Caverns and Shrine Conversion at Monte Gargano," *Speculum* 75 (2000), 567–588; G. Otranto, "Note sulla tipologia degli insediamenti micaelici nell'Europa medievale," in *Culto e santuari di san Michele nell'Europa medievale*, ed. by P. Bouet, G. Otranto, and A. Vauchez (Bari, 2007), 385–415.

10. *Martyrologium*, Migne *PL* 123: 369.

11. The eight doors in the corpus are: Amalfi, cathedral (*c.* 1061), Montecassino (1066); Rome, San Paolo fuori le Mura (1070); Monte Sant'Angelo, Sanctuary of St. Michael (1076); Atrani, San Salvatore (1087); Venice, San Marco, Porta S. Clemente (1080s); Salerno, cathedral (*c.* 1099); Venice, San Marco, main door (*c.* 1112). Salient literature: C. Angelillis, *Le porte in bronzo nelle chiese d'Italia* (Arezzo, 1924); G. Matthiae, *Le porte bronzee* (as in note 8); H. Bloch, *Monte Cassino in the Middle Ages*, 3 vols. (Cambridge, Mass., 1981); S. Salomi, ed., *Le porte di bronze dall'antichità al secolo XIII*, 2 vols. (Rome, 1990); A. Iacobini, ed., *Le porte del Paradiso. Arte e tecnologia bizantina tra Italia e Mediterraneo* (Rome, 2009); A. Gobbi and G. Gasbarri, "Il progetto Portae byzantinae Italiae: documentazione grafica e database informatico," in *ibid.*, 565–595.

12. The doors are not true bronze, but what Pliny called *auricalchum*, a low-lead technique that lends itself to incised detail when cool, thus facilitating pictorial and epigraphic elaboration. For the technical properties of the Monte Sant'Angelo doors and their restoration of 1938, see F. Vona, "Officine fusorie e porte di bronzo in Puglia: Alcune considerazioni," in *Arte in Puglia dal Medioevo al Settecento: Il Medioevo*, Exhib. cat., ed. by F. Abbate (Rome, 2010), 205–213; S. Angelucci, "Committenti, artefici, tecniche e materiali delle porte costantinopolitane d'Italia, con appendice epigrafica di Giuseppe De Spirito," *Annali della Scuola Normale Superiore di Pisa, Classe di Lettere e Filosofia. Quaderni*, 4th ser. 8, *L'artista medievale*, ed. by M. M. Donato (Pisa, 2003), 101–121; A. Iacobini, "Le porte bronze bizantine in Italia: arte e tecnologia nel Mediterraneo medievale," in *Le porte del Paradiso. Arte e tecnologia bizantina tra Italia e Mediterraneo*, ed. by A. Iacobini (Rome, 2009), 15–54. For the origins of this technique in small-scale works of art, see W. E. Kleinbauer, "A Byzantine Revival: the Inlaid Bronze Doors of Constantinople," *Archaeology* 29 (1976), 16–29.

13. See the classic study of A. Hofmeister, "Der Übersetzer Johannes und das Geschlecht Comitis Mauronis in Amalfi," *Historische Vierteljahrsschrift* 27 (1932), 225–284, 493–508, 831–833; M. V. Marini Clarelli, "Pantaleone d'Amalfi e le porte bizantine in Italia meridionale," in *Arte profana e arte sacra a Bisanzio*, ed. by A. Iacobini and E. Zanini (Rome, 1995), 641–652.

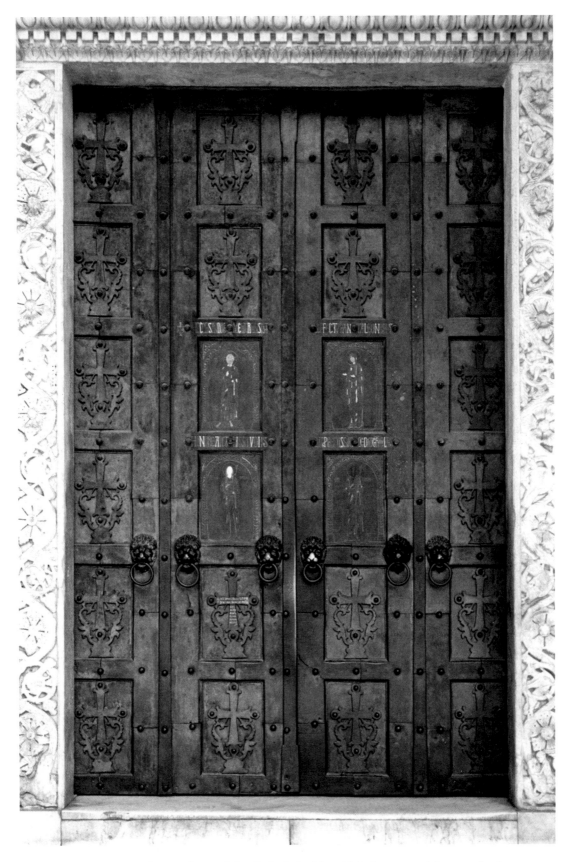

FIGURE 2. Bronze doors of the Cathedral of Amalfi, Italy, *c.* 1061 (photo: author).

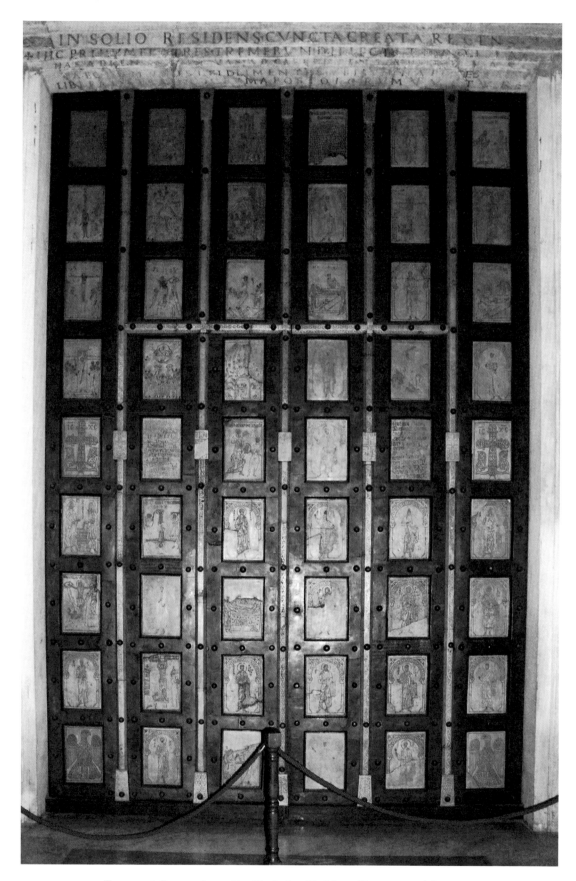

FIGURE 3. Bronze doors, San Paolo fuori le Mura, Rome, 1070 (photo: courtesy of Colum Hourihane).

and the canon's critical fortunes. This is not surprising; it goes without saying that identifying the sponsors or initiators of medieval works of art has yielded significant insights into the genesis of new, influential, and ambitious art forms. To varying degrees, most discussions of patronage replicate the discipline's attributional structure and the questions initially asked about artists: who did what, when, and why? This approach creates a secondary narrative, one that highlights great patrons rather than great artists. For the era before "art" and named artists, the patron-based narrative has particular prominence. Hence, the status of the likes of Constantine, Suger, or Jean de Berry and of scholarly accounts of their transformative endeavors.[14]

Because these attributional studies draw heavily upon textual sources such as contracts, inventories, wills, and chronicles, they generally focus on the elite authorities for whom extensive documentation survives. The result is that the field's core solidifies around powerful patrons, who in turn continue to exert a strong gravitational pull and strengthen that center—until the theoretical turn of the 1980s and 90s, that is, when alternate patronal formations, such as queens, nuns, merchants, and so on, became legitimate subjects of inquiry. Yet emphases on attribution continue and also fuel debates over a prolific patron's "œuvre." Works of art linked to major patrons achieve a kind of legitimacy, whereas those "anonymous" productions are more prone to marginalization. Thus a patronal variation on conventional attribution debates ensues.

The doors of Monte Sant'Angelo have prompted considerable discussion of this type. Inscriptions link the Maurone Comite clan of Amalfi, whose name derives from their position as counts in the ninth century, to a handful of works of art; in addition to the bronze doors at Amalfi, Montecassino, and San Paolo fuori le Mura, these works include a Greek manuscript of the Homilies of Basil the Great and the so-called Farfa Casket, an ivory box of *c.* 1071 that bears the name of Mauro and his four sons, including Pantaleone.[15] Since the Monte Sant'Angelo doors closely resemble in design, technique, and style those of the Cathedral of Amalfi and San Paolo fuori le Mura in Rome, many scholars have identified the Pantaleone named on them as Pantaleone de Maurone Comite.[16] However, others have doubted this premise. Patricia Skinner recently argued that the different renderings of the inscribed names should open up other attributional possibilities.[17] At Amalfi, the patron is identified as *Pantal(eo) filius Mauri de Panta(leone) de Maur(o) de Maurone Comite* (*c.* 1061); at San Paolo, as the *consul malfigenus* Pantaleone (1070);[18] and at Monte Sant'Angelo, *dominus* Pantaleone (1076).

But what's in a name, particularly before the codification of surnames? The divergent contexts of the doors may explain their different approaches to patronal identification. At Amalfi, Pantaleone's citation of four generations of ancestors monumentalizes local scribal practices rooted in the social and legal exigencies of merchant culture (Fig. 4).[19] For diasporic Amalfitan communities, extended genealogies functioned in charters and other texts not only to identify

14. E.g., Erwin Panofsky, ed., *Abbot Suger on the Abbey Church of St.-Denis and its Art Treasures* (Princeton, N.J., 1946); M. Meiss, *French Painting in the Time of Jean Duc de Berry: The Limbourgs and Their Contemporaries* (New York, 1974).

15. Recent literature on the Farfa Casket includes F. Bologna, ed., *L'enigma degli avori medievali da Amalfi a Salerno*, Exhib. cat. (Naples, 2008). The eleventh-century manuscript was in Pantaleone's possession before he donated it to an unnamed monastery, perhaps at Mt. Athos. L. Perria, "Una nuova testimonianza su Pantaleone de comite Maurone in una nota del codice Scorial. Ψ II.7," *Rivista di studi bizantini e neoellenici*, n.s. 30 (1993), 116–121.

16. E.g., Hofmeister, "Der Übersetzer Johannes" (as in note 13), 251, 268; Matthiae, *Porte bronzee* (as in note 8), 83; H. Bloch, *Monte Cassino* (as in note 11), 1: 153; Bertaux, *L'art dans*

l'Italie méridionale (as in note 8), on same patron at Rome and Monte Sant'Angelo, 404.

17. Skinner put forth another Pantaleone from the Amalfi coast as the likely candidate for the doors, but her hypothesis has not gained traction. P. Skinner, "Commercio internazionale e politica locale nell'Amalfi medioevale: le porte di bronzo e il loro donatore nell'IX secolo," *Rassegna del Centro di cultura e storia amalfitana* 31–32 (2006), 65–78.

18. PAULE BEATE PRECES DNO NE FUNDERE CESSES CONSULE MALFIGENO PANTALEONE, and merely "Pantaleone" before his image as devotee. Matthiae, *Porte bronzee* (as in note 8), 75; Marini Clarelli, "Pantaleone d'Amalfi" (as in note 13), 641.

19. J. Caskey, *Art and Patronage in the Medieval Mediterranean: Merchant Culture in the Region of Amalfi* (Cambridge, 1994), 168–169.

FIGURE 4. Inscription, bronze doors of Amalfi, *c.* 1060 (photo: author).

individuals as members of old and prestigious clans; they also established legal specificity, which was particularly important if the individuals in question were absent from town for long periods of time (as was Pantaleone) and, consequently, were not known personally to the denizens of the coast. Thus the Amalfi doors name the patron in a way that guaranteed he would be correctly identified and his distinguished local ancestry duly appreciated. Furthermore, the inscription ensures that the right Pantaleone received credit for the novelty, technical bravado, and cultural reach of the imported doors, the very qualities that created a vogue for such works. (These doors are, after all, the ones that Desiderius of Montecassino sought to emulate at his new abbey church; after having seen them during a trip to Amalfi, the abbot promptly enlisted Pantaleone's father to help him procure a similar set.)[20] Finally, the placement of the inscription within one of the door's protruding crosses and the addition of white inlay to its letters enhance the text's visual prominence.[21] Located at the precise height where one's hands would reach to grasp the rings of the leonine knockers (as the wear marks make clear), the full identification of the patron is difficult to miss.

On the second set of doors linked to Pantaleone, those at San Paolo fuori le Mura in Rome, his identification as *consul malfigenus* performed other functions. As a Latinization of the title *hypatos* bestowed upon him by the emperor, *consul* testified to the political and military clout he displayed during various diplomatic negotiations in Constantinople concerning investiture, Byzantine-Lombard relations, and Norman expansion in southern Italy.[22] Redolent of ancient Rome, the title aligns the eleventh-century

bronze doors with admired antecedents at the Pantheon and the Temple of Romulus/Sts. Cosmas and Damian.[23] More tangible, however, is the idea that the inscription articulated Pantaleone's official status at the site of the apostle's grave. It secured his presence at the revered shrine while also placing him within a distinguished ecclesiastical network that included Hildebrand, the titular cardinal of San Paolo and future Gregory VII. A second inscription, which was damaged in the fire of 1823, names Hildebrand as *dominus*, *monachus*, and *archidiaconus*, as well as Alexander (II) as *dominus* and *papa*.[24] The litany of names and titles on the doors places the *consul* Pantaleone within this hierarchy of papal politics while subtly differentiating him from it.

Skinner is right that the *dominus* moniker at Monte Sant'Angelo is not enough to tie the doors there to Pantaleone de Maurone Comite. But it is not enough to sever the tie, either. A more specific identity might not have been necessary for several reasons. Given the fact that Monte Sant'Angelo is a pilgrimage site distant from Pantaleone's home town of Amalfi, from his adopted city of Constantinople, and from one source of his prestige and power, papal Rome, perhaps *dominus* conveyed sufficient status. Perhaps his renown as a patron of bronze doors was widespread and consequently his identity sufficiently understood. Or, perhaps after a decade and a half of such commissions, the doors had lost their novel shine for him, and he no longer needed to nail down his identity as firmly as he had earlier in life. Or, as Gioia Bertelli posited in her work arguing for Pantaleone de Maurone Comite's role at Monte Sant'Angelo, his full name was not needed because the doors constituted a private gift to the shrine.[25]

20. Among many others, Bloch, *Monte Cassino* (as in note 11), 40–41; V. Pace, "Da Amalfi a Benevento: Porte di bronzo figurate dell'Italia meridionale medievale," *Rassegna del Centro di cultura e storia amalfitana* 25 (2003), 41–69.

21. New takes on epigraphy: S. Riccioni, "The Word in the Image: An Epiconographic Analysis of Mosaics of the Reform in Rome," *Acta ad Archaeologiam et Artium Historiam Pertinentia* 24 (2011), 85–137; also, J. Hamburger, "The Iconicity of Script," *Word & Image* 27 (2011), 249–261.

22. Recent assessment of the title and the rapidly shifting political affiliations and reconciliations of the clan in Marini Clarelli, "Pantaleone d'Amalfi" (as in note 13).

23. On the enduring prestige of antique bronze doors, B. Brenk, "Committenza e retorica," in *Arti e storia nel Medioevo*, vol. II: *Del Costuire. Tecniche, artisti, artigiani, committenti*, ed. by E. Castelnuovo and G. Sergi (Turin, 2006), 30–31.

24. The inscription was likely added to the doors after their arrival in Rome. Bloch, *Monte Cassino* (as in note 11), 143; Pace, "Arte di Bisanzio" (as in note 20), 88; Marini Clarelli, "Pantaleone d'Amalfi" (as in note 13), n. 27, 648.

25. G. Bertelli, "La porta del santuario di S. Michele a Monte Sant'Angelo: aspetti e problemi," in *Le porte di bronzo dall'antichità al secolo XIII*, ed. by Salomi (as in note 11), 297.

Although I am not inclined to agree with Bertelli's explanation, the setting does beg the question of how patronage at pilgrimage sites differed from the practice in other settings. In discussions of, say, the monastic orders, the support of a queen is read as her public endorsement of the order's ideals and an indication that her piety actually aligns with those ideals.[26] In some cases, the more public forum of pilgrimage sites potentially weakens the presumed correlation between patronal activities and personal devotional preferences. In other cases, personal ideas might be amplified, as in case of some ex votos. Consequently, not only do pilgrimage sites accommodate a wider audience, but they also have the potential to display a wide range of patronal motives, and, consequently, to prompt a deeper understanding of the diverse uses of medieval art.

Observing pilgrimage sites from this vantage point takes for granted the premise that medieval patrons were capable of varying style, material, or cultural referents to suit specific occasions. Research by Brenk, Binski, Bruzelius, and others has suggested that the conscious pursuit of eclecticism and alterity was a consistent element of court and other elite cultures across the West, both north and south of the Alps.[27]

Studies of Roger II of Sicily, for instance, have characterized him as actively shaping a unique visual culture that deployed ideas, materials, and artists from multiple artistic centers, from Spain to Egypt to Constantinople.[28] The implications of such findings for the practice and priorities of art history are vast. First, the traditional correspondence in art history between the style of a work of art and a specific time and place falls apart. Second, to probe eclecticism, art historians must broaden their perspectives to take into account more than a single medium. Not only are individual medieval environments examined from a multi-media perspective, as at, say, the Cappella Palatina in Palermo, but studies of a prolific patron's œuvre also branch out to consider a range of media. Thorny questions potentially arise about the relationships among different art forms and their relative value as historical evidence.[29] Furthermore, studies of art patronage have highlighted the fluidity of cultural formations. Along with research on the movement of portable objects, such studies of patronage have helped build new areas of interdisciplinary research in Mediterranean Studies and the Global Middle Ages.[30] The history of medieval art has changed dramatically since Ernst Kitzinger decried portrayals of the "mindless

26. E.g., recent discussions of Mary of Hungary and Sancia of Majorca in Naples. J. Elliott and C. Warr, eds., *The Church of Santa Maria Donna Regina: Art, Iconography and Patronage in Fourteenth-Century Naples* (Aldershot, 2004); C. Bruzelius, *The Stones of Naples: Church Building in Angevin Italy, 1266–1343* (New Haven, Conn., 2004).

27. E.g., P. Binski, *Westminster Abbey and the Plantagenets: Kingship and the Representation of Power 1200–1400* (New Haven, Conn., 1995); C. Bruzelius, *The Thirteenth-Century Church at St.-Denis* (New Haven, Conn., 1985), and *eadem*, *The Stones of Naples* (see source above, note 26); B. Brenk, "Arte del potere e la retorica dell'alterità: La cattedrale di Cefalù e San Marco a Venezia," *Römisches Jahrbuch der Bibliotheca Hertziana* 35 (2003–2004), 83–100; F. Dell'Acqua, "Parvenus eclettici e il canone estetico della varietas. Riflessioni su alcuni dettagli di arredo architettonico nell'Italia meridionale normanna," *Römisches Jahrbuch der Bibliotheca Hertziana* 35 (2003–2004), 50–79.

28. B. Brenk, ed., *La Cappella Palatina a Palermo*, 4 vols. (Modena, 2010); W. Tronzo, *The Cultures of His Kingdom: Roger II and the Cappella Palatina in Palermo* (Princeton, N.J., 1997); *idem*, "Restoring Agency to the Discourse on Hybridity: The Cappella Palatina from a Different Point of View," in *Die Cap-*

pella Palatina in Palermo. Geschichte, Kunst, Funktionen, ed. by T. Dittelbach (Swiridoff, 2011), 579–585.

29. J. Caskey, "The Look of Liturgy: Identity and *ars sacra* in Southern Italy," in *Ritual and Space in the Middle Ages, Proceedings of the 2009 Harlaxton Symposium*, ed. F. Andrews, Harlaxton Medieval Studies, XXI (Donington, 2011), 108–129.

30. E.g, O. Grabar, "The Shared Culture of Objects," in *Byzantine Court Culture from 829 to 1204*, ed. by H. Maguire (Washington, D.C., 1997), 115–129; Tronzo, *Cultures of his Kingdom* (as in note 28); A. Cutler, "The Parallel Universes of Arab and Byzantine Art (with Special Reference to the Fatimid Era)," in *L'Egypte fatimide: son art et son histoire. Actes du colloque, organisé à Paris les 28, 29 et 30 mai 1998*, ed. by M. Barrucand (Paris, 1999), 635–648; A. Shalem, "The Otherness in the Focus of Interest, or, If Only the Other Could Speak," in *Islamic Artefacts in the Mediterranean World: Trade, Gift Exchange and Artistic Transfer*, ed. by C. Schmidt Arcangeli and G. Wolf (Venice, 2011), 29–44; E. Hoffman, "Pathways of Portability: Islamic and Christian Interchange from the Tenth to the Twelfth Century," *Art History* 24 (2001), 17–50.

patron" and "sovereign artist" in early discussions of the mosaic of Christ crowning Roger II at Santa Maria dell'Ammiraglio in Palermo.[31]

Helpful ways of conceptualizing prolific patrons like Pantaleone are also found in research dealing with gifting and gender. Developing the foundational work of Mauss in anthropology, Bell, Brubaker, Cutler, and others have pointed out that gifted works of medieval art serve as conduits of cultural and artistic transmission, often crossing borders and becoming radically recontextualized.[32] In addition, they are ambiguous; they range from concretizations of a giver's desires, idealizations, and assumptions to reasonable fulfillments of the needs, taste, or wishes of the recipient.[33] In her analysis of gender and the less pleasant dynamics of gifting, Caviness has argued that much of the imagery in the Hours of Jeanne d'Évreux (*c.* 1324) works "against" the young queen. Its ribald marginalia cater less to her spiritual interests than to the desire of her new, aged husband to shape her views of marriage, sexuality, and reproduction.[34]

Therese Martin contends that we need to reconsider the evidence of both patronage and artistic production and look for women in both places.[35] Because medieval inscriptions commonly use *fecit* to express both artistic and patronal agency, Martin urges us to be conscious of our preconceptions about who was doing what. Rather than assuming, say, that women were more likely to be patrons than creators of a book or reliquary, we should reconsider the evidence un-derlying such suppositions and pursue the alternatives until we can make a more informed judgment.

PATRONAGE WITHIN THE PRODUCTION PROCESS

As the *Vita Constantini* suggests, patrons did not stand alone, even ones as resourceful as Constantine and his successors like Suger of Saint-Denis or Louis IX. Studies since the 1970s have emphasized the webs of interaction that led to the creation of works of medieval art. Considering the social and political overtones of patronage helps reconceptualize the dynamics of artistic production, as well as pointing out the roots of the word in Greco-Roman society.[36] Just as the generous actions of a first-century *patronus* invited and ensured the cooperation and support of less fortunate associates, whether in a law court, market, or *domus*, so the relationship between medieval patron and artist entailed various forms of reciprocity. As Martindale, Warnke, Fleck, and others have established in their studies of court artists, patronage was potentially about both participants gaining distinction, access to other artists/patrons, intellectual camaraderie, and so on.[37]

Within this collaborative model, who was responsible for the rigorous theological or ideological concepts found in so many works of medieval art? At Monte Sant'Angelo, did Pantaleone—whether Pantaleone de Maurone Comite or another individual—specify its iconographic content, or was his role more limited?

31. E. Kitzinger, "The Gregorian Reform and the Visual Arts: A Problem of Method," *Transactions of the Royal Historical Society* 22, 5th ser. (1972), 90; versus the "highly purposeful patron who chooses his artists with a view to realizing a particular program," 91.

32. M. Mauss, *The Gift: The Form and Reason for Exchange in Archaic Society*, trans. by W. D. Halls (London, 1990); S. Bell, "Medieval Women Book Owners: Arbiters of Lay Piety and Ambassadors of Culture" (1982), reprinted in *Women and Power in the Middle Ages*, ed. by M. Ehler and M. Kowaleski (Athens, Ga., 1988), 149–187; L. Brubaker, "The Elephant and the Ark: Cultural and Material Interchange Across the Mediterranean in the Eighth and Ninth Centuries," *DOP* 58 (2004), 175–195; A. Cutler, "Gifts and Gift Exchange as Aspects of the Byzantine Arab, and Related Economies," *DOP* 55 (2001), 247–278.

33. M. Camille, *The Medieval Art of Love* (New York, 1998), ch. 2.

34. M. Caviness, "Patron or Matron? A Capetian Bride and a *Vade Mecum* for her Marriage Bed," *Speculum* 68 (1993), 333–362.

35. T. Martin, "Exceptions and Assumptions: Women in Medieval Art History," in *Reassessing the Roles of Women as 'Makers' of Medieval Art and Architecture*, ed. by T. Martin (Leiden, 2012), 8–9.

36. T. Cooper, "*Mecenatismo* or *Clientelismo*? The Character of Renaissance Patronage," in *The Search for a Patron in the Middle Ages and Renaissance*, ed. by D. Wilkins and R. Wilkins (Lewiston, N.Y., 1996), 19–32; for social patronage, A. B. Wheatley, *Patronage in Early Christianity: Its Use and Transformation from Jesus to Paul of Samosata* (Eugene, Ore., 2011).

37. A. Martindale, *The Rise of the Artist in the Middle Ages and Early Renaissance* (London, 1972); C. Fleck, "The Rise of the Court Artist: Cavallini and Giotto in Fourteenth-Century Naples," *Art History* 31 (2008), 460–483.

If it was more limited, is it accurate to conceptualize him as a "patron"? Brenk has illuminated this problem with the idea of a *concepteur*: an individual whose creativity and intellect shaped the more sophisticated, nuanced, or original aspects of medieval works of art.[38] Initiators of commissions could act as such *concepteurs*, as discussed below. In many cases, *concepteurs* were theological advisers, as Brenk posits for the fifth-century mosaics at Santa Maria Maggiore in Rome. For the twelfth-century cloister at Monreale, in contrast, he points to the head of the sculpture workshops. This artist-*concepteur* brought forth a unique ensemble of motifs and styles that defined an ambitious aesthetic of *varietas* and alterity for William II of Sicily (Fig. 5).[39] However, efforts to pinpoint agency in these formations can create problems. Hard evidence of third-party *concepteurs* is few and far between, and conjuring them up distracts us from apprehending the abilities of the artist or the qualities of the work in question, as Brenk has pointed out. It also potentially reduces the dynamics behind the commissioning and making of works of art into mechanistic formulae or pat divisions of labor. Furthermore, Therese Martin has argued that compartmentalizing agency in this way can conceal women's participation in highly collaborative processes.[40] Women were often silent or hidden partners in patronage and production, as recent research on Parisian manuscript workshops indicates.[41]

The bronze doors at Monte Sant'Angelo, the fourth works in the corpus of doors made in Byzantium and installed in Italy, reveal the problems posed by static conceptualizations of patronal agency and mechanistic divisions of labor. Each door features twelve small panels; twenty-three of them contain narrative scenes and short identifying inscriptions, and one presents a long inscription in majuscule and no narrative imagery (Fig. 6). Most of the panels feature an individual scene of angelic intervention from the Old or New Testament, ranging from the Sacrifice of Isaac to the less commonly represented St. Peter in Prison and the Fall of the Rebel Angels (Rev. 12:7–9) (Fig. 7).[42] The iconography at Monte Sant'Angelo does not achieve the breadth or exegetical sophistication of the doors at San Paolo fuori le Mura, the second doors associated with Pantaleone. But the imagery at Monte Sant'Angelo is far more complex than that of the first set of doors tied to him, those at Amalfi. At Amalfi, figural representations are limited to four panels depicting Andrew, Peter, Mary, and Christ, each of whom stands within an ornamented arch supported by knotted columns (Fig. 8). The colorful architectural motifs anticipate those in the Mt. Sinai Homilies of Gregory of Nazianzos, which was painted in Constantinople some seventy-five years later.

As a diplomat and leader of the sizable community of Amalfitan merchants in Constantinople, Pantaleone was certainly literate and worldly enough to have requested the straightforward iconic imagery of the Amalfi doors and the accompanying inscriptions. In subsequent bronze door commissions, however, the increasing level of complexity and the multiplication of local references indicate that other individuals played key roles in shaping the pictorial and epigraphic displays.

The imprint of the abbot Hildebrand is likely behind the unusual iconography of the doors at San Paolo. The fifty-four panels include twelve scenes from the life of Christ; icon-like portraits of the

38. B. Brenk, "Le texte et l'image dans la 'Vie des Saints' au Moyen Age: Rôle du concepteur et rôle du peintre," in *Texte et image*, Actes du Colloque international de Chantilly, 1982 (Paris, 1984), 31–39.

39. B. Brenk, "Art and *Propaganda fide*: Christian Art and Architecture, 300–600," in *The Cambridge History of Christianity*, vol. 2: *Constantine to ca. 600* (Cambridge, 2007), 715 (Rome); for Monreale, *idem*, "Il contribuito dell'artista alla concezione progettuale e iconografica," *Annali della Scuola Normale Superiore di Pisa, Classe di Lettere e Filosofia. Quaderni*, 4th ser. 16 (2003), 82.

40. T. Martin, "Exceptions and Assumptions" (as in note 35), 31.

41. Discussed in T. Martin, "Exceptions and Assumptions" (as in note 35), 20.

42. On the angelic iconography, André Grabar, "La porte de bronze byzantine du Mont-Gargan et le cycle de l'Ange," in *Millenaire monastique du Mont Saint-Michel* (Paris, 1971), 3: 355–368; R. Flaminia, "L'Angelus Domini e la coronatio dei santi Cecilia e Valeriano sulla porta di Monte Sant'Angelo," in *Le porte del Paradiso* (as in note 12), 345–373.

FIGURE 5. Cloister of Monreale (photo: author).

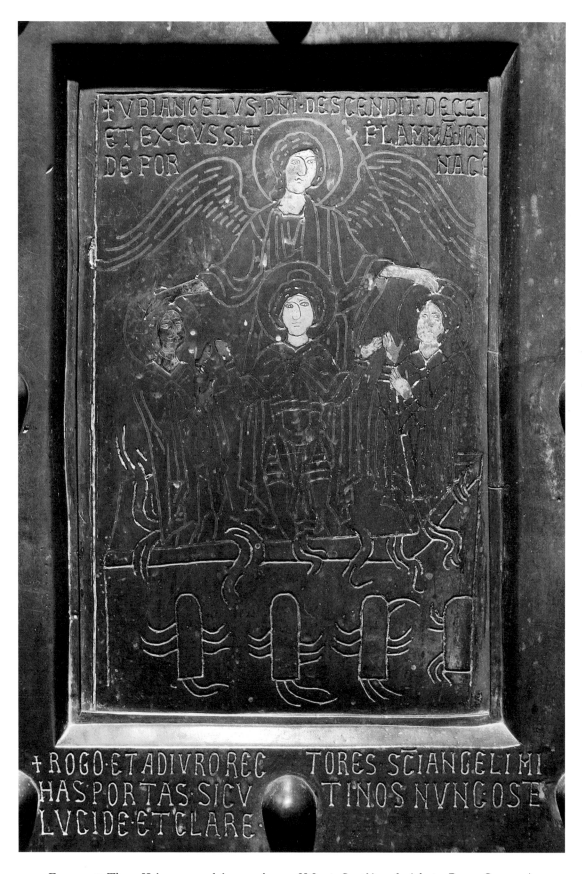

FIGURE 6. Three Hebrews panel, bronze doors of Monte Sant'Angelo (photo: Beppe Gernone).

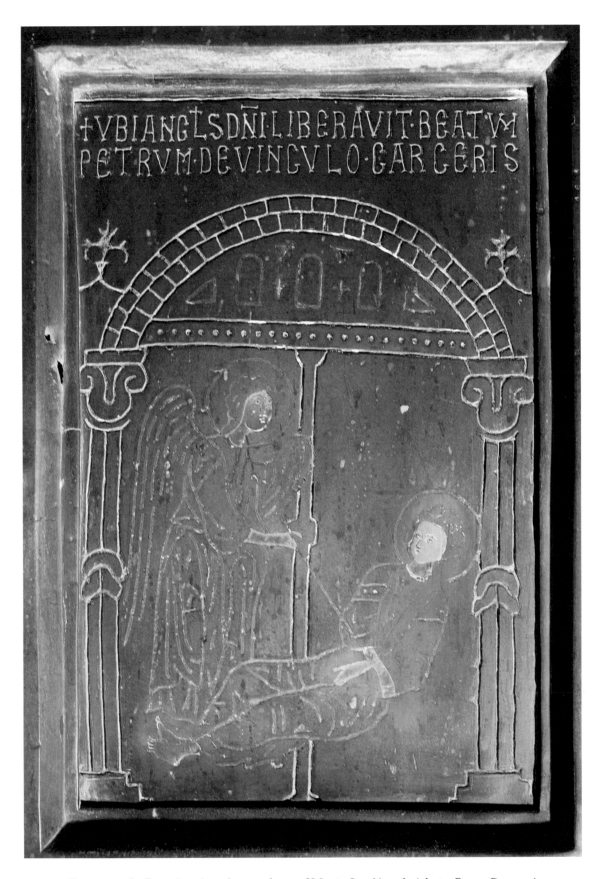

FIGURE 7. St. Peter in prison, bronze doors of Monte Sant'Angelo (photo: Beppe Gernone).

FIGURE 8. Bronze doors of Amalfi, central panels (photo: author).

apostles and images of each one's death (usually by martyrdom) are accompanied by identifying inscriptions in Greek. The array of Christological and apostolic martyrdom scenes articulates ideas of the Gregorian Reform, with its idealization of the early Church, glorification of its founders, and emphasis on miracles associated with them.[43] In addition, the more Byzantine and Greek features of the doors bring them into the orbit of Desiderius's Greek artists and commissions of liturgical furnishings from Constantinople for the reconstruction of Montecassino. Thus the San Paolo doors highlight the close institutional ties between the mother house and San Paolo and also the personal, intellectual, and ideological rapport between Hildebrand and Desiderius.

Placed in this wider field of the ecclesiastical and monastic hierarchies and ideologies, Pantaleone and his role can be characterized in various ways. Complementing Hildebrand, the presumed initiator and *concepteur* of the Roman doors, the *consul* Pantaleone was the donor, meaning that he paid for them. He also had himself represented in text and image as a devotee of St. Paul, demonstrating the pious underpinnings of his support (Fig. 9). But to conceptualize him as mere holder of the purse is not quite right. Presumably Hildebrand did not seek him out only because he could pay for the doors. The papal city—to say nothing of central Italy or the Benedictine network—surely presented a wealth of potential patrons from the great Roman families and immigrant elites. Pantaleone offered other benefits: his forms of expertise. He could negotiate old and New Rome, their languages, and the sea routes between them. He was already familiar with bronze casters in Constantinople. This array of skills helped Hildebrand realize in an expedient manner the philo-Byzantine ideas he sought. Thus, it is possible that Pantaleone not only paid for the doors, but also

served as intermediary between the Roman abbot and the designer and bronze caster(s), who are named on the door.[44] Here, then, is a variation on the *Vita Constantini*'s account of the construction of the Holy Sepulchre: within this hierarchical and collaborative effort linking Italy to the eastern Mediterranean, the "patron" who paid for the work and appeared in text and image upon it was less of a delegator than a person delegated *to*, and less of a decision-maker than financier and facilitator.

A variety of evidence suggests a similar scenario for the fourth doors in the corpus, those at Monte Sant'Angelo. Scholars have detected in iconography of the doors distinct ideologies and identities in play. While eighteen of the twenty-three scenes depict biblical tales involving angels, two scenes on the lower right valve feature stories that relate neither to biblical narratives nor to miracles associated with the particular site. In one panel, two angels help St. Martin of Tours destroy a pagan temple, an event adapted from Sulpicius Severus's *vita* of the saint; in the panel in the lower right corner, the pious Romans Cecilia and Valerian receive crowns of martyrs from a central *angelus* (Fig. 10). Cecilia's loros and crown betray the composition's appropriation of imperial coronation imagery.[45]

These two scenes bring Monte Sant'Angelo into the monastic network that generated the doors of Montecassino and San Paolo. As several scholars have pointed out, at Montecassino St. Benedict created an oratory on the site of a temple of Apollo;[46] the scene of Martin on the doors thus evokes Benedict's actions as well as that of the fourth-century bishop of Tours. Desiderius, who oversaw the architectural transformation of his abbey in the 1060s (including Mauro's bronze doors), not only renewed that dedication, but was cardinal at Santa Cecilia in Rome; her relics were

43. The literature on the Reform is of course vast; see S. Romano and J. Enckell Julliard, eds., *Roma e la Riforma gregoriana: Tradizioni e innovazioni artistiche (XI–XII secolo)* (Rome, 2007); J. Osborne, "Proclamations of Power and Presence: The Setting and Function of Two Eleventh-Century Murals in the Lower Church of San Clemente, Rome," *Mediaeval Studies* 59 (1997), 155–172; Pace, "L'arte di Bisanzio" (as in note 12); Bloch, *Monte Cassino* (as in note 11); R. Flaminia, "L'Angelus Domini" (as in note 42).

44. The designer Theodoros, whose name and prayer appear unobtrusively along the sides of a panel perpendicular to the plane of the door, and the caster-founder, Staurakios, now lost but noted by Seroux d'Agincourt. Iacobini, "Porte bronze" (as in note 12), 18; De Spirito, "Appendice epigrafica" (as in note 12), 116–117.

45. R. Flaminia, "L'Angelus Domini" (as in note 42), 345–373.

46. H. Bloch, *Monte Cassino* (as in note 11), 1: 55–56.

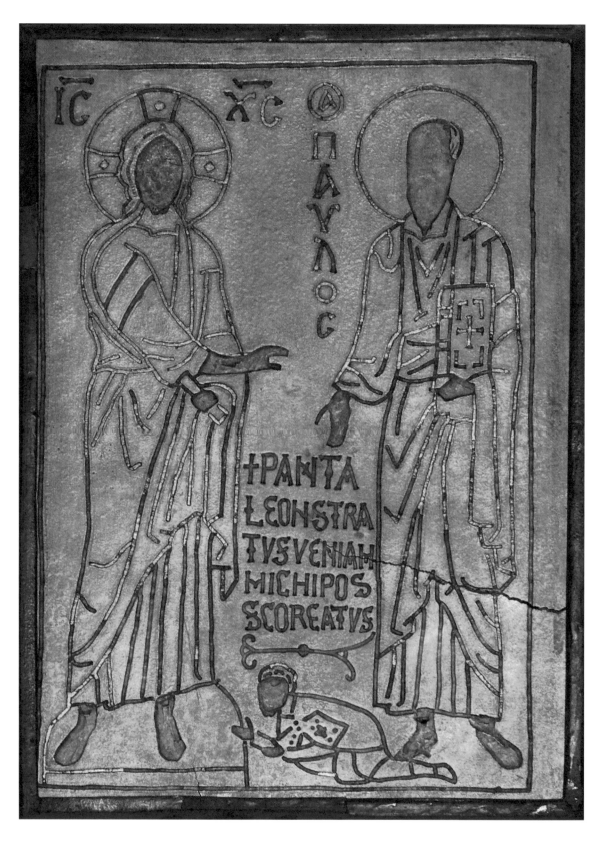

FIGURE 9. Bronze doors, San Paolo fuori le Mura, Pantaleone before St. Paul and Christ (photo: Colum Hourihane).

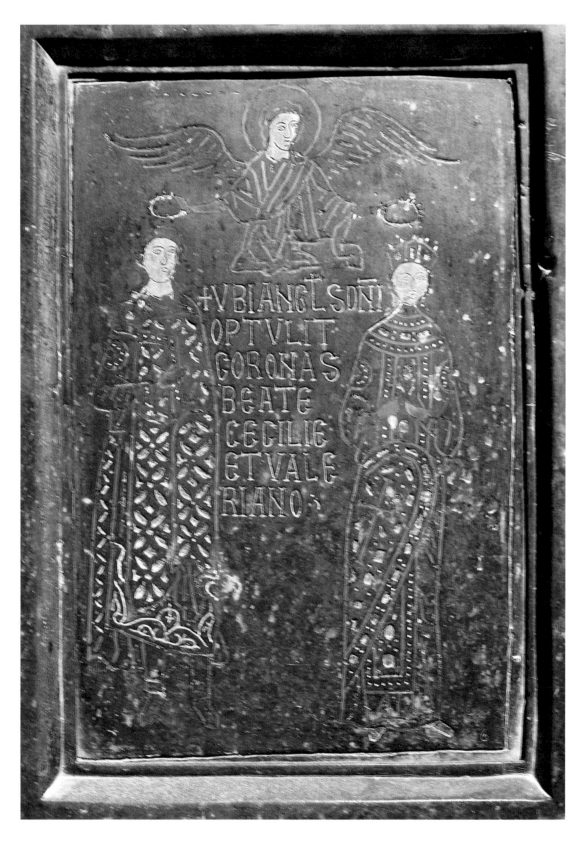

FIGURE 10. Bronze doors of Monte Sant'Angelo, Sts. Cecilia and Valerian (photo: Beppe Gernone).

enshrined in a new altar at the abbey.[47] Yet to cast this leader of the Benedictine Reform as Brenkian *concepteur* of the doors at Monte Sant'Angelo is not quite right. Gerardo, the newly appointed archbishop of Siponto whose see had just acquired jurisdiction over the shrine, is the better candidate for this role.

As a monk at Montecassino, Gerardo witnessed the consecration of Desiderius's abbey church in 1071 before being appointed to the newly created metropolitan see in 1073 or 1074 by Gregory VII (Hildebrand).[48] Thus Gerardo not only was familiar with the bronze doors at Montecassino—and probably those at San Paolo as well—but he also would have had an opportunity to meet Pantaleone's father Mauro at the consecration ceremony, thereby forging a personal connection to the family of prolific patrons. Based on this intersecting cast of characters and events, Bertelli and others have argued strenuously for the identification of Monte Sant'Angelo's *dominus* as Pantaleone de Maurone Comite.[49] I am inclined to agree. How much of an impact he had on the doors—or, to put it another way, the extent to which his proactive engagement registered upon them—remains to be seen. The initiative for the doors most likely came from the archbishop, Gerardo.

Gioia Bertelli observes the agency of Gerardo in the three scenes featuring a sleeping bishop. In each panel, the archangel appears and establishes his desires for the cave (Fig. 11). The sleeping figure is not identified as Lawrence of Siponto, the local bishop-saint whose early eleventh-century *vita* describes the visions; he is labeled merely *episcopo*. While underscoring the miraculous events that precipitated the foundation of the shrine, the figure's lack of precise identity detaches him from his sixth-century origins, collapsing the past and present and emphasizing the ongoing potential for "new wonders every day" to occur at the shrine site. It also alludes to the links between sleep, holy visits, and miraculous cures, for incubation was practiced at Monte Sant'Angelo as

at other Michelene sites. Furthermore, the figure's lack of identity also elides the current archbishop with that of his canonized predecessor, enhancing his prestige and proximity to the holy founder. Bertelli establishes that the inscribed passages describing the scenes derive from the oldest version of the miracles, the eighth-century *Apparitio*, suggesting that Gerardo understood it to be the holiest and most authentic of the miracle texts.[50] Thus, Bertelli locates the impetus for the doors and the development of the pertinent iconography and inscriptions squarely with a Reform-minded Benedictine, Gerardo.

Given the fact that the agency of Gerardo registers in the inscriptions of the dream scenes and in the inclusion of Roman and Cassinese saints (but, interestingly, not of Benedict or Paul), the archbishop becomes the real patron of the doors for Bertelli.[51] Pantaleone is but one player in larger networks stretching from Rome and Montecassino to the newly created metropolitan see at Siponto. Whether or not this Pantaleone was Pantaleone de Maurone Comite or another figure altogether, he is relegated to the more passive role of sponsor; his wealth benefitted the shrine, but only because of the initiative of a resourceful and well-connected cleric.[52] But as at San Paolo, he likely served as mediator between the shrine site and the workshops in Constantinople, where the doors were made. However, while the archbishop had a profound impact on the doors in all the ways Bertelli posits, Pantaleone remains essential for any characterization of patronal agency at Monte Sant'Angelo. For on the doors themselves, Pantaleone is a far more explicit and active presence than Gerardo.

THE LANGUAGE OF MEDIEVAL PATRONAGE

As Therese Martin has written, "The flexibility of the word 'fecit' indicates the need for a more nuanced way of interpreting the connections among the various roles played by medieval patrons and

47. G. Bertelli, "La porta di Monte Sant'Angelo tra storia e conservazione," in *Le porte del Paradiso,* ed. by A. Iacobini (as in note 11), 325.

48. M. Clarelli, "Pantaleone d'Amalfi" (as in note 13), 644.

49. G. Bertelli, "La porta di Monte Sant'Angelo" (as in note 47), 319–344.

50. G. Bertelli, "La porta di Monte Sant'Angelo" (as in note 47), 328.

51. Girardo as "committente" in G. Bertelli, "La porta di Monte Sant'Angelo" (as in note 47), 325.

52. G. Bertelli, "La porta di Monte Sant'Angelo" (as in note 47), 325.

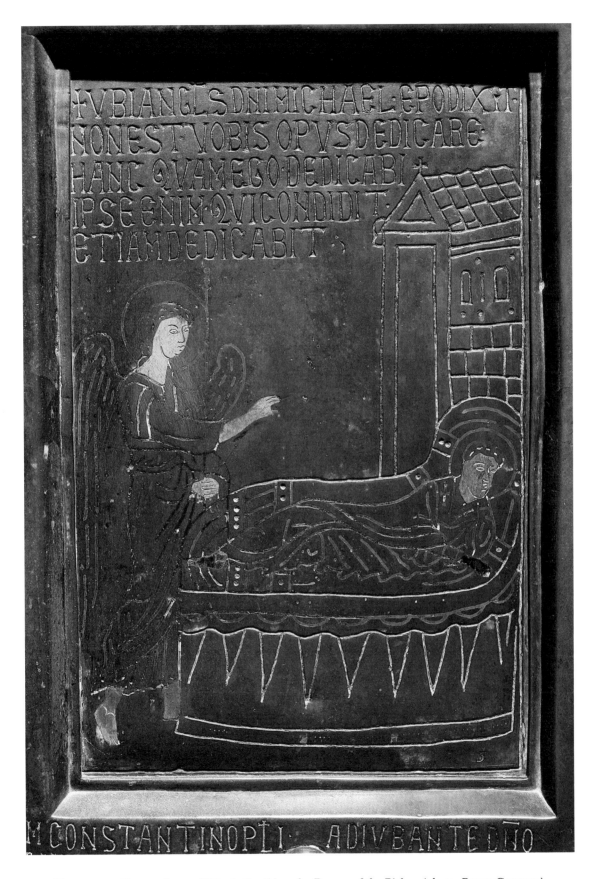

FIGURE 11. Bronze doors of Monte Sant'Angelo, Dream of the Bishop (photo: Beppe Gernone).

artists."[53] Not only is the language of patronage ambiguous or inconsistent, but it also challenges our own linguistic habits. Whereas we gravitate toward such nouns as patron, donor, or founder to characterize initiators of art production, medieval people did not. In a typical example, the inscription on the cross on the Amalfi doors states that "Pantaleone had this work made for the redemption of his soul" (*Hoc opus fieri iussit p[ro] re|demptione animae sue Pantal[eo]*) (see Fig. 4).[54] The doors at Monte Sant'Angelo include a similar "had it made" phrase.[55] This is an old formula; one of its earliest extant manifestations dates from the mid-seventh century and appears on a pier in one of the Lombard chambers at Monte Sant'Angelo.[56] Examples from other cultural contexts utilize similar language, as well as prominent displays of script, including Paschal's silver reliquary box from the Sancta Sanctorum (817–824) (*Paschalis episcopvs plebi dei fieri ivssit*), and the Herimann Cross of 1056 (*Herimannus archiepiscopus me fieri iussit*). *Fieri fecit* was a more prevalent expression, however, seen in such diverse works as the so-called Lothar Crystal (*c.* 860) and the Luttrell Psalter (1330s). This limited but representative sample shows a consistent rhetoric of delegation across papal, imperial, episcopal, monastic, and lay settings.

While some of the inscriptions at Amalfi and Monte Sant'Angelo follow widespread conventions, others deviate markedly from them. At Amalfi, a second dedicatory inscription incised along two horizontal bands reads, "Hoc opus Andree memori consistit|honore auctoris studiis|effectu(m) Pantaleonis his|ut pro gestis succedat gra(tia) culpis."[57] In contrast to the compact white letters of the inscription on the cross, this script is more elongated, stylized, and colorful, with yellow and white letters lending visual *varietas* to the precisely delineated scroll-like strip of words (Fig. 12). At Monte Sant'Angelo, two attributional inscriptions also use the term *auctor*. The primary inscription, which fills an entire panel on the right valve, reads, "Pray ... for the soul of Pantaleone who was the *auctor* of this work," followed by "O Michael ... intercede for the soul of this *auctor*" (Fig. 13).[58] Although *auctor* and its variants appear on several works of medieval art, including the enamel plaque of Henry of Blois (1171), the world of Constantine and his immediate successors sheds some light on Pantaleone's inscriptions.[59] A dedication in the apse of Old St. Peter's used the word in a patronal context, according to the collection of inscriptions preserved in Einsiedeln.[60] The text, which recorded what was visible at some point before the ninth century, read:

> This [church] that you see is a seat of justice, a house of faith, and a hall of modesty. All piety possesses it. This celebrated [church] rejoices in the

53. T. Martin, "Exceptions and Assumptions" (as in note 35), 4.

54. On the prestigious overtones of *fecit* due to its repetition in descriptions of Solomon and the Temple, see N. Pevsner, "Terms of Architectural Planning in the Middle Ages," *JWCI* 5 (1942), 232–237. By contrast, *iussit* appears in the Vulgate in the negative patronage context of 1 Maccabees, ch. 1.

55. For Monte Sant'Angelo: "Hoc opus completum est in regia(m) urbem Constantinop(o)li adiubante d(omi)no Pantaleone qui eas fieri iussit..." P. Skinner, "Commercio internazionale" (as in note 17).

56. In Crypt B, dated 662–687: D[E] DONIS D(E)I ET [S(AN]C(T)I A[RCHA]N+GELI FIERE IVSSE ET DON[AVIT] |+ROMOVALD DUX AGE[R]E PIETATE||+GAIDEMARI FECI[T]. A. Dietl, *Die Sprache der Signatur: Die Mittelalterlichen Künstlerinschriften Italiens* (Berlin, 2009), vol. 2, 1073. Many thanks to Nino Zchomelidse for this reference.

57. Transcription from Matthiae, *Porte bronzee* (as in note 8), 63.

58. "Roga vos om(ne)s qui hic venit-|is causa orationis ut prius|Inspiciatis tam pulchrum|Laborem et sic intrantes|Precamini D(omi)n(u)m proni pro anima|Pantaleonis qui fuit auctor huius laboris|O summe princeps Michael|Nos te rogamus qui venimus|Ad orandum tuam gratiam ut nostris precib(us) adias pro|Auctoris huius anima ut|Una nobiscu(m) fruatur se(m)pi|Terna gaudia qui tui nominis|S(an)c(t)itas fecit decorare talia." Transcription and analysis in G. De Spirito, "Appendice epigrafica" (as in note 12), 110–111.

59. Discussion in U. Bergmann, "PRIOR OMNIBUS AUTOR—an höchster Stelle aber steht der Stifter," in *Ornamenta Ecclesiae. Kunst und Künstler der Romanik*, Katalog zur Ausstellung des Schnütgen–Museums in der Josef-Haubrich-Kunsthalle, ed. by A. Legner (Cologne, 1985), 1: 117–148.

60. IUSTITIAE SEDIS FIDEI DOMUS AULA PUDORIS|HAEC EST QUAM CERNIS PIETAS QUAM POSSIDET OMNIS|QUAE PATRIS ET FILI VIRTUTIBUS INCLYTA GAUDET|AUCTOREMQUE SUUM GENITORIS LAUDIBUS AEQUAT. R. Krautheimer, "A Note on the Inscription," 317; R. R. Holloway, *Constantine and Rome* (New Haven, Conn., 2004), 80.

FIGURE 12. Bronze doors of Amalfi, large inscription (photo: author).

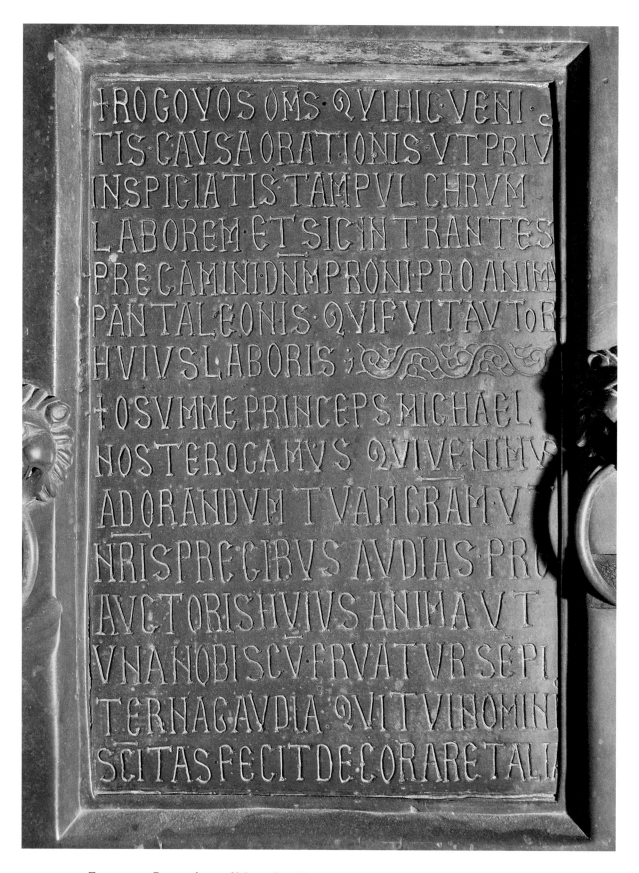

+ ROGO VOS OMS · QVI HIC VENI · S
TIS CAVSA ORATIONIS VT PRIV
INSPICIATIS TAM PVLCHRVM
LABOREM · ET SIC INTRANTES
PRECAMINI DNM PRONI PRO ANIM
PANTALEONIS · QVI FVIT AVTOR
HVIVS LABORIS ;

+ O SVMME PRINCEPS MICHAEL
HOS TE ROGAMVS QVI VENIMVS
ADORANDVM TVAM CRAM VT
NRIS PRECIBVS AVDIAS PRO
AVCTORIS HVIVS ANIMA VT
VNA NOBISCV FRVATVR SEPI
TERNA GAVDIA QVIT VI NOMIN
SCITAS FECIT DECORARE TALI

FIGURE 13. Bronze doors of Monte Sant'Angelo, inscription panel (photo: Beppe Gernone).

virtues of the father and son, and it makes its own *auctor* equal in the praises of the *genitor*.[61]

In his work on the inscription, Krautheimer rather uncharacteristically did not put much pressure on the term *auctor*, suggesting that it "could mean creator, builder, or founder, in this case might as well mean donor."[62] Although he tackled the lexical complexity of the inscription and the polyvalence of some of its words, his concerns lay elsewhere, namely with the identity of this *auctor* and what precisely he "authored." In 1987 Krautheimer put forth Constantine as *genitor* and one of his sons, likely Constantius, as *auctor*, after having associated the pairing with God the Father and Christ decades earlier. Krautheimer posited that Constantius was the *auctor* of a new apse mosaic that replaced the aniconic gold one built by his father; the new commission, then, was equal in the praises of the *genitor* and founder of the church, Constantine.[63] The complex inscription has prompted other interpretations. Bowersock holds that *auctor* refers to Constantine's other son, Constans, to whom he attributes the foundation of Old St. Peter's, rather than merely the apse mosaic.[64] This patronal act was of such importance that it was in line with his father's overall achievement; hence the *auctor/genitor* reference.

I cite the Vatican apse inscription not to take sides in this attributional debate, but to demonstrate that patronal agency could be expressed and conveyed in a variety of ways. Of course *auctor* carried several meanings in both the fourth and eleventh centuries, some of which align with the polyvalent modern English word

"author."[65] But its contractual, legal overtones in the imperial period merit consideration here. An *auctor* was first and foremost one who takes action, makes decisions, serves as a representative, and advocates persuasively.[66] Legislative initiatives in the senate, for instance, were put forth by an *auctor*, including the emperor. Although the term also pertained to writers (particularly those who were experts in their field), it more frequently conveyed the sense of legal or administrative authority.[67] This wider linguistic framework for the inscription at Old St. Peter's suggests how the rhetoric of artistic patronage could intersect with the legalese of imperial rule and its social and political structures.

The associations between *auctor*, *auctoritas*, and power became more pronounced during the Middle Ages, albeit with a fundamental shift.[68] As Chenu's etymological analysis of the word has shown, *auctor*, which eventually was rendered as *autor*, moved away from its initial roots in *augeo* and came to denote a recognized authority, the *auctor* in *auctoritas*. This idea is perhaps best illustrated by Scholastic views of canonical writers, but overall the term conveyed a more general sense of actors, producers, or doers endowed with authority and authenticity, than of composers of texts per se. Hence the philosopher and bishop of Poitiers, Gilbert de la Porrée (1076–1154), vividly characterized the triune God not as three *autores*, but as one.[69] Pantaleone's self-identification as *auctor* of the doors at Amalfi and Monte Sant'Angelo conveys in those public sites that he possessed *auctoritas*: a recognized authority, legitimacy, and authenticity

61. Translation, R. Van Dam, *The Roman Revolution of Constantine* (Cambridge, 2007), 221–223; versus Krautheimer's: "This which you see and which Mercy undivided inhabits is the Seat of Justice, the House of Faith, the Hall of Chastity (Awe), which delights in the virtues of the father and son and equals its donor (auctor) with the praise of his (genitor) sire." Krautheimer, "A Note on the Inscription" (as in note 60), 317.

62. Krautheimer, "A Note on the Inscription" (as in note 60), 317.

63. Recent discussion in F. M. Moretti, "La Traditio Legis nell'abside," in *L'Orizzonte tardoantico e le nuove immagini 312–468. La pittura medievale a Roma, Corpus*, 312–1431, ed. by M. Andaloro (Rome, 2006), 1: 87–90.

64. G. Bowersock, "Peter and Constantine," in *St. Peter's in*

the Vatican, ed. by W. Tronzo (Cambridge; New York, 2005), 11–12.

65. *Oxford Latin Dictionary*, ed. by P. G. W. Glare (Oxford, 1982; reprint 1996), 204–207; *A Latin Dictionary, Lewis and Short* (Oxford, 1879; reprint 1996), 198–200; *Dictionary of Greek and Roman Antiquities* (1890), available at www.perseus.tufts.edu.

66. *Dictionary of Greek and Roman Antiquities* (as in note 65).

67. Sixteen clusters of definitions appear in the *Oxford Latin Dictionary*; those associated explicitly with cultural production being at number nine. *Oxford Latin Dictionary*, 205.

68. M.-D. Chenu, "Auctor, Actor, Autor," *Archivum Latinitatis Medii Aevi, Bulletin Du Cange* 3 (1927), 81–86.

69. M.-D. Chenu, "Auctor, Actor, Autor" (as in note 68), 85–86.

derived from expertise, power, and long-standing prestige. The uses of *auctor,* then, complement and extend the meanings of the genealogical inscription on the first doors at Amalfi by suggesting that the *auctor*'s *auctoritas* stemmed (in part) from his distinguished family tree. As an *auctor,* Pantaleone was an officially sanctioned producer, doer, or agent, whose agency stemmed from a range of factors, both past and present.

AGENCY

In the wake of Alfred Gell's influential anthropological theorizations, agency has offered ways of conceptualizing the effect of people, things, and ideas on people, things, and ideas. His posthumous *Art and Agency* (1998) encapsulates agency as "attributable to those persons ... who/which are seen as initiating causal sequences of a particular type, that is, events caused by acts of mind or will or intention, rather than the mere concatenation of physical events An agent is the source, the origin, of causal events."[70] Christopher Tilley sees agency as "providing affordances and constraints for thought and action" and a way of conceptualizing "effects."[71] These two examples suggest that agency intersects but is not synonymous with a variety of concepts, including will, causation, power, intentionality, action, choice, initiative, freedom, and creativity, many of which are as entrenched as they are problematized in art historical and other discourses. Perhaps because of the centuries-old centrality of agency/causation in philosophy and its currency within many disciplines today, each with its own attendant histories, priorities, and disagreements, the term cannot be but imperfect.[72] Yet its prevalence in sociology, anthropology, and other fields, including art history, demonstrates its possibilities as an interpretive tool.

In a recent attempt to dissect the discourse of agency in sociology and to clarify its potential mean-

ings, Emirbayer and Mische posed the following: "We define [agency] ... as *the temporally constructed engagement by actors of different structural environments—the temporal-relational contexts of action—which, through the interplay of habit, imagination, and judgment, both reproduces and transforms those structures in interactive response to the problems posed by changing historical situations.*"[73] The ghosts of Constantine and Eusebius, Louis IX, and Pantaleone de Maurone Comite haunt this dense prose! Given the place of patronage studies within the social history of art, such sociological formulations are not only apt, but useful. Emirbayer and Mische insist upon the socially transformative nature of agency. Patronage is by its very definition engagement with others, often entailing hierarchical relationships or "different structural environments," like Constantine and Macarius, or Pantaleone de Maurone Comite and the Benedictines. Research in medieval patronage has highlighted what Emirbayer and Mische call the "interplay of habit, imagination, and judgment"—what each participant brought to the table, such as the patron's eschatological, ideological, or aspirational ideas, along with specific requests about medium, iconography, scale, price, and so on. The artist or artists, meanwhile, brought a comparably complex array of ideas, skills, materials, tools, and experiences to the project in question. The initial encounter and ensuing "interplay" respond to "changing historical situations," and, critically, offer the potential of transforming these situations. This potential is there when the situation is as complex and far-reaching as the emergence of monumental Christian architecture in the fourth century, or as circumscribed as the sexual-political anxieties of a middle-aged French king in the fourteenth.

Such theorizations are helpful not merely because they provide an interpretive framework into which art historical evidence readily fits. What the above definitions and many other recent discussions of agency

70. A. Gell, *Art and Agency: An Anthropological Theory* (Oxford, 1998), 16.

71. C. Tilley, "Materiality in Materials," *Archaeological Dialogues* 14 (2007), 19.

72. In the critique of the anthropologist Tim Ingold, agency emerges from the "dreams of theorists" and is a "magical mind-dust that, sprinkled among its constituents is supposed to set

them physically in motion." T. Ingold, "Materials against Materiality," *Archaeological Dialogues* 14 (2007), 11. By contrast, see *Art's Agency and Art History*, ed. by R. Osborne and J. Tanner (Malden, Mass.; Oxford, 2007).

73. Italics original. M. Emirbayer and A. Mische, "What is Agency?" *American Journal of Sociology* 103 (1998), 970.

share, and why I find them compelling, is an emphasis on the significance of (human) action and interaction and their shifts across time and space. Such emphases counteract one effect of the predominance of iconicity in recent scholarship on medieval art, which, given its overriding emphases on image and reception theory, tends to sideline patronal initiative.

However, studies of patronage and reception need not be at odds. Just as the above snapshot of agency in sociology does not address what happens when the transformative work of art is in the world, so studies of the iterative dynamics of patronage generally focus on what might be called the ante-natal, the processes of production. Yet agency extends well beyond the patronal field and arena of production. Art historians need to consider not only how works of art both large and small were created, viewed, and received, but also how agency was conceptualized, represented, attributed, and understood. Patronage studies need to bridge the ante- and post-natal to address these fundamental questions and reach their full potential.

What happens to patronal and artistic agency after the work of art is born? With Gell, it shifts to the index, to the work of art itself. Medievalists do not tend to be troubled by this theory; we are used to the concept of art connecting multiple temporalities, and thus bridging the ante- and post-natal. Studies of gifting that are steeped in anthropological ideas (versus theological ones) also extend the agency of the patron well into the future. Each time Jeanne d'Évreux perused or used her prayer book, she potentially performed (or rejected) the devotional and social lessons encoded within it by her husband Charles IV. Each time an aristocratic lady used an ivory-encased mirror while she groomed, the giver of the gift was reflected, too, evoked, and implicated. As Therese Martin recently wrote, "Studying the reception history of an object or structure can … help to complete the circle that began with its conception and manufacture. Thus, we should ask whether the role of the "maker" can be extended to the *recipient* of a work of art or architecture: without the woman for whom it was made, such a piece would not exist." [74] I am inclined to put

this idea another way: when studies of patronage and agency can bridge the ante- and post-natal phases of art production, they have the potential to bring people back into the narrative. They can do so in a more active and lively way than have formalist accounts of medieval art or scholarship on image theory.

Back to the bronze doors and the multiple temporalities of medieval art. In a typical justification for artistic production, Pantaleone had the Amalfi doors made for the redemption of his soul (of course that is only part of the story, but it is what he chose to represent on the expanses of bronze). Thus, while embodying the living patron's hopes for salvation after his death, the doors reach out to a future moment when Pantaleone will or will not be so rewarded. Thus the doors assume a kind of agency, continuing the work initially undertaken by the patron and artist when they are (long) gone. This agency enacted by the doors is typical; many works of medieval art carry similar inscriptions and reveal similar anxieties over sin and salvation.

Inscriptions at Monte Sant'Angelo activate the doors in a more immediate and constant way. First, on the left valve, running along the horizontal frame below scenes of the Three Hebrews in the Fiery Furnace and the Sacrifice of Isaac, is the following:

> I pray and implore the rectors of St. Michael the Archangel that they have cleaned one time a year these doors in a way in which now we have shown you, so that they will always be splendid and bright. [75]

Inscribed in bronze, Pantaleone's instructions create a contract that invites, prompts, and guarantees regular action (Fig. 14). Thus it carries the legal traces evoked by the inscription in the apse at Old St. Peter's, the genealogical inscriptions at Amalfi, and the valences of power embodied in *auctor*. Demarcating the entrance to an underground sacred cave, the doors had to shine with splendor, like Constantine's marbles and ceiling in the Holy Sepulchre, or the bronze sheathing in which the emperor sealed the tombs of Peter and other Roman martyrs, according to the *Liber Pontificalis*. It is probable that the dark, dank

74. Martin, "Exceptions and Assumptions" (as in note 35), 6.
75. "Rogo et adiuro rectores s(anc(t)I angeli Micha(elis) ut

semel in anno detergere faciatis has portas sicuti nos nunc ostendere fecimus ut sint semper lucide et clare."

FIGURE 14. Detail of three Hebrews panel, bronze doors of Monte Sant'Angelo (photo: Beppe Gernone).

location of the Monte Sant'Angelo doors made the desire for splendor that much more pressing and its effect that much more dazzling. Furthermore, the doors required ritual cleaning, as if they were animate and needing to be scrubbed free of dirt and sin. The inscription and ritualized cleaning evoke the washing of the feet of the Sancta Sanctorum icon of Christ, a ritual performed during annual processions through the city of Rome for the vigil of the Assumption of the Virgin.[76]

Conspicuously placed between two leonine knockers on the right valve, the long inscription panel at Monte Sant'Angelo permanently broadcasts additional instructions, this time to the faithful (see Fig. 12):

> I pray to you all who come here | To pray, that first you admire this very beautiful work and then when you've entered | call out on your knees to the Lord for the soul | of Pantaleone who was the *auctor* of this work.[77]

Thus the door continues to express the desires and needs of the supplicant and devotee, Pantaleone. It reaches out beyond the ante-natal and works to shape the behavior of future believers whose own pious needs can assimilate Pantaleone's and perform this ritual on his behalf. In other words, the doors at Monte Sant'Angelo underscore the various ways in which the agency that initially unfolded in the patronal field can accrue around the object itself and continue to affect change long after the demise of the patron, donor, *concepteur*, artist, or other agent or *auctor*. Thus, within the network of institutions and individuals that helped shape the iconography, inscriptions, and literal pieces of the doors—a network that stretched from Rome and Montecassino to Siponto and Constantinople—the impact of Pantaleone was as great as that of the archbishop of Siponto, Gerardo. It simply registered, and continues to register, in different ways: in the prayers and on the knees of fellow supplicants, and on the hands of cleaners and restorers who strive to keep the bronze panels "splendid and bright."

Within the history of art, the social structure and implications of patronage endow it with a methodological flexibility that has helped sustain patronage studies over many decades. Chameleon-like, patronage can readily absorb the coloration of theories developed in related fields of inquiry. If the study of patronage is on the cusp of resurgence, then it is in part because of the applicability of a number of frames of reference to the dynamics of patronage. No single theory holds the key, but it is up to us to play with them to see what doors might open.

76. H. Kessler and J. Zacharias, *Rome 1300: On the Path of the Pilgrim* (New Haven, Conn.; London, 2000).

77. See note 58 above.

JULIAN LUXFORD

The Construction of English Monastic Patronage

THE FOLLOWING discussion conflates two themes: the nature and study of the art-patronage of English medieval monasteries and the general status of patronage as an object of scholarly inquiry. A focus on English monasticism is due partly to the need to choose a domain suited to my interests and partly to the advantages—some of which are briefly outlined below—that study of the religious orders has for the analysis of patronage. Thinking about this subject has unavoidably induced concern with art-patronage in the abstract. To make patronage the basis of one's work is effectively to reify it, and doing this obliges one to think about what it is and how it can be used to gain insight. Thus far, art historians have commonly been reluctant to divorce patronage from individual objects and transactions. This reluctance is in most cases entirely reasonable, but it means that the conceptual utility of patronage is under exploited. My main aim here is to emphasize some neglected possibilities and potential problems in the study of monastic art and architecture that could be opened up by a more versatile understanding of patronage than that currently in circulation. Discussion of these issues is followed by some remarks on how the concept of patronage might be developed.

At the end of the Middle Ages, England contained over 600 houses of monks, regular canons, and nuns. These were scattered throughout urban and rural areas: monasticism was a ubiquitous element of English medieval culture that intersected with the lives of vast numbers of people. England had some of the wealthiest monasteries in Europe, as well as what can only have been some of the poorest.[1] The greater among these institutions were famous for their material elaborateness and beauty. A Venetian traveling in England around the year 1500, whose grounds for comparison were certainly splendid enough, was left awe-struck by what he called "enormously rich Benedictine, Carthusian and Cistercian monasteries [...] more like baronial palaces than religious houses."[2] There is evidence that even the small and fraily endowed priories made zealous attempts to maintain, renew and embellish their infrastructure according to prevailing fashions and standards of decorum.[3] The physical development of English monasticism was incessant: few religious houses seem to have stood still in art and architectural terms. Artistic patronage in this sphere was thus a pervasive, incalculably varied constant.

Medieval English monasticism is thus fertile territory for patronage studies. As a unit of analysis, it is historically grounded, the most emphatic evidence for this being its wholesale extirpation in the 1530s and early 1540s. Yet it can be subdivided logically by order, institutional type (for example, cathedral priory, dependency, alien priory, nunnery),

I am very grateful to Colum Hourihane for the opportunity to present some of my ideas about monasticism and patronage at the conference "Medieval Patronage: Patronage, Power and Agency in Medieval Art," and also for his editorial solicitude. I am also pleased to thank Anthony Emery for providing me with images of manor houses.

1. English (and Welsh) religious houses are tabulated in D. Knowles and R. N. Hadcock, *Medieval Religious Houses: England and Wales* (London, 1971). In 1535 the monastery with the largest annual income was Glastonbury (Benedictine: £3311), while rural nunneries such as Benedictine Lambley (Northumberland), Cistercian Fosse (Lincolnshire), and Augustinian Rothwell (Northamptonshire) got by on £7 or less.

2. *A Relation, or Rather a True Account of the Island of England ... About the Year 1500*, ed. C. A. Sneyd (London, 1847), 29–31, 40–41.

3. For example, the small Benedictine priories of Cowick and Kington St. Michael, discussed in J. M. Luxford, *The Art and Architecture of English Benedictine Monasteries, 1300–1540: A Patronage History* (Woodbridge; Rochester, N.Y., 2005), 94–95 (Cowick); 5, 130, 192–193 (Kington St. Michael). See also M. R. V. Heale, "Veneration and Renovation at a Small Norfolk Priory: St. Leonard's, Norwich in the Later Middle Ages," *Historical Research* 76 (November, 2003), 431–449.

or individual house, to suit scholarly agendas and resources. Its extent, methods of display, and intensive self-documentation mean that evidence for attitudes to building and ornamentation is sufficient for meaningful analysis, even if the majority of sources has been lost. Monasticism's tentacular involvement in practically all levels of lay and ecclesiastical society inevitably left a strong socio-political stamp on much of its art and architecture. These things, along with the monastic tendency to regard agency and achievement as collective as well as (or instead of) personal, add agreeable layers of sophistication to its art history.

Despite these attractions, there are few detailed analyses of the patronage of monastic art and architecture. This may be because few art-historical studies base themselves on monasticism. As a category of study, monasticism has traditionally and coherently been regarded as historical rather than art historical. This attitude endures: a striking recent evidence of it is the absence of monasticism from the catalogue of the most ambitious and materially inclusive of any exhibition of English late medieval art.[4] Because so many of its objects are monastic, English art history deals with monasticism as a matter of course, but typically in no great depth. With a few exceptions, most of them concerned with the period before 1200, the studies in which monasticism and patronage loom largest are those dealing with individual objects or institutions, where the refinement of focus is usually thought to necessitate historical contextualization.[5]

Another reason for lack of attention to patronage in this sphere may be the want of a concept of patronage that will bear intensive analysis. This raises the problem of definition, and, it is to be hoped, helps to establish a broader relevance for what I have to say. No definition of artistic patronage will be stipulated here, because a consensual definition would not be possible.[6] There is a strong implicit recognition of this in the most searching exploration of the meaning and value of patronage for medievalists—Jill Caskey's essay of 2006. (One effect of Caskey's analysis is to show that the competition of approaches and ideologies at work in academic art history effectively precludes agreement on such matters.)[7] In discussions of English monastic art, and for that matter more broadly, the problem of definition is almost always avoided, and a dyadic model adopted that represents patronage as a transaction or series of transactions between a party producing a work and another receiving it.[8] This model embodies an obvious and potentially confusing dichotomy. Depending on the circumstances, an act of patronage is understood as one of

4. *Gothic: Art for England 1400–1547*, Exhib. cat., ed. R. Marks and P. Williamson (London, 2003). The absence is particularly obvious because the exhibition had a strong socio-historical bent, as noted by Willibald Sauerländer in a review in *Apollo* 159 (2004), 59–60.

5. See, for example, *The Eadwine Psalter: Text, Image, and Monastic Culture in Twelfth-Century Canterbury*, eds. M. Gibson, T. A. Heslop, and R. W. Pfaff (University Park, Pa., 1992); P. Fergusson and S. Harrison, *Rievaulx Abbey: Community, Architecture, Memory* (New Haven, Conn.; London, 1999); P. Fergusson, *Architecture of Solitude: Cistercian Abbeys in Twelfth-Century England* (Princeton, N.J., 1984); *idem, Canterbury Cathedral Priory in the Age of Becket* (New Haven, Conn.; London, 2011).

6. This has been recognized, *mutatis mutandis*, by sociologists working on patron-client relations: see, for example, J. Waterbury, "An Attempt to Put Patrons and Clients in their Place," in *Patrons and Clients in Mediterranean Societies*, ed. E. Gellner and J. Waterbury (London, 1977), 329–342 (329). In the same volume, see also E. Gellner, "Patrons and Clients,"

1–6 (4): "no one has the right to impose his definitions [of patronage] on others."

7. J. Caskey, "Whodunnit? Patronage, the Canon, and the Problematics of Agency in Romanesque and Gothic Art," in *A Companion to Medieval Art: Romanesque and Gothic in Northern Europe*, ed. C. Rudolph (Oxford; Malden, Mass., 2006), 193–212.

8. While it seems invidious to give cases in point, L. Gee's *Women, Art and Patronage from Henry III to Edward III: 1216–1377* (Woodbridge; Rochester, N.Y., 2002) may serve, with appropriate apologies, as a characteristic example that is heavily focused on English monasticism and has the word "patronage" in its title. More broadly, one can single out the three art-historical essays in *Patronage in the Renaissance*, eds. G. F. Lytle and S. Orgel (Princeton, N.J., 1981), most of the essays in *Patronage, Art, and Society in Renaissance Italy*, eds. F. W. Kent, P. Simons, and J. C. Eade (Oxford, 1987), and even, despite its formidable depths, F. Haskell's *Patrons and Painters: A Study in the Relations between Italian Art and Society in the Age of the Baroque* (New York, 1963).

either commission and purchase or donation. Thus, a party hiring an artist or shop to produce a work is a patron, and so is a party who gives a work to someone else (typically the recipient is ecclesiastical). In this manner, a given party is a patron twice over if he, she, they, or it commissions a work and subsequently donates it to some other person or institution.

This way of conceptualizing patronage is entirely reasonable, particularly where the scholar's main focus is on objects rather than social processes. If the model is convenient, nobody with any insight supposes that the reality was simple. In some cases, the most striking of which are formalist studies of the sort conducted by Henri Focillon, there are ideological reasons for downplaying patronage.[9] Elsewhere, restricted definitions have been consciously adopted. In my own study of the patronage of Benedictine art and architecture in England, I counted only transactions that could be documented or inferred beyond reasonable doubt as acts of patronage. This was in part a deliberate reaction to what I considered the imprecision of the term in existing literature, and the consequent attribution of patronage on weak grounds.[10] The main limitation of such restricted usage lies in the under-exploitation of a concept that can sustain heavier and deeper critical investigation. An opportunity to develop a promising avenue of art history is thus overlooked. In essence this is not a new insight. Julian Gardner, for example, has called for "suppler views of patronage as system," and points out that "our conceptual models of patronage in the late Middle Ages are not particularly well developed."[11] Other scholars have emphasized the elasticity of the term and the difficulties this can produce for art historians.[12] But the

art-historical discussion around patronage remains, to say the least, rich in possibilities.

On the brink of this theoretical problem I wish to draw back and focus in greater detail on English monastic art and architecture. There are aspects of monastic practice and thought that have been little investigated but hold particular promise for the historian of patronage. A sample of these, based on questions that have arisen in my own research, should indicate their potential value for developing a fully rounded art history of monasticism. Certain assumptions about the nature of patronage embedded in the following discussion are easily clarified by stressing the influence of psychology on patronage and its products. The parties involved in the exercise or reception of monastic patronage included lay and ecclesiastical donors, their families and representatives, the individuals who commissioned and paid for works (most obviously superiors, obedientiaries, and cloister monks and nuns), those who took receipt of works or the money or materials for their manufacture, heads of house to whom agency might be ascribed for various reasons, and convents understood as collectives that were greater than the sum of their parts. If one is working on the basis of monastic assumptions, then God, often along with one or more of his saints, should be added to these. It goes without saying that each of the human participants acted for a variety of reasons, most of which cannot be known even where patronage is documented. But living in a given place at a given time involved certain common beliefs and habits of thought that are often perceptible in the documentary record and can help to explain the

9. Patronage, and even artisanship, was for Focillon part of a misguided sociological approach to art. The topic is thus ignored in his *The Art of the West in the Middle Ages*, 2 vols. (London, 1963). See also H. Focillon, *The Life of Forms in Art*, trans. C. B. Hogan and G. Kubler (New York, 1992), 130–135.

10. Luxford, *Art and Architecture* (as in note 3), 1–2.

11. J. Gardner, "Pattern and Narrative: Patrons and Programmes," in *Bilan et perspectives des études médiévales en Europe*, ed. J. Hamesse (Louvain-la-Neuve, 1995), 305–311 (309, 310). Gardner has made two important attempts to ameliorate matters (although neither contains a theoretical discussion of pa-

tronage *per se*): *The Tomb and the Tiara: Curial Tomb Sculpture in Rome and Avignon in the Later Middle Ages* (Oxford, 1992); *Giotto and His Publics: Three Paradigms of Patronage* (Cambridge, Mass.; London, 2011).

12. See, for example, the essays by Ronald Weissman (25–45) and Gary Ianziti (299–311) in *Patronage, Art, and Society* (as in note 8); P. Binski and E. A. New, "Introduction: Patrons and Professionals in the Middle Ages," in *Patrons and Professionals in the Middle Ages*, eds. P. Binski and E. A. New, Harlaxton Medieval Studies, XXII (Donington, 2012), 1–4; Caskey, "Whodunnit?" (as in note 7).

motivation for patronage, as well as the type, appearance, and quantity of its fruits. Where the outlook of monks and nuns is concerned, it is particularly beneficial to explore the character of local monastic history and tradition, and the values of the societies in which monasteries were situated.[13] Social values invite consideration most immediately when and where monasteries felt themselves threatened; but these were not the only circumstances where they affected patronage. The relationship of one monastery to another, and to non-monastic institutions from the royal household down, is worth pondering in the case of ostentatious patronage, not least because proximity encouraged emulation. Interpretation of religious rules, primarily that of St. Benedict, always deserves to be taken into account. In some cases, such as the early Cistercians and the Carthusians, specific choices about art and architecture reflect the moral timbre of an entire order, at least as articulated by its general chapter.[14] And, of course, there are the possible effects of prevailing economy, politics, fashion, and other things, the nature of which varied with time and place. The assumption to be underlined is simply that analysis of local climate matters—is indeed surpassingly important—because it conditioned the personal motives and choices that underlay all acts of patronage.

Perhaps the commonest generic issue that arises in the study of "internal" monastic patronage—that is, the acquisition of art and architecture by religious men and women for their own use, or for circulation within their order—is that of agency.[15] A medi-

eval habit of ascribing responsibility to superiors has been followed in modern scholarship, where heads of houses are often the only members of the monastic hierarchy to rate a mention. This habit of attribution is convenient, but it disguises a complex reality. Where sources can be checked, it often turns out that projects ascribed to superiors were largely organized by monastic officials and paid for, in part at least, with conventual funds. These funds might include officials' incomes, money specially raised for the purpose by soliciting donations or systematic exploitation of estates, gifts made by the laity, contributions to cult-objects and images, and the pittances of every member of a given house.[16] There seems to have been a common awareness of this. The special emphasis on a superior's largesse that crops up in some documents implies that monastic readers normally assumed patronage to be a conventual enterprise regardless of its attribution. A surviving eulogy for a fourteenth-century abbot of Glastonbury, Walter of Monington, states emphatically that he rebuilt and embellished the east end of his abbey's church without accepting any contribution towards the work from the convent or officials (Fig. 1).[17] Like those from other monasteries, the chronicles of the same abbey routinely ascribe internal patronage to the abbots without this qualification, but the eulogist evidently assumed that to do so in this case would risk misrepresenting Monington's generosity.[18] Elsewhere, after recording the name of an official (Richard Thidenhanger, the chamberlain) responsible for work on his abbey's church, the

13. "Local" here refers to time as well as place. A "local" environment is thus one defined by period as well as physical and social geography.

14. The remains of Carthusian cells at Coventry and Mount Grace are examples of this. Even where official pronouncements appear to have been contravened, as rapidly occurred in the development of English Cistercian architecture (see Fergusson, *Architecture of Solitude* [as in note 5], 13–16), it is worth investigating whether some spirit of them was locally preserved.

15. The problem outlined here is discussed in greater depth in Luxford, *Art and Architecture* (as in note 3), esp. 31–36, 218–220. This study is also the source of the terms "internal" and "external" patronage (see xxi–xxii for their justification).

16. Examples in which estates were exploited with some large art or architectural goal in mind are likely to be very numerous, but the phenomenon has not been investigated.

Usually, such cases seem to have involved the ring-fencing of part of a monastery's endowment: a broadly representative example, relating to the reconstruction of the campanile at Bury St. Edmunds abbey, is found in a document dated 1438 in London, British Library (hereafter BL), Ms. Add. 14848, fol. 336[r].

17. J. M. Luxford, "*Nichil ornatus in domo domini pretermittens*: The Professional Patronage of Walter of Monington, Abbot of Glastonbury," in *Patrons and Professionals* (as in note 12), 237–260 (257).

18. For Glastonbury's main domestic chronicles see *Adami de Domerham Historia de rebus gestis Glastoniensibus*, ed. T. Hearne, 2 vols. (Oxford, 1727); *The Chronicle of Glastonbury Abbey: An Edition, Translation and Study of John of Glastonbury's "Cronica sive Antiquitates Glastoniensis Ecclesie*," ed. J. P. Carley, trans. D. Townsend (Woodbridge, 1985).

FIGURE 1. Glastonbury Abbey: fragment of the presbytery remodelled in the mid-fourteenth century by Walter of Monington (photo: author).

thirteenth-century chronicler Matthew Paris stated that architectural patronage at his native St. Albans was attributed to abbots as a matter of reverence (*ob reverentiam*), by which he meant respect for the outstanding dignity of both the individual and his office. He qualified this by saying that a work is attributed to the person in whose authority it is done.[19] Here, too, is a suggestion that contemporary readers understood the balance of responsibilities to be, in a mundane sense, different.

Monastic chroniclers cannot rightly be accused of trying to deceive their readers or generate myths of untrammelled personal largesse. It is reasonable to think that individuals were idealized in this and other ways not simply out of respect for their office but also because doing so brought luster to the con-

vents they represented. A special virtue of this representation relevant in the current context was that it preserved the anonymity of other monks. In some cases, individuals of lower status are extolled in documents for important acts of patronage. They are usually priors, sacrists, or masters of the works, all officers routinely involved in large projects of building and embellishment.[20] In these cases patronage is identified with organization and oversight, but there is no less reason for thinking of it as broadly institutional. Another reason for identifying individuals as patrons is that they paid for projects with monies assigned to their offices. But it is reasonable to question whether income assigned to a superior or official out of revenues that were donated to monasteries collectively was considered private: it was all, as one abbot

19. *Gesta abbatum monasterii sancti Albani: A Thoma Walsingham, regnante Ricardo Segundo ... compilata,* ed. H. T. Riley, 3 vols., Rerum Britannicarum medii aevi scriptores, 28.4 (London, 1867–1869), I: 280 (*Ille enim facit, cujus auctoritate quippam fieri dinoscitur*).

20. Accounts from the Benedictine monasteries of Bury St. Edmunds, Ely, St. Augustine's Canterbury, Rochester, and Worcester are among those to single out the sacrist as patron of large projects.

of St. Albans noted, God's money, which he simply administered on behalf of his house.[21] The overarching scholarly challenges here are to understand how competing ideas of personal and collective agency were reconciled in particular cases, and, where possible, to identify actual types and degrees of input. Doing so requires close attention to the language of documents, coupled with a broadly contextualized understanding of this language. It is also important to know both the legislative documentation of a given order and, where possible, the obedientiary structures and financial organization of the relevant monastery.

The problem of agency has a particular, if not unparalleled, status in the study of monastic patronage.[22] Werner Gundersheimer's observation that "no patron, however wealthy, powerful or exulted, is an island" has a double resonance where individual actions were habitually conflated with collective ones.[23] One's view of agency naturally affects the way the whole subject is understood. But other matters are similarly influential. One of these involves trying to understand how art-patronage relates to other kinds of gift-giving. The subject is a difficult one but it invites and requires consideration: there is a mass of evidence for it. It is normal to hive art-patronage off from the larger domain of material support for monasticism, and the tendency of chroniclers to group art and architectural achievements together provides some justification for this. However, it was common for monks and nuns to record other achievements, such as the recruitment of new religious, acquisition of land and revenues, and payment of debts in combination with accounts of art-patronage. For example,

Euphemia de Walliers, who ruled the Benedictine nunnery of Wherwell in Hampshire from 1226 until 1257, is recorded in a narrative passage of her abbey's cartulary to have doubled the number of nuns, increased their allowance for clothes, set an example by her piety, constructed a large number of buildings, and cleared away others both within the monastery and on its manors; she exercised zealous charity, adored the beauty of God's house and augmented it with precious objects, reconstructed a collapsed campanile, and demolished the church's decrepit presbytery, as well as laying the first stone of the new one with her own hands.[24] These endeavours—which her eulogist considered so powerful that she seemed more greatly to display the spirit of a man rather than a woman (*non femineum sed virile magis animum gerere videretur*)—are represented collectively, as "good works," and lose much of their intended impact if removed from context and classified by type or counted separately. This way of listing achievements, which is always calculated, is repeated many times over in the sources (it is particularly common in chronicles and martyrologies, and is also found in the eulogies that preface obit-rolls).[25] It suggests that art-patronage was often understood, in retrospect at least, as a component of something greater, and that it shared characteristics with other sorts of largesse. Like the acquisition of land, say, or augmentation of conventual allowances, it was an act of devotion, charity, and accountability, as well as a signifier of generic virtue.

With a different emphasis, art-patronage and other sorts of enterprise are also conflated in account rolls and registers, which list outgoings and receipts in

21. *Chronica Monasterii S. Albani. Annales monasterii s. Albani a Johanne Amundesham, monacho, ut videtur, conscripti, (A.D. 1421–1440)*, ed. H. T. Riley, 2 vols., Rerum Britannicarum medii aevi scriptores, 28.5 (London, 1870–1871), ii: 196.

22. Parallels can be sought in the patronage of other corporations: secular ecclesiastical institutions, of course, and also religious and craft guilds, aristocratic and gentry families, and even neighborhoods. See, for example, W. L. Gundersheimer, "Patronage in the Renaissance: An Exploratory Approach," in *Patronage in the Renaissance* (as in note 8), 3–23 (19–20); F. W. Kent, "Ties of Neighbourhood and Patronage in Quattrocento Florence," in *Patronage, Art, and Society* (as in note 8), 79–98.

23. Gundersheimer, "Patronage in the Renaissance" (as in note 22), 19.

24. London, BL, Ms. Egerton 2104, fols. 43ᵛ–44ᵛ. For a translation see *The Victoria History of the County of Hampshire and the Isle of Wight*, ed. H. A. Doubleday and W. Page, 7 vols. (London, 1900–1914), ii: 132–133; reprinted in V. G. Spear, *Leadership in Medieval English Nunneries*, Studies in the History of Medieval Religion, 24 (Woodbridge, N.Y., 2005), 217–218. An edition of the cartulary (which contains more material on nuns' patronage) is R. P. Bucknill, "Wherwell Abbey and Its Cartulary," 2 vols. (Ph.D. diss., University of London, 2003), ii.

25. *Recueil des rouleaux morts (VIIIᵉ siècle–vers 1536)*, ed. J. Dufour, 4 vols. (Paris, 2005–2008), iii: 200–201 (no. 304), 678–681 (no. 346). Both these examples are from Durham.

FIGURE 2. Detail of Worcester Cathedral Library, Register A XI, fol. 46ʳ, setting out Prior More's expenses for one week of 1521. Items include pocket money and gratuities, sweet wine, shoes, a cup, and "lymnyng gyldyng, & drawyng of certen of my masse boks" (photo: Christopher Guy, Worcester cathedral archaeologist; reproduced by permission of the Chapter of Worcester cathedral).

chronological order and thus do not usually group goods and services by type. In the account-book of William More, a late prior of Worcester (he ruled from 1518–1536), things that an art historian does and does not study are all jumbled up together: in two places an illuminated missal sits next to boots or shoes, and a painted cloth showing the Nine Worthies is listed alongside routine household expenditure (Fig. 2).[26] This practical method of organization suggests a fluid typology of objects based on chronology of and responsibility for expenditure, and also intended location (for example, chapel, church, manorhouse, university residence), as much as material or iconographic character. It would be impractical to force these points, because there are also documents that demonstrate a distinctive interest in art and ar-

chitecture. For example, an early sixteenth-century canon of Thornton in Lincolnshire trawled his abbey's compotus rolls to produce an account of art and architectural achievements in the *longue durée* (Fig. 3), and a similar document, though relating to a shorter period, survives for fourteenth-century patronage at Worcester.[27] However, the point to be stressed is that a balanced understanding of monastic art-patronage depends on careful consideration of the larger culture of expenditure and benefaction in which it was situated.

Understanding the nuances of patronage—its priorities, balance, rhythms—also requires an inclusive view of what a monastery actually was. The current art-historical tendency is to regard a monastery, in physical terms at least, as the buildings contained

26. *Journal of Prior William More*, ed. E. S. Fegan (London, 1914), 99, 120, 132.

27. The account from Thornton is partially printed in K. Major, "The Thornton Abbey Chronicle (Bodleian Library,

Tanner Ms. 166), with Extracts Relating to the Fabric of the Abbey," *Archaeological Journal* 103 (1946), 174–178. That from Worcester is printed in full in U. Engel, *Worcester Cathedral: An Architectural History* (Chichester, 2007), 225–226.

FIGURE 3. Oxford, Bodleian Library, Ms. Tanner 166, fol. 12ᵛ: part of an early sixteenth-century chronicle of Thornton listing building and furnishing done at the abbey between 1329 and 1347 (photo: Bodleian Library; reproduced by permission).

FIGURE 4. Broadway (Worcestershire), an early to mid-fourteenth-century manor-house of the abbots of Pershore (photo: Anthony Emery; reproduced by permission).

within a given precinct. But convents owned or had a stake in manors, cells, parochial churches, chapels of ease, university halls of residence, and other domains, each of which entailed responsibility to build, maintain, and ornament, often sumptuously. Indeed, by the later Middle Ages, a large monastery can be viewed in similar terms to a lay aristocratic seat, as the *caput honoris* of a domain that could extend over great distances and often included representation in London and other centers of strategic importance.[28] Manor-houses and their associated granges, which signified the character of the institutions they belonged to, and which required serial renovation to

suit changing standards of living and display, were particular targets of expenditure (Fig. 4).[29] While it absorbs most art-historical attention, the architecture and embellishment of a monastery's church was not always prioritized over such projects. Just as Abbot Suger of St.-Denis turned his attention to estate architecture and the priory of Corbeil before starting on his abbey's church, so English monastic superiors, under the aegis of conventual identity, often began where work seemed most needful.[30] Abbot Brokehampton of Evesham (1284–1316) had a windmill built at a place called Littleton before tuning his attention to the Lady chapel, chapter house, cloister, and other

28. For example, Abbot John of Whethamstede of St. Albans (1420–1440, 1452–1465) is said to have spent £85 repairing his hostel, and a brewery, in London: *Annales monasterii sancti Albani* (as in note 21), II: 200.

29. For surviving examples, see A. Emery, *Greater Medieval Houses of England and Wales, 1300–1500*, 3 vols. (Cambridge;

New York, 1996–2006), I: 44–47, 85–87; II: 145–147, 323–324, 411–412, 432, 551–553; III: 50–53, 53–55, 71–72, 97–99, 101–104, 384–386, 398–399, 412–413, 591–594, 624–626, 649–650.

30. L. Grant, *Abbot Suger of St-Denis: Church and State in Early Twelfth-Century France* (London, 1998), 227, 233, 238–239.

projects within the precinct. One of his successors, Roger Yatton (1379–1418), was a very busy patron of tithe-barns, cattle-houses, dove-houses, mills, and other estate buildings. He also had the bridge at Evesham reconstructed, and paved the town. "Later on" (*postea*), the domestic chronicler writes, he helped to rebuild the abbey church's presbytery.[31] Within the precinct, the church (usually the main focus of scholarly interest) often had to wait for attention until conventual buildings had been seen to. The historian of Louth Park (Lincolnshire), a Cistercian house, says that the first thing Abbot Richard of Dunham (1227–1246) did on election was to build an infirmary and kitchen: "thereafter" (*deinde*) he built the western half of the nave. At Bath (Somerset), another Benedictine house, Prior John of Dunster (1461–1481) spent 1,000 marks on a new dormitory but, apparently, nothing on the conventual church, which was creaking with age and had to be taken down shortly after.[32] These examples, which could be greatly multiplied, suggest fresh perspectives on the development and reach of monastic patronage.

Such patterns of expenditure make clearest sense if the work of maintaining and augmenting a monastery's art and architecture is viewed as a continuous process, rather than one broken up by the careers and personalities of individual superiors. While heads of houses did identify with pet projects—Matthew Paris complained that abbots of St. Albans initiated new buildings at the expense of those begun by their predecessors—the demands of maintenance, moral and legal obligation, taste, decorum, and the other things that dictated the pace and order of projects developed along their own lines.[33] When viewed diachronically, the works of building and embellishment

reported in the documentation of a given monastery suggest an almost organic process of dying off and new growth.[34] This idea has parallels in the continuous ebb and flow of a convent's monks or nuns (that is, its "living stones"), and also in the tendency to conceptualize the foundation and development of monastic houses, and whole orders, as trees with bountiful branches.[35] In this light, the patronage of any individual party emerges as a contribution to a historical enterprise, which built upon a heroic act of foundation and gave its practitioners a stake in that act. Domestic chronicles that are arranged according to the succession of superiors convey the idea of foundational inheritance and continuation through narratives presented in quasi-genealogical terms. For many readers, the link with genealogy must have been immediate, given that chronicles and pedigree rolls of kings and aristocrats were structured along the same lines. A particularly clear example of this is found in an early sixteenth-century roll-chronicle from St. Augustine's abbey at Bristol. The front of the roll displays the ancestry of the Berkeley family, while the dorse records the descent of the kings of England, abbots of St. Augustine's, and mayors and sheriffs of Bristol.[36] As usual, the aristocratic and royal pedigrees are set out in roundels connected by lines of descent, and this is done for the abbots, too, despite the lack of any blood-relationship between them. The abbots' main patronage achievements are inscribed within or alongside the roundels, with particular emphasis on building activity (Fig. 5). Readers were thus presented with an account that encouraged them to trace the architectural development of their monastery, via the various stages of its patronage, back to a foundational point in the twelfth century.

31. *Chronicon abbatiae de Evesham ad annum 1418*, ed. W. D. Macray, Rerum Britannicarum medii aevi scriptores, 29 (London, 1863), 284–289, 303–310 (quotation at 305).

32. *Chronicon abbatie de Parco Lude*, ed. E. Venables, trans. A. R. Maddison (Horncastle, 1891), 13; Luxford, *Art and Architecture* (as in note 3), 133.

33. *Gesta abbatum* (as in note 19), II: 283.

34. Compare the comments of W. Sauerländer, "Integration: A Closed or Open Proposal?," in *Artistic Integration in Gothic Buildings*, ed. V. C. Raguin, K. Brush, and P. Draper, reprint of 1995 edition (Toronto, 2000), 3–18 (esp. 10–11).

35. A vivid example, involving a tree with branches laden

with cowls to illustrate Glastonbury's status as the *fons et origo* of British monasticism, is found in *Chronicle of Glastonbury* (as in note 18), 128. For images of "trees" of various religious orders, see C. Klapisch-Zuber, *L'Ombre des ancêtres: essai sur l'imaginaire médiéval de la parenté* (Paris, 2000), 280–287; *eadem, L'arbre des familles* (Paris, 2003), 158–161; Luxford, *Art and Architecture* (as in note 3), 146 and pl. 7.

36. Berkeley Castle archives, Select Roll 98. The text relating to the abbots is printed in I. H. Jeayes, "Abbot Newland's Roll of the Abbots of St. Augustine's Abbey by Bristol," *Transactions of the Bristol and Gloucestershire Archaeological Society* 14 (1889–1890), 117–130.

FIGURE 5. Detail of Berkeley Castle archives, Select Roll 98, membrane 12, showing the "pedigree" of late medieval abbots of Bristol and their patronage achievements (photo: author, reproduced by permission of the Berkeley Will Trust).

This integrated view of patronage and its products is attractive because it ties material development into the concepts of foundation and continuity on which monastic authority was largely based. It is also suggestive of the associative value of patronage, not just for superiors, but also, for example, lay aristocrats whose forebears had founded a particular monastery and were buried within it. Contribution to a monastery begun and sustained by illustrious ancestors entitled laymen and women to identify themselves as founders and associate themselves with the virtue and stability of a past age. The outstanding example of this in England is Henry III and his partial reconstruction of the abbey church of Westminster, previously rebuilt by the saintly Anglo-Saxon king Edward the Confessor (Fig. 6). This astonishing enterprise, which cost Henry more than £42,000 between 1245 and 1272, not only honored a saint to whom he was specially devoted but also established an edifying relationship based on shared patron-status.[37] Henry became the equal of and even surpassed his hero in a highly visible way. (Contemporary perception of this relationship must also have been conditioned by the sumptuous shrine—said to have cost more than the building—that Henry had made for his paragon.)[38] There is no parallel for this in later medieval England. Within a century of foundation, the contribution of founding families to the structure and embellishment of a monastery was usually reduced to tombs, stained glass, and chantry gear. Patronage in other kinds might continue, but it seems to have been assumed— reasonably enough—that a well-endowed monastery should fund its own art and architecture.[39] However,

tombs and other commemorative objects were perfectly sufficient to advertise their patrons' place in a continuum of material and moral support, and were valuable to convents as both embellishments and demonstrations of faith in monastic integrity. Their associative potential was heightened when they were juxtaposed with monuments and objects commemorating other members of the same dynasty. Where extensive, as at the Victorine abbey of Wigmore (Herefordshire), burial-place of fourteen members of the Mortimer family, a series of monuments must have suggested a genealogy in stone, which could be traced back to the tomb of a first founder.[40] Sometimes the same idea was expressed iconographically on a single tomb. At Tewkesbury abbey (Gloucestershire), a wealthy Benedictine house, an exquisite chapel built by Isabel Despenser in 1423 was decked with twelve sculptures of lords of the honor of Tewkesbury, of whom her husband, interred in the chapel, was the latest (Figs. 7, 8). These figures must have begun with Robert Fitzhamon, who founded the monastery and is thus shown holding a votive church in a series of manuscript illustrations based on the sculptures.[41] Elsewhere, Guisborough priory (Yorkshire), which was Augustinian, contained a monument displaying eleven members of the founding family of Brus. This was a monastic commission: it is embellished with a prior's rebus, and a community of canons is represented on one of its short ends. Convents as well as lay patrons invested in this sort of art to advertise their historical and ongoing political connections.[42]

The expression through patronage of historical and dynastic associations could have practical as well as

37. For the sum of money involved, see *The History of the King's Works*, eds. H. M. Colvin *et al.*, 4 vols. (London, 1963– 1982), 1: 156–157. For detailed documentation, see also *Building Accounts of King Henry III*, ed. and trans. H. M. Colvin (Oxford, 1971), 189–287.

38. On Henry III's broader identification with Edward the Confessor, see P. Binski, *Westminster Abbey and the Plantagenets: Kingship and the Representation of Power, 1200–1400* (New Haven, Conn.; London, 1995), 52–89. The shrine is reputed to have cost 100,000 marks (£66,000): see *Chronica Johannis de Oxenedes*, ed. H. Ellis, Rolls Series, vol. 13 (London, 1859), 169.

39. This view is unconventional but based on broad and inclusive consideration of medieval sources.

40. For Wigmore's "pedigree in stone," see H. Brakspear,

"Wigmore Abbey," *Archaeological Journal* 90 (1933), 26–51 (46).

41. P. G. Lindley, "The Later Medieval Monuments and Chantry Chapels," in *Tewkesbury Abbey: History, Art and Architecture*, ed. R. K. Morris and R. Shoesmith (Logaston, 2003), 161–182 (172–176); J. M. Luxford, "Sculpture as Exemplar: The Founders' Book of Tewkesbury Abbey and Its Sculptural Models," *Sculpture Journal* 12 (2004), 4–21.

42. W. Brown, "The Brus Cenotaph at Guisborough," *Yorkshire Archaeological Journal* 13 (1894–1895), 226–261; J. M. Luxford, "The Idol of Origins: Retrospection in Augustinian Art during the Later Middle Ages," in *The Regular Canons in the Medieval British Isles*, ed. J. Burton and K. Stöber (Turnhout, 2011), 417–442 (438–442).

FIGURE 6. Westminster Abbey Church, north side of the choir and part of the north transept (photo: Courtauld Institute of Art; reproduced by permission).

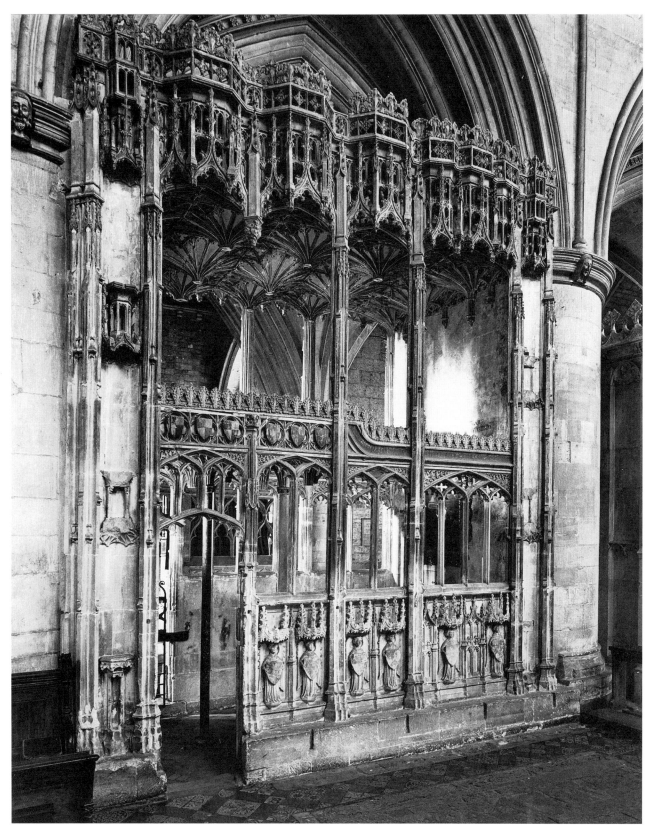

FIGURE 7. South elevation of the "Warwick" (or "Beauchamp") Chantry Chapel at Tewkesbury Abbey (photo: Courtauld Institute of Art; reproduced by permission).

FIGURE 8. Two heads of secular lords from the Warwick Chantry Chapel (photo: author).

symbolic value. This emerges with unusual clarity in late medieval records of disputes about entitlement to bear particular coats of arms. These cases do not document the direct exercise of art-patronage, but they show how past acts of patronage could be construed as dynastic ones in which the litigants had a share. They also highlight some of the reasons the litigants, and by extension other armigerous men and women, had for maintaining the patronage of monastic art, the main one being that it refreshed and reinforced, in a solicitous, publicly accessible environment, the links on which status and legal entitlements depended. Records of only three such disputes survive from England, but each involves material evidence located in religious houses.[43] This takes the form of objects with armorial decoration conferred by predecessors of the litigants, and was produced to show that a given party's right to bear the disputed arms was long-standing and publicly acknowledged. When Richard Scrope and Robert Grosvenor fought a case between 1385 and 1390, Scrope relied heavily (and in the event successfully) on tombs and other art-objects located in churches in Yorkshire, including the two Premonstratensian abbeys of Easby and Coverham. He got the abbot of Easby to testify that the arms existed on sculpted tombs commemorating his ancestors, and also in windows, "tables" (perhaps panel-paintings), and on vestments. A number

43. A historian's précis of all three cases, which were fought in the Court of Chivalry, can be found in M. Keen, *Origins of the English Gentleman: Heraldry, Chivalry and Gentility in Medieval England, c. 1300–c. 1500* (Stroud, 2002), 43–70.

of lay deponents also knew these tombs. The abbot of Coverham stated that there was one such tomb in his church bearing the coat of arms, along with several other art-objects.[44] Other monks and canons reinforced this testimony: the abbots of Cistercian Rievaulx and Jervaulx, the priors or sub-priors of Augustinian Guisborough, Lanercost, Newburgh, and Warter, and the cellarer of Watton, a Gilbertine house, all testified that the arms embellished vestments, windows, and other objects in their monasteries that had been donated by members of the Scrope family. A layman also noted that the arms could be found in a refectory window in the distant Benedictine house of Abbotsbury in Dorset.[45] Similar depositions were made in the other two surviving cases: in one of them, Robert, Lord Morley, produced thirty monks, canons, and friars from nine East Anglian religious houses to testify about heraldic art and architecture donated by his forebears.[46]

While many of the associative functions of art and its patronage are recognized, the subject as a whole is largely fallow. This is especially true of the period from which these cases come—a period traditionally but questionably considered one of monastic decline in England. Ideally, these observations about art-patrons' empathy with founders and lineage would be tested and expanded through research on major houses like Christ Church Canterbury, Durham, and St. Albans, or whole orders like the Augustinians (not to mention the friars) whose patronage history in England has scarcely been studied. The results of this work would contribute to a fuller overall picture of the role of art-patronage, and art itself, in lay-monastic relationships. This subject is undoubtedly open to development. For example, as things stand, an instance of aristocratic or gentry patronage of monastic art is normally understood in terms of its commemorative benefits and the opportunity it gave for the expression of lay power. Viewed in these terms, it is partially an

act of exchange and partially an exercise of privilege bestowed by dynastic or financial status. In either regard the convent emerges as a passive, deferential recipient whose own power is curbed by the humility and obedience of its members. But historical understanding of such transactions cannot have been so simple, even if, for a combination of pious and practical reasons, convents cultivated humble responses to them. Regardless of a lay patron's status, the convent was substantially or completely in control of his or her commemoration. Even heroes were at the mercy of conventual diligence: the fifteenth-century topographer William Worcestre complained about the dereliction of the Benedictine monks paid to commemorate the war-captain Sir John Fastolf (d. 1459), but was powerless to do anything about it.[47] In this light the great benefactor looks as much a client as a patron, who gave in a state of spiritual anxiety and hoped for something of surpassing benefit in return. Some of the complexities of the situation are suggested by a cleverly contrived image in the so-called Founders' Book of Tewkesbury abbey, now in the Bodleian Library at Oxford (Ms. Top. Glouc. D.2). This shows Isabel Despenser (d. 1439), who paid for the chapel mentioned above, lying on her deathbed and handing a copy of her will (or possibly a reconfirmation of traditionally held privileges) to an abbot, presumably William of Bristol, who was ruling when she died (Fig. 9). The abbot is only recognizable by his crozier; otherwise he is humbly representative of his convent as a whole. This sort of inverted presentation image is quickened by the presence beneath it, and on the following page, of the main terms of the will, which include a gift of jewels and vestments to the value of 300 marks and instructions about Isabel's commemoration. The image suggests *noblesse oblige*, but the lavishness and detail of her chantry—four Masses of different dedications each day to be celebrated by newly instituted monk-priests—reveals the testator's

44. *De controversia in curia militari inter Ricardum le Scrope et Robertum Grosvenor, milites, Rege Ricardo Secundo, 1385–1390,* ed. N. H. Nicolas, 2 vols. (London, 1832), I: 95–96, 97–98, 117–118, 129, 131, 154.

45. *Ibid.,* I: 76, 93–95, 98–99, 99–100, 100–101, 102–103.

46. Kew, The National Archives, C47/6/1, membranes 23–29. The documents of this case (Morley vs. Lovell) are unpublished.

47. *William Worcestre: Itineraries,* ed. and trans. J. H. Harvey (Oxford, 1969), 2–3, 92–93. Over a decade later the monks were still not maintaining Fastolf's chantry properly: *Visitations of the Diocese of Norwich A.D. 1492–1532,* ed. A. Jessopp, Camden Society, N.S. 43 (Cambridge, 1888), 62.

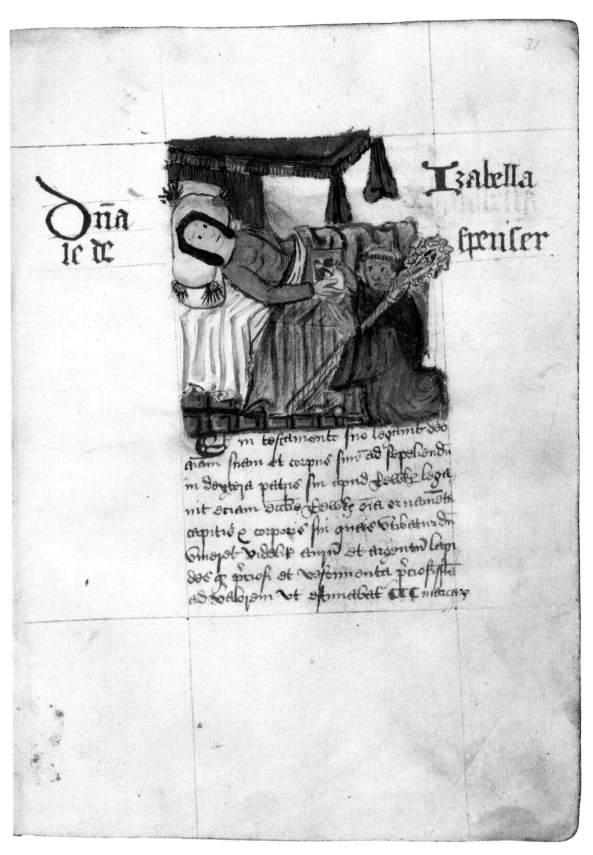

FIGURE 9. Oxford, Bodleian Library, Ms. Top. Glouc. D. 2 (the "Founders' Book" of Tewkesbury abbey), fol. 31ʳ (photo: Bodleian Library; reproduced by permission).

spiritual agitation.[48] Her grasp of the power-balance also emerges in the full text of her will, which survives as an independent document and states that she gives her jewels so that the monks may not complain about (and perhaps obstruct) the erection of her tomb in the position she desires. The imagery of the now-lost tomb is described: it was to incorporate a cadaver, "all naked, and no thing on my hede but myn here cast bakwardys," and monumental images of saints Mary Magdalene, John the Evangelist, and Antony.[49] Here is a starker acknowledgement of Isabel's post-mortem dependency on others. Like all aristocratic monuments, Isabel's tomb made a statement about weakness as well as power. Clearly, this aspect of lay-monastic relations was not to be spelled out or visibly exploited, but medieval awareness of it obliges one to reconsider the idea of the passive monastic recipient, and the attitude of all parties to the display of commemorative art.

These ideas should be sufficient to indicate some of the lines along which a comprehensive history of monastic patronage could be constructed. Others that recommend themselves can be outlined in less detail. For instance, little thought has been given to either the socio-economic range of English monastic patronage or the roles of imagination and affect in the planning of commissions and gifts. Both topics are suggested by a document of 1451 that projects a major new sculpture (*ymaginem sive statuam*) of the Virgin, plated with silver and encrusted with gems, for the Augustinian cathedral priory at Carlisle. Unable or unwilling to pay for this by themselves, the prior and convent petitioned for an indulgence that would permit the image to be financed, as it were, by subscription. This was issued in the names of the archbishop of York and the bishop of Carlisle.[50] Here, it is not only the nexus of agency (including the project's monastic initiators, its authoritarian enablers, and those whose oblations it attracted), but also the capitular and wider processes of decision-making and organization that inspire interest. A further basis for research is the analysis of the language of art-patronage as it occurs in documentation. This subject's importance has been recognized in the past, but it awaits systematic and broadly based investigation.[51] Patronage is discussed in most genres of medieval writing, and a wide range of terms, moods, and ploys (such as stating amounts of money or effort spent) is used to account for it. As a rule, this language differs according to both documentary type (will, historical account, inventory, contract, etc.) and the quiddity of its object (patron, recipient, thing commissioned, purchased or donated, material or intellectual context of patronage, etc.). Attempting to reconcile these variations with ideas about the reception and use of works is of greater potential value than assuming, as is frequently done, the unmeditated resort of writers to commonplaces or hyperbole.[52] A third challenge, not unrelated to that of language-analysis, lies in understanding medieval ideas about God's role in art-patronage. It is tempting to deal with this matter by thinking of God as a general enabler of monastic enterprise, and the chronicler's claim that works were achieved "with God's cooperation" (*Deo cooperante*) as a deferential assumption based on a successful outcome rather than any experience of divine intervention.[53] But this needs to be sympathetically tested against a range of instances in which God or a saint is invoked as an inspirer, participant, authorizer, or recipient, and also against works of art and monumental inscriptions that advertise God's involvement in the patronage hierarchy.[54] There are two examples of such advertisement in the Sherborne Missal, where the makers and patrons are

48. For the text, see W. Dugdale, *Monasticon Anglicanum*, ed. J. Caley, H. Ellis, and B. Bandinel, 6 vols. (London, 1817–1830), II: 63.

49. *The Fifty Earliest English Wills in the Court of Probate, London A.D. 1387–1439*, ed. F. J. Furnivall, Early English Text Society, 78 (London, 1882), 116–117.

50. *The Priory of Hexham: Its Chroniclers, Endowments, and Annals*, ed. J. Raine, 2 vols., Surtees Society 44, 46 (Durham, 1864–1865), I: xcvii–viii.

51. E.g., Luxford, *Art and Architecture* (as in note 3), 35, 36; Caskey, "Whodunnit?" (as in note 7), 197.

52. Although, clearly, there is a danger of circular reasoning where the evidence-pool is low.

53. The quotation is from *Chronicon abbatiae de Evesham* (as in note 31), 305.

54. For example, according to one of the earliest monumental inscriptions in an English church, the basilica of St. Paul at Jarrow (Northumberland) was dedicated "in the fifteenth year

presented on ascending stages beneath the figure of Christ (Fig. 10).[55] Both evoke God's status as recipient and also agent of patronage by demonstrating that the Missal was commissioned, made, and financed as a divine oblation under divine aegis. Finally, these images suggest a further important line of inquiry, that of the conflation of artisanship and patronage. On one side of this question it can be said that artists exercised a sort of patronage through their inimitable share in an act of creation that celebrated and honored God. The artist donated something of his or her self through the application of judgement and skill, without which the exercise of patronage would naturally have been impossible. On the other side, patrons emerge as artists to the extent of their input into design processes and their adjustment or reconfiguration of the *Gesamtkunstwerk*.[56] Patrons might even be said to have executed works themselves: Caskey has noted this with reference to the Cistercians, and it crops up in the chronicle of the Benedictine abbey of Gloucester, where in 1242 it is claimed that monks rather than lay workmen were responsible for completing the vaults over the nave.[57] Issues like this may

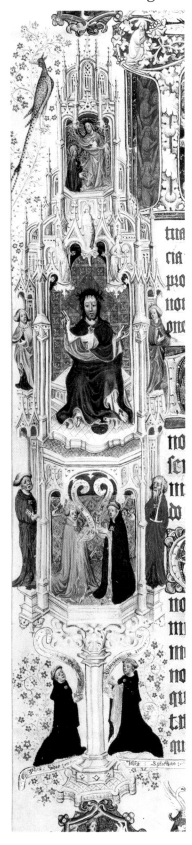

FIGURE 10. Detail of London, British Library, Ms. Add. 74236 (Sherborne Missal), p. 216, showing, in ascending order, the scribe John Whas and illuminator John Siferwas, Abbot Robert Brunyng of Sherborne and Bishop Richard Mitford of Salisbury (flanked by saints Peter and Paul), and the resurrected Christ (photo: The British Library Board; reproduced by permission).

of King Ecfrid, and in the fourth year of Abbot Ceolfrid [i.e., 685], founder, by the guidance of God, of the same church." (*Dedicatio basilice Sancti Pauli viiii. kalendis Maii Anno xv° Ecgfridi Regis Ceolfridi Abbatis ejusdem quo que Ecclesie deo auctore conditoris anno iiii.*) See R. Cramp, *County Durham and Northumberland*, 2 vols., British Academy Corpus of Anglo-Saxon Sculpture in England, 1 (Oxford, 1984), I: 113–114; II: pl. 98 (524).

55. London, BL, Ms. Add. 74236, pp. 216, 276. For illustrations of both, see J. Backhouse, *The Sherborne Missal* (London, 1999), 22, 30.

56. M. Schapiro, "On the Relation of Patron and Artist: Comments on a Proposed Model for the Scientist," *American Journal of Sociology* 70, no. 4 (1964), 363–369; T. A. Heslop, "The Alabaster Tomb at Ashwellthorpe, Norfolk: Its Workmanship, Costs and Location," in *Patrons and Professionals* (as in note 12), 333–346 (345–346); L. R. Shelby, "Monastic Patrons and their Architects: A Case Study of the Contract for the Monk's Dormitory at Durham," *Gesta* 15 (1976), 91–96; Caskey, "Whodunnit?" (as in note 7), 197–198.

57. Caskey, "Whodunnit?" (as in note 7), 198; *Historia et cartularium monasterii sancti Petri Gloucestriæ*, ed. W. W. Hart, 3 vols., Rerum Britannicarum medii aevi scriptores, 33 (London, 1863–1867), I: 29. The Gloucester story is paralleled by the supposed building activities of St. Benedict's monks at Monte Cassino, and may express a sympathetic relationship between

ultimately prove intractable, but considering them more curiously will strengthen historical understanding of the larger subject.

By way of conclusion, I wish to return briefly to the question of how patronage is defined. I am aware that what I have to contribute is baldly suggestive, and may not strike all readers as novel or even practicable given the impossibility of properly granular analysis of any department of medieval culture. The point I wish to make is simply that the subject of patronage can be grown through selective, sympathetic engagement with pre-existing theories about decision-making and expenditure, as well as by the closer attention to documentation recommended above. If the sorts of issues raised in the foregoing discussion are investigated, then a subtle but also rather catholic concept of patronage will inevitably emerge. It should be clear that this will not lend itself to concise definition: patronage, in the monastic sphere at least, combined action and ideology, and was often something that could not be independently practised or controlled. The approaches suggested above take patronage out of the domain of simple, individual choice and frame it with reference to social interdependence and religious belief. These are the stamping grounds of sociology and anthropology, disciplines that have made a small industry of studying the political, economic, and ritual dialectics of patron-client relationships (these relationships are often referred to as "clientelism,"

"clientelage," or "clientage").[58] The literature of these fields has already contributed much to the development, and in some cases the over-development, of art history, the most conspicuous point of intersection being Alfred Gell's 1998 book, *Art & Agency*.[59] Case studies in clientelism regard patron-client relationships, and their outcomes, as both culturally determined and constitutive of culture.[60] This assumption is a profitable starting-point for studies of monastic patronage, and indeed art-patronage in general. It is already present, of course, in numerous art-historical studies: one thinks instinctively of Michael Baxandall's work, and the "image anthropology" of Hans Belting.[61] However, to the extent that one's interests lie in currents of activity and thought rather than objects, it can be constructive to leave surviving works a little further behind than mainstream art-historical scholarship tends to. (For the historian of patronage, a lost but documented work is often of greater utility than an undocumented surviving one.) The focus on such things as morality, power, and myth in studies of clientelism is conceptually transferable to the monastic sphere, where all transactions involving art-patronage had a moral dimension, where the balance of power, as suggested, was complex and subtle, and where patronage often made an important contribution to institutional self-fashioning.

I will cite only a handful of workable approaches, of miscellaneous character. Of particular relevance to studies of religious orders is a body of theory about

these paragons and a thirteenth-century convent: compare, for example, *Legenda aurea*, ed. G. P. Maggioni, 2 vols. (Florence, 1998–1999), 1: 314.

58. A vast literature exists. The essays in *Patrons and Clients* (as in note 6), and the scholarship they cite, give some impression of the industry referred to here, and also the refinement of focus.

59. A. Gell, *Art and Agency: An Anthropological Theory* (Oxford, 1998). Though theoretically ponderous and given to off-putting diagrammatic language, Gell's book rewards the patronage-historian's perseverance. For example, his observation that "The very essence of successful performance of the 'patron' role, necessitates a show of reverence towards the products of patronage" (48) is highly valuable for anyone interested in the social history of religious art and architecture.

60. Most sociologists do not attempt concise definitions of patronage. Indeed, there is recognition that patronage is more

easily represented by stating what it is not (Gellner, "Patrons and Clients" [as in note 6], 1–3).

61. Particularly, M. Baxandall, *The Limewood Sculptors of Renaissance Germany* (London; New Haven, Conn., 1980) and *Painting and Experience in Fifteenth-Century Italy*, 2nd ed. (Oxford: New York, 1988); H. Belting, *Likeness and Presence: A History of the Image Before the Era of Art*, trans. E. Jephcott (Chicago, Ill., 1994); idem, *An Anthropology of Images: Picture, Medium, Body*, trans. T. Dunlap (Princeton, N.J., 2011). Baxandall's ostentatious preference for the term "client" rather than "patron" for the commissioning and financing party in a patronage relationship (*Painting and Experience*, 1 et passim) is justified by a particularly subtle understanding of the balance of power in patronage relationships. ("Client" had earlier been used in the same sense by Haskell, *Patrons and Painters* [as in note 8], 6, 14; see also Schapiro, 'On the Relation' [as in note 56], 366.)

collective action variously represented in the work of Mancur Olson and Mary Douglas.[62] Olson analyzes the bases of collective action on the premise that individuals with shared interests do not in practice work to achieve common goals, while Douglas examines the concepts of institutional "minds" and processes of thought, together with their implications for behavior. Both scholars had a fundamental interest in the ontology of groups. The main value of this work for the subject discussed above is to encourage subtler thinking about the practical unity of convents (which historians already know to have been weak in many cases) in light of, and despite, the medieval rhetoric grounded in Psalm 132: "Ecce quam bonum et quam iucundum habitare fraters in unum."[63] Ideas about patronage decisions (which often affected monastic standards of living through such things as reduced diet and pocket-money, interruption of routine, and physical discomfort), the collective value placed upon given projects, and the reception of monastic patronage by external observers stand to benefit by this. Another area of potential value is represented by Marcel Mauss's classic analysis of gift-economy in "archaic" societies and his extension of his model to industrialized ones.[64] This systematizes many ideas that crop up routinely in the study of medieval art-patronage. Matters of honor and obligation, cycles of gift-giving, and the power of gifts are canvassed in ways that have value for the medievalist able to drop his or her aversion to transcultural and transhistorical paradigms. The gift itself, although not Mauss's central object, is presented as a complex rather than simple phenomenon, in part because of the activities and beliefs that generate it: this is appealing, relevant, and to an extent familiar in medievalists' thinking about patronage.[65] Mauss also discusses the sumptuary destruction of wealth as an aspect of gift-giving: this stimulates one to think about the conceptual role of destruction in architectural patronage, a largely unexamined topic for which there is much evidence in the sources.[66] Demolition of venerable buildings must often have established a moral imperative to produce replacements that would justify the act. This is latent in Abbot Suger's comments on the Carolingian parts of the church at St.-Denis, and it surfaces powerfully in the lament of Bishop Wulfstan (1062–1095) for the destruction of the Anglo-Saxon cathedral at Worcester that he had personally overseen: "We unfortunates are destroying the work of saints in order to win praise for ourselves. In that happy age [in fact, only a century past], men were incapable of building for display; their way was to sacrifice themselves to God under any sort of roof [...] but we strive to pile up stones while neglecting souls."[67]

Mauss's interest in the ritual aspects of ostentatious expenditure overlaps with more recent work on consumerism, which evaluates (in the broadest sense) the cultural meaning of the consumption of goods and services.[68] Theories of consumerism are typically rooted in modern or contemporary data, but nothing precludes the development of parallel medieval approaches where the evidence-base will allow

62. M. Olson, *The Logic of Collective Action: Public Goods and the Theory of Groups* (Cambridge, Mass.; London, 1971); M. Douglas, *How Institutions Think* (Syracuse, N.Y., 1986).

63. This verse is inscribed on the fifteenth-century pavement-tiles in the presbytery of Gloucester abbey (now cathedral): A. Kellock, "Abbot Sebrok's Pavement: A Medieval Tile Floor from Gloucester," *Transactions of the Bristol and Gloucestershire Archaeological Society* 107 (1989), 171–188.

64. M. Mauss, *The Gift: The Form and Reason for Exchange in Archaic Societies*, trans. W. D. Halls (London, 1990).

65. *Ibid.*, 36.

66. *Ibid.*, 5–7. Relevant to this question is a case made for the preservation by burial of redundant but valued monumental statues at St. Mary's abbey, York, in the later Middle Ages: C. Norton, "The Buildings of St Mary's Abbey, York and

Their Destruction," *Antiquaries Journal* 74 (1994), 256–288 (275–278).

67. *Abbot Suger on the Abbey Church of St.-Denis and Its Art Treasures*, ed. and trans. E. Panofsky, 2nd ed., ed. G. Panofsky-Soergel (Princeton, N.J., 1979), 44–45, 50–53; William of Malmesbury, *Gesta Pontificum Anglorum. Volume I: Text and Translation*, ed. and trans. M. Winterbottom (Oxford, 2007), 431.

68. See, for instance, Patrick Geary's essay in *The Social Life of Things: Commodities in Cultural Perspective*, ed. A. Appadurai (Cambridge, 1986); M. Douglas, "The Consumer's Revolt," in *eadem*, *Thought Styles: Critical Essays on Good Taste* (London; Thousand Oaks, Calif., 1996), 106–125; and the essays in *The Social Economy of Consumption*, eds. H. J. Rutz and B. S. Orlove, Monographs in Economic Anthropology, 6 (Lanham, Md., 1989).

it: indeed, this has already occurred.[69] The registers of priors and abbots, which can furnish detailed impressions of personal character, contain entries that help to substantiate the point. In the first register of William Curteys, who ruled Bury St. Edmunds from 1429 to 1446, there is a contract dated in January 1430 for a customized crozier that savors richly of the *arriviste* abbot's desire to make a glamorous impact, and impresses the reader with the range of choice and opportunity for expenditure that lay open to such a man once in possession of his *mensa* and ensconced in his London residence (the contract was drawn up in London, where the goldsmith was based). The crozier was to weigh almost thirteen pounds, be made of gold and silver, incorporate images of the twelve apostles, martyrdom of St. Edmund, and Annunciation and Assumption of the Virgin in tabernacles, and have three knops on its rod. Everything had to be of the best possible workmanship: it cost £40 (more than many religious houses realized in a year).[70] This and related cases present clear opportunities for analysis of the determinants, ideas, assumptions, and choices that account for consumer behavior. Lastly, and in different terms, social psychology offers the historian of patronage a literature on situationism, the theory that circumstances frequently or always have a greater influence on behavior than traits of character.[71] Because one's position on this question determines much of what one accepts about the exercise of morality, it is notionally relevant to any moral dimension of art or architectural patronage (the relation of character to "splendid" or "excessive" patronage, for example). In practical terms, positive acquaintance with situationism is most likely to inflect rather than determine judgements about individual decisions made under given conditions. The spirit of emulation that is often invoked as a catalyst for medieval acts of patronage can be approached in this light, to the extent that it was contingent on social circumstances (the specific material achievements of another individual or group), and compounded of admiration and envy rather than moral considerations.

* * *

To claim that the status of patronage in medieval art history is in any general sense immature would be mistaken. Patronage is at least a latent constituent of all art history, and as such is deeply embedded in the literature from Vasari onwards. There have, moreover—and of course—been numerous studies of art and architectural patronage in isolation. Yet in spite of this, the subject remains potential-rich, both in its ability to harness more of the original object domain than stylistic and material analysis can (because it deals as happily in the lost as the existing object), and its receptiveness to ideas generated by other disciplines. This has been explained here with reference to English monasticism, and it would be perfectly possible to apply the same exercise to other patron- or object-groups. Methodological flexibility is another aspect of the subject's potential.

For the professional scholar, the strengths of patronage embody its weaknesses. In particular, subordinating objects to their contexts of production and exchange involves academic art historians in considerable risk, because it distances them from the domain in which they are expected to operate, and on which their authority depends. If the study of patronage progresses at the expense of connoisseurship and other sorts of technical knowledge, then the defences of surviving objects that need informed support will also be jeopardized.[72] Conversely, the broader avenues

69. See the recent discussion, and references, in J. Cherry, "Medieval Jewelry: From Collections to Consumerism," in *From Major to Minor: The Minor Arts in Medieval History*, ed. C. Hourihane, Index of Christian Art Occasional Papers, 14 (Princeton, N.J., 2012), 141–151 (150–151).

70. London, BL, Ms. Add. 14848, fol. 79ʳ⁻ᵛ; A. Way, "Indenture for Making a Pastoral Staff for William Curteys, Abbot of St Edmunds," *Proceedings of the Suffolk Institute of Archaeology and History* I.5 (1850), 160–165. For a parallel case, involving a miter and crozier, see *Journal of Prior William More* (as in note 26), ii–iii, 144–145, 163, 164, 179.

71. For example, J. Fletcher, *Situation Ethics: The New Morality* (Philadelphia, Pa., 1966); O. Flanagan, *Varieties of Moral Personality: Ethics and Psychological Realism* (Cambridge, Mass., 1991), 260–268, 300–305, 313–314; J. Doris, "Persons, Situations, and Virtue Ethics," *Nous* 32, no. 4 (1998), 504–530; D. C. Russell, *Practical Intelligence and the Virtues* (Oxford, 2009), 169–172, 241–331.

72. This is an urgent consideration for the historian of architecture, whose field of inquiry is threatened by the relentless triumvirate of natural decay, philistinism, and diminishing resources for restoration.

relevant to the study of patronage have the capacity to build support for the discipline by attracting scholars who might otherwise consider art history too narrow or recondite. One's impression is that the discourse surrounding patronage will become increasingly conspicuous in medieval art history, and that it will be of corresponding significance for the status of the discipline. In this case, and anyway, it seems important that more effort be directed by scholars of patronage to explaining the premises on which their studies proceed. If the assumptions are tacit, then the concepts may appear flabby or unstimulating. In practice this may turn out to be too great a risk to run, for a historian of medieval monasticism or anything else.

ELIZABETH CARSON PASTAN

Imagined Patronage:
The Bayeux Embroidery & Its Interpretive History

THE BAYEUX EMBROIDERY is an eleventh-century work of such importance that it was once joked that no medieval conference could take place without some mention of it.[1] Its significance, broadly stated, is three-fold. First, it is an exceptional survivor of the once extensive medieval textile tradition,[2] now attested to mainly in textual references and fragmentary remains.[3] Second, it is quite large, allowing great scope for its extensive pictorial narrative; although only 20 inches high, it is nearly 225 feet long, and is estimated to have continued another 10 feet.[4] And third, the hanging has as its subject an historical event, the invasion of England in 1066 under Duke William of Normandy. These three characteristics—survival, narrative scope, and historical content—have guaranteed the presence of the Bayeux Embroidery in nearly every medieval survey text.

Yet the tools of our discipline are challenged by the effort to encompass such a work of art, which is quite literally without a context. There are few extant medieval textiles with which to compare it, and certainly none on this scale. No incontrovertible refer-

For the title of this study, as for much else, I am indebted to my colleague, Stephen D. White. I also thank Colum Hourihane for his kindness and inclusiveness, Ashley Laverock for expert research assistance, Mildred Budny for sharing mutual interests, Madeline Caviness for inspiration and encouragement, Kate Gilbert for astute editorial counsel, and Sylvette Lemagnen and Julie Deslondes for extending archival resources in France to me.

1. From the extensive bibliography on the Bayeux Embroidery, see: *The Bayeux Tapestry: A Comprehensive Survey*, ed. F. Stenton (1957; rev. 2nd ed., New York, 1965); N. P. Brooks and H. E. Walker, "The Authority and Interpretation of the Bayeux Tapestry," in *Anglo-Norman Studies* 1 (1978), 1–34 and 191–199; D. M. Wilson, *The Bayeux Tapestry: The Complete Tapestry in Colour* (London, 1985); D. J. Bernstein, *The Mystery of the Bayeux Tapestry* (Chicago, Ill., 1987); S. A. Brown, *The Bayeux Tapestry: History and Bibliography* (Woodbridge, 1988); and R. Gameson, "The Origin, Art, and Message of the Bayeux Tapestry," in *The Study of the Bayeux Tapestry*, ed. idem (Woodbridge, 1997), 157–211. To avoid confusion, these studies will be referred to by their shortened subtitles: F. Stenton, ed., *Comprehensive Survey*; D. M. Wilson, *Complete Tapestry*; S. A. Brown, *Bibliography*; and R. Gameson, ed., *Study*. References to scenes within the embroidery are based on their plate number in Wilson's text.

2. For extant examples of medieval textiles, with attention to embroideries, see A. G. I. Christie, *English Medieval Embroidery* (Oxford, 1938); G. Wingfield Digby, "Technique and Production," in F. Stenton, ed., *Comprehensive Survey*, 37–55; M. Budny, "The Anglo-Saxon Embroideries at Maaseik: Their Historical and Art-Historical Context," in *Mededelingen van de Koninklijke Academie voor Wetenschappen, Letteren en Schone Kunsten van België, Klasse der schöne Kunsten*, 45 (2) (Brussels, 1984), 55–133, esp. her overview, 58–70; K. Staniland, *Medieval Craftsmen: Embroiderers* (London, 1991); C. R. Dodwell, *The Pictorial Arts of the West, 800–1200* (New Haven, Conn., 1993), 11–31; and E. Coatsworth and G. R. Owen-Crocker, *Medieval Textiles of the British Isles, A.D. 450–1100: An Annotated Bibliography* (Oxford, 2007).

3. For textual references, see J. Osborne, "Textiles and their Painted Imitations in Early Medieval Rome," *Papers of the British School at Rome* 60 (1992), 309–351; C. R. Dodwell, *Anglo-Saxon Art: A New Perspective* (Ithaca, N.Y., 1982), esp. 129–169, and idem, *Pictorial Arts* (as in note 2), with extensive reference to the foundational studies of V. Mortet and P. Deschamps, *Recueil de textes relatifs à l'histoire de l'architecture et à la condition des architectes en France, au Moyen-Âge, XIᵉ–XIIIᵉ siècles*, 2 vols. (1911 and 1929; reprint in one vol., Paris, 1995), and O. Lehmann-Brockhaus, *Schriftquellen zur Kunstgeschichte des 11. und 12. Jahrhunderts für Deutschland, Lothringen und Italien ...* (1938; reprint New York, 1971), and idem, *Lateinische Schriftquellen zur Kunst in England, Wales und Schottland, vom Jahre 901 bis zum Jahre 1307*, 5 vols. (Munich, 1956).

4. Or 45.7 to 53.6 cm. × 68.38 m., according to D. Renn, "How Big is It—and Was It?" in *The Bayeux Tapestry, New Approaches: Proceedings of a Conference at the British Museum*, ed. M. J. Lewis, G. R. Owen-Crocker, and D. Terkla (Oxford, 2011), 52–58. Also see M. K. Foys, "Hypertextile: Closure and the Missing End of the Bayeux Tapestry," in *Virtually Anglo-Saxon: Old Media, New Media, and Early Medieval Studies in the Late Age of Print* (Gainesville, Fla., 2007), 79–109.

ences to the embroidery have been found in the first four centuries of its existence, leaving us without any contemporaneous evidence for its medieval setting.[5] Moreover, despite a recent series of interesting scholarly engagements drawing attention to its complexity as a narrative,[6] the textile is still routinely framed as a straightforward victory monument attesting to its putative patron's greatness.[7]

This study will contribute to the understanding of the textile through analyzing the methods by which scholars have traditionally sought answers. Accordingly, several key works in the interpretive history of the Bayeux Embroidery will be examined with emphasis on how notions of patronage have served their arguments. As we shall see, while inquiry into the patronage of the Bayeux Embroidery may initially have given rise to fruitful speculations, the identification with a particular patron has since become a limitation to be accommodated. In addition, closer attention to the materiality of this great artifact, and the re-examination of the earliest extant evidence we have in the fifteenth-century inventory from Bayeux Cathedral, suggest that the secular context often imagined for the hanging needs to be reassessed. It is the argument of this study that we have not adopted the appropriate model of patronage for understanding the Bayeux Embroidery.

HISTORIOGRAPHY

The modern history of the Bayeux Embroidery began with its discovery in Bayeux Cathedral by the Benedictine scholar Bernard de Montfaucon, who, in his *Monumens de la Monarchie françoise* of 1729, was the first to publish the textile.[8] Montfaucon thoroughly reviewed the history of the Norman Conquest of England, primarily using textual accounts of Norman authors such as the *Gesta Guillelmi* of William of Poitiers (*c.* 1071–1077),[9] although later Anglo-Norman works were also used to good effect when they offered a fuller or more colorful account.[10] Montfaucon's view that the Bayeux Embroidery was a Norman victory monument was shored up by his comparison of it to Roman triumphal columns, a now-standard analogy that Montfaucon, who had previously published a popular multi-volume work on the monuments of antiquity, was the first to make.[11] Montfaucon set aside issues of provenance other than to assert that, after first encountering it through early eighteenth-century drawings that came from the estate of an administrator in Normandy (Fig. 1), he had succeeded in locating the hanging in Bayeux Cathedral (Fig. 2). To the extent that Montfaucon considered issues of patronage, it was to repeat the local legend that William the Conqueror's wife Matilda oversaw the hanging's production, thereby reinforcing his implicit assumption that it was a Norman undertaking.[12]

However, within his detailed discussion, Montfaucon repeatedly pointed to incidents where he found the textile's pictorial narrative frustrating in comparison to the Norman textual accounts that were his chief frame of reference. For example, in analyzing the presentation of the death of King Edward the Confessor (Fig. 3), whose demise without biological heir in 1066 set in motion the succession crisis in England that lay

5. S. A. Brown, *Bibliography* (as in note 1), 1–2.

6. See especially the following recent anthologies: *The Bayeux Tapestry: Embroidering the Facts of History*, eds. P. Bouet, B. Levy, and F. Neveux (Caen, [2004]); *King Harold II and the Bayeux Tapestry*, ed. G. R. Owen-Crocker (Woodbridge, 2005); and *The Bayeux Tapestry: New Interpretations*, eds. M. K. Foys, K. E. Overbey, and D. Terkla (Woodbridge, 2009).

7. See E. C. Pastan and S. D. White, "Problematizing Patronage: Odo of Bayeux and the Bayeux Tapestry," in M. K. Foys, *New Interpretations* (as in note 6), 1–24.

8. B. de Montfaucon, *Les Monumens de la Monarchie françoise, qui comprennent l'Histoire de France: avec les figures de chaque règne, que l'injure des tems a épargnées*, 5 vols. (Paris, 1729–1733), 1: 371–379, with images interspersed. The Institut national d'histoire de l'art in Paris (INHA) has an electronic version on its website: http://www.purl.org/yoolib/inha/7731 (accessed 15 November 2012).

9. *The Gesta Guillelmi of William of Poitiers*, ed. and trans. R. H. C. Davis and M. Chibnall (Oxford, 1998), xx–xxi for dating.

10. E. C. Pastan, "Montfaucon as Reader of the Bayeux Tapestry," in *Medieval Art and Architecture after the Middle Ages*, eds. J. T. Marquardt and A. A. Jordan (Cambridge, 2009), 89–110, with further bibliography.

11. B. de Montfaucon, *L'Antiquité expliquée et représentée en figures*, 10 vols. (Paris, 1719). For B. de Montfaucon's references to Trajan's column, see *idem, Monumens* (as in note 8), 1: 375 and 2: 8.

12. B. de Montfaucon, *Monumens* (as in note 8), 2: 2. Also referred to in G. Huard, "Quelques lettres de Bénédictins normands à Dom Bernard de Montfaucon pour la documentation

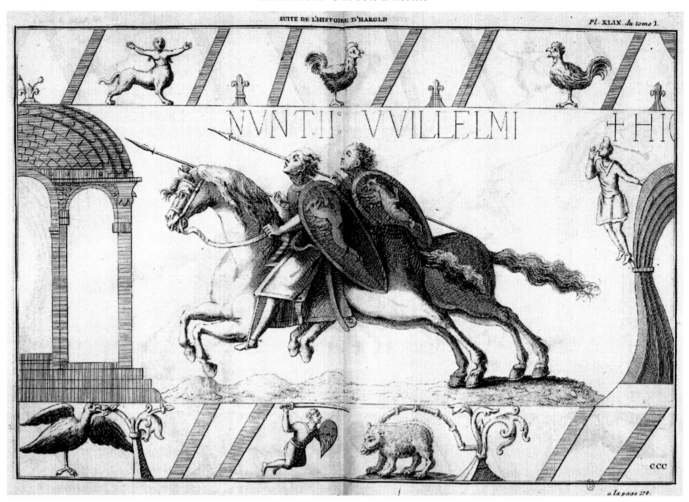

FIGURE 1. Duke William's Messengers, detail of image after the Bayeux Embroidery found in collection of Nicholas-Joseph Foucault, *c.* 1724, published by Montfaucon in *Les Monumens de la Monarchie Françoise* (Paris, 1729), i, pl. XLIX.

behind the Norman Conquest, we can see the difficulties that this scene presented for Montfaucon. First, the scene is not a focus of any of the early Norman histories. In William of Poitiers' detailed account, for example, King Edward's death occurs offstage and is mentioned only cursorily: "the English land had lost its king and ... Harold was wearing its crown."[13] Yet in its presentation on the embroidery, the king's death compels attention because of its extended treatment, including the unique "double-decker" composition of the framing architectural structure,[14] the scenes that appear to address the beholder directly through their tipped-up perspective and the prominent gestures of the participants,[15] and the comparatively lengthy

des *Monumens de la Monarchie Françoise*," *Bulletin de la Société des antiquaires de Normandie* 28 (1913), 359–361, where Huard reproduces the letter of 22 September 1728 from the prior of Saint Vigor of Bayeux that first reported that the embroidery was hung in the nave of Bayeux and says that it had been sewn by Queen Matilda.

13. *Gesta Guillelmi* (as in note 9), ii: 1, 100–101; and see also ii: 12, 118–119, where William of Poitiers refers to a deathbed

bequest, but downplays its importance by bringing it up out of chronological sequence, in a speech made by Harold's envoy just before the battle. See discussion in E. C. Pastan, "Montfaucon as Reader" (as in note 10), 99–102.

14. See remarks in R. Gameson, "Origin, Art, and Message" (as in note 1), 187–188, 194–195, and 200–201.

15. See O. Pächt, *The Rise of Pictorial Narrative in Twelfth-century England* (Oxford, 1962), 9–11, and related discussion,

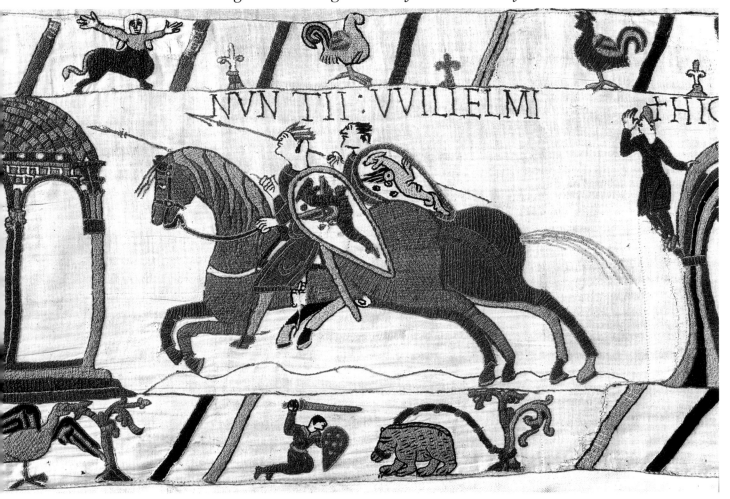

FIGURE 2. Duke William's Messengers, Bayeux Embroidery scenes 11/12. Details from the Bayeux Embroidery, eleventh century (by special permission of the City of Bayeux).

accompanying inscriptions that further flag the importance of the scene, with their repeated use of the demonstrative *Hic*: "Here King Edward in bed talks to his faithful followers," and then above the lower tier, "and here he is dead."[16]

In addition, the treatment of the scene can be construed as acknowledging the politically freighted notion that King Edward overturned his previous appointment of his cousin Duke William of Normandy as his heir in favor of a last-minute deathbed bequest to his brother-in-law, Earl Harold Godwinson of England.[17] Interestingly, the earliest text that elaborates on the death of King Edward is not a Norman one, but the biography known as the *Vita Ædwardi* (c. 1067), which was probably made in Canterbury for Edward's widow, Queen Edith.[18] The *Vita* offers several

29–32, for an insightful visual analysis; and L. Musset, *The Bayeux Tapestry*, trans. R. Rex (Woodbridge, 2005), 164–166.

16. The embroidery's inscriptions have been often transcribed and translated; now see E. Coatsworth, "Inscriptions on Textiles Associated with Anglo-Saxon England," in *Writing and Texts in Anglo-Saxon England*, ed. A. R. Rumble (Cambridge, 2006), 91–95.

17. See *The Anglo-Saxon Chronicle*, trans. and ed. D. Whitelock with D. C. Douglas and S. Tucker (New Brunswick, N.J., 1961), C, D, and E versions, 139–140; also *The Anglo-Saxon Chronicle*, ed. and trans. M. J. Swanton (London, 1996), 192–197.

18. *The Life of King Edward Who Rests at Westminster, Attributed to a Monk of Saint-Bertin*, ed. and trans. F. Barlow

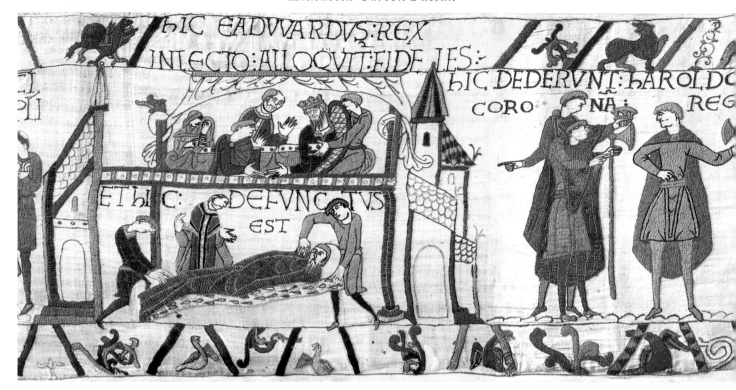

FIGURE 3. Death of King Edward and the Offering of the Crown to Earl Harold, Bayeux Embroidery scenes 30/31.
Details from the Bayeux Embroidery, eleventh century (by special permission of the City of Bayeux).

striking similarities to the embroidery's pictorial narrative, among them the focus on the king's last moments and the description of the four *fideles* present at the bedside. It is by no means an easy text to interpret, as the dying king is portrayed as offering up a mixture of astute-sounding prophecies and feverish ramblings, culminating in Edward's ambiguous "commendation" of the kingdom and Queen Edith to Harold.[19] Nonetheless, the *Vita*'s commendation may be reflected in the central reach of Edward and Harold towards one another, as the fingertips of their right hands touch,[20] as well as in the presence of the queen among those gathered at the king's bed—a telling detail, since she is one of only six women out of the 626 figures depicted on the hanging as a whole.[21]

Further, the tall multitasking figure in the next episode (Fig. 3, at right), who with one hand offers Harold the crown of the kingdom and with the other

(Oxford, 1992), xxix–xxxiii for dating. A connection between the embroidery and the *Life of King Edward*, or *Vita Ædwardi*, was first recognized by E. A. Freeman, *The History of the Norman Conquest of England, Its Causes and Its Results*, 6 vols. (Oxford, 1867–1879), III: 391–392. For the argument that the *Vita Ædwardi* was made in Canterbury, see E. C. Pastan, "Building Stories: The Representation of Architecture in the Bayeux Embroidery," *Anglo-Norman Studies* 33 (2011), 159–160.

19. *Life of King Edward* (as in note 18), II: 11, 24. For very different analyses of the complexities of the king's "commending" of the kingdom to Harold, see D. C. Douglas, *William the Conqueror: The Norman Impact Upon England* (Berkeley, Calif., 1964), 252; F. Barlow, *Edward the Confessor* (Berkeley, Calif.,

1970), 151–153; H. E. J. Cowdrey, ed., "King Harold II and the Bayeux Tapestry: A Critical Introduction," in G. R. Owen-Crocker, *King Harold* (as in note 6), 8; G. Garnett, *Conquered England: Kingship, Succession, and Tenure, 1066–1166* (Oxford, 2007), 7–9; and L. Ashe, *Fiction and History in England, 1066–1200* (Cambridge, 2007), 35–47, esp. 45.

20. See N. P. Brooks and H. E. Walker, "Authority and Interpretation" (as in note 1), 11–12; and P. Bouet, "Is the Bayeux Embroidery Pro-English?" in *idem*, ed., *Embroidering the Facts* (as in note 6), 209–213.

21. C. E. Karkov, "Gendering the Battle? Male and Female in the Bayeux Tapestry," in G. R. Owen-Crocker, *King Harold* (as in note 6), 139–147, esp. 140 and 145, for her nuanced

motions back to the deathbed, can be interpreted as indicating cause and effect, namely, that King Edward's bequest led to Harold's coronation.[22] At the very least, it must be conceded that the designer of the embroidery was not obliged to render the death of the king as a two-tiered event with a separate upper scene that could be seen as massaging the issue of a countermanding royal bequest. The net effect of the embroidery's depiction is to visualize the possibility that such a complicating gift of the kingdom to Earl Harold of England had taken place, a nuance that surely would not have been a requisite for the Norman triumphal monument Montfaucon sought to portray.

For these reasons, in presenting this scene, Montfaucon departed from his usual dispassionate comparative textual analyses—for which he claimed to rely on the texts of "the best historians of Normandy" as a basis for judgment[23]—in order to personally decry what he termed Harold's "unsubstantiated claim."[24] In Montfaucon, the Bayeux Embroidery had a scholar engaged by the question of what had happened during the Norman Conquest of England, an interest that he largely satisfied through reading Norman textual accounts. Yet he inadvertently backed into problems of interpretation by closely observing the differences between the Norman textual accounts and the way

the embroidery represented the story.[25] As we have seen, Montfaucon's handling of patronage was not so much focused on a particular person as it was on the Norman victors' version of events, but in repeatedly demonstrating that the Bayeux Embroidery's rendition departed in key ways from Norman authors' narratives, he called into question his own supposition that it was a Norman work of art.

The designation of a particular patron for the Bayeux Embroidery was one of the chief contributions of the volume edited by Sir Frank Stenton in 1957.[26] The anthology synthesized scholarship from the previous century on a variety of topics, but its contents largely coalesced around a single issue, which had also been present in the literature for some time: the embroidery's supposed patronage by William the Conqueror's half-brother Odo of Conteville (Fig. 4), who was the bishop of Bayeux, and, after the Conquest, the earl of Kent.[27] In the anthology, issues of the embroidery's problematic editorial perspective, to which Montfaucon had accidentally drawn attention, were dealt with only in passing, with the concession that the Normans' grace in victory was reflected in the embroidery's "magnanimous" treatment of Harold.[28] But as Stenton opined, the scope of the embroidery's story was determined "by the necessity of satisfying

remarks, which draw attention to the similarities between the text and the embroidery while refraining from suggesting that the *Vita* determined the images.

22. See N. P. Brooks and H. E. Walker, "Authority and Interpretation," 2; and R. Gameson, "Origin, Art, and Message," 195 (both as in note 1).

23. B. de Montfaucon, *Monumens* (as in note 8), 1: 373, discussing the reasons for Harold's journey to the Continent.

24. *Ibid.*, 11: 14 on the "prétendue déclaration."

25. E. C. Pastan, "Montfaucon as Reader" (as in note 10).

26. F. Stenton, *Comprehensive Survey* (as in note 1). On the various Stenton authors' discussions of a patron, see *ibid.*, F. Stenton, "Historical Background," 9, 11, and 23; F. Wormald, "Style and Design," 33–34; G. Wingfield Digby, "Technique and Production" (as in note 2), 52; and C. Gibbs-Smith, "Notes on the Plates," 174.

27. Arguments for Bishop Odo as the patron of the embroidery were first offered by T. Amyot, "A Defence of the Early Antiquity of the Bayeux Tapestry," *Archaeologia* 19 (January, 1821), 192–208, and most comprehensively, H. F. Delauney, *Origine de la Tapisserie de Bayeux prouvée par elle-même* (Caen, 1824). See the useful overview in S. A. Brown, *Bibliography*

(as in note 1), 23–33, and now E. C. Pastan and S. D. White, "Problematizing" (as in note 7).

28. F. Stenton, "Historical Background" (as in note 26), 15 and 23. That Stenton's concession to the embroidery's treatment of the defeated enemy did not begin to handle the issue of the textile's complex editorial perspective, however, was evidenced in Charles Gibbs-Smith's pointed disagreement with his fellow co-authors in the volume. See C. Gibbs-Smith, "Notes on the Plates" (as in note 26), 174–175. Here he observed that the opening scene—routinely interpreted in the light of Norman texts as the king sending Harold to Normandy to confirm Edward's alleged promise that William should succeed him on the English throne—could in fact be interpreted entirely differently in relation to the observations of later authors, including Eadmer of Canterbury and William of Malmesbury, as Harold's own initiative or a fishing trip gone awry. For Harold's journey in these texts, see *Eadmer's History of Recent Events in England, Historia Novorum in Anglia*, trans. G. Bosanquet (London, 1964), 7–8; and William of Malmesbury, *Gesta Regum Anglorum: The History of The English Kings*, ed. and trans. R. A. B. Mynors, completed by R. M. Thomson and M. Winterbottom, 2 vols. (Oxford, 1998), 1: ii.228.7, 417–419.

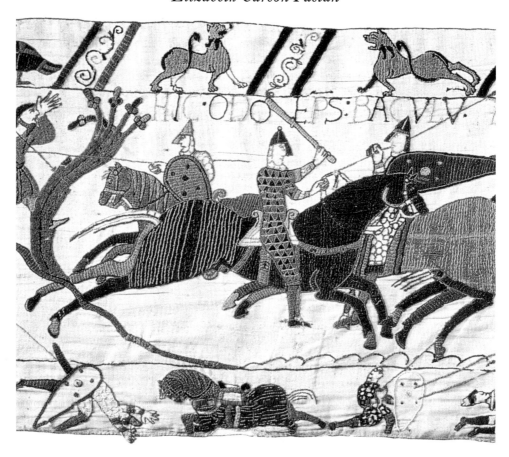

FIGURE 4. Bishop Odo of Bayeux, Bayeux Embroidery, scene 67. Detail from the Bayeux Embroidery, eleventh century (by special permission of the City of Bayeux).

[this] formidable patron," further emphasizing that "the designer … could not do other than follow the tale most acceptable to his patron."[29] A named patron, even an imagined one, offered the work a new sense of purpose by encompassing its English and Norman affinities in a single personalized embodiment, since it was suggested that Odo ordered the embroidery from within his English earldom for his Norman bishopric. In addition, Odo's patronage served to narrow the date, by connecting its commission to the 1077 consecration of Bayeux Cathedral, as we shall presently discuss.

The most lasting contribution of the Stenton volume was Frances Wormald's argument that the hanging was made in Canterbury, a case that has remained the basis of all subsequent discussions.[30] Wormald traced the embroidery's colorful linear technique to the *Utrecht Psalter* and its English descendants, noting that the tall lithe figures with their "remarkable sense of bustle," complemented by energetic gestures and meaningful glances, compare closely.[31] He conceded that the determination of an English provenance based on style alone was inconclusive because of the relatively poor survival of Norman illuminations.[32]

29. F. Stenton, "Historical Background" (as in note 26), 23 and 9, respectively.

30. F. Wormald, "Style and Design" (as in note 26), 25–36.

31. *Ibid.*, 29–32; and now see W. Noel, "The Utrecht Psalter's Legacy in England," in *The Utrecht Psalter in Medieval Art: Picturing the Psalms of David*, ed. K. van der Horst, W. Noel,

and W. C. M. Wüstefeld (Tuurdijk, 1996), 232–255, with further bibliography.

32. F. Wormald, "Style and Design" (as in note 26), 30, 32. On Norman illuminations, see J. J. G. Alexander, *Norman Illumination at Mont St. Michel, 966–1100* (Oxford, 1970).

Nonetheless, Wormald argued for English manufacture based on factors other than style, particularly the appearance in the embroidery of several motifs traceable to English manuscripts, which he dubbed "so close ... that those in the [embroidery] look like modifications of the [manuscript] models."[33] This point may be illustrated with one of Wormald's examples, the unusual scene of bear-baiting in the *Passional of St. Augustine's* and the related motif in the border of the embroidery (Figs. 5 and 2, respectively).[34]

Since all six of the English manuscripts on which Wormald based his case are from Canterbury, his argument for the English origin of the Bayeux Embroidery was really a case for its origin in Canterbury.[35] For subsequent scholars, given the nature and extent of the influences of manuscripts from the venerable abbey of St. Augustine's, Canterbury, on the embroidery, this was tantamount to a case for the textile's creation there.[36] In particular, the highly original biblical pictorial narratives of the *Old English Hexateuch* have been seen as a "thesaurus of imagery" for the embroidery, as shown by Wormald's own comparison of the scenes of bird slingers (Fig. 6).[37] Characteristically, the affinities between the *Hexateuch* from St. Augustine's of the mid-eleventh century and the embroidery

FIGURE 5. Detail of Bear Baiting from the initial for St. Leogardus in the *Passional of St. Augustine's*, London, BL, Arundel Ms. 91, fol. 47) (© The British Library Board. All rights reserved).

33. F. Wormald, "Style and Design" (as in note 26), 32, and his figures 16 and 17.

34. For the *Passional* (London, BL, Arundel Ms. 91), see C. M. Kauffmann, *Romanesque Manuscripts, 1066–1100*, A Survey of Manuscripts Illuminated in the British Isles, 3 (London, 1975), cat. no. 17, 61, with further bibliography.

35. Other than the *Passional*, these are: the *Cædmon Genesis* (Oxford, Bodleian Library, Ms. Junius 11), Prudentius's *Psychomachia* (London, BL, Cotton Ms. Cleopatra c.viii), an Anglo-Saxon copy of the *Utrecht Psalter* (London, BL, Harley Ms. 603), a *Miscellany with the Wonders of Creation* (London, BL, Cotton Ms. Tiberius b.v), and the *Old English Hexateuch* (London, BL, Cotton Ms. Claudius b.iv). For more on these works, see Elżbieta Temple, *Anglo-Saxon Manuscripts, 900–1066*, A Survey of Manuscripts Illuminated in the British Isles, 2 (London, 1976), cat nos. 49, 63, 87, and 86, respectively; C. R. Hart, "The Bayeux Tapestry and Schools of Illumination at Canterbury," *Anglo-Norman Studies* 22 (1999), 117–167; and G. R. Owen-Crocker, "Reading the Bayeux Tapestry through Canterbury Eyes," in *Anglo-Saxons: Studies Presented to Cyril Roy Hart*, ed. S. Keynes and A. P. Smyth (Dublin, 2006), 243–265.

36. See the summary of the case for St. Augustine's in N. P.

Brooks and H. E. Walker, "Authority and Interpretation" (as in note 1), 9–18; and the more recent assessments of the evidence by R. Gameson, "Origin, Art, and Message" (as in note 1), 169–173, and E. C. Pastan and S. D. White, "Problematizing" (as in note 7), 20–24. Among those scholars who argue that the Bayeux Embroidery was designed at St. Augustine's are: C. R. Dodwell and P. Clemoes, *The Old English Illustrated Hexateuch, British Museum Cotton Claudius B. IV* (Copenhagen, 1974), 71–73; Bernstein, *Mystery* (as in note 1), 37–81; C. R. Hart, "The Canterbury Contribution to the Bayeux Tapestry," in *Art and Symbolism in Medieval Europe: Papers of the "Medieval Europe Brugge 1997" Conference*, V, ed. G. de Boe and F. Verhaeghe (Zellik, 1997), 7–15; M. Baylé, "The Bayeux Tapestry and Decoration in North-Western Europe: Style and Composition," in P. Bouet, *Embroidering the Facts* (as in note 6), 307–310; C. R. Hart, "The Bayeux Tapestry and Schools of Illumination," 117; G. R. Owen-Crocker, "Canterbury Eyes" (both in note 35), 243–244; and now M. Baylé, "Vikings, normandes, anglaises ou carolingiennes? Les sources artistiques de la Tapisserie de Bayeux," in *La Tapisserie de Bayeux: Une chronique des temps Vikings? Actes de colloque international de Bayeux*, ed. S. Lemagnen (Bonsecours, 2009), 114.

37. D. J. Bernstein, *Mystery* (as in note 1), 40–41.

Bird Slinger, British Museum, Cotton MS. Claudius B. iv, f. 26b.

Bird Slinger. Detail from Pl. 12.

FIGURE 6. Frances Wormald, Figures 16 and 17 from Sir Frank Stenton, *The Bayeux Tapestry* (London, 1957) comparing the bird slingers in the *Old English Hexateuch* from St. Augustine's and the Bayeux Embroidery, scene 11.

from the latter third of the eleventh century are not exclusively stylistic in nature, nor are the images identical. Rather the scenes in the embroidery show the adaptation in a completely new context of some distinctive element found in the Canterbury manuscripts, suggesting that the motifs were not slavishly copied, but part of the artistic repertoire of the monastic designer.[38] In the *Hexateuch*, for example, the scene of escape involving a slip rope (Fig. 7) appears in an illustration of the biblical chapter of Joshua (2: 7–21), the lowering of the Israelite spies from the walls of Jericho, while in the embroidery (Fig. 8), the scene is part of the visual imagining of Duke William's Breton campaign when he pursues Conan of Dol.[39]

If Wormald persuasively established the case for the embroidery's design at St. Augustine's in Canterbury, the case for Odo as its patron nonetheless remained conjectural. One example will suffice to illustrate the nature of the case for Odo's patronage: the embroidery's putative connection with the 14 July 1077 consecration of Bayeux Cathedral.[40] Although the authors in the Stenton volume were generally

38. For this scene of escape, see E. C. Pastan, "Building Stories" (as in note 18), 167–168. For consideration of the so-called pictorial sources of the embroidery, see E. C. Pastan, "A Feast for the Eyes: Representing Odo at the Banquet in the Bayeux Embroidery," in *The Haskins Society Journal: Studies in Medieval History* 22 (2012), 83–121, esp. 114–121.

39. For the *Hexateuch,* see C. R. Dodwell and P. Clemoes, *Old English Hexateuch* (as in note 36), 40; for textual accounts of the Breton expedition, see G. Beech, *Was the Bayeux Tapestry Made in France? The Case for Saint-Florent of Saumur* (New York, 2005), 61–90; and R. H. C. Davis, "William of Poitiers

and his History of William the Conqueror," in *The Writing of History in the Middle Ages: Essays presented to Richard William Southern,* ed. R. H. C. Davis and J. M. Wallace-Hadrill (Oxford, 1981), esp. 81–82.

40. F. Stenton, "Historical Background," 9, 11; F. Wormald, "Style and Design," 23, 33–34; G. Wingfield Digby, "Technique and Production," 52; and C. Gibbs-Smith, "Notes on the Plates," 174 (all as in note 26). The date traditionally cited for the consecration of Bayeux Cathedral comes from Orderic Vitalis; see *The Ecclesiastical History of Orderic Vitalis,* 6 vols., ed. and trans. M. Chibnall (Oxford, 1969–1980), 3: v.ii.305,

FIGURE 7. The Lowering of the Israelite Spies from the Walls of Jericho, from the *Old English Hexateuch*, London, BL, Cotton Ms. Claudius B.IV, fol. 141ᵛ ().

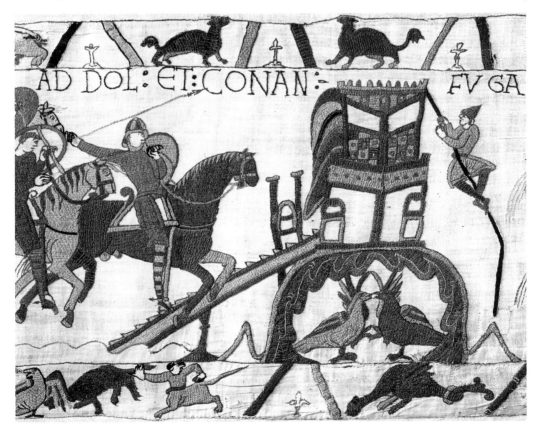

FIGURE 8. The Siege of Dol with Duke Conan fleeing by slip rope, Bayeux Embroidery scenes 20/21. Details from the Bayeux Embroidery, eleventh century (by special permission of the City of Bayeux).

careful to articulate the case in the conditional, as reflected in Wormald's statement, "If [the embroidery] was made at Odo's command then it is equally likely that it was made in connexion with the dedication of his cathedral,"[41] the repetition of this notion across different chapters served to reify it.

In support of the Bayeux Embroidery's connection to the cathedral's consecration, particularly given the absence of any internal documentation in Bayeux, one would expect that the cathedral and its relics would be highlighted on the textile. However, Bayeux Cathedral is not shown, while ecclesiastical sites of more importance in an English context, such as the church at the inlet harbor of Bosham in West Sussex, are depicted (Fig. 9).[42] The town of Bayeux is mentioned in an inscription near an architectural structure that depicts either the town gates or the portal of Duke William's castle there, but the connection between this structure and Harold's oath to William in the accompanying scene is ambiguous (Fig. 10). Moreover, the hybrid form *"Bagias"* in the embroidery's inscription (Fig. 10, upper left), an anglicized version of the Latin *"Baiocensis"* or *"Baiocas"* for Bayeux, does not suggest that the textile was commissioned to hang in the Norman town.[43] Indeed the cathedral's relics, such as those of its most prominent saints Ravennus and Rasyphus, do not receive any explicit endorsement in the swearing of the oath, nor does the singular gold- and gem-encrusted reliquary Odo gave to the cathe-

FIGURE 9 (*Opposite, top*). Earl Harold departing for the Continent from Bosham, Bayeux Embroidery scenes 3/4. Details from the Bayeux Embroidery, eleventh century (by special permission of the City of Bayeux).

FIGURE 10 (*Opposite, bottom*). Duke William comes to Bayeux ("Bagias") and Harold makes an Oath, Bayeux Embroidery scenes 25/26. Details from the Bayeux Embroidery, eleventh century (by special permission of the City of Bayeux).

dral to house their collective saintly remains.[44] Odo's reliquary, described by a sixteenth-century antiquarian as "a miniature version of Bayeux Cathedral that was taller than a ten-year old girl," would seem to offer a great subject for representation, but it is not shown.[45] Expressively, the depiction of Harold's oath to Duke William on two small separate shrines contributes to the effect of Harold appearing "crucified" by his oath.[46] But were Odo the micromanaging patron often portrayed in the secondary literature—and identified as such by Stenton—his gift of the reliquary surely would have been emphasized. Because Bayeux Cathedral and the relics of its most important saints, let alone the large church-shaped reliquary Odo gave to it, are not shown, and even the name given for the Norman town is an English hybridized form, there is no rationale for connecting the Bayeux Embroidery with the 1077 consecration of the cathedral. Indeed, most scholars who now regard Odo as the patron of the textile have dropped the tie-in to the consecration

10–11. Now see J.-M. Bourvris, "La dédicace de l'Eglise de la Cathédrale Notre-Dame de Bayeux (14 juillet 1077)," *Société des Sciences, Arts et Belles-Lettres de Bayeux* 28 (1982), 3–16.

41. F. Wormald, "Style and Design" (as in note 26), 33.

42. On Bosham, see E. C. Pastan, "Building Stories" (as in note 18), 162–166.

43. R. Lepelley, "A Contribution to the Study of the Inscriptions in the Bayeux Tapestry: *Bagias* and *Wilgelm*" (1964), reprint and trans. in R. Gameson, *Study* (as in note 1), 40–43; and I. Short, "The Languages of the Bayeux Tapestry Inscription," *Anglo-Norman Studies* 23 (2000), 271, n. 8. See the assessment of their different approaches in Coatsworth, "Inscriptions on Textiles" (as in note 16), 86–89.

44. For the relics of Bayeux Cathedral, with further bibliography, see F. Neveux, "Les reliques de la cathédrale de Bayeux," in *Les Saints dans la Normandie médiévale*, ed. P. Bouet and F. Neveux, Actes du Colloque de Cerisy-la-Salle, 26–29 september

1996 (Caen, 2000), 109–33; and K. E. Overbey, "Taking Place: Reliquaries and Territorial Authority in the Bayeux Embroidery," in M. K. Foys, *New Interpretations* (as in note 6), 36–50.

45. E. Deslandes, "Le Trésor de l'église Notre-Dame de Bayeux d'après les inventaires manuscrits de 1476, 1480, 1498, conservés à la bibliothèque du chapitre de Bayeux," *Bulletin archéologique du comité des travaux histoiriques et scientifiques* (1896), 345, citing Charles de Bougerville, also known as Charles de Bras, *Les Recherches et antiquitez de la province de Neustrie, à présent Duché de Normandie, comme des villes remarquables d'icelle: mais plus spécialement de la Ville & de l'université de Caen* (1588; reprint, Caen, 1833), 264.

46. As observed by J.-L. Chassel, "Le Serment de Harold dans la tapisserie de Bayeux et dans les sources pro-Normandes des xɪᵉ et xɪɪᵉ siècles," in *Le serment: actes du colloque international CNRS, Paris X Nanterre, 25–25 mai 1989*, 2 vols., ed. R. Verdier (Paris, 1991), ɪ: 45.

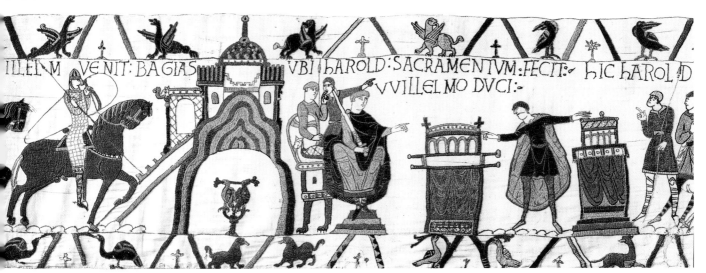

of Bayeux Cathedral put forth in the Stenton volume, and instead prefer a secular context.[47]

Nonetheless, the case for Odo's patronage deepened in the literature published in the decades after the Stenton volume, not because of new evidence, but because prevalent views of the bishop of Bayeux's role changed. Odo was increasingly described as a cleric "in name only," who was "much in evidence in the service of Mars, but never in the service of God."[48] The embroidery was now called "a memorial to Odo's private ostentation," in which he had had himself represented "unabashedly."[49] The following selection

47. See the discussion of the setting of the embroidery in D. J. Bernstein, *Mystery*, 105–107; S. A. Brown, *Bibliography*, 34–35, and D. M. Wilson, *Comprehensive Survey*, 201–203 (all as in note 1); and now G. R. Owen-Crocker, "Brothers, Rivals, and the Geometry of the Bayeux Tapestry," in conjunction with C. Henige, "Putting the Tapestry in its Place," in *eadem*, *King Harold* (as in note 6), 107–123, and 125–137, respectively.

48. C. R. Dodwell, "The Bayeux Tapestry and the French Secular Epic," *Burlington Magazine* 108 (1966), 549–560.

49. *Ibid.*, 549 and 550, respectively. However, see D. R. Bates, "The Character and Career of Odo, Bishop of Bayeux

from David Bernstein's study published in 1986 shows the kind of case proposed, along with a new theory as to where the embroidery was displayed:

> Since Odo was apparently the kind of ecclesiastic who would have been more comfortable listening to the Song of Roland than to a debate on transubstantiation ... the Tapestry may not have been made for his Cathedral at all, but for private display in a great hall.... We might imagine Odo commissioning this great embroidery to adorn the walls of one of his palaces.[50]

As Bernstein's statements reflect, the secular setting now evinced by scholars is not a provenance with any new factual grounding, but a supposition based on their conception of its patron.

On the basis of the literature on the Bayeux Embroidery briefly reviewed here, it is clear that scholars have generally preferred to emphasize textual accounts of the Conquest by its Norman victors over the complex pictorial narrative told by the embroidery itself; they have sought a personalized explanation in the form of a directive patron, despite the ample indications of monastic design and production; and finally, they have determined first a sacred and then a secular context for the textile based on their understanding of that patron. As we shall see, these speculative conclusions are further called into question by consideration of the materials of the hanging.

MATERIALITY

Scholars from a range of disciplines and perspectives, including Madeline Caviness and David Herlihy, have contributed fruitfully to an understanding of the embroidery's materiality.[51] The traditional terminology, which refers to the work as a tapestry, associates the Bayeux Embroidery with the large tapestries that were hung in baronial halls such as the one pictured in the fifteenth-century calendar page for January from Jean de Berry's *Très Riches Heures* (Fig. 11), a setting well suited to the secularized Odo scenario.[52] While the hangings shown in the back left corner of the Duc de Berry's hall with their scenes of battle and prominent inscriptions resemble the Bayeux Embroidery superficially, they differ in size, technique, and function. Tapestries were woven on large rectangular looms that approximated the dimensions of the walls they would cover, whereas the ribbon-like proportions of the Bayeux Embroidery are approximately the maximum width on which embroiderers can work comfortably.[53] Technically speaking, an embroidered image is stitched on top of the fabric, not woven into a dense, continuous surface, as is the case for tapestry.[54] With their resulting thick and densely structured weave, tapestries thus offer warmth and insulation, and thereby serve a practical function in addition to their decorative one, while an embroidery is made to adorn or to tell a story. Whether or not scholars referring to the Bayeux Embroidery as a tapestry consciously mean to invoke a baronial hall, these are overwhelmingly the connotations of the term.[55] The intrinsic associations of medieval embroidery with linens and vestments for the divine office, and its status as the quintessential *opus muliebre*, are lost when the work is inaccurately referred to as a tapestry.[56] Of course, all kinds of textiles were ubiquitous in both churches and castles and exchanged between them, and as Mildred Budny has demonstrated, the terminology employed in medieval texts does not

(1049/50–1097)," *Speculum* 50 (1975), 1–20, who argues that by accepting Orderic Vitalis's "dramatic vilifications" of Odo at face value, modern scholars have not made a fair assessment of the evidence.

50. D. J. Bernstein, *Mystery* (as in note 1), 104.

51. M. H. Caviness, *Reframing Medieval Art: Difference, Margins, Boundaries*, e-book, 2001, http://dca.lib.tufts.edu/Caviness (accessed 17 November 2012), 2, reprinted in revised form as *eadem*, "Anglo-Saxon Women, Norman Knights and a 'Third Sex' in the Bayeux Embroidery," in M. K. Foys, *New Interpretations* (as in note 6), 85–118; and D. Herlihy, *Opera Muliebria, Women and Work in Medieval Europe* (New York, 1990).

52. Chantilly, Musée Condé, Ms. 65, fol. 1ᵛ. See B. Buettner,

"Past Presents: New Year's Gifts at the Valois Courts, ca. 1400," *The Art Bulletin* 83/4 (2001), 612–613.

53. C. Hicks, *The Bayeux Tapestry: The Life Story of a Masterpiece* (London, 2006), 41.

54. See T. J. Campbell, *Henry VIII and the Art of Majesty: Tapestries at the Tudor Court*, (New Haven, Conn., 2007), xv–xviiii.

55. On terminology, see D. Koslin, "Turning Time in the Bayeux Embroidery," *Textile & Text* 13 (1990), 28–29; and N. de Reyniès, "Bayeux Tapestry, or Bayeux Embroidery? Questions of Terminology," in P. Bouet, *Embroidering the Facts* (as in note 6), 69–76.

56. D. Herlihy, *Opera Muliebria* (as in note 51), 5.

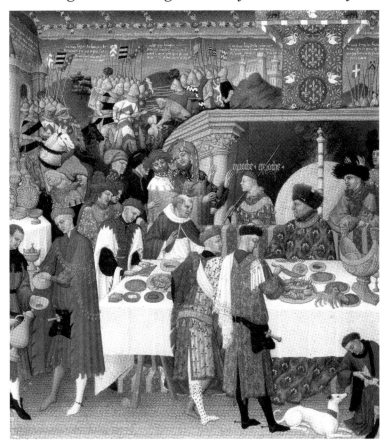

FIGURE 11. The Calendar scene for the month of January, the *Très Riches Heures of Jean Duc de Berry*, early fifteenth century. Chantilly, Musée Condé, Ms. 65, fol. 1ᵛ.

necessarily allow us to ascertain precisely what materials are involved, but it only makes sense to refer to textiles as accurately as possible.[57]

Many Anglo-Saxon textiles, such as the vestments commissioned by Queen Ælflæd for Bishop Frithestan of Winchester (909–916) and now preserved in the treasury of Durham Cathedral, were sewn in gold-wrapped thread and adorned with semi-precious gems.[58] This technique, estimated to have involved 20–26 stitches per centimeter,[59] covered the background of a textile so completely that the cloth was transformed into "a solid mass of the precious metal."[60] The absence of metallic threads on the Bayeux Embroidery has led to a variety of suppositions about its unfinished state, its ordinariness, and even its secular setting.[61] However, setting aside

57. M. Budny, "The Byrhtnoth Tapestry or Embroidery," in *The Battle of Maldon, A.D. 991*, ed. D. Scragg (Oxford, 1991), 263–278.

58. See contributions by E. Plenderleith, "The Technique," C. Hohler, "The Iconography," and R. Freyhan, "The Place of the Stole and Maniples in Anglo-Saxon Art of the Tenth Century," in *The Relics of Saint Cuthbert*, ed. C. F. Battiscombe (Oxford, 1956), 375–396, 396–408, and 409–432, respectively.

59. For an instructive effort to recreate a gold-threaded Anglo-Saxon textile, see H. M. Stevens, "Maaseik Reconstructed: A Practical Investigation and Interpretation of 8th-century Embroidery Techniques," in P. Walton and J. P. Wild, eds., *Textiles in Northern Archaeology: North European Symposium on Archaeological Textiles (NESAT) III, Textile Symposium in York, 6–9 May 1987* (London, 1990), 57–60.

60. C. R. Dodwell, *Pictorial Arts* (as in note 2), 26.

61. B. de Montfaucon, *Monumens* (as in note 8), 2: 2, assumed it was unfinished; C. R. Dodwell, *Anglo-Saxon Art* (as in note 3), 139, argued that it is "quite ordinary" by Anglo-Saxon standards; S. A. Brown, *Bibliography* (as in note 1), 35, observed that gold or silver threads would be "expected" in church vestments and hangings.

aesthetic and devotional considerations,[62] it is important to recognize that if an embroidery of this length had a background of gold-wrapped threads, it would not only be prohibitively expensive, it would also be impossible to lift.[63] An amusing reference to a lavish gold-embroidered chasuble in Mainz, a garment that is quite small in comparison to the Bayeux Embroidery, referred to the fact that it was "so heavy that ... scarcely anyone could wear it to celebrate the Divine Mysteries unless he were very strong," and even then it had to be changed for a more pliant fabric part-way through the service.[64] The unadorned linen ground of the Bayeux Embroidery makes it more manageable to hoist, although additional rings and channels for ropes on backing sheets, added from the sixteenth century and later suggest that the strain of hanging the textile within the cathedral was an ongoing concern.[65]

Admittedly, there were tapestries commissioned to portray real battles and hung in celebration of them, and these share some similarities with the Bayeux Embroidery.[66] The *Battle of Pavia* tapestries now in Naples (Fig. 12), for example, shown here in a detail of "The Invasion of the French Camp and the Flight of the Women and Civilians," depict the imperial army's defeat of France, which effectively put an end to French expansionist policies in Italy.[67] Bernaert van Orley, the most important artist working in Brussels in the early sixteenth century, designed the set of seven 14 by 26 foot panels, which were manufactured in the workshop of Willem and Jan Dermoyen

and presented to Emperor Charles V in March 1531 by the Estates-General. In addition, we know that when the *Battle of Pavia* tapestries were later hung in the "grande salle" of the Brussels Royal Palace for the signing of the treaty of Vaucelles in 1556, the French envoy objected that the humiliating defeat of an earlier French sovereign was an inappropriate choice of decoration for the occasion.[68] This brief introduction to the sixteenth-century tapestry set is enough to show that there are many things known about the commission for the *Battle of Pavia* that have in essence been read back into Bayeux Embroidery, among them the separation of its designer from its producer, its victory context, and its secular display. It is also noteworthy that the *Battle of Pavia* tapestries are routinely alluded to as such; no one has ever denied the implications of their materials by referring to them as "the tapestries traditionally known as the Embroidery of the Battle of Pavia."

Of particular interest is the fact that the Battle of Pavia's triumphal context and impact on beholders are alluded to in the anecdote involving its censorship by the French envoy, which reminds us that we lack any such contemporaneous feedback for the medieval embroidery. Editorial intent has sometimes been read into the fables depicted in the borders of the Bayeux Embroidery, where they have been viewed variously as the undercutting of the subjects in the main field devised by some combination of its English designer and its subversive English seamstresses, or as the means of emphasizing a Norman message.[69] These

62. R. Gameson, "Origin, Art and Message" (as in note 1), 192–193, emphasized the legibility of the raised embroidery on a plain linen ground; also H. Bloch, *A Needle in the Right Hand of God: The Norman Conquest of 1066 and the Making and Meaning of the Bayeux Tapestry* (New York, 2006), 76–81.

63. J. M. Crafton, *The Political Artistry of the Bayeux Tapestry: A Visual Epic of Norman Imperial Ambitions* (Lewiston, 2007), 12, n. 11; and D. M. Wilson, *Comprehensive Survey* (as in note 1), 201.

64. C. R. Dodwell, *Pictorial Arts* (as in note 2) 25–26, citing Lehmann-Brockhaus, *Schriftquellen zur Kunstgeschichte* (as in note 3), no. 2643, 623–624.

65. See I. Bédat and B. Girault-Kurtzeman, "The Technical Study of the Bayeux Embroidery," in P. Bouet, *Embroidering the Facts* (as in note 6), 102, diagram 6, indicating the "stratigraphy" of the various additions to the embroidery over time;

on 87–89 they discuss and illustrate the various devices added for hanging the textile.

66. Also in this lineage are the "Battle of Roosebeke" commissioned by Philip the Bold in the 1380s; the "Battle of Liège" commissioned by John the Fearless in the early fifteenth century, and the "Battle of Formigny," *c.* 1475, works that are no longer extant. See T. P. Campbell, *Tapestry in the Renaissance: Art and Magnificence*, Exhib. cat. (New York: The Metropolitan Museum of Art, 2002), 16–17, 20, 29–30, and 297, respectively.

67. See the entry by I. Buchanan in Campbell, *Tapestry in the Renaissance* (as in note 66), cat. no. 36, 321–328.

68. *Ibid.*, 326.

69. Contrast the approaches of G. I. Berlin, "The Fables of the Bayeux Tapestry: An Anglo-Saxon Perspective," in *Unlocking the Wordhoard: Anglo-Saxon Studies in Memory of Edward B. Irving, Jr.*, ed. M. C. Amodio and K. O. O'Keefe (Toronto,

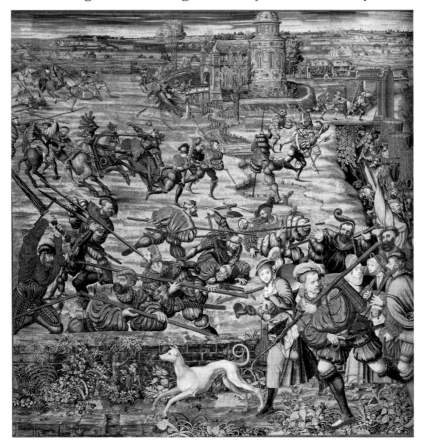

FIGURE 12. Bernaert van Orley, Detail of "The Invasion of the French Camp and the Flight of the Women and Civilians," from the *Battle of Pavia* tapestry set, *c.* 1531, now in Naples, Museo e Gallerie Nazionale di Capodimonte (I.G.M.N. 144486).

pro-English or pro-Norman readings, using the same evidence to different ends, ultimately have the effect of cancelling each other out, as one can envision in constructing a message around the fable of the Fox and Crow shown in the lower border as Harold leaves Bosham (Fig. 9, lower right, and Fig. 13). Would it be better to be compared to the devious Fox who tricks the Crow out of the cheese, or to the vain Crow, who stole the cheese in the first place and coughs it up when flattered into singing? Recently, Stephen D. White has persuasively argued that such fables, which he shows were routinely studied in the monastic schools,

2003), 191–216; and D. Terkla, "Cut on the Norman Bias: Fabulous Borders and Visual Glosses on the Bayeux Tapestry," *Word & Image* 11.3 (1995), 264–290.

FIGURE 13. Detail of the Fable of the Fox and Crow, lower border of Bayeux Embroidery, scenes 3/4. Details from the Bayeux Embroidery, eleventh century (by special permission of the City of Bayeux).

ultimately support neither side, but rather provide an ironizing commentary on plundering by lay lords.[70] The presence of fables pointing to a monastic context thus complements the implications of the choice of materials in suggesting that the Bayeux Embroidery is not another secular battle tapestry but rather, as Montfaucon had intuited, a complex narrative with its own perspective on the Norman Conquest of England.

THE INVENTORY OF BAYEUX CATHEDRAL

Turning now to the earliest indisputable reference to the textile, found in the Inventory of Bayeux Cathedral, we can see how this documentation deepens our consideration of the embroidery.[71] The inventory was compiled in the fall of 1476 by a special committee appointed by Bishop Louis II d'Harcourt (1424–1479), which examined the treasury's holdings and notarized the resulting list. Oft-cited, but little studied (Fig. 14), the inventory offers insight into the materials and functions of a later medieval treasury. Its entire organization is based on liturgical use, and provides a vivid picture of a smoothly functioning ecclesiastical environment. Reliquaries, which receive pride of place in the first two chapters of the inventory, were prominently stored near the main altar in the choir;[72] mantles and chasubles were found "to the right side of the pulpit beneath the crucifix";[73] books that were not in the library but were needed for the office were "in the choir and in chapels around the choir";[74] while the large textiles that were "used to prepare the church for its feasts" were kept in the vestiary.[75] As this phrase quoted from the inventory

reflects, what drew all the entries in the inventory together was their role in the liturgy, the ultimate celebration of the material and spiritual endowments of the cathedral.[76]

Each of the 355 entries listed in the inventory is accompanied by brief descriptions in the vernacular that identify the works. The Bayeux Embroidery is one of the fifty-five works inventoried in the fifth chapter devoted to large textiles. It is noteworthy how unexceptional the reference to the embroidery is (Fig. 15), occurring as it does some thirty entries into the large textile chapter and thus receiving no particular distinction within the inventory as a whole, or even within its chapter. The entry (no. 262, the second full entry from the top of the page) leaves no doubt that it refers to the Bayeux Embroidery, because it mentions the hanging's distinctive proportions, embroidered narrative, and inscriptions that relay the story of the Norman Conquest, and concludes by mentioning the work's display for the Feast of Relics (1 July):

Item, une tente très-longue et estroicte de telle à broderie de ymages et escripteaulx, faisans representation du conquest d'Angleterre, laquelle est tendue environ la nef de l'église le jour et par les octaves des Reliques.[77]

Item, a very long and narrow textile that is embroidered with images and inscriptions that show the conquest of England, which is hung around the nave of the church the day and octave of the Feast of Relics.

Other entries on the same page further attest to the medieval textile's complete visual and devotional assimilation into the cathedral's holdings. Also used in the celebration of the Feast of Relics were the hangings portrayed in the noticeably longer entry listed

70. S. D. White, "The Beasts Who Talk on the Bayeux Embroidery: The Fables Revisited," *Anglo-Norman Studies* 34 (2012), 209–236.

71. Caen, Archives départementales du Calvados, série G, Bibliothèque du chapitre cathédrale de Bayeux, Ms. 199. E. Deslandes, "Trésor" (as in note 45), 340–403. It is in this publication that Deslandes numbered the entries listed in the inventory; although the fifteenth-century manuscript does not have them, we will retain Deslandes's numbers for ease of reference.

72. *Ibid.*, 361.

73. *Ibid.*, 380.

74. *Ibid.*, 396, and see 403–433 for the library inventory of 1480.

75. *Ibid.*, 391.

76. See E. Palazzo, "Le livre dans les trésors du Moyen Age: Contribution à l'histoire de la *Memoria* médiévale," *Annales. Histoire, Sciences Sociales* 52 (1997), 83–118; and C. Hahn, "Relics and Reliquaries: The Construction of Imperial Memory and Meaning, with Particular Attention to Treasuries at Conques, Aachen and Quedlinburg," in *Representing History, 900–1300: Art, Music, History*, ed. R. A. Maxwell (University Park, Pa., 2010), 133–147.

77. E. Deslandes, "Trésor" (as in note 45), 394.

FIGURE 14. Opening Page of the Inventory of Bayeux Cathedral, *c.* 1476. Caen, Archives départementales du Calvados, série G, Bibliothèque du chapitre cathédrale de Bayeux, Ms. 199, fol. 71*bis*/77.

just above it (no. 261): two embroidered silk textiles given by Bishop Louis d'Harcourt that served as decorative coverings for the relics on the altar.[78] Together the entries allow us to visualize the contrast between the medieval embroidery on linen that was hung around the nave and the newer and more sumptuous materials that surrounded the relics themselves. Although we may think of the Bayeux Embroidery's size as exceptional, the entry that follows it in the inventory (no. 263), refers to "another long and narrow textile that covered the images of the [choir screen] at Lent."[79] The textiles' inherent portability functioned well within an ecclesiastical context, as they could be raised and lowered on an annual basis, as called for in the liturgical celebrations of the church calendar.

Despite being so often portrayed as "secular" and compared to the large rectangular tapestries hung in baronial halls, the Bayeux Embroidery turns out to have been incorporated into the liturgy of Bayeux

78. *Ibid.* 79. *Ibid.*

FIGURE 15. Entry for the Bayeux Embroidery (no. 262, second full entry from the top) from the Inventory of Bayeux Cathedral, *c.* 1476. Caen, Archives départementales du Calvados, série G, Bibliothèque du chapitre cathédrale de Bayeux, Ms. 199, fol. 89/95.

Cathedral for well over three centuries—a span of time that extended from at least 1476, when the inventory was drawn up, until 1794, when members of the Fine Arts Commission, set up to protect artistic treasures in the wake of the French Revolution, took possession of the textile in the cathedral sacristy, whence it was never to return.[80] While the hanging could in principle travel between different kinds of settings, its preservation suggests fairly circumscribed circumstances of display. The brief cleaning and technical analysis of the textile undertaken in 1982–1983 disclosed that the ten different hues of dyed wool making up its pictorial narrative are without significant fading, a finding consistent with the limited interior

80. For the later history of the textile, see S. Bertrand, "The History of the Tapestry," in F. Stenton, *Comprehensive Survey*, 88–97; S. A. Brown, *Bibiliography* (both in note 1), 8–22; and C. Hicks, *Masterpiece* (as in note 53), esp. 61–139.

exposure afforded by infrequent use in the celebration of a single feast in the liturgical calendar.[81]

There are also strong scriptural precedents for the use of textiles in an ecclesiastical context.[82] The practice of using richly decorated hangings to adorn sanctuaries, as well as to define liturgical spaces within them, is shown in the instructions God gave to Moses for the preparation of the tabernacle: "Make ten hangings of linen ... rich with featherstitch embroidery."[83] Moreover, throughout the Bible, linen is consistently portrayed in laudatory terms, as the garment of priests (1 Sam. 2:18), the fabric of saints (Rev. 19:8), and the material of the Lord's shroud (Mark 15:46). The numerous notices of papal gifts of textiles to churches in Rome recorded in the *Liber Pontificalis* demonstrate their currency in the early Middle Ages.[84] For the period when the Bayeux Embroidery was undertaken, C. R. Dodwell worked persuasively from literary references and textiles preserved in such sites as Augsburg, Durham, Gerona, and Quedlinburg to show how widespread had been the practice of hanging medieval textiles, and especially embroideries, in an ecclesiastical setting.[85] Moreover, scenes of the saints' lives, such as the cloth with the scenes of the martyrdom and triumph of St. Edmund that was hung near his shrine in the abbey church of Bury, often took the form of a painted or embroidered hanging.[86]

Reviewing the extant textual references to hangings in medieval churches, it is clear that large textiles were such an accustomed aspect of the ecclesiastical environment that only special circumstances such as instruction, disaster, or some other unusual feature within the hanging led to textiles being described in any detail.[87] The eleventh-century work once known as the Farfa Customary, the earliest liturgical document of this length to survive from a western monastery and made for adaptation by Cluny's sister houses, offers one such opportunity.[88] Its instructions for the preparations for Easter Sunday state that the monks were to adorn the church "with linen hangings, woolen draperies, and curtains over the walls throughout...," and an embroidery was to be positioned over the doors of the exterior façade.[89] Guibert de Nogent referred to a set of hangings in Laon Cathedral so large that they could only be hoisted by several men using pulleys. These textiles eventually perished in a fire at the cathedral because the thieves seeking to take advantage of the disaster could not muster sufficient numbers of men quickly enough to make away with them.[90] Herman de Lerbeke, the chronicler of the bishops of Minden, referred to a hanging from 1158 "surpassing in size all the hangings I have seen," which depicted the epistles of Paul, was elaborated by many axioms and proverbs,

81. I. Bédat and B. Girault-Kurtzeman, "Technical Study," in P. Bouet, *Embroidering the Facts* (as in note 6), 103.

82. See J. Osborne, "Textiles" (as in note 3), esp. 312–313.

83. Exodus 26: 1–6. This is also reflected in the veil of the Jewish Temple (3 Kings), and elaborated in Josephus, *The Jewish War*, 3 vols., trans. H. St. J. Thackeray (1927–1928; Cambridge, Mass., 1997), III: V (4), 265.

84. J. Osborne, "Textiles" (as in note 3), 317, where Pope Hadrian I (772–795) is named as the donor of some 1,343 textiles.

85. C. R. Dodwell, *Pictorial Arts* (as in note 2), 11–31.

86. C. M. Kauffmann, *Romanesque Manuscripts* (as in note 34), 74; and V. J. Flint, "The Bayeux Tapestry, the Bishop and the Laity," in P. Bouet, *Embroidering the Facts* (as in note 6), 220–221, on *tabulae* for pilgrims. There were also *rotuli* with saint's lives that were brought out on feast days. See R. Branner, "The Saint-Quentin Rotulus," *Scriptorium* 21 (1967), 252–260, esp. 257, where it is compared to other medieval scrolls, as well as the Lenten curtain formerly at Augsburg.

87. See ed. U. Chevalier, *Ordinaire et Coutumier de l'église ca-*

thédrale de Bayeux (XIIIᵉ siècle) (Paris, 1902), 402, for the Customary of Bayeux Cathedral (Caen, Archives départementales du Calvados, série G, Bibliothèque du chapitre cathédrale de Bayeux, Ms. 122; compiled by Raoul Langevin *c.* 1269, describing the preparations for feasts in very general terms, "XLV. De modo parandi ecclesiam et altare."

88. See the discussion of this work in S. Boynton, *Shaping A Monastic Identity: Liturgy & History at the Imperial Abbey of Farfa, 1000–1125* (Ithaca, N.Y., 2006), 106–143.

89. C. R. Dodwell, *Pictorial Arts* (as in note 2), 15, citing V. Mortet and P. Deschamps, *Recueil de textes* (as in note 3), I: 139–140; and now see *Liber Tramitis Aevi Odilonis Abbatis*, ed. P. Dinter, Corpus Consuetudinum Monasticarum, 10 (Siegburg, 1980), 83.

90. C. R. Dodwell, *Pictorial Arts* (as in note 2), 16, citing V. Mortet and P. Deschamps, *Recueil de textes* (as in note 3), I: 319; now see Guibert of Nogent, *Monodies and On the Relics of Saints: The Autobiography and A Manifesto of a French Monk from the Time of the Crusades*, trans. J. McAlhany and J. Rubenstein (London, 2011), 137.

Elizabeth Carson Pastan

and inscribed with the names of its makers, Rederich and Cunegund.[91]

The performative role that textiles played in Bayeux Cathedral was further suggested by the cathedral archivist Father Eucher Deslandes. He connected yet another entry from the inventory (see Fig. 15, no. 264, just above the stamp for the chapter library), which describes the textile hung at Lent between the main altar and the choir, to the directions in the Ordinary of Bayeux Cathedral, compiled *c.* 1228–1270, which state that at the Easter reading of the mortal death of Jesus, the cord from which the hanging was suspended was to be cut at the words, "And behold the veil of the old temple was torn asunder."[92] This instance of scriptural re-enactment, uniting prophecy, biblical reading and the dropping of the actual liturgical hanging in a single theatrical moment, again reinforces the central role that medieval textiles once played in ecclesiastical settings.

As we have seen, the Bayeux Embroidery's participation in the liturgy of Bayeux Cathedral from at least the fifteenth century on provides a reasonable explanation not only for its preservation, but also for both its form and the materials from which it is made. While there is no evidence to suggest that the embroidery was commissioned for the consecration of Bayeux Cathedral, its full integration into the liturgical life of the cathedral for over three centuries demonstrates the feasibility of an ecclesiastical setting.[93]

* * *

The Bayeux Embroidery is a work we may feel familiar with because of its prominence in discussions of the Middle Ages. Yet among the characteristics almost always ascribed to it are that it is a Norman triumphal narrative, that it is a tapestry, and that it is secular. None of these is true, as I have sought to demonstrate, and all of these characterizations depend on assumptions that arguably stem from a certain conception of its patronage. Were we to imagine the history of the Bayeux Embroidery differently, it might look something like this: The community of St. Augustine's, Canterbury, as suggested in the reference in their Martyrology to the death of Harold and "very many of our brothers who perished at the Battle of Hastings,"[94] determine to remember the Norman Conquest with a monumental embroidery to be hung in their new church, initiated under Abbot Scolland (*c.* 1070–1087).[95] Based on their rich artistic traditions, the monks of St. Augustine's conceive, design, and produce the textile, depicting several Norman benefactors who belonged to their confraternity and were to be prayed for on the anniversaries of their deaths, including their chief benefactors Bishop Odo and King William.[96] They also allude to the origin of Scolland, who had served as a scribe and treasurer at Mont-Saint-Michel before being named as abbot of St. Augustine's (Fig. 16).[97] Part penitential and part commemorative, the embroidery acknowledges

91. C. R. Dodwell, *Pictorial Arts* (as in note 2), 16, citing D. Lehmann-Brockhaus, *Schriftquellen* (as in note 3), no. 2605, 610.

92. E. Deslandes, "Trésor" (as in note 45), 394, n. 2. For the Customary (Caen, Archives départementales du Calvados, série G, Bibliothèque du chapitre cathédrale de Bayeux, Ms. 121), see the transcription in U. Chevalier, *Ordinaire et Coutumier* (as in note 87), 121, Feria IIIIa. On the ways that the different kinds of texts (inventory, ordinary, customary) produced by Bayeux Cathedral offered complementary kinds of details about the church's holdings, see E. C. Pastan, "*Item, une tente très-longue*: The Inventory of Bayeux Cathedral and its Implications," in *Inside and Beyond the Bayeux Tapestry*, ed. G. R. Owen-Crocker and A. Henderson (Manchester University Press, forthcoming).

93. Also see R. Gameson, "Origin, Art and Message" (as in note 1), 209; and V. J. Flint, "Bishop and the Laity" (as in note 86), 224.

94. London, BL, Ms. Cotton Vitellius B.XII, fol. 145ᵛ, and see C. M. Kauffmann, *Romanesque Manuscripts* (as in note 34), cat. no. 18, 61–62.

95. For the abbey church of St. Augustine's, see R. Gem, "The Anglo-Saxon and Norman Churches," in *St. Augustine's Abbey*, ed. *idem*, English Heritage (London, 1997), 90–122, with bibliography, 170–171; *idem*, "The Significance of the 11th-century Rebuilding of Christ Church and St. Augustine's, Canterbury in the Development of Romanesque Architecture," in *Medieval Art and Architecture at Canterbury before 1200*, The British Archaeological Association Conference Transactions for the Year 1979, V (Leeds, 1982), 1–19; T. Tatton-Brown, "The Buildings and Topography of St. Augustine's Abbey, Canterbury," *Journal of the British Archaeological Association* 144 (1991), 61–91; and R. Sharpe, "The Setting of St. Augustine's Translation, 1091," in *Canterbury and the Norman Conquest: Churches, Saints and Scholars, 1066–1109*, ed. R. Eales and R. Sharpe (Hambledon, 1995), 1–13.

96. E. C. Pastan and S. D. White, "Problematizing Patronage" (as in note 7), 16–17.

97. R. Gameson, "Origin, Art and Message" (as in note 1), 171–172.

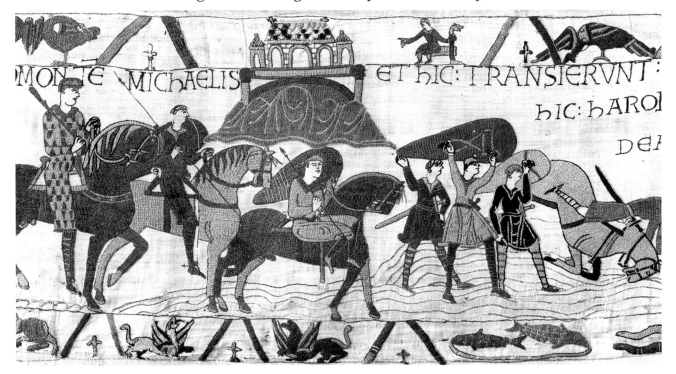

FIGURE 16. Duke William and his men with Earl Harold crossing the river near Mont-Saint-Michel, Bayeux Embroidery scenes 19/20. Details from the Bayeux Embroidery, eleventh century (by special permission of the City of Bayeux).

the war and its dead, but lays blame on neither the monastery's traditional English constituents nor its new Norman benefactors, on whose continued support the monastery depends.[98] Its story reflects the circumspect stance on the Conquest which enabled the monastery to thrive after 1066, a circumspection evident in works such as the *Anglo-Saxon Chronicle* and the *Vita Ædwardi* that viewed the Conquest as God's punishment for the sins of the English people.[99]

In concluding with this imagined patronage scenario, I draw upon studies going back to Wormald's that have long pointed to the monastery of St. Augustine's in Canterbury for motifs and production without embracing the possibility of monastic agency in authoring and designing its narrative. Casting Bishop

Odo in the role of a patron-author and basing the purpose, dating, and display of the embroidery on his supposed commission not only ignores the evidence of original artistic productions generated at St. Augustine's, but also turns a probable internal institutional benefactor to be prayed for into a paying author-client. If the precise context for the Bayeux Embroidery remains elusive, surely its incorporation into the liturgical life of Bayeux Cathedral for over three centuries deserves more consideration. Finally, I submit that the enterprise of thinking of it as collaborative, monastic, and tied to the aspirations of post-Conquest monasteries like St. Augustine's is less far-fetched and has more to recommend it than many of the scenarios that have been offered to date.

98. For a connection to the penitential ordinance of *c.* 1070 imposed on those who had fought at Hastings, see V. J. Flint, "Bishop and the Laity" (as in note 86), 230–231.

99. R. Gameson, "Origin, Art and Message" (as in note 1),

210–211; the *Anglo-Saxon Chronicle*, Whitelock trans., D version for 1066, 143, the *Anglo-Saxon Chronicle*, Swanton trans., D version for 1066, 199 (both as in note 17); and F. Barlow, *Life of King Edward* (as in note 18), 106–111, 116–119.

FIGURE 1. Bourgfontaine, view from the east of the church and early modern buildings of the charterhouse (image: authors).

FIGURE 3. Bourgfontaine, view of the outer court showing the late medieval guest chapel, gatehouse, and other buildings (image: authors).

SHEILA BONDE & CLARK MAINES

The Heart of the Matter:
Valois Patronage of the Charterhouse at Bourgfontaine*

IN MEMORY OF LÉON PRESSOUYRE

FRIEND COLLEAGUE MENTOR

INTRODUCTION

THE Carthusian monastery of Bourgfontaine was formally established between 1323 and 1325 by Charles, count of Valois. Charles died in 1325 with the construction at the monastery underway but unfinished. His son and successor, Philip, saw to the completion of the project. When Philip ascended to the throne in 1328 as the first Valois king of France, the comital foundation became a royal one.

Bourgfontaine survives today as a monumental ruin and a working farm. The shell of the church (Fig. 1, *opposite*), and portions of the precinct wall framing the great cloister, are all that survive above ground of the monastic portion of the site (Fig. 2, *right*). A number of buildings in the outer court, including a gate, guest chapel, and parts of the outer enclosure wall also survives (Fig. 3, *opposite*).

Charles and Philip VI each had his body divided after death, with heart, corpse, and entrails interred at different religious houses. Philip's heart was buried at Bourgfontaine.[1] Surviving documentary and iconographic sources allow us to reconstruct an idea of the intact house, and to explore the intertwined complexities of comital, royal, and monastic patronage at this Carthusian house. As we shall see, Philip's

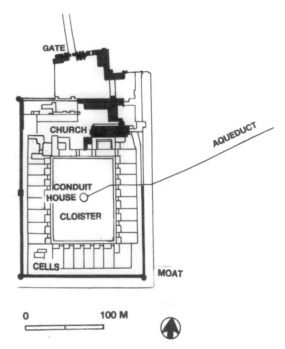

FIGURE 2. Bourgfontaine, plan of charterhouse (redrawn based on the plans of L. Marchand, *Essai historique sur Bourgfontaine*, Château-Thierry, 1953 [itself based on a drawing by dom Sochay], and IGN carte topographique 2512–Est, Villers-Cotterêts).

entombed presence at Bourgfontaine became the heart of the matter.

* We gratefully acknowledge the support and encouragement for our work that we have received from M. Hubert and Mme. Nathalie Mathet, owners of the charterhouse of Bourgfontaine. Without it, this study could not have been carried out. We would also like to acknowledge the collegial contributions of Rita Keane, Aden Kumler, and Evelyn Lincoln.

1. J. Adhémar, in collaboration with G. Dordor, "Les tombeaux de la collection Gaignières, Dessins d'archéologie du XVIIᵉ siècle, tome I," *Gazette des Beaux-Arts*, 6th series, 84 (1974), 1–192; "tome II, suite du catalogue," *Gazette des Beaux-Arts*, 6th series, 88 (1976), 1–88; and "tome III, fin du catalogue, table," *Gazette des Beaux-Arts*, 6th series, 90 (1977), 1–76; the heart tomb of Philip VI is, II: 139, n° 764.

APPROACHES TO PATRONAGE

The questions we ask of Bourgfontaine are informed by recent scholarship in patronage studies. This body of literature has explored the complex relationships between the makers and sponsors of works of art and architecture, and has urged us to question authorship and to accord greater credit to multiple contributors.[2] Medieval support of religious art was especially fraught with complications. Patronage might be deployed in order to make an eloquent statement about social position. The acquisition of wealth through a donor might be especially troubling, however, to an austere religious community.[3]

Scholarship has explored the patronage of religious foundations such as monasteries, particularly in England.[4] Patronage of an institution rather than an object requires that we complicate our investigative strategies. Such institutions were seldom passive recipients of patrons' charity but rather participants in a reciprocal spiritual economy.[5]

Julian Luxford and Karen Stöber remind us that a royal patron could be a mixed blessing, and that a cash-starved royal patron could sponsor a monastic house in order to lay claim to revenues.[6] For example, Edward III of England, Philip VI's contemporary, largely expanded his patronage of monastic houses in order to extend his influence over appointments, benefices, and revenues.[7] Charles of Valois, and Philip VI after him, provided richly for their new house at Bourgfontaine and did so, as we shall show, for reasons dramatically different from those of Edward III.

Network theory can be helpful to an exploration of the ways in which religious patronage implicated both the patron and community in the creation of a web of interconnected relationships.[8] In the sometimes fierce competition for patrons, monasteries needed to be active agents, casting themselves as worthy destinations

2. See, for example, G. Ianziti, "Patronage and the Production of History: The Case Study of Quattrocento Milan," in *Patronage, Art and Society in Renaissance Italy*, eds., F. W. Kent and P. Simon, with J. C. Eade (New York, 1987), 299–311; R. Chartier, "Princely Patronage and the Economy of Dedication," in his *Forms and Meanings: Texts, Performances and Audiences from Codex to Computer* (Philadelphia, Pa., 1995), 25–42, esp. 34–35; M. Baxandall, "Rudolph Agricola on Patrons Efficient and Patrons Final: A Renaissance Discrimination," *Burlington Magazine* 124 (1982), 424–425. For a recent overview of medieval patronage, see P. Binski and E. A. New, "Introduction: Patrons and Professionals in the Middle Ages," in *Patrons and Professionals in the Middle Ages*, ed. P. Binski and E. A. New, Harlaxton Medieval Studies, XXII (Donington, 2012), 1–4.

3. See, for example, J. M. Luxford, "The Space of the Tomb in Carthusian Consciousness," in *Ritual and Space in the Middle Ages*, ed. F. Andrews, Harlaxton Medieval Studies, XXI (Donington, 2011), 259–281.

4. See S. Wood, *English Monasteries and their Patrons in the Thirteenth Century* (London; New York, 1955); K. Stöber, *Late Medieval Monasteries and Their Patrons: England and Wales, c. 1300–1540*, Studies in the History of Medieval Religion, vol. 29 (Woodbridge, Suffolk; Rochester, N.Y., 2007); J. Luxford, *The Art and Architecture of English Benedictine Monasteries, 1300–1540: A Patronage History* (Woodbridge, Suffolk, 2005); L. Bourdua, *The Franciscans and Art Patronage on Late Medieval Italy* (Cambridge; New York, 2011); R. Goffen, *Piety and Patronage in Renaissance Venice: Bellini, Titian, and the Franciscans* (New Haven, Conn., 1986). K. Stöber and R. Goffen pay particular attention to non-royal lay patronage.

5. See, for example, S. Sweetinburgh, *The Role of the Hospital in Medieval England: Gift-Giving and the Spiritual Economy* (Dublin; Portland, Ore., 2004); and J. M. Luxford, *Art and Architecture* (as in note 4), 115–155.

6. J. M. Luxford, *Art and Architecture* (as in note 4), 151; and K. Stöber, *Late Medieval Monasteries* (as in note 4), 25–26.

7. On Edward III's patronage of churches, see W. M. Ormrod, *The Reign of Edward III* (Stroud, Glos., 2000), 118–127. Louis VII of France similarly patronized churches in the south of the country a century and a half earlier. On Louis' patronage, see M. Pacaut, *Louis VII et son royaume* (Paris, 1964), esp. 106–107; and S. Bonde, *Fortress-Churches of Languedoc: Architecture, Religion, and Conflict in the High Middle Ages* (Cambridge; New York, 1994), 61–65.

8. On the formation of monastic networks, see E. L. Jordan, *Women, Power, and Religious Patronage in the Middle Ages* (New York; Basingstoke, 2006). On letters as a form of network, see P. D. McLean, *The Art of the Network: Strategic Interaction and Patronage in Renaissance Florence* (Durham, N.C., 2007); and J. P. Haseldine, "Friendship, Intimacy and Corporate Networking in the Twelfth Century: The Politics of Friendship in the Letters of Peter the Venerable," *English Historical Review*, 126 (2011), 251–280. On network theory, see especially B. Latour, *Reassembling the Social: An Introduction to Actor-Network Theory* (Oxford; New York, 2005); I. Hodder, *Entangled: An Archaeology of the Relationships between Humans and Things* (Oxford, 2012); and C. Knappett, *An Archaeology of Interaction: Network Perspectives on Material Culture and Society* (Oxford; New York, 2011).

for pilgrimage, retirement, burial, and commemoration.[9] The performative aspect of patronage must be noted, with noble and royal patrons displaying legitimacy, piety, and power, and forming social networks of control through the foundation of a holy site.[10]

Our approach to patronage in this study develops these ideas and pursues a multivariate, rather than a monocausal, path. We attempt to identify the various individuals and institutions implicated in the foundation of Bourgfontaine, and we then consider their actions, and the motivations behind them. We look at the patronage of a monastery as an evolving corporate enterprise in which secular and religious individuals interacted to form associations and networks to benefit both the institution and themselves. We examine the context for the foundation of the charterhouse, the practice of burial, and the evidence for commemorative spaces and images.

SCHOLARSHIP ON BOURGFONTAINE AND ITS PATRONAGE

Scholarship on Bourgfontaine and its patronage has been limited.[11] A surprising number of original documents, or near-contemporary copies of them, attesting to the kinds and monetary value of gifts made to the house survive from the charterhouse at Bourgfontaine, the papacy, and the house of Valois.[12] Many of these have been catalogued and edited by Françoise Billotey, who examined them principally from a monastic point of view.[13] Lucien Marchand, who was invited by the Carthusian order in 1945 to write a history of Bourgfontaine, depended heavily upon Billotey's unpublished study and continued the monastic focus.[14] By contrast, Marie-Pierre Leignel's *mémoire de maîtrise* approached the charterhouse from a secular Valois perspective.[15] In the late nineteenth century, the abbé Poquet surveyed the "pre-history" of the site, the circumstances of foundation and Valois patronage, as well as the domain of the charterhouse and its architecture.[16] Joseph Petit's biography provides the only substantial study of Charles of Valois and includes limited discussion of his patronage.[17] There has been no biography of Philip VI, though his reign has been discussed in studies of the Valois dynasty and of the Hundred Years War.[18] Moreover, no in-depth architectural study has been carried out on any of the surviving buildings of the charterhouse, including the church that is an important example of

9. J. M. Luxford, *Art and Architecture* (as in note 4), 117.

10. See A. M. Schor, "Patronage Performance and Social Strategy in the Letters of Theodoret, Bishop of Cyrrhus," *Journal of Late Antiquity*, 2.2 (2009), 274–299, and, more generally, E. Gertsman, ed., *Visualizing Medieval Performance: Perspectives, Histories, Contexts* (Aldershot; Burlington, Vt., 2008).

11. The early modern historians of the Valois, Bergeron, Muldrac, and Carlier, are important sources. N. Bergeron, *Le Valoys royal* (Paris, 1583), republished by the Société historique de Compiègne, in *Pièces rares relatives à l'histoire de Compiègne* (Compiègne, 1908), 237–293; Carlier, *Histoire du duché de Valois*, 3 vols. (Paris; Compiègne, 1764); F. A. Muldrac, *Le Valoys roial* (Bonnefontaine, 1662).

12. No systematic survey of archival records has yet been undertaken for Bourgfontaine. Substantial holdings can be found in Beauvais, Archives départementales, série H (clergé régulier): H 3584 – H 4063 and H 11958 – H 11968, including H 3652 ("extrait des privilèges des rois de France, 1330–1579"). Most of the documents are later, however, and date from the 15th to the 18th centuries. Laon, Arch. dép., série H (clergé régulier) H 1369 contains various documents dated from the 16th to the 18th centuries.

13. F. Billotey, "La chartreuse de Bourgfontaine-en-Valois: des origines à la Révolution," Position des thèses pour le di-plôme d'archiviste-paléographe (Paris, 1948). Thirteen original documents, or extracts from them, are edited on pp. 166–203. See also F. Billotey, "La chartreuse de Bourgfontaine en Valois des origines à la Révolution," *Cahiers raciniennes*, I (1957), 14–29.

14. L. Marchand, *Essai historique sur Bourgfontaine ou La Fontaine Notre-Dame, ancienne Chartreuse du diocèse de Soissons, 1323–1792* (Château-Thierry, 1953).

15. M.-P. Leignel, "La Chartreuse de Bourgfontaine et les Valois" (Mémoire de maitrîse d'histoire, Université de Paris, 1995–1996).

16. L'abbé Poquet, "La chartreuse de Bourgfontaine, son histoire, sa description, ses possessions territoriales," *Bulletin de la Société archéologique, historique et scientific de Soissons*, 2nd ser., x (1879), 173–181.

17. J. Petit, *Charles de Valois (1270–1325)* (Paris, 1900), reprinted 2005.

18. On the events and character of the reigns of the early Valois kings, see R. J. Knecht, *The Valois, Kings of France 1328–1589* (London; New York, 2004), esp. 1–39. For a psychological history of the early dynasty, see A. Denieul-Cormier, *Wise and Foolish Kings, the First House of Valois, 1328–1498* (trans. *Rois fous et sages de la première maison de Valois*) (Garden City, N.Y., 1980), 1–41.

fourteenth-century comital/royal patronage.[19] The charterhouse has remained in private hands since the French Revolution and, until very recently, has been largely outside the realm of archaeological and architectural investigation.[20]

ESTABLISHMENT OF THE CHARTERHOUSE

The establishment of a new monastic house was a complex process rather than a single event, one that typically extended over several decades.[21] In the case of Bourgfontaine, it involved the count and his wife, his son and his wife, and the pope, as well as the Carthusian prior-general and the new community's first prior. While the process of foundation of Bourgfontaine may have been begun earlier,[22] the formal act of foundation, that is the legal event documenting the establishment of the charterhouse, occurred between the years 1323 and 1325. A series of charters, letters, and papal privileges dated to these years reflects this process, and permits us to perceive the complicated sequence of patronage at the house. The earliest document seems to be a letter, dated July, 1323, from Aymes, prior-general of the Carthusian order to Charles of Valois, acknowledging the establishment of the new house.[23] It makes clear that Charles had:

… commencié à edifyer et proposez hasteement et devotement à accomplir et souffisement douheir de rentes et d'aultres choses necessaires pour plein couvent de nostre ordre une meison en [son] contei de Valoys…[24]

VALOIS PATRONS AND THEIR VARIED MOTIVATIONS

Traditionally, and beginning in the fourteenth century, Charles of Valois (1270–1325) has been given credit for the foundation of the charterhouse of Bourgfontaine. As we shall see, however, other members of the family, notably Charles' third wife, Mahaut de Saint-Pol (1293–1358), his son, Philip VI of Valois (1293–1350), and, later, Blanche de Navarre (1331–1398), Philip VI's second wife, all had major roles to play in the foundation and development of the community of Bourgfontaine.

CHARLES

Charles of Valois was a remarkable, if little studied, man. Son of a king, brother of a king, uncle to three kings and father of one, he never became king himself, though he pursued a crown vigorously through

19. Most authors, including Poquet, Billotey, and Marchand, as well as a more popular study by Plouvier and Riboulleau, provide descriptions of the buildings at Bourgfontaine. F. Billotey, "La Chartreuse (1948)" (as in note 13), 151–158; L. Marchand, *Essai historique* (as in note 14), 35–37; and M. Plouvier and C. Riboulleau, "Deux chartreuses dans l'Aisne: Le Val Saint-Pierre et Bourgfontaine," *Graines d'Histoire*, n° 14 (2001), 2–10, esp. 6–7. General, comparative statements about plan and form have been made by J.-P. Aniel, *Les Maisons de Chartreux, des origines à la Chartreuse de Pavie*, Bibliothèque de la Société française d'archéologie, 16 (Paris; Geneva, 1983), which treats Bourgfontaine in passing, 56–66 *et passim*. A summary rescue excavation was undertaken following the accidental uncovering of a corner of the great cloister in 2004. Excavation and analysis of the cloister was carried out and published by J.-L. Bernard, "Le grand cloître de la chartreuse de Bourgfontaine," in *Moines et moniales dans l'ordre des Chartreux: L'apport de l'archéologie, Actes du Premier Congrès international d'Archéologie Cartusienne, 22–25 juin 2006*, ed. M. Valdher (Salzburg, 2007), 117–138.

20. See S. Bonde and C. Maines, "The Technology of Medieval Water Management at the Charterhouse of Bourgfontaine," *Technology & Culture*, 53/3 (2012), 625–670, as well

as M. Plouvier and C. Riboulleau, "Deux Chartreuses" (as in note 19), 2–10, and J.-L. Bernard, "Le grand cloître" (as in note 19), 117–138.

21. See S. Bonde and C. Maines, eds., *Saint-Jean-des-Vignes in Soissons: Approaches to its Architecture, Archaeology, and History*, Bibliotheca Victorina, xv (Turnhout, 2003), 54–83, and the bibliography within.

22. C. Carlier, *Histoire du duché* (as in note 11), ii: 179, claimed that religious were already at Bourgfontaine by 1315. F. Billotey, "La Chartreuse" (1948) (as in note 13), 19, argues against Carlier on the grounds that there are no traces of this claim among the monastery's surviving documents and because Carlier misunderstood the date of a papal document, thinking it dated to 1316 rather than 1324. Nevertheless, some work on the new charterhouse may have been begun before the formal act of foundation, since it seems that monks were in residence and monastic buildings were at least well underway before the end of the decade of the 1320s.

23. Paris, Archives nationales, j 164 b, n°45, cited by F. Billotey, "La Chartreuse" (1948) (as in note 13), pièce justicative n° 1, 166–168.

24. F. Billotey "La Chartreuse" (1948) (as in note 13), 167, and M.-P. Leignel, "La Chartreuse" (as in note 15), 165.

marriage, political intrigue, and warfare.[25] His piety during his lifetime may be judged typical for the period, though his patronage of religious establishments seems more focused upon accruing benefits to himself than upon donating support to a particular group of religious men or women.[26] He founded no less than seven chaplaincies in various churches. While the religious communities benefitted from these foundations, the principal motivation for them was the establishment of prayers for his own soul. He also gave sums of money to nine other churches, including the charterhouse of Vauvert in Paris.[27] Some of these cash gifts may also have been for establishing chaplaincies. Charles seems, however, to have aided in the construction process of only two churches: Saint-Jacques-aux-Pelerins in Paris and Bourgfontaine in his own county of Valois.[28] To the latter, he also gave relics of Saint Martin in his possession.[29]

There can be no doubt that the foundation of the charterhouse at Bourgfontaine was Charles' most important pious act. That he felt the need to found a monastery can reasonably be attributed to a desire to atone for his avarice and envy, manifest in his constant pursuit of wealth and his insatiable desire for kingship. The immediate motivation for the foundation may also be attributed to guilt over his involvement in the downfall and death of an enemy, Enguerran de Marigny. Out of favor during the later part of the reign of his brother, Philip the Fair, Charles returned to power with the accession of his nephew, Louis X, to the throne of France.[30] This position led to Charles' altercation with his brother's chamberlain, Enguerran, and ultimately to the latter's trial and execution on trumped-up charges of sorcery and *malversations* (essentially corruption and breach of trust).[31] Shortly before his death in 1325, Charles seems to have recognized his guilt in Marigny's death. Charles gave alms to the Parisian poor who were obliged, according to the donation, to *Priez Dieu pour monseigneur Enguerran de Marigny et pour monseigneur Charles de Valois,*[32] and he established the charterhouse at Bourgfontaine. In the same year of 1325, Charles recorded his gift of properties sufficient to produce 600 *livres tournois* in annual revenue to support the foundation of the ... *meson de Fontaine Nostre Dame de l'ordre de Chartreuse....*[33]

MAHAUT OF SAINT-POL

Charles of Valois did not, however, act alone in his effort to establish the charterhouse. Charles' letter of 1325, which gave the charterhouse 600 *livres tournois* of annual rent, contains two passages in which he acts together with his third wife, Mahaut de Saint-Pol: *Saychent touz que comme nous et Mahaut de Saint Pol, nostre chiere compaigne,...* at the opening of the letter and *Et nous, Charles et Mahaut dessus ditz, en tesmoing des chouses ...* at its closing.[34]

More importantly, the letter contains a third passage

25. The crowns pursued by Charles included those of Aragon (J. Petit, *Charles de Valois* [as in note 17], 17–23) and Constantinople (J. Petit, *Charles de Valois*, 53–58, 120). His failures were not without benefits, however, as his renunciation of the crown of Aragon made him one of the wealthiest nobles in France (J. Petit, *Charles de Valois*, 17).

26. For a summary of Charles' acts of piety, see J. Petit, *Charles de Valois* (as in note 17), 230–235.

27. According to F. Billotey, "La Chartreuse" (1948) (as in note 13), 27 (citing Paris, Arch. nat. J 164 B, n° 45), both King Philip the Fair and Charles of Valois supported Vauvert.

28. J. Petit, *Charles de Valois* (as in note 17), 232–233 and 234–235, respectively.

29. J. Petit, *Charles de Valois* (as in note 17), 234–235.

30. The remarks that follow are drawn from J. Petit, *Charles de Valois* (as in note 17), 146 and 149–150. For a detailed assessment of the conflict between the two men, see J. Favier, *Un conseiller de Philippe le Bel: Enguerran de Marigny*, Mémoires et Documents publiés par la Société de l'École des Chartes,

16 (Paris, 1963), 191–220. See also D. Gillerman, *Enguerran de Marigny and the Church of Notre-Dame at Ecouis: Art and Patronage in the Reign of Philip the Fair* (University Park, Pa., 1994), 18–19.

31. Petit, *Charles de Valois* (as in note 17), 135 and 140–141. The vendetta against Marigny stemmed from a diplomatic mission to Flanders in 1311, where the chamberlain openly defied Valois who was officially head of the embassy.

32. See the "Chronique Parisienne anonyme," published in the *Mémoires de la Société de l'histoire de Paris, et de l'Île-de-France*, vol. XI, 101. For other sources, see J. Petit, *Charles de Valois* (as in note 17), 219 and n. 9.

33. Paris, Arch. nat., K 41, n° 26, and the extracts in F. Billotey, "La Chartreuse" (1948) (as in note 13), pièce justicative n° 3.

34. Paris, Arch nat. JJ 65 B n° 143, On Mahaut, see R. and M. Rouse, "French Literature and the Counts of Saint-Pol ca. 1178–1377," *Viator* 41, no. 1 (2010), 101–140, esp. 130–131.

in which Mahaut acts alone in agreeing to the gift and in forbidding her heirs and successors to interfere with it:

> *Et nous, Mahaut de Sainct Pol, sa compaigne devant dite, considérant le très loable et très dévot propos de nostre très chier seigneur dessus dit, toutes les chouses dessus dites et chascune dicelles en la fourme et en la manière que elles sont dessus faites et devisées, en tant comme il nous touche et appartient et puet touchier et appartenir, volons, loons, ratefions et approvons et tant comme nous poons, et prometons en bonne foy pour nous, pour hoirs et pour nos successeurs, que, contre les dites choses ou aucune dicelles ne vendrons ne venir ne ferons ou temps avenir.*[35]

Both Charles and Mahaut affixed their individual seals to the letter. Mahaut's role should thus be recognized as active and independent.[36]

PHILIP VI

Charles' will acknowledges that the work was not finished as Charles approached death:... *se la dite meson de chartreuse n'estuil parfuite avant mon deces, je vueil que ele soit parfaite des cent mil livres dessus dites.*[37] It was left to Charles's son to carry the work to "perfection." In Philip's letter of 1329, the king refers to the completion of his father's project:

> *... que comme nostre cher seigneur et pere dont Diex ait l'ame, fondast en son vivant,...le lieu de la Fontaine Notre Dame en la forest de Rest où il establit freres de l'ordre de chartreuse...avec les edifices qu'il fist faire ou dit lieu pour les diz freres feist aussi faire pour lui et pour sa gent quant il vouleroit a venir plusieurs autres edifices, lesquels n'etaient pas parfaiz ne accompliz au jour qu'il trespassa de cest siegle et lesquex nous avons fait faire depuis et faisons encor parfaire....*[38]

The culmination of the formal process of establishment occurred in 1329 when Philip VI "again gives" the site of Bourgfontaine and all it contains to the Carthusians living there:

> *... nous qui aux prieres des diz religieux avons très grant devotion et espiritance qu'elles nous doivent estre profitable à l'ame, avons donné et donnons, les devant diz edifices avec toutes les appartenances et aizances soient prales, jardins et autres choses qui sont enclos dedanz les murs qui encloient tout enviror le lieu dessus dit....*[39]

Philip VI's support for his father's enterprise continued for the rest of his reign and included numerous visits to the charterhouse,[40] as well as many gifts to help create a landed domain to support the community and a gift of 120 *livres tournois* of annual rent.[41]

For Philip, the issues were more complex. Partly, his support for Bourgfontaine was the action of a

35. Paris, Arch nat. JJ 65 B n° 143.

36. On Mahaut's handling of her own affairs, see Petit, *Charles de Valois* (as in note 17), 246.

37. The testament is found in Paris, Arch. nat., J 164 B, n° 54; J.-C. Bonnet, *Testament de Charles de Valois (duc d'Anjou)* (Aix-en-Provence, 1630), remains the only published edition of the will. The passage is quoted from Billotey, "La Chartreuse" (1948) (as in note 13), p. 23 and n. 1, p. 24.

38. The original is found in Paris, Arch. nat., JJ 67, n° 2. The passage is quoted from F. Billotey, "La Chartreuse" (1948), 181, and M.-P. Leignel, "La Chartreuse" (as in note 15), 170.

39. Paris, Arch. nat., JJ 67, n° 2, and F. Billotey, "La Chartreuse" (1948) (as in note 13), 181, pièce justicative n° 6. In this document, Philip VI affirms that he has *fait faire* (since his father's death) *et faisons encore parfaiz* his father's charterhouse. He also modifies his father's gift by turning the secular buildings on the site over to the care of the prior and the monks. He then "gives" the charterhouse site in its entirety to the monks again.

40. See A. Moreau-Neret, "Philippe VI de Valois et la Chartreuse de Bourgfontaine où son Coeur fut déposé," *Mémoires de la Fédération des Sociétés d'Histoire et d'Archéologie de l'Aisne,* 13 (1967), 149–163. Moreau-Neret includes a brief section cataloguing the visits made to Bourgfontaine by Philippe VI, and the gifts and privileges he accorded to the priory, both of which are useful for demonstrating the king's continuing interest in his father's foundation. Moreau-Neret, "Philippe VI de Valois," 152–154 and 154–156, respectively. In cataloguing the visits, Moreau-Neret took his information from J. Viard, "Itinéraire de Philippe VI de Valois," *Bibliothèque de l'école des chartes,* 74 (1913), 74–128, 525–619; in discussing the gifts and privileges, however, he seems to have worked directly from the manuscripts listed by Viard for each site given in the itinerary (88–128, 525–592). There were fourteen visits between 1328 when Philip became king and his death in 1350, six of them coming in the first four years of his reign. Moreau-Neret lists eleven gifts and privileges, many of which are discussed by Billotey, "La chartreuse" (1948) (as in note 13), and Leignel "La Chartreuse" (as in note 15).

41. For example, see F. Billotey, "La Chartreuse" (1948) (as in note 13), 29–32. Paris, Arch. Nat. JJ 68, n° 47, for the gift of the Ourcq River; Paris, Arch. nat. JJ 66 n° 35 and Arch. Nat. L 1003, for the gift of rent.

dutiful son fulfilling his father's wishes. Purgatorial thought in the High Middle Ages held that alteration of a gift, or the failure to complete it, deprived the original donor of at least some, if not all, of the gift's benefits.[42] Philip would likely have been aware of this himself, and spiritual counselors would have reminded him if he were not. Completing his father's foundation at Bourgfontaine would thus have had a component of obligation and would have constituted filial piety in the richest sense. In the same vein, Philip seems to have been implicated in the affair Marigny, at least indirectly. After the latter's execution, Philip was given Marigny's residence near Saint-Germain l'Auxerrois by the king, Louis X.[43]

There is, however, a further component to Philip's actions. When Philip succeeded his father, the monks at Bourgfontaine sought confirmation of Charles' gift from his successor, much as a monastery might seek confirmation of its possessions from a successor bishop or pope. Philip, however, did not merely confirm his father's gift but, as we have seen, gave it again in 1329.[44] In doing so, he inserted himself into the original gift, in effect making himself co-founder of the charterhouse.[45]

It may also be that Philip saw his re-gifting of Bourgfontaine as a thank-offering for his remarkable accession to the throne of France. Sources are not clear as to what extent Philip was chosen to be king by the lords of the realm and to what extent he moved to seize the opportunity from his position as regent. Philip has sometimes been known as *le fortuné*, the Lucky.

The early reign of Philip VI risks being seen retrospectively through the lens of the Hundred Year's War and Philip's struggles with Edward III of England. Yet Philip's reign, which began with his appointment as regent and accession to the throne through application of Salic law, was initially accepted by Edward III.[46] The first decade of Philip's rule, from 1328 to the beginning of hostilities with England in 1337, was characterized by lavish displays—performances of kingship as demonstrations of his legitimacy to rule.[47] Philip's patronage of Bourgfontaine—in precisely this decade—should be viewed as part of this royal performance.

BLANCHE OF NAVARRE

Blanche of Navarre—Philip's second wife—was not even born when Bourgfontaine was founded, but she, too, had an important role to play in supporting Bourgfontaine.[48] In 1396, she established elaborate funerary Masses for herself at the four mendicant churches in Paris and Bourgfontaine. In each church, twelve candles were to burn during the vigil and the Mass, placed in the choir around a "representation of her body," according to her will. She also gave

42. See S. J. White, "The *Laudatio Parentum* in Northern France in the Eleventh and Twelfth Centuries: Some Unanswered Questions," *American Historical Association Proceedings* (1977), 1–28, esp. 14–16, and "*Pactum … Legem Vincit et Amor Judicium*, the Settlement of Disputes by Compromise in Eleventh-Century Western France," *American Journal of Legal History*, 22 (1978), 281–308, esp. 305–307.

43. J. Viard, "Philippe de Valois avant son avènement au trône," *Bibliothèque de l'École des chartes*, 91 (1930), 307–325, esp. 311. It is to be regretted that Viard never published a biography of Philip VI on whom many of his publications focused.

44. Paris, Arch. nat., JJ 67, n° 2. The written sources are ambiguous on this issue. Bourgfontaine was founded in the Valois comital land. The text suggests that Charles had not quitclaimed the buildings he had built or begun at the time of his death, though one must assume that was his intention. Philip VI finished the building campaigns of his father and officially gave the ensemble to the Carthusian community living there. He also required future counts of Valois to be responsible for maintenance and repairs.

45. Inserting oneself into an existing earthly/spiritual relationship was a venerable practice. Abbot Suger introduced himself into a reciprocal relationship between the Charles the Bald and Saint Denis when he revived and reconstituted memorial observances for the king. See C. Maines, "Good Works, Social Ties and Hope for Salvation," in P. Gerson, ed., *Abbot Suger and Saint-Denis* (New York, 1986), 76–94, esp. 84 and 85, n° 3.

46. R. J. Knecht, *The Valois* (as in note 18), 1–2.

47. See L. Pressouyre, ed., *Le dévoilement de la couleur, Relevés et copies de peintures murales du Moyen Âge et de la Renaissance*, catalogue de l'exposition, Paris, Conciergerie, 15 décembre 2004–28 février 2005 (Paris, 2004), 114–117, esp. 114.

48. On Blanche, see L. Delisle, "Testament de Blanche de Navarre, reine de France," *Mémoires de la Société de l'Histoire de Paris et de l'Île de France*, XII (1886), 1–64. See also M. Keane, "Most Beautiful and Next Best: Value in the 'Testament de Blanche de Navarre, reine de France,'" *Journal of Medieval History* 34 (2008), 360–373. We are grateful to Professor Keane for sharing her study, "Memory and Identity in the Chapel of Blanche of Navarre at Saint-Denis," which will appear in

pittances to Bourgfontaine and the other churches to establish Masses for her soul on the anniversary of her death.

Further, the monks of Bourgfontaine approached Blanche independently to propose a daily Mass during the rest of her life and, each year after her death, a requiem for her soul and the soul of her husband Philip VI, which proposal she accepted.[49] In exchange for the services, the monks received forty *livres parisiens* of annual rent. This exchange makes clear that funerary patronage could be a two-way street, one along which a religious community might actively solicit benefits for their house in exchange for services rendered.

THE ROLE OF THE POPE AND THE CARTHUSIANS IN THE FOUNDATION OF BOURGFONTAINE

The decision by Charles, Mahaut, and Philip to found a Carthusian house, and to establish it within their own Valois county, signaled an important ideological choice. In their combination of communal and eremetic traditions of monasticism, and by their rejection of the wealth that characterized other "successful" reform orders, medieval charterhouses became especially popular with the high nobility in the fourteenth century.[50] The burial and gift choices made by the Valois partly reflect this general popularity, but they also seem to reflect a specific attempt to align the Valois and other cadet branches of the Capetian family with the patronage of their sainted ancestor, Louis IX. As we shall see, that pattern can be ex-tended to the foundation of Bourgfontaine itself as we turn to the role of the Carthusians in supporting the new charterhouse.

The conceptual model for the Valois in their patronage of a charterhouse was the example of Vauvert, the Carthusian house in Paris.[51] Founded by Charles' sainted grandfather, Louis IX, Carthusians entered the Château de Vauvert in 1257. Construction of eight cells began in 1270, but was interrupted by the death of the founder on crusade. Construction recommenced in 1276 and must have expanded in 1291 when Jeanne of Châtillon (wife of Louis' son Pierre of France) established funds for fourteen more monks. The church at Vauvert was consecrated only in 1325, making it a near contemporary with the church at Bourgfontaine.

The establishment of a new charterhouse at Bourgfontaine, only 60 kilometers outside Paris, and at the same time as Saint Louis' house was nearing completion, can only have resonated among the high nobility in France as an extension of patterns of Capetian patronage both familial, and later, royal. The relationship between these two charterhouses was confirmed in 1330 when Philip VI took both Vauvert and Bourgfontaine under his special protection.[52]

In his study of Benedictine monastic patronage in England, Luxford distinguishes usefully between "internal" and "external" patrons. Luxford, however, uses the term "internal" to refer to financial patronage that was made possible through a relaxation of official strictures concerning monastic ownership of private property.[53] At Bourgfontaine, it seems likely

Citation, Intertextuality, and Memory in the Middle Ages, ed. Y. Plumley and G. de Bacco (Exeter, forthcoming). Her book on Blanche of Navarre, when it appears, will greatly expand our understanding of the queen's patronage.

49. L. Delisle, "Testament de Blanche de Navarre" (as in note 48), 7.

50. According to J.-P. Aniel, *Les maisons de chartreux* (as in note 19), 46, "… l'ordre atteignit au xivᵉ siècle son point culminant." During this century, growth was three times greater than during the thirteenth century, a rate that doubled the total number of charterhouses. The majority of these houses was founded by the high nobility (J.-P. Aniel, *Les maisons de chartreux*, 47). See also E. M. Hallam, "Aspects of the Monastic Patronage of the English and French Royal Houses, *c.* 1130–1270," 2 vols., (University of London, Ph.D. diss., 1976), 336–337, and Appendices I and II (377–384). Less wealthy lay patrons could found individual cells, often leading to a form of corporate patronage for the order. See K. Stöber, *Late Medieval Monasteries* (as in note 4), 13 and 26–28.

51. On the construction chronology of Vauvert, see *La Chartreuse de Paris, Catalogue de l'exposition tenu au Musée Carnavalet, 12 mai–9 août, 1987*, ed. J.-P. Willesme (Paris, 1987), 14 and 23–26, and P. Delaphon, "La chartreuse de Paris," in *Un jardin de chartreux* (Grenoble, 2004), 8–21, esp. 12.

52. *La Chartreuse de Paris* (as in note 51), p. 14, and for Bourgfontaine, Paris, Arch. nat. JJ 66, n° 392. Nine years later, in 1339, Philip VI also took Bourgfontaine under his "sauvegarde" (Arch. nat. JJ 71, n° 143), a term clearly similar to "protection," but evidently nuanced in some way. On monastic protection in thirteenth-century England, see Wood, *English Monasteries* (as in note 4), 136–160.

53. See also J. M. Luxford, *Art and Architecture* (as in note 4), xx–xxii and 36.

that Carthusians did indeed play an active, "internal" role in the process of establishing the new charterhouse. There, however, we see non-financial forms of patronage that may also contribute to the establishment of a new religious house, such as freedom from episcopal control.

Charles of Valois certainly knew Vauvert's prior, Eustache, well before his decision to found a Carthusian house. Charles had residences in Paris and surely was aware of his grandfather's foundation at Vauvert to which, as mentioned above, Charles had given gifts. Whether Charles sought out Prior Eustache for advice about founding a charterhouse, whether the impulse came from Mahaut, or whether Eustache approached him with the idea we cannot know. That Eustache played a critical role is, however, clear. Eustache evidently served as Charles' emissary to the general chapter during the foundation process in 1323.[54] Once the new foundation was agreed to by

the prior-general, the latter sought papal privileges that enhanced the value of Charles of Valois' initial gift.[55] The order thus also actively supported the new foundation. A letter dated to 1 February 1324, from pope Jean XXII to Aymes, the prior-general of the Carthusian order, requested that the order send four monks from another charterhouse from among whom Charles of Valois was to choose a prior.[56] Those four came from nearby Vauvert in Paris. Charles asked Aymes to name Eustache as his first prior. Eustache was one of the original four, and he thus abandoned his priorship in Paris.[57]

Furthermore, the Pope also granted privileges to Bourgfontaine, freeing them from episcopal control and placing the new house under direct papal protection. A letter of pope John XXII dated 12 September 1323, makes mention of the establishment of Bourgfontaine.[58] Other letters from the same pope exempt the monks from traveling to councils and from paying

54. Paris, Arch. nat. J 164 B, n° 45. See F. Billotey "La Chartreuse" (1948) (as in note 13), 167 and M.-P. Leignel, "La Chartreuse" (as in note 15), 165, "… comme nostre amei le prieur de Vaulvert de lez Paris nouz ha raportei en nostre dit chapystre."

55. G. Mollat, Jean XXII (1316–1334), *Lettres communes analysées d'après les registres dits d'Avignon et du Vatican*, 16 vols. (Paris, 1904–1929): 5 (1909), letters n° 18959 and 18961 (1 Feb. 1324), "N. v. Carolo regis Franciae filio, comite Valesii, supplicante, conc. prioribus et fratribus ord. Cartusien., qui pro tempore fuerint in monast. domus fontis Dominae nostrae, dicti ord., Suessionen. di., ab ipso constructo et dotato, ut ad quod cumque concilium auct. ordinaria celebrandum ire minime teneatur," and "Praefato comite supplic., indulgetur priori et fratribus qui pro tempore fuerint in jamdicto monast., ut de bonis suis alicui decimam solvere minime teneantur," respectively; letter n° 18962 (1 Feb. 1324), "Eodem comite supplicante, dictum monast., prior ejusque fratres recipiuntur sub b. Petri et S. A. protectione, ac eximuntur a jurisdictione ep.i Suessionen. et a metropolitano loci;" letter n° 18963 (1 Feb. 1324), "Eod. supplicante, conc. priori et fratribus praefati monast. ut omnibus privilegiis, quibus alia monast. ejusd. ord. gaudent, gaudere valeant."

56. G. Mollat, *Jean XXII, Lettres communes* (as in note 55), letter n° 18960, "Priori generali ord. Cartusiensis mand. ut unum fratrem dicto ord., quem praedictus comes expedientem esse crediderit, pro priore monast. supradicti cum tribus aliis fratribus deputet in eod. monasterio."

57. Dom C. Le Couteulx, *Annales ordinis cartusiensis ab anno 1084 ad annum 1499* (Montreuil-sur-Mer, v, 1890).

58. G. Mollat, *Jean XXII, Lettres communes* (as in note 55),

letter n° 18224, "Ep.us Silvanecten., et s. Germani de Pratis Parisien., ac s. Dionysii, Parisien. Di., monast. abbates dantur ut judices conservatores ad quinquennium priori et fratribus monasterii sub vocabulo domus fontis nostrae Dominae, Cartusien. Ord., Suessionen. Di., a n. v. Carolo nato cl. me. Philippi Regis Franciae, comite Valesii, fundati et dotati." See also the discussion in F. Billotey, "La Chartreuse" (1948) (as in note 13), 19. On the reign of Jean XXII, see G. Mollat, *Les Papes d'Avignon*, 9th ed. (Paris, 1949); and Y. Renouard, *The Avignon Papacy, 1305–1403*, trans. D. Bethell (London, 1970). This is followed by two letters of Jean XXII dated to 19 July 1324, that reflect some of the financial negotiations involving Charles de Valois that were intended to support the new charterhouse. Mollat, *Jean XXII, Lettres communes* (as in note 55), letters n° 19939 and 19940, "Mag. et fratribus hospitalis s. Joannis Jerosolimitani licentia stipulandi contractum per quem ipsi, loco pensionis vitalitiae 1200 l. t. Carolo Regis Franciae filio, comiti Valesii, et Mathildi, consorti ejus, debitae, assignare debent 600 lib. similes pensionis annuae et perp. per dictum comitem monasterio Fontis Dominae nostrae Cartusien. Ord., Suessionen. Di., ab ipso fundato, applicandas," and "Abb. monast. s. Genovesae Parisien., et Jacobo de Provino fratri hospitalis s. Joannis Jerosolimitani, ac Guillelmo de Noa mil. mand. ut complere faciant contractum, licentia per P. P. jam concessa, iniendum, per quem mag. et fratres hospitalis s. Joannis Jerosolimitani assignare debent Carolo comiti Valesii et Mathildi [*sic*] consorti ejus praedictas 600 libr. tur. parvorum renduales in perp. super certis bonis dicti hospitalis in regno Franciae consistentibus," respectively. See also F. Billotey, "La chartreuse" (1948) (as in note 13), pièce justicative n° 2, extracts from Paris,

tithes, presumably to free more funds to aid the new foundation.[59] These letters remove the charterhouse from the jurisdiction of the bishop of Soissons to place it under papal protection,[60] and extend to Bourgfontaine privileges given to other houses of the Carthusian order.[61] This sequence of events demonstrates the reciprocal nature of secular and ecclesiastical patronage in the establishment of Bourgfontaine.

While prior, Eustache used his position to form a network of spiritual associations with a number of other Carthusian houses in the greater region, among them Liget (1327), Vauvert (1330), and Val Saint-Pierre (1331), as well as the nearby Praemonstratensian abbey of Valséry (1340).[62] The monks of the Carthusian house in Cahors encountered difficulties with the Hospitalers, as a result of which the general chapter asked Eustache to take that house under the prior's protection by reason of his relationship with the king.[63] Philip honored his relationship with the prior and aided the larger network of monastic houses (Fig. 4). Eustache served as Bourgfontaine's prior until about 1340 when he was finally allowed to give up his post. He died in 1354, probably in his early seventies.[64]

The events surrounding the establishment of Bourgfontaine and the formation of a larger associa-

tion of monastic houses make clear that neither the Carthusian order, nor the papacy, were passive recipients of Valois generosity. In important ways, they played key roles in moving the Valois proposal to reality. We cannot tell, however, what the Carthusian role was at the initiation of the idea. We can see, in at least one case, where the charterhouse brought pressure to bear on their royal patron. In June of 1328, during Philip VI's first visit to Bourgfontaine as king, members of his entourage passed through the claustral ranges to engage in games in the great cloister, causing considerable concern among the monks.[65] Subsequently, Philip VI ordered that no one was to be received or lodged in the charterhouse proper except himself.[66]

BOURGFONTAINE AND CARTHUSIAN PLANNING

Carthusian monasteries generally followed a strikingly standardized plan.[67] The layout of buildings at the charterhouse of Bourgfontaine was, in most respects, typical for the order and, by the fourteenth century, would have been recognizable to churchmen and laypeople alike (see Fig. 2). The church and monastic buildings closed the north side of the great cloister, which was otherwise surrounded by the indi-

Archives nationales, κ 41, n° 26, and her discussion on p. 20. For a reconfirmation of this arrangement received from the same pope four years later by the count's widow, Mahaut, see Mollat, *Jean XXII, Lettres communes* (as in note 55), letter n° 40982.

59. G. Mollat, *Jean XXII, Lettres communes* (as in note 55), letters n° 18959 and 18961 (1 Feb. 1324), "N. v. Carolo regis Franciae filio, comite Valesii, supplicante, conc. prioribus et fratribus ord. Cartusien., qui pro tempore fuerint in monast. domus fontis Dominae nostrae, dicti ord., Suessionen. di., ab ipso constructo et dotato, ut ad quod cumque concilium auct. ordinaria celebrandum ire minime teneatur," and "Praefato comite supplic., indulgetur priori et fratribus qui pro tempore fuerint in jamdicto monast., ut de bonis suis alicui decimam solvere minime teneantur," respectively.

60. G. Mollat, *Jean XXII, Lettres communes* (as in note 55), letter n° 18962 (1 Feb. 1324), "Eodem comite supplicante, dictum monast., prior ejusque fratres recipiuntur sub b. Petri et S. A. protectione, ac eximuntur a jurisdictione ep.i Suessionen. et a metropolitano loci."

61. G. Mollat, *Jean XXII, Lettres communes* (as in note 55), letter n° 18963 (1 Feb. 1324), "Eod. supplicante, conc. priori

et fratribus praefati monast. ut omnibus privilegiis, quibus alia monast. ejusd. ord. gaudent, gaudere valeant."

62. L. Marchand, *Essai historique* (as in note 14), 20–21, and F. Billotey, "La Chartreuse" (1948) (as in note 13), 33 and n. 1.

63. L. Marchand, *Essai historique* (as in note 14), 21, and F. Billotey, "La Chartreuse" (1948) (as in note 13), 34.

64. Prior Eustache had a remarkable career. Entering Vauvert during the decade of the 1290s, he became its prior in 1300, probably while in his early twenties. Twelve years later, Eustache became a *définiteur* of the general chapter of the order. During his priorship, several monks of Vauvert became priors at other Charterhouses, both circumstances that reflect the esteem with which other religious regarded the prior. On Eustache's career, see, F. Billotey, "La Chartreuse" (1948) (as in note 13), 27–29.

65. Paris, Arch. nat. JJ 65 A, n° 106 and F. Billotey, "La Chartreuse" (1948) (as in note 13), 30–31.

66. Paris, Arch. nat. JJ 65 A, n° 106 and C. Carlier, *Histoire* (as in note 11), p. 230, cited in F. Billotey, "La Chartreuse" (1948) (as in note 13), 31.

67. J.-P. Aniel, *Maisons des chartreux* (as in note 19), 54–64.

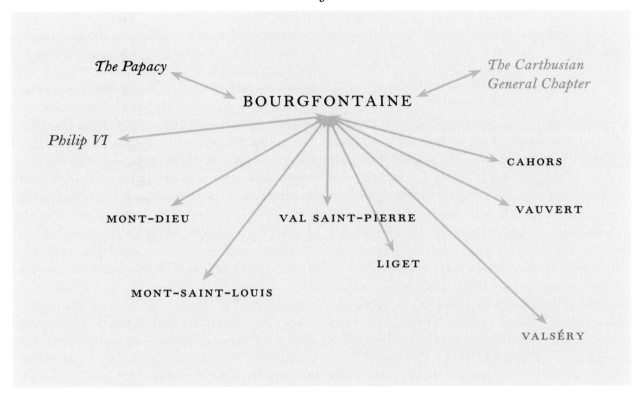

FIGURE 4. Schema of Bourgfontaine's network of spiritual associations (image: authors).

vidual cells and gardens of the monks. A smaller cloister flanked the south side of the church and projected into the greater one. Beyond the church and monastic buildings, to the north, stood the outer court. This contained a guest chapel, as well as domestic and functional buildings of the lay brothers and the home farm. The guest chapel retains an inscribed date of 1480, indicating that the construction chronology of the site as a whole extended well beyond the early fourteenth century.[68] The outer court also contained residential buildings belonging to the Valois counts. What survives today is much modified. The fortified gate, guest chapel, and an adjacent building survive from the later medieval period. The Valois residential buildings are probably fourteenth century in their foundations, but they were reworked in the seventeenth century, and

heavily restored in the nineteenth.[69] The ensemble of the outer court remains essentially unstudied and merits further investigation.

Despite the standardization of Carthusian plans, two features of the layout of Bourgfontaine are exceptional among other charterhouses of the Middle Ages. First, early construction on the site apparently included a residence for Charles of Valois and service buildings for him and his retinue. That these buildings were completed early is evident from a *vidimus* made by Philip VI in May of 1329.[70] Second, the central facet of the polygonal apse was opened after construction to connect a retro-choir to the church itself. This structure is now completely destroyed and has never been discussed in the literature on the charterhouse, but can be seen in an anonymous, early modern

68. There may have been an earlier chapel in the same location. M. Plouvier and C. Riboulleaux, "Deux Chartreuses" (as in note 19), p. 6, date the existing chapel to the beginning of the sixteenth century on the basis of style.

69. M. Plouvier and C. Riboulleaux, "Deux chartreuses" (as in note 19), 7.

70. Paris, Arch. nat., JJ 67 n° 2. See also A. Moreau-Neret, "Philippe VI" (as in note 40), 155. Moreau-Neret was working from the Inventaire des registres n°s 3.367–3.372 in the Archives nationales in Paris. He does not give a specific citation for the act, though he clearly had the document before him.

cavalier view, in radar imaging, and in the remains of its portal attached to the chevet of the church (see Figs. 9–12).

Although largely unnoticed in Carthusian scholarship, the church at Bourfontaine still stands, complete in plan and with its walls remarkably preserved nearly to their full height (Fig. 5). Like most Carthusian churches, it is a modest building, only 40 meters in length (Fig. 6). It is a single-vesselled building, originally covered by a wooden roof, and terminating in a three-faceted polygonal apse. Doors opened into the church from the west, north, and south sides.[71]

Construction of the church appears to have occurred in a single campaign. The coursing is homogenous; although there have been extensive repairs, as well as medieval, early modern, and contemporary alterations to its coursing.[72]

Attached at its north side is a three-storey tower accessible from the church (Fig. 7). Integral with the church in its masonry coursing, this tower is situated near the church's east end. The upper storeys of the tower are accessible from the interior by an integral stair turret at the tower's southwestern corner where it joins the church (see Fig. 6). Nearly square in plan, and measuring 8 by 8.5 meters on the exterior, the tower is composed of three superimposed rooms, the lowest of which is vaulted, the upper two not. The decorative forms (keystone, rib profiles, consoles) are all commensurate with first half of the fourteenth-century work. Recent restoration of the room, carried out for the owners of the site, revealed tiles *in situ*. While they may have been reset in a later floor, the tiles are commensurate with fourteenth-century tiles from the region. Open to the church, it seems likely that the ground floor of the tower (accessible by a stair turret from the residential rooms above) allowed Charles, and later his son Philip, to witness services in the sanctuary.[73] This tower had few parallels in Carthusian architecture at the time of its construction.[74]

Written sources from the fourteenth century make clear that Charles of Valois built a residence at "his" monastery. The sources also suggest that his son Philip VI "brought to perfection" the residence begun by his father.[75] Following his father's death, Philip visited the charterhouse for periods of time and, while there, sometimes conducted royal business having nothing to do with the charterhouse itself.

Almost certainly, the tower attached to the church,

71. The door on the north side was presumably opened later to provide access to the funerary chapels visible in the cavalier view on the north side of the church. Similar chapels and access appear on the plans of the church at Vauvert.

72. M. Plouvier and C. Riboulleaux, "Deux chartreuses" (as in note 19), 10. The façade has been altered in the late-seventeenth/early-eighteenth century but certainly not "rebuilt," since the coursing runs through from the sides onto the façade. Rather, examination of the thickness of the façade wall indicates that much of the decoration represents a "carving back" of the fourteenth-century wall, and in some areas, later projecting sculptures have been slotted in.

73. Martène and Durand, *Voyage littéraire de deux religieux benedictins* (Paris, 1724), 7. Speaking of Charles and Philip VI, they wrote, *Ils alloient à couvert de leur palais dans l'église, pour y assister aux offices divins dans une tribune, d'où ils admiroient la modestie des religieux sans être vûs...* It seems evident that the Valois could view Mass from a space accessed from their residence. It is strange to speak of a ground floor space as a tribune, but there is no evidence of any reworking of the church-side wall of the tower above this space. Further, the space is accessed from the church today by a single step, but we have no secure

information about circulation levels in the church, which may have been several steps lower. In the end, we are prepared to accept the use of the term tribune for this space because we find no alternative.

74. The charterhouse at Trisulti had, from its foundation in the early thirteenth century, a building known as the palace of Innocent III. This building was adjacent to the church and opened to it on the ground floor. See A. Taglienti, *La certosa di Trisulti* (Casamari, 1979), and J.-P. Aniel, *Maisons des chartreux* (as in note 19), 63. Residential structures adjacent to Carthusian churches are also known at the Certosa di Firenze, founded in 1342, and the Chartreuse de Champmol, founded in 1383, but both date well after the tower at Bourgfontaine. According to texts, Béatrix de la Tour du Pin had a residence built adjacent to the church—from which she could view the offices without being seen—at the charterhouse of Sainte-Croix-en-Jarez, which was founded in 1281; see J.-P. Aniel, *Maisons des chartreux*, 63; A. Vachez, *La chartreuse de Sainte-Croix-en-Jarez* (Lyons, 1904); and J. Combe, *La chartreuse de Sainte-Croix-en-Jarez* (Saint-Etienne, 1959).

75. Paris, Arch. nat., JJ 65 A, and F. Billotey, "La Chartreuse" (1948) (as in note 13), 29.

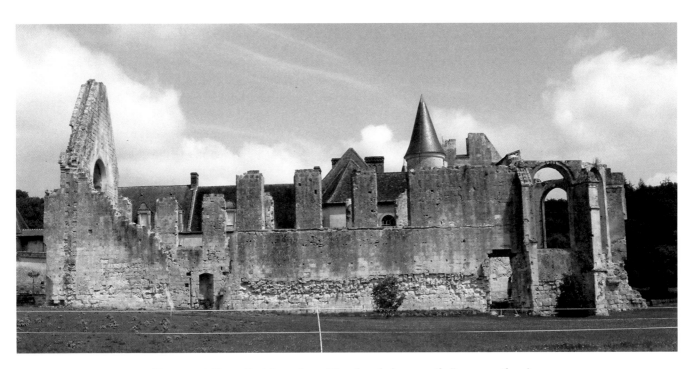

FIGURE 5. Bourgfontaine, view of the church from south (image: authors).

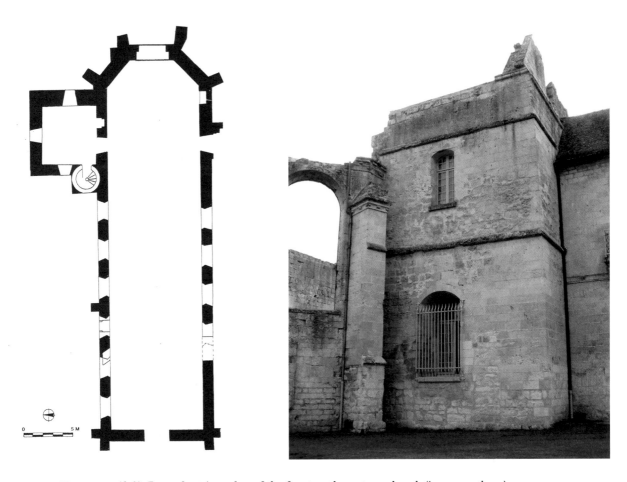

FIGURE 6 (*left*). Bourgfontaine, plan of the fourteenth-century church (image: authors).

FIGURE 7 (*right*). Bourgfontaine, 'Tour Valois,' view of the exterior from the east (image: authors).

which we would call the Tour Valois, formed part of the royal residential complex of the founder-patrons of the monastery. These buildings, together with the functional buildings in the outer court (stables, etc.) used by the king and his entourage, were all built within the larger walled enclosure of the charterhouse, bringing the residential complex into close alignment with contemporary fortified residences.[76] It is as if the monastery proper, or at least its church, served as the chapel of the residence.

A royal palace is typically defined architecturally as a hall with private rooms and a chapel. Considering a palace functionally, as a place where the king resides and where he conducts royal affairs, allows us to see the Valois residence at the charterhouse as part of this building type. Identifying the surviving tower as a part of a fourteenth-century comital/royal fortified palace-residence adds to our knowledge of Valois patronage and royal practice.

PATTERNS OF VALOIS BURIAL

The charterhouse at Bourgfontaine also held a commemorative function. Our understanding of Valois patronage is enhanced by an examination of patterns of family burial. One of the gifts bestowed by royal patrons on their religious foundations was often their own body, or a body part, for burial at the house.[77] When Charles of Valois died in December, 1325, at Nogent-le-Roi, he had already sought and gained permission for the 'dispersal' of his body parts. A letter from Pope Clement V to Charles of Valois dated 8 April 1312, gave Charles the privilege of dividing his body after death among several (unidentified) churches.[78] According to his wishes, his body was buried in the Dominican Church on the rue Saint-Jacques in Paris and his heart in the Franciscan House in the same city.[79] We suspect that neither his body, nor his heart or his entrails, was buried at Bourgfontaine because the church was not yet completed when he was on his deathbed.[80]

It is important to point out, however, that lay, or even non-Carthusian, burial posed a potential problem for a Carthusian house, as it did for houses of other reform orders.[81] The twelfth-century Carthusian customs explicitly forbid burial of non-Carthusians in Carthusian cemeteries, and this stricture was initially understood as including burial within their churches.[82] Nevertheless, the community at Bourg-

76. See É. Sirot, *Noble et forte maison: L'habitat seigneurial dans les campagnes médiévales, du milieu du XII^e au début du XVI^e siècle* (Paris, 2007); and, for regional parallels, J. Mesqui, *Île-de-France gothique, II, Les demeures seigneuriales* (Paris, 1988).

77. On heart tombs, see X. Dectot, "Les tombeaux des comtes de Champagne (1151–1284), Un manifeste politique," *Bulletin monumental*, 162/1 (Paris, 2004); X. Dectot, *Pierres tombales médiévales, Sculptures de l'au-delà* (n.p., 2006); A. Erlande-Brandenburg, *Le roi est mort, étude sur les funérailles, les sépultures et les tombeaux des rois de France jusqu'à la fin du XIII^e siècle*, Bibliothèque de la Société française d'archéologie, 7 (Geneva, 1975); A. Erlande-Brandenburg, "La priorale Saint-Louis de Poissy," *Bulletin monumental*, 129/2 (1971), 85–112; and A. McGee Morganstern, *Gothic Tombs of Kinship in France, the Low Countries and England* (University Park, Pa., 2000). On heart burials, see C. A. Bradford, *Heart Burial* (London, 1933); D. Westerhof, *Death and the Noble Body in Medieval England* (Woodbridge, 2008); and Hallam, "Aspects of the Monastic Patronage" (as in note 50), chap. VI, section 5, 309–310, on "Mausolea as memorials." According to Hallam, the practice may have originated in Germany during the eleventh century and had become widespread in Europe by the twelfth and thirteenth. In 1299, Pope Boniface VIII forbade mutilation of the dead, although the rule quickly became relaxed and licenses

for separate burial of hearts became a source of papal revenue (Hallam, "Aspects of the Monastic Patronage," 310).

78. J. Petit, *Charles de Valois* (as in note 17), 386: "Cum itaque sicut asseris, certa consideratione pie tue voluntatis inductus, corpus tum postquam fueris rebus humanis exemptus in diversis ecclesiis ad quas devotionem te gerere asseris specialem desideres sepeliri, tuis devotis precibus inclinati, auctoritate tibi presentium indulgemus ut hujusmodi corpus tuum, postquam diem claudere te continget extremum, dividi et sepeliri valeat prout in testamento tuo duxeris ordinandum, constitutione felicis recordationis Bonifacii pape VIII predecessoris nostris hoc specialiter prohibente et qualibet alia in contrarium edita non obstante." The original document is Arch. nat., L 295, n° 39.

79. Paris, Arch. nat. J 164 B, n° 54. According to his testament, Charles wanted his body to be buried between the tombs of his first two wives, his heart where his third wife chose to be buried and his entrails in the Cistercian abbey nearest to where he died. See J. Petit, *Charles de Valois* (as in note 17), 219.

80. Wooden chapels were quite common in the early stages of monastic establishment.

81. Guigo I, *Consuetudines Carusiae/Coutumes de Chartreuse*, ed., dom M. Laporte, *Sources chrétiennes*, 313 (Paris, 1984), 14: 1–4.

82. On burial in Carthusian houses, see recently J. M. Lux-

fontaine seems to have made a claim for their founder's body. They were, however, ultimately unsuccessful in this quest.[83]

Philip's disposition of his own remains is revelatory. His body, as a matter of course, was sent to Saint-Denis to be interred with his royal predecessors. His entrails were sent to the Jacobin church where his father's body was buried, but his heart was entombed at Bourgfontaine, perhaps echoing his father's wishes for his own.[84]

Valois patronage, expressed through the choice of burial place, suggests another layer of intention.[85] Both the Dominican church in Paris, and the Franciscan one, were heavily supported by Louis IX.[86] Other members of the house of France were also interred in these churches in the decade before Charles of Valois's death and Philip's accession to the kingship. Robert of France, count of Clermont, lord of Bourbon and brother of Philip III (thus Charles' uncle) ✝1318,[87] as well as Louis of France, count of Évreux and brother of Philip IV (thus Charles' brother), ✝1319,[88] were interred in the Dominican church. Philip of France, count of Poitiers, ✝1316,[89] and Blanche of France, the *infanta* of Castile, ✝1320, were buried in the Franciscan church.[90] Marie of Brabant (✝1321), second wife of Philip III, was also buried there.[91] At the end of the decade, Clémence of Hungary (✝1328), second wife of Louis X, was buried in the Jacobin church.[92]

This same pattern is repeated at the end of the fourteenth century, as witnessed by the testament (1396) of Blanche of Navarre (✝1398).[93] Blanche was engaged to the future John the Good, but was obliged to marry his father Philip VI, who died a year later. She declined all later marriage proposals and was buried at Saint-Denis. She established elaborate funerary Masses for herself at the four mendicant churches in Paris and Bourgfontaine.[94] In each church there were to be twelve candles of six pounds that were to burn during the vigil and the Mass. They were to be placed in the choir around, "*... nostre representacion de nostre corps que on y fera.*" She also gave pittances of sixty francs each to Bourgfontaine, the Cordeliers, and the Jacobins, which appear in the will as a group, and pittances of forty francs to the other two mendicant houses, the Augustinian and Carmelite friars of Paris, all to establish Masses for her soul on the anniversary of her death in each of them.

Finally, Blanche willed to the religious of Bourgfontaine, *un grant ymaige d'argent de Nostre Dame qui tient en sa main un poy de cristal, duquel ist une fleur de liz, et y a dedenz du let Nostre Dame; et ou pié de l'ymaige a de pluseurs reliques.*[95] While we have, as yet, no further information about this gift, it can only have been one of considerable significance.

These burial and gift choices may partly reflect the popularity of the preaching orders and charterhouses. They also seem, however, to reflect an attempt to align the Valois and other cadet branches of the Capetian family with the patronage of their sainted ancestor, Louis IX.

THE HEART CHAPEL OF KING PHILIP VI

Philip VI of Valois followed the example set by his father and continued the practice of their recent

ford, "The Space of the Tomb in Carthusian Consciousness," in *Ritual and Space in the Middle Ages*, ed. F. Andrews, Harlaxton Medieval Studies, xxi (Donington, 2011), 259–281, and S. C. M. Lindquist, *Agency, Visuality and Society at the Chartreuse de Champmol* (Aldershot, 2008), 25–26.

83. "Chronique parisienne anonyme," *Mémoires de la Société de l'histoire de Paris et de l'Île-de-France*, xi (1884), p. 102, cited in Petit, *Charles de Valois* (as in note 17), p. 220, n. 4.

84. J. Adhémar, "Les tombeaux" (as in note 1), i: 138, no. 763.

85. See Stöber, *Late Medieval Monasteries* (as in note 4), 112–146, on the relation between burial practice and benefaction in England.

86. See L. K. Little, "Saint Louis' Involvement with the Friars," *Church History*, 33 (1964), 125–148, esp. 134. For brief re-

marks on the buildings themselves, see M. S. Doquang, "The Lateral Chapels of Notre-Dame in Context," *Gesta* 50 (2011), 137–161, esp. 152.

87. J. Adhémar, "Les tombeaux" (as in note 1), i: 114, n° 618.

88. J. Adhémar, "Les tombeaux" (as in note 1), i: 115, n° 624.

89. J. Adhémar, "Les tombeaux" (as in note 1), i: 113, n° 611.

90. J. Adhémar, "Les tombeaux" (as in note 1), i: 116, n° 630.

91. L. Moreri, *Le grand dictionnaire historique ou le Mélange curieux de l'histoire sacrée et profane*, 10 vols., new ed. (Paris, 1759), ii: 218.

92. J. Adhémar, "Les tombeaux" (as in note 1), i: 123, n° 670.

93. L. Delisle, "Testament" (as in note 48), 7, items 11 and 9, items 20–21.

94. L. Delisle, "Testament" (as in note 48), 7, item 11.

95. L. Delisle, "Testament" (as in note 48), 9, item 21.

Capetian ancestors by willing that his heart be buried separately from his body.[96] While his body went to the "royal mausoleum" at Saint-Denis, his heart was given to the Carthusian monks at Bourgfontaine. For Philip, Bourgfontaine was not only a family foundation but a royal one. Philip's funerary monument at the charterhouse was desecrated in the sixteenth century during the Wars of Religion,[97] though it was clearly not entirely destroyed since Philip's heart tomb is known from an engraving after a drawing in the collection of Roger de Gaignières (Fig. 8).[98] The accompanying text describes it as made of black marble. The remains of the monument seen by Gaignières disappeared during the French Revolution. Further information about the tomb is provided by Carlier, an eighteenth-century historian of the Valois:

> ... *ce coeur, contenu dans une boite de plomb, estoit accompagné d'ornemens sculptés, ciselés et gravés; deux anges d'argent le soutenoient. Plusieurs groupes de chérubins de bronze, d'airain ou de cuivre argenté, décorent l'arcade du sanctuaire sous laquelle cette représentation avoit été placé.*[99]

The location of this tomb is problematic. The text accompanying the Gaignières drawing states that it was situated *in the choir.* Local amateur excavators have searched for remains of the tomb within the church, but no fragments have been found, nor has the considerable footing it would have required. This latter is important because there would have been no reason for revolutionary iconoclasts to have attacked the foundations of the king's heart tomb. There is, however, an alternative location for the tomb.

An early modern cavalier view of the charterhouse

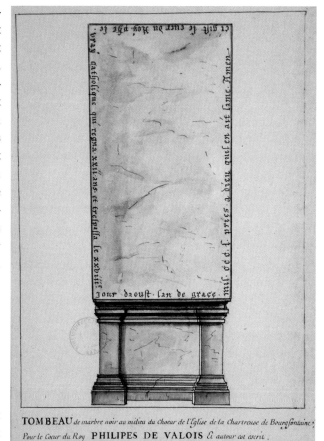

FIGURE 8. Engraving after the Gagnières drawing of the heart tomb of Philip VI (Bibliothèque national de France, Département des manuscrits, Collection Clairambault).

provides important information (Fig. 9).[100] Careful examination of this view reveals a small, presumably three-vesselled structure standing between the apse

96. An area meriting further study is the relationship between body-reliquaries and body-part tombs, especially those of kings. The former are created to be prayed to, while the latter are created to be prayed for. Body-part tombs of kings, however, would seem to occupy an interstitial position, since the king's body is anointed with holy oil. On body parts and reliquaries made for them, see among recent literature, B. Reudenbach, "Visualizing Holy Bodies: Observations on Body-Part Reliquaries," in C. Hourihane, ed., *Romanesque Art & Thought in the Twelfth Century*, Index of Christian Art Occasional Papers, 10 (Princeton, N.J., 2008), 95–106, and the papers in the special issue of *Gesta* 36/1 (1997), ed. C. Bynum and P. Gerson devoted to body parts and body-part reliquaries.

97. L. Marchand, *Essai historique* (as in note 14), 25.
98. J. Adhémar, "Les tombeaux" (as in note 1), II: 139, n° 764.
99. C. Carlier, *Histoire du duché de Valois* (as in note 11), II: 623.
100. A seventeenth-century painted cavalier view of Bourgfontaine was recently discovered at La Grande Chartreuse and has now been restored. All subsequent views of the charterhouse (including the engraving illustrated here) are based on this painting. See, P. Paravy, "Deux cartes du XVIIe siècle de la Province de France sur Seine Bourgfontaine et Bourbon-lez-Gaillon," *Chartreuses, d'Europe, Lettre d'information*, n° 8 (Oct. 2012), 4–13.

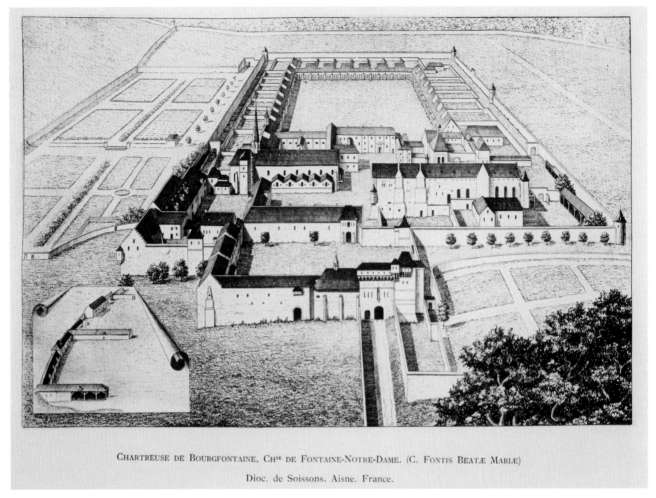

CHARTREUSE DE BOURGFONTAINE, CHᵁᴱ DE FONTAINE-NOTRE-DAME. (C. FONTIS BEATÆ MARIÆ)

Dioc. de Soissons. Aisne. France.

FIGURE 9. Bourgfontaine, seventeenth- or eighteenth-century cavalier view of the Charterhouse (Laon, Archives départementales).

of the church and a gate that allowed entry to the little cloister and evidently attached to both (Fig. 10). The central vessel is represented as raised, and one side-aisle is clearly visible, leading to the inference that the building represented was basilical in section.

Vestiges of this structure survive above ground. Remains of a socle level arcading that formed part of the western wall of the chapel are attached to the apse buttresses of the church, with which they are not integral (Fig. 11). The "hole" in the axial facet of the apse was in fact reworked to accommodate the insertion of a portal leading from the chapel into the church. On each side of the opening, vestiges of capitals carved in soft limestone, now badly abraded by wind and atmospheric pollution, remain *in situ*.

Our remote sensing east of Bourgfontaine's church

FIGURE 10. Bourgfontaine, detail of Fig. 9 showing the church and retro-choir chapel.

FIGURE 11. Bourgfontaine, detail of the apse showing vestiges of the portal (capitals, cornice) linking the retro-choir to the church, and, to the right, vestiges of the dado arcade of the west wall of the retro-choir (image: authors).

in 2006 established evidence for the foundations of a structure approximately fifteen meters square (Fig. 12).[101] The preliminary results of our campaign of radar testing confirm our initial hypothesis about the shape of the building.

Iconographic, physical, and scientific evidence lead us to interpret this small structure as a retro-choir that served to monumentalize the tomb of the heart of Philip VI (Fig. 13). There can be no doubt about the existence of this small building or about its relationship to the church proper. It remains to confirm by excavation the details of the plan of this structure and to locate the foundations of the heart tomb of Philip VI.

The presence of a royal mausoleum at Bourgfontaine has important implications for our understanding of early Valois patronage. Lay burial in houses of the reform orders posed problems for both seculars and monastics as Luxford has recently shown.[102] Over the course of the twelfth century, and more clearly in the thirteenth and early fourteenth, the high nobility found ways to maintain and subvert the impact of

101. It is a pleasure here to acknowledge our colleague, Faycal Rejiba (Université de Paris VI), who carried out the GPR survey.

102. J. M. Luxford, "Space of the Tomb" (as in note 3), 259–281.

FIGURE 12 (*left*). Bourgfontaine, results of the 2006 radar survey revealing evidence for the foundations of the retro-choir chapel (image: Fayçal Rejiba for the authors).

FIGURE 13 (*below*). Bourgfontaine, view of church plan with plan of the presumed retro-choir added (image: authors).

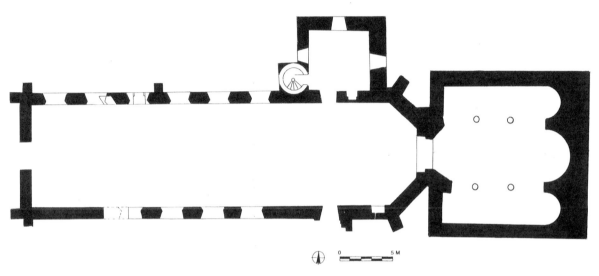

reform. For example, Cistercian statutes were modified to accept noble burials, and elite patronage of that order developed quickly in response.[103] Similarly the Carthusian customs were modified in 1174 to permit intramural burial of prelates and founders.[104] The Charterhouses of Vauvert, London, and Champmol each responded to this legislative change by accommodating elaborate tombs for prelates and founders.[105] Monasteries were especially appropriate places for burial because of their capacity for inter-

cessory prayer.[106] The Carthusians at Bourgfontaine, together with their early Valois patrons, participated in this trend.

THE VALOIS 'DONORS WITH MODEL' WALL PAINTING

A final piece of evidence pertaining to Valois patronage is known from Bourgfontaine. Today, almost nothing survives, apart from traces of several consecration crosses, of the interior decoration of the church

103. See J. Hall, "The Legislative Background to the Burial of Laity and other Patrons in Cistercian Abbeys," in J. Hall and C. Kratzke, eds., *Sepulturae Cistercienses: Burial, Memorial and Patronage in Medieval Cistercian Monasteries*, Cîteaux Commentarii Cistercienses, 56 (Cîteaux, 2005), 363–372.

104. See A. Devaux, *L'architecture dans l'ordre des Chartreux*, 2 vols., Analecta Cartusiana, 146 (Sélignac Charterhouse, 1998–), I: 136–137.

105. Carthusian plans often evolved to incorporate a series of funerary chapels on the side to their churches away from

the great cloister, as at Vauvert, Villeneuve-les-Avignon, and Bourgfontaine. We can thus assert that distinct burial spaces apart from the choir of the church existed at those sites. The problem, of course, is that construction of such chapels remains to be securely dated.

106. Hallam, "Aspects of the Monastic Patronage" (as in note 50), section VII, 326–328: Mausolea form "...a specific example of the patronage interests of kings..." and "...a symbol of their growing interest in burial in the twelfth and thirteenth centuries."

at Bourgfontaine. An unknown painter working for Roger de Gaignières, however, recorded in gouache a wall painting that the artist said was located ... *au dessus de la grande porte de l'Eglise de la Chartreuse de Bourgfontaine...*,[107] which we take to mean that it was located on the inside of the west façade. The caption accompanying the gouache identified the three figures represented as Saint Louis of Toulouse (✝1297, canonized 1317), Charles of Valois, and his son Philip VI.[108] Saint Louis of Toulouse was a member of the House of Anjou, a cadet branch of the Capetians and therefore a family relative of the Valois. Charles Sterling believed this painting was datable to the reign of Philip of Valois and the late Léon Pressouyre seems to have agreed with him.[109] We see no necessary reason to disagree, though we wonder if the wall painting is not part of the project that built the mausoleum to contain Philip VI's heart. If so, this would move the painting into the early years of the reign of Philip's son, Jean the Good.[110]

The image (Fig. 14) shows Charles of Valois kneeling at the center of the composition, wearing a blue cloak covered in golden fleur-de-lys and a bonnet tied beneath his chin.[111] Saint Louis stands to the left of Charles, clad in episcopal costume befitting his rank as bishop of Toulouse.[112] He holds a crozier in his

107. See Pressouyre, *Le dévoilement* (as in note 47), 114–117.

108. Pressouyre, *Le dévoilement* (as in note 47), 115.

109. C. Sterling, *La peinture médiévale à Paris, 1300–1500*, 2 vols. (Paris, 1987–1990), I: 167; Pressouyre, *Le dévoilement* (as in note 47), 116.

110. Two other lost paintings, known to us from copies made for Roger de Gaignières, also represent members of the early Valois family, although there is some disagreement as to whom the figures represent. A panel painting purportedly showing Jeanne of France, either Philip VI or Jean the Good, and Blanche of Navarre once hung in the Chapel of Saint-Hippolytus in the abbey church of Saint-Denis, on which see Sterling, *Peinture médiévale* (as in note 109), I: figs. 119–120 (pp. 204–205). For the commentary, see I: 203–208. The second painting purportedly showing Jean the Good, the Dauphin Charles, and Blanche of Navarre once hung in the Chapel of Saint-Michel in the royal palace on the Île de la Cité in Paris, on which see Sterling, *Peinture médiévale*, I: fig. 87 (p. 166). For the commentary, see I: 167–168. See also Keane, "Memory and Identity" (as in note 48). Taken together with the Bourgfontaine painting, these images provide some insight into how the early Valois represented themselves.

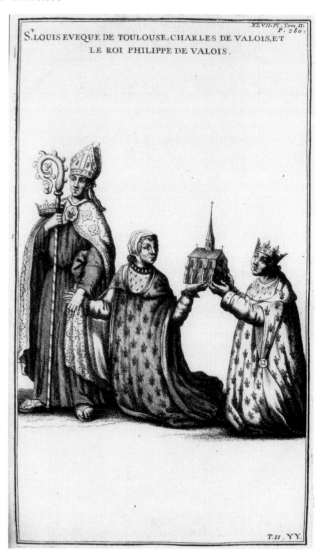

FIGURE 14. Montfaucon's engraving after Gagnières' painting that copies a wall painting showing Charles and Philip of Valois as donors in the presence of Saint Louis of Toulouse.

111. In describing this image, we accept the general goal of accurate reportage that underlies this type of painting; but we recognize that, in the absence any controls, we cannot be absolutely certain of the details and even less sure regarding matters of style.

112. Louis of Toulouse was the second son of Charles II of Anjou, King of Naples, and Maria Arpad, daughter of the king of Hungary. He was also a nephew of Louis IX, the sainted Capetian king. He succeeded to the right of succession when his eldest brother died (1295), but he renounced that right for a religious vocation. On the saint's life and career, see Abbé V. Verlaque, *Saint Louis, prince royal, évêque de Toulouse et la famille d'Anjou au XIIIᵉ siècle, d'après des documents inédits* (Paris, 1885).

right hand on top of which rests a crown. Beneath his cope, which is held by a clasp bearing a golden fleur-de-lis against a blue ground, the saint wears the robes of the Franciscan order, which he insisted on joining before becoming a bishop. We suspect that the fleur-de-lis clasp symbolized his kinship with the Valois family in France. Finally, on the right of Charles, the figure of Philip of Valois appears crowned and clad in a cloak similar to his father's.

Headgear plays a symbolic role in this image. The mitre and the crown, worn by Saint Louis and Philip VI, respectively, are appropriate symbols of the rank of each figure. These contrast sharply with the simple, close-fitting cap of Charles of Valois—with ear flaps ending in strings that allow the cap to be tied beneath the chin worn by the figure.[113] Known as a *cale* or a *coif*, this cap was worn throughout much of the Middle Ages by all classes of society from peasant to noble.[114] As a headcovering, it was informal and practical, serving to keep the head warm and to contain the hair while doing tasks. In this painting, its humble, everyday quality can only serve to contrast with Saint Louis' mitre and Philip's crown, but more importantly with the crown held in the saint's right hand. That crown symbolizes not only Saint Louis' royal parentage but also the kingship that he rejected to enter the church. It was a kingship that Charles of Valois so ardently desired but never attained. The message of the four head coverings would thus seem to be ironic and one that called attention to Charles' unbridled ambition. One is left to wonder whether it was his son, or the Carthusians of Bourgfontaine, who stood behind Charles' new-found humility.

In this donor-image, gesture, gaze, and pose are also used to communicate meaning and, we believe, suggest a larger iconographic context. In the center, Charles holds Saint Louis' left hand in his right, but turns his head to his left to gaze toward his son and

the model of the church at Bourgfontaine, of which he holds the eastern part in his left hand. Philip gazes slightly upward to the left, while he holds the western part of the model church in both his hands. All three figures are shown turned slightly toward the viewer's left.

Given the pose, gaze, and gesture of the three figures, this painting would seem to correspond to a seven-figure "donor-with-model" composition.[115] If true, this would require that both a pendant three-figure composition and a central figure, perhaps in the façade window, did not survive into the early modern period or were not recorded.[116] We think it very likely that the painting was located to the right of the entrance to the church, on the north interior wall (Fig. 15).

In the painting, Philip VI seems to offer the model of the church at Bourgfontaine to his father, symbolizing his completion of Charles' project. Charles receives it, presumably to offer it in turn to the missing central figure. Finally, Saint Louis appears to present Charles of Valois to that (now missing) holy person. The painting thus represented not only a particular act of patronage, but also one that incorporated multiple levels of kinship and support embedded within the act of gift-giving. It is reasonable to suppose that the monks of Bourgfontaine prayed for the souls of both Charles and Philip of Valois in exchange for the gift of their charterhouse. They also prayed to a recently canonized Valois dynastic saint for his intercession.

CONCLUSION

The charterhouse at Bourgfontaine provides an opportunity to examine a remarkable example of early fourteenth-century corporate patronage in which the Carthusian prior Eustache and the community of monks, the general chapter of the Order, and the

113. We are grateful to Lucy Freeman Sandler for challenging us at the Princeton conference to comment more fully on Charles' *cale*.

114. See F. Boucher, with a new chapter by Y. Deslandes, *20,000 Years of Fashion, the History of Costume and Personal Adornment*, expanded ed., translated from the French (New York, 1987), 184 *et passim*.

115. E. Lipsmeyer, "The Donor and his Church Model in Me-

dieval Art from Early Christian Times to the Late Romanesque Period" (unpublished Ph.D. thesis, Rutgers University, 1981).

116. Such a pendant composition might have included Eustache, the first prior of the house, Charles' wife Mahaut, and Saint Bruno, the founder of the order, or perhaps St. Louis IX. The central figure might have been a Virgin Mary, to whom the charterhouse was dedicated.

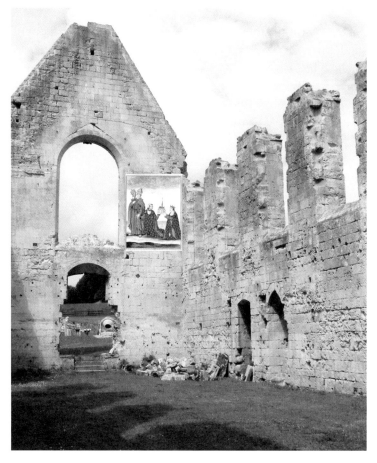

FIGURE 15. Bourgfontaine, view of church interior showing presumed placement of Gagnières'
copy of the wall painting (composite image: authors).

pope collaborated actively with men and women of the Valois family to establish the charterhouse. This collaboration created a network of relationships for the Valois king Philip VI that helped to legitimize his rule by creating links to royal and saintly Capetian predecessors. The larger collaboration also helped to create a network among Carthusian houses (and one non-Carthusian abbey) in the north of France that directly benefitted those houses and the Order.

Valois patronage at Bourgfontaine has left us with what is almost certainly a residential tower for the donor/patron of the monastery, and later with a mau-soleum for a king's heart. These features are exceptional within the tradition of Carthusian architecture, and reveal the ways in which monks of a very austere order accommodated themselves and their site to the benefits and burdens of the highest levels of noble patronage. The bodies of the count and king remained visible when present—and implied when absent—in the royal tower adjacent to the church. The large painting at the interior of the church also reminded the community of their patrons. Even after death, the royal founding patron remained physically present with his heart interred in the retro-chapel.

CLAUDINE LAUTIER

The Canons of Chartres:
Their Patronage and Representation in the
Stained Glass of the Cathedral[1]

HISTORIANS of Chartres Cathedral, and of its stained glass in particular, have not paid sufficient attention to either the role or the representation of canons in its many windows. Instead, they have looked at images of the craft guilds at the bottom of many windows. Scholars studied details of the men at work, assessing their implication in the decoration of the cathedral and their place in the society of Chartres.[2] Using the iconography of the two transept façades and the roses in the choir, research was undertaken on noblemen and royal donations. But the chapter and the bishops were evidently not studied enough, even though they clearly played a major role in the construction and decoration of the church. In fact, as this study will demonstrate, the canons of the cathedral also donated many stained glass windows. There are no less than sixteen donor canons represented in the windows of Chartres Cathedral, and they are shown performing the ecclesiastical functions of praying or celebrating Mass. The names of a few are recorded, and can be identified thanks to the cartulary of the cathedral.[3] Other canons also made donations over the centuries, especially towards funding altars or offering reliquaries and other precious liturgical objects.[4]

THE CANONS OF CHARTRES
CATHEDRAL

In the Middle Ages, Chartres was one of the largest and richest dioceses in France. The chapter of the canons had been founded in the mid-sixth century by Saint Leobinus, a bishop who established the limits of the diocese. From the start, the chapter was extremely large, numbering seventy-two canons, and it stayed that size until the end of the Middle Ages.[5] The chapters of Reims, Paris, and Laon were the only ones with more canons. The chapter of Chartres had seventeen dignitaries: a dean and vice-dean, a cantor and vice-cantor, a chancellor, archdeacons, the provosts, and other administrators. The dean alone was elected by the chapter; the other seventy-one canons were nominated by the bishop with the approval of the chapter. Unlike many cathedral chapters, the minimum number of priests in the canons' college was not defined. But, as was the case elsewhere, priests were a minority, with the balance of canons being deacons or sub-deacons. The canons generally came from the local aristocracy, and rarely from other dioceses. They lived in houses near the cathedral, generally to its north, or near the west façade; the bishop's palace was north-east of the church.

1. I wish to thank Claire-Lise Chevalley, who translated this article. Pascal Montaubin who is presently writing a book on the diocese of Chartres for *Fasti ecclesiae gallicanae: répertoire prosopographique des évêques, dignitaires et chanoines de France de 1200 à 1500*. Brigitte Kurmann-Schwarz for our fruitful discussions about the iconography of Chartres stained glass windows.

2. See the assessment of the literature in Brigitte Kurmann-Schwarz, "Récits, programme, commanditaires, concepteurs, donateurs: publications récentes sur l'iconographie des vitraux de la cathédrale de Chartres," *Bulletin monumental* 154 (1996), 55–71, with further bibliography.

3. The reference book on Chartres stained glass windows was published by Yves Delaporte, *Les vitraux de la cathédrale de Chartres. Histoire et description*, 1 vol. with text and 3 vols. with illustrations (Chartres, 1926).

4. See the many indications on altar funding and donations of precious objects in Claudine Lautier, "Les vitraux de la cathédrale de Chartres. Reliques et images," *Bulletin monumental* 161/1 (2003), 3–96 *et passim*.

5. Louis Amiet, *Essai sur l'organisation du chapitre cathédral de Chartres (du XIᵉ au XVIIIᵉ siècle)* (Chartres, 1922).

At the end of the twelfth century, Chartres was a thriving city, vividly described by the historian André Chédeville.[6] In 1194, the Romanesque cathedral built in the eleventh century was almost totally destroyed by a fire, although the crypt, the choir, and the west façade that was added during the twelfth century were not affected. Reconstruction was immediately undertaken: firstly the nave (as early as 1195), then the choir (around 1210 to 1220),[7] and finally the transept with its clerestory (around 1220 to 1235). Although the canons occupied the choir in 1221, they celebrated Mass under a timber roof for nearly forty years, as the choir was only vaulted shortly before the dedication of the cathedral in 1260, as has been recently proven.[8]

The bishop and the chapter certainly gave part of their income for a prescribed period, as was usual for most cathedral chapters. The wealth of the diocese and the chapter is also evidenced in a number of documents, especially in the cartulary of the cathedral.[9] Lay donations were numerous. The stained glass windows show the donors, like the crafts guilds, mainly in the lower windows, with the noblemen mainly in the clerestory windows.[10] The *Livre des Miracles de Notre Dame*, written in Latin at the beginning of the thirteenth century (translated into French in mid-thirteenth century), describes the fire in the Romanesque cathedral in *Miracle III*, as well as the impetus of the people to reconstruct the cathedral. The Pope's legate admonished the bishop and the chapter to persuade them to start the work immediately. They agreed to give part of their income for three years towards the reconstruction. After that promise, the Chasse

with the relic of the Virgin's veil was taken out of the "cave," or crypt, where it had been safely kept, and was presented with great flourish to the people and the assembly.[11]

The sixteen canons represented in windows at Chartres is quite a significant number when compared to other thirteenth-century stained glass ensembles. Some cathedrals also have images of priests or donor canons. At Auxerre, at the entrance to the central chapel of the ambulatory, clerics are shown offering a window around 1230. On the south side, a certain HVRRICVS is depicted kneeling under the Virgin and Child and offering a window; he is facing a donor priest under a picture of Saint Germain on the north side.[12] In the mid-thirteenth-century ambulatory of Le Mans Cathedral, canon Philippe Romanus can be seen being blessed by Saint Julien, the patron saint of the cathedral (window 108). Guillaume Roland—who was to become bishop at Le Mans in 1256—is featured in window 109, praying at an altar and offering a window. In the choir, other clerics are also represented as donors, such as the abbot of Notre Dame de l'Épine at Evron (window 105), and the abbot of Notre Dame de la Couture at Le Mans (window 207 of the clerestory).[13] In Saint-Vincent's chapel at Beauvais Cathedral, canon Raoul of Senlis, who died in 1393 or 1394, is shown four times at the bottom of the lancets of two windows (around 1290) in the chapel where he is buried.[14] Multiple images of the same donor are unusual in France. With few exceptions, the practice of representing donor-canons in thirteenth-century stained glass is not frequent in French cathedrals.

6. André Chédeville, *Chartres et ses campagnes (XI^e–XIII^e s.)* (Paris, 1973), 411–525.

7. Brigitte Kurmann-Schwarz and Peter Kurmann, *Chartres, la cathédrale* (Paris, 2001), 96–126.

8. Cf. the thematic issue of *Bulletin monumental* 169/1, 2011, 3–40. The renovation of the colored coating in the choir and the heraldic ornaments on the keystones confirmed that the vaults were constructed no earlier than between 1257 and 1260.

9. Eugène de Lépinois and Lucien Merlet, *Cartulaire de Notre-Dame de Chartres*, 3 vols. (Chartres, 1862–1865), I (1862), LXIJ–LXIX and XCVJ–CXIII; Michel Lheure, *Les églises des XI^e et XII^e siècles dans l'archidiaconé du Pincerais* (Ph.D. diss., Université Paris IV-Sorbonne, 1998), I: 140–145 and 187–200.

10. For a different view of the workers depicted at the bottom

of the nave windows, see Jane Welch Williams, *Bread, Wine, & Money: The Windows of the Trades at Chartres Cathedral* (Chicago, Ill.; London, 1993).

11. Jean Le Marchant, *Miracles de Notre-Dame de Chartres*, Pierre Kunstmann, ed. (Ottawa, 1973), 66.

12. *Les vitraux de Bourgogne, Franche-Comté et Rhône-Alpes*, Corpus Vitrearum–France, Recensement des vitraux anciens de la France, II (Paris, 1986), 111–114.

13. Louis Grodecki, "Les vitraux de la cathédrale du Mans," *Congrès archéologique de France*, 119 (1961), 81–95; Catherine Brisac in André Mussat, ed., *La cathédrale du Mans* (Paris, 1981), 113–126.

14. Michael W. Cothren, *Picturing the Celestial City: The Medieval Stained Glass of Beauvais Cathedral* (Princeton, N.J.; Oxford, 2006), 126–135.

Bishops are more frequently shown. Troyes Cathedral has an exceptional window depicting "Pouvoir et hiérarchie ecclésiastique" (window 207). These are not donor figures, strictly speaking, for the window shows the clergy of Troyes, amongst whom is the contemporary bishop Herveus. The clergy faces the representatives of secular power, and thus assert the supremacy of ecclesiastical power. It is obviously a political statement, rather than strictly an image of their gift.[15] Reims Cathedral, where French kings were crowned, was a metropolitan church at the head of a vast ecclesiastical province. Here, the political-ecclesiastical intentions are even more obvious. In the axial window, the archbishop of Reims, Henri of Braine, standing next to a schematic view of his cathedral, is shown below the Virgin and the Crucifixion. In the side windows, suffragant bishops can be seen with an image of their cathedral.[16] In other cathedrals, such as Tours in the mid-thirteenth century, representations of bishops or archbishops are more numerous. The dean of the chapter is the only canon depicted as a donor in the windows. Archbishop Jacques de Guérande is also represented, but the most impressive window over the main altar is the one with eight archbishops and bishops of Tours, who are not identified by inscriptions. They stand in two rows against a grisaille background. The location of the window is highly symbolic.[17] In the apse at Amiens cathedral, bishop Bernard of Abbeville is featured twice in the axial window offering his window to the Virgin and Child under a row of angels carrying crowns. A large inscription glorifies his donation in 1269. He thus proves the prominent role of the bishop in the decoration of this cathedral.[18]

At Chartres, the canons only gave windows in the choir and transept (Fig. 1). Their work dates to the second and third construction campaigns, between 1215 and around 1230–1235. To these should be added later panels (1328), which were inserted at the bottom of a thirteenth-century window in the south transept. Figures of donor-canons can be seen at the lower level in two ambulatory chapels and in the north aisle of the choir. At the higher level in the choir and transept the canons are found at the bottom of lancets and in two rose windows. There are no representations of donor-canons in the nave. They are as close as possible to the presbytery with its three altars: the main altar in the third bay of the choir after the transept crossing, the obit altar in the fourth bay, and the Corps-Saints altar at the far end of the apse, under an elevated platform with several reliquary caskets. Other parts of the treasure of relics were also located in the choir, in lateral cupboards. The Sainte Chasse with the relic of the Virgin's veil, the aim of the pilgrimage, was set in the center of the presbytery, against the main altar.[19]

DONOR-CANONS IN THE LOWER WINDOWS OF THE CATHEDRAL

The axial chapel is decorated with a window showing the life and martyrdom of Saints Simon and Jude (window 1 in the plan shown in Fig. 1),[20] which can be dated to about 1215 to 1220. The donor-canon is featured twice at the bottom of the window, and his name, HENRICVS NOBLET, is written on a banderole. He is mentioned in the obituary of the cathedral, where his memory is celebrated on 27 July. The obituary records that he gave sixty pounds to the cathedral for

15. Sylvie Balcon, in Elizabeth C. Pastan and Sylvie Balcon, *Les vitraux du chœur de la cathédrale de Troyes (XIIIᵉ siècle)*, Corpus Vitrearum–France II (Paris, 2006), 227–230 and 436–444.

16. Meredith Parsons Lillich, *The Gothic Stained Glass of Reims Cathedral* (University Park, Pa., 2011), 61–103.

17. Claude Andrault-Schmitt, *La cathédrale de Tours* (La Crèche, 2010), 173–189.

18. Nathalie Frachon-Gielarek, *Amiens: Les verrières de la cathédrale* (Amiens, 2003), 32–33.

19. About the liturgical elements in the choir, see Claudine Lautier, "The Sacred Topography of Chartres Cathedral: The Reliquary Chasse of the Virgin in the Liturgical Choir and

Stained Glass Decoration," in Evelyn Staudinger Lane, Elizabeth Carson Pastan, and Ellen M. Shortell, eds., *The Four Modes of Seeing: Essays on Medieval Imagery in Honor of Madeline Harrison Caviness* (Farnham, 2009), 174–196.

20. The windows in the cathedral are numbered according to the system shown in Corpus Vitrearum France, *Les vitraux du Centre et des Pays de la Loire*, Corpus Vitrearum France–Recensement des vitraux anciens de la France, II (Paris, 1981), 25–45, and see plan, p. 26. Also see the concordance between the numbering in the French Corpus Vitrearum volumes and Delaporte in Colette Mahnes-Deremble, *Les vitraux narratifs de la cathédrale de Chartres: Étude iconographique*, Corpus Vitrearum France–Études II (Paris, 1993), 296–297.

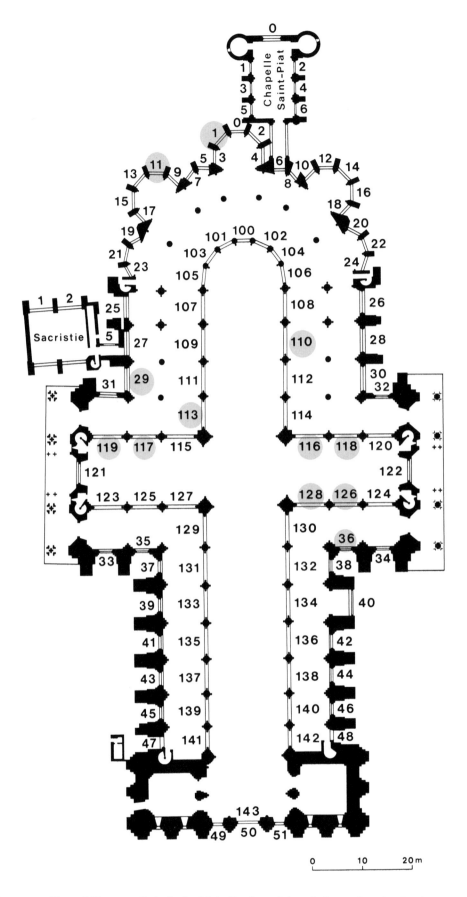

FIGURE 1. Plan of Chartres Cathedral with indication of the windows given by the donor-canons (© Centre André Chastel, Paris; drawing: Chantal Drouard).

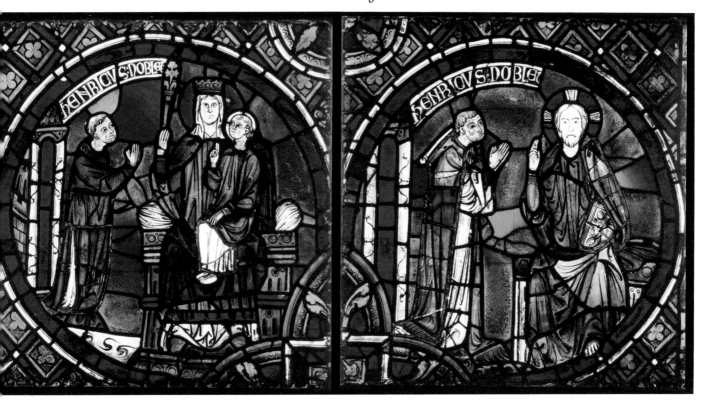

FIGURE 2. Donor Henricus Noblet praying in front of the Virgin and Child and in front of Christ (window 1) (© Centre André Chastel, Paris; photo: Christian Lemzaouda).

the celebration of his anniversary.[21] In the first panel, Henricus Noblet is kneeling in front of the enthroned Virgin and Child in an undefined enclosed space (Fig. 2). A single gate of a church or a city can be seen behind the canon. The donor is wearing an alb covered with a dalmatic, and is thus identified as a deacon or sub-deacon. The Virgin, crowned and bearing a scepter, is seated on a decorated throne; she looks at the viewer, not at the donor. She is not only the mother of Christ, but also of the Church itself. The Christ Child faces the donor and blesses him, thus acting as mediator in the canon's salvation. In the second panel, Henricus Noblet is kneeling in front of Christ enthroned. The donor now wears the cope, which is a more solemn piece of clothing worn at offices and Mass. Christ, like the Virgin in the previous panel,

faces the viewer, and seems to be a judge. He blesses with his right hand and holds the Holy Scriptures in his left hand. In both panels, the thrones on which the Virgin and Child and Christ sit are depicted as altars. In the Middle Ages, the altar was considered Christ's tomb.[22] To be consecrated, it had to hold relics of one or more saints in a cavity inside the upper part of the table. The closeness of these two pictures, one showing the donor in front of the enthroned Virgin and Child, and the other the donor in front of enthroned Christ, is quite exceptional in thirteenth-century stained glass. Both may show what the canon sees in his mind as he prays to the Virgin and Christ, thus suggesting that the viewer do the same.

At the bottom of the window featuring the life and martyrdom of Saint Pantaleon in Saint Stephen's

21. Auguste Molinier, *Obituaires de la province de Sens*, II, *Diocèse de Chartres* (Paris, 1906), 77; *Cartulaire de Notre-Dame* (as in note 9), I (1862), 144. Delaporte, *Vitraux de la cathédrale* (as in note 3), I: 302.

22. Johannes Heinrich Emminghaus, "Altar," in *Lexikon*

des Mittelalters, I (Munich; Zurich, 1980), cols. 461–464. Markus Maisel, *Sepulchrum Domini. Studien zur Ikonographie grossplastischer Grablegungsgruppen am Mittelrhein und im Rheinland* (Mainz, 2002), 56–58.

chapel (window 11 on the plan in Fig. 1), a canon is praying in front of the Virgin and Child (Fig. 3). His name, NICOLAVS LESCINE, is written on a banderole, with a mistake by the glass painter. The donor belonged to the wealthy Lescene or Li Sesne family in the region of Chartres. His name is repeatedly mentioned in the cartulary, where his obit, as well as those of his parents and brother, can be found. He was still alive in 1223 and did transactions for the bishop.[23] The scene takes place in a church, the main arcades of which can be seen in the background. The donor wears an alb, a dalmatic, and a maniple on his left arm. The Virgin and Child are set on an altar covered in white altar cloth with colored fringes, and the statue-like pair are scaled smaller than the donor. Mary is crowned and holds a fruit as the new Eve.[24] She faces the viewer, as in the previous window, while the Child turns toward the donor and blesses him. The Virgin and Child, however, seem alive and play an active role in the canon's prayer. According to Yves Delaporte, this representation of the Virgin and Child is similar to the three-foot-high, gilded silver statue of the Virgin and Child that was found on the main altar. However, we have no drawings or engravings, nor a detailed description of the statue. It was offered by Pierre of Bordeaux, archdeacon of Vendôme, probably in 1220.[25]

In the north aisle of the choir (window 29), there are two single lancets with one oculus (see plan, Fig. 1). The left lancet (29a) features the life of Saint Germain of Auxerre, and the right a miracle of Saint Nicholas against paganism. At the bottom of the left lancet one can see canon Gaufridus Chardonel (identified by an inscribed banderole as GAVFRID[VS] CHARDONE) kneeling and praying in front of the Virgin (Fig. 4). She holds a fruit, while the Child blesses the donor. Gaufridus Chardonel, canon of Chartres cathedral, provost and then archdeacon of Dunois, died in 1236. His anniversary in the obituary of Saint-Saturnin of Chartres is recorded as 21 October, whereas it is listed as 22 October in the obituary of Chartres cathedral. He was one of the most prominent members of the chapter and his name is referenced in many documents between 1220 and 1230.[26] The donor was a priest, as can be seen from his liturgical clothes. He wears an alb, a dalmatic, and a chasuble, and has a maniple on his left arm. He is kneeling and praying in front of the Virgin and Child. She is depicted as a statue within a tabernacle with open doors to be set on an altar. This layout is similar to that of the Virgin of Notre Dame Sous Terre, destroyed during the French Revolution. Though it is not shown in engravings, it is known that the statue was preserved in a tabernacle with doors, which was restored in the fifteenth century, thanks to a donation from king Louis XI.[27] This wooden statue was perhaps carved at the time of bishop Fulbert in the eleventh century.[28] It was set on the altar of a chapel in the crypt, and was very important for services in the cathedral as well as a popular object of pilgrimage. This statue, however, was composed differently than the statue facing Gaufridus. The Virgin of Notre Dame Sous Terre was, in fact, facing the viewer directly, with her two hands holding the Child's hips; she did not hold a fruit

23. *Cartulaire de Notre-Dame* (as in note 9), II (Chartres, 1863), 102–103: in 1223, the name Nicolas Lescene can be found in a letter of bishop Gautier. He made donations for the obits of his brother, Jean, a knight, his mother, Emma de Brodio-Melio, and his father, Rogerius; see the obituary, *Cartulaire de Notre-Dame* (as in note 9), III (Chartres, 1865), 11, 13, 93. His own obit was written on 20 October: Molinier, *Obituaires* (as in note 21), 123. Delaporte, *Vitraux de la cathédrale* (as in note 3) I: 326–327. He was obviously linked to the knighted local aristocracy.

24. Ernst Guldan, *Eva und Maria. Eine Antithese als Bildmotiv* (Graz; Cologne, 1966), 117–118, 124–126. Gertrud Schiller, *Ikonographie der christlichen Kunst*, 4/2 *Maria* (Guttersloh, 1980), 182–183.

25. Yves Delaporte, *Les trois Notre-Dame de la cathédrale de Chartres* (Chartres, 1965), 38–42.

26. Lucien and René Merlet, *Dignitaires de l'église Notre-Dame de Chartres: Listes chronologiques*, Archives du diocèse de Chartres, V (Paris, 1900), 147. Molinier, *Obituaires* (as in note 21), 461. *Cartulaire de Notre-Dame* (as in note 9), III (Chartres 1865), 201. Delaporte, *Vitraux de la cathédrale* (as in note 3), I: 370–371.

27. Delaporte, *Les trois Notre-Dame* (as in note 25), 26.

28. Ilene Forsyth, *The Throne of Wisdom: Wood Sculptures of the Madonna in Romanesque France* (Princeton, N.J., 1972), 106–111. Lautier, "Les vitraux de la cathédrale" (as in note 4), 36–38.

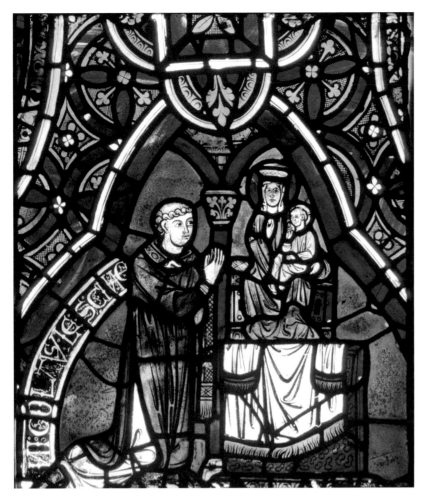

FIGURE 3. Canon Nicolaus Lescene praying in front of the Virgin and Child (window 11) (© Centre André Chastel, Paris; photo: Christian Lemzaouda).

FIGURE 4. Canon Gaufridus Chardonel praying in front of the Virgin and Child (window 29a) (© Centre André Chastel, Paris; photo: Christian Lemzaouda).

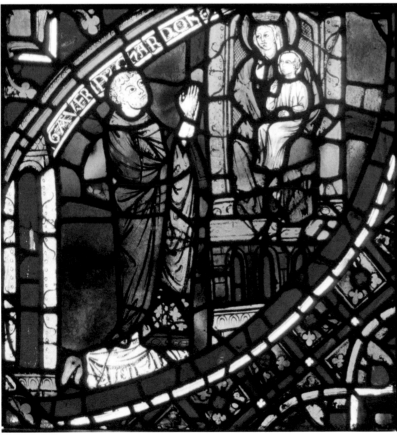

and the Child held a globe.[29] That is why the praying canon might not be in front of the statue of the Virgin of Notre Dame Sous Terre, but rather in front of the statue of the Virgin and Child set on the main altar in the presbytery. In that case, the image would be similar to the one Nicolas Lescene worships. Another hypothesis is that the designers of this window wanted to fuse the image of Notre Dame Sous Terre with the Virgin and Child set on the main altar. Such tabernacles or altarpiece-tabernacles with painted or carved doors or wings, enclosing a Virgin and Child, are rare in France,[30] but are frequently found in thirteenth- and fourteenth-century Italy.[31]

The statue with Gaufridus Chardonel seems to be alive and emerging from the tabernacle. The Virgin is crowned, wears colorful clothes, and probably holds a fruit, as in the window offered by Nicolas Lescene. On her lap, the Child blesses the donor. Unlike the previous images, the Virgin does not face the viewer, but, like the Child, turns toward the canon and seems to listen to his prayers. There is obvious communication between the donor and the Virgin and Child. The donor thus wished to show that the Virgin had listened to him and that he had a special bond with her. Even more clearly than the figure of Henricus Noblet, this scene shows the close bonds between the one who prays and the object of his prayer. The Virgin and Child seem to be alive and listening. Images such as this, in which the object of the prayer seems alive, appeared very early on in Chartres. Images of the same type, but even more explicit, can be seen more often in early fourteenth-century manuscripts, especially in books of Hours, as Jeffrey Hamburger

has shown. He looked at not only German, but also French examples, such as the *Trois Estaz de bonnes ames* or the Psalter-Hours belonging to Bonne of Luxembourg, in which the object of prayer seems to be alive to the point of coming out of the framework to greet the worshipper.[32]

The next lancet in the same window (window 29b on the plan in Fig. 1), showing the miracle of Saint Nicholas during his battle against the worship of Diana, was given by another canon of the same family. A partly erased inscription shows his name— STEPH[ANVS] CARDINALIS DEDIT [H]A[N]C V[I]TREA[M]—Stephanus Cardinalis, or Chardonel, a cousin of the Gaufridus (Fig. 5). This person was a canon in Paris and came from a wealthy family in the Chartres area, which produced no fewer than three canons for Chartres.[33] The scene takes place in a church with great arcades supported by columns with capitals. Lamps are suspended from ropes in the background, as was generally done in front of altars. The donor is a priest wearing an alb and a cope, the latter with a cowl, decorated with fringes and orphreys. The Virgin and Child, inside a tabernacle with doors with a small cross at the top, look like a silver or ivory statue on a small platform set on thin colonettes.[34] As in the previous lancet, the Virgin is crowned and holds a fruit, while the Child blesses with his right hand, leading us to believe that it is modelled on the same religious object (Fig. 6). The representation is indeed of an object, and not a living person. Is this once again the statue of the Virgin and Child, but clearer than in the other windows? One might think so. The liturgical context of the scene is even more

29. See for instance Leroux's engraving from the late seventeenth century, Chartres, Bibliothèque municipale, Ms. NA 29.

30. In France, only two wood tabernacles dedicated to the Virgin and Child of the thirteenth century still exist, one in a church in the Pyrénées-Orientales (the Virgin and Child disappeared in 1976), the other in the Puy-de-Dôme (the door has disappeared). See *Les premiers retables (XIIᵉ–début du XVᵉ siècle). Une mise en scène du sacré*, Exhib. cat., Pierre-Yves Le Pogam, ed. (Paris: Louvre, 2009), 54–68.

31. Klaus Kruger numbered about ten thirteenth- and fourteenth-century works still in their original churches in Italy, or in museums: Klaus Kruger, *Der Frühe Bildkult des Franzizkus in Italien. Gestalt- und Funktionswandel des Tafelbildes im 13. und 14. Jahrhundert* (Berlin, 1992), 17–24 and 219–230.

32. Jeffrey F. Hamburger, *The Visual and the Visionary: Art and Female Spirituality in Late Medieval Germany* (New York, 1998), 111–113; "Le Trois Estaz de bonnes ames," London, British Library, Yates Thompson, Ms. II (Add. 39843), fol. 29ʳ; Psalter and Hours of Bonne of Luxembourg, New York, The Metropolitan Museum of Art, The Cloister Collection, 1969, fol. 329ʳ.

33. Delaporte, *Vitraux de la cathédrale* (as in note 3), I: 368.

34. The representation of the small statue on white glass was not renewed in the fourteenth century as Delaporte thought. It was done in the thirteenth century, as my study of the window in the restoration workshop showed (forthcoming). Delaporte, *Vitraux de la cathédrale* (as in note 3), I: 367.

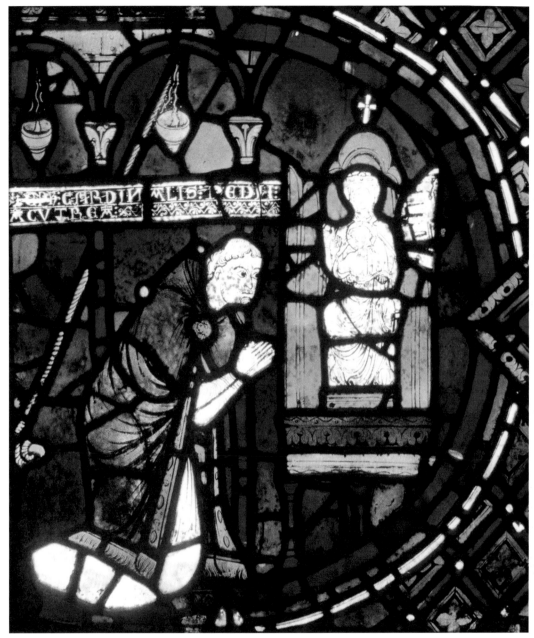

FIGURE 5. Canon Stephanus Chardonel praying in front of the Virgin and Child (window 29b) (© Centre André Chastel, Paris; photo: Christian Lemzaouda).

emphasized, as, unlike the previous windows, there is no interaction between the Virgin and Child and the donor during prayer. The attitude of the praying man is also different in the two scenes with the Chardonel canons. In the first, canon Gaufridus Chardonel lifts his gaze toward the Virgin and the Child, who answer his prayer by listening to him. In the second scene, Stephanus Chardonel's prayer is internalized,

and he looks down, while the Virgin remains static.

In the next panel of the same lancet, we can probably see close relatives of Stephanus Chardonel. Both figures are praying in a church in front of the same statue of the Virgin and Child, but here the statue is not in a tabernacle. It stands on a small platform or altar, which was probably closer to reality, yet it must be the same liturgical object.

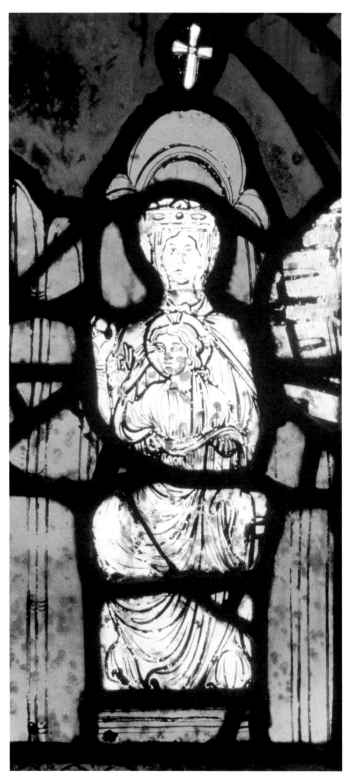

FIGURE 6. Canon Stephanus Chardonel praying in front of the Virgin and Child, detail (window 29b) (© Centre André Chastel, Paris; photo: Christian Lemzaouda).

In the lower windows, a few fourteenth-century panels, inserted at the bottom of a narrative window of the early thirteenth century, show the development of the theme of the donor-canon praying in front of the Virgin and Child. In 1328, a narrative window telling the story of Saint Apollinaire and showing the Celestial Hierarchy, previously located in the south aisle of the choir, was transferred to the south transept (window 36 on the plan shown in Fig. 1). The lower part of the thirteenth-century window was removed and replaced with a series of panels in a totally new style (Fig. 7). They surely constitute the first example of stained glass to be made entirely of white glass with brown and black paint and silver stain. A long inscription bears the name of the donor and the date of the gift, as well as the names of the featured saints. The inscription shows that Guillaume Thierry, a canon of the cathedral, founded an altar to Notre Dame and saints featured in the window. The altar was founded on All Saints Day in the year of our Lord 1328 and two perpetual chaplains were also funded.

There are quite a number of documents relating to this person. Guillaume Thierry was a canon from 1309, and became purveyor of the fabric of the cathedral in 1314, a post he kept until he died in 1336 or 1337. The title was awarded to two or three administrators of the fabric of the cathedral, who were elected or re-elected every year. They kept the keys to the treasure of the church and canonical houses; they paid the workers and expenses, were in charge of maintaining and repairing the church and the canonical houses, and they also bought all the necessary objects for the building. Canon Thierry is known to have taken an active role in the construction of the Saint Piat chapel to the east of the choir. At his death, Guillaume Thierry bequeathed the house he owned in the precinct to the chapter. He gave thirty pounds and eight deniers to fund the celebration of his anniversary on 27 September in the cathedral of Chartres, and also gave thirty pounds for his anniversary in Saint Père abbey at Chartres.[35] The altar he funded was propped

35. Claudine Lautier, "Un vitrail parisien à Chartres: la grisaille du chanoine Thierry," in *Glas, Malerei, Forschung, Internationalen Studien zu Ehren von Rüdiger Becksmann*, Hartmut Scholz, Ivo Rauch, Daniel Hess, eds. (Berlin, 2004), 143–150.

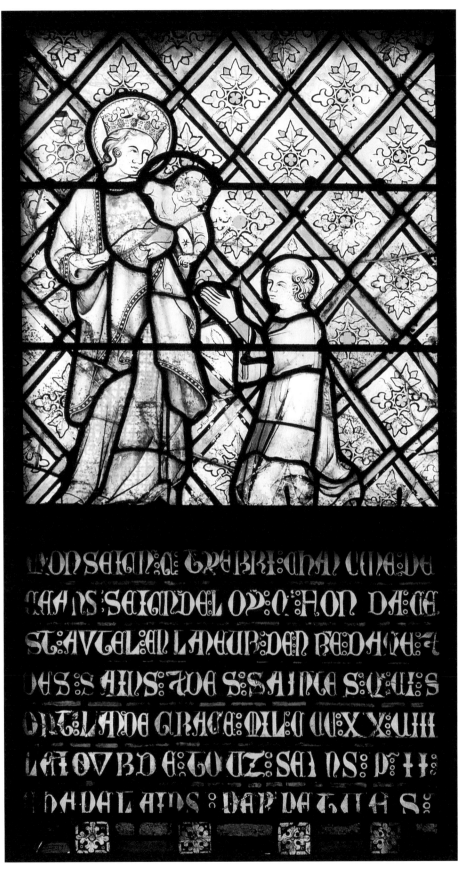

FIGURE 7. Canon Guillaume Thierry praying in front of the Virgin and Child (window 36) (© Centre André Chastel, Paris; photo: Christian Lemzaouda).

against a nearby pillar. Canon Thierry is represented on the central panel, in front of the Virgin and Child. On either side are the saints the canon particularly worshipped. Installed one century later than the ambulatory windows, the image of the praying donor has markedly evolved. The Virgin is no longer a statue, but a living person listening to the worshipper. There is no altar or tabernacle, nor architectural background showing the interior of a church. The kneeling canon is the same size as the Virgin and saints on either side. The Virgin lovingly holds the Child in her arms, and one of his feet in one hand. Christ bends towards the canon with magnanimity. The distance between the worshipper and God is abolished by prayer, which is perfectly expressed in the picture.

DONOR-CANONS IN THE CLERESTORY WINDOWS OF THE CATHEDRAL

The four images discussed above are the only ones that attest to the canons' gifts for the lower level of the cathedral. They show the prominent worship of the Virgin and Child. The other images of canons can be seen in the clerestory of the choir and transept. The first and most enigmatic of these is located in the presbytery, in the south window above the main altar, before the latter was moved in the sixteenth century (window 110 shown in the plan in Fig. 1).[36] The inferior panels of the window, along with the base of the altar and the figure's legs, were destroyed in the eighteenth century and replaced in 1921 by Charles Lorin, glass painter of the cathedral. The drawing done in the late seventeenth century for the historian Roger de Gaignières was used to reconstruct the missing parts.[37] The panels show a canon whose name, PETRVS BAILLART, is written on a banderole in the background (Fig. 8). He is kneeling and praying in front of an altar with a cross on top. Legends from the seventeenth century record that this was a portrait of Peter Abélard, the famous theologian of the early twelfth century. The historian Ferdinand de Mély believed that it was Baillardus, another twelfth-century theologian in Paris, but the latter identification is no more solid than the former.[38] Of the two opinions, Delaporte is rightly more prudent, and has shown that Petrus Baillart is mentioned neither in the obituary of the cathedral, nor in any obituary in the vicinity of Chartres.[39] The canon was not present in the diocese of Sens while Chartres cathedral was suffragant to the metropolitan church of Sens. Delaporte nonetheless thinks that the figure depicts a canon of Chartres cathedral, who may have ended his career elsewhere. I am tempted to agree with him, since the image holds an important place in the iconography of the choir.

But the second canon featured in a window of the clerestory is well known. He can be seen in window 113, in the angle with the north transept near the arms of Renaud of Mousson, a bishop in Chartres from 1182 to 1217. Renaud was the son of Renaud the second, count of Bar, and Agnes of Champagne, and was a cousin of king Philip Augustus.[40] It is interesting to notice that the bishop had himself represented only by his arms (Fig. 9), unlike other bishops whose portraits are shown in the windows, as for example at Reims or Amiens.

In the right lancet, Robertus de Berou is identified by a long and explicit inscription: ROBERTVS DE BEROV CARTONENSIS CANCELLARIVS (Fig. 10). He was from a famous family in the region of Chartres and was chancellor of the chapter of the cathedral between 1213 and 1216. These dates are very important, because they enable us to accurately date the window

36. See the plan of liturgical elements in the choir in the thirteenth century in Lautier, "The Sacred Topography" (as in note 19), 179.

37. Bibliothèque nationale de France, Cabinet des Estampes, Roger de Gaignières, *Histoire du costume*, pl. XLII. Published in Henri Bouchot, *Inventaire des dessins exécutés pour Roger de Gaignières et conservés aux Départements des estampes et des manuscrits, Bibliothèque nationale* (Paris, 1891), n° 57; Joseph Guibert, *Les dessins d'archéologie de Roger de Gaignières* (Paris, 1912), II, B57.

38. Ferdinand de Mély, "Etude iconographique sur les vi-

traux du treizième siècle de la cathédrale de Chartres," *Revue de l'art chrétien*, nouvelle série, VI (1888), 423.

39. Delaporte, *Vitraux de la cathédrale* (as in note 3), I: 457. Pascal Montaubin has come to the same conclusions (see note 1).

40. The identification of these arms was debated. Delaporte suggests he was closely related to Renaud de Mousson: Delaporte, *Vitraux de la cathédrale* (as in note 3), I: 486. As for the heraldist Pinoteau, he readily identified the bishop himself: Hervé Pinoteau, *Notre-Dame de Chartres et de France. Le voile de la Vierge et autres merveilles* (Paris, 2008), 51–52.

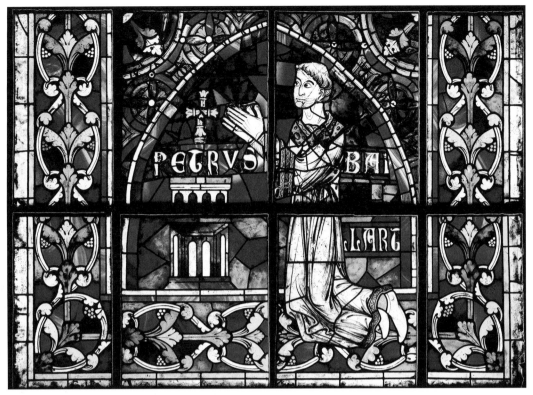

FIGURE 8. Canon Petrus Baillart praying (window 110a) (© Centre André Chastel, Paris; photo: Céline Gumiel).

FIGURE 9. Arms of bishop Renaud of Mousson (window 113a) (© Centre André Chastel, Paris; photo: Céline Gumiel).

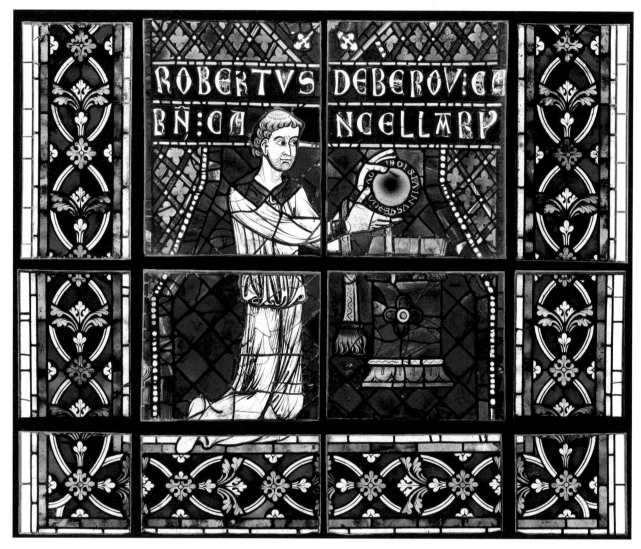

FIGURE 10. Chancellor Robertus de Berou holding the seal of the chapter of Chartres Cathedral (window 113b) (© Centre André Chastel, Paris; photo: Céline Gumiel).

itself, as well as all the clerestory windows in the choir. His name is found in several documents in the cartulary of the cathedral.[41] The donor is kneeling in front of a simple altar without cross or chandelier. He wears the liturgical clothes of a sub-deacon, an alb, an amice around his neck, and the maniple on his left arm. He holds a large seal in his hands from which knotted silk cords hang. The seal is the insignia of his responsibility. The chancellor is one of the highest dignitaries of the chapter. He is in charge of the

Episcopal school, writes the charters, holds registers, and prepares decrees. He is mainly the keeper of the seals, which formalize all the charters of the chapter.[42] The one Robertus holds is outsized, and bears an inscription all around. But the glass painter has painted letters only meant to simulate, as, unlike the donor's name in the other inscription, these small letters do not form words and cannot be read from ground level.

These two images of donor-canons are the only ones in the clerestory of the choir. All the others are

41. *Cartulaire de Notre-Dame* (as in note 9), II (Chartres, 1863), 24, 71; Merlet, *Dignitaires de l'église Notre-Dame* (as in note 26), 106.

42. Amiet, *Essai sur l'organisation du chapitre* (as in note 5), 92–98.

FIGURE 11. Canon Jean of Courville (window 128 rose) (© CRMH–DRAC Centre).

located in the clerestory windows of the transept, and date from the last glazing campaign, between 1225 and 1235. In the rose of window 128, a deacon—or sub-deacon—stands facing the viewer. He is not in a church, but in a landscape represented by two trees on low hills (Fig. 11). His attitude and the landscape background are unique amongst the representations of donor-canons in the cathedral. He is outside a li-turgical scene and is neither praying nor celebrating Mass. He wears an alb and dalmatic, an amice around his neck, and a maniple on his right arm; and he holds a book close to his chest. A banderole bearing the in-scription IENS DE CORRVIL (Johannes de Curvavilla) is found behind his shoulders. The name of a certain Jean of Courville appears on 8 June in an obituary of the abbey of Saint-Père-en-Vallée at Chartres. We do

not know if this person was a canon of Notre-Dame of Chartres, and we do not know when he died.[43] According to Delaporte, the deacon in the stained glass window can only be the donor of the whole window.[44]

Representations of the other donor-canons are closely linked to the liturgy of the Mass. All these images were made ten to twenty years after the fourth Lateran Council, which was held in November 1215. More than 1,200 prelates attended the council, which was called by Pope Innocent III.[45] The first canon that was published by the council dealt with faith and the role of the priest within the Church, including Mass and the Eucharist, and the doctrine of transubstantiation, through which bread and wine became the body and blood of Christ. It was promulgated that it is the priest alone who could convert bread and wine into the body and blood of Christ during Mass.[46] Even though transubstantiation became dogma during the Council of Trent in the mid-sixteenth century, it was certainly a major concern for theologians for many centuries.[47] It is clear that the canons of Chartres and the Episcopal school, which was well known in the twelfth century (even if it was surpassed by the University of Paris in the thirteenth century), had a good reputation for the quality and standard of its theological debates.

The windows in the transept that can be dated to after the fourth Lateran Council of 1215 show Mass being celebrated by the canons. There are, in fact, no less than nine canons celebrating Mass in the transept: one in window 116; two in window 118; one in window 126 in the south transept; two in window 117; and three in window 119 in the north transept (see plan, Fig. 1). This significantly high number of images of the Mass, which really is unequalled in thirteenth-century windows, shows the theological and liturgical concerns of the canons of Chartres.

Three images show a priest celebrating Mass in front of an altar with one cross but no other liturgical objects, apart from an altar cloth (windows 116a, 118b, 126b).[48] In other windows an over-sized chalice is present either with the cross (window 118a), or without (windows 117 and 119). The image of the Mass in the rose of window 117 is the only one featuring a normal-sized chalice. Jane Welch Williams believes that the many scenes of priests celebrating Mass in front of an altar with an over-sized chalice must refer to Maundy Thursday Mass. According to her, the chalice used during this Mass was disproportionately large so that every worshipper could take part in the celebration. These liturgical objects were supposedly called "*calices ministériels*."[49] It has to be noted that the same scene is repeated five times, i.e., the priest is standing or kneeling in front of so large a chalice that it can be seen from ground level. The over-sized chalice may also represent something more fundamental than Maundy Mass celebration. The worshippers were led to accept the transubstantiation doctrine, clearly defined by the fourth Lateran Council.

Near the crossing of the transept in window 116a in the south arm, donor Geoffrey can be seen, as the inscription at his feet says: [G]IEFROI (Fig. 12). But the name is too common to give a precise identification. He wears the alb, the dalmatic, the amice, and the chasuble. Under a double arcade inside a church, the priest is standing in front of an altar covered with two altar cloths—one red and one white with colored braids and fringes—and with a cross. Secondary reliquaries or ex-voto offerings are hanging from the arms of the cross. The two chandeliers, which were required for celebrating Mass, cannot be seen in this image.[50] In the rose of window 116 there is an unidentifiable shrouded bishop standing before

43. Molinier, *Obituaires* (as in note 21), 190.

44. Delaporte, *Vitraux de la cathédrale* (as in note 3), I: 427.

45. On the fourth Lateran Council, see for instance Raymonde Foreville, *Les conciles de Latran I, II, III et de Latran IV: 1123, 1139, 1179 et 1215*, vol. 6 of *Histoire des conciles œcuméniques*, Gervais Dumeige, ed. (Paris, 1965), 245–284.

46. The full text of the canons of the fourth Lateran Council was published in Latin and translated into French in *Les conciles œcuméniques: Les décrets*, vol. II-1: *Nicée I à Latran V*, Giuseppe Alberigo, ed. (Paris, 1994), 494–577.

47. James F. McCue, "The Doctrine of Transubstantiation from Berengar through Trent: The Point at Issue," *The Harvard Theological Review* 61/3 (1968), 385–430.

48. The stained glass in window 126 is in very poor condition, the scenes are barely readable because of corrosion and dirt.

49. Williams, *Bread, Wine, & Money* (as in note 10), 96–98.

50. Julian Gardner, "Altars, Altarpieces, and Art History: Legislation and Usage," in *Italian Altarpieces 1250–1550: Function and Design* (Oxford; New York, 1994), 9.

FIGURE 12. Canon Geoffroy celebrating Mass (window 116a) (© CRMH–DRAC Centre).

an altar with two huge chandeliers. Their absence in representations of the Mass cannot be explained, as they are frequently found elsewhere in other narrative windows in the cathedral.

A similar image is found at the bottom of the right lancet of window 118b, in the southern arm of the transept (Fig. 13). A priest who is called [G]IEF[R]OI, but not accurately identifiable, stands in front of the altar with a simple cross, but without hanging objects. It is impossible to claim that the donor is the same as the one in the previous window. A similar image is found in the west wall of the transept (window 126b),

showing an unknown priest standing in front of an altar with a cross.

In the left lancet of window 118, another unknown priest is celebrating Mass in an enclosed space under a double arcade (Fig. 14). The layout of objects is even more detailed than in other windows of this group. There are three overlapping altar cloths. The first seems to be a decorated, blue, thick cloth with yellow fringes; the second is white with golden braids and fringes, and the third is similar, but shorter.[51] A white corporal with red fringes is found under the chalice, but it is draped differently from the cloths and

51. Presently the three altar cloths must be only white. The artist colored them so that they could be seen clearly.

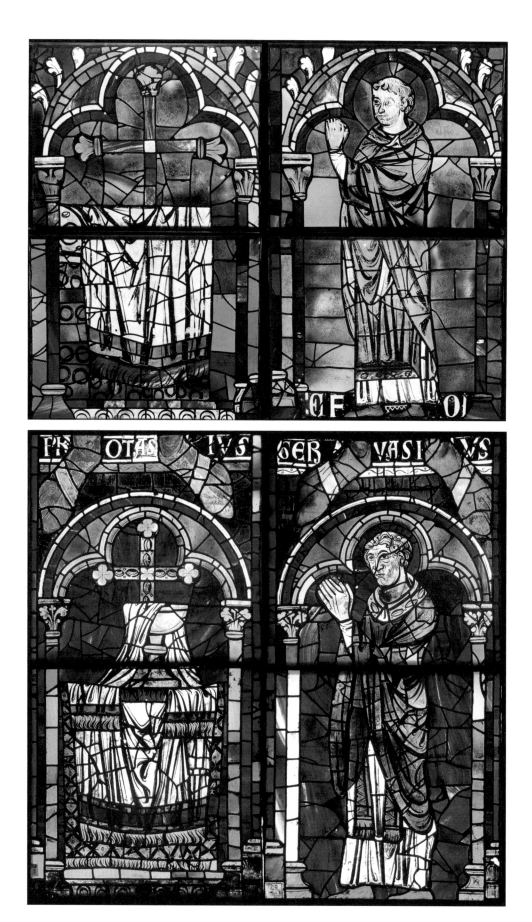

FIGURE 13. Canon Geoffroy celebrating Mass (window 118b) (© photo: Laurence Cuzange).

FIGURE 14. Anonymous canon celebrating Mass (window 118a) (© photo: Virginie Lelièpvre).

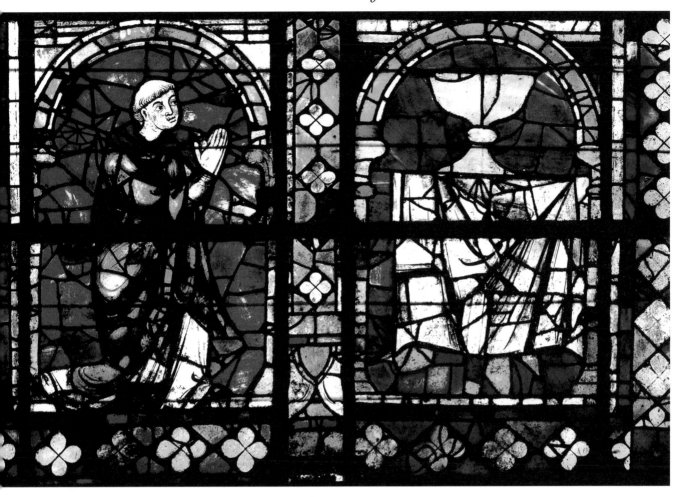

FIGURE 15. Anonymous canon celebrating Mass (window 119b) (© CRMH–DRAC Centre).

is more conspicuous. Another corporal covers the big chalice on the altar. A large cross can be seen behind the chalice. The link with the first canon published by Innocent III after the fourth Lateran Council is clear.

In the northern transept, five images show donor-canons, all unidentified and all celebrating Mass. Three are in window 117 and two are in window 119 (Fig. 15). It seems that the whole chapter, or at the very least the priests of the chapter, gave these windows during the last glazing campaign. The two images of canons at the bottom of the lancets in window 117 were made after the same cartoon in the same colors. The priest is kneeling and his hands are joined in an attitude of prayer. He looks at the chalice on the altar that has an altar cloth. Here, too, the chalice is over-sized. At the bottom of window 119, we can see the same priests, also made from the same cartoons, but their chasubles are of different colors.

It should be noted that, up to now, all the canons shown celebrating Mass in the transept windows, whether kneeling or standing, face towards the presbytery where the main altar is. The ones in the south turn towards the left, the others in the north look towards the right. This focuses the attention of the viewer on the main altar—the most sacred place in the church. It was here that the main relic of Chartres, the Virgin's *Santa Camisa*, was preserved in a reliquary set on a small platform adjoining the main altar. One canon, however, is an exception to this rule. He is in the rose of window 117 (Fig. 16), and is considerably taller than that the four praying canons in the lower panels of windows 117 and 119. Unlike his colleagues,

FIGURE 16. Anonymous canon celebrating Mass (window 117 rose) (© CRMH–DRAC Centre).

while celebrating Mass before an altar with a chalice, he faces the end-wall of the north transept, and not the choir. And it is precisely through the north portal that canons, coming from the precinct, entered the cathedral to attend offices and celebrate Mass. This image could thus be a sort of calling to Eucharist, at the top of the cathedral just under the vault.

This brief analysis of images of the donor-canons of Chartres Cathedral has hopefully brought attention to an important neglected group, who played a major role in the construction and decoration of their church. The focus of images of the lower windows is on prayer, worship of the Virgin, and ecclesiology, and are meant to show the worshipper who he should pray to and how. Those in the higher windows are all focused on the Eucharist, and are meant to claim the doctrine of transubstantiation. Thus the donor-canons are considered to be on a par with lay donors, such as noblemen and guild craftsmen.

ANNE DERBES

Patronage, Gender & Generation in Late Medieval Italy: Fina Buzzacarini and the Baptistery of Padua

THOUGH many women commissioned works of art during the trecento,[1] it is only relatively recently that scholars have begun to take note. Among others, Catherine King, Cordelia Warr, Benjamin Kohl, Eva Giurescu Heller, and Gail Solberg have made significant contributions to our understanding of the topic,[2] and one question that some of them address is that of a female patron's agency: if a woman funded a chapel or church, how much control would she have exercised over the final product? While there are no easy answers to such a question, one should note that even male patrons rarely had absolute authority over their commissions, especially given the dominant patterns of patronage in late medieval Italy. For instance, anyone seeking to establish a family chapel in a mendicant church would have had to negotiate a range of issues with the resident order.[3] For women, the challenges inherent in initiating any

1. To consider only trecento Padua and its environs, works commissioned by women include a chapel funded by Elena Bovolini in Bassano del Grappa; an enormous crucifix by the Paduan painter Guariento d'Arpo commissioned by Maria Bovolini for S. Francesco, Bassano del Grappa (for both, see L. Bourdua, "Guariento's Crucifix for Maria Bovolini in S. Francesco, Bassano: Women and Franciscan Art in Italy during the Later Middle Ages," in *Pope, Church and City: Essays in Honour of Brenda Bolton*, ed. F. Andrews, C. Egger, C. M. Rousseau [Leiden, 2004], 309–323); an altarpiece by Guariento, possibly for the cathedral of Piove di Sacco near Padua, and now in the Norton Simon Museum of Art, commissioned by an anonymous woman depicted in the Last Judgment (see C. King, "Women as Patrons: Nuns, Widows, and Rulers," in *Siena, Florence, Padua: Art, Society and Religion 1280–1400*, vol. ii: *Case Studies*, ed. D. Norman [New Haven, Conn., 1995], 243–266, at 262); the funerary chapel of Tebaldo Cortelliero in the Eremitani Church, Padua, commissioned by his mother, Traversina Cortelliero (B. Kohl, "Fina da Carrara, née Buzzacarini: Consort, Mother, and Patron of Art in Trecento Padua," in *Beyond Isabella: Secular Women Patrons of Art in Renaissance Italy*, ed. S. Reiss and D. Wilkins [Kirksville, Mo., 2001], 19–36, at 26); frescoes in the chapel of S. Benedetto, Padua, commissioned by Anna Buzzacarini, abbess of S. Benedetto (King, "Women as Patrons," 249–250); an altarpiece of 1382 by Altichiero, commissioned by "la Margareta" (for her identity, see J. Richards, *Altichiero: An Artist and his Patrons in the Italian Trecento* [Cambridge, 2000], 220), and the three major commissions for Fina Buzzacarini discussed here. The extensive work on the S. Giacomo Chapel in the Santo, though initiated by Bonifacio Lupi, was supervised for more than a year by his wife, Caterina dei' Francesi, whose portrait appears several times there (see Richards, *Al-*

tichiero, 156–157; L. Bourdua, *The Franciscans and Art Patronage in Late Medieval Italy* [Cambridge, 2004], esp. 121–122). Women were, of course, also recipients of paintings; for one example, see L. Bourdua, "Altichiero's 'Anchona' for Margareta Lupi: A Context for a Lost Painting," *Burlington Magazine* 144 (2002), 291–293. Pertinent here are Therese Martin's comments about women as patrons and artists during the Middle Ages more generally: "At what point do these perceived aberrations from the norm become rather a new pattern waiting to be recognized?" ("Exceptions and Assumptions: Women in Medieval Art History," the introduction to her edited volume, *Reassessing the Roles of Women as 'Makers' of Medieval Art and Architecture* [Leiden, 2012], vol. i, 1).

2. For cogent overviews of women's patronage in late medieval Italy, see King in "Women as Patrons" (as in note 1); *eadem*, "Medieval and Renaissance Matrons, Italian-Style," *Zeitschrift für Kunstgeschichte* 55 (1992), 372–393, esp. 373–379. King's monograph, *Renaissance Women Patrons: Wives and Widows in Italy c. 1300–1550* (Manchester; New York, 1998), also includes relevant material. The other scholars examine specific case studies. See C. Warr, "Painting in Late Fourteenth-Century Padua: The Patronage of Fina Buzzacarini," *Renaissance Studies* 10 (1996), 139–155; Kohl, "Fina" (as in note 1); E. G. Heller, "Access to Salvation: The Place (and Space) of Women Patrons in Fourteenth-Century Florence," in *Women's Space: Patronage, Place and Gender in the Medieval Church*, ed. V. Raguin and S. Stanbury (Albany, N.Y., 2005), 161–183; and G. Solberg, "The Painter and the Widow: Taddeo di Bartolo, Datuccia Sardi Da Campiglia, and the Sacristy Chapel in S. Francesco, Pisa," *Gesta* 49 (2010), 53–74.

3. On the limits of male patrons' control, see M. Caviness, "Anchoress, Abbess, and Queen: Donors and Patrons or

significant work and seeing it through must have been considerable. Thus Catherine King states: "We must be careful in considering women as patrons not to think in terms of individual autonomy.... [women] commissioned with groups of men surrounding their decision-making...." [4]

And yet some women may have exerted more control over commissions than one might imagine. In his will of 1380, the merchant Mainardo Cavalcanti funded the construction of a chapel in the transept of Sta. Maria Novella in Florence that was to serve both as the church sacristy and as the family's mausoleum. Monna Andrea, his widow and the executor of his will, undertook the decoration of the sacristy after his death. Ena Giurescu Heller publishes an important contract of 1386 stipulating that the images of the stained glass in the sacristy were to be "quelle storie che piaceranno alla detta madonna Andrea." This is an intriguing case: a sacristy in a mendicant church, where the resident friars presumably had to grant approval of the narrative program—and indeed Heller assumes that Monna Andrea "could hardly have had such freedom in deciding the subject matter." [5] But

the language of the contract seems unambiguous; even if the friars established broadly acceptable subjects, the selection of specific scenes was apparently left to the patron.

Assessing the extent to which a female patron might have imposed her will on a commission is admittedly difficult—but despite the obstacles that they must have faced, some women succeeded in shaping the works that they financed. This article considers a single case: the Baptistery in Padua, which was converted into a family mausoleum in the 1370s at the behest of Fina Buzzacarini. [6] Fina was the consort of the ruling lord of Padua, Francesco da Carrara, whom she married in 1345. Though Fina bore four children—three daughters and then a son—the marriage was evidently not a happy one. Francesco also sired numerous extramarital offspring, and after a time Fina lived apart from her husband, with a group of about twenty noblewomen and female servants, in a separate palace, the Palazzo di Levante, within the Carrara compound—an unconventional arrangement that has been called "the first gendered space in the Italian courts of the early Renaissance." [7]

Intercessors and Matrons?" in *The Cultural Patronage of Medieval Women*, ed. J. McCash (Athens, Ga., 1996), 105–154, at 105. J. Gardner, in a discussion of the Bardi Chapel, S. Croce, Florence, argues that the friars rather than the Bardi family were responsible for important aspects of the program (*Giotto and his Publics: Three Paradigms of Patronage* [Cambridge, Mass., 2011], esp. 61–73). Renaissance scholars have similarly challenged assumptions of male patrons as independent actors—even wealthy and powerful men, like the Medici—and have proposed instead the notion of shared agency. See M. Bullard, "Heroes and their Workshops: Medici Patronage and the Problem of Shared Agency," in *Patterns of Patronage in Renaissance Italy: Essays in Honor of John R Spencer. Journal of Medieval and Renaissance Studies* 24 (1994), 179–198.

4. King, "Women as Patrons" (as in note 1), 243.

5. Heller, "Access to Salvation" (as in note 2), 164. Solberg, "The Painter and the Widow" (as in note 2) considers a situation analogous to that of the S. Maria Novella sacristy, the decoration of a sacristy chapel in a mendicant church (S. Francesco, Pisa). Though she acknowledges the role of the order in determining the iconographic choices (58), she argues that "Datuccia left her personal imprint multiple times in the chapel program" (54). In the contract for Duccio's Rucellai Madonna for a chapel in S. Maria Novella, Florence, commissioned by a confraternity of the Compagnia dei Laudesi, the patrons asserted their prerogatives forcefully. It notes that the

artist would receive no payment if the panel was not "embellished according to the wishes and desires of the same lessors" (that is, representatives of the confraternity). See J. Satkowski, *Duccio di Buoninsegna: The Documents and Early Sources*, ed. H. Maginnis (Athens, Ga., 2000), 52.

6. The basic source for her life and patronage is Kohl, "Fina" (as in note 1). See also *idem, Padua under the Carrara, 1318–1405* (Baltimore, Md.; London, 1998), 152–154; *idem,* "Giusto de' Menabuoi e il mecenatismo artistico in Padova," in A. M. Spiazzi, ed., *Giusto de' Menabuoi nel Battistero di Padova* (Trieste, 1989), 13–30; Warr, "Painting" (as in note 2). For the Baptistery frescoes, by Giusto de' Menabuoi, see B. Delaney, "Giusto de' Menabuoi: Iconography and Style" (Ph.D. diss., Columbia University, 1972); C. Bellinati, "Iconografia e teologia negli affreschi del Battistero," in Spiazzi, *Giusto,* 41–82; A. M. Spiazzi, "Giusto a Padova: La Decorazione del Battistero," in Spiazzi, *Giusto,* 83–127; F. d'Arcais, "Giusto de' Menabuoi nel Battistero di Padova," in A. M. Spiazzi, ed., *Attorno a Giusto de' Menabuoi: aggiornamenti e studi sulla pittura a Padova nel Trecento: atti della giornata di studio, 18 dicembre 1990* (Canova, 1994), 11–16. For a useful consideration of the Baptistery's architecture and the tombs of Francesco and Fina, see H. Saalman, "Carrara Burials in the Baptistery of Padua," *Art Bulletin* 69 (1987), 376–394.

7. Kohl, "Fina" (as in note 1), 22. He cites several documents in which the Palazzo di Levante is described as the residence of the Carrara women (33, note 28). In *Padua* (as in note 6),

Documents reveal that Fina was both an enormously wealthy woman in her own right, thanks to bequests from her father and her uncle, and a shrewd businesswoman, engaging in real estate transactions in the Veneto through agents, and amassing vast holdings in the region. She used her considerable wealth, in part, to fund the construction and renovation of churches. The local chronicler Bernardino Scardeone, writing in the late sixteenth century but drawing from earlier chronicles, describes Fina as "an exceedingly wise and most religious woman … [responsible for] many things which make her worthy of our memory." He then recounts three commissions:

And indeed when the very grand home of Niccolò da Carrara [Francesco's grandfather] was shattered and razed to the ground because of treason, this woman, devoted to God, was granted by her husband permission to build a temple there, dedicated to the glorious Virgin, mother of God. Thus she arranged for the church of the holy Mary to be built on that abandoned site, in the name of the Servites.

Similarly, she completed the very beautiful temple of St. John the Baptist, next to the cathedral, with a famous high dome, and most beautiful paintings by a highly praised painter, with scenes of the Old Testament and New Testament above and below, and most richly decorated all around, a great delight to

see. There one can see a portrait of her in a stance of prayer. She died in 1378 and was buried with greatest pomp in the sanctuary of John the Baptist.

She also had [a chapel] built in the temple of S. Benedetto, where the following epigram can be seen in stone:

This chapel was built and donated by the noble lady Fina Buzzacarini, consort of the most famous lord Francesco, lord of Padua, and was restored by the lady Anna Buzzacarini, abbess, in 1394.[8]

Of the three commissions, the grandest and the one that was of central importance to Fina was the Baptistery. A second chronicler, Michele Savonarola, writing *c.* 1450, informs us that the interior was painted by the Florentine artist Giusto de' Menabuoi—an attribution that has never been seriously challenged.[9] In the dome (Fig. 1) is a bust-length Christ recalling a Byzantine Pantocrator; directly below, surrounded by scores of heavenly figures—angels, Old Testament personages, and saints—stands an orant Virgin. Below her is a narrative cycle representing the sweep of salvation history, from Genesis, in the drum of the dome, to the New Testament on three walls below—west (Fig. 2), north, and east (Fig. 3)—and the life of John the Baptist on the south (Fig. 4). In the apse (Fig. 3) is a comprehensive cycle of the Apocalypse,

293, he estimates that a dozen ladies-in-waiting and ten servants lived there. For the palace complex of the Carrara family, known as the Reggia, see C. Gasparotto, "La Reggia dei Da Carrara, il palazzo di Ubertino e le nuove stanze dell'Accademia Patavina," *Atti e Memorie dell'Accademia Patavina di scienze, lettere ed arti* 79, pt. 1 (1966–1967), 71–116; N. Nicolini and A. Rossi, *La Reggia dei Carraresi a Padova: La Casa della Rampa* (Milan, 2010).

8. B. Scardeone, *De antiquitate urbis Patavii, et claris civibus Patavinis* (Basel, 1560, reprint Bologna: Forni, 1974), 412. The text reads:

Fuit & altera Fina Pathari Buzzacharini filia, & uxor Francisci Carrariensis senioris principis Patavini, sapientissima ac reliogissima foemina. Quae inter caetera, quae memoratu digna fecerat, id omnino reticendum non est.

Quum enim aedes amplissimae Nicolai Carrariensis perduellionis rei, de more diruptae & adaequatae solo fuissent, mulier Deo devota impetravit a marito aedificari ibi templum, Dei matri virgini gloriosae dicandum. Quare eo in solo ita derelicto aedem divae Mariae cognomento Sevorum extruendam curavit.

Item perfecit pulcherrimum phanum D. Joanni Baptiste Ecclesiae Cathedrali contiguum, sublimi testudine insigne, ac speciosissimis picturis laudatissimi pictoris, cum veteris ac novi testamenti historia sursum & deorsum & circunquaque ornatissimum, & visu maxime jucundum. Ibi inspicitur ejus effigies habitu suppplicantis. Obiit anno salutis MCCCLXXVIII & cum maxima pompa sepulta est in eodem sacello sancti Joannis Baptistae.

Haec etiam erexit altare in aede S. Benedicti, ubi epigramma sequens in saxo conspicitur:

Capella aedificata & donata per nobiliem D. Finam de Buzzacharinis consortem clarissimi Domini domini Francisci, domini Padue: & instaurata per dominam Annam de Buzzacharinis Abbatissam, anno Domini MCCCXCIIII.

9. *Libellus de magnificis ornamentis regie civitatis Padue. Rerum Italicarum Scriptores*, ed. L. A. Muratori, vol. 24, part 15 (Città di Castello, 1902), 44, line 17. Savonarola gives a brief description of the Baptistery: "the very large site which the Paduans call their Baptistery" (*locum amplissimum quem Patavi Baptisterium vocant*) and to episodes from the Old Testament and New Testament, "represented with the greatest skill" (*maximo etiam cum ornatu figuratur*); he does not mention patronage.

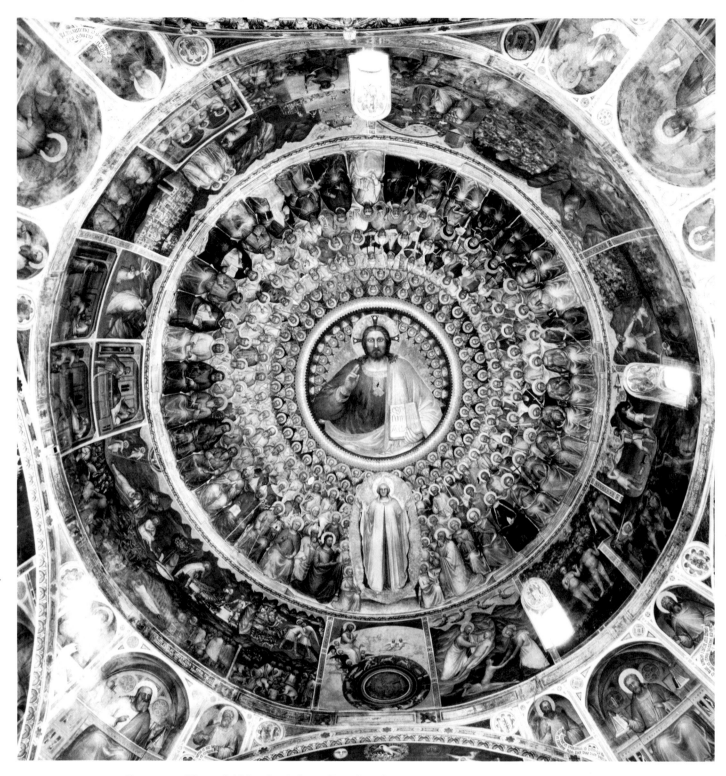

Figure 1. Giusto de' Menabuoi, dome: Paradise, Genesis cycle. Baptistery, Padua, mid-1370s (photo: © Genevra Kornbluth).

FIGURE 2. Giusto de' Menabuoi, west wall, Baptistery, Padua, mid-1370s (photo: Valentino Pace).

and on the altar stands a polyptych, also painted by Giusto, depicting the Virgin and Child, saints, and events from the life of John the Baptist. On the west wall (Fig. 2), below the Annunciation, John the Baptist and John the Evangelist present the kneeling Fina to the Virgin, Child, and saints; above the donor portrait is the ornate carved canopy that originally extended over the tomb where she was once buried (Fig. 5).[10] With its narratives ranging from the first book of the Bible to the last, the Baptistery represents perhaps the most comprehensive fresco program surviving from the later trecento—and one of the most ambitious commissioned by a woman in northern Italy during the Middle Ages.[11]

10. The standing figure of John the Baptist beneath the donor portrait is a later addition, probably from the early quattrocento, replacing Fina's tomb; on this fresco, and on the fate of the tomb, see Saalman, "Carrara Burials" (as in note 6).

11. Noted similarly by Warr, "Painting" (as in note 2), 142. I exclude the extensive patronage of royal women in Angevin Naples, for which see J. Elliott and C. Warr, "Introduction," *The Church of Santa Maria Donna Regina: Art, Iconography, and Patronage in Fourteenth-Century Naples,* ed. J. Elliott and C. Warr (Aldershot, 2004); on pp. 1–2 they enumerate the major examples. The essays in the volume provide further information on women's patronage at this site and others in Angevin Naples. See also C. Fleck, "'Blessed the Eyes That See Those Things You See': The Trecento Choir Frescoes at Santa Maria Donnaregina in Naples," *Zeitschrift für Kunstgeschichte* 67 (2004), 201–224.

FIGURE 3. Giusto de' Menabuoi, east wall with view into apse, Baptistery, Padua, mid-1370s (photo: © Genevra Kornbluth).

FIGURE 4. Giusto de' Menabuoi, south wall, Baptistery, Padua, mid-1370s (photo: ©
Genevra Kornbluth).

FIGURE 5. Giusto de' Menabuoi, Fina Buzzacarini presented to the Virgin and Child. Baptistery, Padua, mid-1370s (photo: Valentino Pace).

Though few documents have survived, one pertinent record exists: Fina's will, drawn in 1378, shortly before her death.[12] It is a reflective text, revealing both Fina's awareness of her high station and a wariness borne of experience. In the opening paragraphs she writes: "the greater is one's dignity, honor, and exalted status in this life, the more must one be aware of the deceits and sins of mortal men."[13] Subsequent passages reveal a woman accustomed to asserting her desires clearly—many of which concern the Baptistery. The will states that she wishes to be buried in the Baptistery, and that a tomb be constructed for her befitting her station—pointedly, "with attention and respect to the testatrix": *attentis et respectibus dicte*

12. For the text of the will, see Kohl, "Giusto" (as in note 6), 24–28; for his translation, quoted here, see B. Kohl, "Last Will and Testament of Fina da Carrara, 1378," in *Major Problems in the History of the Italian Renaissance*, ed. B. Kohl and A. Smith (Lexington, Mass.; Toronto, 1995), 337–342. An incomplete version of the text appeared earlier in Saalman, "Carrara Burials" (as in note 6), 390–394. For a discussion of the will, see Saalman, "Carrara Burials," 381–382; Warr, "Painting" (as in note 2), 142; King, "Medieval and Renaissance Matrons" (as in note 2), 376–378; King, "Women as Patrons" (as in note 1), 251; Kohl, "Fina" (as in note 1), 27–28; *idem, Padua* (as in note 6), 152–154.

13. Kohl, "Last Will" (as in note 12), 337.

testatrice. The next provision directs Francesco, her executor, to see that the Baptistery is endowed from her estate: *de bonis magnifice domine testatricis*. She further orders that all her silver and all her clothing be sold to provide for the ornamentation of the Baptistery and its altars—likely referring to the liturgical objects and vestments needed for the celebration of the Mass.[14] Throughout the will, she is specific and direct about bequests—the vast majority of which went to women; and twice she chides anyone who might have resented some of her decisions: "and in this matter she instructs and orders her other heirs to be quiet and content."[15] Among the disgruntled parties may have been her consort: though she named Francesco her executor, she left him nothing. Perhaps her phrase, the "deceits and sins of mortal men," was directed at her husband.[16]

Despite the repeated references to the Baptistery in her will, and despite Scardeone's clear statement that Fina was responsible for the commission, some scholars believe that her role was secondary, and credit Francesco, her consort, with initiating the project. Catherine King, who believes that Fina may have been involved in the design of the program, states that she "handled an important commission for her husband."[17] Howard Saalman goes further, arguing that Francesco commissioned the frescoes only after Fina's death—a judgment with which Joachim Poeschke concurs.[18] Gail Solberg has recently discussed the Baptistery, granting Fina a role, but finding the visual evidence of her involvement slender.[19] While other scholars assume greater responsibility for Fina, most of them are somewhat tentative in their suggestions.[20]

Fina obviously did not operate independently in taking on the Baptistery project. Scardeone notes that she sought her husband's permission before undertaking her first major commission, the construction of a church, Sta. Maria dei' Servi, on the site of

14. This passage (*ad ornatum et pro ornamento ipsius Capelle et altaris*—Kohl, "Giusto [as in note 6], 26) has been interpreted by some scholars as referring to the frescoes (Saalman, "Carrara Burials" [as in note 6], 381–382; J. Poeschke, *Italian Frescoes: The Age of Giotto, 1280–1400* [New York, 2005], 404 [originally published as *Wandmalerei der Giottozeit in Italien 1280–1400* (Munich, 2003)]). But as others have argued (Spiazzi, "Giusto a Padova" [as in note 6], 94, followed by Warr, "Painting" [as in note 2], 142; King, "Medieval and Renaissance Matrons" [as in note 2], 376–378; King, "Women as Patrons" [as in note 1], 251; and Kohl, "Fina" [as in note 1], 28), the phrase more probably refers to liturgical furnishings, and possibly to the altarpiece. In fact such items were considered more important than the altarpiece itself: on this point see C. Gardner von Teuffel, "Clerics and Contracts: Fra Angelico, Neroccio, Ghirlandaio and Others: Legal Procedures and the Renaissance High Altarpiece in Central Italy," *Zeitschrift für Kunstgeschichte* 62 (1999), 190–208, at 197. As surviving inventories and wills suggest, the liturgical furnishings alone would have been costly; see, for instance, the inventory for the S. Giacomo Chapel in the Santo, published by A. Sartori, "Nota su Altichiero," *Il Santo* 3 (1963), 291–326, document XII, pp. 316–317, or the lengthy list of liturgical items given to S. Maria a Rignalla by Tommaso Spinelli in 1458 (P. J. Jacks and W. Caferro, *The Spinelli of Florence: Fortunes of a Renaissance Merchant Family* [University Park, Pa., 2001], 331). The liturgical objects used in the Baptistery, a site designed to showcase the leading family of the city, must have been particularly opulent.

15. Kohl, "Last Will" (as in note 12), 341.

16. Kohl, *Padua* (as in note 6), 154, observes that "[Francesco's] callous philandering had apparently cost Fina much mental anguish." Saalman, "Carrara Burials" (as in note 6), 381, errs in referring to Francesco as Fina's universal heir; it was rather her son, Francesco Novello, who inherited everything that was not otherwise specified by the will (see Kohl, "Last Will" [as in note 12], 342).

17. King, "Women as Patrons" (as in note 1), 249.

18. Saalman, "Carrara Burials" (as in note 6), 381–382; Poeschke, *Italian Frescoes* (as in note 14), 404. Saalman bases his argument on his reading of Fina's will; see note 14 above.

19. Solberg, "The Painter and the Widow" (as in note 2), 69; she suggests that "Francesco da Carrara ... may have put a damper on his wife's plans."

20. While King suggests that Francesco initiated the project, she proposes that Fina and her sister Anna, abbess of S. Benedetto, "might have played some part in developing this complex dynastic commission" ("Women as Patrons" [as in note 1], 254). Kohl, "Fina" (as in note 1), 28–29, considers "the possibility ... that Fina had some role in the iconography of the Baptistery." Warr, "Painting" (as in note 2) more confidently ascribes greater agency to Fina, maintaining that "she was able to commission a fresco cycle that reflected her individual needs" (155). She focuses on a single fresco, the Birth of John the Baptist, arguing for Fina's control of the image (153). In an article in press, a major study of saints' cults in late medieval Padua, Kohl also assigns a larger role to Fina, maintaining that she and the local bishop, Raimondo Ganimberti, collaborated on the commission. See B. Kohl, "Competing Saints in Late Medieval Padua," ed. M. Knapton, J. Law and A. Smith, *Reti Medievali* (Florence University Press, forthcoming). I am grateful to the editors for allowing me to read and cite the article in advance of publication.

his grandfather's palace (*mulier Deo devota impetravit a marito aedificari ibi templum...*).[21] The case of the Baptistery, an ecclesiastical structure rather than a privately owned palazzo, would have been considerably more complex. Though the building continued to function as a baptistery, the grand plan of transforming it into a family mausoleum, and the attendant structural alterations and pictorial decoration, would have required the approval of ecclesiastical authorities. Raimondo Ganimberti, named bishop of Padua in January, 1374, would have posed no obstacle: he was a close ally of the Carrara.[22]

Though Fina must have secured the cooperation of both her husband and the bishop before moving ahead, I argue that the commission was very much hers: much about the building itself and about the fresco program strongly implies choices made by Fina herself. Her tomb, originally mounted on the west wall and crowned by the canopy that still survives, was prominently situated so that citizens of Padua would have encountered it immediately on entering the Baptistery through one of the two doors flanking the apse (see Fig. 2).[23] Further, Fina's monogram is emblazoned both on the consoles supporting her tomb canopy (see Fig. 5) and on the lavabo in the sacristy; the Carrara and the Buzzacarini coats of arms appear on the altarpiece.[24]

If these decisions suggest Fina's active involvement, the fresco program is similarly revealing; the minimizing of her responsibility for the Baptistery is difficult to reconcile with the imagery. Consider first the donor portrait: centered on the west wall and crowned by its canopy, it commands the attention of visitors (see Figs. 2, 5). Here Fina kneels before the Virgin, child, and assembled saints, most of whom gesture toward Fina, further directing the viewer's gaze to her. Both Fina's place of honor, at the privileged right hand of the Virgin and child, and her size, perhaps three-quarters that of the saints, likewise signal her high station. Trecento donors, both male and female, usually presented themselves more humbly: either in significantly smaller scale than their saintly intercessors, or at the Virgin's left, or both. Particularly pertinent are earlier tomb monuments of the Carrara lords themselves; thus the monument of Marsilio da Carrara (d. 1338) depicts Marsilio at the Virgin's left, and in diminutive scale, less than half the size of the holy figures, and the two male votive figures from the tomb monument of Jacopo II da Carrara (d. 1350), Fina's father-in-law, are also significantly smaller than the Virgin.[25] In the Baptistery Fina's scale and placement seem to be the visual analogues to her will in asserting her "dignity, honor, and exalted status." Perhaps most significantly, in the Baptistery's donor

21. See note 8.

22. For Ganimberti see Kohl, *Padua* (as in note 6), 25, 129–130; *idem*, "Competing Saints" (as in note 20). Kohl, "Fina" (as in note 1), 25, proposes that Fina was assisted by Ganimberti. In his "Competing Saints," Kohl notes the preponderance of bishops in Fina's donor portrait and argues that Fina and Ganimberti jointly authored the program. If so, there may have been a falling-out along the way. One passage in Fina's will seems to suggest a degree of hostility to the bishop: after stipulating £1000 as a dowry for one of three possible young women, it concludes: "The said testatrix wants and orders that the said £1000 can and must, in no way, come into the hands of the Lord Bishop of Padua" (Kohl, "Last Will" [as in note 12], 342). As Ganimberti served as bishop of Padua from 1374 until 1386 (Kohl, *Padua*, 25), the passage can refer only to him.

23. The reconstruction by Saalman, "Carrara Burials" (as in note 6), 383, fig. 8, suggests the tomb's visual dominance in the interior. As Saalman argues, there were originally four doors—the two for citizens, on the east wall, opening onto the piazza, one for canons on the west wall, and a fourth, now closed, on the south, possibly used for processional entrances on major feast days. For the site of Fina's tomb, aligned with the door from the piazza, as the most desirable placement of funerary monuments, see D. Pincus, *The Tombs of the Doges of Venice* (Cambridge, 2000), 92, discussing the tomb of Doge Giovanni Soranzo in the baptistery of S. Marco, which was similarly located. As discussed below, important frescoes in the Padua Baptistery emulate the mosaics of S. Marco.

24. See Saalman, "Carrara Burials" (as in note 6), 379, for the monogram on the tomb consoles; *ibid.*, 387 and fig. 24 for the lavabo; for the coats of arms, see Delaney, "Giusto" (as in note 6), 108–109.

25. For both tombs, see D. Norman, " 'Splendid models and examples from the past': Carrara Patronage of Art," in *Siena, Florence, Padua: Art, Society and Religion 1280–1400*, vol. 1: *Interpretative Essays*, ed. D. Norman (New Haven, Conn., 1995), 155–175, esp. 156–158, fig. 161 (Marsilio), fig. 164 (Jacopo II). One could point to numerous other examples of comparative humility; for instance, in his donor portrait of 1371 in the Church of S. Maria delle Grazie, Magione, Francesco Casali is placed at the Virgin's left and in small scale. See A. Dunlop,

portrait Fina appears as the only patron; her husband, Francesco, is nowhere to be seen. In trecento painting, female patrons appear alone relatively rarely, and those who are shown alone are almost invariably identified either as nuns or as widows.[26] But Fina was no widow: at the time this fresco was painted, Francesco was very much alive—indeed he outlived her by fifteen years.

Francesco was not excluded from the Baptistery, which was intended as a mausoleum for husband and wife. The Carrara coat of arms appear several times in the building, and his grand marble sarcophagus once stood on the floor of the Baptistery—below that of his wife.[27] But the donor portrait, which not only privileges Fina visually but identifies her as the sole patron, suggests her control of the imagery here. In fact, as several scholars have observed, Fina's portrait is not limited to the donor fresco; instead her likeness is inserted repeatedly into the narrative program. In the Birth of John the Baptist (Fig. 6), perhaps the most obvious instance of these portraits, Fina stands to the far right, wearing an opulent burgundy gown; the

three elegantly clad young women next to her have been identified as her daughters. Two, both of whom had married at the time the frescoes were executed, wear the discrete head covering of wedded women; the bare head of the third, the youngest, attests to her status as a maiden.[28]

This image is itself remarkable, but it is not unique: Fina makes several cameo appearances in the Ministry and Passion cycles. Her appearance varies somewhat. The color of her robe changes, presumably because an elaborate wardrobe would itself have been a marker of the family's vast wealth. Moreover, in her portraits in these cycles, she wears a wimple; she is bare-necked in the donor portrait and the Birth of John the Baptist. Despite these differences, in each of the scenes where Fina's portrait has been identified, she is fairly prominent in the composition, and always richly attired, consistently wearing an elaborate headdress with a padded roll just above her brow, similar to the one she wears in the Birth of John the Baptist.[29] She can be identified, too, by the company she keeps: she is consistently surrounded by an

"Masculinity, Crusading, and Devotion: Francesco Casali's Fresco in the Trecento Perugian *Contado*," *Speculum* 76 (2001), 315–336, fig. 1. For a discussion of the small scale typical of donors in trecento painting, see D. Kocks, *Die Stifterdarstellung in der italienischen Malerei des 13–15 Jahrhunderts* (Ph.D. diss., University of Cologne, 1971), 133, cited by King, *Renaissance Women Patrons* (as in note 2), 129, and for female patrons more specifically, see King, *Renaissance Women Patrons*, 129–151. She observes: "No sole donatrixes are known to have commissioned a realistically-sized portrait of themselves until the last quarter of the 15th century" (130), but notes that a few female donors, among them Fina, are shown in three-quarters the scale of the accompanying saints (131). For placement to the left or right, see the important article by C. Schleif, "Men on the Right—Women on the Left: (A)symmetrical Spaces and Gendered Places," in *Women's Space*, ed. Raguin and Stanbury (as in note 2), 207–249; she cites a few instances in which female patrons occupy the heraldic right (230–236). For other examples, see Caviness, "Anchoress" (as in note 3), 126–128. For an example in Padua, probably painted shortly after the Baptistery, in which a female donor occupies the dexter side, see the Chapel of S. Giacomo in the Santo, painted by Altichiero, depicting Bonifacio Lupi and Caterina de'Francesi. She has the privileged right; the supervision of the chapel's construction was entrusted to her. Another in which a female donor has the privileged space is a triptych by Altichiero now in Richmond, Virginia Museum of Fine Arts. For the S. Giacomo Chapel and

Caterina's portraits there, see Richards, *Altichiero* (as in note 1), 156–157; for the Richmond triptych, *ibid.*, 222.

26. Solberg, "The Painter and the Widow" (as in note 2), 54, notes that Datuccia Sardi appears without a consort in the sacristy of S. Francesco, Pisa, and concludes that she must have been widowed at the time: "Were her husband alive, by rights an image of him would appear as co-donor ... the depiction of her image alone while her consort was still living would connote preeminence in a way practically unknown for a private woman of her time" (her footnote acknowledges Fina as an exception). E. L'Estrange, *Holy Motherhood: Gender, Dynasty and Visual Culture in the Later Middle Ages* (Manchester, 2008), in a wide-ranging and thoughtful study, erroneously assumes that Fina was a widow (26–27).

27. For the Carrara coats of arms, just below the donor portrait (Fig. 5), in the pendentives (Fig. 2), and on the altarpiece, see Delaney, "Giusto" (as in note 6), 108–109. For the probable placement of Francesco's sarcophagus, see the reconstruction in Saalman, "Carrara Burials" (as in note 6), 383, fig. 8.

28. Spiazzi first recognized these figures as Fina and her daughters; see "Giusto a Padova," (as in note 6), 96–97. See also King, "Women as Patrons" (as in note 1), 253; Warr, "Painting" (as in note 2), Kohl, "Fina" (as in note 1), 30–31.

29. Fina's headdresses vary somewhat in the details of construction, such as the height of the roll, but remain consistent enough to distinguish her from the rest of her entourage. For the wimple in trecento art and culture, see R. Levi Pisetzky,

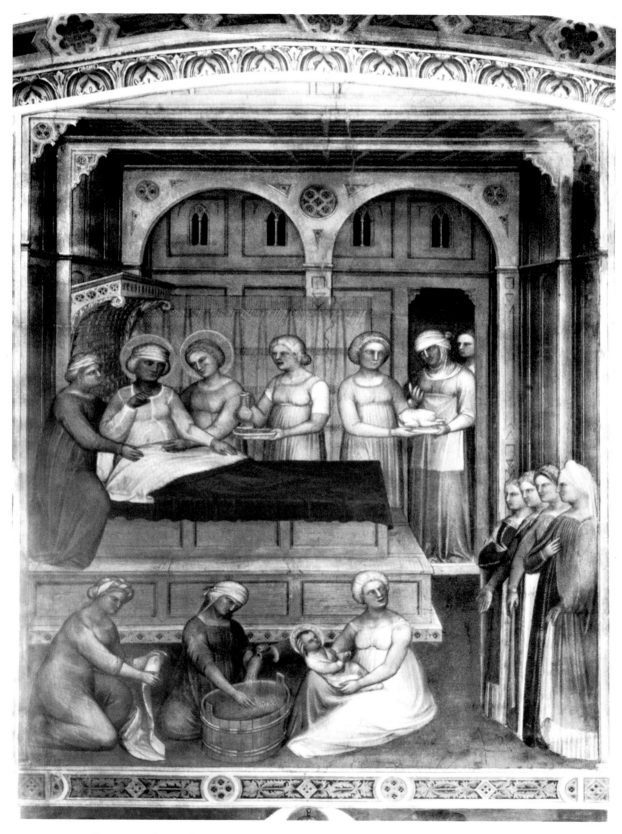

FIGURE 6. Giusto de' Menabuoi, Birth of John the Baptist. Baptistery, Padua, mid-1370s
(photo: © Genevra Kornbluth).

entourage of women—reminding one of the noble-women with whom she lived in her palazzo within the Carrara compound. Her sister Anna, the Benedictine abbess, is always among the group.

In an unusual fresco of Christ working miracles (Fig. 7), Fina appears next to the poet Francesco Petrarch, a favorite of the Carrara court; on the other side of the poet is her husband. The young women to her right are her daughters, and just below her is Anna, wearing the habit of her order, a black cloak with white wimple and white lining of the veil (Fig. 8).[30] In the Way to Calvary (Fig. 9), Fina and the women who accompany her remarkably stand in for the "daughters of Jerusalem" (Luke 12:28); the soldiers address them, much as they address the Virgin and holy women in more conventional renderings of the subject. Here, Fina wears a headdress and wimple that are almost identical to those in the Miracles of Christ, and gestures with hands extended in prayer; Anna is one row behind her sister. The next fresco, the Crucifixion (Fig. 10), also includes an appearance by Fina and her entourage, whose ranks have greatly expanded. Fina, now in a deep blue gown and a somewhat grander version of the headdress, stands just behind the swooning Virgin; Anna is again one row back. Fina and other members of the Carrara court may also appear in the Raising of Lazarus and the Entry into Jerusalem, both of which feature large crowd scenes, but the two frescoes are too badly damaged to be certain.[31]

The insistent portraits of Fina, to which I will return, can be understood on several levels. In a sense, they are characteristic of late medieval painting in Padua: so-called "crypto-portraits" have been identified in several other sites.[32] The S. Giacomo Chapel in the Santo, painted by Altichiero probably in the later 1370s, provides pertinent examples. In the Council of King Ramiro, recognizable figures from the Carrara court, including Petrarch, appear among the crowds to either side of the monarch.[33] But this fresco and others insert portraits into relatively minor narrative scenes, distant from the biblical canon. The portraits of Fina in the Baptistery seem more daring: Fina and her entourage appear as witnesses to, even participants in, events from the life of Christ.

These portraits can be read as documents of her piety: devotional texts like the *Meditations on the Life of Christ* instructed readers to imagine themselves present at biblical events. But they also seem to be pointed assertions of authority, overt claims of agency, injected through the program. It is worth noting that most other examples of crypto-portraiture depict men; these are perhaps the most extensive portraits of a female patron in late medieval Italy.

Elsewhere in the program, too, we sense the controlling hand of a powerful female patron. The representation of Paradise in the dome, in particular the myriad saints that populate it, deserves close attention. John the Baptist and John the Evangelist kneel before the Virgin at the head of the three concentric

Storia del costume in Italia, vol. 2: *Il Trecento* (Milan, 1964), 119–121, and G. Ragionieri, "Origini e fortuna di un motivo iconografico: la Madonnna con il soggolo," in *Giotto e Bologna*, ed. M. Medica (Cinisello Balsamo, 2010), 37–45. At least in trecento Padua, visual evidence indicates that the wimple was favored by elite women in mid-life; thus in the Baptistery, Elizabeth wears a wimple in the Visitation, while the Virgin does not. My thanks to Tawny Sherrill for discussing these aspects of costume with me.

30. For the portraits of Fina, Anna, Francesco, and Petrarch in the Miracles of Christ, see Spiazzi, "Giusto a Padova" (as in note 6), 111; Bellinati, "Iconografia" (as in note 6), 58; Kohl, "Fina" (as in note 1), 31; *idem*, "Giusto" (as in note 6), 19. For the habit of Benedictine nuns, see G. Kaftal, *Iconography of the Saints in Tuscan Painting* (Florence, 1952), xxv.

31. Bellinati, "Iconografia" (as in note 6), 67, identifies the portraits of Fina and her daughters in the Crucifixion. Spiazzi refers to other portraits in the Raising of Lazarus, as well as Christ before Pilate ("Giusto a Padova" [as in note 6], 111). M.

Plant, "Patronage in the Circle of the Carrara Family: Padua, 1337–1405," in F. W. Kent and P. Simons, eds., *Patronage, Art, and Society in Renaissance Italy* (Canberra; Oxford, 1987), 190, also identifies Fina and Francesco in the fresco of Christ before Pilate.

32. See G. Mardersteig, "I Ritratti del Petrarca e dei suoi amici di Padova," in *Italia medioevale e umanistica* 17 (1974), 251–280; M. Plant, "Portraits and Politics in Late Trecento Padua: Altichiero's Frescoes in the S. Felice Chapel, S. Antonio," *Art Bulletin* 63 (1981), 406–425, and Richards, *Altichiero* (as in note 1), 148. C. Schleif has rightly pointed out the problematic nature of this term. See her "Nicodemus and Sculptors: Self-Reflexivity in Works by Adam Kraft and Tilman Riemenschneider," *Art Bulletin* 75 (1993), 599–626, at 617.

33. Mardersteig, "I Ritratti" (as in note 32); Plant, "Portraits" (as in note 32), 409–416; Richards, *Altichiero* (as in note 1), 156–158.

FIGURE 7. Giusto de' Menabuoi, Miracles of Christ. Baptistery, Padua, mid-1370s (photo: ©
Genevra Kornbluth).

FIGURE 8. Giusto de' Menabuoi, Miracles of Christ, detail: Francesco da Carrara, Francesco
Petrarch, Fina Buzzacarini, Anna Buzzacarini, members of the Carrara court. Baptistery,
Padua, mid-1370s (photo: © Genevra Kornbluth).

FIGURE 9. Giusto de' Menabuoi, Way to Calvary, detail: Fina Buzzacarini and entourage. Baptistery, Padua, mid-1370s (photo: © Genevra Kornbluth).

FIGURE 10. Giusto de' Menabuoi, Crucifixion, detail: Fina Buzzacarini and entourage. Baptistery, Padua, mid-1370s (photo: © Genevra Kornbluth).

Anne Derbes

FIGURE 11. Giusto de' Menabuoi, Dome, detail: Virgin, heavenly court. Baptistery, Padua, mid-1370s (photo: Valentino Pace).

circles of saints (Fig. 1, Fig. 11); choirs of angels occupy the top two circles. As Catherine King has observed, female saints appear in surprising numbers: in the largest, most prominent circle, just behind John the Baptist and John the Evangelist, fully half of the assembled saints are female.[34] The emphasis upon them becomes starker when one considers that the apostles, who are normally given pride of place in such compositions, are here relegated to the third circle, visually almost indistinguishable from the saintly hordes surrounding them.

Just behind John the Evangelist, at the head of the group, identified by the inscription on her footstool, is Martha, sister of Mary and Lazarus (Fig. 11).[35] Her position of honor may seem curious, for she was

typically eclipsed by the cult of her more famous sister. Moreover, her cult did not figure significantly in Padua; there is no church or chapel of Sta. Marta in Padua or the Padovano, nor was her feast recorded in the Paduan liturgical calendar.[36] But late medieval texts such as the *Golden Legend* and the *Meditations on the Life of Christ* associate Martha with the prudent oversight of the household and of family estates. She would have been a particularly apt exemplar for Fina, who had similar responsibilities.[37]

Holy women appear as well among the predominantly male half of the ranks, and there, too, though their numbers are now smaller, they are nonetheless at times privileged visually. In the first circle, behind John the Baptist, is a triad of Paduan saints from the

34. King, "Women as Patrons" (as in note 1), 252–253. There are seventeen women behind John the Evangelist, seventeen men behind the Baptist—along with an eighteenth woman, S. Giustina, among the men.

35. See Bellinati, "Iconografia" (as in note 6), 49, for these inscriptions.

36. See the thorough discussion of the many saints venerated locally by Kohl, "Competing Saints" (as in note 20).

37. The entry for Mary Magdalen in *The Golden Legend* (trans. and ed. W. Ryan [Princeton, N.J., 1993], 1, 375) says of

Martha: "prudent Martha kept close watch over her brother's and sister's estates and took care of the needs of her armed men, her servants, and the poor." The entry for Martha (Ryan, 2, 23–26) describes her royal lineage, her eloquence, and her graciousness. In the *Meditations on the life of Christ* (trans. and ed. F. Taney, Sr., A. Miller, O.S.F., and C. Stallings-Taney [Asheville, N.C., 1999], 199), the author quotes a sermon by Bernard of Clairvaux on the Assumption of the Virgin: "Let Martha receive the Lord in her house, for surely the household management has been entrusted to her."

early Christian era: the first bishop of Padua, Prosdoscimo, Giustina, and Daniel (Fig. 11). Notably, Giustina is the largest of the three; she is allotted considerably more space than the men to either side of her, particularly Prosdoscimo, who seems wedged into his throne.[38] In the second tier are Joachim and Anna—Anna gazing directly upon the Virgin, while Joachim looks at his wife—Zachariah and Elizabeth, an unidentified male, and four Old Testament matriarchs: Sara, Rebecca, Rachel and Leah. Their spouses—Abraham, Isaac, and Jacob—sit behind them, consigned to the third circle.

While all of this is striking, what interests me most in the Baptistery is the emphasis not merely on female sanctity but on maternity: references to motherhood, and more broadly to fecundity, generativity, and generation, recur throughout the program. A baptistery is itself a site of spiritual rebirth, and medieval theologians had long associated the sacrament of Baptism with maternal imagery: the influential canonist Durandus notes that the Church is sometimes called "mother, for daily through Baptism she bears spiritual sons to God."[39] And throughout the cycle, from the Genesis scenes in the drum of the dome through the Apocalypse in the apse, themes featuring motherhood figure prominently. Mothers are especially conspicuous in the Genesis cycle: repeatedly biblical

matriarchs are inserted into the narrative in unexpected, even unprecedented, ways. Not only are they included in narratives from which they are typically omitted; at times they even take active roles, roles that accord them not merely visibility but agency. Moreover, neither their presence nor their participation can be explained by the text of Genesis; in some instances the images go so far as to contradict the biblical account. Two sections of the drum, the Noah cycle (Fig. 12) and the Jacob cycle (Fig. 13), seem especially suggestive. In Noah's prayer of thanksgiving after the flood—itself a most unusual subject in the trecento[40]—he is joined not only by his sons but also by his wife and his daughters-in-law. Genesis 8:20 states only that "Noah built an altar unto the Lord," with no mention of his family's participation. In the next episode, the Drunkenness of Noah, the wife of Noah not only witnesses his inebriation, but, remarkably, has removed her own cloak; grasping it with both hands, she is about to extend it to shield his nakedness. Genesis 9:21–27 states that two of Noah's sons dutifully covered their father; his wife is not mentioned at all in this context.[41] In the wine-making to the right, two young women, presumably Noah's daughters-in-law, take part, joining one of his sons.

The episodes from the life of Jacob (Fig. 13) are equally curious, and are likewise at odds both with

38. For the identification of all of the saints in the dome, see Bellinati, "Iconografia" (as in note 6), 49. Giustina is also privileged in Giusto's fresco in the Baptistery's sacristy, depicting the Man of Sorrows flanked by Giustina and Prosdocimo; she appears to Christ's right (Saalman, "Carrara Burials" [as in note 6], fig. 23).

39. "Quandoque mater, quia quotidie in baptismo spirituales filios Deo parit," *Rationale Divinorum Officiorum* ed. J. Beleth (Naples, 1859), 12. The translation by T. Thibodeau, *The Rationale Divinorum Officiorum of William Durand of Mende: A New Translation of the Prologue and Book One* (New York, 2007), 4, mutes the generative connotations of Durandus's *parit* ("she daily provides God with spiritual sons through Baptism"). For the baptismal font as womb in patristic thought, see R. Jensen, *Living Water: Images, Symbols, and Settings of Early Christian Baptism* (Leiden; Boston, Mass., 2011), 247–251.

40. Delaney, "Giusto" (as in note 6), 145–146, emphasizes the theme's rare occurrence. Noah's thanksgiving is depicted in the densely illustrated late fourteenth-century Padua Bible, fol. 5ᵛ. (Rovigo, Biblioteca dell'Accademia dei Concordi, Ms. 212 fondo Silvestri; London, British Library, Ms. Add. 15277),

with almost 900 miniatures, but there he alone appears at the altar. See *Bibbia istoriata padovana della fine del trecento: Pentateuco, Giosuè, Ruth,* ed. G. Folena and G. Mellini (Venice, 1962), pl. 10. For this manuscript, see also F. Toniolo, "La Bibbia istoriata padovana," in *Visibile parlare: La "Bibbia istoriata padovana" tra parola e imagine* (Modena, 1999), 4–17; *La Miniatura a Padova dal Medioevo al Settecento,* Exhib. cat., ed. G. Molli, G. Mariani, and F. Toniolo (Modena, 1999). Many thanks to Maria Saffioti Dale for her generous assistance with these references.

41. Delaney, "Giusto" (as in note 6), 148, notes the inclusion of Noah's wife, observing that it may be unique; he does not comment on her action. The color of her mantle, the same mustard yellow that she wears in the scene of thanksgiving above, confirms her identity. Noah's wife, sometimes scorned as a shrew (especially in medieval English texts), was at times seen as virtuous, even as a type of the Virgin; a moralized Bible explains: "Noe significat Christum, uxor eius beatam Mariam" (cited by A. Mill, "Noah's Wife Again," *PMLA* 56 [1941], 613–626, at 615).

FIGURE 12. Giusto de' Menabuoi, Dome, detail: Noah cycle. Baptistery, Padua, mid-1370s
(photo: Valentino Pace).

the biblical text and with pictorial tradition.⁴² The
narratives include the rarely depicted episode of Jacob
and the spotted sheep (Genesis 30:25–43)—a kind of
genetic engineering ploy through which he extricated
himself from the services of his uncle, and father-in-
law, Laban. Though the text does not mention the
participation of his wives, Rachel and Leah, here they
are actively engaged in the scheme, one pouring water
into the animals' trough and the other holding one
of the "green rods" mentioned by the text (Genesis
30:37) and tending a small son.⁴³ Next is the more
familiar narrative of Jacob wrestling with the angel.
Here, Rachel, Leah, and their children sit to the left,
observing the struggle; their inclusion is particularly
striking given the text, which states that Jacob was
alone—*solus* in the Vulgate (Genesis 32:23)—at the
time of the encounter.⁴⁴ Mothers and children ap-

pear prominently as well in the unusual episode of
the reconciliation of Jacob and Esau, though now
the text (Genesis 33:2) warrants their presence. In
a fourth episode, Joseph recounts his dream to his
parents, Jacob and Rachel; Jacob is enthroned, but
Rachel stands next to her husband and looks on at-
tentively. Rachel's inclusion is most unusual; Genesis
37:10 states only that "he had told [the dreams] to
his father and brethren."

In the final narrative cycle, the Apocalypse in the
apse (see Fig. 3), other images focus attention on ma-
ternity, and it is in the context of this cycle, I believe,
that the significance of these images for Fina becomes
most clearly revealed. The Apocalypse is seen in-
frequently in northern Italian painting during the
trecento, and this cycle, which recounts the horrific
events of Revelation in detail, is often overlooked in

42. For a detailed consideration of the few pictorial prec-
edents for these scenes, see Delaney, "Giusto" (as in note 6),
155–167.

43. The episode is depicted in the Padua Bible, fol. 22ᵛ, where
Jacob is shown carrying out his plan alone; the wives are not

present even as observers. See Folena and Mellini, *Bibbia isto-
riata* (as in note 40), pl. 44.

44. Again, in the Padua Bible, fol. 23ᵛ, Rachel and Leah do
not appear (*ibid.*, pl. 46).

FIGURE 13. Giusto de' Menabuoi, Dome, detail: Jacob cycle. Baptistery, Padua, mid-1370s (photo: © Genevra Kornbluth).

the literature on the Baptistery.[45] Both early sources on the Baptistery, Savonarola and Scardeone, mention only the Old Testament and New Testament cycles, and some modern scholars who discuss the Baptistery frescoes refer to the Apocalypse narratives only in passing or ignore them entirely. The cycle begins on the north wall with a great lunette depicting John's vision on Patmos. Above the altar in a second lunette is Christ in majesty, with the twenty-four elders, and in the registers below, the events of Revelation 4–22 unfold. As Figure 3 suggests, the size of the frescoes in the apse varies considerably. After the two lunettes, largest in size are the six narratives on the north wall of the apse, to the left of the altar, below John on Patmos. The six are visibly larger than those on the wall opposite (not shown here) and considerably

larger than those on the altar wall, as Figure 3 indicates. Centered in the group of six are two frescoes featuring the woman of Revelation 12, often called the Apocalyptic woman. The particular prominence accorded this subject seems noteworthy, and as the biblical text reveals, the woman's pregnancy and delivery are central to the narrative; the entire chapter is devoted to the woman and her travails.

The chapter opens with the appearance of "a great sign in heaven" (*signum magnum ... in caelum*): "A woman clothed with the sun and the moon under her feet, and on her head a crown of twelve stars" (*mulier amicta sole et luna sub pedibus eius et in capite eius corona stellarum duodecimo*). Rev. 12:2 goes on to describe the pregnancy and labor of the woman: "And being with child, she cried travailing in birth: and was in pain

45. The sole center to evince consistent interest in depicting the Apocalypse narrative is the Angevin kingdom of Naples. In the early fourteenth century, Queen Mary of Hungary founded the convent of S. Maria Donna Regina; the queen was responsible for the Apocalypse cycle, now damaged, over a doorway, and for the towering fresco of the Virgin as the Apocalyptic

Woman in the nun's choir. For this church, see the essays in Elliott and Warr, *Santa Maria Donna Regina* (as in note 11), and for the Apocalypse images, see in particular J. Elliott, "The 'Last Judgement': The Cult of Sacral Kingship and Dynastic Hopes for the Afterlife," in Elliott and Warr, 175–193. According to sixteenth-century sources, Giotto painted an Apocalypse

FIGURE 14. Giusto de' Menabuoi, Apocalyptic Woman and Son Menaced by the Dragon. Baptistery, Padua, mid-1370s (photo: © Genevra Kornbluth).

to be delivered" (*in utero habens et clamat parturiens et cruciatur ut pariat*); subsequent verses recount the appearance of the seven-headed dragon that threatens to devour the son she delivers (Rev. 12:5), the rescue of the child from the beast, and the escape of the woman to the wilderness. On the left (Fig. 14), the woman and her infant are menaced by the dragon. A solar disc on her torso signifies that she is clothed with the sun;

a second disc, representing the moon, is at her feet, and a star-studded crown encircles her head. She has already given birth, for her small son lies on her lap. As the dragon approaches, she recoils and gestures in alarm, hands in the air. Just above the woman, an angel hovers, about to spirit the baby away, "up to God and his throne" (Rev. 12: 6).

The second fresco (Fig. 15), more poorly preserved,

cycle for S. Chiara, Naples. Other apocalyptic works commissioned by the Angevins include three Bibles with extensive cycles of Revelation (A. Bräm, *Neapolitanische Bilderbibeln des Trecento: Anjou-Buchmalerei von Robert dem Weisen bis zu Johanna I*, 2 vols. [Wiesbaden, 2007]; C. Fleck, *The Clement Bible at the Medieval Courts of Naples and Avignon: A Story of Papal Power, Royal Prestige, and Patronage* [Surrey; Burlington, Vt., 2010], 54–67); and the panels now in Stuttgart, for which see

R. Wright, "Living in the Final Countdown: The Angevin Apocalypse Panels in Stuttgart," in *Prophecy, Apocalypse, and the Day of Doom, Proceedings of the 2000 Harlaxton Symposium*, ed. N. Morgan, Harlaxton Medieval Studies, XII (Donington, 2004), 261–276. For a discussion of the Apocalypse cycle at all of these sites, as well as the Baptistery, see L. Rivière Ciavaldini, *Imaginaires de l'apocalypse: pouvoir et spiritualité dans l'art gothique européen* (Paris, 2007).

FIGURE 15. Giusto de' Menabuoi, Battle in Heaven; Escape of the Woman to the Wilderness; Worship of the Beast. Baptistery, Padua, mid-1370s (photo: © Genevra Kornbluth).

conflates several episodes of the text. To the left is the war that breaks out in heaven: St. Michael and his forces battle the dragon and his minions (Rev. 12:7); to the right, the creature fights on, lunging at the woman and spewing water at her (Rev. 12:15), as the woman, now equipped with eagle's wings (Rev. 12: 14), soars aloft. As she flies, she gestures with arms widespread much as in the first fresco. Finally, to the lower right, is a later moment of the narrative: kneeling turbaned figures worship the dragon, as described in Rev. 13:4.

This detailed treatment of Revelation 12 is most unusual in late medieval Italian fresco programs. I know no other program that represents the Apocalyptic woman more than once, and no other that offers such comprehensive treatment of these verses. What seems most pertinent in the sign system of the Baptistery program as a whole is the woman's gesture: in each of the two frescoes, she is shown with hands outstretched. The stance is fairly common in trecento narrative contexts, most often connoting shock or grief, a meaning applicable here. But the gesture is also visually related to the ancient orant stance, signifying prayer or submission to God—and variants

FIGURE 16. East dome, S. Marco, Venice, 12th cent. (photo: © Dumbarton Oaks, Image Collections and Fieldwork Archives, Washington, D.C.).

of this gesture occur, most unusually, elsewhere in the program of the Baptistery.

Most obviously, the Virgin appears as an orant in the dome, where she stands with hands outstretched (see Fig. 1, Fig. 11). This hieratic, formal stance is an anomaly in trecento images of the Virgin; both her stiff frontality and her gesture seem consciously archaizing. They specifically recall the twelfth-century east dome of S. Marco in Venice (Fig. 16); there, too, the orant Virgin appears in the dome, below the half-length Christ, accompanied by heavenly figures.[46] The appropriation of the S. Marco mosaic seems strategic,

aligning Fina and Francesco with the prestige of Venice in general and the doges in particular, who often elected to be buried in S. Marco; in the fourteenth century, two doges were interred more specifically in S. Marco's baptistery.[47]

But, though the fresco evokes the S. Marco mosaic, the two differ in multiple ways. In S. Marco, the Virgin appears in the company of thirteen prophets; in the Baptistery, those few have multiplied into throngs of saints and angels, defining the setting as Paradise.[48] In S. Marco, the Virgin is only slightly taller than the prophets; in the Baptistery, she is a dominant

46. The obvious reference to the east dome of S. Marco has long been observed; see Delaney, "Giusto" (as in note 6), 118, with earlier literature. Bellinati also notes links between episodes from the Old and New Testament in the Baptistery and S. Marco ("Iconografia" [as in note 6], 41–42).

47. The first was Doge Giovanni Soranzo (d. 1328); Pincus notes that this was the first time a ruler was buried in a baptistery in western Europe (*Tombs* [as in note 23], 90) and characterizes the burial of Sorzano in the baptistery as a "radi-

cal act" ("Venice and Its Doge in the Grand Design: Andrea Dandolo and the Fourteenth-Century Mosaics of the Baptistery," in *San Marco, Byzantium, and the Myths of Venice*, ed. H. Maguire and R. Nelson [Washington, D.C., 2010], 245–271, at 248). The second doge buried in S. Marco's baptistery was Andrea Dandolo (d. 1354). For both, see Pincus, *Tombs*, ch. 6 (Sorzano), ch. 8 (Dandolo); for Dandolo, see also Pincus, "Venice and Its Doge."

48. For the dome as a depiction of Paradise, and its appro-

figure, dwarfing those surrounding her. In S. Marco, she stands on a low gem-studded footstool, while in the Baptistery she hovers, as if levitating, before the crowd. An immense golden mandorla of fine, radiating lines, a kind of sunburst, now surrounds her. Finally, in contrast to S. Marco, where the Virgin wears her usual maphorion, in the Baptistery a massive crown rests atop her veil.

All of these points of divergence suggest her transformation from Byzantine orant to *mulier amicta sole*. The woman of Rev. 12 had long been identified with the Virgin,[49] and images of Mary in the guise of the Apocalyptic Woman become increasingly common in the fourteenth century and continue into the fifteenth. The radiant mandorla is one of several devices commonly used in later medieval painting to signify that she is clothed with the sun, and the crown is an almost omnipresent attribute. To cite a single example, in the Hours of Catherine of Cleves, Catherine kneels before the Virgin and Child. A resplendent golden mandorla much like the one in the Baptistery dome surrounds mother and son, and the Virgin wears a large crown.

In the illumination an additional attribute, the crescent moon at her feet, along with the mandorla and crown, confirms the Virgin's identity as the Apocalyptic Woman.[50] In the Baptistery, other aspects of the image also accord with the text of Revelation 12:1: "a great sign appeared in heaven" (*signum magnum paruit in caelum*). Towering over the saints and heavenly hosts, the Virgin is an ethereal, hovering presence—an apparition. Furthermore, her stance is also consistent with the iconography of the *mulier amicta sole*, who appears fairly often as an orant in medieval art.[51] Taken together, all of these points suggest that the Byzantine orant of S. Marco is here re-imagined as the woman of Revelation 12, clothed with the sun and crowned with the stars. The Virgin in the dome thus functions on multiple levels, in intervisual dialogue both with the S. Marco mosaic and with multiple medieval images of the Apocalyptic Woman.[52]

On the west wall of the Baptistery, the Virgin of the Annunciation (Fig. 17) participates in the same dialogue. Gabriel's pose is nothing exceptional; it bears a strong resemblance to Gabriel's in the Arena

priateness for the Baptistery, see Delaney, "Giusto" (as in note 6), 112; 116–121; Poeschke, *Italian Frescoes* (as in note 14), 405.

49. For commentaries, see G. Lobrichon, "La Femme d'Apocalypse 12 dans l'Occident latin (760–1200)," in *Marie: Le culte de la Vierge dans la société médiévale*, ed. D. Logna-Prat, E. Palazzo, and D. Russo (Paris, 1996), 407–439.

50. For this manuscript (New York, Morgan Library, Ms. M. 945, *c.* 1440), see the online digital facsimile, www.themorgan.org/collections/works/cleves/default.asp.

51. For a cogent discussion, see J. Hamburger, *The Rothschild Canticles: Art and Mysticism in Flanders and the Rhineland circa 1300* (New Haven, Conn., 1990), 100–104; that manuscript includes an early image of the Virgin as *mulier amicta sole* isolated from the narrative context of Revelation, and there, too, she appears as an orant (Yale, Beinecke Library, Ms. 404, fol. 64ʳ; Hamburger, fig. 41). The gesture is not as uncommon as Hamburger suggests (102); he points to a single earlier occurrence, in a thirteenth-century manuscript from Verona, not far from Padua, Ms. Vat. lat. 39, fol. 163ʳ, his fig. 184. Others include a Neapolitan fresco in S. Maria Donna Regina, *c.* 1320 (see Elliott, "'Last Judgement'" [as in note 45], 175–177, fig. 76); a French manuscript of *c.* 1370–1390 in the British Library, Ms. Yates Thompson 10, fol. 19 (N. Morgan, "The French Interpretations of English Illustrated Apocalypses," in *England and the Continent in the Middle Ages: Studies in Memory of Andrew Martindale, Proceedings of the 1996 Harlaxton Symposium*, ed.

J. Mitchell and M. Moran, Harlaxton Medieval Studies, VIII [Stamford, 2000], 137–156 [at 138, n. 7]); and several copies of the *Speculum humanae Salvationis*, such as Paris, Bibliothèque Nationale, Ms. lat. 512, fol. 158ᵛ. The fresco in S. Maria Donna Regina is especially close to the Baptistery Virgin, similarly iconic in its frontality, and as Elliott notes, 175, the disc on the woman's torso links this image with a Byzantine icon known as the Blachernitissa-Platytera: the Virgin is shown as an orant, and the image denotes Mary's pregnancy, for the disc, encircling a tiny Christ child, is a formulaic depiction of the child *in utero*. In S. Maria Donna Regina, the conjoining of the Blachernitissa-Playtera and the Apocalyptic woman redoubles the allusion to pregnancy—which is central both to the icon and to the narrative in Rev. 12.

52. The Baptistery's allusion to the mosaic in S. Marco's east dome specifically is pertinent, for as O. Demus has shown, both the depiction of Christ as Emmanuel—the Logos before the Incarnation—and the scrolls held by six of the thirteen prophets, which refer to the coming of Christ, underline the mosaic's incarnational meaning, one highly appropriate to this reading of the Baptistery fresco. See O. Demus, *The Mosaics of San Marco in Venice*, I: *The Eleventh and Twelfth Centuries*, vol. 1: Text (Chicago; London, 1984), 160–161. Despite interventions by later restorers, the mosaic is iconographically intact, according to E. Hawkins and L. James, "The East Dome of San Marco, Venice: A Reconsideration," *Dumbarton Oaks Papers* 48 (1994), 229–242, at 241.

FIGURE 17. Giusto de' Menabuoi, Annunciation. Baptistery, Padua, mid-1370s
(photo: Valentino Pace).

Chapel, which is not unexpected—for Giotto's compositions had a long afterlife in Padua. But Giusto's Virgin shares nothing with Giotto's, who crosses her arms across her breast; instead, with arms raised and palms out, she stands and solemnly faces the kneeling Gabriel. This is a most unusual way of depicting the Annunciate Virgin in trecento Padua, where the Virgin most often keeps her hands demurely close to her

body, either with one hand discreetly raised or with arms crossed in Giottesque fashion.[53] How are we to interpret this curious deviation from usual practice? Mary's gesture in the Baptistery has at times been read as expressing surprise or fear[54]—a reference to her disquiet at Gabriel's words (Luke 1:29: *turbatus est in sermone eius*), and indeed, trecento painters occasionally chose to represent this moment in the

53. See, for instance, Guariento's strikingly Giottesque Annunciation in the enormous polyptych now in the Norton Simon Art Foundation; F. D'Arcais, "Profilo di Guariento," *Guariento e la Padova carrarese,* ed. D. Banzato, F. D'Arcais, and A. M. Spiazzi (Venice, 2011), 20, fig. 4; Altichiero's Annunciation in the Oratory of S. Giorgio, Padua, 1379–1384 (Richards, *Alti-*

chiero [as in note 1], pl. 77); or Giusto's own fresco in the Belludi chapel of the Santo (G. Bresciani Alvarez, *La Cappella del Beato Luca e Giusto de' Menabuoi nella Basilica di Sant'Antonio* [Padua, 1988]; Bourdua, *Franciscans* [as in note 1], 131–144).
54. For instance, Delaney, "Giusto" (as in note 6), 193, describes the Virgin as "shielding herself" from the Holy Spirit.

FIGURE 18. Giusto de' Menabuoi, Annunciation, detail of right wing of polyptych, 1367 (photo: © The National Gallery, London).

narrative. Giusto was among them: his Annunciate Virgin in the right wing of a polyptych of 1367 (National Gallery, London; Fig. 18), painted before he arrived in Padua, also responds to Gabriel by raising her hands.[55] But, as this panel makes obvious, Giusto was quite capable of depicting unambiguous alarm: here, the Virgin clearly turns from Gabriel, recoiling, her body twisting away from her visitor. The

demeanor of the Annunciate Virgin in the Baptistery is calm rather than tremulous, coolly receptive rather than fearful. Now Giusto depicts not Mary's initial apprehension (Luke 1:29) but the culminating moment in the narrative, her submission to the divine plan (Luke 1:38: *ecce ancilla Domini fiat mihi secundum verbum tuum*). Indeed the position of her feet suggests that she has taken a step toward Gabriel in her readiness to conceive.

Both gesture and stance thus seem calculated to emphasize the moment of her impregnation as the dove speeds toward her—and influential texts and a local dramatic enactment make the moment explicit. In the *Golden Legend*, Jacobus da Voragine, after a lengthy consideration of the Annunciation, quotes Bernard of Clairvaux exhorting the Virgin to acquiesce: "Now Bernard: 'Quick, Virgin, give your answer! O Lady, say the word and accept the Word..., rise up, run, open yourself! Arise by faith, run by devotion, open by giving your consent!' Then Mary, raising her hands and her eyes to heaven, said, *Behold the handmaid of the Lord, be it done to me according to thy word....* And in an instant the Son of God was conceived in her womb...."[56] A still more pertinent local example would have been enacted annually in the Cathedral, next to the Baptistery, in a liturgical drama dating from the fourteenth century. The surviving text includes stage directions specifying the gestures of the actors at key moments; at the point of her assent, "Mary rises, and, standing, with open arms, with a noble voice, begins: "Behold the handmaid."[57] The gesture of the Annunciate Virgin (see Fig. 17) thus establishes the precise instant enacted here, the moment of conception, and reprises the gesture of the orant Virgin in the dome (see Fig. 11) who in turn recalls the *mulier amicta sole* in the apse (see Figs. 14, 15). These images of women with hands outstretched, images evocative of conception, pregnancy, and birth, echo from dome to wall to apse, each accruing meaning from the others.

55. D. Gordon, *The Italian Paintings before 1400*, National Gallery Catalogues (London, 2011), 262–271.

56. *Golden Legend* (as in note 37), 1, 200.

57. K. Young, *Drama of the Medieval Church*, 2 (Oxford, 1933), 248–250; the relevant text reads: "Maria [se] eleuet, et stando brachijs apertis alta uoce incipeat *Ecce ancilla*" (249). Bellinati,

"Iconografia" (as in note 6), 60, also notes the connection to the play. In fact, the Baptistery was still more intimately associated with the drama: the actors playing Mary, Elizabeth, Joseph, and Joachim processed from the Cathedral to the Baptistery, where the boy playing the part of Gabriel waited to be lifted and carried into the Cathedral (Young, *Drama*, 2, 248).

To return to Fina: the images under discussion were likely deeply personal for her. Bearing a son was then incumbent upon all married women, but for Fina, as the consort of the ruling lord, the pressure to produce an heir was especially intense. After marrying Francesco in 1345, when she was 20, she gave birth to three daughters in rapid succession, but the requisite son and heir was not forthcoming. In 1354, nine years after her marriage, Fina's failure to bear a son triggered a family feud about succession that culminated in a murder plot against Francesco; though the plot was foiled, the crisis must have only intensified the fraught atmosphere at court.[58] Finally, in 1359, at the then-advanced age of 34, Fina gave birth to a boy, known as Francesco Novello, who would ultimately succeed his father as lord of Padua.

Cordelia Warr has persuasively argued that the significance of the birth is suggested in the Birth of John the Baptist, which is prominently situated in the Baptistery, centered at the top of the south wall (see Fig. 4, Fig. 6).[59] As noted earlier, Fina is included in the composition, along with her three daughters. Elizabeth, like Fina, conceived her son late in life; here she gazes and gestures in Fina's direction, and

Fina responds by pointing delicately to herself. But if we return to the Apocalyptic woman and to the text of Rev. 12, John's language may also help enlarge our understanding of Fina's intentions here. Verse 5 reads: "she brought forth a man child, who was to rule all nations with an iron rod" (*et peperit filium masculum qui recturus erat omnes gentes in virga ferrea*)—language that likely resonated for Fina, whose own long-awaited *filium masculum* was also destined to rule. Fina was not the only member of the ruling elite drawn to apocalyptic themes, and in particular to the *mulier amicta sole*; the relevance of Rev. 12:5 to their own lives presumably did not escape other aristocratic and royal women, and their consorts.[60]

Even after Fina's death, her closest family members evidently found the Apocalypse a subject of particular interest. In 1393 or 1394, Francesco Novello, then the ruling lord of the city, commissioned a commentary on the Apocalypse[61]—perhaps significantly, around the time of his father's death in October, 1393.[62] And about the same time Fina's sister Anna, abbess of S. Benedetto in Padua, commissioned frescoes for a chapel of her convent church; the frescoes included, on the soffit of the triumphal arch, a brief Apocalypse

58. For these events, see Kohl, *Padua* (as in note 6), 97.

59. Warr, "Painting" (as in note 2), 153–154.

60. An early example may have been Queen Maria of Hungary, who commissioned the frescoes of S. Maria Donna Regina, Naples, which include an extraordinary image of the Virgin in the guise of the Apocalyptic Woman in the Last Judgment; Elliott observes that this "pregnant Madonna ... may have evoked thoughts of Ecclesia ... or even of Queen Mary of Hungary, herself a mother of two kings and a saint" ("Last Judgement" [as in note 45], 179; see also note 51). In Karlštejn Castle outside Prague, a remarkable cycle of the Apocalypse depicts, as V. Dvořáková has argued, the empress Anna of Swidnica, mother of Emperor Charles IV's long-awaited heir, in the guise of the *mulier amicta sole*. See "The Ideological Design of Karlštejn Castle and its Pictorial Decoration," in *Gothic Mural Painting in Bohemia and Moravia 1300–1378*, ed. V. Dvořáková *et al.* (London; Oxford; New York, 1964), 59–60. In the Book of Hours of Catherine of Cleves (as in note 50), where Catherine appears before the Virgin as *mulier amicta sole*, the facing page clearly alludes to fecundity: the angel announces to Joachim the coming pregnancy of Anna as rabbits cavort in the countryside. Several scholars, among them M. Camille ("Visionary Perception and Images of the Apocalypse in the Later Middle Ages," in *The Apocalypse in the Middle Ages*, ed. R. Emmerson and B. McGinn [Ithaca, N.Y.; London, 1992], 276–289, at

278); in the same volume, P. Szittya, "Domesday Bokes: The Apocalypse in Middle English Literary Culture" (374–397, at 385–386) and C. Meale (*Women and Literature in Britain*, ed. C. Meale [Cambridge, 1993], 128–158, note 40), have observed in passing that many manuscripts featuring the Apocalypse were owned by women, but to my knowledge none have considered a connection with Rev. 12:5. I pursue these arguments, and the possible involvement of Petrarch, a guest at the Angevin court in Naples and at the court of Charles IV in Prague before coming to Padua, in a study of the Padua Baptistery now in progress.

61. A. Luttrell, "Federigo da Venezia's Commentary on the Apocalypse, 1393/94," *Journal of the Walters Art Gallery* 27/28 (1964/65), 57–65.

62. Francesco Novello's rule was initially turbulent. In 1388, with the city facing near-certain defeat at the hands of the Visconti of Milan, Francesco il Vecchio transferred power to his son, but Francesco Novello was forced to surrender only a few months later. In exile he plotted his return, and recaptured the city two years later, in June, 1390. Peace was not negotiated until early 1392; Francesco Novello gradually consolidated his power, even assuming the new titles of *Dux* and *Comes* in 1393–1394. For these events see Kohl, *Padua* (as in note 6), 240–292; for the lavish funeral of Francesco il Vecchio, itself an opportunity to promote Carrara rule, see *ibid.*, 307–308.

cycle—which included the *mulier amicta sole*. The chapel was the third of Fina's commissions mentioned by Scardeone; an inscription of 1394 recorded Fina's patronage: *Fuit haec capella constructa ... per illustrem et generosam Dominam Finam de Buzzacarinia bonae memoriae....*[63]

Additional images in the Baptistery's program likely had particular significance for Fina. As Warr noted, John was conceived miraculously, long after the age of childbearing, and Fina may have considered the Baptistery renovation a thank-offering for the birth of her own son.[64] I would add that images of miraculous pregnancy recur elsewhere in the program, and that they are visually aligned, prompting viewers to read them together. In the Genesis scenes on the drum of the dome, Abraham bows before the three angels; below, in an interior suggesting a grand palazzo, he offers hospitality to the three as his wife, Sara, and a servant boy observe (Fig. 1, Fig. 19). After the meal, one of the angels announces to Abraham that Sara, then well advanced in years, will bear a son. The gestures make the moment clear: the angel on the left addresses Abraham, delivering this news, as the patriarch, shocked by the announcement, points questioningly to himself. The inscription beneath also identifies the precise moment, quoting Genesis 18:10–11—first the announcement of Sara's coming pregnancy: "Et habebit filium uxor tua Sara," then Sara's incredulous response: "Quo audito Sara risit post ostium tabernaculi. Erant autem [ambo senes]."[65]

This fresco is framed, presumably indicating an interior space—unlike the others surrounding it, and indeed unlike all of those in the drum of the dome (see Fig. 1), with the exception of three episodes of the bedridden Isaac with Esau and Jacob, which are also set in an interior. But the choice of an interior for the Hospitality of Abraham is curious, for Genesis 18:8 specifically places the meal outside, under a tree (*sub arbore*). The frame thus seems intended not merely to indicate the setting but also to highlight the episode, italicizing it visually and isolating it from those nearby. Moreover, the interior architecture is distinctive: two elegant arches supported by piers rise above the figures, with a central pier bisecting the room. The paired arches appear in none of the other Genesis narratives, including the Isaac scenes—but they do recur elsewhere in the program, twice in conjunction with a miraculous pregnancy: the Annunciation (see Fig. 17) and the Birth of John the Baptist (see Fig. 6). In the Birth of John, the architecture of the interior is especially close to that of the Hospitality of Abraham, with sturdy central piers rather than a more delicate colonnette supporting the arches, and those piers effectively terminating just below the spring of the arch, interrupted by the central angel's halo in the Hospitality and by a curtain in the Birth of John. Echoing gestures further confirm the pairing of the Hospitality of Abraham and the Birth of John: Abraham's raised hand, index finger extended, is almost identical to that of Fina in the Birth. The two frescoes are thus insistently linked—and the strategic repetition of these pictorial cues signals the importance of miraculous pregnancy in the program. Perhaps significantly, the Hospitality of Abraham appears directly above the Visitation, the meeting of the newly pregnant Virgin and Elizabeth, whose miraculous conceptions were anticipated by Sara's. The left borders of the two compositions are almost perfectly aligned.[66]

Indeed Fina, who like Sara conceived her son late in life, likely experienced his birth as a miracle. As noted

63. The inscription is transcribed in S. Bettini, *Giusto de' Menabuoi e l'arte del Trecento* (Padua, 1944), 102–103, 138, n. 4; for an English translation, see King, "Women as Patrons" (as in note 1), 249. The chapel was largely destroyed during World War II, but pre-war photos survive in the Museo Civico, Padua. See L. Rivière Ciavaldini, "L'Apocalypse de Giusto de'Menabuio [sic] à San Benedetto de Padoue," in '*Tout le temps du veneour est sanz oyseuseté': Mélanges offerts à Yves Christe pour son 65ème anniversaire*, ed. C. Hediger (Turnhout, 2005), 133–150. Rivière Ciavaldini suggests that Anna chose the episodes from Revelation in homage to Fina, recognizing her personal devotion to the Apocalypse.

64. Warr, "Painting" (as in note 2), 154.

65. The inscriptions are recorded by Bellinati, "Iconografia" (as in note 6), 49.

66. An important precedent for the Genesis cycle in the Baptistery, also painted in continuous narrative, with accompanying inscriptions, is the cycle in the Carrara chapel in the Reggia (now Accademia Galileiana di Scienze Lettere ed Arti in Padova). That cycle, painted by Guariento probably in the early 1350s, includes Abraham's encounter with the three angels but depicts only the first episode, the patriarch bowing before the three. It omits the subsequent meal, where Sara appears. Similarly, the explanatory inscription

FIGURE 19. Giusto de' Menabuoi, *Hospitality of Abraham*. Baptistery, Padua, mid-1370s
(photo: © Genevra Kornbluth).

earlier, Fina's portrait appears elsewhere in the program, among them a scene of Christ working miracles (see Fig. 7)—not a single miracle, as was usually the case, but every miracle imaginable: here, the deaf, the mute, the lame, and the bereaved all beseech Christ for a cure. The image is taken from Matt. 11:4–5, and alludes to Christ's words to two disciples of John the Baptist: "Go and relate to John what you have heard and seen. The blind see, the lame walk, the lepers are cleansed, the deaf hear, the dead rise again" The subject is rarely seen in Christian narrative, and here the setting is unmistakably local: the crowd gathers before the loggia of the Cathedral of Padua, right next to the Baptistery.[67] The iconographic inclusiveness of

refers only to Abraham, omitting any mention of Sara. For the fresco, see D'Arcais, "Profilo di Guariento" (as in note 53), 26–27, fig. 11; for the inscriptions, see F. Benucci, "I *tituli* dipinti della cappella carrarese," in *Guariento* (as in note 53), 70–71.

67. Bellinati, "Iconografia" (as in note 6), 58; the Cathedral's Romanesque façade and loggia were destroyed to make way for a Renaissance façade that was never completed. For the few other instances of the subject, see Delaney, "Giusto" (as in note 6), 235.

this fresco, the Paduan architecture, and the presence here of Francesco as well as Fina suggest that they, too, sought divine intervention for their own affliction. If we consider the placement of this fresco on the south wall (see Fig. 4) and follow Christ's gesture, we are directed to the miraculous birth of John the Baptist above, and again to the portrait of Fina.

One final question arises: if the Baptistery was indeed a thank-offering for a son born in 1359, why the long delay—perhaps 13 or 14 years—in setting the commission into motion? Though the dates are not certain, Fina's son, Francesco Novello, was approaching adolescence when the planning for the Baptistery began, probably in the early 1370s. Fina was likely deeply concerned about her son in these years, for his father, long eager for an heir, wasted no time in involving the boy in affairs of state. In 1373, Padua was at war with Venice. On 14 May, Francesco Novello, then a thirteen-year-old boy, led the Paduan troops into battle. Though the Paduan forces triumphed in this clash, they ultimately lost the war, and it was again the boy, in the company of Petrarch, who was dispatched to Venice to accept the humiliating terms of the peace a few months later.[68]

Certain narrative choices in the fresco program seem to attest to Fina's concerns about her son's safety. If we return to the west wall with the donor portrait, we note that the two large frescoes on either side of the tomb canopy, flanking the portrait of Fina, depict the Massacre of Innocents and Christ among the Doctors (see Fig. 2). The decision to feature them so prominently is somewhat unexpected, for neither is a particularly important narrative of the Infancy cycle; subjects like the Annunciation, the Nativity, and the Adoration of the Magi appear far more often in late medieval Italian art.[69] The oddness is compounded when one studies the images closely: both frescoes include rarely photographed details which extend, remarkably, beyond the picture plane and are painted onto the side of the tomb canopy, at right angles to the rest of the wall. The portions of each composition that were selected for this curious extension were carefully considered.

On the left side of the canopy is the continuation of the Massacre of the Innocents, and there we note a familiar figure: King Herod, peering down from a balcony to oversee the horrific events (Fig. 20). Below the balcony, and, significantly, out of Herod's sight, unnoticed by his men, is a much more unusual detail: mothers who attempt to escape with their young sons, glancing over their shoulders as they make surreptitious exits to the right of the composition. Such fleeing women, though rarely seen in trecento painting, are not unprecedented: as Andrew Ladis noticed, a shadowy figure, so lightly painted as to be almost imperceptible, similarly slips away in Giotto's Massacre in the Arena Chapel; she too is on the far right of the composition.[70] The detail calls to mind the escape of St. Elizabeth and the Virgin Mary, both of whom acted swiftly to protect their young sons from Herod's men. The *Protevangelium of James* explains:

> And when Herod realized that he had been deceived by the wise men, he was angry and sent his murderers and commanded them to kill all babies who were two years old and under. When Mary heard that the babies were to be killed, she was afraid and took the child and wrapped him in swaddling clothes and laid him in an ox-manger. But Elizabeth, when she heard that John was sought for, took him and went up into the hill-country. And she looked around

68. Kohl, *Padua* (as in note 6), 123–124: "On 14 May 1373 ..., the combined Hungarian and Paduan forces won their finest victory.... As the Venetian troops began to waver, the Paduan forces charged under the command of Francesco Novello da Carrara ... then age fourteen." Actually, he was just shy of his fourteenth birthday: he was born on 29 May 1359 (Kohl, *Padua*, 133). For the early education of Francesco Novello in the art of war, see Kohl, *Padua*, 133. Warr, "Painting" (as in note 2), 154, also connects Fina's likely concern for her son's safety with the Baptistery frescoes, though her article focuses on a single fresco, the Birth of John the Baptist.

69. E. Garrison's *Italian Romanesque Panel Painting: An Il-* lustrated Index (reprt. New York, 1976), converted to CD-ROM by the Courtauld Institute, offers one indication of the relative frequency of occurrence of Infancy episodes from duecento and early trecento panel painting. The Annunciation appears 51 times, the Nativity 35, the Adoration of the Magi and the Presentation in the Temple each 20. The Massacre of the Innocents appears only four times, and Christ among the Doctors (there identified as Christ Teaching in the Temple) three.

70. A. Ladis, *Giotto's "O": Narrative, Figuration, and Pictorial Ingenuity in the Arena Chapel* (University Park, Pa., 2009), 103–107.

FIGURE 20. Giusto de' Menabuoi, Massacre of the Innocents, detail: Herod; mothers and sons. Baptistery, Padua, mid-1370s (photo: Valentino Pace).

to see where she could hide him, and there was no hiding-place. And Elizabeth groaned aloud and said: 'O mountain of God, receive a mother with a child.'

And immediately the mountain was rent asunder and received her.[71]

Though the mothers in this detail cannot be identified, the image of mothers attempting to escape the massacre may allude to this passage in the *Protevangelium*. There can be no ambiguity about the reference to the legend elsewhere in the Baptistery: in the altarpiece in the apse, also painted by Giusto. On either side of the central Virgin and Child are six scenes from the life of John the Baptist, and on the upper tier to the right is the successful escape of Elizabeth and John to the hill country: Elizabeth clutches her young son to her as they stand safely hidden by the cleft of the mountain, just as the *Protevangelium* explains (Fig. 21). The escape of Elizabeth and John to the wilderness is apparently all but unknown in the art of the trecento; its occurrence here, in conjunction with the detail of the fleeing mothers in the Massacre, is surely significant.[72]

On the right, the fresco of Christ among the Doctors (see Fig. 2) seems at first glance to be missing a standard element: the arrival of Mary and Joseph at the temple in search of their lost son. But closer scrutiny reveals that it has been included: this fresco, too, turns at a right angle and continues onto the side of the tomb canopy, and it is there that the painter has depicted Mary and Joseph returning to the temple (Fig. 22). The link with the Massacre of the Innocents, and the detail of the women attempting to flee with their young sons, seems clear enough: in both, anguished mothers respond to a crisis that threatens their sons' safety. In fact, one influential devotional text, the widely circulated *Meditations on the Life of Christ*, provides a suggestive connection between the Massacre of the Innocents and Christ among the Doctors. The author describes the Virgin as almost crazed with grief after the trip to Jerusalem when she discovered that the Christ child was missing: "She could

71. *The Protevangelium of James,* trans. J. K. Elliott, *The Apocryphal New Testament* (Oxford, 1993), 65–66.

72. M. Lavin discusses the unusual subject briefly in "Giovannino Battista: A Supplement," *Art Bulletin* 43 (1961), 319–326, esp. 319–320. While she provides a lengthy list of instances of the type in note 5, most are Byzantine. Images of the young John in the desert, without Elizabeth, were fairly common in trecento art, perhaps owing to the anonymous *Vita di San Giovanni Battista,* according to which the young saint entered the desert on his own. For the text, erroneously attributed to Domenico Cavalca, see M. Lavin, "Giovannino Battista: A Study in Renaissance Religious Symbolism," *Art Bulletin* 37 (1955), 85–101, and for a synopsis of the legend, see 87, note 19. She corrects the erroneous attribution in "Giovannino Battisto: A Supplement."

FIGURE 21. Giusto de' Menabuoi, polyptych, detail: Eliza-
beth and the infant John. Apse, Baptistery, Padua, mid-1370s
(photo: © Genevra Kornbluth).

FIGURE 22. Giusto de' Menabuoi, Christ among the Doc-
tors, detail: Mary and Joseph. Baptistery, Padua, mid-
1370s (photo: © Genevra Kornbluth).

scarcely keep her senses … she could not be consoled
… Her soul [was] in terrible anguish." In her des-
peration, she recalls the danger to her son during
Herod's massacre: "O most beloved son, where are
you? … Once before I carried you into Egypt when
you were hunted by Herod. May your Father guard
you from every evil, O my son!"[73]

Thus the two details, painted on corresponding
sides of the tomb canopy and flanking the portrait
of Fina, both feature beleaguered mothers of en-
dangered young sons, and their attempts to "guard
[them] from every evil."[74] The parallels with Fina's
life, and her fears for her son, sent into the front lines
of battle when he was little more than a boy, again

73. *Meditations* (as in note 37), 54. Byzantine homilists simi-
larly imagined Mary's anguish as she searched for the Christ
child; see the texts cited by H. Maguire, *Art and Eloquence in
Byzantium* (Princeton, N.J., 1981), 97.
74. We have already encountered an analogous theme in the

Baptistery's apse, where the seven-headed dragon menaces the
mulier amicta sole and her newborn son—and this imperiled in-
fant is compared with the Christ child, threatened by Herod,
in the widely circulated commentary on the Apocalypse by
Berengaudus. Glossing Rev. 12:4, the text states: "Therefore

strongly suggest Fina's active agency in the details of the program. Particularly poignant in this context is Christ's rebuke to his grief-stricken mother when she confronts him at the Temple: at age 12, he tells her that he must "be about his father's business" (Luke 2:49). Fina's anxiety for her son, thrust too young into a position of leadership, similarly charged with attending to his father's business, must have been acute.

To conclude: the visual evidence, taken as a whole, seems to me strongly suggestive of Fina's direct, detailed engagement with decisions regarding the Baptistery, just as her will shows her continuing engagement with it even in the last weeks of her life. In this commission, she succeeded in asserting her autonomy with uncommon boldness: the Baptistery is a document as personal, and as revealing, as her will, and as carefully considered a legacy.

the dragon stood before the woman, that when she should be delivered, he might devour her son: for at the time of the birth of Christ [the dragon] wished to kill him, through his minister Herod" (trans. in N. Morgan, *The Lambeth Apocalypse* [London, 1990], 175). As B. Williamson observes, the Apocalyptic

Woman was juxtaposed with the Massacre of the Innocents in thirteenth-century English Apocalypse manuscripts; see her *The Madonna of Humility: Development, Dissemination and Reception, c. 1340–1400* (Suffolk, 2009), 39–40.

* * *

Many thanks to Colum Hourihane and Elizabeth Pastan for the invitation to participate in this stimulating symposium, and to members of the audience for their comments. Versions of this paper were presented at two other symposia: "Apocalissi: Eschatological Imagination in Italian Culture, from Dante to the Present," the Centre for Research in the Arts, Social Sciences and Humanities, University of Cambridge, 2009, and "Challenging the Myths of Art History: A Symposium in Honor of Linda Seidel," Fordham University, 2011; and at California State University, Long Beach; St. Olaf College, and the University of Wisconsin. Warm thanks to Julia Miller at CSULB, Nancy Thompson at St. Olaf, and Thomas E. A. Dale at the University of Wisconsin, and to the International Center of Medieval Art for sponsoring the latter two talks. I am deeply grateful to Valentino Pace and to Genevra Kornbluth for their splendid photographs; to Aimee Gil and Mary Jean Hughes for their assistance; and to Margaret Hayes, Julia Miller, Amy Neff, Mark Sandona, Corine Schleif, Laurie Taylor-Mitchell, and Diane Wolfthal for their insightful comments on the material. Unless otherwise specified, translations are my own.

BENJAMIN ZWEIG

Picturing the Fallen King:
Royal Patronage and the Image of
Saul's Suicide

MANY SCHOLARS of medieval art are sure to have come across the dramatic image of King Saul falling on his sword or driving it through his wounded body. Indeed, Saul as king of the Israelites, David's nemesis, and tragic suicide are familiar images, often forming part of extended pictorial narratives depicting the life of David or the Book of Kings.[1] Because of their thematic emphasis on kingship and rule, scholars have often considered such programs evidence of an artwork's probable royal patronage, especially in thirteenth-century manuscripts connected to the Capetian court.[2] However, the particular significance of including an image of a king killing himself in artworks made for royalty has received little attention.[3]

This essay examines three case studies of Saul's suicide in artworks connected to Carolingian and Capetian royal patronage: the San Paolo Bible (Rome, San Paolo fuori le mura, s.n.), the Ingeborg Psalter (Chantilly, Musée Condé, Ms. 9 *olim* 1695), and a group of objects associated with the patronage of

Blanche of Castile and Louis IX—the *Bibles moralisées* (Vienna, Österreichische Nationalbibliothek, Codex Vindobonensis 2554 and 1179; Toledo, Cathedral Library, Mss. 1–3 and New York, Pierpont Morgan Library, Ms. M. 240; Oxford, Bodleian Library, Ms. Bodley 270b; Paris, Bibliothèque Nationale de France, Ms. lat. 11560; London, British Library, Ms. Harley 1526–1527) and the stained glass of Chartres Cathedral and the Sainte-Chapelle. In each case, the unusual presence of Saul's death has gone unremarked. Its inclusion in these objects raises two serious questions: Why include a king's suicide in such lavish objects commissioned by or destined for royalty? And how, by addressing each artwork's patronage, can we illuminate the reasons for the image's inclusion and function?

As Jill Caskey demonstrates, the complexity of medieval patronage precludes a single dominant interpretative model, and different cases require separate approaches.[4] For the purpose of this essay, which will examine the impact of multiple patrons all of whom

I am most grateful to Colum Hourihane for inviting me to participate in this conference and for all his helpful advice and encouragement. I am also deeply indebted to Deborah Kahn at Boston University for her unwavering support, and to the helpful discussions I had with Madeline Caviness, Julian Luxford, and Claudine Lautier. I would also like to express my thanks to Stuart Whatling and Painton Cowen for generously allowing me to use their excellent photographs of the glass of Chartres Cathedral and the Sainte-Chapelle.

1. See *King David in the Index of Christian Art*, ed. C. Hourihane (Princeton, 2002); and L. Ross, *Medieval Art: A Topical Dictionary* (Westport, Conn., 1996), 223–224.

2. For example, H. Stahl, *Picturing Kingship: History and Painting in the Psalter of Saint Louis* (University Park, Pa., 2008); idem, "Old Testament Illustration during the Reign of Saint Louis: the Morgan Picture Book and New Biblical Cycles," in

Il Medio Oriente e L'Occidente Nell'Arte del XIII Secolo, ed. Hans Belting (Bologna, 1982), 79–93; G. B. Guest, "The People Demand a King: Visualizing Monarchy in the Psalter of Louis IX," in *Studies in Iconography* 23 (2002), 1–27; idem, "Between Saul and David: Picturing Rule in the Morgan Library Old Testament," in *Between the Picture and the Word: Manuscript Studies from the Index of Christian Art*, ed. C. Hourihane (University Park, Pa., 2005), 72–80; S. Cockerell, *A Psalter and Hours Executed Before 1270 for a Lady Connected with St. Louis, Probably His Sister, Isabelle of France* (London, 1905).

3. One of the only entries that treats Saul or his suicide as distinct subject is L. Réau, *Iconographie de l'art Chrétien*, vol. 2, part 1 (Paris, 1957), 268.

4. J. Caskey, "Whodunnit? Patronage, the Canon, and the Problematics of Agency in Romanesque and Gothic Art," in *A Companion to Medieval Art: Romanesque and Gothic in Northern Europe*, ed. C. Rudolph (Oxford, 2006), 193–212.

had a vested interest in depicting Saul's suicide in a royal artwork, Beat Brenk's distinction of the patron-*donateur* from the patron-*concepteur* provides a useful interpretative framework.[5] A third aspect may be added to Brenk's distinctions and that is the intended patron-*récepteur*, who may be the *donateur, concepteur,* or neither, but nonetheless impacted the selected iconography.[6] Locating each case study within a flexible patronage network of *donateurs, concepteurs,* and *récepteurs* will help elucidate the reasons for including Saul's suicide in these artworks.[7]

Since the image of Saul's suicide was mainly significant for a minority of elite patrons—kings, queens, and their ecclesiastical supporters—I shall firstly outline the intellectual tradition in which it held the most capital: discourses on sacral kingship and the Carolingian and later Capetian political theology of *rex et sacerdos.* I shall then examine the image within each artwork's larger material context and the surrounding networks of creation and reception. Ultimately, I posit that the royal patronage of Saul's suicide contributed to the construction of Carolingian and Capetian sacro-historic identities that either reinforced their divine character or warned about the tenuous nature of rule, and shall suggest the specific historical reasons for its presence in each object.

SAUL IN THE BIBLE AND EARLY INTERPRETATIONS

Saul's reign is recounted in the Book of I Kings (also known as the Book of I Samuel in the Hebrew Bible), which presents a somewhat ambiguous picture of both the individual man and the institution of kingship. After the Israelites demanded the Prophet Samuel to be their king, he reluctantly selected Saul the Benjamite and anointed him as the one chosen and protected by the Lord.[8] Although often a righteous and

capable leader, Saul loses God's favor after failing to heed Samuel's command to kill the king of the neighboring Amalekites, for which Samuel reproves him: "… as thou hast rejected the word of the Lord, the Lord hath also rejected thee from being king."[9] God then directed Samuel to Bethlehem, where he found and anointed the young shepherd David, who became part of Saul's house and eventually replaced him as king of the Israelites.

Saul's final downfall came at the end of I Kings at the hands of the Philistines on Mount Gilboa. After the Philistines slayed his sons and enemy archers fatally wounded him, Saul ordered his armor-bearer to kill him so that he would not die at the hands of the uncircumcised. The terrified armor-bearer refused. Saul then "took his own sword, and fell upon it."[10] His armor-bearer followed suit. An alternate version of Saul's death occurs at the beginning of II Kings (II Samuel), when an unnamed Amalekite comes before David and announced how he found the wounded Saul leaning on his spear and beheaded him at the dying king's request.[11] Furious that a foreigner killed the Lord's anointed, David orders his servant to kill the Amalekite and then mourned over Saul.[12] A third account of Saul's death in I Chronicles repeats the story from I Kings, but ended with a moralization explaining how, "Saul did for his iniquities, because he transgressed the commandment of the Lord … therefore he [the Lord] slew him and transferred his kingdom to David."[13]

Early Christian authors located Saul's death within a typology of Christian history that contrasted him with his successor David. In *City of God*, Augustine saw Saul's downfall and David's rise as a symbolic change from the Old to the New Covenants, and as a sign of the priesthood and the monarchy merging into the single entity of Christ the King.[14] John

5. B. Brenk, "Committenza," in *Enciclopedia dell'arte medievale*, vol. 5 (Rome, 1994), 203–219.

6. See M. Caviness, "Reception of Images by Medieval Viewers," in *A Companion to Medieval Art* (as in note 4), 65–85.

7. H. Flora, "Patronage," *Studies in Iconography* 33 (2012), 209.

8. I Kings 8–10. All biblical references and quotations from the Douay-Rheims Catholic Bible. I follow the Vulgate numbering of the psalms.

9. I Kings 15: 23.

10. I Kings 31: 4.

11. II Kings 1: 1–6.

12. II Kings 1: 11–20.

13. I Chronicles 10: 13–14.

14. Augustine, *City of God*, vol. 5, trans. E. M. Sanford and W. M. Green (London; Cambridge, Mass., 1965), 223–225.

Chrysostom viewed Saul and David as opposites, with the former representing wickedness and the latter humility.[15] In his influential work the *Pastoral Care*, Pope Gregory the Great contrasted Saul's *superbia* or *elatio* ("pride") against David's *humilitas* ("humility"), asking, "What is shown by Saul except the pride of the powerful, and by David the humble lives of the saints?"[16]

Such ideas formed the touchstone for many later interpretations of Saul's character and his reign, especially for the Carolingians, who constructed a lasting systematic characterization of Saul's downfall within their political theology of sacral kingship, and produced the first known images of his suicide.

SACRAL KINGSHIP AND SAUL

The Carolingians developed a political theology of sacral kingship that, in its ideal manifestation, exalted a monarch as *rex et sacerdos* ("king and priest"), an honorific Paulinus of Aquileia first used when he described Charlemagne at the Diet of Frankfurt in 794.[17] The basic tenet of this political theology upheld the foundation of kingship depended upon a king's divine right to rule. It did not mean a king was a priest or had spiritual functions. Rather, it signified that a ruler acquired his authority through God's favor, which legitimated his claims to royal power.[18] The monarchy became a divine institution.

The Carolingians based their theology of sacral kingship upon the Old Testament kings David and Solomon, who, as God's chosen rulers, symbolized all the virtues required for a king, including obedience to the Church and its representatives, humility, and wisdom. In a self-conscious desire to locate their dynasties within sacred history, Frankish kings often portrayed themselves as a *novo David* or *novo Solomon*.[19] As did their ecclesiastical supporters, such as Alcuin of York, who addressed Charlemagne as his dear "David."[20] Epithets and images addressing or depicting a king as David or Solomon saturated the intellectual and visual culture of the court, such as in the First Bible of Charles the Bald (*c.* 845–846), in which the dedicatory poem compares Charles to David or addresses him as such no less than five times.[21]

Carolingian kings' claims to be *rex et sacerdos* were formalized through the rite of Episcopal unction and the crowning of the monarch, described to varying degrees in the coronation *ordo*.[22] The combination of anointing and crowning established the monarch's dual identity as blessed by God and chosen by his people. It also defined his obligation to recognize the clergy as the source of his power. This ritual was part of Carolingian kingship since Pope Stephen II consecrated King Pepin the Short and his sons Charlemagne and Carloman at the Abbey of Saint-Denis in 754.[23] By the ninth century such was the importance of royal unction that Archbishop Hincmar of Reims

15. John Chrysostom, *Homilies on the Gospel of Matthew*, ed. and trans. P. Schaff (Grand Rapids, Mich., 1956), 385.

16. Gregory the Great, *Liber regulæ pastoralis*, Migne *PL* 77: 53. *Quid enim per Saulem, nisi elatio potentum, et quid per David innuitur, nisi humilis vita sanctorum?*

17. Paulinus of Aquileia, *Libellus sacrosyllabus contra elipandum*, Migne *PL* 99: 166.

18. For an overview of a complex topic, see J. L. Nelson, "Kingship and Empire in the Carolingian World," in *Carolingian Culture: Emulation and Innovation*, ed. R. McKitterick (Cambridge, 1994), 52–87; and W. Ullmann, *The Carolingian Renaissance and the Idea of Kingship* (London, 1969).

19. F. Oakley, *Kingship: The Politics of Enchantment* (Malden, Mass., 2006), 96–98. See also E. Kantorowicz, *The King's Two Bodies: A Study in Mediaeval Political Theology.* (Princeton, N.J., 1957), 81. For a critique, see M. Garrison, "The Franks as the New Israel? Education for an Identity from Pippin to Charlemagne," in *The Uses of the Past in the Early Middle Ages*, eds. Y. Hen and M. Innes (Cambridge, 2000), 136–138.

20. Alcuin, *Epistolae 41*, in *Epistolae Karolini aevi*, vol. 2, ed. E. Dümmler, Monumenta Germaniae Historica (MGH hereafter) (Berlin, 1895), 84.

21. For the dedication, see P. E. Dutton and H. L. Kessler, *The Poetry and Paintings of the First Bible of Charles the Bald* (Ann Arbor, Mich., 1997). For some discussions on the image of David in Carolingian art, see *ibid.*, 84–87; M. Imhof and C. Winterer, *Karl der Grosse: Leben und Wirkung, Kunst und Architektur* (Petersberg, 2005), 86–88; W. Diebold, *Word & Image: An Introduction to Early Medieval Art* (Boulder, Colo., 2000), 82–84.

22. A classic study on this subject remains Kantorowicz, *The King's Two Bodies* (as in note 19). The Carolingians were not the first to anoint their monarchs, as the Visigoths, Merovingians, and Anglo-Saxons had done likewise. See J. Canning, *A History of Medieval Political Thought: 300–1450* (London, 1996), 26–29.

23. A papal emissary had in fact anointed Pepin at Soissons in 750–751 and again in 754. See J. L. Nelson, *The Frankish World, 750–900* (London, 1996), 102–103.

developed the myth of Saint Remigius' baptismal unction of the Frankish King Clovis with a flask of heavenly oil to support the anointing of Charles the Bald.[24]

Unction also formed the connective tissue that symbolically united the Carolingians with their Old Testament forbearers. The Prophet Samuel's anointing of Saul and David, and Zadok's anointing of Solomon, invested the biblical kings with divine grace and authority. These figures served as powerful sacro-historic precedents for the liturgical coronation rites of the Carolingian monarchs. In the *ordo* for Louis II's coronation on 8 December 877, Hincmar invokes David's humility and Solomon's wisdom at the very moment of the king's anointing.[25]

Within this theology of sacral kingship, Saul's anointing and downfall provided a resonant *exemplum* for princes and kings about the tenuous nature of their God-given rule—that unction did not preclude the withdrawal of *dei gratia*. *Fürstenspiegel*—didactic "Mirrors of princes" composed by clerics for royal education—followed Gregory the Great's position from the *Pastoral Care* and cast Saul's disobedience of Samuel and suicide as the consequence of his *superbia*, and contrasted it against David's ascension and *humilitas* before the prophet Nathan.[26] In *The Royal Way*, Smaragdus, abbot of Saint-Mihiel warns Louis the Pious, "You see, therefore, O King, that one [Saul] by means of pride is cast down from the royal throne, and the other [David] is elevated to the glory of kingship by humility."[27] He later cautions, "Therefore, O King,

wisely be very much afraid and beware the curse of pride."[28] In *On Christian Rulers*, Sedulius Scottus likewise warns the presumed recipient Lothar II, "Thus, the impious King Saul of Israel was deprived of his kingdom and his life because he did not stand before the Lord as a faithful minister."[29] In the *Commentary on the Four Books of Kings*, an influential exegesis on kingship, Rabanus Maurus explains how Saul and his sons would have prevailed had he not offended God through his pride.[30]

THE EARLY CAROLINGIAN IMAGE

Given Saul's significance for a Carolingian king's sacro-political identity, it is not surprising the earliest depictions of his suicide appear in art connected to royal patrons. The first surviving example of Saul's suicide is a badly damaged fresco fragment from a once-extensive David cycle covering the south wall of the Benedictine convent church of St. John in Müstair (built *c.* 775–800, painted *c.* 835), a foundation with royal connections supposedly going back to Charlemagne.[31] The ochre and red fragment pictures Saul falling upon his sword as a regiment of Philistine archers pursues him. The faint trace of a figure next to him probably depicted his armor bearer. Scholars have suggested the Saul and the David cycle was imperial propaganda defending the Emperor Louis the Pious during or shortly after two civil wars with his sons Lothar and Pepin.[32] While the fragment's poor state prohibits anything beyond tentative specula-

24. J. L. Nelson, "Hincmar of Reims on King-making: The Evidence of the Annals of St. Bertin, 861–882," in *Coronations: Medieval and Early Modern Monarchic Ritual*, ed. J. M. Bak (Berkeley, Calif., 1990), 22–24.

25. Hincmar of Reims, *Ordo coronationis Hludowici balbi*, in *Capitularia regum Francorum*, vol. 2, ed. A. Boretius and V. Krause, MGH (Hannover, 1883), 461.

26. For the *fürstenspiegel* tradition, see H. H. Anton, *Fürstenspiegel und Herrscherethos in der Karolingerzeit* (Bonn, 1968).

27. Smaragdus, *Via regia*, Migne *PL* 102:957. *Vides ergo, rex, quia unus ex illis de regni solio per superbiam est dejectus, et alius regni gloriam per humilitatem est evectus.* See also R. Deshman, "The Exalted Servant: The Ruler Theology of the Prayerbook of Charles the Bald," *Viator* 11 (1980), 407.

28. Smaragdus, *Via regia*, Migne *PL* 102:961. *Tu ergo, prudentissime rex, time tantum et cave superbiae malum.*

29. Quoted in *Carolingian Civilization: A Reader*, 2nd ed., ed. P. E. Dutton (Peterborough, 2004), 380.

30. Rabanus Maurus, *Commentaria in libros IV Regum*, Migne *PL* 109: 70.

31. Only one of two surviving from the south wall, the fragment is now housed in the Schweizerischen Landesmuseums, Zurich. The most recent examination is J. Goll *et al.*, *Müstair: Die mittelalterlichen Wandbilder in der Klosterkirche* (Munich, 2007). See also L. Wüthrich, *Wandgemälde von Müstair bis Hodler: Katalog der Sammlung des Schweizerischen Landesmuseums Zürich* (Zurich, 1980), 17–41.

32. J. S. Cwi, "A Study in Carolingian Political Theology: The David Cycle at St. John, Müstair," in *Riforma religiosa e arti nell'epoca carolingia*, ed. A. A. Schmid, Atti del XXIV^e Congresso Internazionale di Storia dell'Arte, 1979, 24: 1–2 (Bologna, 1983), 117–127. Cwi discusses the unusual emphasis on David's son Absalom in the cycle, and suggests that it com-

tion, its importance resides in the fact that the fist known image of Saul's suicide forms part of a royal commission.

The first completely preserved image of Saul's suicide appears in the frontispiece to I Kings (fol. 83ᵛ) in the San Paolo Bible (*c.* 870–875), a lavishly illustrated pandect bible associated with Charles the Bald's patronage and produced in a scriptorium at Reims (Fig. 1).[33] The miniature is exceptional for its early inclusion of Saul's death and for being the first surviving example of a full narrative Kings cycle.[34] One of the book's fourteen Old Testament miniatures, the frontispiece visually summarizes the book in four densely packed registers. The top register depicts the prophet Samuel's mother Hannah praying for a son and the presentation of the young Samuel before Eli the priest, all identified by painted *tituli*. In the second register Samuel anoints Saul with a horn of oil, while a large group of armed men gesture towards Saul and recognize the authority invested in him by Samuel. In the third, Saul watches the young David fight and behead Goliath. The final fourth register portrays Saul's defeat and suicide.

The lowest register with the Israelites defeat at the hands of the Philistines and Saul's suicide presents a detailed and energetic scene. On the left, two Philistine cavalrymen wielding spears trample over the Israelites' dead bodies as they chase five soldiers fleeing the battle. All the figures are interchangeable, as both the Philistine and Israelite soldiers wear the same silver Roman legionnaire armor, reddish-pink tunics, and brownish-red capes. On the right, a bearded Saul falls on the point of his sword, planted hilt-first into the ground. A faded *tituli* above the dying king identifies him as Saul. On the extreme right stands Saul's armor bearer, gazing at the fallen king and waving his open hand in concern.

Beyond its early date and completeness, the frontispiece is remarkable for how it telescopes attention to the two most important episodes of Saul's reign in Carolingian political theology: his anointing and suicide. Samuel's anointing of Saul occupies two-thirds of the second register. Saul's frontal stance and outspread arms, and the surrounding men's acclamations, draw the viewer's attention to the scene. The fourth register is entirely devoted to Saul's downfall and isolates his suicide at the lower left. The space allocated to contrasting Saul's anointing and downfall recalls Smaragdus' warning about how God cast down Saul as a consequence of his pride. Indeed, the frontispiece's single David scene, his battle with Goliath, underscores its theme of pride. Medieval exegetes had long interpreted the battle as a symbol of *humilitas* slaying *superbia*, with Augustine claiming the shepherd's defeat of the giant demonstrated how "humility kills pride."[35]

A Saul-David/*superbia-humilitas* paradigm expressed in a manner similar to a *fürstenspiegel* emerges when we view the I Kings miniature together with the II Kings frontispiece ten folios later (fol. 93ᵛ) (Fig. 2).[36] A monumental enthroned David orders the beheading of the Amalekite messenger, who presents Saul's crown and lance to the new king. David's commanding position in the upper half and blessing by a godhead (?) in the upper-left corner articulates his divinely appointed position. His reception of the crown

mented on the filial rebellion of Louis' sons. See *eadem*, "St. John, Müstair and St. Benedict, Malles: A Study in Carolingian Imperial Iconography," (Ph.D. diss., Johns Hopkins University, 1978), 91–96.

33. Rome, Saint Paul Outside the Walls, s.n. See *La Bibbia di S. Paolo fuori le mura*, ed. V. Jemolo and M. Morelli (Rome, 1981), pl. 11. For a detailed discussion of the frontispiece, see J. E. Gaehde, "The Pictorial Sources of the Illustrations to the Books of Kings, Proverbs, Judith and Maccabees in the Carolingian Bible of San Paolo Fuori Le Mura in Rome," in *Frühmittelalterliche Studien* 9 (1975), 360–369; and C. R. Dodwell, *The Pictorial Arts of the West, 800–1200* (New Haven, Conn., 1993), 67.

34. Earlier detailed cycles probably existed. For example, the fragments illustrating scenes for II Kings in Quedlinburg Itala, Berlin, Staatsbibliothek zu Berlin Preussischer Kulturbesitz, Cod. theol. lat., fol. 485 (*c.* 420–430), suggest a very extensive program. For a brief overview of the fragments, see Kurt Weitzmann, *Late Antique and Early Christian Book Illumination* (New York, 1979), 15–20.

35. Augustine, *Enarrationes in Psalmos*, Migne *PL* 36: 302. *Humilitas occidit superbiam*; and Rabanus Maurus, *Commentaria in libros IV Regum*, Migne *PL* 109: 52–53.

36. *La Bibbia di San Paolo* (as in note 33), pl. 12.

FIGURE 1. Frontispiece to I Kings, San Paolo Bible, *c.* 870–875, folio 83ᵛ (photo: Basilica San Paolo fuori le mura).

FIGURE 2. Frontispiece to II Kings, San Paolo Bible, *c.* 870–875, folio 93ᵛ (photo: Basilica San Paolo fuori le mura).

visualizes the transition of power from the old to the new. The eleven men surrounding David and holding spears and shields probably represent the tribes of Israel who now recognize David's place as their king. When both Kings frontispieces are read together as either complementary pairs or as a continuous narrative, they generate a visual typology of wrongful and rightful kingship, of Saul's fall and David's rise.

As briefly mentioned, the San Paolo Bible is often connected to Charles the Bald's patronage. This attribution rests on the presence of a full-page portrait of the king (fol. 1ʳ, although originally located at the book's end) and dedicatory poem. If made at the king's request for his own personal use, as a direct patronage model would suppose, the frontispiece's emphasis on good and bad kingship could have functioned as a visual *fürstenspiegel* for his personal viewing. But as William Diebold demonstrates, little concrete evidence exists to support Charles as the book's patron or intended recipient, although the portrait connects him to the bible.[37] Indeed, Charles, who already owned several lavish bibles, gave the book away shortly after its completion to Pope John VIII during his coronation in Rome in 875.[38]

Rather than seeing Charles as the unmediated patron, Herbert Schade, C. R. Dodwell, Lawrence Nees, and Diebold all suggest the king's friend, advisor, and occasional rival Hincmar of Reims designed or commissioned the manuscript, either for Charles or as a gift for the pope on Charles' behalf.[39] That the book was illuminated at Reims instead of at Charles' court school further supports Hincmar's involvement.[40] The manuscript, then, may have had several possible interested "patrons" that all contributed to the frontispiece's iconography and the inclusion of Saul's suicide: Hincmar, the *donateur-concepteur*, Charles, the *donateur-récepteur*, and possibly Pope John VIII, the intended *récepteur*.

If Hincmar directed the bible's iconographic program with either Charles or the pope in mind, he may have selected the imagery to present an idealized and rhetorical *imago principis* of Charles and the institution of kingship designed to meet both royal and ecclesiastical approval and support.[41] Part of this *imago* used visual similes to connect the Carolingian crown with its "ancestors" David and Solomon, who both appear in the manuscript's miniatures in a style and composition similar to Charles' portrait, while also acknowledging royal authority's dependency on the church.[42] In this respect, the I Kings frontispiece's emphasis on Saul's anointing and downfall visualizes the features of his reign that both king and clergy deemed most important—his election, his pride, the withdrawal of divine grace, and his suicide. These subjects would have spoken equally to Hincmar, Charles, and the pope about the nature of kingship and the relationship between *regnum* and *sacerdotium*.

While the lack of comparable Carolingian examples of Saul's suicide makes it difficult to explore this idea further, the major issues encountered in the San Paolo Bible's frontispiece reoccur in later art. Firstly, the basic image of Saul's suicide either as a lone figure or in battle remains generally consistent. Secondly, the typology contrasting Saul and David—good kingship and bad kingship, pride and humility—becomes the standard rhetorical strategy used in many subsequent pictures.[43] Thirdly, the image of Saul's suicide, while often located in later royal artworks, is embedded

37. See W. Diebold, "The Ruler Portrait of Charles the Bald in the S. Paolo Bible," *The Art Bulletin* 76 (March, 1994), 6–18.

38. Diebold, "Ruler Portrait" (as in note 37), 16–18.

39. Diebold, "Ruler Portrait" (as in note 37), 16–18; Dodwell, *Pictorial Arts* (as in note 33), 67; L. Nees, "Problem of Form and Function in Early Medieval Illustrated Bibles from Northwest Europe," in *Imaging the Early Medieval Bible*, ed. John Williams (University Park, Pa., 1999), 143–146; H. Schade, "Studien zur der Karolingischen Bilderbibel aus St. Paul vor den Mauern in Rom 1. Teil," *Wallraf-Richartz Jahrbuch* 21 (1959), 14–20.

40. Diebold, "Ruler Portrait" (as in note 37), 15; Dodwell, Pictorial Arts (as in note 33), 67.1; Schade, "Studien" (as in note 39), 32–36.

41. J. Lowden, "The Royal/Imperial Book and the Image or Self-Image of the Medieval Ruler," in *Kings and Kingship in Medieval Europe*, ed. A. J. Duggan (London, 1993), 240. This is what Lowden calls "an image of kingship, rather than the image of a king."

42. Diebold, "Ruler Portrait" (as in note 37), 15–18; and H. Schade, "Studien zu der Karolingischen Bilderbibel aus St. Paul vor den Mauern in Rom 2.Teil," *Wallraf-Richartz Jahrbuch* 22 (1960), 15–23.

43. This contrast is made explicitly in the virtues and vices illustration in the so-called Prüfening *Glossarium salomonis*, Munich, Bayerische Staatsbibliothek Clm 13002, fols. 3ᵛ–4ʳ, (c. 1158 and 1165). For a description of the manuscript, see

in a complex patronage network involving different *donateurs, concepteurs,* and *récepteurs* for whom Saul's suicide carried significance. However, the image of Saul's suicide would not appear in French royal works again until the end of the twelfth century under the Capetians, to whom we now turn.

THE CAPETIANS AND SAUL

Like the Carolingians, the Capetian Dynasty (987–1328) employed the theology of sacral kingship as a model of and justification for their rule.[44] As John Baldwin has demonstrated, the sacred character of early Capetian power closely followed Carolingian precedence and derived its authority through the ritual of unction, dynastic continuity with the House of David, and the close relationship between state and church.[45] Indeed, under the Capetians, the political theology of a king as *rex et sacerdos* expanded to an unprecedented degree from the eleventh through thirteenth century.[46]

The hermeneutic tradition regarding Saul's suicide also expanded during this time. In fact, as Paris became the scholastic epicenter of northern Europe, educational institutions supported by the Capetians, such as the Abbey of Saint-Victor and the newly established university, disseminated both old and new interpretations of Saul's death.[47] For instance, Rabanus' *Commentary on the Four Books of Kings* became a standard theological exegesis on Saul's downfall after

its inclusion in the *Glossa ordinaria* (c. 1120).[48] In addition, the compilers of the *Glossa* also claimed Saul "killed himself with good reason, for he had received the power for the common good, which he either did not use or abused, and so pierced himself with his own sword with which he should have driven away the enemy, but aided him instead."[49] In the *Policraticus* (c. 1160), John of Salisbury, who spent the last years of his life as Bishop of Chartres, considered Saul's downfall to be the rightful end of a tyrant.[50] In the *Historia scholastica* (c. 1173), Peter Comestor comments how "Saul died for his iniquities," and then argues how his reign had depended upon Samuel, stating, "For Saul reigned for eighteen years when Samuel was living, but only two years after he died. And during these years, he failed to observe the Holy Scriptures."[51] Given the close relationship between the intellectual centers of Paris and the crown, university scholastics, confessors, or even the general intellectual *milieu* probably transmitted these ideas about Saul to the royal house.

While the intellectual tradition behind Saul's suicide remained strong and even increased during the twelfth century, contemporaneous surviving artworks connected to Capetian patronage contain no examples of Saul's death, suggesting there was little desire to picture his downfall or even the king at all.[52] Moreover, the iconography remained unused throughout "French" lands during the eleventh and twelfth

E. Klemm, *Die romanischen Handschriften der Bayerischen Staatsbibliothek Teil I: Die Bistümer Regensburg, Passau, und Salzburg* (Wiesbaden, 1980), 60–64.

44. B. Weiler, "Politics," in *The Central Middle Ages, Europe 950–1320,* ed. Daniel Power (Oxford, 2006), 100–103.

45. J. W. Baldwin, *The Government of Philip Augustus: Foundations of French Royal Power in the Middle Ages* (Berkeley, Calif., 1986), 65–67, 355–393.

46. J. Dunbabin, *France in the Making, 843–1180,* 2nd ed. (Oxford, 2000), 256–259.

47. See S. C. Ferruolo, *The Origins of the University: The Schools of Paris and their Critics, 1100–1215* (Stanford, Calif., 1985), 11–17.

48. For an overview on the *Glossa ordinaria,* see B. Smalley, *The Study of the Bible in the Middle Ages,* 3rd ed. (Oxford, 1983), 44–66.

49. *Glossa ordinaria,* Migne *PL* 213: 562. *Arripuit itaque … merito se ipsum occidit: sic qui potestate pro communi utilitate ac*

cepta, aut non utitur aut abutitur, suo se nimirum gladio confodit, et quo ab hoste defendi debuerat, hostem potius juvat.

50. John of Salisbury, *Policraticus,* ed. and trans. C. J. Nederman (Cambridge, 1990), 61.

51. Peter Comestor, *Historia scholastica,* Migne *PL* 198: 1323–1324. *Mortuus est Saul, propter iniquitatis suas … Et regnavit Saul, vivente Samuele, octodecim annis, et, eo mortuo, duobus annis. Hos annos sacra tamen Scriptura non adnotavit.*

52. This, of course, could just be an accident of time. For a discussion of pre-thirteenth-century Capetian political artistic patronage, see D. Reilly, "The Roots of Capetian Royalty and the Saint-Vaast Bible," in *Manuscripts in Transition: Recycling Manuscripts, Texts, and Images,* Corpus of Illuminated Manuscripts Series, 15, B. Dekeyzer and J. Van der Stock, eds. (Leuven, 2005), 31–39. See also *La France romane au temps des premiers Capétiens (987–1152),* Exhib. cat., ed. D. Gaborit-Chopin (Paris, 2005), 338–357.

centuries, rare exceptions being its inclusion in a full-page miniature prefacing the psalms in the Bible of Stephen Harding (an Englishman) from Cîteaux (Dijon, Bibliothèque municipale, Ms. 14, *c.* 1109–1111) and in an illustrated copy of the *Historia scholastica* from Corbie (Paris, Bibliothèque nationale de France, Ms. lat. 16943, *c.* 1185).[53] A more prominent although contextually very different tradition of depicting Saul's suicide did exist in twelfth-century German and English monumental books, such as the Admont Bible (Vienna, Österreichisches Nationalbibliothek, Ms. ser. n. 2701, *c.* 1140), the Worms Bible (London, British Library Ms. Harley 2803, *c.* 1150), the Lambeth Bible (London, Lambeth Palace Library, Ms. 3, *c.* 1155–1160) and the Great Canterbury Psalter (Paris, Bibliothèque nationale de France, Ms. lat. 8846, *c.* 1180–1190).[54] But the turn of the thirteenth century witnessed a dramatic increase in artworks containing the image of Saul's suicide and produced under Capetian patronage, beginning with its very unusual inclusion in one of the first great royal manuscripts, the Ingeborg Psalter.

SAUL'S SUICIDE IN THE INGEBORG PSALTER

The first example of Saul's suicide in art connected to a Capetian patron occurs in the D-initial to Psalm 101 (fol. 129[r]) in the Ingeborg Psalter (*c.* 1195–1200), the famous manuscript long recognized as destined for the troubled Queen of France Ingeborg of Denmark (1175–1236) (Fig. 3).[55] Against the smooth gold background, a tall, crowned, and bearded king, not identified by an inscription but certainly Saul, impales himself with a long spear as blood pours forth from the entry wound. He teeters with one foot planted on the frame of the initial, suspended between life and death. A young boy dressed in red stockings and a blue tunic grabs hold of the weapon's shaft and Saul's elbow, attempting to intervene in the king's suicide. The presence of the spear suggests that the illuminator followed the account of Saul's death from II Kings, which is the only one that mentions the weapon.[56]

The image of Saul's suicide in the book is exceptional for several reasons that have gone unnoticed. Firstly, together with a miniature in a damaged contemporaneous Psalter from Charité-sur-Loire (London, British Library, Ms. Harley 2895, *c.* 1175–1200), it is the earliest example of Saul's suicide accompanying a psalm.[57] It pre-dates the more common usage of Saul's suicide in historiated initials, usually to Psalm 52, by three decades.[58] While the manuscript's lavish prefatory cycle has antecedents connected with royal patronage, such as the Franco-Crusader Queen Melisende Psalter (London, British Library Ms. Egerton 1139, *c.* 1135), the psalm initials do

53. The Bible of Stephen Harding, Dijon, Bibliothèque municipale, Ms. 14, fol. 13[r]. The *Historia scholastica*, Paris, Bibliothèque nationale de France, Ms. lat. 16943, fol. 80[r]. For both of these manuscripts, see W. Cahn, *Romanesque Manuscripts: The Twelfth Century*, 2 vols. (London, 1989).

54. The Admont Bible, Vienna, Österreichisches Nationalbibliothek, Ms. ser. n. 2701, fol. 126[r]. The Worms Bible, London, British Library, Ms. Harley 2803, fol. 133[v]. The Lambeth Bible, London, Lambeth Palace Library, Ms. 3 fol. 151[r]. For Saul in the Lambeth Bible, see D. Shepard, *Introducing the Lambeth Bible: A Study of Texts and Images* (Turnhout, 2007), 140–141. The Great Canterbury Psalter, Paris, Bibliothèque nationale de France, Ms. lat. 8846, fol. 2[v]. For this manuscript, see N. Morgan, *Early Gothic Manuscripts 1190–1250*, vol. 1, Survey of Manuscripts Illuminated in the British Isles (London, 1982), 47–49. As the historical differences are great, the image of Saul's suicide in English and German artworks requires a future separate discussion.

55. Chantilly, Musée Condé, Ms. 9 *olim* 1695. L. Delisle, *Notice sur le psautier d'Ingeburge* (Paris, 1867), 1–6. Delisle first noticed the connection between Ingeborg and the manuscript.

The major study on the Psalter remains F. Deuchler, *Der Ingeborgpsalter* (Berlin, 1967). The exact dating will probably remain unknown, but a late twelfth-century date seems most likely. See F. Avril, "L'atelier du Psautier d'Ingeburge: problèmes de localization et de datation," in *Hommage à Hubert Landais: Art, Objets d'art, collection: Études sur l'art du Moyen Age et de la Renaissance sur l'histoire du goût et des collections* (Paris, 1987), 16–21.

56. II Kings 1:6. The Amalekite mentions coming upon Saul who "leaned on his spear."

57. London, British Library, Ms. Harley 2895, fol. 15[v]. Little is known about the manuscript from Charité-sur-loire. It appears to have been produced in Northern France during the last quarter of the twelfth century. It does not share stylistic or compositional affinities with the Ingeborg Psalter.

58. This occurs mostly in Psalters from England but occasionally in Flemish and Northern French manuscripts. See A. Belkin, "Suicide Scenes in Latin Psalters of the Thirteenth-Century as Reflection of Jewish Midrashic Exposition," *Manuscripta* 32.2 (1988), 75–92.

FIGURE 3. Initial to Psalm 101, Ingeborg Psalter, *c.* 1195-1200, Chantilly, Musée Condé, Ms. 9 *olim* 1695, folio 129ʳ (photo: RMN Grand Palais/Art Resource, N.Y.).

not.[59] Secondly, it is the *only* instance where Saul's suicide is connected to Psalm 101.[60] And thirdly, there is no exegetical tradition connecting Saul to this psalm. Fortuitously, the general circumstances surrounding

the Psalter's creation are known and considering them may illuminate these problems.

The manuscript was made in Northeastern France, possibly at the monastery of Cysoing in the diocese of Noyon, between *c.* 1195 – *c.* 1200 for Princess Ingeborg of Denmark during the first half of her long imprisonment and exile after her repudiation by King Philip Augustus the day after their wedding on 15 August 1193.[61] After Ingeborg refused to concede to Philip's demand for a divorce, her family appealed to Pope Celestine III, who declared the divorce invalid. Philip ignored the pope's decree and remarried the German princess Agnes of Méran in 1196. Philip's re-marriage engendered a bitter conflict between Philip and Celestine's successor Pope Innocent III, who threatened the king with excommunication and pronounced an interdict on the realm on 13 January 1200, which lasted through September of that year.[62] Subsequent attempts to reconcile Ingeborg and Philip failed until 1213, when Philip reinstated her *pro forma* as queen to press his claims to the throne of England.[63]

Given Ingeborg's dramatic predicament at the time of the manuscript's creation, scholars have focused their attention on the manuscript's unique prefatory cycle and have interpreted several miniatures, notably the Mariological Tree of Jesse (fol. 14ᵛ) and the crowned Virgin receiving the spirit at Pentecost (fol. 32ᵛ), as a visual defense of Ingeborg by herself or her supporters.[64] However, Ingeborg's precise role

59. For the relationship between the Ingeborg Psalter and Queen Melisende Psalter, see K. S. Schowalter, "The Ingeborg Psalter: Queenship, Legitimacy, and the Appropriation of Byzantine Art in the West," in *Capetian Women*, ed. K. Nolan (New York, 2003), 99–118.

60. A still useful source for comparing twelfth- and early thirteenth-century French Psalters is G. Haseloff, *Die Psalterillustration im 13. Jahrhundert: Studien zur Geschichte der Buchmalerei in England, Frankreich und den Niederlanden* (Cologne, 1938), 19–21, 102–105.

61. Deuchler, *Ingeborgpsalter* (as in note 55) 110–111; Avril, "L'atelier" (as in note 55), 16–18; L. Grodecki, "Le psautier de la reine Ingeburge et ses problèmes," *Revue de l'Art* 5 (1969), 73–78. Recently Patricia Stirnemann questioned whether the book was possibly made earlier, *c.* 1192–1193, as a coronation present for Ingeborg. See P. Stirnemann, "The Copenhagen Psalter Reconsidered as a Coronation Present for Canute VI (Kongel. Bibl., Ms. Thott 143 2°), in *The Illuminated Psalter:*

Studies in the Content, Purpose and Placement of its Images, ed. F. O. Büttner (Turnhout, 2004), 328.

62. A good overview for Ingeborg's situation is G. Conklin, "Ingeborg of Denmark, Queen of France, 1193–1223," in *Queens and Queenship in Medieval Europe*, ed. A. Duggan (Woodbridge, 1997), 39–52. See also F. Menant *et al.*, *Les Capétians: Histoire et Dictionnaire, 987–1328* (Paris, 1999), 231; E. M. Hallam and J. Everard, *Capetian France 987–1328*, 2nd ed. (New York, 2001), 253.

63. Baldwin, *Government of Philip Augustus* (as in note 45), 85–87; Menant, *Les Capétians* (as in note 62), 231.

64. Schowalter, "Ingeborg Psalter" (as in note 59), 114–118; M. H. Caviness, "Anchoress, Abbess, and Queen: Donors and Patrons or Intercessors and Matrons?" in *The Cultural Patronage of Medieval Women*, ed. J. H. McCash (Athens, Ga., 1996), 133. See also M. Caviness *et al.*, "The Gothic Window from Soissons: A Reconsideration," in *Fenway Court*, Isabella Stewart Gardner Museum, 1983 (Boston, Mass., 1984), 15–17.

in the manuscript's production, conceptually and monetarily, remains uncertain, and it is unlikely she commissioned the work for herself.[65] It is quite possible the queen's defenders Bishop Stephen of Tournai and the wealthy countess Eleanor of Vermandois, who both supported Ingeborg's claim to the throne, facilitated the manuscript's creation.[66] Indeed, Stephen, a long-trusted advisor to Philip, developed a close relationship with Ingeborg during her exile and wrote letters in her defense praising her beauty and her queenly virtues.[67] Through his intimacy with the royal house, defense of Ingeborg, and close proximity to Cysoing, Stephen is a good candidate as the manuscript's *donateur-concepteur*.[68] Even so, one must consider Ingeborg as the *récepteur*; the patron insofar as the program was destined for the eyes of the queen during her time of distress.

Why, then, include the image of Saul's suicide in the initial of Psalm 101? The psalm itself offers no clues for the picture's inclusion. It is the fifth penitential psalm and an individual lament for personal restoration through humility and the rebuilding of Jerusalem. The psalm is replete with pleading and lamenting passages that would have resonated with the exiled and imprisoned queen, such as "All day long my enemies reproached me; and they that praised me did swear against me."[69] But there are no textual, exegetical, or comparable visual examples linking Saul to the psalm. In the major glosses on Psalm 101—Peter

Lombard's *Commentary on the Psalms*, Cassiodorus's *Exposition on the Psalms*, Augustine's work of the same title—no mention of Saul is to be found.[70] When the psalm is illustrated, it typically features a supplicant figure before Christ.[71] This occurs even in the initial to Psalm 101 in the sister manuscript painted by the Ingeborg atelier master and now at the Getty Museum, Los Angeles.[72]

When the psalm's initials are viewed together as a single entity rather than individual textual illustrations, as Florens Deuchler observes, Saul's suicide forms part of a detailed Davidic narrative cycle.[73] The cycle begins in the *Beatus* initial to Psalm 1 (fol. 37v) with Samuel's elevation of David, dressed in red stockings and a deep blue tunic. The prophet anoints the future king with a horn of oil as the *manus dei* descends from heaven and blesses him. The narrative then proceeds with David before Saul (fol. 58v, Ps. 26), David playing his harp before Saul (fol. 72r, Ps. 38), David standing before Goliath (fol. 84r, Ps. 51), the battle with Goliath (fol. 84v, Ps. 52), David beheading Goliath and presenting it to Saul (fol. 97r, Ps. 68), David before a group of women (fol. 112v, Ps. 80), Saul threatening David (fol. 127r, Ps. 97), Saul's suicide (fol. 129r, Ps. 101), David receiving the crown (fol. 142v, Ps. 109), David's humility before God (fol. 145v, Ps. 114), and David kneeling before Christ (fol. 173r, Canticle 4).[74] As part of a David cycle, Saul's suicide seems less out of place than it first appears.

65. K. Nolan, *Queens in Stone and Silver: The Creation of a Visual Imagery of Queenship in Capetian France* (New York, 2009), 225, n. 171.

66. Deuchler, *Ingeborgpsalter* (as in note 55), 113–115.

67. Conklin, "Ingeborg of Denmark" (as in note 62), 40–42.

68. For an overview, see C. J. Liebman, "Art and Letters in the Reign of Philip II Augustus of France: The Political Background," in *The Year 1200*, vol. II, ed. F. Deuchler (New York, 1970), 1–6. Some scholars also see Eleanor as having played a more decisive role in the manuscript's production. See Avril, "L'atelier" (as in note 55), 18–19.

69. Psalm 101:9.

70. By the end of the twelfth century Peter's gloss had become the standard exegesis on the psalms. See C. F. R. de Hamel, *Glossed Books of the Bible and the Origins of the Paris Booktrade* (Woodbridge, 1984).

71. This occurs often in English Psalters. See N. Morgan, "Patrons and their Devotions in the Historiated Initials and Full-Page Miniatures of 13th-Century English Psalters," in

The Illuminated Psalter (as in note 61), 309–322. Compare the tables in Haseloff, *Psalterillustration*, 102–121; and R. Branner, *Manuscript Painting in Paris During the Reign of Saint Louis: A Study of Styles* (Berkeley, Calif., 1977), 178–193.

72. See A. Bennett, "The Transformation of the Gothic Psalter in Thirteenth-Century France," in *The Illuminated Psalter* (as in note 61), 214.

73. Deuchler, *Ingeborgpsalter* (as in note 55), 77–80. Deuchler first noted that the uniformity of the picture cycle takes precedence over text-image relationships, but did not examine the issue further. A similar example of a David narrative constituting psalm initials is also found in the Little Canterbury Psalter (*c.* 1215), which also contains an image of Saul's suicide at Psalm 68. See M. Caviness, "Conflicts between *Regnum* and *Sacerdotium* as Reflected in a Canterbury Psalter of ca. 1215," *Art Bulletin* 61 (1979), 38–58.

74. See Deuchler, *Ingeborgpsalter* (as in note 55), 75–90. The initial cycle uses an odd eleven-part division rather than the more usual eight- or ten-part division.

Beyond picturing a simple David cycle, the iconography articulates the theme of David's rise and Saul's fall, of humility's rewards and pride's consequences. The anointing and blessing of David in the *Beatus* initial establishes the young king as God's chosen, prefiguring Saul's eventual destruction; a point forcefully made by beginning the cycle with David's unction, which in the biblical story occurs immediately after God abandons Saul.[75] This transference of power from Saul to David occurs within the initial of Psalm 101 itself, in which the boy reaching out towards Saul as he kills himself wears the same blue and red garments that adorns David in each preceding initial. This visual continuum alludes to the boy as the new king rather than the expected figure of Saul's armor-bearer. The following initial depicts an older, bearded, and crowned David receiving Saul's crown from the Amalekite, fulfilling the prophecy of David's rightful place as king announced in the *Beatus* illustration. The cycle is thus bookended by David's anointing (the sacred) and crowning (the secular), the two features upon which the legitimacy of Capetian kingship depended.

While there are no comparable textual or pictorial links between Saul and the psalm, there exists an intriguing connection between King Philip and the psalm made by Ingeborg herself—one that may lend the image of Saul's suicide a particular significance. In a letter addressed to Pope Celestine III from 1196, Ingeborg pleads her case as the rightful queen of France. When describing her situation to the pope, she laments, "… I eat bread with anguish and am constantly forced to mix tears with a drink…"[76] This is, in fact, a specific reference to verse 10 of Psalm 101: "For I did eat ashes like bread, and mingled my drink with weeping."[77] Ingeborg then describes Philip as one who "spreads his evil example to Christians and the entire kingdom."[78] She then expresses her outrage at Philips' prideful actions against the pope and his retinue: "Such anguish! He fears not to spurn your holiness' letters. He refuses to listen to the commands of the cardinals. He scorns the words of the archbishops and prelates, and he rejects the warnings of the pious ones."[79] Ingeborg describes Philip in terms that would have easily applied to Saul, and may have been a reference connecting the two kings directed at the pontiff or his circle. Such a connection would not have been new, for during the Investiture Controversy Pope Gregory VII wrote to Henry IV and reminded him to pay heed to Saul's failure lest he suffer the same fate.[80]

It may not be too far-fetched to suggest that Saul's suicide and the Davidic cycle were included in the manuscript as a response to Ingeborg's battle with Philip over the divorce and as a reference to the troubled Capetian monarch. Madeline Caviness suggests similar possible readings of the manuscript's prefatory miniatures.[81] Whether the image of Saul's downfall at Psalm 101 spurred such an association between the two kings as implied in the letter to the pope or was placed there because Ingeborg had previously made the correlation is, regrettably, lost to time. Nonetheless, as an *exemplum par excellence* of prideful and self-destructive kingship that connoted the actions of Philip, the shining image of Saul's suicide at Psalm 101, a cry for restoration and a prayer for the unjustly afflicted, would certainly have spoken to the displaced and maltreated queen and furnished a target for her lament.

BLANCHE OF CASTILE, LOUIS IX, AND SAUL'S SUICIDE

After the Ingeborg Psalter, the image of Saul's suicide continues to appear in many lavish artworks connected with the Capetians during the first half of the thirteenth century: the *Bibles moralisées*, the north

75. I Kings 16.

76. The letter is preserved under Celestine III, *Epistolae et privilegia*, Migne *PL* 206: 1278A. … *qui panem comedo cum dolore et potum cum lacrymis assidue permiscere compellor….*

77. Psalm 101:10.

78. Celestine III, *Epistolae et privilegia*, Migne *PL* 206: 1278…. *Christianis et universis de regno suo exemplum tribuit malignandi.*

79. *Ibid.* Migne *PL* 206: 1278 B. *Proh dolor! spernera vestrae*

sanctitatis litteras non formidat, audier cardinalium jussa recusat, archiepiscoporum et praesulum dicta contemnit, et admonitions religiosorum quorumlibet aspernatur.

80. The letter is reproduced and translated in *Select Historical Documents of the Middle Ages*, ed. and trans. E. F. Henderson (London, 1892), 403–404.

81. Caviness, "Anchoress, Abbess, Queen" (as in note 64), 133.

transept window at Chartres Cathedral, and the Kings window in the Sainte-Chapelle. The thread connecting these works beyond their royal origin or destination is that they are connected to the patronage (in its manifold forms) of Blanche of Castile (1188–1252) and Louis IX (1214–1270). Indeed, Blanche and Louis were perhaps the first great Capetian patrons of the visual arts, with many illustrated Bibles, Psalters, glass programs, and buildings attributed to their sponsorship.[82]

The image of Saul's suicide appears in all four thirteenth-century *Bibles moralisées*, the lavish and selective Parisian "picture" bibles.[83] As Robert Branner and more recently John Lowden show, the manuscripts were products by or for the Capetian royal family.[84] The earliest of these, the French-language manuscript in Vienna (Vienna 2554, *c.* 1220–1225), was intended for Blanche of Castile.[85] The second manuscript in Vienna (Vienna 1179, *c.* 1220–1225), written in Latin, may have been a gift from Blanche to her husband Louis VIII (1187–1226).[86] Blanche may have commissioned the manuscript in Toledo Cathedral (*c.* 1230) for her son Louis IX, as the fa-

mous image of a king and queen from the detached quire from the manuscript in the Morgan Library is often identified as the queen and her son.[87] The Oxford-Paris-London manuscript (*c.* 1230–1235) may also have been commissioned by Blanche and hastily produced alongside or shortly after the Toledo copy.[88]

With the books' size and theological complexity, the Capetian's role as the manuscripts' patrons needs some parsing. Like the San Paolo Bible and the Ingeborg Psalter, the patronage network indicates the mutual interests and investments of several different groups. The Capetians may have acted as the *donateurs*, supplying the basic finances, materials, and locations for the books' production. But they were not the manuscript's thematic *concepteurs*, a duty handled by a number of spiritual advisors, university scholars, or mendicant friars close to the royal family.[89] Yet the restricted circle of royal viewers, the intended *récepteurs*, directly or indirectly dictated much of the books' iconography, resulting in a program resonating with multiple parties.

In Blanche's book (Vienna 2554), Saul, crowned

82. For manuscripts, see Branner, *Manuscript Painting* (as in note 71), 3–4, 30–35; R. and M. Rouse, *Illiterati et uxorati. Manuscripts and Their Makers: Commercial Book Producers in Medieval Paris, 1200–1500*, 2 vols. (Turnhout, 2002), 1: 33–34, 41–45. For a recent discussion of Blanche's architectural patronage, see A. Gajewski, "The Patronage Question Under Review: Queen Blanche of Castile (1188–1252) and the Architecture of the Cistercian Abbeys at Royaumont, Maubisson, and Le Lys," in *Reassessing the Roles of Women as 'Makers' of Medieval Art and Architecture*, vol. 1, ed. T. Martin (Leiden, 2012), 197–244; and M. Shadis and C. H. Berman, "A Taste of the Feast: Reconsidering Eleanor of Aquitaine's Female Descendants," in *Eleanor of Aquitaine: Lord and Lady*, eds. B. Wheeler and J. C. Parsons (New York, 2002), 189, 192–195.

83. The bibliography on the *Bibles moralisées* is extensive. Major publications include J. Lowden, *The Making of the Bibles Moralisées*, 2 vols. (University Park, Pa., 2000); A. de Laborde, *La bible Moralisée conservée à Oxford, Paris, et Londres; reproduction intégrale du manuscrit du XIIIᵉ siècle accompagné d'une notice*, 5 vols. (Paris, 1911–1927); G. B. Guest, *Bible Moralisée: Codex Vindobonensis 2554, Vienna, Österreichische Nationalbibliothek* (London, 1995); and the collected works of R. Haussherr, *Bible moralisée: Prachthandschriften des Hohen Mittelalters: gesammelte Schriften von Rainer Haussherr*, eds. E. König *et al.* (Petersberg, 2009). For a recent overview of the scholarship, see B. Hellemans, *La Bible moralisée: une œuvre à part entière:*

temporalité, sémiotique, et création au XIIIᵉ siècle (Turnhout, 2010), 202–207.

84. Branner, *Manuscript Painting* (as in note 71); 3–4; Lowden, *Making*, vol. 1 (as in note 83), 8, 50–54, 94, 127–131, 183–185; *idem, Making*, vol. 2 (as in note 83), 208–209.

85. Vienna, Österreichische Nationalbibliothek, Codex Vindobonensis 2554. See Lowden, *Making*, vol. 1 (as in note 83), 50–54.

86. Vienna, Österreichische Nationalbibliothek, Codex Vindobonensis 1179. The portrait of a king at the manuscript's end may be Louis VIII. See Guest, *Bible moralisée* (as in note 83), 16–17; and Lowden, *Making*, vol. 1 (as in note 83), 88–89, fig. 34.

87. Toledo, Cathedral Library, Mss. 1–3 and New York, Pierpont Morgan Library, Ms. м. 240. See Lowden, *Making*, vol. 1 (as in note 83), 127–132. For the Toledo manuscript's subsequent history and its relationship to King Alfonso IX; *idem*, "'Reading' Images and Texts in the *Bibles moralisées*: Images as Exegesis and the Exegesis of Images," in *Reading Images and Texts: Medieval Images and Texts as Forms of Communication: Papers from the Third Utrecht Symposium on Medieval Literacy, Utrech, 7–9 December 2000*, eds. M. Hageman and M. Mostert (Turnhout, 2005), 495–526.

88. Oxford, Bodleian Library, Ms. Bodley 270b; Paris, Bibliothèque Nationale de France, Ms. lat. 11560; London, British Library, Ms. Harley 1526–1527.

89. Lowden *Making*, vol. 2 (as in note 83), 2–3.

and dressed in chainmail armor, falls upon the point of his spear (fol. 43ʳ) (Fig. 4). A young man dressed in a blue tunic steadies Saul's head and raises a sword above it, ready to behead the king. Like the image in the Ingeborg Psalter, the details of the scene indicate the designer followed the Amalekite's account from II Kings.⁹⁰ In the moralizing roundel below a three-faced demon pushes a king resembling Saul and a group of Jews into Hell, while the text equates them with the people of the anti-Christ.⁹¹ The thematic typology is reminiscent of Peter of Riga's interpretation of Saul's death as the Jews' rejection of grace.⁹² The folio's remaining medallions follow David's story through his election, while the exegetical illustrations present him as a pre-figuration of Christ. On the whole, the page lucidly narrates the story of Saul's fall and David's rise in a traditional manner, although the moralizations perhaps belie deeper theological ambitions.

The depictions of Saul's suicide in the slightly later Toledo and Oxford-Paris-London manuscripts present a more gruesome and complex scene. The roundel in the Toledo manuscript's right column (fol. 114ʳ) depicts Saul, crowned and armed for battle, ready to fall on his sword (Fig. 5). Behind him a mad-looking armor bearer impales himself through his heart with a long spear, as the bloodied bodies of Saul's sons and kinsmen collapse into a pile of corpses. In the moral roundel below two tonsured prelates holding money purses stab themselves with daggers while a demon forces four others, including a bishop, into Hell. The scene of Saul's suicide and the moralizing roundel in the Oxford-Paris-London manuscript are nearly identical to the Toledo illuminations, except that a king now accompanies the clergy on their voyage into perdition (fol. 146ʳ).⁹³

The equation of Saul with the spiritually suicidal prelates in the Toledo manuscript suggests a stronger impact of the theological *concepteurs* and sources compared to the earlier manuscript. Whereas Vienna 2554 locates Saul's suicide within a familiar moral typology accompanied by descriptive captions, the Toledo image presents his demise in a more theological framework, associating Saul's suicide with a Christian's spiritual death. The emphasis on spiritual death is perhaps the result of the *concepteurs'* choice for the roundel's text, which references Rabanus Maurus' interpretation of Saul's suicide as that of Christians who kill themselves with their own daggers after losing all hope from *Commentary on the Four Books of Kings*.⁹⁴ Moreover, the word opening the text accompanying Saul's suicide, *arripuit* ("seized," a reference to his sword), likewise begins the commentary on his death in the *Glossa ordinaria*, demonstrating the scholastic impact on the iconography.⁹⁵ The two roundels also comment on the inextricable relationship between bad kings and bad prelates, suggesting that as one falls so does the other.

As Lowden argues, one of the books' multivalent functions was to act as a pedagogical tool, presenting an extended and multi-layered visual and thematic program from which Blanche, Louis VIII, Louis IX and a few select others drew moral *exempla* and wrestled with the program's spiritual and political implications.⁹⁶ In this context, the inclusion of Saul's suicide followed the tradition of literature composed by the clergy for royalty, which continued under the Capetians. This warned the recipient of the tenuous nature

90. The accompanying text states, "Here Saul comes and throws himself on his lance to kill himself and a boy who was of his law comes before him and Saul orders him to cut off his head and he does so." Quoted from Guest, *Bible moralisée* (as in note 83), 119. The composer or scribe is mistaken, as the Amalekite who beheaded Saul was a foreigner.

91. Guest, *Bible moralisée* (as in note 83), 119.

92. Peter of Riga, *Aurora: Petri Rigae Biblia versificata. A Verse Commentary on the Bible*, Publications in Mediaeval Studies, XIX, ed. P. E. Beichner (Notre Dame, Ind., 1965), 270.

93. Oxford, Bodleian Library, Ms. Bodley 270b.

94. Rabanus Maurus, *Commentaria in libros IV Regum*, Migne *PL* 109: 70–72.

95. See note 52.

96. Lowden, *Making*, vol. 2 (as in note 89), 208–209. Several doctoral dissertations have interrogated the relationship between ideas of kingship and the manuscripts, although none have examined Saul's suicide. See J. M. Heinlen, "The Ideology of Reform in the French Moralized Bible," (Ph.D. diss., Northwestern University, 1991), who posited the manuscripts were a *speculum principis*; G. B. Guest, "Queens, Kings, and Clergy: Figures of Authority in the Thirteenth-Century Moralized Bibles," (Ph.D. diss., New York University, 1998); and P. Büttner, "Bilder zum Betreten der Zeit: Bible Moralisée und kapentengisches Königtum," (Ph.D. diss., University of Basel, 1997).

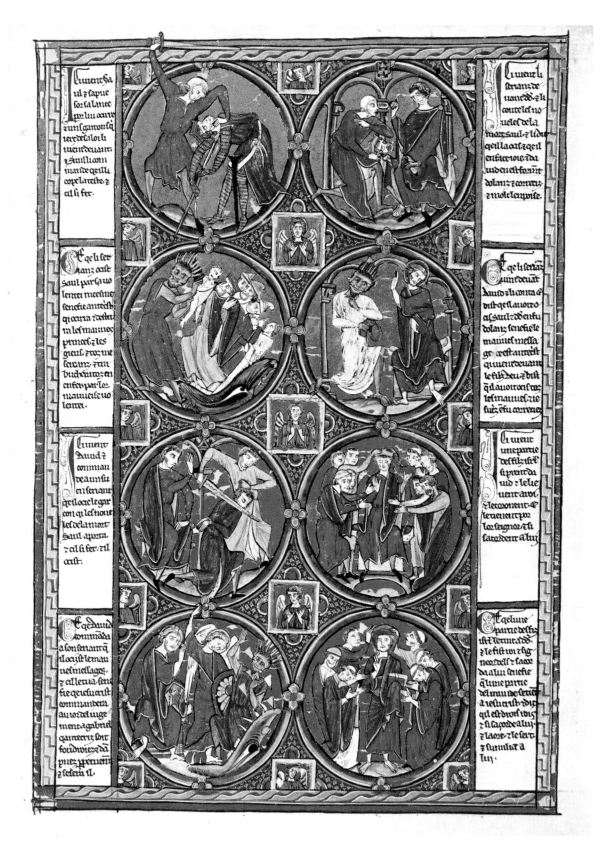

FIGURE 4. Saul's suicide and Kings cycle, *Bible moralisée*, *c.* 1220–1225, Vienna, Österreichische Nationalbibliothek, Codex Vindobonensis 2554, folio 43r (photo: Österreichische Nationalbibliothek).

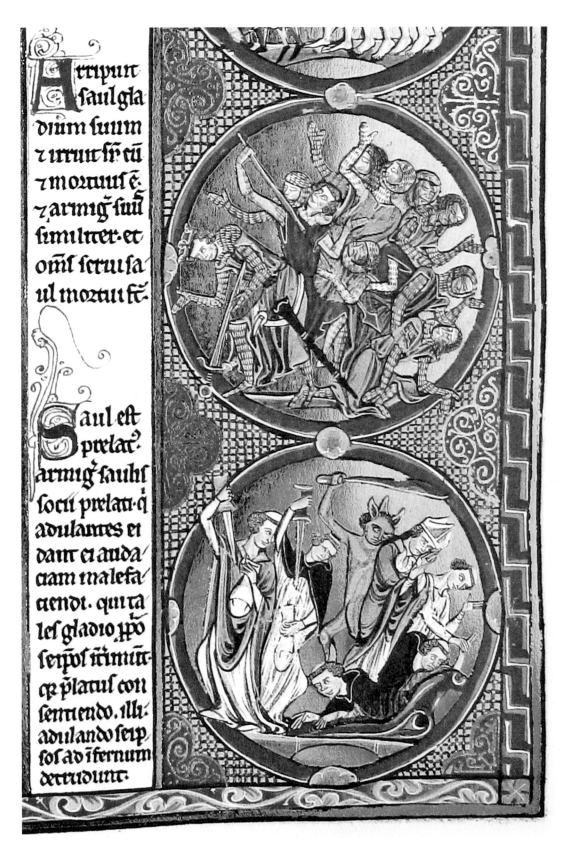

FIGURE 5. Saul's suicide and moralizing roundel, detail, *Bible moralisée*, *c.* 1230, Toledo Cathedral Library, Mss. 1–3, folio 114ʳ (photo: Toledo Cathedral Library).

of kingship while simultaneously defining their own claims to the office. Yet whether the intended royal readers ever glanced at these images is a practical issue that will never be known. Nonetheless, they were still produced and included in an extravagant manuscript made for royal eyes with the expectation that, when gazed upon, they understood the tasks required of them by the image.

Also connected to Capetian patronage, and the most remarkable in its material, size, and more public context, is the depiction of Saul's suicide in a lancet window underneath the rose window in Chartres Cathedral's north transept (*c.* 1226–1235) (Figs. 6 and 7).[97] Dressed in a yellow tunic and blue cape, Saul impales himself with his sword underneath the large standing figure of King David, who strums a harp. Saul and David form one of the four Old Testament typological pairs separated by the central figure of Saint Anne holding the Virgin. On the left, Melchizedek stands over Nebuchadnezzar and David rises above Saul. On the right, Solomon towers over the idolatrous Jeroboam while Aaron stands above the tumbling Pharaoh.

Although often reproduced in scholarship on the cathedral's glass, the inclusion of Saul's suicide in the lancet window is quite extraordinary for several rea-

sons. It is the *first* occurrence of the subject in stained glass. Moreover, it is only one of three extant examples in a glass program, the others being in a David cycle in the northern ambulatory of Auxerre Cathedral and in the Kings cycle window on the south wall of the Sainte-Chapelle.[98] Finally, while Saul's death is connected with David, it is extracted from a Davidic cycle or any other narrative context, appearing as a semi-detached emblematic image.

Scholars generally attribute the window to Capetian patronage in general and Blanche of Castile in particular on the presence of the arms of France and Castile scattered across the window. Although Blanche did have a history of donating to the cathedral—the cartulary of Chartres records her promise of 200 pounds per year to acquire property dedicated to the Virgin Mary—her role in the window's donation and iconographic selection remains elusive, and it remains a difficult task disentangling the patronage network.[99] Nonetheless, Beat Brenk, Willibald Sauerländer, James Bugslag, Lindy Grant, and others argue the transept windows, some of the choir clerestory glass, and the north portal's sculpture display the Capetians' political ambitions and the ideology of *rex et sacerdos*.[100] While these claims have not gone unchallenged, they present a useful framework for

97. The dating of the window is extraordinarily complex, and I have given here the wide range of dates for its possible creation. For an overview on the discussion and further references, see C. Mahnes-Deremble, *Les vitraux narratifs de la cathedral de Chartres: Étude iconographique* (Paris, 1993), 9–12. See the classic studies that outline the problem: Y. Delaporte, *Les vitraux de la cathédrale de Chartres*, 3 vols. (Chartres, 1926); L. Grodecki, "Chronologie de la Cathédrale de Chartres," *Bulletin Monumental* 116 (1958), 91–119; P. Frankl, "The Chronology of the Stained Glass in Chartres Cathedral," *The Art Bulletin* 45 (1964), 301–322; J. van der Meulen, "Recent Literature on the Chronology of Chartres Cathedral," *The Art Bulletin* 49 (1967), 152–172.

98. For Saul's suicide at Auxerre, see V. C. Raguin, *Stained Glass in Thirteenth-Century Burgundy* (Princeton, N.J., 1982), 140; and *Les Vitraux de Bourgogne Franche-Comté et Rhône-Alpes*, Corpus Vitrearum France Recensement III (Paris, 1986), 111–112. For Saul in the Sainte-Chapelle, see L. Grodecki, *La Sainte-Chapelle*, 3rd ed. (Paris, 1979), 54; M. Aubert, L. Grodecki *et al.*, *Les Vitraux de Notre-Dame et de la Sainte-Chapelle de Paris*, Corpus Vitrearum Medii Aevi, France 1 (Paris, 1959), 276–288; and most recently A. A. Jordan, *Visualizing*

Kingship in the Windows of the Sainte-Chapelle, Publications of the International Center of Medieval Art, 5 (Turnhout, 2002), 24.

99. *Cartulaire de Notre-Dame de Chartres*, vol. II, eds. E. de Lépinois and L. Merlet (Paris, 1856), 213. The cartulary records in Blanche's obit of 27 November 1252: *Ducentus libras parisienses nobis realiter assignando et tradendo pro redditibus perpetuis aquirendis et convertendis ad augmentationem cultus Domini, et specialiter pro una missa de Spiritu-Sancto vel de beata virgine Maria, singulis annis....* Blanche also possibly donated a small grisaille window dedicated to the Virgin in the cathedral's central apsidal chapel. See M. Shadis, "Piety, Politics, and Power: The Patronage of Leonor of England and Her Daughters Berenguela of León and Blanche of Castile," in *Cultural Patronage of Medieval Women* (as in note 64), 214.

100. B. Brenk, "Bildprogrammatik und Geschichtsverständnis der Kapetinger im Querhaus der Kathedrale von Chartres," in *Arte medievale* 2, Series 5 (1991), 71–96; W. Sauerländer, "Integrated Fragments and the Unintegrated Whole: Scattered Examples from Reims, Strasbourg, Chartres, and Naumburg," in *Artistic Integration in Gothic Buildings*, eds. V. C. Raguin, K. Brush, and P. Draper (Toronto, 1995), 161–162; J. Bugslag,

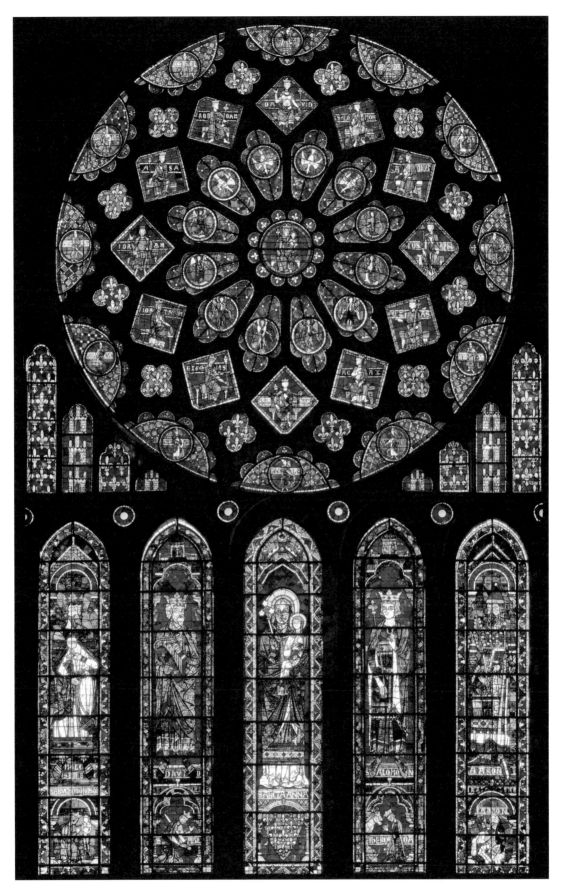

FIGURE 6. North transept rose and lancet windows, Chartres Cathedral, *c.* 1226–1235
(photo: Stuart Whatling).

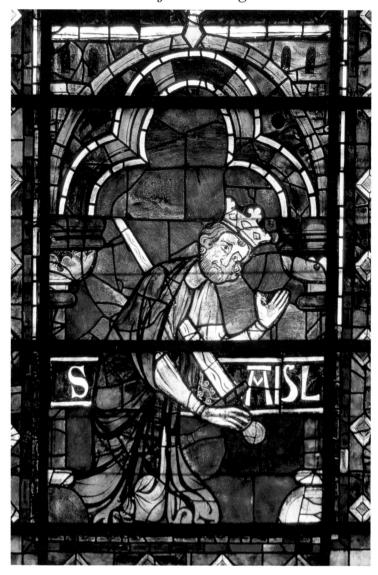

FIGURE 7. Saul's suicide, detail, lancet window, Chartres Cathedral, *c.* 1226–1235
(photo: Stuart Whatling).

exploring the possible reasons behind Saul's inclusion in the window, even if the evidence gathered is circumstantial and the conclusions drawn remain speculative.[101]

If viewed from the vantage point of Capetian rhetoric, the lancet window repeats the theme of David's rise and Saul's fall as typological *exempla*, and forms one section of the lower windows' overall empha-

"Ideology and Iconography in Chartres Cathedral: Jean Clément and the Oriflamme," in *Zeitschrift für Kunstgeschichte* 61 (1998), 491–508; L. Grant, "Representing Dynasty: The Transept Windows at Chartres Cathedral," in *Representing History, 900–1300: Art, Music, History* (University Park, Pa., 2010), 109–114. See as well D. Kimpel and R. Suckale, *Die Gotische Architektur in Frankreich 1130–1270* (Munich, 1986), 490, note

9; and J-P. and C. Deremble, *Les Vitraux de Chartres* (Paris, 2003), 236–238.

101. For a criticism of this idea, see B. Kurmann-Schwarz, "Récits, programme, commanditaires, concepteurs, donateurs: publications récentes sur l'iconographie des vitraux de la cathédrale de Chartres," *Bulletin Monumental* 154 (1996), 62–63, 67–68.

sis on the triumph of *rex et sacerdos*, articulated by the equal pairing of a king and priest flanking Saint Anne: Melchizedek and David on the left, Solomon and Aaron on the right. In each case, king and priest defeat the vices of idolatry and pride: Nebuchadnezzar and Jeroboam for the former, Saul and Pharaoh for the latter.[102] The central lancet figure of Saint Anne, who stands upon a shield of fleur-de-lis, provides a central vertical axis connecting the Old Testament monarchs with the central roundel of the Virgin holding the Christ child in the rose window, surrounded by concentric circles of angels, the twelve kings of Israel, and Old Testament prophets. The rose window also emphasizes the divine support of the royal house, for the Virgin holds a scepter capped with the fleur-de-lis. The entire window certainly seems in favor of the Capetians.

But what prompted the specific inclusion of Saul's suicide in the window? This is a difficult problem. Brenk and Roland Halfen interpret Saul's suicide as a reference to Louis VIII's crusade against the Albigensians in Languedoc.[103] This interpretation has much merit. However, another possible explanation may be found closer to the heart of Capetian politics around the time of the window's creation. When Louis VIII unexpectedly died on crusade in 1226, the Capetians faced a dynastic crisis. Louis IX was twelve years old, not yet of age for the throne. Blanche became regent of France and ruled in his stead until his maturity sometime in the early 1230s. Rebellious nobles frequently challenged her rule, in particular Peter de Dreux, Duke of Brittany, who led failed rebellions against Blanche in 1226 and 1229.[104] A fiercely capable ruler, Blanche enjoyed the strong support of the clergy, especially that of Bishop Gauthier of Char-

tres.[105] Gauthier even accompanied Blanche and the royal army on their march into Brittany to subdue Peter in 1231, and had earlier escorted her husband on the Albigensian crusade and acted as a *conseil* to Louis IX.[106]

If the windows were created as something of a monument to the royal house, as seems likely, and were produced during or in reaction to the unstable political climate of the 1220s or early 1230s, a public display of the lasting power of the Capetian dynasty and its *dei gratia* would have made a strong statement. As the glass transformed the Capetian rhetoric of *rex et sacerdos* into tangible visual emblems, Saul's suicide functioned as an *emphatic effect* articulating what they were not—prideful and idolatrous kings—while announcing what they were: God's chosen, pious defenders of the Church, and the new House of David. And like the virtues over the vices, the Capetians crushed idolatry and pride. Chartres was an opportune place to make such a statement, given the crown's warm relationship with the bishopric and the physical and symbolic presence of the Dreux family in the south transept windows.

If this were the case, then perhaps both the Capetians and the Chartres clergy can be considered the window's *donateurs-concepteurs*. The window's iconography fulfilled both parties mutual need to express the ideas behind *rex et sacerdos*. While Blanche or another member of the Capetian house probably did not personally direct the window's iconography, they must have had some input into the program, for the crown's interests saturate the glass.[107] I thus differ from Lindy Grant's recent argument that Saul's suicide and the other Old Testament pairings depict a Cistercian's view of what "the polity of France ought

102. Delaporte, *Les vitraux* (as in note 97), 494. There is a very strong relationship between the lancet window's composition and the virtue and vice cycles on the west façades of the cathedrals of Paris and Amiens, and on the outer porch columns of Chartres' south portal. Although Delaporte dismissed the connection as a formal coincidence, I believe there may be a more intriguing problem here. See also R. Halfen, *Chartres: Schöpfungsbau und Ideenwelt im Herzen Europas*, vol. 3 (Stuttgart, 2007), 621.

103. Brenk "Bildprogrammatik"(as in note 100), 95; Halfen, *Chartres* (as in note 102), 618.

104. See É. Berger, *Histoire de Blanche de Castille, reine de France* (Paris, 1895), 193–199. For Peter de Dreux, see S. Painter, *The Scourge of the Clergy: Peter of Dreux, Duke of Brittany* (Baltimore, Md., 1937).

105. For the effective "royal" character of Chartres, see J. W. Williams, *Bread, Wine, and Money: The Windows of the Trades at Chartres Cathedral* (Chicago, Ill., 1993) 32, note 95.

106. For Blanche's relationship with Gauthier, see Bugslag, "Ideology" (as in note 100), 504–505; and E. de Lépinois, *Histoire de Chartres*, vol. 1 (Paris, 1856), 133–135.

107. Nolan, *Queens in Stone and Silver* (as in note 65), 133.

Benjamin Zweig

to have been, rather than a king's or queen's image of kingship."[108] This presumes the two had different ideas about the nature of French kingship, and implies they were oppositional ones. But given the long history of the sacral character of Capetian kingship, it seems more likely bishops, kings, and queens shared a similar ideal (if not practical) image of royalty, one in which the conjunction *et* was the ideological hinge.

While Saul's suicide is unprecedented in a glass program before Chartres, it appears shortly thereafter in the Kings window in the south wall of the Sainte-Chapelle, a two-storied royal edifice constructed to house the crown of thorns after Louis IX purchased them from the Latin emperor of Constantinople Baldwin II around 1239.[109] Consecration of the chapel took place in 1248. Although the building's primary purpose was to house the passion relics, Louis Grodecki, Beat Brenk and Alyce Jordan all note the windows' highly political iconography representing the Capetian's Old Testament lineage and their dynasty as a sacred hereditary institution.[110] It is thus in the same ideological context as at Chartres that Saul's downfall once again appears.

Located in the upper half of the inner right lancet, Saul's suicide constitutes one of the many panels in the Kings window (bay B), and is part of an extended narrative on the reigns of Saul and David comprising the bay's four lancet windows (Fig. 8).[111] Adorned in a green tunic and pinkish mantel, and standing on a small piece of earth probably meant to signify Mount Gilboa, Saul falls towards panel's left side, already impaled by his sword. Scenes of David attacking the Amalekites and receiving the news of Saul's death flank the panel. The Battle of Mount Gilboa is absent from the window, but likely formed part of the cycle

in its original state. When compared to the Chartres window, the image is re-integrated into the fabric of a complex narrative that would have been more difficult to perceive because of the panel's high elevation.

The panel's composition evokes the miniature of Saul's suicide in the aforementioned Toledo *Bible moralisée*. Both images depict Saul falling towards the left with his right arm extended outwards with an open palm while his left arm protrudes before the sword. The details between the two are not exact— nor should they be given the necessary material differences between glass painting and manuscript illumination—but the similarities attest to the close connection between the manuscripts and the chapel's windows, a relationship long noted by scholars.[112] And both objects shared the same circle of *donateurs*, *concepteurs*, and *récepteurs*.

In a Capetian monument that emphasized the themes of dynasty and lineage, the inclusion of Saul's suicide in the Sainte-Chapelle is a logical one that by the 1240s had predecessors at Chartres and in the *Bibles moralisées*. It is difficult to ascribe a particular relevance to the image within the glass program beyond contending that the image of the once anointed and now fallen king would have resonated with the chapel's patrons and viewers, whether kings, queens, or clergy. The major point to be taken from the Sainte-Chapelle is that by the middle of the thirteenth century the image of Saul's suicide had become a familiar element in the Capetian's visual repertoire, and was a subject worth representing precisely because of its negative status.

I must also briefly mention that Saul's suicide appears in two other works often connected to Louis IX's patronage. The first is in the lavish Morgan

108. Grant, "Representing Dynasty" (as in note 100) 114. For an earlier and similar argument, see Kurmann-Schwarz, "Récits" (as in note 101), 68.

109. J-M. Leniaud and F. Perrot, *La Sainte-Chapelle* (Paris, 1991), 50–53. Louis bought the relics for the huge amount of 135,000 *livres*.

110. Grodecki *et al.*, *Les virtraux* (as in note 98), 276–288; B. Brenk, "The Sainte-Chapelle as a Capetian Political Program," in *Artistic Integration in Gothic Buildings* (as in note 100), 193–213; Jordan, *Visualizing Kingship* (as in note 98); also D. Weiss, *Art and Crusade in the Age of Saint Louis* (Cambridge, 1998); and L. Grodecki, *La Sainte-Chapelle*, 3rd ed. (Paris, 1979), 55.

111. The panel is not in its original location and does make much narrative sense where it currently sits. For a reconstruction, see Jordan, *Visualizing Kingship* (as in note 98), 117–119.

112. For the Kings window in particular, see M. Grossenbacher, "La Bible du Roi: Prélude à l'étude du vitrail des Rois de la Sainte-Chapelle: les panneaux du réseau supérieur," *Cahiers archéologiques* 51 (2003–2004), 93–104. For a critique of too readily attributing the *Bibles moralisées'* direct impact on the windows, see J. Lowden, "Under the Influence of the *Bibles Moralisées*," in *Under the Influence: The Concept of Influence and the Study of Illuminated Manuscripts*, eds. J. Lowden and A. Bovey (Turnhout, 2007), 178.

FIGURE 8. Saul's suicide, detail, Kings window, Sainte-Chapelle, 1239-1248 (photo: Painton Cowen).

Picture Bible (New York, Pierpont Morgan Library, Ms. M. 638, *c.* 1244–1254).[113] Produced in Northern France (possibly Paris), Saul's suicide is part of a large and detailed scene depicting his defeat by the Philistines on Mount Gilboa (fol. 34ᵛ). On the left of the lower register, Saul kneels on the mountain, thrusts his sword into his bloodied torso, and gazes back at the enemy cavalry and archers who call for his demise.

As Gerald Guest argues, the manuscript's emphasis on the histories of Saul and David (60 percent of the imagery) suggests that the book's presumed royal patrons and audience saw the stories of the two kings as a gloss on rule that visually merged past histories with contemporary politics.[114]

The second example is in the Arsenal Bible (Paris, Bibliothèque de l'Arsenal, Ms. 5211, *c.* 1250–1254),

113. New York, Pierpont Morgan Library, Ms. M. 638, fol. 34ᵛ. For the Morgan Picture Bible, see *The Book of Kings: Art, War, and the Morgan Library's Medieval Picture Bible*, eds. W. Noel and D. Weiss (London, 2002).

114. Guest, "Between Saul and David" (as in note 2), 73. When the manuscript was a true picture Bible before the addition of inscriptions the image's significance would have presumably been readily understood.

a book long connected to Louis IX and possibly pro-
duced in Acre during his crusade.[115] Saul's suicide
appears in the bottom two roundels in the I Kings
frontispiece (folio 120[r]), in which the king stabs him-
self in chest (*left*) as two enemy soldiers prepare to
behead him and despoil the bodies of his kin (*right*).[116]
While the painting style differs from the Parisian
manuscripts, the favored themes of war, kingship,
and divine rule courses through the Arsenal Bible's
iconography. At this point is it certainly unsurpris-
ing Saul's suicide once again appears in such a book
meant for royal eyes.

CONCLUSION

As Saul and his downfall occupied a significant place
in Carolingian and Capetian political theology, it like-
wise occupied an important place in their visual rheto-
ric of kingship. By considering the complex patron-
age network of *donateurs, concepteurs,* and *récepteurs,* I
hope to have suggested a pattern of royal patronage
and shed a faint glimmer of light onto the particu-
lar circumstances of its inclusion and significance in
some royal artworks. Will examining Saul's suicide
lead to similar conclusions in all cases? While paral-
lels may exist, the answer must be no. The image of
Saul's suicide in Capetian works is not subject to the
same historical conditions of creation and reception
as its presence in an English Psalter, a Genoese bible,
or a German *Weltchronik.* But its appearance—which
is often strategic rather than conventional, unusual
rather than typical, and indicative of an elite viewing
community—invites deeper consideration as to why
the image of the fallen king is included in an artwork
and as to who might have wanted it there.

115. For the Arsenal Bible, see J. Folda, *Crusader Art in the
Holy Land, From the Third Crusade to the Fall of Acre, 1187–1291*
(Cambridge, 2005), 283–295; and Weiss, *Art and Crusade* (as
in note 110), esp. 139–140.

116. Reproduced in D. Weiss, "Biblical History and Medieval
Historiography: Rationalizing Strategies in Crusader Art," in
Modern Language Notes 108.4 (1993), 718, fig. 1.

NIGEL MORGAN

What are they Saying? Patrons and Their Text Scrolls in Fifteenth-Century English Art

TEXT within images, as opposed to text around, beside, above and below images, has perhaps not received the attention it deserves, above all when that text is in the form of a scroll held by persons as a means of verbal communication, perhaps better termed a speech scroll. Scrolls with texts held by figures can of course also have the intention of "speaking" to the onlooker, most famously in the common imagery of the prophets holding scrolls of their prophecies as a proclamation. Even in a dialogue context, as when a patron/donor kneels before Christ, the Virgin Mary, or a saint with a petition directed toward the heavenly figures, it cannot be excluded that these words are also intended to be read by the onlooker, with in some cases the hoped for response that the onlooker joins in the petitionary prayer for the patron/donor. This is obviously the case where the text/speech scroll prays for the soul or the good state of the patron/donor, and survives in a public image, such as stained glass or monumental brasses long after the original patron has departed this life. Text scrolls quite frequently occur in narrative images from the twelfth century onwards with a few examples from the eleventh century, but patrons with these scrolls are rarely found before the thirteenth century.[1]

In various contexts from the thirteenth to the sixteenth centuries in England, as elsewhere in Europe, above all in illuminated manuscripts, stained glass, and monumental brasses men and women kneel holding petitionary scrolls.[2] It is often assumed that these texts are conventional in content, endlessly repeating "Pray for the soul of…" or "Pray for the good state of…," but in fact there is a great variety expressing differing intentions. In most discussions of such works of art these inscriptions have not been fully transcribed, compared, and discussed. What the scrolls say is of course much conditioned by the context and location of the image. Some, above all those in illuminated manuscripts, were designed for private viewing by the owners of these books. Others, such as stained glass, were set in public spaces in churches, although in some cases they would be set in private chapels exclusive to a particular family or to such religious associations as guilds. Many of those in churches would have been on public display in which the status of the patrons depicted kneeling with their scrolls assumes particular importance, and the words on the scrolls may have been intended as much for somebody else to read as a personal prayer of the donor. It seems best to present the examples in illuminated manuscripts first, almost all "private,"

1. W. Cahn, "Représentation de la parole," *Connaissance des Arts* 369 (1982), 82–89, discusses early examples of scrolls used in a narrative context in French manuscripts. The development of scrolls in English manuscripts in the twelfth century has yet to be studied.

2. This paper concentrates on the evidence from the fifteenth century in which the number and variety of content and context of text scrolls is much greater than for the thirteenth and fourteenth centuries. Images of patrons kneeling before various devotional images in this period are discussed, but with only occasional mention of text scrolls, in K. L. Scott, "*Caveat lector*: Ownership and Standardization in the Illustration of fifteenth-century English MSS," *English*

Manuscript Studies 1100–1700, 1, eds. P. Beal and J. Griffiths (1989), 19–63; N. Morgan, "Patrons and Devotional Images in English Art of the International Gothic *c*. 1350–1450," in *Reading Texts and Images: Essays on Medieval and Renaissance Art and Patronage in Honour of Margaret M. Manion*, ed. B. J. Muir (Exeter, 2002), 93–121; R. Marks, *Image and Devotion in Late Medieval England* (Stroud, 2004), *passim*. The last focuses on the parish church contexts of such images. Also, of particular relevance to this paper is R. Marks, "Picturing Word and Text in the Late Medieval Parish Church," in *Images, Text and Church 1380–1600. Essays for Margaret Aston*, eds. L. Clark, M. Jurkowski, and C. Richmond (Toronto, 2009), 162–188.

followed by examples in stained glass, in the main "public," and finally the special case of monumental brasses, which fall into both in private and public contexts.[3] It should be noted that images of patrons with scrolls are so numerous that it is hard to present a selection which can truly be said to be representative, and the subject needs book-length treatment.[4]

Those images in illuminated manuscripts in most cases have a precisely defined context according to the text they are set beside or face. Most of the images of patrons are found in Books of Hours or Psalters, which of course fall into the category of private books for the use of the person represented, or perhaps more widely also by other members of their family. On rare occasions lay people are depicted as donors in public service books such as Missals, donated by them to a parish church or religious house, and this is essentially a public statement of patronage, analogous to the gift of a stained glass window to a church or chapel. Patrons of Missals kneeling with petitionary scrolls are rare, but there is a famous example of an unidentified man and woman in the very large late fourteenth-century Missal made for, and presumably under the direction of, the Carmelites of Whitefriars, London, and Carmelite friars are depicted in several of the initials.[5] These two lay people, probably husband and wife, must have contributed toward the cost of this certainly extremely expensive book, sadly cut up in the early nineteenth century and now only surviv-

ing as fragments. The initial with the kneeling man and woman is for the Votive Mass of the Holy Trinity. The Trinity is at the top with the Woman in the Sun from the Apocalypse, in the guise of the Virgin Mary, standing below, flanked by the two kneeling figures. They hold scrolls from the opening of the Litany: "Father of Heaven have mercy on us; Holy Mary, pray for us."[6] Above their heads is the Trinitarian invocation with which the Canon prayer of the Mass concludes: "And through Him, and with Him, and in Him."[7] Finally the scrolls beside the Virgin Mary refer to her predestination and the incarnation: "The Lord chose me a predestined me; I have brought forth God and man."[8] Only the donors hold what can properly be termed "speech scrolls," whereas the other scrolls are essentially proclamations of doctrine, analogous to the prophecy scrolls often held by prophets. This is a special case in which the simple litany petitions of the kneeling man and woman are surrounded by a theological "gloss" on the Trinity and the Incarnation, assuredly planned out by one of the Carmelite friars for whose priory the Missal was intended.[9]

Devotion to the Holy Trinity was popular in late medieval England and appears in different forms in two Books of Hours of the Use of York more or less contemporary with the Carmelite Missal. The first, probably made in York, and by artists not of the first rank, is in the so-called Bolton Hours (York, Minster Library, Add. 2).[10] The unidentified family at

3. In my lecture at the symposium I presented the material in rather a different order, but have subsequently realized that for clarity of argument it would be much better to do so in this way.

4. I should note that, although I would certainly much like to take on this task of writing a book on this theme, there seems no possibility of doing this in the foreseeable future, and it is hoped somebody else might take on this task.

5. On the manuscript, see M. Rickert, *The Reconstructed Carmelite Missal: An English Manuscript of the Late XIV Century in the British Museum* (London, 1952); R. Marks and N. Morgan, *The Golden Age of English Manuscript Painting* (London, 1981), 90–93, pl. 26A; K. L. Scott, *Later Gothic Manuscripts 1390–1490*, Survey of Manuscripts Illuminated in the British Isles, 6, 2 vols. (London, 1996), II: 24–30, no. 2; V. Edden, "A Fresh Look at the Reconstructed Carmelite Missal: London, British Library, Ms. Additional 29704-05," in *Imagining the Book*, ed. S. Kelly and J. Thompson (Turnhout, 2005), 111–120; V. Edden, "Visual Images as a Way of Defining Identity: The Case of the Reconstructed Carmelite Missal," *Carmelus 56* (2009), 55–71.

6. "Pater de celis miserere nobis," held by the man; "Sancta Maria ora pro nobis," held by the woman.

7. "O beata Trinitas" is set at the center of the Trinity group; "Et per ipsum, et cum ipso, et in ipso," is set below the Trinity and above the Woman in the Sun.

8. "Elegit et predestinat me Dominus"; "Genuit Deum et hominem."

9. I have discussed this imagery and theology in connection with the Coronation of the Virgin by the Trinity in N. Morgan, "The Coronation of the Virgin by the Trinity and other Texts and Images of the Glorification of Mary in Fifteenth-Century England," in *England in the Fifteenth Century, Proceedings of the 1992 Harlaxton Symposium*, ed. N. Rogers, Harlaxton Medieval Studies, IV (Stamford, 1994), 230–232.

10. For a description of the manuscript, see N. R. Ker and A. J. Piper, *Medieval Manuscripts in British Libraries, IV, Paisley-York* (Oxford, 1992), 786–791, and Scott, *Later Gothic Manuscripts*, II: 119–121, no. 33, fig. 138 (the Trinity image). For interpretations of the patronage and illustrations see R. Marks

prayer before the Holy Trinity were evidently the first owners of the book, but subsequently it passed to the Bolton family. In the image with donors kneeling with scrolls, the Trinity is in the form of the "Throne of Mercy" or "Gnadenstuhl" in which God the Father holds Christ on the Cross with the Holy Spirit as a Dove between them. Long scrolls fly up to the Trinity from four kneeling figures of a family below with the words: "O Father, O Son, O you called the bountiful Spirit, so we ask you for your mercy, O majesty, dwelling in heaven, the triune God in one power, grant the rewards which in your protection of us make us pure and virtuous."[11] It is hard to be certain at what theological level the patrons understood this petition, but it would not need too much knowledge to understand it a prayer for divine grace to be given purity and virtue through the help of God and the inspiration of the Holy Spirit. The great popularity of devotion to the Trinity in fourteenth- and fifteenth-century England is difficult to explain without detailed discussion beyond the scope of this paper. Elsewhere in the book individual members of the family with simple petitionary scrolls kneel before the saints, as in the woman, mother or daughter who kneel before the rare local York saint Richard Scrope with the scroll having only the words "St. Richard Scrope pray for us."[12]

Another example in an early fifteenth-century Book of Hours of York Use, Oxford, Bodleian Library, lat. liturg. f. 2, has kneeling patrons with scrolls which on first impression imply devotion to Christ of the Transfiguration before whom they kneel (Fig. 1).[13]

If that was the case, it would be the only example of donors devoted to that image known to me in all English medieval art.[14] An elegantly dressed man and woman kneel before a ghost-like figure of the standing transfigured Christ with the inscription "Transfiguratio" above him. The text scrolls, however, have no reference to the Transfiguration but refer to the Trinity. The scroll above Christ has the words: "He that has seen me has seen the Father, for I am in the Father, and the Father is in me, and the Holy Spirit proceeds from both of them."[15] The combined scrolls of the kneeling man and woman say: "Blessed be the Holy Trinity and the Undivided Unity. We will give thanks to him for the mercy he has done to us."[16]

It is significant that in these first three examples none of the donors are of sufficient social status to bear coats of arms—there is no heraldic decoration beside them or elsewhere in the books. This is a reminder, and the same is so for donors in stained glass, that a high proportion of art of late medieval England, often of very good quality, was patronized by men and women who were in no sense aristocratic or very rich, although of course if from the merchant classes they may have possessed quite considerable wealth, and luxury illuminated books were well within their means.

Devotion to their Guardian Angel was also popular in late medieval England, but only rarely with the patrons holding scrolls. The Beaufort-Beauchamp Hours (London, British Library, Royal 2 A. xviii) is in two parts, the first part made *c.* 1401–1410 probably for John Beaufort (d. 1410) and his wife Margaret

and P. Williamson, eds., *Gothic, Art for England 1400–1547*, Exhib. cat., Victoria and Albert Museum (London, 2003), 278, no. 141; S. Rees Jones and F. Riddy, "The Bolton Hours of York: Female Domestic Piety and the Public Sphere," in *Household, Women and Christianities in Late Antiquity and the Middle Ages*, eds. A. B. Mulder-Bakker and J. Wogan-Browne (Turnhout, 2005), 215–260 (see front cover for a good color plate of the Trinity image with the patrons); S. Rees Jones, "Richard Scrope, the Bolton Hours and the Church of St. Martin in Micklegate: Reconstructing a Holy Neighbourhood in Late Medieval York," in *Richard Scrope, Archbishop, Rebel, Martyr*, ed. P. J. P. Goldberg (Donington, 2007), 214–236.

11. "O Pater, O Nate, tu spiritus alme vocate, quod petimus a te, concede tua pietate celica majestas trinus Deus una potestas, premia qui prestas nos castas fac et honestas."

12. Marks and Williamson, *Gothic* (as in note 10), 59, fig. 33 for color plate of this.

13. For a description of this manuscript, see Scott, *Later Gothic Manuscripts* (as in note 5), ii: 89–92, no. 22.

14. I have not checked through the files of the Index of Christian Art to see whether they contain any examples of this imagery, and that my assertion is correct.

15. "Qui vidit me videt et Patrem quia ego in Patre (et Pater) in me est, et Spiritus Sanctus ab utroque procedens."

16. "Benedicta sit sancta trinitas atque indivisa unitas," held by the man; "Confitebimur ei quia fecit nobiscum misericordiam suam," held by the woman. The final words might be better translated as "the mercy he has shown (or given) to us."

FIGURE 1. Patrons before Christ of the Transfiguration, York Book of Hours, *c.* 1410, Oxford, Bodleian Library lat. liturg. f. 2, fol. 2ᵛ.

FIGURE 2. Margaret Beauchamp kneels before her Guardian Angel, Book of Hours, *c.* 1440–1443, London, British Library Royal 2 A.XVIII, fol. 26ʳ. (© The British Library Board. All rights reserved).

Holland (d. 1439), who do not hold text scrolls, was once in a Psalter, Rennes, Bibliothèque municipale 22. A section of text with miniatures was removed from this Psalter and incorporated in the Book of Hours of *c.* 1440–1443 made for Margaret Beauchamp, Duchess of Somerset, their daughter-in-law.[17] There is an historiated initial in the later section for the prayer to the Guardian Angel with the rarely found instance of the angel replying to the patron's petition. Margaret's

scroll says "Protect me under your wings," and the angel replies "The Lord keep you from evil" (Fig. 2).[18] These texts paraphrase the words of Psalm 90 (91), *Qui habitat*, read at Compline, which is concerned with protection from evil by God and his angels, using the words "under his wings" and in v. 11, "For he shall give his angels charge over thee."[19] This is not the only portrayal of Margaret Beauchamp in her Book of Hours, for she appears again kneeling in the

17. For a descriptions and discussions of the manuscript, see Scott, *Later Gothic Manuscripts* (as in note 5), II: 127–132, no. 37; J. Backhouse, "Patronage and Commemoration in the Beaufort Hours," in *Tributes to Lucy Freeman Sandler: Studies in Illuminated Manuscripts*, eds. K. A. Smith and C. H. Krinsky (London, 2007), 331–344; S. McKendrick, J. Lowden, and K.

Doyle, *Royal Manuscripts, the Genius of Illumination*, Exhib. cat., British Library (London, 2012), 146–149, no. 25.

18. "Sub umbra alarum tuarum protege me"; "Dominus custodiat te ab omni malo."

19. F. Procter and C. Wordsworth, *Breviarium ad usum insignis ecclesiae Sarum*, 3 vols. (Cambridge, 1879–1886), II, col. 223.

historiated initial below the miniature of the Annunciation at the beginning of Matins of the Virgin. Margaret looks up at Mary in the Annunciation, and Mary seems to be looking down at her rather than at the Angel who is approaching. The words on Margaret's scroll, "Mother, pray to thy Son that after this exile he gives me joy without end,"[20] are influenced by the popular prayer, the *Salve Regina* which contains the words "Turn thou most gracious advocate, thine eyes of mercy towards us, and after this our exile show us the blessed fruit of thy womb, Jesus."[21]

Margaret Beauchamp's "speech scrolls" are very special and so far no exact parallels have been found. The same is true for the image of Humphrey, Duke of Gloucester, in his Prayer Book, London, British Library, Royal 2 B.I, of *c.* 1430–1440.[22] Humphrey was brother of Henry V and of John, Duke of Bedford, regent during the minority of Henry VI. The Prayer Book opens with a series of select psalms beginning with Psalm 4, *Cum invocarem*, "When I called upon Him the God of my justice heard me. When I was in distress you have encouraged me. Have mercy on me and hear my prayer." The *titulus* to the psalm is also relevant to the interpretation of the text scroll: "A psalm of David giving thanks to God for his release from the hands of Saul." This has a political relevance in the harsh world of English politics and wars of the 1430s, not to say that for Humphrey there was any direct equivalent of Saul's persecution of David.[23] But it is the context of the image which primarily conditions the content of Humphrey's scroll, and it is a very special and unusual one. Christ as a sort of Gregorian Man of Sorrows is placed above an altar

on which is a chalice with a Host above it, into which blood pours from the wound in the side, emerging through Christ's fingers which are indicating the side wound. This prominent indication of the wound with the fingers is an iconographic form popular in England since the thirteenth century, above all in images of Christ Judge in the Last Judgement.[24] The Man of Sorrows is set in the context of the Trinity with God the Father above with the Dove at the top right. Humphrey is presented by St. Alban to whom he had great devotion. His text scroll has the words "Your mercy (or grace) has been worked in me."[25] As in the image of the kneeling patrons in the Bolton Hours, the text acknowledges the working of divine grace, in this case specifically the sacramental grace of the Holy Mass conveyed by the chalice and Host on the altar. It is significant that the theological words "operetur in me" are used, that is the grace received at the Mass working to achieve virtue in him. Assuredly a more complex theological interpretation could be read into this image.

So far, most of the examples of text scrolls have presented quite developed theological concepts, but more often simple petitions for intercession are found. In the Hours of *c.* 1415–1420 of Sir John Cornwall, husband of the Princess Elizabeth, sister of Henry IV (Cambridge, Trinity College, B.11.7), there is a full-page miniature of Sir John kneeling before the standing Virgin and Child, holding a text scroll bearing the opening words of the *Salve Regina* "Hail Queen, Mother of Mercy," a direct plea for Mary's intercession (Fig. 3).[26] Sir John, like the previous two examples, was a patron from among the high aristocracy,

20. "Mater ora filium ut post hoc exilium nobis donet gaudium sine fine." For a color plate, see Scott, *Later Gothic Manuscripts* (as in note 5), I, pl. 6.

21. "Eia ergo, advocata nostra, illos tuos misericordes oculos ad nos converte. Et Iesum, benedictum fructum ventris tui, nobis post hoc exsilium ostende."

22. On this book, see Scott, *Later Gothic Manuscripts* (as in note 5), II: 239–241, no. 83, and McKendrick, Lowden, and Doyle, *Royal Manuscripts* (as in note 17), 162–163, no. 32, with color plate of this page. Scott considers the kneeling "patron" figure may be Henry VI, rather than Humphrey, but McKendrick *et al.* argue otherwise for the traditional identification with Humphrey.

23. See G. L. Harris, "Humphrey, duke of Gloucester (1391–

1447)," *Oxford Dictionary of National Biography*, eds. H. C. G. Matthew and B. Harrison, 28 (Oxford, 2004), 787–793, for Humphrey's life.

24. M. E. Roberts, "The Relic of the Holy Blood and the Iconography of the Thirteenth Century North Transept Portal of Westminster Abbey," in *England in the Thirteenth Century, Proceedings of the 1984 Harlaxton Symposium*, ed. W. M. Ormrod (Harlaxton, 1985) 129–142, and for devotion to the Wound in the side in the fifteenth century, N. Morgan, "Longinus and the Wounded Heart," *Wiener Jahrbuch für Kunstgeschichte* 46–47 (1993–1994), 507–518, 817–820.

25. "Pietas tua domine operetur in me."

26. "Salve regina mater misericordie." For descriptions and discussions of the manuscript, see N. Rogers, "The Artist of

FIGURE 3. Sir John Cornwall before the Virgin and Child, Book of Hours, *c.* 1415–1420, Cambridge, Trinity College B.11.7, fol. 20ʳ.

but there is no simple correlation between the complexity or simplicity of the text scrolls between such people and lay people lower down the social scale.

In illuminated manuscripts, ecclesiastical patrons holding scrolls are less often found than lay patrons. This is probably because in the late Middle Ages most of the lay patrons appear in Books of Hours, and very few examples of such books were made for ecclesias-

tics. Where kneeling ecclesiastics are found with text scrolls it is in Missals, probably their personal copies. A famous case is the Sherborne Missal where its patrons, Robert Brunyng, Abbot of Sherborne, and Bishop Richard Mitford of Salisbury, are shown on several pages kneeling holding scrolls.[27] This book is an idiosyncratic example and would need a whole paper to discuss the contexts of its many examples,

Trinity B.11.7 and his Patrons," in *England in the Fifteenth Century, Proceedings of the 1992 Harlaxton Symposium*, ed. N. Rogers, Harlaxton Medieval Studies, IV (Stamford, 1994), 170–186; Scott, *Later Gothic Manuscripts* (as in note 5), II: 152–154, no. 47; P. Binski and S. Panayotova, eds., *The Cambridge Illumi-*

nations: Ten Centuries of Book Production in the Medieval West, Exhib. cat., Fitzwilliam Museum (London; Turnhout, 2005), 196–198, no. 84.

27. For descriptions and discussions of the manuscript, see Scott, *Later Gothic Manuscripts* (as in note 5), II: 45–60, no. 9;

so regrettably will have to be put aside.[28] Another famous Missal for another Benedictine Abbey, Abingdon, made in 1462 for Abbot William Ashenden has him kneeling in the border of the full-page Crucifixion which faces the opening of the Canon Prayer, *Te igitur*, placed below a shield of the Five Wounds held by an angel.[29] His scroll bears the words of a liturgical text from one of the responsories to the Matins lessons of the feast of the Exaltation of the Cross, doubtless resulting from the context of the patron kneeling before an image of the Crucifixion: "We adore you O Christ and we praise you, because by your cross you have redeemed the world."[30]

The lack of ecclesiastical patrons with text scrolls in illuminated manuscripts is amply compensated in English stained glass, from which my next six examples are taken.[31] Most of this glass occurs in parish churches and is relatively poorly published, except in those volumes of the English Corpus Vitrearum Medii Aevi which have been published to date.[32] The text scrolls held by both ecclesiastics and lay people in English glass of the fourteenth, fifteenth, and early sixteenth centuries, when published, will eventually considerably widen the varied repertoire of patrons' text scrolls. The examples discussed here can hardly be considered as representative of the whole picture. The first case is in the considerably restored, but with substantial original sections, east window of the parish church of Ross-on-Wye in Herefordshire.[33] This is not the original location of the glass which comes from the chapel of the Bishop of Hereford at his palace at Stretton Sugwas, which was demolished in 1792 and the stained glass transferred to the parish church of Ross. As would be expected, the kneeling donor figure in one of the lights is a bishop of Hereford, Thomas Spofford, bishop from 1421–1448. The two central lancets of the window should be read together. On the left Bishop Spofford kneels before St. Anne holding the young Virgin Mary, and in the lancet on the right is Joachim, Mary's father. Thus the devotional image is the Holy Family, although the bishop's petition is directed towards the Virgin Mary. He does not only have a scroll but presents his heart to her with the scroll ascending upwards from his face giving the impression that it is a speech scroll: "I pray you accept this heart offered, and cleanse the accused (*reatum*) of sin."[34] The reference to "the accused" alludes to the coming judgement, in which he will be accused and for which he appeals to Mary to help him to avoid sin. The idea of the heart needing

J. Backhouse, *The Sherborne Missal* (London, 1999), figs. 4, 5, 7, 9, 11, 16, 19, 22, 23, 27, 28, 38, 59, 60, 61, for the patrons and monks with text scrolls.

28. The work of Thomas Tolley and Jessica Berenbeim in their theses on the Missal is yet to be published extensively, but both have discussed the patrons in some detail, and would be able to give a much more insightful interpretation of the scrolls of the patrons than me. Dr. Berenbeim's forthcoming book is eagerly awaited, and there is much regret that Dr. Tolley has published very little of his work.

29. K. L. Scott, *Later Gothic Manuscripts* (as in note 5), II: 279–281, no. 101, and for devotion to the Five Wounds, N. Morgan, "An SS Collar in the Devotional Context of the Shield of the Five Wounds," in *The Lancastrian Court, Proceedings of the 2001 Harlaxton Symposium*, ed. J. Stratford, Harlaxton Medieval Studies, XIII (Donington, 2003), 147–162.

30. "Adoramus te Christe et benedicimus te quia per crucem tuam redemisti mundum." R. Marks and N. Morgan, *Golden Age* (as in note 5), pl. 40 for a color plate of this page.

31. A good overview of donors and patrons in English medieval glass is in R. Marks, *Stained Glass in England during the Middle Ages* (London; Toronto, 1993), 3–27.

32. Understandably, the medieval stained glass of the English cathedrals is well known and often referred to, but the very large quantity surviving in parish churches remains little known with only some of it published in articles in antiquarian journals. Only P. Nelson, *Ancient Painted Glass in England 1170–1500* (London, 1913), gives an extensive summary listing by county of glass in parish churches, mentioning briefly the iconography, but his lists are far from complete. The counties so far published in the Corpus Vitrearum Medii Aevi are Cheshire (P. Hebgin-Barnes), Lancashire (P. Hebgin-Barnes), Lincolnshire (P. Hebgin-Barnes), Northamptonshire (R. Marks), Oxfordshire (P. Newton), South Yorkshire (B. Sprakes), and it is hoped that Kent, Norfolk, and West Yorkshire will be published in the not too distant future. Very good accounts of parish church glass in Norfolk and Suffolk, and in Somerset, have been published by Woodforde, and for Surrey by Peatling: C. Woodforde, *Stained Glass in Somerset 1250–1830* (Oxford, 1946), C. Woodforde, *The Norwich School of Glass Painting in the Fifteenth Century* (Oxford, 1950), and A. V. Peatling, *Ancient Stained and Painted Glass in the Churches of Surrey* (Guildford, 1930).

33. D. O'Connor, "Bishop Spofford's Glass at Ross-on-Wye," in *Medieval Art, Architecture and Archaeology at Hereford*, ed. D. Whitehead, British Archaeological Association Transactions, XV (1995), 138–147, pl. B (color plate of this window).

34. "Hoc precor oblatum cor suscipe terge reatum."

to be cleansed from sin comes from the famous beatitude (Matt. 5: 8) "Blessed are the pure in heart, for they shall see God." The imagery is linked to tomb and monumental brass effigies in which the deceased hold in their hands their heart as witness to their hoped for purity.

The very special imagery of Bishop Spofford, for which there seems to be no exact parallel in images of English patrons, points to the frequent individuality of content in the text scrolls of ecclesiastics. A few years later, *c.* 1450, in the parish church of Nettlestead in Kent, in the window on the north side at the east end, close to the high altar, two priests kneel before saints Stephen and Laurence with rather unusual text scrolls: "Stephen, made strong in suffering, ask for us the future kingdom"; "Through you, Laurence, save me from the raging host" (Fig. 4).[35] The first refers to the afterlife, the second perhaps to tribulation from enemies in this present life, or are the enemies meant to be demons? This church, in which a great deal of stained glass of the middle and third quarter of the fifteenth century survives in the nave, had most of its glass under the patronage of the Pympe and Stafford families to judge by the heraldic evidence in the nave glass, but seems very probably to have had at least one window at the east end paid for by priests, possibly the rector and vicar.[36] The manor of Nettlestead was held of the earls of Stafford by the Pympe family. The Pympes were trusted retainers of the Staffords and had married into the Freningham family, even more closely linked to the Staffords. Although they were of the lesser gentry, their possessions in Kent were quite extensive and most of the glazing of the windows in Nettlestead church was probably paid for by the Pympe family themselves.[37]

At Newington in Oxfordshire substantial parts of a window of the late fifteenth century survive on

FIGURE 4. Priest before St. Laurence, *c.* 1450, Nettlestead (Kent), Parish Church.

the north side of the nave with two kneeling priests with text scrolls, although one of the figures is very fragmented.[38] The figure well preserved wears an academic doctor's cap and this immediately suggests a possible association with an Oxford college. Two

35. "Stefane ferens dura pete nobis regna futura"; "Per te Laurenti salve me ab hoste furenti." The priest kneeling before Stephen must have been largely destroyed and is now replaced by a modern copy of the priest kneeling before Laurence.

36. W. E. Ball, "The Stained Glass Windows of Nettlestead Church," *Archaeologia Cantiana* 28 (1909), 157–249, and G. M. Livett, "Nettlestead Church: Architectural Notes," *Archaeologia Cantiana* 28 (1909), 251–277. On John Pympe (1420–1479), the main patron of the glass of Nettlestead, see N. H. MacMichael, "The Descent of the Manor of Evegate in Smeethe with some

Account of its Lords," *Archaeologia Cantiana* 74 (1960), 40–41, with pedigree of the Pympes.

37. The complete stained glass program of Nettlestead survived destruction after the Reformation, and had not a freak hail storm in the eighteenth century destroyed a large part of the windows on the south side, the medieval glazing of the church would still be complete.

38. P. A. Newton, *The County of Oxford: A Catalogue of Medieval Stained Glass*, Corpus Vitrearum Medii Aevi, Great Britain, I (London, 1979), 154–156, pls. 39a–d.

rectors of that church in the second half of the fif-
teenth century had been fellows of All Souls, Ste-
phen Barworth, rector 1478–1482, and Richard Salter,
rector from 1482 until an unknown date. The upper
panels of the window, above the two kneeling priests,
contained two scenes of the glorification of Mary, her
Assumption and her Coronation by the Holy Trinity,
both popular images in fifteenth-century England.
The well preserved priest patron is below the second
scene and has a liturgical text on his scroll relating
to the Holy Trinity from a hymn sung at Compline
on Passion Sunday, "Glory to the Eternal Father, and
Christ the true King, and the Holy Paraclete, now and
forever, Amen" (Fig. 5).[39] The other priest's scroll is
too fragmentary to reconstruct the text, which pre-
sumably was related to the Virgin Mary because he
kneels below the Assumption. There are other in-
stances of academics as kneeling patrons of windows
in Oxford churches, such as at Horley in the early
fifteenth century, with images of Henry Rumworthe,
later archdeacon of Canterbury 1410–1420, and Rob-
ert Gylbert, Bishop of London 1436–1438, both of
whom had formerly been parish priests of Horley.[40] In
this case their scrolls contain simple petitions, "Have
mercy on me, God" with Henry's name and position
as archdeacon of Canterbury in a panel below, and in
the case of Robert only his name on his scroll.

At the parish church of Haseley in Warwickshire
the stained glass of the upper tracery lights of the
west window of *c.* 1450 is almost completely pre-
served, but originally was in the tracery lights of
the east window (Fig. 6).[41] Scrolls and inscriptions
below the figures identify one of the patrons as John
Aynolph, prior and canon regular of the Holy Sep-
ulchre, Warwick.[42] He is designated as patron (i.e.,
rector) of the church, and as the text asks prayers
for his soul it can be assumed that he has died, per-

FIGURE 5. Priest before the Holy Trinity, late fifteenth cen-
tury, Newington (Oxfordshire), Parish Church.

haps leaving money for the making of this window,
but it could have been commissioned, or even made,
to serve as a memorial window before he died. The
other kneeling priest is not named, and may be the
vicar. The imagery in the window is the Annunciation
in the top two lights flanked by saints Catherine and
Winifred. The text scrolls refer to these figures: "St.
Mary, pray for us," "Praise the Lord in his saints."[43]

The glass at Haseley is almost entirely original, but

39. "Gloria eterno Patri et Christo vero regi paraclitoque
sancto et nunc et in perpetuum. Amen." See Procter and Words-
worth, *Breviarium ad usum insignis ecclesiae Sarum,* I, col. dccxv.
Newton, *County of Oxford* (as in note 38), 155, wrongly assigns
the hymn to Compline of Easter Sunday.

40. H. T. Kirby, "Clerical Portraits in Stained Glass: Two
Famous Oxfordshire Rectors," *Antiquaries Journal* 42 (1962),
251–252 (also published in *Journal of the British Society of Master
Glass Painters* 13 [1959–1963], 565–568), and P. A. Newton,
County of Oxford (as in note 38), 113–115, pls. 7b, c.

41. P. Nelson, *Ancient Painted Glass* (as in note 32), 201.

42. "Orate pro anima Iohannis Aynolphi prior et canonici
regulari sancti Sepulchri Warwici huius ecclesie patronus."

43. "Sancta Maria ora pro nobis" and "Laudate Dominum
in sanctis eius."

FIGURE 6. Canon John Aynulph and an unidentified priest before the Annunciation,
c. 1450–1475, Haseley (Warwickshire), Parish Church.

the Crucifixion window of *c.* 1450–1475 at North Cerney in Gloucestershire with a kneeling priest below as donor has been much restored in the nineteenth century, both in the figure and ornamental glass and in the inscriptions. Fortunately the inscribed text scroll held by the kneeling priest is original but the inscriptions at the base of the window are restored, although in the main authentically restored, being based on antiquarian records before this glass was lost or broken.[44] The inscription at the base of the window says "Pray for the soul of John Bigote," who

is presumed to be the priest kneeling below the Crucifixion with a scroll bearing the simple but unusual words "I pray you with steadfastness, save me O Crucified" (Fig. 7).[45]

A final example of a priest patron is the east window of the parish church of Holy Trinity Goodramgate in York, which is dated 1470, as recorded at the bottom of the window, and given by John Walker, rector of the church.[46] John kneels before the *Not Gottes* Trinity, the form in which God the Father holds in his arms the body of the Man of Sorrows with the Holy Dove

44. S. Pitcher, "Ancient Stained Glass in Gloucestershire Churches," *Transactions of the Bristol and Gloucestershire Archaeological Society* 47 (1925), 287–345, 301, discusses the evidence for the authenticity of the inscriptions.

45. "Orate pro anima domini Johannis Bicote" and "Deprecor te obnixe salvum me crucifixe."

46. F. Harrison, *The Painted Glass of York: An Account of the*

Medieval Glass of the Minster and the Parish Churches (London, 1927), 151–154. The inscription naming him as donor and giving a date is at the bottom of the window: "Valcar [i.e., Walker] Rectoris anime miserere Johannis hic domus hic istam fieri atque fenestram hoc in cancello deitatis absque duello anno milleno quater septuageno tamen adjuncto rex in honore tuo."

FIGURE 7. The priest, John Bigote, before the Crucifixion, *c.* 1450–1475, North Cerney (Gloucestershire), Parish Church.

between them. His scroll bears the words "I adore you, and I glorify the Holy Trinity."[47] The first part of his prayer is of course addressed to the suffering Man of Sorrows.

From these examples it seems that it was quite common for rectors, parish priests, and former parish priests, to donate whole windows to their parish churches.[48] Only when the extensive survival of stained glass in these churches is eventually fully

documented will this aspect of the patronage of their decoration be able to be assessed. The complex interaction of clerical and lay patrons of differing social status and wealth, and of course also the religious guilds attached to every parish, makes these churches a key element in the history of patronage of art and architecture in late medieval England.

My examples of lay patrons in stained glass are fewer than for clerics, in part because they appear to have simpler text scrolls, and in part because I have examined only a small proportion of the many examples of these patrons with scrolls that survive. Another limitation is the issue of antiquarian records of lost text scrolls and the problems of inscriptions probably incorrectly restored in the nineteenth century, and even twentieth century too. The first example is from All Saints North Street, York, a church which has retained a number of complete windows of its medieval glass, many containing kneeling patrons, only some of which have text scrolls.[49] Some of these patrons have been moved into different windows than those they originally occupied, but the original arrangement can to some extent be reconstructed from antiquarian notes of the seventeenth century.[50] In the Works of Corporal Mercy window of *c.* 1425 a layman, laywoman, and a priest kneel at the bottom.[51] They must have identified themselves with the man who performs the acts of mercy in the window above, although their text scrolls do not obviously relate to this subject matter, and they may have been moved from another window. Their scrolls and the text in the

47. "Te adoro et glorifico, sancte Trinitas."

48. A fourteenth-century example would be the two rectors, William de Luffwyk and Roger Travers in Aldwincle in Northamptonshire, the latter figure being a complete nineteenth-century restoration with only the identifying inscription original: R. Marks, *The Medieval Stained Glass of Northamptonshire*, Corpus Vitrearum Medii Aevi Great Britain, Summary Catalogue, 4 (Oxford, 1998), 6–7, pl. 2. Also, another fifteenth-century example is in the east window at Oddingley (Worcestershire) with two priests, John and William Harries, the latter dressed as a Doctor of Divinity: M. A. Green, "Old Painted Glass in Worcestershire, part IX," *Transactions of the Worcestershire Archaeological Society* 22 (1945), 73–74. The medieval stained glass of Worcestershire was catalogued by Mary Green (d. 1941) and published in a series of articles in the *Transactions of the Worcestershire Archaeological Society*, some published

posthumously by her friends from her notes, and reprinted in M. A. Green, *Old Painted Glass in Worcestershire* (Worcester, 1948). Her manuscript notes were bequeathed to the Worcester Archaeological Society. The evidence for the authenticity of the inscriptions and figures comes from the recusant Thomas Habington's notes of the first third of the seventeenth century where, from the appearance of the window at that time, he concluded that the two priests were patrons of the glazing: J. Amphlett, ed., *A Survey of Worcestershire by Thomas Habington*, 2 vols. (Oxford, 1895), 1: 456.

49. E. A. Gee, "The Painted Glass of All Saints Church North Street, York," *Archaeologia* 102 (1969), 151–202.

50. This has been done in Gee's 1969 article, but further research needs to be done.

51. E. A. Gee, "Painted Glass" (as in note 49), 162–164.

priest's book, which he has before him, refer to saints: "Pray for us blessed (saints) that we may be worthy of the promises of Christ" (Fig. 8); "All Saints (pray for us)"; "St. Cecilia pray for us"; "St. Lucy pray for us."[52] It seems likely that the priest, perhaps Reginald Bawtre, came from another window in the church, which may have contained figures of Cecilia, Lucy, and other saints. As the Works of Mercy window takes its text from Matthew 25, which is concerned with the Last Judgement, it would be expected that if they were associated with that window their text scrolls would pray for intercession and mercy at the judgement. This example illustrates that much care is always necessary to assess restorations and moving of stained glass panels in the centuries after the Reformation.

The second example is from the parish church of Himbleton on Worcestershire, a window of *c.* 1430–1450 date with the Crucifixion flanked by the Virgin Mary and St. John with a series of kneeling patrons in panels below. There is a good deal of restoration, particularly in the figures of the Crucifixion, but certain antiquarian records elucidate some of the problems as to what is authentic and what is not, and these sources are discussed in the account of the Himbleton glass by Mary Green.[53] A praying man and woman, with a prayer book on the floor beside them, set below St. John the Evangelist, have a text scroll "St. John pray for us" (Fig. 9).[54] These people, from the inscription at the bottom of the window, are Henry Goddy and Agnes his wife.[55] Below the Virgin Mary are another man and woman with a scroll "St. Mary pray for us," who might possibly be identified with the help of the recusant antiquary Thomas Habington (1560–1647), who recorded a now lost inscription "Pray for the

FIGURE 8. Man and woman patrons, Works of Mercy window, *c.* 1425, All Saints North Street, York, Parish Church.

souls of Thomas Collet and … his wife" in an adjacent window.[56] Below the Crucifixion are kneeling a bishop accompanied by a priest, with a scroll, now of nineteenth-century date, but copying one recorded by

52. "Ora pro nobis be(ati sancti) ut digni efficiamur promissionibus Christi"; "Omnes sancti (orate pro nobis)"; "Sancta Cecilia ora pro nobis"; "Sancta Lucia ora pro nobis."

53. M. A. Green, "Old Painted Glass in Worcestershire, Part VI, Himbleton-Honeybourne," *Transactions of the Worcestershire Archaeological Society* 17 (1940), 3–4.

54. "Sancte Iohannes ora pro nobis."

55. "Orate pro animabus Henrici Goddi et Agnetis uxoris eius."

56. "Sancta Maria ora pro nobis" and "Orate pro animabus Thomae Collet et … uxoris eius." Thomas Habington, who narrowly escaped execution after his supposed implication in

the Gunpowder Plot, describes the windows in this part of Himbleton church in precise detail, and his account is worth including *in extenso*, proving the window has been little changed since the first third of the seventeenth century: "In the west wyndowe of the North Ile is Henry Goddy, a benefactor of the Churche. In a chappell on the southe part of the Churche in the east windowe and myddell pane is under the Crucifix a Byshop in his Pontificality, with hys Chapelyn behynd him, all praying Miserere nostri [*sic!*] Domine. In the pane on the ryght hand the picture of our Blissid Lady, and under a man and hys wyfe in gownes and civill habyt on theyre knees prayinge Sancta Maria ora pro nobis. The lyke couple on the left

FIGURE 9. Henry Goddy and his wife, Agnes, Crucifixion window (*top*), and Thomas Collet and wife, in adjacent window (*right, bottom*), *c.* 1430–1450, Himbleton (Worcestershire), Parish Church.

Habington: "Have mercy on us, Lord."[57] The window was evidently a commission of the Goddy family, and possibly Collett family, perhaps also of the Bishop. It has been suggested that this man may possibly be Thomas Bourchier, Bishop of Worcester (1435–1443) and his chaplain William Palmer who was a priest at Himbleton. The reason why a bishop was a joint patron of the window is difficult to understand, unless he had some personal connection with the parish.

The second example is from the east window of the parish church of East Harling in Norfolk, which in-

pane prayinge on theyre knees under St John the Evangelist, Sancte Johannes ora pro nobis, and belowe Orate pro Henri Goddi et Agnetus [*sic!*] uxoris eius. In the southe wyndowe of thys chappell and lowest part thereof, Orate pro anima Thomae Collet et ... uxoris eius": Amphlett, *A Survey of Worcestershire by Thomas Habington* (as in note 48), I: 287.

57. "Miserere nobis Domine."

FIGURE 10 (*right, top*). Sir William Chamberlain, east window, *c.* 1462–1480, East Harling (Norfolk), Parish Church.

FIGURE 11 (*right, bottom*). Sir Robert Wingfield, east window, *c.* 1462–1480, East Harling (Norfolk), Parish Church.

corporates glass from other window locations in the church.[58] Originally at the base of the window were four large panels of kneeling donors of which only two survive, but the others are recorded in antiquarian sources. These were the rich heiress Anne Harling (lost), her two husbands, the first Sir William Chamberlain (d. 1462) and her second Sir Robert Wingfield (d. 1480), both of whom are still in the window, and the fourth panel was probably her son. As the inscription at the bottom says "Orate pro bono statu et vita" for Anne and Robert, it must have been made between Thomas's death and Robert's death, *c.* 1462–1480.[59] Each of these figures held four consecutive petitions praying to the Holy Trinity, directly derived from the beginning of the litany:[60] "God, Father of Heaven, have mercy on us; God the Son, Redeemer of the World, have mercy on us; God the Holy Spirit, have mercy on us; Holy Trinity, One God, have mercy on us" (Figs. 10, 11).[61] This is yet another example of devotion to the Holy Trinity as has been seen in the illuminated manuscripts.

It is fitting to end this paper with a consideration of patrons' text scrolls on monumental brasses, an area of late medieval English art rather better documented than stained glass.[62] These scrolls, as might be expected, predominantly quote from the liturgical

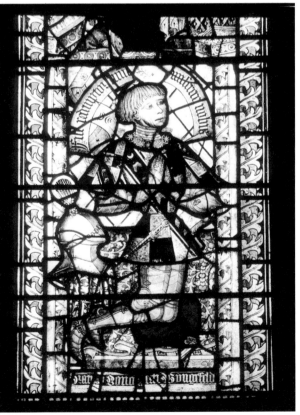

58. C. Woodforde, *Norwich School of Glass Painting* (as in note 32), 42–44, 51–53.

59. "Orate pro bono statu et vita Anne uxoris Roberti Wyngefield militis."

60. F. Procter and C. Wordsworth, *Breviarium ad usum Sarum* (as in note 19), II, col. 250.

61. "Pater de celis Deus miserere nobis" (held by Anne, her figure lost); "Fili redemptor mundi Deus miserere nobis" (held by Robert); "Spiritus sancte Deus miserere nobis" (held by the son, his figure lost); "Sancta Trinitas unus Deus miserere nobis" (held by William).

62. For a general discussions of inscriptions on brasses, see J. Bertram, "Inscriptions on Late Medieval Brasses and Monuments," in *Roman, Runes and Ogham: Medieval Inscriptions in the Insular World and on the Continent*, ed. J. Higgitt, K. Forsyth, and D. N. Parsons (Donington, 2001), 190–201.

text of the Office of the Dead, although there are in-
dividual unconventional examples, and with these I
shall begin. A special context represents the deceased
person as a cadaver and not as a kneeling figure in
the flesh, which is the normal form, irrespective of
whether the brass was made before or after the death
of the patron. My first example, the brass of Ralph
Hamsterley (d. 1518) at Oddingley in Oxfordshire,
was made before his death, perhaps *c.* 1511, because
blank spaces have been left after the date MCX.... to
insert the year of his death when he died. Hamsterley,
fellow of Merton College, has a cadaver effigy being
consumed by worms holding a text scroll inscribed
with words of a *contemptus mundi* theme: "Here I am
given to the worms, and thus try to show that as I
am laid aside in such a way here, all the honour of the
world is put away" (Fig. 12).[63] The "honour of the
world" in its material and carnal form is thus seen
as rejected and forgotten with the decay of the flesh.
Ralph Hamsterley's life is very well documented.[64]
Although he probably was buried at Oddingley where
this brass is, he also had other memorial brasses at
Merton College (Fellow *c.* 1480–1509), University
College (Master 1509–1518), Durham College and
Queen's College, where his obit was observed.[65] Mul-
tiple memorials of this sort indicate an intention to
solicit prayers for his soul in the collegiate commu-
nities in Oxford with which he had been involved.

It is relevant to compare another brass of the de-
ceased in shrouds at Brampton in Norfolk of Robert
and Isabel Brampton with text scrolls in Latin verse
asking for intercession of the Virgin Mary, who is at
the top of the brass above them: "O glorious mother
have mercy on us miserable ones"; "O Virgin, worthy
of God, be kind in praying for us."[66] Here the words
are similar to those of living patrons in illuminated
manuscripts and stained glass in requesting the inter-

FIGURE 12. Ralph Hamsterley, cadaver brass, *c.* 1511, Odd-
ingley (Oxfordshire), Parish Church.

63. "Vermibus hic donor et sic ostendere conor, quod sicut
hic ponor ponitor omnis honor." On this brass see M. Stephen-
son, *A List of Monumental Brasses in the British Isles* (London,
1926, repr. 1964), 410; M. Norris, *Monumental Brasses, The
Memorials* (London, 1977), 2 vols., I: 205, 209; and M. Nor-
ris, *Monumental Brasses, The Craft* (London, 1978), 63, fig. 61.

64. A. B. Emden, *A Biographical Register of the University of
Oxford to A.D. 1500, F to O* (Oxford, 1958, repr. 1989), 864–865.

65. On these memorials, see A. Wood, *The History and Antiq-
uities of the Colleges and Halls in the University of Oxford* (Oxford,
1786), 26, 51–52, 62, 163.

66. "Mater magnifica miseris miserere Maria" and "Virgo
deo digna precantibus est benigna." On this brass, see M. Ste-
phenson, *List of Monumental Brasses* (as in note 63), 325, and
M. Norris, *Monumental Brasses: The Memorials* (as in note 63),
I: 182, 204, 208; II, fig. 242.

cession of Mary, in this case for the deceased as souls in Purgatory. The Brampton brass was made a long time after the death of Robert (d. 1468), probably *c.* 1483, and it is a matter of speculation whether Isabel, their family or the executors of their will chose the words on the text scrolls.

The majority of scrolls on monumental brasses quote from the Office of the Dead, mostly passages from the book of Job used for the nine lessons of Matins of the Dead. For example, as three scrolls in the 1439 brass of Edmund Forde at Swainswick in Somerset: "I believe that my redeemer liveth, and in the last day I shall rise out of the earth, and in my flesh I shall see God my saviour" (Job 19:25–26).[67] In these brasses the figures can be standing or kneeling, or their heart held up by disembodied hands with the text scrolls emerging from the heart. Occasionally the heart is placed above the standing or kneeling figures of the deceased, as on the right in the 1516 brass of Thomas Knightley at Fawsley in Northamptonshire.[68] The heart held up by hands occurs on the 1462 brass of Denis Willys at Loddon in Norfolk, and an unknown person in the *c.* 1460 brass at Souldern in Oxfordshire (Fig. 13).[69] This imagery of the heart, and its image in these contemporary brasses, adds further comment to the context of the image discussed earlier of Bishop Thomas Spofford offering his heart to the Virgin Mary in the stained glass at Ross-on-Wye.

On brasses the deceased are sometimes represented as skeletons after the worms have done their work, as they are seen doing in Ralph Hamsterley's brass, as in the three skeleton brasses at Weybridge (Surrey) where two of the three hold scrolls, "I trust in the

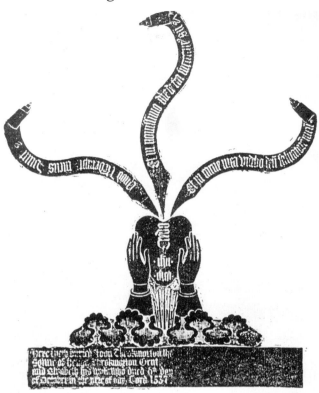

FIGURE 13. Unknown person, heart brass, *c.* 1460, Souldern (Oxfordshire), Parish Church.

Lord" and "Have mercy on me God," but the upper part of the third figure is missing.[70] This imagery also exists in stained glass and panel painting. At West Wickham in Kent is a window depicting the patron, Sir Henry Heydon (d. 1503/4), who kneels as a skeleton holding a text scroll containing the words of the antiphon to the Penitential Psalms, usually part of the standard content of a Book of Hours: "Remember not Lord our offences, nor the offences of our

67. "Credo quod redemptor meus vivit, et in novissimo die de terra surrecturus sum, et in carne mea videbo deum salvatorem meum." On this brass, see M. Stephenson, *List of Monumental Brasses* (as in note 63), 439, and A. B. Connor, *Monumental Brasses in Somerset* (Bath, 1970), 290–292.

68. The texts are the same as on Edmund Forde's brass. On this brass, see M. Stephenson, *List of Monumental Brasses* (as in note 63), 383, and M. Norris, *Monumental Brasses: The Memorials* (as in note 63), 1: 198.

69. The Loddon brass has lost part of its scroll inscriptions, reading only "Credo [on the heart] quod redemptor meus vivit ... et in carne mea...." On this brass, see M. Stephenson, *List of Monumental Brasses* (as in note 63), 344, and M.

Norris, *Monumental Brasses: The Memorials* (as in note 63), 1: 198. The Souldern brass has the same scroll texts as Edmund Forde's brass, but "Credo" is on the upper part of the heart, and "Ihesus miserere" on the lower part. On this brass, see M. Stephenson, *List of Monumental Brasses* (as in note 63), 344, and M. Norris, *Monumental Brasses: The Memorials* (as in note 63), 1: 198.

70. "In domino confido" and "Miserere mei deus." The third scroll was recorded before its loss as "Domine miserere mei." On these, see M. Stephenson, *A List of Monumental Brasses in Surrey* (Guildford, 1922; repr. Bath, 1970), 518–520 with plate; M. Norris, *Monumental Brasses: The Memorials* (as in note 63), 1: 209.

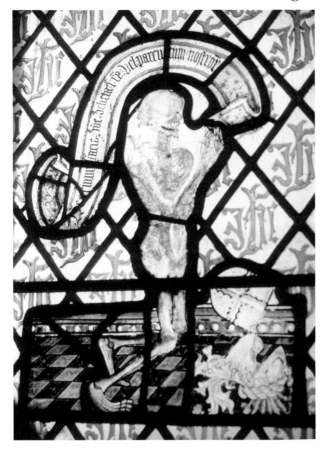

FIGURE 14. Sir Henry Heydon, late fifteenth or early six-teenth century, West Wickham (Kent), Parish Church.

FIGURE 15. Soul in the flames of Purgatory, Book of Hours, *c.* 1400–1410, Southwark, Roman Catholic Cathedral 7, fol. 5ᵛ.

parents" (Fig. 14).[71] Here the words pray not only for himself but his parents too. On painted panels from a screen at Sparham in Norfolk a skeleton shrouded in a tomb quotes from Lesson IX of Matins of the Dead: "I should have been as if I had not been, carried from the womb to the grave" (Job 10:19).[72] This is a profound, if despairing, reflection on the purpose of earthly life, and is in the *contemptus mundi* tradition of the inscription on Ralph Hamsterley's brass. Earthly life with its wealth, pleasures, and honors counts as nothing when, in the words said to each person on

Ash Wednesday as they are ashed "Remember, man, that thou art dust, and unto dust thou shalt return" (Genesis 3:19).[73]

A final example, which seems to be a unique one, is of a full-page miniature of a man suffering in the flames of Purgatory who holds a scroll asking his friends to pray for him in a *c.* 1400–1410 Sarum Hours made in Bruges, Southwark, Roman Catholic Cathedral Ms. 7 (Fig. 15): "Have pity on me, have pity on me, at least you my friends" (Job 19:21).[74] This raises the issue of text scrolls spoken to the onlooker

71. "Ne reminiscaris domine delicta nostra vel parentum nostrorum." On the stained glass of the church and Henry Heydon, see J. G. Waller, "Painted Glass in West Wickham Church," *Proceedings of the Society of Antiquaries of London*, 2nd ser., 15 (1893/5), 94–96, and C. R. Councer, "The Medieval Painted Glass at West Wickham, Kent," *Journal of the British Society of Master Glass Painters* 10 (1947/51), 67, 70–72.

72. "Fuissem quasi [qui] non essem de utero translatus ad

tumulum." A full discussion of this and the other paintings at Sparham is given by J. Luxford, "The Sparham Corpse Panels: Unique Revelations of Death from Late Fifteenth-Century England," *Antiquaries Journal* 90 (2010), 299–340, esp. 316–320, figs. 2, 12.

73. "Memento homo, quis pulvis es, et in pulverem reverteris."

74. "Mei miserimini, miserimini mei, saltem vos amici mei."

which seems often to be the case also on monumental brasses when they ask for prayers for the soul of the deceased. These texts are usually not on the scrolls held by the deceased or his cadaver, but are placed at the base of the brass. For example, on Ralph Hamsterley's *c.* 1510 brass at Oddington in Oxfordshire the text below the cadaver figure is: "Pray for the soul of canon Ralph Hamsterley formerly fellow of Merton College, Oxford, rector of this church who died in the year MCCCCC ... on the ... day of the month of"[75] The final date of the year and day and month of his death was left incomplete because the brass was made before his death. He died in 1518.

This small sample of the many hundreds of text scrolls held by patrons in fifteenth-century England demonstrates their variety. Some have their texts determined by the context of the devotional image before whom the patron kneels, whereas others, such as monumental brasses have texts appropriate to the context of the artwork. Some are personal and private to the patrons, whereas others in public contexts are intended to be read by all in view of the public situation of the artwork. When more have been surveyed it may be possible to suggest the direct intervention of the patrons in deciding on the texts to be placed on their scrolls. If their personal involvement can be deduced then "speech scrolls" might be a better terminology, but at present "text scrolls" is more prudently used, and the issue of orality, as opposed to reading, can be left aside for the time being.

N. R. Ker, *Medieval Manuscripts in British Libraries, I,* London (Oxford, 1969), 328–330, for a description of the manuscript, which has now been deposited at the British Library.

75. "Orate pro anima canonici Radulphi Hamsterley, quosdam socii collegii de Merton in Oxonia, rectoris huius ecclesie qui obiit anno MCCCCC ... die mensis" A. Wood, *History and Antiquities of the College and Halls* (as in note 65), 52, notes "his executor did not add the day and year of his death."

ROBIN CORMACK

'Faceless Icons': The Problems of Patronage in Byzantine Art

PRELIMINARIES

PATRONAGE and how to handle it has been a recurrent (and unresolved) issue in Byzantine art history. Patronage in this field is frequently treated on an abstract level, such as Ernst Kitzinger's (mostly ignored) attempt to distinguish between unconscious "inner directed" and conscious "other-directed" causes of change in style.[1] At best it might be seen as a concept of "agency" before Alfred Gell. Anthony Cutler tried to introduce a different theoretical approach into the field, suggesting the relevance of particular motivations for patronage—"social aspiration, ostentation, vanity and economy among them."[2] I myself have given commissioned conference papers on "aristocratic patronage" as something to be set against "monastic patronage" (a very dodgy dichotomy) and on "Patronage and new Programs of Byzantine iconography in the 9th and 10th centuries."[3] Others have examined other themes, and in particular "women's patronage," a very fruitful area, and more tricky, Crusader art.[4] The reason for adopting these general approaches has been the perceived lack of documentation, as well as the opaqueness of Byzantine texts and rhetoric. In other words, the refrain has been what is the point of pursuing the question of individual patronage if we know no more than the names of the individuals—they are essentially faceless. It may be conceded that changes in stylistic and iconographic choices might, as argued in other periods, be connected with patronage, but the difficulties rather than the opportunities have been recognized. Communal values rather than individual values have been seen to be the engine which dictated the production of Byzantine art.

But the documentary position today has radically changed for the historian of Byzantine art. The massively expanded online accessibility of Byzantine texts in *TLG* and the appearance of new visual materials (such as the icons at Sinai), as well as new editions, commentaries, and translations of the texts, perhaps most notably for this area of research the Dumbarton Oaks corpus of monastic Charters (*Typika*), makes the study of patrons more immediately accessible.[5] But the Cretan notarial archives are also a major source of materials about artists and patron in Cretan Venice.[6] It is opportune to start again to look at the issues of patronage in Byzantine art.

1. Ernst Kitzinger, "On the Interpretation of Stylistic Changes in Late Antique Art," *Bucknell Review* 15/3 (December, 1967), 1–10: reprinted in W. Eugene Kleinbauer, ed., *The Art of Byzantium and the Medieval West: Selected Studies by Ernst Kitzinger* (Bloomington, Ind.; London, 1976), 32–48.

2. Anthony Cutler, "Art in Byzantine Society: Motive Forces of Byzantine Patronage," *Jahrbuch der Österreichischen Byzantinistik* 31/2 (1981), 759–787.

3. Robin Cormack, *The Byzantine Eye: Studies in Art and Patronage* (London, 1989), studies IX and X.

4. For cases of women's patronage, see Jeffrey Anderson, "Anna Komnene, Learned Women, and the Book in Byzantine Art," in T. Gouma-Peterson, ed., *Anna Komnene and Her Times* (New York; London, 2000), 125–156; and Sarah T. Brooks, "Poetry and Female Patronage in Byzantine Tomb Decoration: Two Epigrams by Manuel Philes," *Dumbarton Oaks Papers* 60

(2006), 223–248. For a web-bibliography on gender studies in Byzantium, see http://www.doaks.org/research/byzantine/resources/bibliography-on-gender-in-byzantium. A survey of Crusader art is available in Jaroslav Folda, *The Art of the Crusader in the Holy Land, 1098–1187* (Cambridge, 1995), and Jaroslav Folda, *Crusader Art in the Holy Land, From the Third Crusade to the Fall of Acre, 1187–1291* (Cambridge, 2005).

5. For the *Thesaurus Linguae Graecae, A Digital Library of Greek Literature*, the URL is: http://tlg.uci.edu. John Thomas and Angela Constantinides Hero, eds., *Byzantine Monastic Foundation Documents* (Washington, D.C., 2000). For the some of the possibilities of the use of the *Typika*, see for example Vassiliki Dimitropoulou, "Giving Gifts to God: aspects of Patronage in Byzantine Art," in Liz James, ed., *Companion to Byzantium*, (Oxford, 2010), chap. 13.

6. See Robin Cormack, *Painting the Soul: Icons, Death Masks*

This paper can only outline some of the new materials and problems, and will cover the whole period, focussing on religious paintings and mosaics rather than secular art and other media.[7] A question in the context of the conference at which this paper was presented is how far the Byzantine experience can and should be treated as paralleling that of the West. I might have chosen to compare examples of similar types of patronage in the Greek East and Latin West, but in the event there is so much material that I leave the reader to make connections.

AT THE CENTER OF BYZANTIUM

I start (as I shall end) with the obvious site for investigating patronage, the Patriarchal church of St. Sophia at Constantinople, the most important (and most visited therefore) church in the empire (Fig. 1). It is an instant example of the problems of who controlled its decoration. The mosaic in the lunette above the central entrance door from the narthex to the nave was inserted after iconoclasm in the ninth or tenth century to replace the previous decoration of a cross, and shows an emperor prostrate before Christ enthroned between medallions of the Virgin and an Archangel.[8] The emperor is not named, and this omission must surely be intentional and significant. This is the only image of an emperor in the church who is not specifically identified by name. The figure of this emperor is generally identified on circumstantial

grounds as representing either Basil I or his successor Leo VI. We do not know if the patron was the Patriarch or the Emperor (though it is surely one or the other and perhaps both). Without the evidence of who the patron was, the subject of the imagery is ambivalent. Was it the ecclesiastical humiliation of an individual sinful emperor or was it the benevolent granting of Holy Wisdom to the emperor (or indeed to any emperor) in his generic role as Christ's representative on earth?

We are in the same uncertain position over the precise nature of the patronage of Leo VI's son, the emperor Constantine VII Porphyrogenitos (915–959), the inauguration of whose sole reign in 945 is celebrated in an ivory, now in Pushkin Museum, Moscow.[9] The accolade of the emperor Constantine VII Porphyrogenitos as a major patron in Byzantine history was based on extraordinary optimism (much promoted by Kurt Weitzmann at Princeton) in the face of little evidence. Romilly Jenkins somewhat recklessly described Constantine Porphyrogenitos as "a patron of the arts whose like the world hardly saw in the thirteen centuries which divided Hadrian from Lorenzo the Magnificent."[10] Although this is certainly an exaggeration, in the course of Constantine's long reign a considerable amount of art was produced in Constantinople, and some of it can perhaps either be connected with Constantine or with court circles.[11] The tenth century also witnessed the major enterprise

and Shrouds (London, 1997), esp. 167–217, and Maria Vassilaki, ed., The Hand of Angelos: An Icon Painter in Venetian Crete, Exhib. cat. (Athens, 2010).

7. For secular art, see for example Eunice Dauterman Maguire and Henry Maguire, Other Icons: Art and Power in Byzantine Secular Culture (Princeton, N.J.; Oxford, 2007).

8. No mosaic in the church has received more scholarly attention, the most provocative being the paper of Nicolas Oikonomides, "Leo VI and the Narthex Mosaic of Saint Sophia," Dumbarton Oaks Papers 30 (1976), 151–172, which argues on the basis of the speculative identification of both the patron and the emperor, both of them contentious. The context of the mosaic is discussed recently by Leslie Brubaker, "The Visualization of Gift Giving in Byzantium and the Mosaics at Hagia Sophia," in Wendy Davies and Paul Fouracre, The Language of Gift in the Early Middle Ages (Cambridge, 2010), 33–61. She wishes to connect the mosaic with the patronage of Constantine VII, assuming that patronage can solve the dilemma of its meaning.

9. Robin Cormack and Maria Vassilaki, eds., Byzantium 330–1453, Exhib. cat. (London, Royal Academy, 2008), cat. 68, 397–398.

10. Quoted by Dmitri Obolensky in a review of Arnold Toynbee, Constantine Porphyrogenitus and his World (Oxford, 1973), in The English Historical Review 90, no. 357 (Oct. 1975), 847–850, esp. 849.

11. For the connections of the emperor Constantine between 945 and 959 with the Limburg Reliquary of the True Cross and its later enamel adornment by Basil the Proedros between 963 and 985, see Nancy P. Ševčenko, "The Limburg Staurothek and its Relics," in Museum Benaki, Thumiama in Memory of Laskarina Bouras, vol. I (Athens, 1994), 289–294. Constantine's name also appears on the tenth-century Palazzo Venezia ivory triptych, see D. Talbot Rice, The Art of Byzantium (London, 1959), pls. 98–99 and pp. 313–314; and Anthony Cutler, The Hand of the Master: Craftsmanship, Ivory, and Society in Byzantium (9th–11th Centuries), (Princeton, N.J., 1994), 157.

FIGURE 1. St. Sophia at Constantinople, mosaic in the narthex showing an emperor prostrate before Christ (photo: author).

of copying into the newly developed miniscule script the major Greek classics of Antiquity, a scholarly activity which has been confidently attributed to the patronage of Constantine Porphyrogenitos.

One mid-tenth-century manuscript brings us closest to Constantine VII Porphyrogenitos, and it is remarkable for its choice of classicizing style for the fourteen miniatures. Hugo Buchthal accepted the argument that the Exaltation of David in Paris Psalter (fol. 7ᵛ, Paris, bibliothèque nationale, grec. 139) was originally the first in the cycle of author images and argues that the text in the book held open by David is a significant clue to the understanding of its context.[12] The text is the *incipit* from Psalm 71 (72), and says "Give the king your justice, God, and your righteousness to the royal son." Buchthal connects this sentiment of a father hoping for his son to rule with righteousness with the same reference to this psalm in the preface of the book *De Administrando imperio*, which Constantine wrote for his son and future emperor Romanos II, and which was intended to act as a guide to be a good ruler. This treatise was given to his son in 952 on the occasion of his fourteenth birthday. Buchthal suggests that at the same moment the manuscript which he thought the Paris Psalter copied was also given as a present to Romanos by his father. If this hypothetical connection is accepted, and there is good reason to do so, there is a possible further twist in the story. We might want to eliminate the complication of the supposed existence of a lost model for the Paris Psalter, the actual manuscript commissioned by Constantine for his son. Buchthal and Weitzmann always supposed that the cycle of miniatures that we have were made for a different manuscript than the

12. Hugo Buchthal, "The Exaltation of David," in his collected reprinted studies, *Art of the Mediterranean World, A.D. 100 to 1400* (Washington, D.C., 1983), 188–193.

one in which they are now found (some of the folios are cut down), and that the miniatures were some 25 years older than the text. But Suzy Dufrenne in 1981 (and John Lowden at greater length in 1988) rejected this assumption, and proposed that the miniatures and text of the Paris Psalter are coeval.[13] The anomalies in the cutting of the folios with miniatures are due on this interpretation to mistakes during a later binding process. It follows that the simpler description of the manuscript is that this was the actual one made at the commission of Constantine. In other words, this might have been the actual present given by Constantine to his son, and the differences of quality of execution in the miniatures is due to differing abilities of the artists rather than to poor copies of some lost model. The edition of the psalms and odes in this codex is one with a very full set of catena commentaries; it is an academic book rather than a practical service book. If this case of the circumstance of patronage of the Paris Psalter is accepted, it remains true that even at the center of power in Byzantium, evidence of the processes of patronage and of any individual choices made by the patrons is very thin indeed.

THE FRINGES OF BYZANTIUM

Moving to the fringes of the Byzantine world, the appearance of new materials from the monastery of St. Catherine's at Sinai is, as already mentioned, key evidence for the study of patronage. Of course, there is one overall problem in the study of the icons and other treasures of the monastery, and that is the lack of information about the provenience of the objects— whether they were made in the monastery, in the Byzantine regions (or outside), or at Constantinople itself. Many objects were carried there as gifts, and

may have had an alternative life before they entered the monastery. An example of the nature of this new evidence is a thirteenth-century icon of the Mother of God with Moses and Patriarch Euthymios II of Jerusalem.[14] The Virgin is shown in the local Sinaitic iconography of Mary at the Burning Bush; Moses holding the Tablets of the Law is on the left. The unhaloed, tonsured patron, Euthymios, is on the right, in his patriarchal chasuble, with the Greek inscription: "Euthymios by the mercy of God Patriarch of Jerusalem, the Blessed," the last word indicating he was dead. Two liturgical *troparia* are written on the icon, one in honor of St. Euthymios, no doubt his patron saint, and the other is directed to the Virgin and is part of the daily commemoration of the dead during nocturns. The artist has signed his name beside the *maphorion* of the Virgin—"Prayer of Peter the Painter" (this painter has signed three other icons at Sinai).[15] It seems reasonable to presume that this icon was commissioned by Euthymios before his death, and that it was intended to be placed above his tombstone at Sinai in the north-east corner of the Basilica, written in Greek and Arabic and dated Wednesday 13 December 1223. But this Euthymios is of course most famous today for his appearance on this icon! More generally, though, the fact of his name and career being recorded at Sinai is evocative historical evidence of the relations between Jerusalem and Sinai after the fall of Jerusalem to Muslim control.

Another, and more impressive, example from Sinai is the related pair of large icons: Elijah fed by the Raven and Moses receiving the Law.[16] Both have bilingual Greek and Arabic inscriptions along the base of the panels, and these can be translated as follows:

13. Suzy Dufrenne, "Problèmes des ateliers de miniaturistes byzantins," *Jahrbuch der Österreichischen Byzantinistik* 31/2 (1981), 445–470, esp. 461. The same conclusion is reached with fuller justification by John Lowden, "Observations in Illuminated Byzantine Psalters," *Art Bulletin* 70 (1988), 242–260, esp. 251–255.

14. See Georgi R. Parpulov in Robert S. Nelson and Kristen M. Collins, eds., *Holy Image, Hallowed Ground: Icons from Sinai*, Exhib. cat. (Los Angeles, Calif., 2006), cat. 53, pp. 259–261 (with full bibliography).

15. Doula Mouriki studied this artist in several works, but most conveniently in Konstantinos A. Manafis, ed., *Sinai: The*

Treasures of the Monastery of Saint Catherine (Athens, 1990), 112–113.

16. See Georgi R. Parpulov in Robert S. Nelson and Kristen M. Collins, eds., *Holy Image, Hallowed Ground: Icons from Sinai*, Exhib. cat. (Los Angeles, Calif., 2006), cat. 28 and 29 pp. 191–193; Doula Mouriki, see Manafis (1990), 109–110. See also Yuri Piatnitsky in Yuri Piatnitsky *et al.*, eds., *Sinai Byzantium Russia: Orthodox Art from the Sixth to the Twentieth Century*, Exhib. cat. (London, 2000), cat. 58–59, pp. 242–244, and Maria Vassilaki in Robin Cormack and Maria Vassilaki, eds., *Byzantium 330–1453*, Exhib. cat. (London, 2008), cat. 316, pp. 460–461, who retains the later dating.

Below Elijah in Greek verse: For Stephen who fashioned your image, O Tishbite, give by your favors pardon for my sins.

Below Elijah in Arabic: Forgiveness for Stephen who painted you, O prophet Elijah. May God forgive him the sins he has committed.

Below Moses in Greek verse: He who painted your likeness, named Stephen, requests, Prophet, release from his errors.

Below Moses in Arabic: O you who have seen God, grant forgiveness to Stephen who painted your virtuousness.

On the Moses icon, another inscription in Greek is apparently added later and above the Burning Bush: Remember, Lord, the soul of Manuel.

Doula Mouriki saw the raised hands of Elijah to be in symbolic response to the written prayer, and she (and others) saw Stephen as the painter and donor of the two icons, painted on Sinai and dating on the basis of style to the early thirteenth century (a time when the inclusion of artist's names on icons was a recent and new idea). Parpulov has, however, dated the icons on the basis of palaeography to the second half of the eleventh century, taking Stephen to be the rich donor of these grand pieces, and not the painter.

So this bilingual Stephen is an enigmatic figure—as is the later name of a second patron Manuel (assuming it is later—the sixteenth century has been proposed—and he contributed something and this is not actually the painter). These two icons are major donations to the monastery, actually the largest icons in the collection and of great quality. But the circumstances of the patronage and production are opaque despite the prominence of the inscriptions, even if their role in enhancing the chances of Stephen reaching paradise are clear enough. How the patron made his iconographical and stylistic choices is undocumented, but the subjects are logical for this pilgrimage site—where a chapel dedicated to the cave of Elijah is half way up the mountain, and the chapel where Moses received the Law is on the summit. It is possible that these icons

were made for devotions at these sacred sites, but by the sixteenth century these icons were recorded as being in the church in the monastery itself, and may have been intended to be there from the beginning. It is most likely they were painted at the monastery for use there. Perhaps Stephen was a monk rather than a pilgrim, but the inscriptions do not prioritize his identity.

BACK TO THE CENTER

Let us go back to Constantinople at the center of Byzantine power. The fourteenth-century Chora monastery (completed 1321, now known under its Ottoman name of the Kariye Camii) is the best documented Byzantine case of patronage and personality.[17] Theodore Metochites was both scholar and politician and he is represented above the door into the church at the height of his power, wearing a silk robe ornamented with gold and with a turban-like headgear, and offering his monastic foundation to Christ (Fig. 2). Ihor Ševčenko fully documented his politically powerful career, and subsequent fall from power, and developed the idea that his style of writing was reflected in the complexity of style and obscurity of the iconographic references of the mosaics and wall paintings around his mortuary chapel. Theodore's polemic with his intellectual rival Nikephoros Choumnos was to attack his "excessive clarity." Theodore is a case where his life, writings, and art can be analyzed, with the consequent contextualization of art and patronage which would have been impossible without the combination of primary documents and the monument. But the case of Theodore is unique in Byzantine history, although his conscious guilt of his own moral corruption must of course be compared with the patron of the near contemporary Scrovegni Chapel at Padua (but the name of Theodore's artist is unknown). It is also the case that Theodore was determined not to disclose his inner beliefs and thoughts in his public expressions, and he delegated work to the monks there. So the art historical study of the Kariye Camii

17. Ihor Ševčenko, "Theodore Metochites, the Chora, and the Intellectual Trends of His Time," in Paul A. Underwood, ed., *The Kariye Djami*, vol. 4, *Studies in the Art of the Kariye Djami and Its Intellectual Background* (London, 1975), 17–91; and Jeffrey M. Featherstone, *Theodore Metochites' Poems 'To Himself.' Introduction, Text and Translation* (Vienna, 2000). For a recent monograph on the church, see Robert Ousterhout, *The Art of the Kariye Camii* (London, 2002).

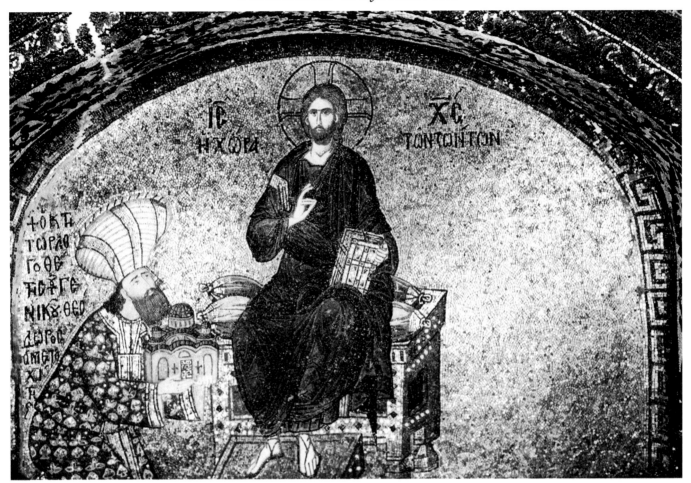

FIGURE 2. Theodore Metochites presenting his monastery to Christ, mosaic over the door to the Church of the Kariye Camii (Chora Monastery) (© Dumbarton Oaks, Image Collections and Fieldwork Archives, Washington, D.C.).

is also an exercise in attempting to uncover the hidden thoughts of the patron. Such an analysis does raise the possibility that some of the parallels of the Chora with the West (such as the similar compositional schemes as at Anagni) may be hidden clues to his knowledge of the West. We know that his father was dangerously (for the time) interested in the union of the Catholic and Orthodox churches. The Chora is not unique in Byzantium for documenting the individual patronage of mortuary chapels, and a contemporary case in Constantinople is the church of St. Mary Pammakaristos

(Fetiye Camii) and the decorated and earlier ossuary of the monastery of the Mother of God Petritzonitissa at Bachkovo in Bulgaria.[18] But the Chora remains the most evocative.

More individual cases of prestigious patronal power in Byzantium can be found too, and notably, of course, among emperors: for example, in the manuscript of 1375 containing the theological writings of the deposed Emperor John VI Kantakouzenos (Paris, bibliothèque nationale, grec. 1242).[19] The miniatures in this book are as important an indication of the patron's

18. See Hans Belting, Cyril Mango, and Doula Mouriki, *The Mosaics and Frescoes of St. Mary Pammakaristos (Fethiye Camii at Istanbul)* (Washington, D.C., 1978), and Elka Bakalova, *The Ossuary of the Bachkovo Monastery* (Plovdiv, 2003). The twelfth-century Pantocrator Monastery was the mausoleum of the

Komnenian emperors, and its foundation regulations are recorded in its *Typikon*, see John Thomas and Angela Constantinides Hero, eds., *Byzantine Monastic Foundation Documents* (Washington, D.C., 2000), vol. 2, no. 28, pp. 725–781.

19. See John Lowden in Helen C. Evans, ed., *Byzantium:*

intellectual profile as the texts. Folio 5v shows him presiding over the church Council of 1351 while still emperor. The text which follows this miniature in the book consists of selected acts of that council, which promoted as Orthodox the ideas of Hesychasm in the form developed by Gregory Palamas. No doubt the miniature of the Transfiguration on folio 92v is also a reference to the importance of the sight of the divine light which is emphasized in this doctrine. After his abdication in 1354, the emperor became a monk and chose Joasaph as his monastic name. His double personality is shown in his double portrait on folio 123v. The image is very carefully integrated with his personal and intellectual history. The scroll which he holds in his hand in his portrait as a monk reads: "Great is the God of the Christians," which is the opening sentence of his anti-Muslim treatise (this follows the illumination in the manuscript). His right hand points up to the Trinity, shown here symbolically in the form of the three Angels. It is chosen as a clear Christian image and anti-Muslim polemic. To read the illuminations requires both knowledge of the texts in the manuscript and of the career and interests of the patron. The luxury manuscript was a presentation copy for the theologian Nicholas Cabasilas and written by the famous scribe Joasaph of the Hodegon Monastery in Constantinople. Despite the lack of precise information about its agency and who designed the book, it does enlarge our understanding of the emperor's personal faith and his spiritual thinking, and may illuminate in addition his motives in giving several pious gifts while he was still emperor to several monasteries of Mount Athos. Of outstanding quality among these is the silk *epitaphios* at the monastery of Vatopedi, which has a prominent inscription at the

feet of Christ: "the offering of the pious emperor John Kantakouzenos."[20] This grand embroidery remains in good condition, in part because its function was limited to one annual appearance on Good Friday.

Another prestigious case where knowledge of the patronage is paramount for insights into the choice of iconography are the icons connected with Maria Angelina Komnene Doukaina, the Palaeologina (*c.* 1350–1394), wife of Thomas Preljubović (despot of Ioannina 1367–1384).[21] Among their donations to the Transfiguration monastery at Meteora is the Doubting of Thomas icon, with its unusual title, The Touching of Thomas.[22] What is unique is the incorporation of the donors as witnesses—Christ reaches out to touch, not the disciple Thomas, nor even the Despot Thomas, but the living royal and believing Maria. Historical documentation of this self-proclaimed imperial lady suggests a strong and dominant character. She may have been complicit in the assassination of her husband in December 1384. Within months of his death she married the Florentine noble (and adventurer) Esau de' Buondelmonti, who remained despot of Ioannina till his death in 1411.

AMBIGUITIES OF THE CONVENTIONS OF PATRONAGE

The more conventional values of piety and prayers for forgiveness are to be found embedded further down the social scale and in regional patronage. An example is the fourteenth-century church of St. Demetrianos, at Dali, in Frankish Cyprus.[23] The painted donor inscription is over the west wall, and below an image of holy tile which is itself below the portrait of the donor, who is shown holding a model of his church and followed by his wife (Fig. 3). This dedication in-

Faith and Power (1261–1557), Exhib. cat. (New York, 2004), cat. 171, pp. 286–287.

20. See Nikolaos Toutos, in Petit Palais Exhib. cat., *Le Mont Athos et l'Empire byzantin* (Paris, 2009), cat. 56, p. 150, and see the following catalogue entries (57–59, p. 152).

21. Helen C. Evans, ed., *Byzantium: Faith and Power (1261–1557)*, Exhib. cat. (New York, 2004), cat. 24A–c, pp. 51–54; and Lazaros Deriziotis in Maria Vassilaki, *Mother of God: Representations of the Virgin in Byzantine Art*, Exhib. cat. (Athens, 2000), cat. 30, pp. 320–321; Maria Vassilaki, "Female Piety, Devotion and Patronage: Maria Angelina Doukaina Palaiologina of Ioannina and Helena Uglješa of Serres," in Jean-Michel

Spieser and Elisabeth Yota, eds., "Donation et donateurs dans le monde byzantin," Actes du colloque international de l'université de Fribourg, 13–15 mars 2008 (Paris, 2012), Réalités byzantines, no. 14.

22. Nancy Patterson Ševčenko discusses this icon, "The Representation of Donors and Holy Figures on four Byzantine Icons," *Deltion tis Christianikis Archaiologikis Etaireias* 17 (1993–1994), 157–164.

23. Andreas Stylianou and Judith A. Stylianou, *The Painted Churches of Cyprus: Treasures of Byzantine Art* (London, 1985), 425–427.

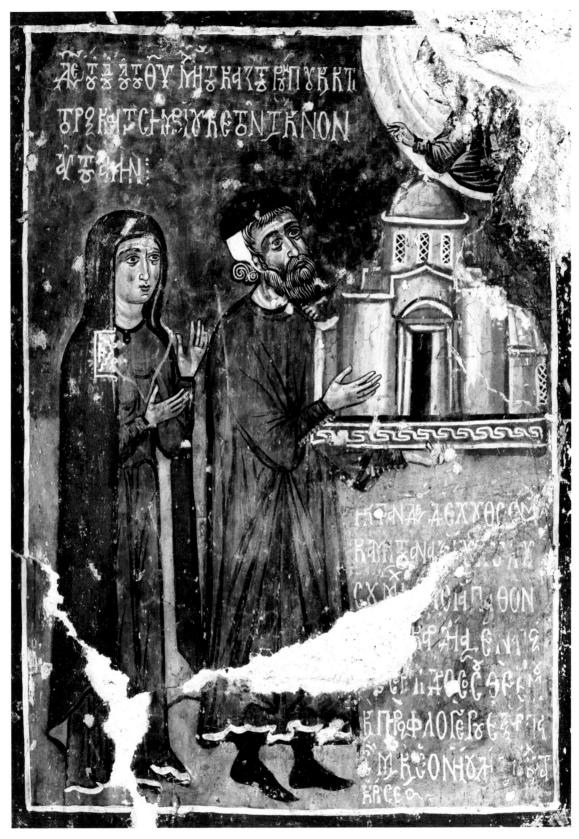

FIGURE 3. Portrait of the donor holding a model of his church and followed by his wife from the fourteenth-century church of St. Demetrianos, at Dali, in Frankish Cyprus (photo: courtesy of George Philotheou).

scription reads: "The most venerable church of our father among the saints, Demetrianos Andridiotis, was renovated and painted through the donation and great desire of Michael son of Katzouroubis, and of his wife and children, amen; in the year 6825, indiction" This corresponds to the year 1317. In the donor portrait panel where the husband and wife stand in trendy French outfits are two inscriptions, one in prose and one in verse, the latter which has a surprising deviation from the norms of donation prayers:

> *Top left*: Supplication of the servant of God, Michael son of Katzouroubis the founder, and of his wife and his children, amen.

> *Bottom right in verse*: Accept O my God, the pitiful prayer of me, your unworthy servant, Michael, suffering from heart-burn, quench it, O my God, with your dew and snatch me from the flaming fire and save me from eternal damnation.

Moreover, there are some much more eccentric patrons in their handling of art. Cyprus also has the late-twelfth-century cave-church near Paphos, the Hermitage or *Enkleistra* of the self-styled and self-taught Saint Neophytos.[24] His strategic use of imagery in the wall paintings in his cell (1183) and in the subsequent decoration in the church (around 1197) operates in a carefully managed way. The method is to express his inner prayers and hopes more visually explicit than in words. On the vault of the sanctuary, one image shows a conventional Ascension of Christ, the pendant image shows Neophytos himself carried upwards by two archangels. The words in this panel read as a prayer for the future: "May I join the community of these two angels by virtue of my 'angelic' habit." The picture shows the actuality of the two angels sweeping him up to heaven—we see the future. His prayer is realized, his confidence rewarded; but the "fact" is never explicitly stated in words, it is only fulfilled in the image. He must have stared at this image for the thirty years before this death in 1314.

On the boundaries of Byzantium in Nubia (Upper Egypt), the wall paintings of the Cathedral at Faras offer further examples of a similar proleptic use of the visual image. There is the panel of Bishop Marianos who has represented himself in full ecclesiastical regalia, shortly after his appointment in 1005. On his left is Christ with his left hand on the right shoulder of Marianos; on the right are the Virgin and Child, with Mary's hand on his left shoulder.[25] This iconography has been read as Marianos under the protection of Mary and the Child. But its proleptic promise of the entry into Paradise of the serving bishop is surely what is meant. He is touched by Christ and the Virgin, and so is symbolically in their presence. Like Neophytos, he uses imagery to express the unsayable confidence in his sanctity—not yet haloed, but promised. These are, at first sight, two extreme cases, which have been introduced here with the word eccentric. But this is probably a misleading term. Rather, these examples teach us two important issues about patronage. The first is that despite the reputed anonymity of Byzantine culture, these are cases where we can see the self-conscious awareness of the individual in society. They can hardly be unique events, and they undercut the superficial notion that the "individual" did not exist in the Byzantine Middle Ages. Significantly, the wall paintings made for Neophytos are signed on the wall by the artist, Theodore Apseudes, and the date is given. In every sense this decoration is personalized. Secondly, they illuminate the patronal awareness of the power of images in Byzantine society. It cannot be the case that regional art was more daring than the art of the capital Constantinople. These two cases of the use of art explain why patrons thought visual imagery was an essential adjunct to religious verbal discourse and how it was used. That must surely be a general perception in Byzantium—as well as in the West.

More conventional portraits of church patrons are

24. Cyril Mango and Ernest J. W. Hawkins, "The Hermitage of St. Neophytos and its Wall Paintings," *Dumbarton Oaks Papers* 20 (1966), 119–206; Robin Cormack, *Writing in Gold: Byzantine Society and its Icons* (London, 1985), 215–251; translation of the *Testament* of Neophytos by Catia Galatariotou in John Thomas and Angela Constantinides Hero, eds., *Byzantine Monastic Foundation Documents* (Washington, D.C., 2000), vol. 4, no. 45, pp. 1338–1373.

25. The church is now submerged under Lake Nasser, and the detached frescoes are split between museums in Warsaw and Khartoum. See Kazimierz Michałowski, *Faras* (Warsaw, 1974), cat. 45, pp. 218–225, for photographs and a reconstruction of the Marianos panel.

FIGURE 4. Foundation inscriptions from the Church of St. Michael at Polemitas in the Mani
(1278) (photo courtesy of Sharon Gerstel).

found all over the Byzantine world, but instead of looking at the better-known examples in Sicily (like George of Antioch at the Martorana) or in Serbia (like King Uroš I at Sopoćani), I am going down-market to Kastoria in North Greece where several of the small churches of the city record their patronage.[26] The early eleventh-century church of the Anargyroi, Kosmas and Damian, has two layers of fresco, and in both phases their donors recorded their names: the founder was Constantine (now "asleep" according to the inscription), and the second founders in the twelfth century were Theodore Lemniotes, his wife Anna Radene (depicted as larger and grander than her husband) and his son John, and in addition the monk Theophilos Lemniotes. This family's re-dedication included a long verse inscription to St. George, and another verse inscription to Kosmas and Damian by Theodore, requesting Paradise for his family. They wear rich clothes, and it has been suggested that they were an exiled noble family from Constantinople, but more likely they were from the local landed gentry. But these inscriptions are their only documentation. Their values are common to all levels of Byzantine society. This family, however, had the money and opportunity to express their prayers visibly on the walls of the church. Knowing their names does not help to indicate their personal motives or stylistic choices.

Still lower down the social scale, we have foundation inscriptions from South Greece, such as the church of St. Michael at Polemitas in the Mani (1278) (Fig. 4).[27] These inscriptions have been collected and studied as part of an important project of the University

26. See Ernst Kitzinger, *The Mosaics of St. Mary's of the Admiral in Palermo* (Washington, D.C., 1990); Vojislav J. Djurić, *Sopoćani* (Belgrade, 1963); Stylianos Pelekanidis and Manolis Chatzidakis, *Byzantine Art in Greece. Kastoria* (Athens, 1985).

27. Sophia Kalopissi-Verti, *Dedicatory Inscriptions and Donor Portraits in Thirteenth-Century Churches of Greece* (Vienna, 1992), see cat. 21, 71–75 and 100.

of Athens. All the donors and their contributions to the cost of the church are named in the inscription in this small church. There are over thirty donors and their families; and their gifts are mostly fields, vineyards, and olive trees for the foundation and decoration or upkeep of the church. This kind of communal village patronage opens up a different approach to Byzantium through social history. The patronage of the saints in the hopes of divine help for the travails of life (poor health, infertility, and poverty and failure or ambition) is a perennial feature of the Orthodoxy even today—witness the many *tagmata* (*ex-voto* plaques) to be found attached to icons in the church. But it might be thought, too, that communal rural art was not the seedbed of great art.

CONCLUSION

The argument of this paper is that we can today find a much richer documentation of patronage in Byzantium than was hitherto available, and this new situation needs to be further exploited. The question is how to progress. Patronage is in many respects pretty much a virgin field in Byzantium. There is now the opportunity to focus on a number of individuals and explore their private passions and how it influenced them as commissioners of works of art; or at the other extreme we can ask about social history and its connections with art. As an example of an individual there is the luxury Bible of Leo Patrikios, an educated eunuch in the high society of Constantinople in the tenth century, whose huge manuscript has a series of pictures, each surrounded by verses he wrote himself.[28] It brings us into the orbit of an intellectual of the period, and that looks promising. But his personality is known only by this book and a reference to him in some letters of a schoolmaster. Or we can look at Theotime, whose tiny book of Psalms must have been made for her own private use *c.* 1274, and

which has somehow ended up in the library at Sinai.[29] But we only know that she was a nun somewhere, and that was not in the male monastery at Sinai. Yet both objects demonstrate the perennial importance of the Virgin Mary as a mediator for the pious faithful in Byzantium. As people we have both their names, but as individuals they are lost in time. The evidence they offer is more about how such art was viewed than how it was produced.

One area that has been well explored recently is patronal knowledge and the use of exegesis in the formation of images and cycles in manuscripts. This methodology was opened up by Sirapie der Nersessian in 1962 with her study of the the Homilies of Gregory of Nazianzus (Paris, bibliothèque nationale, grec. 510), a highly illuminated manuscript of around 880 from Constantinople.[30] There was a polemic in her work against the "Princeton" search for lost models in the time of Weitzmann (which she is clearly criticizing), but she turned the subject around constructively by asking how the iconography of each miniature was chosen (and not about the sources of the images). Her method was to work from a close reading of the text of each homily which the miniature was designed to illustrate. She saw each miniature as a complex visual commentary on the sermon in question. In the course of this research she came to the conclusion that immense learning of Patriarch Photios (in office from 858 to 867 and from 877 to 886) lay behind the enterprise, and even if the manuscript was dedicated to the (illiterate) emperor Basil I, it was probably commissioned by Photios between 879 and 882. In effect, she deduced an undocumented patron from the theological character and content of the illuminations. Photios is also notable for the homily he wrote for the inauguration of the apse mosaic of St. Sophia on 29 March 867 (Fig. 5).[31] The implication of his text is that the two joint emperors must be flattered

28. Paul Canart, *La Bible du Patrice Léon, Codex Reginensis Graecus 1: commentaire, codicologique, paléographique, philologique et artistique* (Vatican, 2011). Only the Old Testament volume survives.

29. Jennifer Ball in Helen C. Evans, ed., *Byzantium: Faith and Power (1261–1557)*, Exhib. cat. (New York, 2004), cat. 202, pp. 343–344.

30. Sirapie der Nersessian, "The Illustrations of the Homi-

lies of Gregory of Nazianzus, Paris gr. 510," *Dumbarton Oaks Papers* 16 (1962), 195–228; Leslie Brubaker, *Vision and Meaning in Ninth-Century Byzantium: Image and Exegesis in the Homilies of Gregory of Nazianzus* (Cambridge, 1999); and Maria Evangelatou, "Liturgy and the Illustration of the Ninth-Century Marginal Psalters," *Dumbarton Oaks Papers* 63 (2009), 59–116.

31. The essential literature is Cyril Mango, *The Homilies of Photius Patriarch of Constantinople. English Translation, Introduc-*

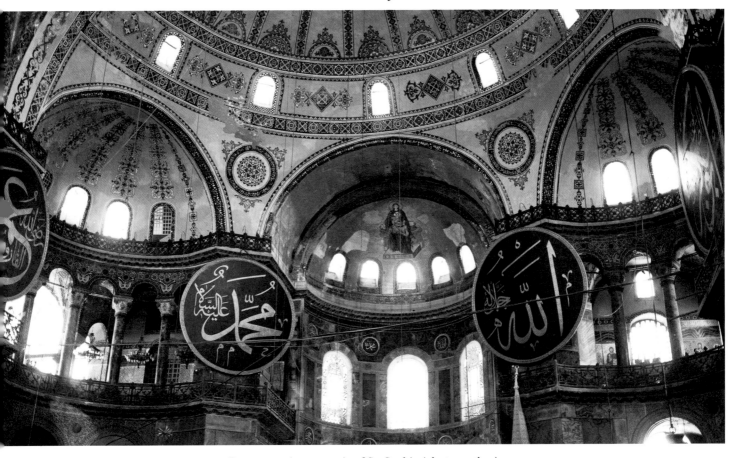

FIGURE 5. Apse mosaic of St. Sophia (photo: author).

as patrons, but that the theological input came from Photios, choosing the Incarnation of Christ as the suitable image to celebrate the ending of Byzantine iconoclasm. The many evocations of the representation of the Virgin and Child are set out in a highly literary and rhetorical text. The homily sets out the theological climate of the time, rather than his individual faith. But only Photios wrote Greek in such mandarin prose as in these sermons.

You can see that any Byzantinist must be attracted by the opportunities of looking at individual intellectual patrons like Photios and Theodore Metochites and in asking in what ways their input influenced style and iconography. How faceless are their icons? But this approach has to be balanced against an alternative methodology: how far should patronage be treated as an index of the communal values of the society in general?

My final point, then, is that in looking at patronage in Byzantine art, we must keep asking the questions: What are we looking at patronage for? What exactly can patronage explain? This paper offers no easy solutions; it is only appropriate therefore that it ends with questions.

tion and Commentary (Washington, D.C., 1958), esp. Homily XVII, pp. 279–296; and Cyril Mango and Ernest J. W. Hawkins, "The Apse Mosaics of St Sophia at Istanbul," *Dumbarton Oaks Papers* 19 (1965), 113–151.

CORINE SCHLEIF

Seeking Patronage: Patrons and Matrons in Language, Art, and Historiography

MY point of departure in the following essay is not the works of art themselves or even the manifestations of those who claimed to be their patrons, but rather the search for patrons by art historians who study the Middle Ages today and by individuals and institutions who lived during the Middle Ages.[1] I am concerned with those who sought to find and define patrons retrospectively in order to tap into patronal power and protect their own agency.

PATRONS AND MATRONS OF ART FROM OUR OWN PERSPECTIVES

As professional art historians we are constantly looking for patrons. We need them, not only to endow university chairs and donate collections to museums, but also, increasingly, to cover the daily operations of universities and museums—especially as the investment income of previous patronage dwindles and public funding becomes scarce. We ourselves are also solicited to become patrons. In exchange for additional financial support to a professional organization we may be granted status above the egalitarian right of belonging as a "member." For assuming responsibility beyond one's own share in annual dues or one's own admission fees for a given day or an event, one is perceived as a person who sustains the greater good, especially when giving support over an extended period or even in perpetuity. In its nuances, the word patron carries lofty associations, more elite than that of "donor," which is usually applied to someone who, perhaps along with others, makes a one-time contribution to a cause that may be religious, charitable, or cultural. By implication, patrons limit themselves to the cultural. Patrons do not have a mission to pros-

elytize; they do not dirty their hands with mundane necessities of subsistence or concerns of alleviating suffering. They promote and protect the beautiful, the aesthetically pleasing, those luxuries of disinterested pleasure. By connotation, their altruism is not bound to their lives and times, but extends beyond, to the future. In some organizations this category assures exclusivity of access to others of the same circle. Often the one level of support beyond that of patron is that of "founder." Founders' clubs require more outlay and more commitment, but in return offer a changed status wrought by the label's implied originary responsibility, which thus also extends back in time. The founders are the patrons who were "always already" there, to borrow Derrida's paired adverbs.

In a different contemporary context, the "patron" can today refer to consumers, especially repeat customers, regular clientele, or users of libraries. By implication, these patrons are reliable in their ongoing anticipations of gratification and continued expectations of reciprocity. Although standing in apparent contradiction to disinterestedness, articulated or unexpressed, conscious or unconscious reciprocity between unequal partners may be the common denominator of most notions of patronage within contemporary parlance, including its negative valences. For instances of the latter, one need only think of the accusations that someone is speaking "patronizingly" in a conversation, or that a government officeholder is guilty of furthering political patronage.

As medievalists we are faced with a dilemma: How do the contemporary terms patron and patronage fit when slipped over those people and projects from the realm of "art before art"?[2] In other words, can we

1. The question was posed and answered somewhat differently for the Italian Renaissance by various authors in *The Search for a Patron in the Middle Ages and the Renaissance*, eds. D. Wilkins and R. L. Wilkins (Lewiston, N.Y., 1996).

2. Hans Belting has traced the history of medieval images before they were perceived as art. Maurice Merleau-Ponty and other theorists employ the notion of "art before art" and use it more abstractly, paralleling it with "speech before speech." See

apply the notion of patronage to cultural production and conservation of those things that have become art, but at the time of their inception belonged to other categories of production, endeavors often involving religious and charitable goals? To be sure, it is an uncomfortable fit, because these patrons were the originators, procurers, or protectors of something they did not and could not deem to be art. Can we speak of art patronage before art patronage? Could it be that we seek patrons and patronage in connection with the fashioning of the art we study, because we subconsciously recognize these patrons as our patrons, in other words, as those who support, sustain, and validate us? Certainly, identifiable patrons are more abundant in the Middle Ages than are named artists or artisans. And indeed without (medieval) patrons there would be no (medieval) art, and without art there would be no art historians (of the Middle Ages). However, beyond this cognizance of the obvious, we might contemplate how intentional patronage of that which would become art elevates this category of objects above "found art." Employing actor network theory, we might claim that patrons, through their roles, serve at the outset to figure the objects within a network, transforming them from actants to actors. In our search for the first patrons, we utilize these nonhuman actors—the "art" objects—in order to find within this heterogeneous web those other human actors who promoted and displayed the objects, thus not only forming and transforming them

but being formed and transformed by them. Although their motivations and goals were certainly quite different from ours as art historians, linking ourselves with these patrons on the other end of a historical filament constituting the connective tissue of "art" can serve reflexively to validate us and our doing.[3] As if viewing the filament from the other end, a recent blogger, in his contemporary call for patronage, sought justification in the opposite direction, claiming, "Today's patronage is tomorrow's art history…"[4] A related notion, that of the patron of the artist, followed the development of the artist as a profession. As the position of court artist began to emerge in the early modern period, the feudal elite or bourgeois family who retained the artist was his or her patron.[5]

Perhaps more vexing is the current linguistic gender gap that manifests itself in the terms patron and patronage, concepts rooted etymologically in the roles of the father and notions of fatherhood. Again the respective comfort or discomfort of these terms may be related to our own positioning as well as to disciplinary demographics. Indeed, women constitute ever greater percentages of those engaged in art history and medieval studies. In our search for historical patrons and patronage we may be gratified to identify female "patrons" seeking and asserting agency through "art." To be sure, higher numbers of women can be found among those who initiated and promoted "art" than among those who actually fashioned it with their hands during the Middle Ages.[6]

"Indirect Language and the Voices of Silence," in *The Merleau-Ponty Aesthetics Reader: Philosophy and Painting*, ed. G. A. Johnson (Evanston, Ill., 1993), 76–120, esp. 84.

3. B. Latour, "On Actor-network Theory: A few Clarifications," *Soziale Welt* 47 (1996), 369–381; B. Latour, *Reassembling the Social: An Introduction to Actor-Network-Theory* (Oxford, 2005), 63–86; J. Law, "Actor Network Theory and Material Semiotics," in *The New Blackwell Companion to Social Theory*, ed. B. S. Turner (Malden, Mass.; Oxford, 2009), 141–158.

4. M. Gleason, "On Arts Patronage, Corporate America Should Take a Hint from Hint Mint," *Huffington Post*, Oct. 22, 2010: Post.http://www.huffingtonpost.com/mat-gleason/on-arts-patronage-corpora_b_772252.html.

5. M. Warnke, *The Court Artist: On the Ancestry of the Modern Artist* (Cambridge, 1993).

6. Several publications have focused on this topic, including Elizabeth Schraut, *Stifterinnen und Künstlerinnen im mittelalterlichen Nürnberg*, Exhib. cat., Nuremburg Stadtbibliothek (Nurem-

burg, 1987); Madeline Caviness, *Sumptuous Arts at the Royal Abbeys in Reims and Braine: Ornatus Elegantiae, Varietate Stupendes* (Princeton, N.J., 1990), centering on the patronage of Agnes of Braine; Adelbert Davids's edited volume *The Empress Theophano: Byzantine and the West at the Turn of the first Millennium* (Cambridge; New York, 1995); Cynthia Lawrence's edited book *Women and Art in Early Modern Europe: Patrons, Collectors, and Connoisseurs* (University Park, Pa., 1997); June Hall McNash's anthology *The Cultural Patronage of Medieval Women* (Athens, Ga., 1996), which included art objects and architecture; Leslie Smith's and Jane Taylor's edited volume *Women and the Book: Assessing the Visual Evidence* (London; Toronto, 1997); Sheryl Reiss's and David Wilkins's collection of essays *Beyond Isabella: Secular Women Patrons of Art in Renaissance Italy* (Kirksville, Mo., 2001); Kathleen Nolan's anthology *Capetian Women* (New York; Basingstoke, 2003); Sarah Stanbury's and Virginia Raguin's edited work *Women's Space: Patronage, Place and Gender in the Medieval Church* (Albany, N.Y., 2005); Dagmar Eichberger's

Searching *patron* in *Feminae,* the database on women and gender administered by Margaret Schaus, yields a total of 590 entries for articles and book chapters. The essays address varied and disparate aspects of women's patronage. Several authors in the present volume have taken up the challenge of embarking on new research in order to demonstrate women's agency as donors and owners.

In the Middle Ages, as today, many married couples utilized communal resources to commission artistic production. Driven by social, political, and religious aims, men and women wished to make a permanent appearance alongside one another. Elsewhere I have called attention to the presence of wives' first names and birth names as well as death dates, images, and heraldry, paralleling that of their husbands in the verbal and pictorial syntax of late-medieval altarpieces and epitaphs—a practice obliterated when art historians subsequently call the "art" solely by the name of the husband.[7] Increasingly, philanthropic organizations of our day are titling themselves using first and last names of couples rather than simply the man's name or a family name—also called a *sir* name. Names like the John D. and Catherine T. McArthur Foundation give audibility and visibility to both parties. Statistically, women live longer than men. If a medieval woman survived childbirth it is likely that she also survived her husband(s), often leaving her with the responsibility of investing excess capital in eternal donations. Nonetheless, women are often nominally excluded.

Should we refer to women as patrons? Would we be better served by inclusive language when we refer to historic individuals? Decades ago, linguists and educators demonstrated that the English pronouns *he, him,* or *his* could never be understood as completely gender neutral because they render women semantically invisible and because they normalize and universalize the masculine. Consequently, most sensitive English-language writers now substitute *they, he* or *she,* or alternate between masculine and feminine pronouns.[8] In Germany, Quebec, and Switzerland feminists have prevailed in requiring pairs of gendered terms for many nouns, especially those referring to roles, occupations, positions, or now even titles of current government office holders. Thus in Continental languages more inflected than our own, these changes have been substantial.

The term *patron* presents a particularly problematic case. In English the vestiges of feminine forms and endings now imply no gender parity, but rather gender imbalance that constructs the feminine as the comparative aberration from the norm, the diminutive, or the inferior, at best; or as a form demoted to the completely derogatory, at worst. Madeline Caviness has discussed such asymmetric terms at length and presented a humorous yet fascinatingly provocative table that lists terms for men with their nonequivalent parallel terms for women.[9] The paired words *patron* and *matron* demonstrate the present-day linguistic gender gap that has resulted from slowly eroded meanings associated with the feminine. Appro-

edited volume *Women of Distinction Margaret of York / Margaret of Austria* (Turnhout, 2005); Corine Schleif's and Volker Schier's *Katerina's Windows: Donation and Devotion, Art and Music as Heard and Seen in the Writings of a Birgittine Nun* (University Park, Pa.); Katherine McIver's edited volume, *Wives, Widows, Mistresses, and Nuns in Early Modern Italy: Making the Invisible Visible through Art and Patronage* (Farnham; Burlington, Vt., 2012); and, most recently, two volumes of invited essays edited by Therese Martin, *Reassessing the Roles of Women as 'Makers' of Medieval Art and Architecture,* 2 vols. (Leiden, 2012), incorporating work on women who were artists as well as women who were the sponsors of art during the Middle Ages, all of whom appear under the gender neutral rubric "makers" as announced on the cover.

7. "Men on the Right—Women on the Left: (A)symmetrical Spaces and Gendered Places," in *Women's Space: Patron-*

age, Place and Gender in the Medieval Church, eds. V. Raguin and S. Stanbury (Albany, N.Y., 2005), 207–249, esp. 237–241; Schleif and Schier, *Katerina's Windows* (as in note 6), 295–307; C. Schleif, "Kneeling at the Threshold: Donors Negotiating Realms Betwixt and Between," in *Thresholds of Medieval Visual Culture: Liminal Spaces* [in honor of Pamela Sheingorn], eds. E. Gertsman and J. Stevenson (Woodbridge, 2012), 195–216, esp. 213–216.

8. See, for example, *Language, Gender, and Professional Writing: Theoretical Approaches and Guidelines for Nonsexist Usage,* eds. F. W. Frank and P. A. Treichler with contributions by H. L. Gershuny, S. McConnell-Ginet, and S. J. Wolfe (New York, 1989).

9. M. Caviness, *Reframing Medieval Art: Difference, Margins, Boundaries*: http://nils.lib.tufts.edu/Caviness/chapter1.html, accessed 19 Dec. 2012.

priated and reflected meanings of *matron* include the female animal kept (alive) for breeding purposes, the woman working as a guard or overseer in a residential institution, and a woman of a certain age. Thus *matron* today carries ageist, classist, and sexist valences. In her pivotal article published in the gender issue of *Speculum* in 1993, Caviness posed the question "patron or matron?" with respect to the role of Jeanne d'Évreux and the famed Book of Hours named for her. Cleverly, Caviness paired these terms obliquely, showing that the patron, probably King Charles IV, who commissioned the book with its provocative marginal illuminations, might have fostered its ideological function as affective instruction for the matron, Jeanne his bride, who probably received the codex as a wedding present and, along with it, goals and roles for herself that would assure the orderly continuation of the Capetian dynasty. Caviness utilizes these paired terms, with the full range of polarities implicit within their reflected meanings, in order to suggest underlying antagonisms. I am therefore not seriously advocating the revival of antiquated feminine endings like *patroness*, nor the (re)introduction or (re)configuration of terms like *matron* for a female patron. In passing I might add that the term *matronage* has been invented in reference to medieval literary sponsorship and with respect to American collectors and museum founders.[10] Perhaps we medievalist art historians would do well to content ourselves with yet another jarring semantic discrepancy that keeps us from stabilizing gender binaries too easily. In our search for paternities we would then find women, who were patrons and commissioned such things as images showing Jesus as mother.

In sum: Art patronage is a theme ubiquitous at the present moment. By implication, those who contribute enough to sustain the arts into the future, and who claim responsibility for the origins of that art in the past or present, qualify as patrons. Inflected meanings tie this concept to benefactors who support the greater good, and to expectations of uneven reciprocity. If we search for patrons of art per se in the Middle Ages, our search will be in vain because no concept of art as a discretely detached aesthetic product existed. In addition to this conceptual distance, a substantial gender split is also apparent linguistically. Rooted in notions of fatherhood, *patron* and *patronage* convey meanings ever farther removed from the increasingly negative nuances of *matron*, the parallel term originally tied to concepts of motherhood. Nonetheless, since the 1990s many art historians and other medievalists have focused attention on women who sponsored and commissioned the objects we today consider art from the Middle Ages.

PATRONAGE EXPRESSED IN MEDIEVAL WRITTEN SOURCES

The notion of the patron predates the Middle Ages. In ancient Rome the *patronus* took his freed slave under his wing. Protection and support were offered in exchange for loyalty and favors, producing a relationship that exuded apparent largess and resultant dependency. During the Middle Ages the semantics of patronage survived in two contexts. One meaning, which in fact persists into the present day, is that of the saintly patron. In a usage that might remind us of the Lacanian concept of the "name of the father,"[11] the titular saints gave their names to institutions—churches, monasteries, or charitable foundations—that were considered to be both under their real protection and under the symbolic or legal authority of saints. Charters and other documents record that giving to such institutions—be it a donation of vast feudal estates or a gift of small coins or jewelry—was tantamount to bringing an offering to that saint. Unlawfully taking something from such an institution or misappropriating resources could be considered stealing from its titular patron.[12]

10. W. Corn, "Art Matronage in Post-Victorian America," in *Cultural Leadership in America: Art Matronage and Patronage / Fenway Court*, Isabella Stewart Gardner Interdisciplinary Symposium (Boston, Mass., 1997), 9–23; S. Delany, "Matronage or Patronage? The Case of Osbern Bokenham's Women Patrons," in *Festschrift for Douglas Wurtele*, ed. J. Toswell, *Florilegium* 16 (1999), 97–105; L. Silver, "Image is Everything: Visual Art as Self-Advertising (Europe and America)," in *The Patron's Payoff: Conspicuous Commissions in Italian Renaissance Art*, eds. J. Nelson and R. Zeckhauser (Princeton, N.J., 2008), 185–224.

11. J. Lacan, *Écrits: A Selection* (London, 2001[1966]), 67–75; 220–221.

12. S. Beissel, *Die Verehrung der Heilgen und ihrer Reliquien in Deutschland im Mittelalter* (Freiburg, 1890), Part 2, 3–4; C.

Closest to our notions of patronage is the medieval legal articulation of *jus patronatus*, known in German as *Patronatsrecht*, which can best be translated as the right of patronage. Those who were granted this right, or had acquired it through donation or perhaps outright purchase, assumed the privilege of naming the clergy who held the benefices in or for an institution supported by the patron. Architecture and furnishings, portable and stationary, certainly belonged to the ancillary realm of such patronage. These rights were especially important for the proprietary churches or monasteries of the early Middle Ages, although the endowment of chapels, chantries, or altars by individuals or families, guilds, or confraternities during the later Middle Ages may be seen as a continuation of these practices, resulting from the redistribution of wealth with the rise of the bourgeoisie beginning in the fourteenth century. By the late Middle Ages, especially in the cities, many variants and hybrid arrangements had developed. Those objects we today consider art were, however, never the focus of these foundations or endowments. Rather, they were merely the stage sets and the costumes, the containers and the scripts, the abbreviations and the visual embellishments, or perhaps even the signage and advertising—to overstate my case slightly. However, as the various holders of the benefices came and went, the architecture, frescoes, altars, altarpieces, reliquaries, vasa sacra, vestments, choir stalls, and liturgical books often remained. These material manifestations—images and objects—with their inscriptions, arms, and figures of devotees, documented the gifts, the giving, and the givers. They constructed the patrons as persons of substantial means, devotional largess, and pious privilege.

In my own work on the commissions of church furnishings that occurred primarily in the late Middle Ages, I have found myself resisting the terms patron, patronage, and art patronage. Indeed, if we look for what we might term a patron's self-awareness, or—parallel to artistic self-consciousness—what we might call patronistic self-consciousness, we find some inter-

esting verbal articulations. Most who, in the course of larger endeavors, took on the responsibilities of patrons of art and architecture saw their actions primarily in other terms. According to medieval written sources, those we see as patrons were commissioning, initiating, authoring, or authorizing, they were administering or sponsoring, they were founding or endowing, they were donating or giving, they were worshiping God, they were venerating the Virgin or the saints, they were performing good works, they were providing goods and services for their fellow constituents or for all faithful souls, they were establishing memorials for themselves and their kin, and they were fervently hoping for eternal salvation. To be sure, like the term patron, these verbs too carry rhetorical inflections that can function ideologically.

Christine Sauer has addressed the matter of terminology for the High Middle Ages. According to her 1993 analysis of written documents dating from 1100 to 1350, the most commonly used terms for those persons or groups who financed an institution or enterprise, of which a material work of architecture and artistry was a part, were *fundatores, benefactores,* and *donatores.*[13] This was, however, not the only verbal vocabulary of the High Middle Ages.

Ornamenta Ecclesiae, that path-breaking 1985 Cologne exhibition with its three-volume catalogue, focused not only on the art and artists of the Romanesque era, but also devoted substantial energies to exploring those we term "patrons," including their motives, roles, and self-awareness. Beginning with the objects themselves, and providing rich evidence of patronage in the form of inscriptions and so-called donor images, the curators demonstrated that those who financed or commissioned the objects came first in the process of origination, and that they were of primary importance. Ulrike Bergmann employed "Prior omnibus autor," a portion of an inscription, as the title for her lengthy chapter with its plenitude of case studies exploring medieval notions of what we are calling patronage. She translated the phrase into German as "an höchster Stelle aber steht der Stifter,"

Schleif, *Donatio et memoria: Stifter, Stiftungen und Motivationen an Beispielen aus der Lorenzkirche in Nürnberg* (Munich, 1990), 17.

13. C. Sauer, *Fundatio und Memoria: Stifter und Klostergründer im Bild 1100 bis 1350* (Göttingen, 1993), 13, 26–31.

thus opting for a hierarchical interpretation of *prior*. For *autor* (usually spelled *auctor*) she uses *Stifter*. The literal English equivalent of her translation would read: "The initiator/endower stands at the highest position."[14] In other words, he or she is above everyone and everything else.

The inscription belongs to one of two enigmatic champlevé plaques, today in the British Museum, believed originally to have been parts of a portable altar, a reliquary, or possibly a processional cross. They are associated with Henry of Blois, brother of King Stephan, and bishop of Winchester from 1127 to 1171, who is believed to be depicted on one of the plaques, holding a rectangular object he is donating (Fig. 1). Much has been written about the plaques and their inscriptions.[15] A nineteenth-century English translator interpreted the line cited above as: "The Creator is above all things," thus taking the *autor* to be God.[16] Of course it could mean the creator in lowercase, the artisan. But with the pictorial and verbal emphasis on Henry, most subsequent readers have taken *autor* to mean the person who initiated and commissioned the work, and thus have translated it as *author*. The medieval term *auctor* carried meanings also associated with feudal authorities—somewhat in the direction of the lord who offered power and protection to his vassals—and thus also approaching some of our notions of the *patron*.[17] Neal Stratford cites two parallel examples of twelfth-century objects bearing inscriptions referring to a commissioner or donor with the term *auctor*. A situla, or container for

the liturgical dispensing of holy water, dating from 1116–1119—once part of the cathedral treasury of Mainz, later given to Speyer cathedral, and today in the Historisches Museum der Pfalz in Speyer—speaks of its origins in the first person. It employs the term *auctor* to distinguish the commissioner from the *factor*, the maker or artist: HAERTWICH ERAT FACTOR ET SNELLO MEI FUIT AUCTOR (Haertwich was the maker and Snello the author/initiator of me). Another inscription on the object identified Saint Alban as the recipient and Abbot Berthold as the gift giver.[18] The foot of a cross in Dublin bears the inscription: ABBAS WALTERUS FUIT AUCTOR OPUS SUPER ISTUD (The abbot Walter was the author of / initiating authority over / this work).[19]

The fuller verbal context of the enamels of Henry of Blois sheds light on their meanings and significances for understanding twelfth-century patronistic self-consciousness. Presumably one or more additional plaques with inscriptions once likewise adorned the object. The two surviving plaques bear the following inscriptions: + MVNERA GRATA DEO PREMISSVS VERNA FIGVRAT: ANGELVS AD CELVM RAPIAT POST DONA DATOREM? NE TAMEN ACCELERRET NE SVSCITET ANGLIA LVCTVS: CVI PXA VEL BELLVM MOTVSVE QVIESVE PER ILLVM. + ARS AVRO GEMMISQ(VE) PRIOR; PRIOR OMNIBUS AVTOR. DONA DAT HENRICVS VIVVS IN ERE DEO ... MENTE PAREM MVSIS (ET) MARCO VOCE PRIOREM. FAMA VIRIS, MORES CONCILIANT SVPERIS. In the catalogue of enamels in the British Museum from 1993,

14. U. Bergmann, *"Prior Omnibus Autor*—an höchster Stelle aber steht der Stifter,"* in *Ornamenta Ecclesiae: Kunst und Künstler der Romanik*, ed. A. Legner, Exhib. cat., Schnütgen-Museum (Cologne, 1985), vol. 1, 117–169, esp. 130–132, 158–159.

15. See N. Stratford, "The 'Henry of Blois Plaques' in the British Museum," in *Medieval Art and Archaeology in Winchester Cathedral: British Archaeological Association Conference Transactions* 6 for 1980 (London, 1983), 28–37; James Robinson and Silke Ackermann, *Masterpieces: Medieval Art* (London, 2008), 100, 102; Henry de Blois plaques, British Museum: http://www.britishmuseum.org/research/search_the_collection_database/search_object_details.aspx?objectid=48053&partid=1&searchText=Henry+de+Blois+enamel+plaques&fromDate=1127&fromADBC=ad&toDate=1171&toADBC=ad&numpages=10&orig=%2fresearch%2fsearch_the_collection_database.aspx¤tPage=1, and the literature cited here.

16. A. W. Franks, "On the Additions to the Collection of National Antiquities in the British Museum," *The Archaeological Journal* 10 (March 1853), 1–13, here 9.

17. "Auctor," in *Mediae Latinitatis Lexicon Minus*, ed. J. F. Niermeyer (Leiden, 1976).

18. F. X. Kraus, *Die christlichen Inschriften der Rheinlande*, vol. 2 (Freiburg im Breisgau, 1894), no. 150; *Ornamenta Ecclesiae*, 481, cat. c55; Stratford, "The 'Henry of Blois Plaques'" (as in note 15), 37; Weihwasserkessel aus St. Alban, Mainz in the Historisches Museum der Pfalz, Speyer, 30 Sept. 2009: http://www.museum-digital.de/nat/index.php?t=objekt&oges=11305, accessed 26 Dec. 2012.

19. Stratford, "The 'Henry of Blois Plaques'" (as in note 15), 37; P. Springer, *Bronzegeräte des Mittelalters*, vol. 3: *Kreuzfüsse: Ikonographie und Typologie eines hochmittelalterlichen Gerätes* (Berlin, 1981), 76.

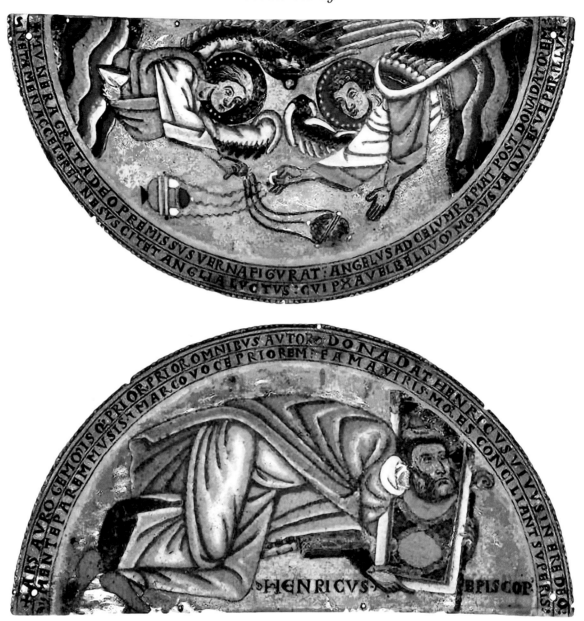

FIGURE 1. Enamel plaques showing censing angles and Henry of Blois holding a donated object, British Museum, London (photo: British Museum).

Stratford provides the following English translation: "The afore-mentioned slave shapes gifts pleasing to God. May the angel take the giver to heaven after his gifts, but not just yet, lest England groan for it, since on him it depends for peace or war, agitation or rest. Art comes before gold and gems, the author before everything. Henry, alive in bronze, gives gifts to God. Henry, whose fame commends him to the heavens, a man equal in mind to the muses and in eloquence higher than Marcus (Cicero)." [20] The *premissvs verna* might refer to an artisan named on an additional plaque now lost or to a saint who had gone before—for example Saint Swithun—in the event that his relics were housed in a reliquary chest that these

20. N. Stratford, *Catalogue of Medieval Enamels in the British Museum*, vol. 2: *Northern Romanesque Enamel* (London, 1993), 53–58.

plaques once adorned. Stratford also mentions that the donor, who would be mourned by England, may refer to Henry's brother King Stephan, although this is not a necessary conclusion. We might also wish to consider *artifice* or *craftsmanship* as a suitable interpretation for *ars*.

The comparison builds on the classical topos, found in Ovid's *Metamorphoses*,[21] but perhaps best known to medievalists today from the verse on the gilt doors commissioned by Abbot Suger for the abbey church of St.-Denis, which was consecrated in 1140: POR-TARUM QUISQUIS ATTOLLERE QUAERIS HONOREM, AURUM NEC SUMPTUS, OPERIS MIRARE LABOREM (Whoever thou art, if thou seekest to extol the glory of these doors, marvel not at the gold and the expense but at the craftsmanship of the work).[22] On the plaque, the patron who initiated or instigated the work and supports or authorizes it is cleverly added to the comparisons in serial fashion. The order of ascent is now: the materials—gold and gems—superseded in importance by the work of the artisan, and finally trumped by the patron—Henry, a man of intellect. Henry is to live on because he is portrayed on the object in bronze. Thus the spiral of precedence goes full circle—material succumbs to the craftsmanship, which must yield to its origins in the intellect. Yet in the end, the eloquent Henry survives because he has become inanimate material—bronze. The short verses convey much about the hopes that patrons attached to their works.

In some ways parallel to this usage of *auctor* is the designation of *architectus* for such church authorities as abbots and bishops who initiated, organized, and secured funds for building campaigns. In some cases these sponsors likewise participated as consultants on building projects, presumably determining the correctness of ground plans as well as the functionality and decoration with respect to the prerequisites of specific orders. The use of the term *architectus* has

caused no end of trouble for the subsequent writers of art history, who at times have read too much into the term and perceived these individuals not only as designers and planners, but also as technicians and engineers. The ninth-century abbot Ratger of Fulda was called a wise architect; the eleventh-century abbot Saracho of Corvey was characterized as a good architect; the eleventh-century bishop Burchard II of Halberstadt was known as a faithful architect; and the twelfth-century Bishop Rudolf of Halberstadt was described as a devoted architect. The well-documented individuals Bernward of Hildesheim, Benno of Osnabrück, and Otto of Bamberg were among the most famous of such "architects," whose true talents, however, showed themselves in administration and management, responsibilities that today would fall under the rubric of patronage.[23]

The converse of this kind of rhetoric must also be noted. "Artisans" could be called "donors." In his twelfth-century report about the scriptorium and library of the Michelsberg monastery in Bamberg, the librarian Burchard tells that his primary purpose is to record the names of those who *gave* books to the monastery, so that these individuals could be memorialized. Astonishingly, the lists that follow include not only the names of those who commissioned or purchased manuscripts, but also—and primarily—names of those who produced them. We read the names of twenty-two scribes who produced about two hundred books over a thirty-year period. For each of the members of the scriptorium, all or some of the books the scribe had written and/or for which he had fashioned decorated initials are listed after the monk's name. Some descriptions are very personal. For example: "Hermann, fulfilling his vow and bearing his splendid gifts on his shoulders, will one day be worthy of reward."[24] In the imagination of Burchard, the image of the scribe presenting his work was much the same as conventional donor images, in which the "patron"

21. "Materiam superabat opus." *Metamorphoses*, 2:5. *Ovid's Metamorphoses*, Books 1–5, ed. W. Anderson (Norman, Okla., 1997), 65.

22. *Abbot Suger on the Abbey Church of St.-Denis and its Art Treasures*, ed., trans. and annotated by E. Panofsky, 2nd ed. G. Panofsky-Soergel (Princeton, N.J., 1979), 46–47.

23. Bergmann, "Prior omnibus Autor" (as in note 14), 118–119 and the literature cited.

24. F. Dressler, "Schreiber-Mönche am Werk: Zum Titelbild des Bamberger Codex Patr. 5," in *Scriptorium opus: Schreiber-Mönche am Werk*. Prof. Dr. Otto Meyer zum 65 Geburtstag am 21. September 1971 (Wiesbaden, 1971), 5–18; K. Dengler-Schreiber, *Scriptorium und Bibliothek des Klosters Michelsberg in Bamberg* (Graz, 1979), 39–64.

presents the finished products to God in the hope of receiving eternal salvation. Thus—although most art historians place the persons who sponsored, commissioned, or donated works in a category quite separate from that of architects, artists, or craftsmen—many written sources from the Middle Ages confounded and conflated these classifications. The general verbal melding of these roles during the Middle Ages betrays that, from the perspective of the writers, these protagonists wished to be viewed in metaphorically similar ways.

Other authors in the present collection of essays explore specific semantic usages in particular cases in far greater depth. As the fruits of new cataloguing projects and databases become available, the comparative study of verbal articulations of artistic and patronistic self-consciousness during the Middle Ages will be furthered.[25]

In sum: In ancient Rome a *patron* acted as the fatherly protector of his freed slave. In the Middle Ages those who legally held the *jus patronatus* exercised their rights, enjoyed privileges, and assumed responsibilities for controlling, overseeing, and protecting ecclesiastical institutions, to which belonged the commissioning and maintaining of associated material objects. In written sources, those who took up these roles are not called patrons but usually founders, donors, benefactors, or even authors and architects, terms that served various ideological functions. Conversely, artisans could also be considered donors. This panoply of semantic variation, as well as the blurring of terms and metaphors, demonstrates the breadth of associations alive in the medieval verbal imagination within the category of responsibilities covered by our term "patronage."

PATRONAGE IN ART

Burchard's description of Hermann the scribe carrying the volumes on his shoulders alerts us to a problem we face. The roles of those who present their books on dedication pages are sometimes difficult to distinguish. In the Marmoutiers Sacramentary (Fig. 2), the action of the simple narrative plays out starkly

FIGURE 2. Marmoutiers Sacramentary. Autun, Bibliothèque Municipale, Ms. 19 *bis*, fol. 173ᵛ.

with figures all in profile fashioned in gold leaf against an otherwise empty deep-blue background. Holding a crozier, the nimbed Abbot Raganald rises from his throne to receive the giver, who approaches carrying a large book open on his shoulders. The giver's identity is not specified, and even his responsibility for the manuscript, whether it be as financier, commissioner, sponsor, author, commentator, translator, scribe, or illuminator, is not indicated.

In another better-known ninth-century example, the author Rabanus Maurus has himself shown handing his *De laudibus sanctae crucis* to Pope Gregory IV (Fig. 3). This full-page illumination introduces

25. See, for example, A. Dietl, *Die Sprache der Signatur: Die mittelalterlichen Künstlerinschriften Italiens*, vols. I–IV (Berlin, 2009).

FIGURE 3. Rabanus Maurus, *Liber de laudibus sanctae crucis.* Österreichische Nationalbibliothek, Vienna, Ms. 652, fol. 3ᵛ.

a model that became codified as a kind of syntax for book dedications. It exhibits the presentation of the book as a gift to a church or secular official, a saint, to the Virgin, or Christ. These conventions persisted well into the early modern era. During the Carolingian and Ottonian periods, the givers approach almost subserviently, as if still in motion, striding into the scene, presumably having just accomplished some act leading to the production of the object "off stage." The earliest literature on this motif concentrated on

origins in images of personifications of the provinces bringing tribute and in symbolic gift-giving rituals.[26]

Image makers manipulated size and scale to their utmost advantage. Illuminators painted images of donors that can live within the books they had donated. Painted on the surfaces of the folios, they can travel down through time with them, even as the books move into new libraries and thus into the hands of subsequent readers. The images were usually meant to be viewed at the same focal length as the lettered

26. P. Bloch, "Zum Dedikationsbild im Lob des Kreuzes des Hrabanus Maurus," in *Das erste Jahrtausend: Kultur und Kunst im werdenden Abendland an Rhein und Ruhr,* ed. V. Elbern (Düsseldorf, 1962), I: 471–494; C. Schleif, "Gifts and Givers that Keep on Giving: Pictured Presentations in Early Medieval Manuscripts," in *Romance and Rhetoric: Essays in Honor of Dhira B. Mahoney,* eds. G. Donavin and A. Obermeier (Turnhout, 2010), 51–71.

FIGURE 4. Mosaic showing Christ, two angels, Saint Vitale, and Bishop Ecclesius. Dome of the apse, S. Vitale, Ravenna (photo: Testus released in the public domain under Creative Commons Attribution-Share Alike 3).

texts and perceived as if existing for just one reader. The images, often in tandem with texts, address each new viewer/reader one on one, sometimes requesting prayers in emotionally compelling ways.

Employing a somewhat antithetical strategy of scale, some sponsors of churches had the size of their gifts reduced. First studied by Elizabeth Lipsmeyer, the practice of rendering ecclesiastical structures as hand-held gifts predates the same custom with manuscripts and likewise endures into post-medieval times.[27] Expansive monastic churches, or in later cases, soaring cathedrals, are rendered so compact—we call them "models"—that their donors can keep them completely under their control and can carry them down in time to present them to each generation of users anew. The giving is forever presentized.

Carola Jäggi has suggested that when this motif was first adopted in the sixth century, the individuals who had themselves thus depicted at the outer edges of rows of saintly patrons, represented in apse mosaics and frescoes, did so by virtue of their roles as founders, administrators, or officials rather than donors (Fig. 4).[28] This adjustment to commonly held hermeneutic assumptions points up once more the ambivalence of the imagery. No matter what the concrete role of the individuals may have been, these persons thus appear as the eternal sponsors and protectors of the objects they hold. In some instances a recipient accepts the structure being presented. Remarkably, however, even here the giver never relinquishes his or her hold on the gift, as evidenced in the donor capital at Autun (Fig. 5). Patrons do not and cannot let go. They thus

27. E. Lipsmeyer, "The Donor and His Church Model in Medieval Art from Early Christian Times to the Late Romanesque Period" (Ph.D. diss., Rutgers University, 1981); E. Klinkenberg, *Compressed Meanings: The Donor's Model in Medieval Art* (Turnhout, 2009).

28. C. Jäggi, "Donator oder Fundator? Zur Genese des monumentalen Stifterbildes," *Georges-Bloch-Jahrbuch des Kunst-historischen Instituts der Universität Zürich*, 9–10 (2002–2003), 27–45. For the most recent suggestions at similarly recategorizing later depictions of historic persons according to role and function see P. C. Claussen, "Bildnis im Hohen Mittelalter," in *Der Naumburger Meister: Bildhauer und Architekt im Europa der Kathedralen*, Exhib. cat. (Petersberg, 2011), vol. 2, 811–818.

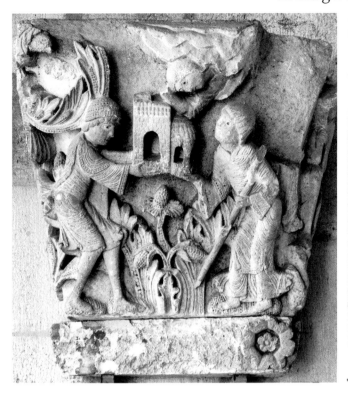

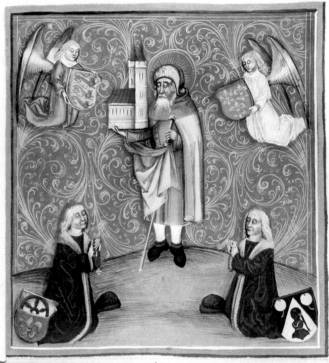

FIGURE 5. Capital, Cathédrale Saint-Lazare, Autun (photo: Volker Schier).

FIGURE 6. Dedication page showing Saint Sebald holding a church model with Sebald Schreyer and Paulus Volckamer as donors. Missale Bambergense, Bamberg: Johann Sensenschmidt, 1490. Nuremberg, Landeskirchliches Archiv, St. Sebald, St. Sebald 2.

maintain protective attachments with their buildings or objects in perpetuity. As an iconographic offshoot of this imagery, traditions developed in which saints were assigned church models as their attributes, in reference usually to their activities commissioning or donating. In some instances, however, this attribute referred to a church bearing their name. For example, a miniature added to a copy of the missal printed for the Bamberg diocese in 1490 marks this particular book as belonging to the Nuremberg parish under the titular protection of Saint Sebald (Fig. 6). Such figures mark the juncture of two semantic uses of the term patron.

Books and church models constitute the objects most frequently depicted as gifts. As demonstrated in the already mentioned Cologne exhibition, the Romanesque era saw the expansion of a vast array of hand-held donations to include nearly anything that could be given, from reliquaries for tiny particles to lands and vast estates. If the above-mentioned enamel plaque with Henry of Blois were still affixed to its object, it would be clear what the depicted gift in Henry's hands actually is (see Fig. 1). With the giver ever present on his or her gift, artisans could play with notions of infinity. The act of giving was depicted within the act of giving, thus implicitly forming a never ending chain of gift giving *ad infinitum* in the pictorial imagination. For example, in the twelfth century, Arnold von Born has himself pictured on a reliquary presenting arm reliquaries (Figs. 7, 8). In the late Middle Ages, when relics themselves were occasionally handled, sponsors could visually suggest even more agency by showing the relic itself in their hands. Emperor Charles IV, who acquired the Holy Lance and initiated its liturgical veneration and display in Prague in the mid-fourteenth century, is portrayed on a pilgrim's badge holding the Lance (Fig. 9). Of course, lands and estates could not be hand held and thus needed to be shown in an abbreviated fashion. Trees growing from clods of earth held by donors functioned synecdochically within the panel

FIGURE 7 (*left, top*). Two arm reliquaries. Treasury, St. Gereon, Cologne.

FIGURE 8 (*left, bottom*). Enamel plaque showing Arnold von Born presenting two arm reliquaries (detail not visible on reliquary on the left in Figure 7). Treasury, St. Gereon, Cologne.

FIGURE 9 (*right*). Pilgrim's badge for the display of the imperial relics in Prague. Prague, Muzeum hlavniho mešta Prahy.

painting executed between 1511 and 1515 by Goswin van der Weyden (Fig. 10).[29]

These donor images were of course augmented by figures who, holding nothing in their hands, stand or kneel on the periphery of chapels, flank portals, or occupy marginal spaces in manuscripts. In panel paintings beginning in the fourteenth century, devotees kneel reverently paying homage to Christ, the

29. A. Bijsterveld, *Do ut des: Gift Giving, Memoria, and Conflict Management in the Medieval Low Countries* (Hilversum, 2007), 73. Such depictions are based on long observed customs of extending a twig or branch as a symbol that ritually functioned to materialize the transfer of estates as donations. See Jäggi, "Donator oder Fundator?" (as in note 28), 29.

FIGURE 10. Goswin van der Weyden /Goossen van der Weijden, *The Gift of Kalmthout.*
Staatliche Museen Preussischer Kulturbesitz, Gemäldegalerie, Berlin, inv. no. 3879.

Virgin, a saint, or saints, or witness a scene from salvation history. Expanded casts of characters, showing extended families of the patrons, became ubiquitous in sculpted and painted altarpieces and epitaphs during the early modern period. German painted epitaphs from the fifteenth and early sixteenth centuries usually include a board or roof-like frame upon which names and death dates of one or more family members were recorded, mounted above a large image showing a narrative scene from salvation history, a hieratic depiction of Christ, the Virgin, a saint, or several saints, with a lower register containing the family (usually one husband, one or more wives, and all of the children). The Nuremberg epitaph for Klara Münzmeister

FIGURE 11. Epitaph for Klara Löffelholz, née Münzmeister. St. Sebald, Nuremberg
(photo: Volker Schier).

FIGURE 12. Jakob Elsner, *Provost Anton Kress Commended by Saint Lawrence before the Holy Trinity*. Kress Missal, Germanisches Nationalmuseum, Nuremberg, Hs. 113264, fols. 2ᵛ–3ʳ.

Löffelholz, dating from 1437, includes the couple with their eight sons and eight daughters beneath an image of *Christ Being Crowned with Thorns* (Fig. 11). Comparing various manifestations of patronistic self-consciousness will be easier in the future, thanks to databases like that of Medieval Memoria Online, a project in progress that strives to document all written and pictorial memorials in the Netherlands.[30]

And finally, one last convention for expressing patronage—particularly of books—was to show the book in use with the venerated saints or biblical characters coming alive as the individual meditated on the content of a given codex. Perhaps the best-known example is the famous full-page miniature in the Hours of Mary of Burgundy, in which Mary can be observed as she witnesses a scene in a church interior. The double-page spread in the Kress Missal from 1513 provides a particularly vibrant example (Fig. 12).[31] Provost Anton Kress kneels before his open missal, and Saint Lorenz recommends him to the Trinity as the heavens open before him. This last visual strategy calls to mind that other use of the term patron as we know it in our own time—that of regular customer. Donors could show themselves to be the first users or readers of a devotional or liturgical book. Thus the sponsors themselves may be portrayed not as participating in production but in consumption.

Emblazoning anything from a small prayer book

30. Medieval Memoria Online: http://memo.hum.uu.nl.
31. Schleif, *Donatio et memoria* (as in note 12), 206–212; Opening the Geese Book, Kress: http://geesebook.asu.edu, accessed 1 Jan. 2013.

to a public bridge to an important church was likewise a method of claiming patronage. The use of heraldry was far more strictly controlled than was the installation of inscriptions or inclusion of figures of devotees.

In sum: Evidence of patronage on works of art and architecture abounds. If we search for representations of patrons within works of art, certain historical developments can be contoured and patronistic strategies can be observed. However, as in written sources, depictions are likewise replete with ambivalence. Sponsors as well as producers were depicted as gift givers, and extended families were shown as devotees.

HISTORIOGRAPHY

Much of what I have put forth and reviewed so far already belongs, strictly speaking, to the realm of historiography, because it involves the telling of history in words, or the portrayal of history through images, or both. Until now I have assumed, however, that patrons saw, felt, or proclaimed their own patronage in one way or another because it was presumably advantageous to that patron. Many of us authoring chapters in the present volume show that patrons did not of course exercise free reign but were faced with restrictions in putting forth their self-promotions, including the more subtle limits that were imposed by conventions. In previous publications, Anne Derbes, Mark Sandona, and Robert Rough have addressed the partially contested patronage of Enrico Scrovegni in the Arena Chapel in Padua, with respect to charges that he had falsely displayed sole patronage rather than sharing credit with the Gaudenti Cavalieri, as reported in a chronicle.[32] Other authors in the present volume, particularly Elizabeth Pastan, have asked how and why sponsorship of a given work, such as the Bayeux Embroidery, was later questioned or denied in the writing of history. But what of the beneficiaries who might have sought the patronage of others, real or imagined? What of wishes to establish false patronage and struggles over patronage after the fact? What of the re-fashioning of early medieval history

drawn up or chiseled subsequently during the high or late Middle Ages? When and how was patronage narratologically and pictorially negotiable?

Increasingly, art historians are discovering claims to patronage made not by the patrons themselves but by later groups or individuals wishing to place themselves under the umbrella of exemplary or protective forebears. Such contentions have been made through texts, heraldry, images, or some combination of the above. One example is clearly legible on the fourteenth-century façade of the parish church of St. Lorenz in Nuremberg (Fig. 13). In the spandrels over the portal, the arms of Bohemia and Silesia for the Holy Roman Emperor Charles IV and his third wife Anna von Schweidnitz, who married in 1353, declare the building to be under imperial sponsorship. However, no record of any financial contributions or subsidy is known. Indeed, in later years the emperors were known to "borrow" money from Nuremberg's wealthy merchant burghers. The city aldermen— among them those appointed as trustees for the *fabric ecclesiae*, who commissioned the late-Gothic building with its emulation of a French cathedral façade—must have desired the appearance of an impressive looming structure that dominated their cityscape and displayed the "logos" of the emperor, thus proclaiming that as a free imperial city its newly modernized and expanded parish church was under his auspices.

In her work on Autun cathedral, Linda Seidel argues that the famed inscription "Gislebertus hoc fecit" was intended to convey patronage rather than as the sculptor's own self-identification, as had been assumed since the nineteenth century (Figs. 14, 15). She believes the person here declared ostensibly to have "made" the twelfth-century cathedral with its sculptural programs, to have been a tenth-century count of Chalon and Autun, who became the duke of Burgundy. If Seidel is correct, this verb usage is especially audacious, because someone who lived, donated land, and died two hundred years earlier is ostensibly credited with erecting a specific Romanesque building. The permanence of something "made" of stone

32. R. Rough, "Enrico Scrovegni, the Cavalieri Gaudenti and the Arena Chapel in Padua," *Art Bulletin* 62 (1980), 24–35; Anne Derbes and Mark Sandona, *The Usurer's Heart: Giotto, Enrico Scrovegni, and the Arena Chapel in Padua* (University Park, Pa., 2008), 34.

FIGURE 13. West portal, St. Lorenz, Nuremberg (photo: Volker Schier).

FIGURE 14 (*opposite, top*). West portal, Cathédrale Saint-Lazare, Autun (photo: PMRMaeyaert—Creative Commons Attribution-Share Alike 3.0 Unported licence).

FIGURE 15 (*opposite, bottom*). Inscription, west portal, Cathédrale Saint-Lazare, Autun (photo: Volker Schier).

was in this case appropriated in order to travel back into history and to announce a historical "fact" as a public warning in the present, against a twelfth-century duke who had attempted to take back ancestral lands previously donated.[33]

A better-documented case manifests itself with the famous mid-thirteenth-century figures in the west choir of the Naumburg Cathedral. With their sumptuous contemporary clothing and jewelry, starkly individuated physiognomies animated with emotion, exuding self-esteem, vitally engaging in dialogue with each other, and seemingly self-conscious in their appearance before an audience, these figures had long been considered by art historians to be portraits capturing true likenesses of real persons (Fig. 16). For many, they fit rather comfortably—even if somewhat precociously—into art history's teleological narrative that traced its trajectory ever upward toward convincing mimetic reproductions of nature in the Renaissance. Although it had been difficult to claim verisimilitude for the French sculptures of Saint Joseph, Gabriel, or the Virgin, German art historians could make the claim more easily for the medieval patrons of Naumburg Cathedral. Then in the 1950s and 1960s historians pointed to a major flaw in this

assumption. The individuals represented, several of whom are named in the extant inscriptions on the shields, had lived in the eleventh century, not in the thirteenth.[34] Exactly who each of them was meant to represent and whether or not these individuals had all been buried in the edifice that was replaced by the High Gothic choir for which the figures were sculpted are today matters of much debate, as are the relative functions of the sculpture with respect to political tensions, legal documents, and liturgical memorial practices. It is nonetheless certain that those sculpted were long dead when their images were fashioned and that these life-like figures manifest the patronage that was sought by those who commissioned their statues. It has been asserted that the figures played a role in connection with the financial aims of Bishop Dietrich II, who called for donations in 1249, and listed the names of the "first founders," several of which also appear in the inscriptions on the figures. Additionally, it has been contended that the figures may have been intended to solidify inherited claims to rights and privileges granted earlier before Naumburg became a diocesan see. Sources on these undoubtedly partially legendary donors are very sparse and seldom predate the sculptures.[35] With the installation of the figures and the continuation of anniversary Masses, the bishops and canons assured that new contributors had worthy role models, and they warranted for potential donors the fulfillment of memorial obligations. Without the upholding of this kind of reciprocity the donational system could not be sustained.

33. L. Seidel, *Stories in Limestone: Lazarus, Gislebertus, and the Cathedral of Autun* (Chicago, Ill., 1999), esp. 63–78.

34. None of the women's names are included in the inscriptions, only the men. Several were refreshed in the sixteenth century, but the older inscriptions beneath the more recent paint correspond in content. See H. Wittmann, "Die Stifterfigur des SYZZO COMES DO in ihren Bezügen zum adeligen Geschlechterbewusstsein der Grafen von Schwarzburg-Käfernburg," in *Der Naumburger Meister: Bildhauer und Architekt im Europa der Kathedralen*, Exhib. cat., Naumburg (Petersberg, 2011), vol. 2, 963–972; C. Kunde, "Das Instrumentarium der 'ersten Stifter': Physiognomie, Gebärden, Bekleidung, Schmuck, Waffen: I. Gestik, Haartracht, Kleidung und Schmuck," in *Der Naumburger Meister*, 2: 973–989.

35. W. Schlesinger, *Meißner Dom und Naumburger Westchor. Ihre Bildwerke in geschichtlicher Betrachtung* (Münster, 1952); R. Ströwesand, *Der Stifter der Stifter: Historie der Naumbur-*

ger Dreizehn (Clausthal-Zellerfeld, 1959); E. Schubert, *Der Westchor des Naumburger Doms: ein Beitrag zur Datierung und zum Verständnis der Standbilder* (Berlin, 1964); W. Sauerländer, "Die Naumburger Stifterfiguren: Rückblick und Fragen," in *Die Zeit der Staufer: Geschichte, Kunst, Kultur*, Exhib. cat., ed. R. Haussherr, vol. 5 (Supplement) (Stuttgart, 1977–1979), 169–245; W. Säuerländer (with J. Wollasch), "Stiftergedanken und Stifterfiguren in Naumburg," in *Memoria: Der geschichtliche Zeugniswert des liturgischen Gedenkens im Mittelalter*, ed. K. Schmidt and J. Wollasch (Munich, 1984), 354–383; C. Folkhard, *Das antistaufische Figurenprogramm des Naumburger Westchors* (Alfeld, 1997). For a critical review of all of the literature, see G. Straehle, "Der Naumburger Meister in der deutschen Kunstgeschichte" (Ph.D. diss., Ludwig-Maximilians-Universität, Munich, 2009): http://edoc.ub.uni-muenchen.de/10043/.

FIGURE 16. Ekkehard and Uta, west choir, Dom Sankt Peter und Paul, Naumburg (photo: Linsengericht—Creative Commons Attribution-Share Alike 3.0 Unported licence).

FIGURE 17. Choir, Dom zum Heiligen Kreuz, Nordhausen (photo: Volker Schier).

The Naumburg figures may be the most innovative and most compelling but they are far from the only example of retrospective representations of patrons in the thirteenth century.[36] In the collegiate foundation in Nordhausen the time lag between the lives of the would-be patrons and the sculpting of their polychromed images in stone is longer. Figures of tenth-century royalty sculpted at the end of the thirteenth century line the choir—the men on the south and the women on the north (Fig. 17). As in Naumburg,

36. M. Hörsch, "Zur Rezeption der Skulpturen des Naumburger Meisters," in *Der Naumburger Meister: Bildhauer und* *Architekt im Europa der Kathedralen*, Exhib. cat. (Petersberg, 2011), vol. 2, 1428–1443.

patronage was sought and actively manifested, employing the visuality and tactility of sculpted figures bearing engaging facial expressions and clad in brightly colored contemporary courtly dress adorned prominently with opulent jewelry. The individual identities are completely conjectural, since no inscriptions are painted on the shields held by the men. In fact no *tituli* are present at all. It is most commonly assumed that husbands and wives face each other across the choir and that the two women holding church models are Queen Mathilda and Empress Theophanu. Proceeding from west to east possible identifications are: Otto I (Fig. 18) and Adelheid (Fig. 19), Henry I (Fig. 20) and Mathilda (Fig. 21), Otto II (Fig. 22) and Theophanu (Fig. 23).[37]

King Henry I had built a castle in Nordhausen, where his wife Mathilda resided from time to time, and where she gave birth to two children. In 927 he bequeathed the castle to Mathilda, who took it over upon his death in 929 as her dowager estate. In 961 Mathilda founded a nunnery for secular canonesses in Nordhausen, to be ruled by an abbess with a provost to represent the foundation externally. According to passages in Mathilda's two *vitae*, she established the foundation for the eternal salvation of her husband Henry I, her son Otto I, and herself. Mathilda alone was the founder, although upon her death her son Otto did donate additional estates from her holdings, and her grandson Otto II later made additional donations of estates to the canonesses as well. Nordhausen was among the places presented to Theophanu, the daughter-in-law of Otto I, as her marriage portion when she was wed to Otto II. Like Mathilda before her, Theophanu spent her years of widowhood at the castle in Nordhausen.[38]

By 1220, when Nordhausen became a free imperial city, much had changed. In this year, the provost of the collegiate foundation betrayed the canonesses, forcing them out of their residence and transforming it into a collegiate foundation for eight to twelve canons. Subsequently, the men usurped most of the estates and lands that supported the foundation and took over all of the anniversary Masses to which the women's foundation had been obligated. These Masses apparently included memorials for Mathilda, Henry I, and Theophanu, all of whom are mentioned in the necrologium that survives from 1334. By 1230, the women had relocated outside the city, where they continued to commemorate Mathilda.

By the end of the century a three-way struggle, fraught with tensions of gender and class, had developed in Nordhausen. The canonesses had established some autonomy and were finally successful in establishing their right to choose their own provost. On another front, however, with the backing of the town council, the citizens drove out the imperial administrators, and in 1277–1278 stormed and destroyed the imperial castle. At this juncture the canons must have decided to commission the life size "chess pieces" that were installed above their choir stalls in the new choir that had been completed before 1267. Modifications were necessary to accommodate the figures that have been stylistically dated to *c.* 1290.[39] Apparently not content simply to celebrate the matronage of Mathilda or of Mathilda and Theophanu, who had left their imprint on Nordhausen, the canons enlisted the patronage of Henry I, Otto I, and Otto II, also adding Adelheid, the wife of Otto I, daughter-in-law of Mathilda, and mother-in-law of Theophanu. For the canons, these royal surrogates legitimated their position against the power that had been usurped by the townsfolk. In so doing the canons demonstrated their long standing validity by constructing continuity with an extended foundation of their own invention.

37. D. Suckow, *Die Stifterfiguren im Dom zu Nordhausen* (Weimar, 2011), 32–45. For a description of the sculpture in the nineteenth century and early attempts at identification, see J. Schmidt, *Beschreibende Darstellung der älteren Bau- und Kunstdenkmäler der Stadt Nordhausen* (Halle, 1888), 87–93.

38. M. Gockel, *Die deutsche Königspfalzen: Repertorium der Pfalzen, Königshöfe und übrigen Aufenthaltsorte der Könige im deutschen Reich des Mittelalters*, vol. 2, *Thüringen*, installment 4, *Nordhausen* (Göttingen, 1991), 369–385; A. Wand, *Das Reichs-*

stift "Zum Heiligen Kreuz" in Nordhausen und seine Bedeutung für die Reichsstadt 961–1810 (Heiligenstadt, 2006), 32–48; Suckow, *Die Stifterfiguren* (as in note 37), 7–19. On Mathilda, see Gerd Althoff, "Causa scribendi und Darstellungsabsicht: Die Lebensbeschreibungen der Königin Mathilde und andere Beispiele," in *Litterae medii aevi: Festschrift Johanne Autenrieth*, eds. M. Borgolte and H. Spilling (Sigmaringen, 1988), 117–133.

39. A. Wand, *Das Reichsstift*, 73–99 (as in note 38); Suckow, *Die Stifterfiguren* (as in note 37).

FIGURES 18–21. Otto I, Adelheid, Henry I, and Mathilda, Dom zum Heiligen Kreuz, Nordhausen (photos: Volker Schier).

FIGURES 22–23. Otto II and Theophanu, Dom zum Heiligen Kreuz, Nordhausen
(photos: Volker Schier).

My third example again shows thirteenth-century monuments for patrons who lived at the end of the tenth and beginning of the eleventh century. At the former women's Augustinian collegiate foundation in Heiningen, stucco figures of the donor Hildeswied and her daughter Alburgis (Walburgis in some occurrences), the first abbess, are installed on the north face of the southwest crossing pier (Fig. 24). Below the figures, an eighteenth-century plaque bearing an inscrip-tion that survives in a fragmentary state identifies the persons and tells their history. Apparently the figures originated as tomb sculpture, although no tomb for the women is evident in the church today. As a donor, Hildeswied supports the model of a three-aisled church on her right arm. Alburgis holds a book as a symbol of her office as abbess. Both are crowned; additionally Alburgis wears a veil. Another extant thirteenth-century work from Heiningen likewise bears

FIGURE 24. Hildeswied and Alburgis, St. Peter und Paul, Heiningen
(photo: Volker Schier).

their images: together with those of the foundation's saintly patrons, figures of the two founders were embroidered on an altar cloth.[40]

The only written source connecting Hildeswied, Alburgis, and the nunnery dates from 1013. In this charter, Emperor Henry II confirms the founding of the monastery through Hildeswied. According to a sixteenth-century account of the founding legend, Hildeswied had been married to a Saxon king, Alfrid. Upon his death in a crusade or "journey to the Holy Land," Hildeswied gives all of her lands to establish a house for canonesses at Heiningen. Bernward of Hildesheim is to have aided Hildeswied by wresting her estates from secular hands. Indeed, historical sources show that the territories supporting Heiningen were long under the stewardship of the Hildesheim bishops.

These figures of Hildeswied and Alburgis were fashioned for Heiningen rather assertively, just as the canonesses were criticized for being too worldly, and a tug of war over their lands was raging between Hildesheim and the Cistercian women's foundation at Wöltingerode. A provost of the (male) Cistercians at Riddagshausen, who had conducted a visitation of the women at Heiningen, was particularly judgmental of them.[41] Remarkably, in these attempts at reform from the outside, correction and protection go hand in hand. Here, however, the women of Heiningen, with their matronly patrons of 250 years, prevailed, and the Cistercians were not able to impose any strict reform measures on the community or force them to join another order.

In sum: With these three examples, long-forgotten or would-be patrons of old were exhumed, dusted off,

dressed in modern finery, and shown radiating with all the energy of life. In the case of patronage politics we might add the word "still" to Derrida's other two adverbs. The patrons are thus "still always already" there to validate and protect.

CONCLUSION

Art historians might seek art patrons in the past in order to validate their own interests and endeavors with medieval objects that have come to be considered art. Many medieval women of means took advantage of opportunities to assume agency through patronage. Due to the language trouble of uneven gender polarities, these women are labeled using the conceits of patriarchy. During the Middle Ages patrons were called founders, donors, benefactors, or makers in written sources. Visual representations likewise include a wide variety of motifs and metaphors used strategically and/or conventionally. Often nonspecific as to particular roles in the production of art, these formal models were shared by many kinds of participants. To ascertain the specifics of patronage, scholars must go beyond both the textual and visual shorthand and venture into complexly particular histories. Since notions attached to patronage are in essence social and economic, reflecting material relationships between or among unequal parties, new insights may be gained by interrogating those attempts to find, verify, or invent patronage. This process becomes transparent in medieval historiographies, both verbal and pictorial, in which the political and economic desires of those seeking validation or protection translate into concretely articulated retrospective self-fulfilling prophecies.

40. K. Mersch, *Soziale Dimensionen visueller Kommunikation in hoch- und spätmittelalterlichen Frauenkommunitäten: Stifte, Chorfrauenstifte und Klöster im Vergleich* (Göttingen, 2012), 169–178; S. Seeberg, "Women as Makers of Church Decoration: Illustrated Textiles at the Monasteries of Altenberg/ Lahn, Rupertsberg, and Heiningen (13th–14th c.)," in *Reassessing the Roles of Women as 'Makers' of Medieval Art and Ar-*

chitecture, ed. T. Martin (Leiden, 2012), 355–392, esp. 384–391.

41. *Monumenta Germanica Historica.* Scriptores 15,2 (Hanover, 1888), 1054–1055; G. Taddey, *Das Kloster Heiningen: Von der Gründung bis zur Aufhebung* (Göttingen, 1966), 14–24; F. Eisermann, *Inschriften auf den Textilien des Augustiner-Chorfrauenstifts Heiningen* (Göttingen, 1996).

ADELAIDE BENNETT

Issues of Female Patronage: French Books of Hours, 1220–1320

IN thirteenth-century northern and eastern France, the Book of Hours constituted a new religious book of devotions for the laity that gradually superseded the popular Psalter. Often portable in size, Books of Hours and Psalter-Hours included texts borrowed principally from liturgical books of breviaries and from prayer books, and established various pictorial programs for texts.[1] This type of prayer book was undoubtedly encouraged by the cult of the Virgin Mary that developed apace in the twelfth century. Over seventy extant examples for this period indicate their use as predominantly female and aristocratic, based on visual and textual evidence. This surely casts a different perspective on the nature of ownership that could change the concept of a devotional book for use by lay women in the household as well as in the oratory, chapel, or church. In her 1982 publication, Susan Bell announced women as the primary patrons of books, religious and secular, certainly for the Gothic period.[2]

How do we define patronage of this new genre of books of devotions in medieval thirteenth-century culture? Patronage, as I will show in this paper, is private and personal. My case studies will demonstrate that Books of Hours/Psalter-Hours were commissioned by and for individuals of the domestic household. This means sponsorship of certain pictorial and textual contents for oneself or for another person. It also includes the notion of a donor, who paid for the book. Patronage encompasses related issues of usership, readership, and ownership.

What kinds of evidence do we have for female patronage of prayer books?[3] Gender identity is linked to text and representation. Texts are gendered, for example, with words of feminine inflections. Choice of texts points to women's concerns and devotions. As a mark of their elite social status, lay women's prayer books are usually *deluxe*: legibly written, richly illuminated, and illustrated with pictures from few to

1. Biblical quotes / translations are from the Latin Vulgate Bible and its English Douai version.

2. S. Bell, "Medieval Women Book Owners: Arbiters of Lay Piety and Ambassadors of Culture," *Signs: Journal of Women in Culture and Society* 7 (1982), 742–767, a pioneering analysis of book culture primarily of the late fourteenth and fifteenth centuries. Nevertheless, she underestimates lay women's devotional Latin literacy, which, I believe, was sufficient. I thank two authors for their important contributions to the Patronage conference sponsored by C. Hourihane on 5–6 October 2012: J. Caskey, "Whodunnit? Patronage, the Canon, and the Problematics of Agency in Romanesque and Gothic Art," in *A Companion to Medieval Art: Romanesque and Gothic in Northern Europe*, ed. C. Rudolph (Malden, Mass., 2006), 193–212, and B. Kurmann-Schwarz, "Gender and Medieval Art," *ibid.*, 128–158.

3. For essays on women's patronage and ownership of Books of Hours, for example, see V. Kessel, "Frauen als Auftraggeberinnen von illuminierten liturgischen Handschriften," *Liturgie und Frauenfrage: Ein Beitrag zur Frauenforschung aus liturgiewissenschaftlicher Sicht*, ed. T. Berger and A. Gerhards, Pietas Liturgica, 7 (St. Ottilien, 1990), 195–209; D. Alexandre-Bidon,

"Des Femmes de bonne foi: La Religion des mères au Moyen Âge," in *La Religion de ma mère: Les Femmes et la transmission de la foi*, sous la direction de J. Delumeau (Paris, 1992), 91–122; M. Caviness, "Anchoress, Abbess, and Queen: Donors and Patrons or Intercessors and Matrons?" in *The Cultural Patronage of Medieval Women*, ed. J. McCash (Athens, Ga.; London, 1996), 105–154; S. Penketh, "Women and Books of Hours," in *Women and the Book: Assessing the Visual Evidence*, ed. J. Taylor and L. Smith (London; Toronto, 1996), 266–281; D. Alexandre-Bidon, "Prier au féminin?: Les Livres d'heures des femmes," in *Homo Religiosus: autour de Jean Delumeau* (Paris, 1997), 527–534; A. Stones, "Some Portraits of Women in Their Books, Late Thirteenth–Early Fourteenth Century," in *Livres et lectures de femmes en Europe entre Moyen Âge et Renaissance*, ed. A.-M. Legaré (Turnhout, 2007), 3–27; R. Bø, "Women and Books of Hours: Gender Differences, Gender Research," *Acta ad Archaeologiam et Artium Historiam Pertinentia* 22 (2009), 129–147; V. Reinburg, "'For the Use of Women': Women and Books of Hours," *Early Modern Women: An Interdisciplinary Journal* 4 (2009), 235–240; *eadem, French Books of Hours: Making an Archive of Prayer, c. 1400–1600* (Cambridge, 2012).

many. One categorical, visual cue is the lay person's comportment as a "devotee" or "devotional figure." This pertains to the figure's pose and gesture identical to the mode of prayer: usually kneeling erectly and raising joined hands with palms pressed as if in prayer or holding a book closed or opened.[4] A devotee may also appear before a *prie-dieu* or an altar, or holy figure(s), or in a scene. In prayer, her kneeling position, of course, is a topos for humility and piety.[5] Devotees' dress and headwear signify their status as secular and aristocratic. What follows is a semi-chronological survey of how and where women are represented in Books of Hours and Psalter-Hours that were made in or exported from the regions of Île-de-France, Picardy, Artois, Thérouanne, Champagne, and Lorraine.

One criterion concerns the visibility of images of women in the Hours of the Virgin. The first canonical hour of Matins with the initial D(*omine labia mea aperies*) was the early favorite choice of women to be portrayed. In a Parisian Book of Hours of *c.* 1230 probably for Soissons Use (New York, Morgan Library and Museum, M. 92), a female devotee, wearing a berbette, lies nearly prostrate with joined hands extended (Fig.

1). She seems to be petitioning or beseeching rather than praying at the feet of the crowned Virgin holding the Christ Child, attended by two censer-swinging angels on clouds.[6] The Virgin mother gazes at her son who looks downward but not directly at the devotee. On their dexter side, the petitioner encroaches into their interior space of the initial D, as if to attain their holiness. In three other initials, the third to be discussed later, the lady is portrayed as a kneeling supplicant.[7] In addition to standard texts of the Hours of the Holy Spirit, Seven Penitential Psalms with the Litany, Office of the Dead, and Commendation of the Soul for thirteenth-century *Horae*, this book incorporates two abbreviated Psalters of Jerome and Augustine, Collectar, Litany of the Virgin, and numerous private Latin and French prayers with at least eighteen gendered references to the woman, among which the *O intemerata* is an early instance. This is a prayer book of compilatory nature (*precum libellus*), personalized for and probably commissioned by the devout lady owner.[8] To date, the *Morgan 92 Hours* may be the earliest extant French Book of Hours with several female devotee portraits.[9]

In the next example of the 1250s, the devotee's pose

4. For this mode, see G. Ladner, "The Gestures of Prayer in Papal Iconography of the Thirteenth and Early Fourteenth Centuries," in *Didascaliae: Studies in Honor of Anselm M. Albareda*, ed. S. Prete (New York, 1961), 247–275, based on examples during the papacy of Gregory IX (1227–1241); for the laity, see, e.g., B. Lane, "The Development of the Medieval Devotional Figure" (Ph.D. diss., University of Pennsylvania, 1970), 4–5 (characterized as "devotional figure" or less often "devotee"), 34–37, 90, 103–107 (her survey of French examples begins with the late thirteenth-century full-page miniature of the female devotee in the so-called *Yolande of Soissons Psalter-Hours*, New York, Morgan Library and Museum, M.729, fol. 232ᵛ). The upright kneeling pose with joined hands was classified as the fourth of seven prayer modes in the late twelfth-century treatise by a prominent Parisian theologian, in R. Trexler, *The Christian at Prayer: An Illustrated Prayer Manual Attributed to Peter the Chanter (d. 1197)*, Medieval and Renaissance Texts and Studies, 44 (Binghamton, N.Y., 1987), figs. on pp. 148–151; J. Schmitt, *La Raison des gestes dans l'Occident médiéval* (Paris, 1990), 289–315, at 295–309. Also for lay rituals of supplication, prostrate or kneeling, entreating for favor or forgiveness to the ruler, see G. Koziol, *Begging Pardon and Favor: Ritual and Political Order in Early Medieval France* (Ithaca, N.Y., 1992), 8–19, 23–26.

5. This prayer mode fits Peter the Chanter's view in his *De Penitentia: Gestus vero corporis et argumentum et probatio mentalis*

devotionis, in Trexler, *Christian at Prayer* (as in note 4), 208, l. 1395; for its English translation, "The gesture of the body is an argument and proof of the devotion of the mind," in Koziol, *Begging Pardon and Favor* (as in note 4), 60. In my essay, I apply to women's piety with their Books of Hours the premise of Peter the Chanter: "that to pray effectively one must read, and to read is to understand" (Trexler, *Christian at Prayer*, 25).

6. Cf. the intention of submissive veneration in the early medieval pose of "proskynesis." The "proskynesis" constitutes the seventh mode of prayer in Trexler, *Christian at Prayer* (as in note 4), figs. on pp. 160–163.

7. A. Bennett, "Making Literate Lay Women Visible: Text and Image in French and Flemish Books of Hours, 1220–1320," in *Thresholds of Medieval Visual Culture: Liminal Spaces*, ed. E. Gertsman and J. Stevenson, Boydell Studies in Medieval Art and Architecture (Rochester, N.Y., 2012), 125–158, at 132–136, figs. 5.2 (fol. 21ʳ), 5.3 (fol. 130ʳ). Three initials: fols. 93ᵛ (Prayer of Augustine, *Domine sancte et septiformis spiritus*), 120ʳ (French prayer to God, *Dex qui Adam e Euem formas*), and 130ʳ (French prayer to the Virgin, *Dex te saut sainte Marie pleine de grace tu ies benoite*).

8. A. Bennett, "Some Perspectives on Two French *Horae* in the Thirteenth Century," in *Books of Hours Reconsidered*, ed. S. Hindman and J. Marrow (Turnhout, forthcoming).

9. From the 1220s is a representation of a female devotee wearing a vair-lined cloak and berbette before the crowned

FIGURE 1. New York, Morgan Library and Museum, M. 92, Book of Hours, *c.* 1230, fol. 21ʳ, Hours of the Virgin, Matins.

FIGURE 2. Cracow, Czartoryski Library, 3466, Psalter-Hours, Use of Arras, 1250s, fol. 109ʳ, Hours of the Virgin, Matins.

and attitude are altered. In the Matins initial D of the Hours of the Virgin for Arras Use in the *Cracow Psalter-Hours,* a veiled lady, almost in profile, kneels erectly holding her open book of prayers opposite the regal Virgin and Child, both seated with their raised right hands acknowledging her devout presence, all rendered on the same scale within the same sacred space (Fig. 2).[10] The book here becomes an attribute of the devotee, exhibiting her pious manner of praying, meditating, reciting, and reading, appropriately imaging the incipit words of Psalm 50, verse 17, *Domine labia mea aperies* (O Lord open my lips). The Virgin

with the Child embodies maternal holiness. In addition to the woman's presence in Matins, there are female hagiographical episodes pictured in four initials of seven other canonical hours: Mary and Martha, both of Bethany, in the resurrection of Lazarus, representing hope for salvation (Sext, fol. 199ᵛ), Margaret of Antioch emerging from the dragon as topos for safe delivery of an infant (None, fol. 201ᵛ), Elizabeth of Hungary performing her humble and charitable act of washing the feet of the sick, a hooded leper covered with spots (Vespers, fol. 203ᵛ), and Agnes of Rome (Compline, fol. 208ʳ).[11] For a married saint canonized

Virgin with the Child at Matins, fol. 165ᵛ, in the Hours by an illuminator probably from Hainaut, appended to the Psalter in Parisian style (Paris, Bibliothèque nationale de France, lat. 1073A), discussed in Bennett, "Making Literate Lay Women Visible" (as in note 7), 131–132.

10. J. Ziętkiewicz-Kotz, "Un Psautier-Livre d'Heures enluminé français du XIIIᵉ siècle dans la Bibliothèque Czartoryski

de Cracovie (ms. 3466)," *Folia Historiae Artium,* Seria Nowa 7 (2001), 17–48, figs. 1–28, at fig. 18 (Hours of the Virgin, Matins, fol. 109ʳ).

11. M. Jarosławiecka-Gąsiorowska, "Psautier et Livre d'heures—XIIIᵉ siècle, France du Nord," *Bulletin de la Société français de reproductions de manuscrits à peintures* 18 (1934), 13–23, at 19; Ziętkiewicz-Kotz, "Psautier-Livre d'Heures" (as in

in 1235, Elizabeth's cult spread quickly from German regions to northern France and its adjacent Francophone regions from the 1250s on, as exemplified by the Cracow illustration of her healing the leper.[12] Among these four saints, Martha and Elizabeth were to become household paragons of the active and married life for women in the thirteenth century.[13] The penitent Mary Magdalen, reputedly the sister of Martha, is invoked twice in the litany. These gendered references underscore the lay woman's concerns with salvation, humility, penitence, and family life.

From the mid-thirteenth century, some French examples set forth a novel iconographical cycle of woman devotees in initials of other canonical hours in the Office of the Virgin. In a Book of Hours of the 1260s for Use of Paris (Baltimore, Walters Art Museum, w. 40), the Matins initial pictures just the Virgin and Child between two candlesticks, but six initials from Lauds to Vespers repeat the image of a lay female devotee wearing a berbette, now praying alone before a *prie-dieu* (Fig. 3). Only in the Terce initial does she hold an open book.[14] These six initials are word-illustrations of Psalm 69, verse 2, *Deus in adiutorium meum intende* (O God come to my assistance). Also in the Office of the Dead, the Matins Psalm 5 shows the matrix image of a female supplicant before a *prie-dieu* by visualizing the first verse, *Verba mea auribus percipe domine intellige clamorem meum* (Give ear, O Lord, to my words, understand my cry), with pleading to the Lord to understand her words.[15] All these devotees in private prayer reinforce the notion

FIGURE 3. Baltimore: Walters Art Museum, w. 40, Book of Hours, Use of Paris, 1260s, fol. 57ᵛ, Hours of the Virgin, Lauds.

note 10), 33, color figs. 19 (Elizabeth of Hungary), and 21 (Agnes of Rome).

12. For comparison of the Cracow picture with the expanded version on folio 103ᵛ of Madame Marie de Rethel's Prayer Book of *c.* 1285 from the Mons area in Francophone Hainaut, see A. Stones, "Madame Marie's Picture-Book: A Precursor of Flemish Painting around 1400," in *Flanders in a European Perspective: Manuscript Illumination around 1400 in Flanders and Abroad*, Proceedings of the International Colloquium Leuven, 7–10 September 1993, ed. M. Smeyers and B. Cardon, Corpus of Illuminated Manuscripts, 8, Low Countries Series, 5 (Leuven, 1995), 429–443, at 431–432 n. 15; *eadem, Le Livre d'images de Madame Marie: Reproduction intégrale du manuscrit Nouvelles acquisitions françaises 16251 de la Bibliothèque nationale de France* (Paris, 1997), 23, 29 and n. 8, 35 and nn. 5, 6, 102–103, color pl. fol. 103ᵛ; and Ziętkiewicz-Kotz, "Psautier-Livre d'Heures"

(as in note 10), 33. See also I. Gerát, "*Dei Saturitas*: St. Elizabeth's Works of Mercy in the Medieval Pictorial Narrative," in *Insights and Interpretations: Studies in Celebration of the Eighty-Fifth Anniversary of the Index of Christian Art*, ed. C. Hourihane, Index of Christian Art Occasional Papers, 5 (Princeton, N.J., 2002), 168–181, at 168–172.

13. A. Mulder-Bakker and J. Wogan-Browne, "Introduction Part II: Medieval Households," in *Household, Women, and Christianities*, ed. A. Mulder-Bakker and J. Wogan-Browne, Medieval Women: Texts and Contexts, 14 (Turnhout, 2005), 125–131, at 129–131.

14. L. Randall *et al., Medieval and Renaissance Manuscripts in the Walters Art Gallery: France, 875–1420* (Baltimore, Md.; London, 1989), 68–71 (no. 29), figs. 58 (Matins of Hours of the Virgin, fol. 33ʳ, erroneously stated fol. 32ʳ) and 60 (Terce, fol. 75ʳ).

15. *Ibid.,* 70 (fol. 134ᵛ).

of the lady as the user and owner of the book. In the Compline initial of the Virgin, however, a male devotee prays before an altar. Presumably he was the husband who as the head of the household might have funded the book for her. Then he would have been the donor, but was he the patron who sponsored the creation of this prayer book? Yet the wife might have been the patron(ess) in commissioning this book of basic devotions, comprising the Hours of the Virgin, Seven Penitential Psalms, Litany with Petitions, Fifteen Gradual Psalms, and Office of the Dead, for her use or even for her household. Notably included in the Litany is Elizabeth of Hungary who would have been perceived as a holy exemplar of married life to the lady. This book seems to affirm the role of the woman's married status in the shaping of personal devotions.

The picture repertory of female supplicants, moreover, is extended to the Hours of the Holy Spirit. The *Cloisters Hours* of the 1270s (New York, Metropolitan Museum, The Cloisters, L. 1990.38), for example, portrays a lady devotee with a berbette before a *prie-dieu* at Sext (Fig. 4), but in other canonical hours women are rendered, for example, as a queen or a young woman without veil, perhaps a penitent sinner.[16] In the Parisian Psalter-Hours of the 1260s, now in a private collection, both offices of the Virgin and the Holy Spirit represent a female devotee wearing berbette or snood throughout initials of the canonical hours (Fig. 5).[17] Meant for the woman viewer/user, these images would cue her to observe time and perform proper conduct for her devotions. Enacting her praying in private, often with a book, sometimes before a *prie-dieu*, would connote her pious interiority. The female laity seemingly joined the rank (of clerics), reading or saying prayers daily.

The woman's family is sometimes featured. In the former *Dyson Perrins Psalter-Hours* of the 1250s, fam-

FIGURE 4. New York, Metropolitan Museum, Cloisters, L.1990.38, Book of Hours, 1270s, fol. 8ᵛ, Hours of the Holy Spirit, Sext.

ily members, a mother with a berbette, a father wearing a hat, and three beardless youthful sons, all kneel with their hands raised toward the Virgin and her Incarnate Son above (Fig. 6). They are represented in the initial S of *Sancta Maria piissima domina, deprecare pro nobis*, a prayer that typically prefaces the Matins text of the Virgin in Books of Hours for Metz Use.[18]

The woman's maternal role as nurturer of children's

16. A. Bennett, "A Thirteenth-Century French Book of Hours for Marie," *Journal of the Walters Art Gallery* 54 (1996), 21–50, at 24-25, figs. 1–6 (fols. 3ʳ, 5ᵛ, 7ʳ, 8ᵛ, 10ʳ, 11ᵛ).

17. I am grateful to Alison Stones for informing me of the Psalter-Hours in a private collection and for allowing me to reproduce folio 260ʳ of the Hours of the Holy Spirit.

18. G. Warner, *Descriptive Catalogue of Illuminated Manuscripts in the Library of C. W. Dyson Perrins* (Oxford, 1920), I:

100–102 (no. 34), pl. 41a (fol. 165ʳ, Hours of the Virgin, Matins); Sotheby's, 29 November 1960, *Dyson Perrins*, lot 107, 32–33, pl. 13; R. Branner, *Manuscript Painting in Paris during the Reign of Saint Louis: A Study of Styles* (Berkeley and Los Angeles, Calif.; London, 1977), 60, 280 (stylistically related to the Dominican Bible of St. Jacques, Paris, in Paris, Bibliothèque nationale de France, lat. 16719-22), but the Calendar, Litany, and Hours of the Virgin are for Metz Use. The Psalter-Hours

FIGURE 5. Paris, Private Collection, Psalter-Hours, 1260s–1270s, fol. 260ʳ, Hours of the Holy Spirit, None and Vespers.

FIGURE 6. Location Unknown, formerly Dyson Perrins, 34, fol. 165ʳ, Hours of the Virgin, Matins.

religious upbringing is the focus of the pictorial program for the Hours of the Virgin in the aforementioned *Cloisters Hours* of the 1270s. In the Matins initial, both the mother with a wimpled veil and her daughter with a hair snood supplicate to the crowned Madonna and her standing son, Jesus, blessing with His right hand (Fig. 7). Here, marginalia highlights the devotees' courtly environment with the viol-playing musician, the mounted knight, and the jousting scene with a standing woman upholding two bannered spears. A rabbit, a symbol of procreation, is found in

the niche below the holy figures and two devotees within the initial D and hints of what is to come. At Prime, the veiled young mother cradles her swaddled infant in the presence of a haloed woman lifting up a book, like an amulet of good fortune, sanctifying the birth of the child. The next initial at Terce represents the pedagogical role of the veiled mother with a book instructing a young man, her son. At None, the young female with a snood prays to the Lord before a *prie-dieu*.[19] Moreover, this maiden is not anonymous. In the first of eight personal prayers in the last section

was made probably in Paris and commissioned by a native of Metz. For account of later Metz Books of Hours, see C. Mark, *Manuscript Illumination in Metz in the Fourteenth Century: Books of Hours, Workshops, and Personal Devotion* (Ph.D. diss., Princeton University, 1991).

19. Bennett, "Book of Hours for Marie" (as in note 16),

25–27, figs. 10 (Prime, fol. 43ʳ), 11 (Terce, fol. 47ʳ), 12 (None, fol. 53ᵛ); *eadem*, "Making Literate Lay Women Visible" (as in note 7), 137–143 (esp. nn. 37–38 for bibliography on mother's role as teacher of *Horae* to her children from the thirteenth to the sixteenth century), figs. 5.6 (fol. 43ʳ), 5.7 (fol. 47ʳ).

FIGURE 7. New York, Metropolitan Museum, Cloisters, L.1990.38, Book of Hours, 1270s, fol. 17ʳ, Hours of the Virgin, Matins.

FIGURE 8. New York, Metropolitan Museum, Cloisters, L.1990.38, Book of Hours, 1270s, fol. 198ʳ, Prayer, *Domine deus pater omnipotens qui es trinus et unus*, with female devotee.

of the book, the young suppliant behind a priest at the altar depicted within the *D* initial on the recto of folio 198 (Fig. 8) is named Marie, as indicated by the words, *famula tua Maria*, on the verso. She is likely to be the daughter who appears with her mother in the Matins initial of the Hours of the Virgin.[20] This family connection suggests that the Cloisters manuscript was commissioned for the young woman as a marriage gift to be used as a family book of religious devotions and teachings, and that the mother was the patron of this book for her daughter. Yet the mother may not have been the donor, for she probably depended on her husband, the head of the household, for financ-

ing this Book of Hours. This codex is a *precum libellus* of miscellaneous texts, all in Latin, albeit often with French rubrics; this bespeaks for instruction in and hence familiarity with devotional Latinity. Aimed for the female user are a prayer of confession in feminine form, a versified prayer to Mary Magdalen the penitent sinner, and three prayers, including one gendered in female form of *ego misera peccatrix*, to Nicholas of Myra, the patron saint of maidens. The *Cloisters Hours* is an early example to identify the female lay recipient by name, here with the eponym of Mary the Virgin and/or Mary Magdalen. This book would be regarded as a precious legacy for generations to come.

20. Bennett, "Book of Hours for Marie" (as in note 16), 28, 33 (*Domine deus pater omnipotens qui es trinus et unus … famula tua maria omnem iactantiam mentis et auge in me compunctionem*

…); *eadem*, "Making Literate Lay Women Visible," (as in note 7), 141.

From the second half of the thirteenth century on, illustrations in Hours of the Virgin reveal a shift in focus from the woman cycle to the narrative cycle of Christ's Infancy and/or his Passion.[21] For instance, in a Book of Hours of the 1270s originally for Paris Use (Baltimore, Walters Art Museum, w. 97), the extant initials of Lauds, Terce, Sext, and None depict the Betrayal of Christ, Flagellation, Christ carrying the Cross, and the Crucifixion. Still, the Matins initial retains the maternal imagery with a devotee (Fig. 9).[22] Inside the large initial D, the kneeling woman with a berbette on the sinister side gazes reverently at the crowned Virgin seated with the Child, all in the same scale. In the right margin appears a tiny man, probably her husband, on a platform of a dragon-stem. Is the husband's diminutive and marginalized presence appropriate to his role as a patron or donor of the book? Despite his size, he was the probable donor, but texts and images could presumably be stipulated by his spouse for herself (and the household). She is portrayed again in the initial A of Psalm 119, the first of Fifteen Gradual Psalms, where she beseeches the Lord before a *prie-dieu*, voicing the incipit words, "with my tribulations I cried to the Lord and he heard me."[23] She expressed her devotions to mendicant saints by commemorating the married Franciscan tertiary, Elizabeth of Hungary, along with Francis, Dominic, and Peter the Martyr, in the Calendar of Parisian Use.

Concurrent with the trend for cyclic episodes of the Virgin and Christ in initials of the Hours of the Virgin, images of devotees are often located in margins

FIGURE 9. Baltimore, Walters Art Museum, w. 97, Book of Hours, 1270s, fol. 7[r], Hours of the Virgin, Matins.

and minor initials. In an early fourteenth-century Book of Hours from Arras (Baltimore, Walters Art Museum, w. 104, fol. 32[v]), the Virgin nurses the Child

21. In the *Christie's Book of Hours* of the 1260s from Champagne or Burgundy, the canonical hours of the Virgin picture the Virgin and Child at Matins, Christological Infancy scenes in Lauds to Vespers, and a Passion scene of Flagellation at Compline. This book lacks gendered references in image and text: *An Intimate Art: 12 Books of Hours for 2012*, Catalogue 17, by S. Hindman and A. Bergeron-Foote, Exhib. cat., 2 May to 25 May 2012 (London, 2012), 20–34 (based on A. Bennett's descriptions, March, 2012). The Psalter-Hours (Cambridge, Fitzwilliam Museum, 300) illustrates the Madonna and Child above Christ's Betrayal and Arrest in the Matins initial and the Passion scenes in initials of seven other canonical hours of the Virgin for Use of Paris. It was made for a royal owner, perhaps Marie of Brabant, who married Philip III, King of France, in 1274; see P. Stirnemann, "Quand le Programme fait

fausse route: les Psautiers de Saint-Alban et de Saint Louis," in *Le Programme: Une Notion pertinente en histoire de l'art médiéval?*, ed. J.-M. Guillouët and C. Rabel, Cahiers du Léopard d'Or, 12 (Paris, 2011), 165–181, at 165, 168–178, and *eadem*, "The So-Called Psalter of Saint Louis," in *Der Psalter Ludwigs des Heiligen, Ms. lat. 10525 der Bibliothèque nationale de France*, Kommentar von P. Stirnemann und M. Thomas (Graz, 2011), 71–77, at 74.

22. Randall, *Manuscripts in the Walters Art Gallery* (as in note 14), 97–99 (no. 41), fig. 85 (fol. 7[r]); Prime, Vespers, and Compline of Paris Use with historiated initials were replaced by those of Rome Use with decorated initials in the fourteenth century.

23. *Ibid.*, fig. 86 (fol. 81[r]).

in the Nativity scene within the Terce initial, whereas in its margins musicians play joyful music and at the *bas-de-page* at right a veiled woman prays. This is the devotee's sole presence in this manuscript.[24]

By contrast, for example, in a Lorraine Psalter-Hours of *c.* 1290 for Metz Use (Metz, Bibliothèque municipale, 1588), the female devotee figures fifty-one times in margins and minor initials throughout the Psalter with Canticles (fols. 14–181[r]), Hours of the Virgin (fols. 183[r]–217[v]), Penitential Psalms with Litany, Petitions, Preces and Collects (fols. 218[r]–228[v]), and Office of the Dead (fols. 229[r]–257[r]), all in Latin. Only at the Matins Hours of the Virgin is she portrayed in the nearly full-page initial *S* of the Marian preface, S*ancta maria piissima domina* (fol.183[r]). On the lap of the seated Virgin, the standing Christ Child performs an unusual act of offering a gold crown to the well-dressed lady, as if to reward her piety.[25] Not the first versicle of *Domine labia mea aperies* but the second versicle of *Deus in adiutorium meum intende* features a veiled devotee before a *prie-dieu* in the three-line initial D (fol. 183[v]). At Sext (fol. 204[r]), the devotional figure reappears, but in the right margin, as though witnessing the momentous event of Christ crucified in the presence of the Virgin pierced with the sword of sorrow and Evangelist John in the monumental initial D (Fig. 10).[26] Among twenty lay women represented in the *Horae* section, one stands with rosary beads over her left arm, apparently "reading" her open book of devotions, placed in the right margin of the third Matins lesson, *Sancta Maria succurre miseris* (fol. 188[r]). Other examples show her engaged in praying or holding or reading an open book, occasionally before a *prie-dieu*, as if to establish cognizance of her literacy in Latin devotions. A male figure, frequently as a tonsured cleric, also appears but only seventeen

FIGURE 10. Metz, Médiathèque du Pontiffroy, 1588, Psalter-Hours, 1290s, fol. 204[r], Hours of the Virgin, Sext.

times throughout both the Psalter and Hours. The cleric's portrayal recurs in the small initials of the Lauds Psalm 99, the None Hymn, and the Compline Psalm 42 in the Hours of the Virgin, and twice with books in the right margins of the second and ninth lessons in Matins of the Office of the Dead. Perhaps his appearance points to his role as a spiritual adviser,

24. A. Stones, "The Manuscript, Paris BNF fr. 1588 and its Illustrations," in Philippe de Remi, *Le Roman de la Manekine*, ed. from Paris BNF fr. 1588 and transl. by B. Sargent-Baur (Amsterdam; Atlanta, Ga., 1999), 1–39, at 32–33, fig. 48; for catalogue description, see Randall, *Manuscripts in the Walters Art Gallery* (as in note 14), 142–145 (no. 55).

25. *L'Art au temps des rois maudits: Philippe le Bel et ses fils, 1285–1328,* Exhib. cat., Paris, Galeries nationales du Grand Palais, 17 mars–29 juin 1998 (Paris, 1998), 314–315 (no. 214 by F. Avril), color fig. p. 315 (fol. 183[r]).

26. Metz, Médiathèque du Pontiffroy, *Les Très Riches Heures de Metz*, Présentation du Psautier-Livre d'Heures à l'usage de Metz acquis par la Ville de Metz ..., Exhib. cat., dossier établi par P. Hoch et P.-E. Wagner, Exposition Salle Mutelet, 9 juillet–15 septembre 1996 (Metz, 1996), color pl., and Metz, Bibliothèques-Médiathèques, *Enlumineurs messins du XVe siècle*, Les Carnets de Medamothi 2007: Revue du patrimoine des Bibliothèques-Médiathèques de Metz, Dossier 2 (Metz, 2007), color fig. p. 75.

or a chaplain, or a confessor to the female user and owner whose portraits are numerous in the book.

In the *Saint-Omer Hours* of *c.* 1320, now divided between London (British Library, Add. 36684) and New York (Morgan Library and Museum, M. 754), appears the "template" image of a well-to-do female devotee. She supplicates, often with a book in the presence of her pet dog, and this is reiterated in the margin of a large historiated initial at each canonical hour in Hours of the Virgin, the Holy Spirit (Fig. 11), the Holy Sacrament (Communion), and the Passion, as well as at the Penitential Psalm 6, and Psalm 5 of the Psalter of Jerome, and in the prefatory miniature to the *Vie de Sainte Marguerite*.[27] Her devotions to the two offices of the Eucharist, a rare text, and the Passion seem exceptional. A male devotee, presumably her husband, figures once in the Lauds incipit initial of the Hours of the Passion and twice in left margins at beginning of Vespers of the Hours of the Holy Spirit and of the Hours of the Passion (M. 754, fols. 59[v], 17[v], 71[v], respectively). This *Horae* is profusely illustrated with astonishing marginalia, many fraught with sexual and scatological manifestations and temptations, as well as displays of household chores often of burlesque rendering (e.g., weaving, churning, and spinning), butterflies, rabbits, monkeys, hybrid creatures, and open books. Some could be seen as word-illustrations of texts.[28] Numerous portrayals of the lady in pious devotions concomitant with private prayers gendered for her would denote her as the user, reader, recipient, and owner; yet the frequent agenda in marginalia of exemplifying and reinforcing proper behavioral role in marriage and sexuality was surely specified through the initiative (agency) of her husband. He was possibly the commissioner and un-

FIGURE 11. New York, Morgan Library and Museum, M. 754, Book of Hours, *c.* 1320, fol. 13[v], Hours of the Holy Spirit, Sext.

doubtedly the donor of the book to his wife. Clearly this *Saint-Omer* Book of Hours was very personal to the wife, as evidenced below.

27. For an example of the Hours of the Virgin at Prime (fol. 39[r]) in the London portion, see J. Backhouse, *Illumination from Books of* Hours (London, 2004), color pl. 118 (fol. 39[r]). The Morgan portion was published in T. Belin, *Les Heures de Marguerite de Beaujeu* (Paris, 1925); for full reproductions of M. 754, see the Index of Christian Art website: http://ica1.princeton.edu. See P. Gerson, "Margins for Eros," *Romance Languages Annual* 5 (1993), 47–53, for a brief but good iconographical survey of the two portions, for the post-1318 date of the second version of the *O intemerata* prayer in the London portion, and for her rejections on heraldic and chronological grounds

of the devotee's identity as Marguerite de Beaujeu, either the first (1311–1337) as the daughter of Guichard V of Beaujeu and spouse of Charles de Montmorency, or the second (1346–1400) as the daughter of Edouard I de Beaujeu and spouse of Jacques de Savoie, Prince d'Achaïe et de Morée. For the *Vie de S. Marguerite* in M. 754, see below.

28. For example, in the bottom margin of the Penitential Psalm 50 on fol. 64[r] in Add. 36684, a hound sniffs the rabbit's genitals, alluding to verses 1–2 on David's sin of adultery with Bathsheba.

The two scripture-based texts, the Fifteen Gradual Psalms and the Seven Penitential Psalms, provide also the pictorial *loci* for female devotees. In the initial A of the first Gradual Psalm 119 in the *Reid Hours* of the 1280s for Use of Reims in Champagne (London, Victoria and Albert Museum, Reid 83), a lady devotee petitions to her intercessor, the Virgin standing with the Child.[29]

In the *Murthly Hours* initial of Psalm 119 (Edinburgh, National Library of Scotland, 21000, fol. 149ᵛ), a woman kneeling before a draped *prie-dieu* raises in her hands an open book nearly to the same level as her eyes. Its portable size appears appropriate to her private devotions. The lady's closed lips suggests that she is silently reading her own book of hours, inscribed with the words of the Matins incipit of *Domine labia me(a) aperies et*.[30] For her piety, she appears blessed by Christ with a tripartite globe above in the cloud-edged arc of heaven. Who was this devotee? This book's origin and patronage is complex because of its Anglo-French connections and clientele. Liturgical evidence points to Sarum Use of the Hours of the Virgin and the Office of the Dead, and to Worcester hagiographical connections in the Calendar and Litany. The script is written in the *textura prescissus*,

as is characteristic of English but also of some French *deluxe* books. On account of the very "French" figure style, decoration, and iconographical program, this Book of Hours was probably produced and illuminated in Paris during the late 1280s by the workshop of the *Montpellier Chansonnier* (Montpellier, Bibliothèque Inter-universitaire, section médicine, H 196), according to John Higgitt.[31] He proposed an English noblewoman of Worcester connections, Joan of Valence as the devotee, the recipient, the user, and the owner of this *Horae*. As a member of the court aristocracy, she was the daughter of the Frenchman William of Valence who was the half-brother of King Henry III of England (1216–1272).[32] She married John Comyn of Badenoch, Scotland around 1292.

Such was the prestige of Parisian art concomitant with the increasing popularity of the *Horae* that the English aristocratic laity across the Channel commissioned them for private devotions. For the first of two more examples considered here, the *Madrid Hours* (Madrid, Bibliotheca Nacional, Vit. 23-10) shows a lady devotee wearing a veiled headdress before a draped *prie-dieu*, blessed by Christ above, for the same Psalm 119 on folio 167ʳ.[33] The book is likely to have been made in Paris by one of the illuminators

29. Victoria and Albert Museum, *Western Illuminated Manuscripts: A Catalogue of Works in the National Art Library from the Eleventh to the Early Twentieth Century, with a Complete Account of the George Reid Collection*, vol. 1, by R. Watson (London, 2011), 114–121, color fig. p. 117 (fol. 197ᵛ).

30. J. Higgitt, *The Murthly Hours: Devotion, Literacy and Luxury in Paris, England and the Gaelic West*, The British Library Studies in Medieval Culture (London; Toronto, 2000), 182–183, color pl. IIa p. x, and fig. 93 p. 145. Cf. P. Saenger, "Silent Reading: Its Impact on Late Medieval Script and Society," *Viator* 13 (1982), 367–414, at 402–403.

31. On the origin and commission, see Higgitt, *Murthly Hours* (as in note 30), 23–26, 86, 97, 113.

32. J. Higgitt, "Les *Heures Murthly*: Un Livre d'heures parisien du 'groupe Cholet,' sa destinataire anglaise et son histoire dans l'Écosse médiévale," in *1300 … L'Art au temps de Philippe le Bel*, Actes du colloque international, Galeries nationales du Grand Palais, 24 et 25 juin 1998, publiés sous la direction de D. Gaborit-Chopin, F. Avril, avec la collaboration de M.-C. Bardoz (Paris, 2001), 239–251. The mother of Joan of Valence and her brother Aymer was Joan de Munchensy, Countess of Pembroke, whose younger relative, Denise de Munchensy, was an early owner of the *Burdett Psalter-Hours* (now in private collection),

probably after 1294. Its first owner was a bearded Knight Hospitaller whose devotee portrait appears before his patron saint of the Order, John the Baptist, in the first full-page miniature, and alone in the left margins of four historiated initials for Psalm 1, Matins of the Hours of the Virgin, Penitential Psalm 6, and Vespers of the Office of the Dead. In Parisian style of the Méliacin Master of the late 1280s and early 1290s, the book was produced probably for a French Hospitaller, Jean de Villers as the Grand Master of the Order (1285–1293, d. 1294) before 1291, when Acre, the capital of Crusaders, surrendered to the forces of Islam. See Avril in *L'Art au temps des rois maudits* (as in note 25), 267, 268; *The Burdett Psalter and Hours*, London, Sotheby's, 23 June 1998, lot 50; J. Backhouse, "*A Very Old Book*: The Burdett Psalter-Hours, Made for a Thirteenth-Century Hospitaller," *Studies in the Illustration of the Psalter*, ed. B. Cassidy and R. Wright, St. Andrews Studies in the History of Art (Stamford, 2000), 55–66.

33. Stones, "Some Portraits of Women in Their Books" (as in note 3), 19. I thank Alison Stones for her substantial notes on this *Horae*. See J. Janini and J. Serrano, *Manuscritos litúrgicos de la Biblioteca Nacional* (Madrid: 1969), 260–261 (no. 208), pl. 24; F. Delclaux, *Imágenes de la Virgen en los códices medievales de España* (Madrid, 1973), 342–349, color figs. pp. 344–349.

of the *Grandes Chroniques de France* for King Philip III le Hardi (Paris, Bibliothèque Sainte-Geneviève, 782), identified as the "Charlemagne Master" active in the Cholet workshop of *c.* 1275–1280.[34] The calendar conforms to Paris Use.[35] In the iconographic cycle of the Hours of the Virgin, three Marian images with the Child and of her Death and Coronation commingle with five scenes of the Passion cycle, the latter featured in current Parisian Books of Hours.[36] In the *Madrid Hours*, however, the Litany includes prominent English saints, and the Office of the Dead follows Sarum Use. Also English is the unusual subject of John the Evangelist as a pauper pilgrim receiving a ring from King Edward the Confessor, depicted

on facing folios 1ᵛ–2ʳ. They introduce twenty-six Christological miniatures from Infancy to Pentecost (fols. 3ᵛ–28). Saint Edward as the almsgiver became a key part of the cult promoted by King Henry III during the latter part of his reign, as manifested in manuscripts, mural painting, sculpture, seals, and tiles of the London-Westminster area.[37] In the Madrid book, however, for private use, these two patronal saints would be suitable exemplars of chastity for the incarnate Christ cycle with the Annunciation to the virginal Mary on folio 3ᵛ, and would remind the female user of the continual need to be virtuously chaste.[38] Also, giving alms was perceived as essential moral duty of the aristocratic faithful. These liturgi-

34. A. Hedeman, *The Royal Image: Illustrations of the Grandes Chroniques de France, 1274–1422*, California Studies in the History of Art, 28 (Berkeley and Los Angeles, Calif.; Oxford, 1991), fig. 5 (fol. 141); *L'Art au temps des rois maudits* (as in note 25), 264–265 (no. 172, by F. Avril), color fig. p. 265, with earlier bibliography; A. Stones, "Les Manuscrits du Cardinal Jean Cholet et l'enluminure beauvaisienne vers la fin du XIIIème siècle," in *L'Art gothique dans l'Oise et ses environs (XIIème–XIVème siècle): Architecture civile et religieuse, peinture murale, sculpture et arts précieux, etc…*, Colloque international organisé à Beauvais les 10 et 11 octobre 1998 par le GEMOB, … (Beauvais, 2001), 239–268, at 250 n. 64. On Anglo-French artistic relationships and connections, see L. Sandler, "Illuminated in the British Isles: French Influence and/or the Englishness of English Art, 1285–1345," *Gesta* 45, no. 2 (2006), 177–188.

35. Only two English saints, Edmund of Abingdon (16 November) and Thomas Becket (29 December), both Archbishops of Canterbury, are recorded in the Calendars of the *Madrid Hours*, and the two related Psalter and Psalter-Hours for the *Capella regis* in Paris (Paris, Bibliothèque nationale de France, lat. 10525, and Cambridge, Fitzwilliam Museum, 300). Edmund had a close relationship with the French royalty. In 1240, Edmund visited Senlis where he met King Louis IX of France and his mother, the Dowager Queen Blanche of Castile, journeyed to Pontigny (where Becket resided before becoming Henry II's adviser and Archbishop of Canterbury), and after a brief illness died in nearby Soisy. In 1246 Edmund was canonized, and a year later his relics were translated to the Cistercian Abbey of Pontigny where the service was attended by Queen Blanche of Castile, King Louis IX of France, and his three brothers (recorded in *The Life of St. Edmund by Matthew Paris*, transl., ed., and with a Biography by C. H. Lawrence (Phoenix Mill, 1996), 150, 167, 180; the 1247 translation of Edmund's relics was recorded in Matthew Paris, *Chronica Majora*, ed. H. R. Luard, Rolls Series, 57 (London, 1872–1883), IV: 361; VI: 129, cited by A. Gajewski, "The Patronage Question under Review: Queen Blanche of Castile (1188–1252) and the Architecture

of the Cistercian Abbeys at Royaumont, Maubuisson, and Le Lys," in *Reassessing the Roles of Women as 'Makers' of Medieval Art and Architecture*, ed. Therese Martin, 2 vols., Visualizing the Middle Ages, 7 (Leiden; Boston, Mass., 2012), I: 222 and n. 100.

36. The Royal Psalter-Hours of the 1270s (Cambridge, Fitzwilliam Museum, 300), and Baltimore, Walters Art Museum, W. 97.

37. Edward the Confessor was the model of charity for King Henry III of England, noted for his royal duty of almsgiving, described in S. Dixon-Smith, "The Image and Reality of Almsgiving in the Great Halls of Henry III," *Journal of the British Archaeological Association* 152 (1999), 79–96; for examples in P. Binski, *Westminster Abbey and the Plantagenets: Kingship and the Representation of Power 1200–1400* (New Haven, Conn.; London, 1995), 66–68, figs. 86 (Cambridge, University Library, EE.3.59, fol. 26ʳ, *La Estoire de seint Aedward le rei* of the 1250s), 89 (seal of Abbot Richard of Ware, 1259), 90 (tile, probably after 1255, in Westminster Abbey Chapterhouse), and 107 (triforium sculptures of south transept in Westminster Abbey); for the largely destroyed images of John the Pilgrim and Edward, executed between 1263 and 1272, on window splays of the south wall in the Westminster Painted Chamber, see idem, *The Painted Chamber at Westminster*, Occasional Paper (New Series), 9 (London, 1986), 114–115, fig. 3 p. 37 and pl. XXXII (elevation plan of decoration), pls. IV, V (copies by Charles Stothard and Edward Crocker). Also in N. Morgan, *Early Gothic Manuscripts (II) 1250–1285* (London, 1988), 91–92 (no. 121, Abbreviated Domesday Book from the Exchequer, 1250–1260, London, Public Record Office, E.36/284, fol. 2ᵛ), and 163 (no. 165, Psalter from Chichester (?), 1270–1280, London, British Library, Add. 21926, fol. 12ʳ). For background and more examples in Henry III's castles in England, see M. Harrison, "A Life of St. Edward the Confessor in Early Fourteenth-Century Stained Glass at Fecamp, in Normandy," *Journal of the Warburg and Courtauld Institutes* 26 (1963), 22–37, at 26 n. 27.

38. On the chaste marriage of King Edward and Queen Edith, see P. Binski, "Reflections on the *La Estoire of Seint Aedward le*

cal and iconographical factors suggest that this *Horae* was commissioned for an English client, the female devotee pictured in Psalm 119. In the Calendar are added two nearly contemporary memorial obits of two Englishmen, John Clinton and son Roger.[39] As for the second example, the *Nuremberg Hours* of *c.* 1290 by a Parisian artist in the style of Honoré for an English female owner (Nuremberg, Stadtbibliothek, Solger 4.4, fol. 179[v]), the wimpled figure ascends on the fifteen steps where she prays to the Lord, who appears, responding to her pleas.[40] In the *Murthly, Madrid,* and *Nuremberg Hours,* only a single image of the lady devotee appears. Clearly, Psalm 119 represents an important visual signature for female use and ownership of the *Horae.*

Like the Gradual Psalms, the text of the Seven Penitential Psalms is essential in Books of Hours, and the most frequently illustrated is Psalm 6. The majority of pictures focus on David the penitent. When occasional examples of female devotees in prayer do appear, they complement textual evidence for gendered use of Books of Hours. In an early fourteenth-century *Horae* from the Lorraine region (Paris, Bibliothèque de l'Arsenal, 288, fol. 130[v]), a lady with a white wim-

pled veil kneels supplicating before the seated Christ who blesses with His right hand to forgive any sins she has committed and raises a globe with His left hand. This penitential representation, coupled with her appearance in the left margin beside the *O intemerata* prayer gendered in female form of the sinner, *peccatrix*, points to the woman user of the book.[41]

Private prayers of meditative, that is, non-liturgical nature give salient evidence for the user's gender in text and image. The *O intemerata* intercessory prayer to the Virgin and Evangelist John is quite popular, as attested in thirty-three French *Horae* from *c.* 1230 to *c.* 1320. Twenty-six examples are gendered in the female form of *peccatrix* or *peccatrici.* Images of the Virgin and Child appear in sixteen manuscripts of which five also depict a woman devotee, for example, in a late thirteenth-century Artois Psalter-Hours (Paris, Bibliothèque nationale de France, lat. 1328, fol. 222[r]).[42] The *Cambrai Hours* of *c.* 1300 (Cambrai, Médiathèque municipale, 87) includes the *O intemerata* in two languages. The Latin text (fols. 108–110[v]) pictures twice a lady supplicant before the Virgin and Child in the initial O (Fig. 12) and the initial I, and mentions twice the penitent in feminine gender.[43] In the versified

Rei: Hagiography and Kingship in Thirteenth-Century England," *Journal of Medieval History* 16 (1990), 345, 349.

39. The 2 March obit of *Dominus Iohannes de Clynton* does not match the obit date of "Clinton" in G. Cokayne, *The Complete Peerage of England, Scotland, Ireland, Great Britain and the United Kindom, Extant, Extinct and Dormant,* new ed., rev. and much enl., 6 vols. (Stroud, 2000), I (vol. 3), 312–313; C. Moor, *Knights of Edward I,* Harleian Society, 80–84 (London, 1929–1930), I: 215–216; and G. Brault, ed., *Rolls of Arms Edward I (1272–1307),* 2 vols., Aspilogia, Being Materials of Heraldry 3 (Woodbridge, 1997), I: 110. For 3 September obit of his son, *Rogerus filius domini Iohannis de Clinton,* Roger is not cited in these same references.

40. E. Simmons, *Les Heures de Nuremberg: Reproduction intégral du calendrier et des images du manuscrit Solger 4.4° de la Stadtbibliothek de Nuremberg* (Paris, 1994), 22, color pl. XXXIX (fol. 179[v]). Another example of a woman standing on the stairway in the Gradual Psalm 119 is a Book of Hours of Paris Use for a lady with Evreux connections, in Copenhagen, Kongelige Bibliothek, Thott. 534.4, fol. 129[r]. Marina Vidas is preparing an article on this manuscript. This picture type of a figure on the stairway resembles that of King David at the bottom stairway, praying to the Lord above, in the same Psalm of the Parisian *Breviary of King Philippe le Bel* of the early 1290s (Paris,

Bibliothèque nationale de France, lat. 1023, fol. 54[r]) of which a photograph exists in the Index of Christian Art.

41. The *O intemerata* prayer appears at the end of the book, fols. 155[r]–156[v]. A second picture of a woman devotee, wearing a wimpled veil, kneeling before Christ on the cross introduces the Suffrage to the Holy Cross (fol. 142[v], initial A of the antiphon, *Adoremus crucis signaculum...*). This Book of Hours has two notable vernacular Passion meditations, the second illustrated with a half-page escutcheon of *Arma Christi* on fol. 15[r], beginning *Uesci la memoire dou li dous ihesus pour nois fut mors et occis,* discussed in G. Toussaint, *Das Passionale der Kunigunde von Böhmen: Bildrhetorik und Spiritualität* (Paderborn, 2003), 120–121, 176–177, fig. 21.

42. P. de Winter, *La Bibliothèque de Philippe le Hardi, Duc de Bourgogne (1364–1404): Étude sur les manuscrits à peintures d'une collection princière à l'époque du 'style gothique international'* (Paris, 1985), fig. 63 (fol. 222[r]). This manuscript is related stylistically to the later Walters 104 of *c.* 1310 or 1315 (see note 24).

43. The initial O of *O intemerata et in eternum benedicta singularis ... esto michi peccatrici pia et in omnibus auxiliatrix* on fols. 108[r]–108[v]; the initial I of the second part, *In huius igitur sacratissimi amoris dulcedine Uobis duobus ego hodie peccatrix cor meum ...* on fol. 109[v].

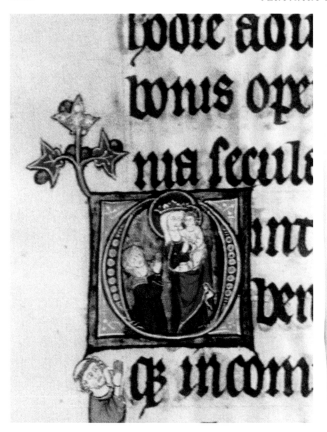

FIGURE 12. Cambrai, Médiathèque municipale, 87, Book of Hours, *c.* 1300, fol. 108ʳ, Prayer of *O intemerata* in Latin, initial O.

FIGURE 13. Cambrai, Médiathèque municipale, 87, Book of Hours, *c.* 1300, fol. 203ʳ, Prayer of *O intemerata* in French, initial O.

French text (fols. 203ʳ–207ʳ),[44] the first initial of *O tu uirge ententive et coie* (Fig. 13) portrays devotees of a couple kneeling with joined hands; both the elegantly clothed wife on the dexter side and the husband in his heraldic garment and ailettes on the sinister side pray to the standing Virgin with the Child on her arms. Perhaps in reference to the husband's presence, this vernacular passage cites the sinner in the masculine, *pecheor,* on folio 203ᵛ. In the second initial *O* addressed

to Evangelist John, *O tu iehans boins eures* (fols. 204ʳ–207ʳ), the same woman prays alone before Christ's favorite disciple, and this versified text quotes her as *Ie pechierres tres douce dame | Commant hui et mon cors et m'ame* (fol. 205ᵛ).[45] Although the wife remains nameless in spite of her heraldic dress (*sable, a lion rampant argent crowned or*) depicted elsewhere,[46] the husband is identified by his coat of arms (*gules, three pales vair, on chief or a lion issuant sable*) as Gaucher de Châtillon

44. J. Sonet, *Répertoire d'incipit de prières en ancien français,* Société de publications romanes et françaises, 54 (Geneva, 1956), no. 1599; K. Sinclair, *Prières en ancien français* (Hamden, Conn., 1978), no. 1599. Besides this French version in Cambrai 87, a French prose of the *O intemerata* appears in London, Victoria and Albert Museum, Reid 83, fols. 215ᵛ–217ᵛ, which is earlier than the one published in A. Wilmart, *Auteurs spirituels et textes dévots du Moyen Âge latin* (Paris, 1932), 491–493 (reference to New York, Public Library, Spencer 56, fols. 372ᵛ–374, in the second decade of the fourteenth century).

45. Two manuscripts, Reid 83, fol. 216ᵛ, and Spencer 56,

fol. 373ᵛ, say as follows: *ie pecheresse hui en cest iour commant m'ame et mon cors....*

46. On folio 200ᵛ in the bottom margin of the first of Nine Joys of the Virgin in the vernacular, the devotee wears a dress decorated with six escutcheons of Brabant (*sable, a lion rampant argent crowned or*), and a mantle with three escutcheons of her husband (*gules, 3 pales vair on chief or a lion issuant sable*) and two of Flanders (*or, a lion rampant sable*). Her armorial suggests that she was a member of a cadet branch of the Dukes of Brabant. Other escutcheons of her arms (*2 and 3 quarterly*) combined with those of her husband (*1 and 4 quarterly*) embellish

d'Austreche, a solicitor at Vic-sur-Aisne and châtelain of Bar.[47] These Latin and French prayers are personalized by gendered words of the sinner, the self-portrayals of the devotees, and the family identity of armorial attires. The wife figures one-hundred-six times throughout the *Horae*, and her husband appears thirteen times. The pictorial program of the Hours of the Virgin focuses on her encounters with the devil's temptations and her attempts to avoid them through her prayers.[48] As she is depicted frequently in supplicating pose throughout the book, she is clearly the user of the book geared to her devotional needs. It is likely, however, that her husband as the donor would have paid for the making of the *Horae*, extensive in numbers of illustrations and prayers. Medieval usage equates the "patron" also to a "protector," which can be applicable not only to the husband's role in financing of the book but also assuring his wife's requisite devotions. Thus the husband is not only the patron but also the protector of his wife.[49]

Other prayers, sometimes with images, were individualized for the female user. In a quarter-page miniature of two panels in the *Berès Psalter-Hours* of the 1250s for Paris Use, a devotee prays beneath hanging lamps before an altar with a covered chalice and a cross in an architectural setting, perhaps a chapel (Fig. 14).[50] To right, a male saint and Apostle Peter, each haloed with a book, are assembled with two groups of male figures, some haloed, and one veiled female. At left, the supplicant visualizes the words below: "I, unworthy and sinner, commit to you, Lord Jesus Christ." This prayer dwells on Christ's commendation of the Virgin to Evangelist John in the Crucifixion, based on John 19:27, "behold thy mother," considered a model for pastoral care of women. This same concern is true of the *O intemerata* prayer, which accounts for its popularity to women users.[51] The commendation prayer is the only one pictured among fifteen personal prayers, of which seven, including the *O intemerata*, are female-gendered.

seven two-line initials in three vernacular prayers: *Marie mere de concorde*, attributed to Gautier de Coincy, fols. 207ᵛ, 208ʳ, and 209ʳ; Theophilus, *Gemme resplendissans roine glorieuse*, fols. 211ʳ, 212ᵛ, and 215ʳ; and *O bele dame tres piue empeeris*, fol. 229ᵛ. She is represented again, this time on the sinister side of her spouse, wearing a cloak of her husband's heraldry somewhat modified (*gules and vairy, on chief or*) in the initial O of *O bele dame tres piue empeeris* on fol. 217ʳ. For identification of these arms, I owe much to Alison Stones' heraldic expertise (also in note 47).

47. On Gaucher de Châtillon d'Austreche, see A. Stones, "The Valenciennes Papias and Learning in the Grammar School in Thirteenth-Century France," in *Teaching Writing, Learning to Write: Proceedings of the XVIth Colloquium of the Comité Internationale de Paléographie Latine*, held at The Institute of English Studies, University of London, 2–5 September 2008, ed. P. R. Robinson, King's College London Medieval Studies, 22 (London, 2010), 294 and n. 6. She notes another representation of Gaucher's arms on a shield borne by a soldier, illustrating verse 646 of *Psychomachia* of Prudentius on fol. 56ᵛ in a Miscellany, completed in 1289 and signed by Iohannes de Curia on fol. 61ᵛ (Paris, Bibliothèque nationale de France, lat. 15158), perhaps from Reims; see R. Stettiner, *Die illustrierten Prudentiushandschriften*, 2 vols. (Berlin, 1895–1905), I: 144–148, 368–371; II: pl. 199 (5). The armorial of Gaucher de Châtillon d'Austreche differs from that of Gaucher de Châtillon, Seigneur of Crecy and Count of Porcien, who bore *gules, three pales vair, on chief or a marlet sable*, as noted in Emmanuel de Boos *et al.*, *L'Armorial Le Breton* (Paris, 2004), p. 180 (no. 423). Gaucher

de Crecy in 1312 married his third wife, Isabelle de Rumigny (d. 1325/1326), the latter once associated, but no longer tenable, with the *Cambrai Hours* (by Sidney Cockerell in his 1904 notes, incorporated in E. Millar, *The Library of A. Chester Beatty: A Descriptive Catalogue of the Western Manuscripts*, 2 vols. in 4 [London, 1927–1930], I: 105).

48. A. Bennett, "A Woman's Power of Prayer versus the Devil in a Book of Hours of ca. 1300," in *Image & Belief: Studies in Celebration of the Eightieth Anniversary of the Index of Christian Art*, ed. C. Hourihane, Index of Christian Art Occasional Papers, 3 (Princeton, N.J., 1999), 89–108, figs. 1–11.

49. A. J. Greimas, *Dictionnaire de l'ancien français: Le Moyen Âge*, Larousse, Trésors du français (Paris, 1997), 448 (the first meaning is *protecteur*; the second is *saint patron*).

50. This Psalter-Hours was sold three times, to my knowledge: Paris, Hotel Drouot, 2 December 1987, lot 247, pl. (fol. 167ʳ); London, Sotheby's, 2 December 1998, lot 1, 8–15, color pls. (fols. 211, 47, 164ᵛ, 175, 223, respectively); London, Christie's, Medieval and Renaissance Manuscripts, 9 July 2001, lot 10, 38–45, color pls. pp. 29, 41, 42, 44, 45. I thank Patricia Stirnemann for the photographs, and Christopher de Hamel for my examining the manuscript at Sotheby's.

51. Fols. 211ʳ–211ᵛ: *Domine ihesu christe ego indigna et peccatrix tibi committo esse posse et nosse meum uiuere ualere et intelligere animam et corpus meum ... que commendasti genitricem tuam discipulo tuo iohanni dicens ecce mater tua....* See F. J. Griffiths, "The Cross and the *Cura monialium*: Robert of Arbrissel, John the Evangelist, and the Pastoral Care of Women in the Age of Reform," *Speculum* 83 (2008), 303–330, at 316–324.

FIGURE 14. Location Unknown, ex-Pierre Berès Collection, Psalter-Hours, 1250s, fol. 211r, Prayer to Christ, *Domine ihesu christe ego indigna et peccatrix.*

Occasionally, Books of Hours incorporated birth, health, and charm prayers at lay women's requests. A notable example is the *peperit* prayer for safe childbirth in the *Stockholm Hours* of Arras Use for a woman probably before 1300 (Stockholm, Nationalmuseum, B.1655–56, fols. 82r–82v).[52] Her appeal invokes biblical and hagiographical paradigms of the holy mothers' miraculous childbirths, "Anna begat Mary, Mary begat Christ, sterile Elizabeth begat John, Celina begat Remigius," along with adjuration of either male or female [infant] be expelled from the womb without pain, citation of *Pater noster* and *Credo in Deum,* and Christ's commands to the female user of the book, "You will say, Christ conquers, Christ reigns, Christ commands, and make the sign of the cross."[53] This follows the standard liturgical group of Litany, Petitions, and three Collects. In fact, the second of nine *Ab* Petitions, *A uariis languoribus,* is a plea for pro-

52. There is no entry for Louis of France, canonized in 1297, on 25 August in the Calendar.

53. Fols. 82r–82v: "*Anna peperit Mariam, Maria peperit Christum, Elizabeth sterilis peperit Iohannem, Celina peperit sanctum Remigium … te adiuro siue sis masculus siue sis femina ut exeas abhoc uentre … sine dolore. Exi Christus te uocat. Pater noster. Et ne nos. Credo in deum. Christus uincit. Christus regnat. Christus imperat famulam tuam .N. fac signum crucis diceris.* See M. Elsakkers, "In Pain You Shall Bear Children," in *Women and Miracle Stories,* ed. A-M. Korte, Studies in the History of Religions, 88 (Boston, Mass.; Leiden, 2000), 179–209, at 182–193, 198, and E.

L'Estrange, *Holy Motherhood: Gender, Dynasty and Visual Culture in the Later Middle Ages,* Manchester Medieval Studies (Manchester, 2008), 55–75. Celina (variously spelled Celine, Celinie, Cilinia, and Ciline) was the aged mother of St. Remigius whose conception and birth were considered "wondrous," according to W. Hinkle, *The Portal of the Saints of Reims Cathedral: A Study in Mediaeval Iconography,* Monographs on Archaeology and Fine Arts sponsored by the Archaeological Institute of America and the College Art Association of America, 13 (New York, 1965), 44–46. Archbishop Remigius of Reims was venerated in the diocese of Arras which was part of the ecclesiastical Province

tection from various illnesses.[54] Towards the end of the book, a group of four private Latin prayers (fols. 154r–161v) commences with one to be said at bedtime according to Picardian French rubric, *au kouchier* (fol. 154r). This is an amuletic text: make the sign of the cross to chase all evil away and also to ensure salvation, and recite the formula AGLA for bearing strength against evil powers. AGLA is a holy acronym of Hebrew words, here given as the English equivalent, "thou are strong to eternity, Lord," as words of power.[55] Also part of this supplicatory series is the intercessory *O intemerata,* gendered in the female (fols. 155v–159r). These various appeals and prayers were read or recited by the lady.[56] She is imaged as an aristocratic devotee in an armigerous garment (*sable lozenges or*), though unidentified, on the sinister side of the Virgin and Child, in the initial of the Five Joys of the Virgin (fol. 168r).[57] Her choice of prayers sheds light on her concerns with child-bearing, motherhood, health, and devotion to Christ and the Virgin, and her self-portrayal surely confirms her as the bookowner. Her book has become her talisman to protect her by the power of the written word. In view of no verbal or visual reference to her spouse, the lay woman probably commissioned this *Horae* for herself.

Marian texts, such as the Joys of the Virgin, and the Litany of the Virgin, enrich the devotional context of Books of Hours. The Litany of the Virgin, patterned after the liturgical litany of saints, lists in the manner of anaphora by repeating *Sancta Maria* every time with an invocation of a metaphorical epithet of her virtue or attribute, many of which derive from Latin hymns. Her exemplary qualities would constitute a role model for devout women users of ten manuscripts out of eleven. In manuscripts, the texts of the Litany of the Virgin do vary in the number and selection of phrases. For an exceptionally personalized example of the Marian Litany in a Book of Hours of *c.* 1290 for Reims Use from Champagne (Baltimore, Walters Art Museum, w. 98, fol. 101r), the maternal image of the Virgin with the Child venerated by a wimpled lady devotee in the K initial introduces seventy-five invocations, each followed by the expression of "pray for your servant" gendered in the feminine, a few in the plural and many in the singular.[58] By sighting the words down the list, the female user would read, recite, meditate on, or ruminate over these Marian phrases.

From the 1220s on, Books of Hours included vernacular texts that catered mainly to women. French rubrics as pointers to Latin texts became the norm. French meditations on the Passion of Christ introduced the canonical hours of the Virgin in several manuscripts by women users.[59] The French *O*

of Reims. He is commemorated in the Stockholm Calendar with Vedaste of Arras on 1 October, and included in the Litany which ranks Vedaste as the first confessor. Remigius baptized King Clovis of France in Vedaste's presence and appointed the latter as bishop of Arras.

54. Fol. 79r: this petition so far remains a *unicum* in my catalogue of French Books of Hours (1220–1320).

55. Fol. 154r: "... *Per crucis hoc signum fugeat procul omne malignum. Et per idem signum saluetur quoque benignum. A + G + L + A. In nomine patris et filii et spiritus sancti. Amen.* For the definition of AGLA, Elsakkers, "In Pain You Shall Bear Children" (as in note 53), 192; M. MacLeod and B. Mees, *Runic Amulets and Magic Objects* (Woodbridge, 2006), 134, and D. Skemer, *Binding Words: Textual Amulets in the Middle Ages,* Magic in History (University Park, Pa., 2006), 112, giving the Hebrew equivalent: "Atta gibbor leolam adonai."

56. With regard to literacy, see L'Estrange, *Holy Motherhood* (as in note 53), 56–57, on prayers for succor by women owners of fourteenth- and fifteenth-century manuscripts.

57. Fig. 72 in C. Nordenfalk, *Bokmålningar från medeltid och renässans i Nationalmusei samlingar* (Stockholm, 1979), 60–64 (no. 13), figs. 67–74, color pl. VII. My gratitude for Dorothy Shepard's help with the *Horae.*

58. *Ibid.,* fig. 211; Randall, *Manuscripts in the Walters Art Gallery* (as in note 14), 121 (no. 49), fol. 101 as the opening leaf, misbound, and fols. 91r–92v; the Marian Litany repeats *deus miserere nobis famule tue* after the first four invocations, and *ora pro famula tua* after seventy-one *Sancta Maria* or *Sancta Mater Maria* invocations. For the Litany of the Virgin, see G. G. Meersseman, *Der Hymnos Akathistos im Abendland, II. Gruss-Psalter, Gruss-Orationen, Gaude-Andachten und Litaneien,* 2 vols., Spicilegium Friburgense, 2–3 (Freibourg 1960–1962), II: 214–240 containing different recensions. For an interesting essay on the Marian Litany, see H. Phillips, "*Almighty and al merciable queene*: Marian Titles and Marian Lyrics," in *Medieval Women: Texts and Contexts in Late Medieval Britain: Essays for Felicity Riddy,* ed. J. Wogan-Browne *et al.,* Medieval Women: Texts and Contexts, 3 (Turnhout, 2000), 83–99.

59. See Bennett, "Making Literate Lay Women Visible" (as in note 7), 128 and n. 11, 132.

intemerata prayer appeared, for instance, in the aforementioned *Reid Hours* and in the *Cambrai Hours*.[60] The Joys of the Virgin were also in French, for instance, in the *Glazier Hours* of *c.* 1300 from Arras (New York, Morgan Library and Museum, Glazier 59, fol. 68ʳ), which pictures the lady supplicant before the Virgin and Child. Numerous other personal prayers existed in the vernacular. For an early, notable example, the *Morgan 92 Horae* of *c.* 1230 contains twenty-seven French prayers of which all but four are deemed unique. The female sinner is specified thirteen times in this section. It is the personalized language of Six Salutations to the Virgin describing her full of grace that most reveals the user's poignant devotion. In this initial D of her fourth and last image (Fig. 15), the devout lady holds her open book in private, prompting the user's supplications to read or to recite the words of Salutations. There are five blessings on the Virgin's motherhood in familial terms after the fifth salutation: "her bearing God, her mouth kissing the Christ Child, her eyes protecting him, her breasts suckling him, and her hand touching him."[61] These words record and accent the intimate sentiment between Mary the mother and Jesus the infant, and their humanity to the devotee. Clearly this Book of Hours was made for and commissioned by the woman user and owner.

Excerpts or texts of saints' lives are of interest to women, for saints offer role models to the users. Collects and suffrages of liturgical origin comprise short intercessory Latin prayers to saints, some of local importance to the user. Initials or miniatures sometimes picture a salient episode, such as martyrdom, torture, performing miracles, preaching, and so forth.[62] Even the canonical Hours of the Virgin picture hagiographical scenes of men and women, as in the Artois *Cracow Psalter-Hours* and the Parisian *Berès Psalter-Hours,* both of the 1250s. Some Books of Hours supplement devotions with a hagiographical

FIGURE 15. New York, Morgan Library and Museum, M. 92, Book of Hours, *c.* 1230, fol. 130ʳ, Prayer of Six Salutations, in French.

novella, especially the life of St. Margaret in Latin or French. The *Berès Psalter-Hours* introduces the Latin prose text of the *Vita,* attributed to Theotimus, with one miniature of two key events of Margaret's life, her escape with her prayer gesture from the dragon's opened back, and her martyrdom by beheading (Fig. 16). More popular is the French *Vie de sainte Marguerite* in the *Troyes Hours* of *c.* 1300 (Troyes, Bibliothèque municipale, 1905, fols. 155ᵛ–175ᵛ). Wace's versified text depicts the cycle from her father's rejection to her martyrdom in twelve initials and her burial in one miniature.[63] Another, more prevalent French version with the incipit, *Apres la sainte passion ihesu crist a l'ascension,* appears in the aforementioned *St. Omer Hours* of *c.* 1320 (New York, Morgan

60. The Reid Hours includes both the Latin (fols. 209ᵛ–211ᵛ) and the French *O intemerata* (fols. 215ᵛ–217ᵛ). See notes 44 and 45 above.

61. Quoted and discussed in Bennett, "Some Perspectives on Two French Horae" (as in note 8), forthcoming.

62. A. Bennett, "Commemoration of Saints in Suffrages: From Public Liturgy to Private Devotion," in *Objects, Images,*

and the Word: Art in the Service of the Liturgy, ed. C. Hourihane, Index of Christian Art Occasional Papers, 6 (Princeton, N.J., 2003), 54–78.

63. A. Stones, "Le ms Troyes 1905, le recueil et ses enluminures," in Wace, *La Vie de sainte Marguerite,* ed. H. Keller (Tübingen, 1990), 197–211, 229–230, figs. 47–59 (from fol. 155ᵛ—Rejected by Father to fol. 175ᵛ—Burial).

FIGURE 16. Location Unknown, Ex-Pierre Berès Collection, Psalter-Hours, Use of Paris, 1250s, fol. 199ʳ, *Vita S. Maragaretae.*

Library and Museum, M.754, fols. 114ʳ–132ᵛ).[64] The fifteen-line initial A on folio 114ʳ illustrates Christ's Ascension, obviously inspired by the incipit words below, but eighteen episodes of the saint's story take place in right margins of the verse text, though they occasionally intrude into other margins. The image of Margaret's triumphant emergence with her cross from the dragon's back signifies her status as patron of parturient women, that is, as protector of mothers

(Fig. 17). In the panel miniature (fol. 113ᵛ), prefacing the *Vie de S. Marguerite,* the female devotee with her swollen abdomen as the mother-to-be prays with her open book, betokening her hope for the safe delivery of her pregnancy (Fig. 18). To secure unimperiled childbirth, the text passages state that the book of Margaret's life be opened or placed on the woman's abdomen as testimony of the saint's efficacy, thereby linking the book with safe delivery.[65] The *Vie de S.*

64. See Belin, *Heures de Marguerite* (as in note 27), pls. fols. 113ᵛ, 114ʳ, 114ᵛ, 115ʳ, 120ᵛ, 124ʳ, 129ᵛ; for all illustrations, see the Index of Christian Art website (as in note 27). M.754 largely follows the French edition in A. Joly, ed., *La Vie de Sainte Marguerite* (Paris, 1879), 99–118; for its English translation as Version G of "The Life of Saint Margaret of Antioch," see B. Cazelles, *The Lady as Saint: A Collection of French Hagiographic Romances of the Thirteenth Century* (Philadelphia, Pa., 1991), 216–237, at 217–228.

65. In M.754, fols. 129ʳ–129ᵛ: *Que dame qui soit ence(i)ntie | Puis qu'ele serra seignie | Du liure ou ma uie sera | Et dedenz regarde aura | Et desus lui metra le livre | Que tu sans peril la deliure* (despite few variants, see vv. 535–540, in Joly, *Vie de Sainte Marguerite* (as in note 64), 114; English edition in Cazelles, *Lady as Saint* (as in note 64), 226; on the expectant mother, J. Steinhoff, "Pregnant Pages: Marginalia in a Book of Hours (Pierpont Morgan Library Ms. M.754 / British Library, Ms. Add. 36684)," in *Between the Picture and the Word: Manuscript*

FIGURE 17. New York, Morgan Library and Museum, M. 754, Book of Hours, *c.* 1320, fol. 122ᵛ, *Vie de Sainte Marguerite*, Margaret emerging from the Dragon.

Marguerite indeed becomes an essential part of the female user's health and family concerns, and her devotions in her *Horae*.[66] Her husband, depicted with a youthful countenance thrice in this codex, was perhaps newly married, likely the donor of this book for his wife, but how extensive his patronal involvement with all of the *Horae* contents and visual imagery needs to be probed further.

Studies from the Index of Christian Art, ed. C. Hourihane, Index of Christian Art Occasional Papers, 8 (University Park, Pa., 2005), 180–186, at 181–182, fig. 251 (fol. 113ᵛ).

66. For background, see W. Larson, "The Role of Patronage and Audience in the Cults of Sts. Margaret and Marina of Antioch," in *Gender and Holiness: Men, Women and Saints in Late Medieval Europe*, ed. S. Riches and S. Salih (London; New York, 2002), 23–35.

FIGURE 18. New York, Morgan Library and Museum, M. 754, Book of Hours, *c.* 1320, fol. 113ᵛ, *Vie de Sainte Marguerite*, Female devotee.

In addition to written evidence of a lady devotee's personal name, such as Marie in the *Cloisters Hours,* heraldry also identifies persons associated with manuscripts, as is the case of the *Cambrai Hours.* In another example from *c.* 1246, heraldic escutcheons of two prominent Artois families are displayed in the Psalter-Hours for Use of Arras (New York, Morgan Library and Museum, M. 730). These are represented by a couple married in 1246, Ghuiluys de Boisleux on the dexter side (*per pale dexter vert a fess argent, sinister or three bends azure, a border gules*) and her husband, Jean de Neuville-Vitasse, on the sinister side (*or, a fretty and canton gules*).[67] They appear in the upper margins of the full-page miniature (repainted in a fourteenth-century North Italian style) on folio 17ᵛ, and the historiated initial of Psalm 109 on folio 129ʳ. The Artois coats of arms also decorate numerous line-fillers throughout the manuscript, but the wife's 166 outnumber her husband's 103. Line endings and minor initials depict both women as standard-bearers or warriors and men as knights in heraldic garments of Boisleux and Neuville-Vitasse. The prose narrative of David's episodes in Picardian French, written unusually in white script on alternating blue and maroon

67. A. Bennett, "David's Written and Pictorial Biography in a Thirteenth-Century French Psalter-Hours," in *Between the Picture and the Word: Manuscript Studies from the Index of Christian Art,* ed. C. Hourihane, Index of Christian Occasional Papers, 8 (University Park, Pa., 2005), 122–140, color pls. 16–19, figs. 179–212; R. Leson, "The Psalter-Hours of Ghuiluys de Boisleux," *Arte medioevale,* n.s. 5, no. 1 (2006), 115–130, figs. 1–18; and V. Sattler, *Zwischen Andachtsbuch und Aventiure: Der Neufville-Vitasse Psalter, New York, PML, MS M. 730,* 2 vols. (Hamburg, 2006). For illustrations, see the Index of Christian Art website (as in note 27).

grounds within gold rulings of text-blocks, accompanies the pictures in the prefatory miniature cycle and those in the psalm initials of the liturgical eight-fold division. These textual segments provide descriptive guides to these images, conveniently geared for the couple as users, readers, and owners of this luxurious book. This vernacular account is likened to a romance, stressing and memorializing the hero David noteworthy for both his virtues and his flaws. The prefatory miniatures and historiated initials of the Psalter, and line-fillers throughout the whole book demonstrate that the couple belonged to a martial and chivalrous society, especially in view of the fact that some of their relatives went to the Holy Land. The section after the Psalter contains Office of the Dead, Commendation of the Soul, Long Hours of the Holy Spirit, and Hours of the Virgin, but no private prayers. Except the Commendation of the Soul, each text is illustrated with a single historiated initial. It is the Matins initial of the Hours of the Virgin (fol. 214r) that divulges the original devotee's identity. It now shows the repainted figures in fourteenth-century Italian style of a lady devotee crowned by the Virgin with her seated Child but within the thirteenth-century initial D and architectural setting, which is still retained. Richard Leson's ultra-violet light examination of these figures reveals an earlier female devotee, surely Ghuiluys de Boisleux, wearing a green dress and white wimple, matching the colors of her armorial (*vert, a fess argent*).[68] The prominence of Ghuiluys de Boisleux as the devotee in Matins of the Hours, the priority of her escutcheons on the dexter side on folios 17v and 129r, and the quantity of her armorials suggest that the Psalter-Hours was commissioned for and even by Ghuiluys de Boisleux. Perhaps, she was the patron(ess) who requested the program designed jointly for the couple, that is, for their use.

The *Rylands Psalter-Hours* (Manchester, John Rylands University Library of Manchester, lat. 117) is also embellished with armorials of a couple, along with others of important families in Flanders and Picardy. They feature on the Beatus page of Psalm 1

and in numerous line-fillers in the latter part of the Psalter and throughout the Hours of the Virgin and Office of the Dead.[69] The heraldry (*or, a lion rampant sable*) identifies the recipient of this book as Jeanne of Flanders, the second wife of Enguerrand IV of Coucy whose marriage occurred in 1288. She was the daughter of Robert of Béthune, a son of Guy of Dampierre, Count of Flanders, and niece of William of Termonde, the brother of Robert. The Coucy arms (*barry, vair and gules*) of a Picardian noble family is, however, the dominant one with fifty-six occurrences over twenty-five Flanders armorials in the book. The married pair is depicted not at the beginning with the first psalm, but instead in the historiated initial of Psalm 80 where the kneeling devotees Jeanne, wearing a berbette, and Enguerrand, with a pair of heraldic lions, flank King David striking bells of the cymbala. In the Hours section, the choice of liturgical uses probably reflects the couple's native origins. The Hours of the Virgin follows the usage of Saint-Quentin in Picardy, and the Office of the Dead adheres to Use of Rome, which spread to Flanders and the adjoining region of Thérouanne in the last quarter of the thirteenth century. Other coats of arms represent relatives of Jeanne and comrades of Enguerrand, the latter who were also participants in tournaments that were recorded in contemporary rolls of arms and in the 1277 *Romance of Hem.* Aside from the chivalrous aspect of heraldry, the lion, delineated in the wife's Flanders shield, recurs as the pictorial leitmotif throughout borders of historiated initials and line-endings. According to Leson, this creature as multivalent symbol of good and bad serves the agenda of reminding the lady with multiple spiritual moralizations against temptations and vices. If the husband initiated the manuscript project for his wife, not only was he the donor and patron but also the protector of his wife's devotions.

In French Books of Hours as the new genre of devotions from the 1220s to *c.* 1320, women's portrayals are placed strategically visible at key sections of the text. Their images may be likenesses, however, only in

68. Leson, "Psalter-Hours of Ghuiluys de Boisleux" (as in note 67), 115.

69. R. Leson, "Heraldry and Identity in the Psalter-Hours of Jeanne of Flanders (Manchester, John Rylands Library, ᴍꜱ Lat. 117)," *Studies in Iconography* 32 (2011), 155–198, figs. 1–3, 6–7, 9–10; M. R. James, *A Descriptive Catalogue of the Latin Manuscripts in the John Rylands Library at Manchester* (Manchester, 1921), 219–222 (no. 117).

posture, gesture, attribute of a book, and dress. Moreover, pictures of women's enclosure for prayer stress the notion of solitude, that is, private female space. Here, a devotee represents a supplicant, a user, an owner, a sponsor, or a patron(ess). It is true that both a devotee and a donor or patron have similar poses of kneeling and gestures of joined hands, but portrayed in these *Horae* women devotees project primarily the concept of holiness in serving the Lord or the Virgin. Female devotees holding open books emphasize their knowledge of texts by reciting, reading, meditating, and praying. They were literate in devotional Latinity as well as vernacular supplicatory and hagiographical texts. If involved with the creation of the *Horae* for their personal usage, women should be considered patrons who are often shown as devotees. Husbands are occasionally represented, suggesting that they undertook patronage, donation, or sponsorship of manuscripts for their wives.

These case studies of French Books of Hours/Psalter-Hours reveal an array of religious and societal issues fostered by women in texts and images. The Hours of the Virgin, although its text varied according to diocesan or monastic use, focused on the Virgin Mary's incarnate role of motherhood, which appealed greatly to women. Pictures of Christ's childhood and the Virgin's motherhood were appropriate for the female viewer, user, owner, and patron. Women expressed their devotions to Christ's Passion with its picture cycle first in Hours of the Virgin and later in the Office of the Passion. Prayers, intercessory or amuletic, for fertility, childbearing, safe childbirth, and protection from health hazards and dangers of temptations were notably pertinent. Through texts and images, the *Horae* provided devotional directives for women and their households; some highlighted the wife's relationship with her husband or the parent's religious counsel to the offspring; some stressed family and kinship ties through heraldry; some exhibited insights on matters of chivalry and crusading to the Holy Land; and, most important, all offered pleas and hopes for salvation through Christ, Virgin Mary, and saints.

In conclusion, these Books of Hours catered largely to aristocratic married women. They were written likely by male scribes who complied with the clientele's personal and family devotional needs. Made and intended for private use, they exhibit customized contents and images. Pictures of female devotees engaged in pious acts of devotions, such as praying or holding or reading a book, are memorialized forever and surely attest to usership, readership, and ownership of Books of Hours. These are portraits of owners—bookowners. We must appreciate that the concept of patronage involves fascinating variations regarding the identities of users, owners, and patrons.

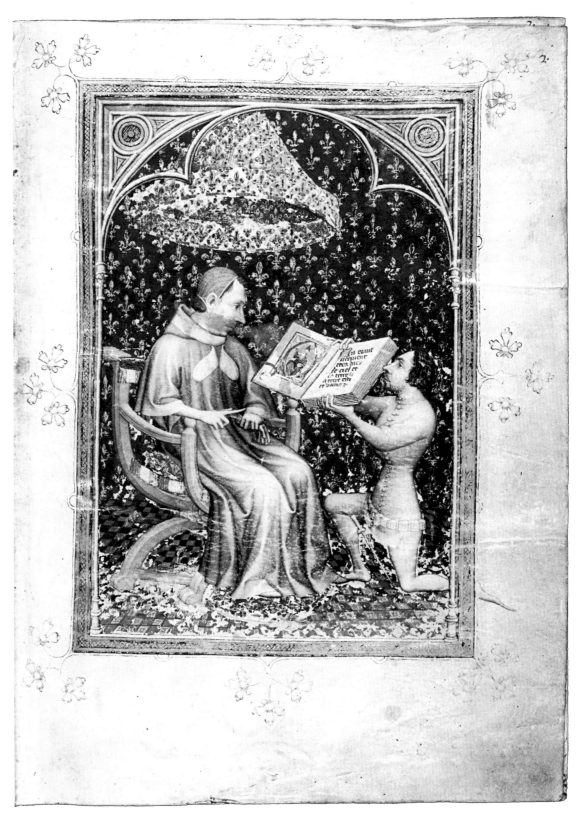

FIGURE 1. Jean Bondol, Jean de Vaudeter presenting the book to Charles V, from the *Vaudetar Bible* (The Hague, Museum Meermanno, Ms. 10 B 23, fol. 2) (photo: Museum Meermanno).

STEPHEN PERKINSON

Portraits & Their Patrons: Reconsidering Agency in Late Medieval Art

ON 28 March of 1372, Jean de Vaudetar presented a lavish copy of the *Bible Historiale* to the French King, Charles V.[1] The book's production must have been a very significant undertaking, and Vaudetar's role in its creation is today acknowledged by the so-briquet commonly applied to the book: the *Bible of Jean de Vaudetar* or, more simply, the *Vaudetar Bible*. Its 580 folios contain 247 single-column miniatures, 11 more miniatures that span both text columns on their folios, 12 historiated initials, and 4 marginal illustrations. At the front of the book, and serving as a frontispiece, we find a staggeringly beautiful full-page presentation scene (Fig. 1), an image widely admired as one of the most impressive examples of the emerging genre of portraiture. A lengthy verse colophon appears at end of the manuscript, added by the book's chief scribe, Raoulet d'Orléans.[2] After noting that Vaudetar arranged the making (*fist faire*) of the "very worthy book (*très digne livre*)" and that Raoulet was its scribe (*l'escrist*), the verses describe the process that led to its presentation to the king. The closing lines of the colophon read:

To you, Charles, full of honor, | Who art the flower of wisdom | above every king in the world, | for the great good which in you does abound, | Jehan de Vaudetar, your servant, | who is here figured (*figuré*) in front, | presents and gives this book. | For never in my life have I seen | a Bible so adorned with images | by a hand portrayed and made (*pourtraites et faites*); | for which he had endured | many goings and comings, | evening and morning, amidst the

streets, | and much rain on his head, | until the moment when the project was complete. | And then, to the above named prince, | this book was offered and given | by the said Jehan, and I do not lie, | in the year 1372, | with a good heart, and it is worth a thousand marcs, | on the 28th day of March.[3]

The frontispiece image seems to record that moment of offering, with Jean de Vaudetar kneeling submissively before the king and holding up a spectacular book, presumably this very volume. Facing this miniature and its portraits, on the verso of the first folio in the volume, we find a dedicatory Latin inscription in monumentally scaled golden letters that further elaborates on the story of the book's creation. It reads, "In the year of the Lord 1371, this work was illuminated by order and in honor of the illustrious prince Charles, King of France, in the thirty-fifth year of his life and the eighth year of his reign; and Jean de Bruges, painter of said king, has made this picture with his own hand."[4]

So now the story of the making of this manuscript has become more complicated. The Latin dedication on folio 1 verso tells us that Charles commissioned the book, making him its "patron" in the most straightforward sense. But speaking in the first-person through the colophon, the scribe wants the reader to know that the book's makers went to great lengths to see the project carried out in an astoundingly splendid way, even enduring physical hardship for the sake of its completion.[5] But in the dedication, another voice—this one adopting an authoritative Latin—assigns

1. The Hague, Rijksmuseum Meermanno-Westreenianum, Ms. 10 B 23.

2. On Raoulet d'Orléans, see R. H. Rouse and M. A. Rouse, *Manuscripts and their Makers: Commercial Book Production in Medieval Paris, 1200–1500* (Turnhout: Brepols, 2000), 1: 273–279 and 2: 121–122, and L. Delisle, *Recherches sur la librairie de Charles V* (Paris: Honoré Champion, 1907), 1: 70–80.

3. L. Delisle, *Recherches*, 1: 75–76.

4. My translation follows, with minor changes, that of E. Panofsky, *Early Netherlandish Painting: Its Origin and Character* (Cambridge, Mass.: Harvard University Press, 1953), 1: 37.

5. The Rouses note that scholars have traditionally assumed that Vaudetar is the person that the colophon describes as en-

responsibility for the execution of the book and its decoration in an even more diffuse manner: Charles commissioned the book, but it was also created in Charles's honor, suggesting that other personalities interjected their wills in the project, hoping thereby to express their admiration for their sovereign. Of these, the painter Jean de Bruges receives a laudatory mention.

Before we proceed, we should briefly consider the term that we've been using—and that is consistently used in discussions of this manuscript—to describe this image: "portrait." Over the course of the last decade or so, art history has witnessed a significant shift in the ways that portraiture is understood—a shift my own work has played a small but, I hope, helpful role in bringing about.[6] Whereas portraits were once largely discussed as relatively straightforward records of individual appearances and as visualizations of the hidden interior truth about their subjects, today we often view them as important elements of social and political systems of communication and exchange. Moving beyond a study of their style and iconography, we've begun to better articulate the ways that the circulation of portraits established allegiances, made alliances visible, and reinforced social actions. At the same time, our more capacious understanding of portraits and the practices associated with them have opened our eyes to ways in which they signal identity—methods of connecting an image to an individual that go beyond physiognomic likeness. We've come to understand that for medieval artists and viewers, an image could also unequivocally establish identity through inscriptions, iconographic elements, formal qualities, and the connotations of its material.

The frontispiece appears to refer to King Charles V through physiognomic likeness; in other words, it is tempting to assume that the features ascribed to the king in the image referred mimetically to aspects of the actual topography of his face.[7] How can we be sure of this though? After all, we cannot compare the image with its subject, as Charles is obviously no longer around. Art historians who have studied this image have thus compared it to other depictions of the king, concluding that perceived similarities between these images can be explained as overlaps and deviations one would expect to see in works by different artists each of whom was striving to accurately record the same person's features.[8] The evidence on that score is, however, somewhat more ambiguous than we might hope. The frontispiece of the *Vaudetar Bible* is one of a great many images of Charles that survive today. Many of those images are the work of that era's most talented artists. These images include Charles's tomb statue (Fig. 2), commissioned in 1364 from André Beauneveu, a sculptor who achieved exceptional status among his contemporaries.[9] There is also the roughly life-sized statue of Charles today in the Musée du Louvre (Fig. 3). This work is believed to have once adorned the eastern entrance to the Louvre when it was a royal palace, presumably placed there as part of Charles's renovations to that structure.[10] In addition, there is the image of Charles kneeling in prayer on the *Parement de Narbonne* of 1375–1380 (Fig. 4).[11] This is the eponymous work of the artist

during "much rain on his head," but they make a compelling case that the sodden individual was meant to be understood as Raoulet d'Orléans, the author of the verses; Rouse and Rouse, *Manuscripts and their Makers* (as in note 2), 1: 277.

6. S. Perkinson, *The Likeness of the King: A Prehistory of Portraiture in Late Medieval France* (Chicago, Ill.: University of Chicago Press, 2009).

7. E.g., C. R. Sherman, *The Portraits of Charles V* (New York: College Art Association of America, 1969), 27: "With unparalleled frankness and precision, the artist describes such homely details as the king's runaway strands of hair. Nor does he disguise Charles V's large nose or his small eye." See also Sterling, *La peinture médiévale à Paris, 1300–1500* (Paris: Bibliothèque des arts, 1987–), 1: 188.

8. See for instance, Georgia Wright, "The Reinvention of

the Portrait Likeness in the Fourteenth Century," *Gesta* 39:2 (2000): 117–134, and C. R. Sherman, *The Portraits of Charles V* (as in note 7), 3–5.

9. For recent overviews of Beauneveu's career, along with additional bibliography, see S. Perkinson, *Likeness of the King* (as in note 6), 214–218 *et passim*, and *"No Equal in Any Land": André Beauneveu, Artist to the Courts of France and Flanders*, ed. S. Nash (London: Paul Holberton Publishing in association with Musea Brugge/Groeningemuseum, 2007).

10. *Les Fastes du gothique: le siècle de Charles V*, eds. B. Donzet *et al.* (Paris: Ministère de la culture, Éditions de la Réunion des musées nationaux, 1981), 119–121, no. 68.

11. On the *Parement de Narbonne*, see most recently S. Nash, "The *Parement de Narbonne*: Context and Technique," in *The Fabric of Images: European Paintings on Textile Supports in the*

FIGURE 2. André Beauneveu, Tomb of Charles V (in background, the entrail tomb of his Queen, Jeanne de Bourbon) (photo: author).

known as the Parement Master, who might possibly be identified with Jean d'Orléans.[12] Jean was the scion of a celebrated family of painters who worked for Kings John II and Charles V. Like Jean de Bruges, Jean d'Orléans also received the title of *"peintre et valet de chambre du roy"* and *"pictor regis."*[13] We could cite as a final example the lovely *grisaille* image of Charles adorning an initial on a charter dated 1367 (Fig. 5).[14] This image has been ascribed to the Master of the Bible of Jean de Sy—an anonymous illuminator whose hand has been associated with the other illuminations in the *Vaudetar Bible.*[15]

In each of these images, Charles appears with a blandly serene face. In each, his nose is his most prominent

Fourteenth and Fifteenth Centuries, ed. C. Villers (London: Archetype Publications, 2000), 77–87.

12. On the attribution of the work of the Parement Master to Jean d'Orléans, see C. Sterling, *La peinture médiévale à Paris: 1300–1500* (Paris: Bibliothèque des Arts, 1987–1990), 1: 218–244; C. F. O'Meara, *Monarchy and Consent: The Coronation Book of Charles V of France* (London: Harvey Miller, 2001), 254–273; and *Paris 1400: les arts sous Charles VI* (Paris: Fayard/Réunion des musées nationaux, 2004), 45–46, 203, and cat. 8 (pp. 47–48). For further consideration of the career of Jean d'Orléans considered in light of that attribution, see S. Perkinson, *Likeness of the King* (as in note 6), 198–208.

13. For documents pertaining to the career of Jean d'Orléans, see P. Henwood, "Jean d'Orléans: Peintre des rois Jean II, Charles V et Charles VI (1361–1407)," *Gazette des Beaux-arts* 95 (1980): 137–140.

14. *Images du pouvoir royal: Les chartes décorées des Archives nationales, XIIIᵉ–XVᵉ siècle*, ed. Ghislain Brunel (Paris: Centre historique des Archives nationales Archives nationales, 2005), no. 19, 142–148; S. Perkinson, *Likeness of the King* (as in note 6), 230–231.

15. Rouse and Rouse, *Manuscripts and their Makers* (as in note 2), 1: 276. Sterling (*La peinture médiévale* [as in note 7], 1: 192) sees the illuminations as "étroitement apparentées à l'art du

feature, but its specific shape varies: in the *Bible historiale* and the Louvre statue (Figs. 1 and 3), his nose descends in a nearly straight line, but in most of the others it takes on a pronounced aquiline form; in the charter initial (Fig. 5), its tip is notably bulbous. His jaw varies in shape from image to image as well: in the charter initial (Fig. 5), the heavy jawbone leads to a jutting chin, whereas in the *Parement de Narbonne* (Fig. 4) and the tomb figure (Fig. 2) the jaw is less pronounced, and in both the Louvre statue (Fig. 3) and the *Bible historiale* frontispiece (Fig. 1) the jaw seems weak and receding. Finally, there are differences in the king's hairline. In Beauneveu's 1364 tomb figure (Fig. 2), the king displays a tall forehead—an appearance accentuated by the way that his forelocks are held up under his crown. In the 1367 charter initial (Fig. 5), the royal hairline has made a miraculous recovery, edging down much closer to the level of his archly raised eyebrow. But by the 1371 *Bible historiale* frontispiece (Fig. 1), whatever miraculous hair elixir he had availed himself of has worn off, and his hairline has retreated back up towards the top of his head.

Now, in gently mocking the king's apparent struggles with his hairline, we have been playing a game here that is in fact one often played in the description of portraits: we have been pretending that the images are transparent windows onto the appearance of a particular person, allowing us to see that individual in an unmediated fashion, as if he were standing directly before us.[16] But of course, that mode of speaking about portraits is hopelessly naïve—these are, after all, *images*. They were created by human artists with particular skills, talents, proclivities and blind spots. They were based on a variety of models—sketches perhaps, but also possibly from memory, and undoubtedly from a range of earlier depictions of this king or

FIGURE 3 (*opposite, left*). Figure of Charles V from the Louvre (Paris, Musée du Louvre, R.F. 1377) (photo: Erich Lessing/ Art Resource, N.Y.).

FIGURE 4 (*opposite, top right*). Detail of Charles V from the *Parement de Narbonne* (Paris, Musée du Louvre, MI 1121) (photo: RMN-Grand Palais/Art Resource, N.Y.).

FIGURE 5 (*opposite, bottom right*). Charter initial depicting Charles V (Paris, AN, J 358, no. 12) (photo: Archives nationales de France).

of other kings. The *Bible historiale* frontispiece, for instance, appears to have been based in part on a lost earlier image that once hung in the Ste.-Chapelle, known through a copy from the Gaignières collection (Fig. 6).[17] That earlier image is believed to have represented King John II engaged in an exchange of a devotional diptych with a pope. John II, or John the Good, was Charles V's father and the person from whom Charles inherited his throne.

Seeking to compensate for our inability to rely on images of Charles to ascertain the precise configuration of his features, art historians have occasionally turned to a seemingly promising textual source for further evidence of his appearance: Christine de Pizan's biography of the king.[18] Christine certainly knew Charles as well as any woman of her rank could have—she grew up at his court, her father was a royal physician charged with attending to Charles's health and well-being, and Christine doubtless owed the king some kind of debt of gratitude for allowing her the run of the royal library, where she developed a vast knowledge of the texts she would engage with in her own literary career. But here again, our attempt to find evidence for the king's appearance encounters difficulties. Most basically, there is the problem of chronology: Christine wrote her biography of the king in

Maître de la Bible de Jean de Sy sans sortir de sa main." In a similar vein, E. Fournié ("Catalogue des manuscrits de la *Bible historiale* [2/3]," *L'Atelier du Centre de recherches historiques* 03.2 [2009], doi: 10.4000/acrh.1468) sees the hand as that of an "excellent disciple" of the Master of the Bible of Jean de Sy.

16. For more on this critique, see G. Didi-Huberman, "The Portrait, the Individual, and the Singular: Remarks on the Legacy of Aby Warburg," in *The Image of the Individual: Portraits in the Renaissance*, ed. L. Syson and N. Mann (London: British Museum Press, 1998), 165–185.

17. On this image, see C. F. O'Meara, *Monarchy and Consent* (as in note 12), 233–244, and C. Sterling, *La peinture médiévale* (as in note 7), 1: 140–145. Sterling also notes the connection between the Sainte-Chapelle image and the frontispiece of the Hague *Bible historiale* (C. Sterling, *La peinture médiévale*, 1: 188).

18. C. de Pisan, *Le livre des fais et bonnes mœurs du sage roy Charles V*, ed. Suzanne Solente (Paris: Honoré Champion, 1936–1940).

nous auons a

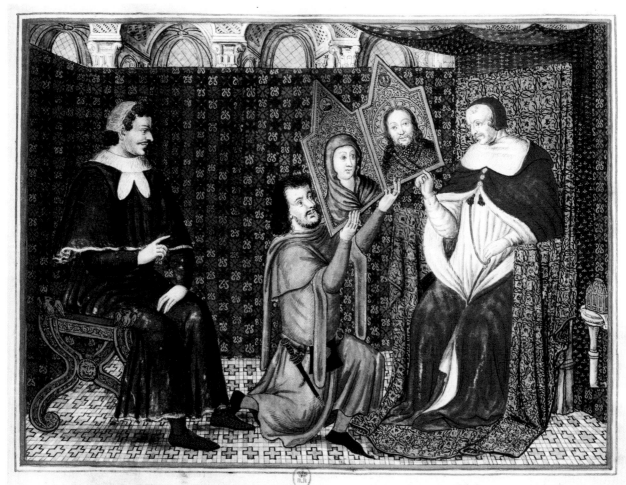

FIGURE 6. *Exchange of a Diptych between John II and a Pope* (after a panel painting that once hung in the Ste.-Chapelle, Paris) (Paris, BnF Est. Rés. Oa 11, fol. 85–88) (photo: Bibliothèque nationale de France).

1404, nearly a quarter century after Charles's death in 1380. But there is also the problem of idealization: as I have noted elsewhere, Christine's painstaking description of the king's body echoes in great detail the descriptions of ideal courtly heroes who inhabit the romances so popular at the late medieval courts.[19] In fact, there is but one moment where Christine's description of Charles's body departs from the conventions of the courtly hero: she notes that his face was "pale," and that his body was "thin." She rapidly dismisses the significance of these deviations from the ideal by stating emphatically that they "came to him by accident of illness and not from his proper condition."[20]

I have suggested in my earlier work that Christine here is trying to balance the conflicting mandates of the genres to which her text belongs. On one hand, her biography is intended to present Charles as a suitable role model for his mentally unstable son, King Charles VI, in hopes that being reminded of his fa-

19. S. Perkinson, *Likeness of the King* (as in note 6), 151.
20. C. de Pisan, *Le livre des fais* (as in note 18), 1:48–49.

ther's virtues might help cure his bouts of insanity.[21] To play that role, Charles needed to be idealized, transformed into another iteration of the courtly hero. But at the same time, Christine and her audience were deeply familiar with the precepts of physiognomic analysis, whereby a careful examination of an individual's features could reveal the otherwise hidden truth of their character. The basic principles of that so-called science were transmitted in a text known as the *Secret of Secrets*, which was spuriously ascribed to Aristotle.[22] Christine was an astute reader of that text, and she alludes to its concepts and methods directly in her biography of Charles.[23] According to the rules of physiognomic analysis, one must report accurately on the features of the individual being analyzed, and even features that were less than ideal had to be taken into account. However, if one could explain those undesirable features as the result of the accidents of nature—if one could claim that they were the traces of fluky mishaps or illness, rather than a surface reflection of some innate tendency—they could be disregarded. That is precisely the move that Christine makes in her description of Charles: she quickly acknowledges that certain aspects of his appearance could be construed as un-ideal, but dismisses those as the result of accident.

Like Christine's biographic description of Charles, artists, too, had to walk a fine line between idealization and truth when rendering a physiognomic likeness. They undoubtedly wanted the image to be identifiable—they wanted the powerful person receiving the work to have that thrilling moment of self-recognition the first time he laid eyes on the finished item—but they also needed to avoid insinuating that

a powerful figure might possess features that would imply inner flaws. So here we encounter another possible reason for the deviation between these images of Charles, as each would have been the work of an artist anxiously trying to reconcile the possibly incompatible demands for veracity and flattery.

At the same time, "likeness" in works such as this is not limited to facial features, however incompletely or deceptively rendered they might have been. Indeed, in a lengthy poetic narrative written in 1373, the poet Jean Froissart expressed skepticism that facial features were a secure means of identifying an individual, noting that "many people look alike when they are together as a group."[24] Artists of his period thus continued to rely on long-established systems of associating an image with a specific individual—systems that modern scholars would often dismiss as "symbolic" and thus less sophisticated than the mimetic forms of representation valued in post-medieval culture. In fact, as Michel Pastoureau noted some time ago, the images we place in the first wave of late medieval veristic portraits emerged in the midst of a tremendous expansion of those long established symbolic codes.[25] What we think of as portraiture can profitably be thought of as just one of several late medieval representational modes—modes which were often deployed alongside and in support of one another, rather than in competition. The *Bible historiale* frontispiece is rife with examples of both old and new symbolic codes. Most notably, there are the fleur-de-lis emblems covering the background, the baldachin, and the cushion on the king's throne and at his feet; these of course denoted the king's participation in the French royal bloodline. The tricolor blue, white,

21. On the text as a model for Charles VI, see L. Dulac, "De l'art de la digression dans 'Le Livre des fais et bonnes meurs du sage Roy Charles V,'" in *The City of Scholars: New Approaches to Christine de Pizan*, ed. M. Zimmermann and D. De Rentiis (Berlin; New York: Walter de Gruyter, 1994), 148–157.

22. The literature on the *Secret of Secrets* is vast. The basic edition is found in Roger Bacon, *Secretum Secretorum, cum glossis et notulis: tractatus brevis et utilis ad declareandum quedam obscure dicta Fratris Rogeri*, ed. R. Steele. Opera hacetenus inedita Rogeri Baconi, fasc. V (Oxford: Clarendon Press, 1920). Key studies include C. B. Schmitt and W. F. Ryan, eds., *Pseudo-Aristotele, The 'Secret of Secrets': Sources and Influences* (London: Warburg Institute/University of London, 1982), and S. J. Williams,

"The Vernacular Tradition of the Pseudo-Aristotelian *Secret of Secrets* in the Middle Ages: Translations, Manuscripts, Readers," in *Filosofia in volgare nel medioevo (Atti del Convegno della Societa' italiana per lo studio del pensiero medievale (SISPM), Lecce, 27–29 Settembre 2002)*, ed. N. Bray and L. Sturlese (Louvain-la-Neuve: Fédération international des institutes d'études médiévales, 2003), 451–482.

23. S. Perkinson, *Likeness of the King* (as in note 6), 150–151.

24. J. Froissart, *Le Joli buisson de jonece*, ed. Anthime Fourrier (Genève: Droz, 1975), vv. 1921–1984.

25. M. Pastoureau, "L'effervescence emblématique et les origines héraldiques du portrait au xiv^e siècle," *Bulletin de la Société nationale des antiquaires de France* (1985 [1987]): 108–115.

and red hues of the fringe on the king's throne, too, align with a color scheme frequently associated with Charles—the adoption of color codes or liveries was one of the innovations introduced in the midst of what Pastoureau has termed the fourteenth-century heraldic "efflorescence." Other aspects of the image help to convey a sense of Charles's specific identity: the king wears a *houce*, a fur-lined robe with distinctive hood, collar, and winged sleeves, also worn by scholars at the University of Paris,[26] while the removal of one glove echoes a pose found in many images of cultured aristocrats.[27] The latter would have conveyed a sense of refined leisure appropriate to an image of someone of Charles's status, while the former would have signaled Charles' intellect, in keeping with his self-presentation as the "wise" king.[28] In cases such as these, of course, the features of the image may simply record actual aspects of the king's appearance, or they may have been chosen for inclusion in this image and others like it because they effectively conveyed qualities that were important to the king. Whatever the case, they all add up to a sense of the king's identity that could not be conveyed by facial likeness alone.

One additional aspect of this image may further contribute to its ability to describe the king's identity. This aspect is less overt than those symbolic codes we've just enumerated, but seems in keeping with the kind of subtle flattery that artists of this period occasionally imbued their works with. The frontispiece appears on a bifolio tipped in to the manuscript. By

the fourteenth century, such presentation scenes had become fairly common in royal commissions, and consistently appeared at the beginning of the book. Jean de Bruges therefore could assume that it would be inserted at the front of the volume. It is interesting, therefore, that he depicts the book being presented to Charles open to what appears to be the first page of the manuscript. In this it is unusual—nearly all such presentation scenes depict the book as closed. But even more interesting is what appears on that opening. The spread folios display a full-page miniature facing a folio with a single column of large lettered text—in short, a layout similar to, if the mirror image of, the opening in which the frontispiece itself appears.

But Jean de Bruges does not replicate the frontispiece—he resisted whatever temptation he may have felt to invent a kind of medieval *mise-en-abyme* by depicting his own work as the image within the image. Instead, the folio visible in the open book displays an image of Christ in majesty surrounded by the symbols of the four evangelists. The text on the facing page, rather than praising Charles, is the beginning of the book of Genesis: "In the beginning God created the heavens and the earth." This constitutes a pared down rendition of the actual beginning of the *Bible historiale* itself (Fig. 7). That first image is large, but not full-page, and the text beneath it occupies two columns, not one. The miniature invokes what had become the standard iconography for French royal commissions of this text: an image of the Trinity or Christ

26. On the *houce*, see A. van Buren, *Illuminating Fashion: Dress in the Art of Medieval France and the Netherlands, 1325–1515* (New York: The Morgan Library and Museum, 2011), 307. Van Buren (*ibid.*, 68) notes that by the time this image was created, the *houce* was an old-fashioned garment.

27. What we might call an "iconography of gloves" remains to be written. Depicting the king as holding his gloves in one hand, rather than wearing them, may have been a means of toning down an image's formality. King Philip the Fair (d. 1314) was depicted as holding his gloves while enthroned in the midst of his family in the frontispiece to the *Livre de Kalila et Dimna* (Paris, Bibliothèque nationale de France, Ms. fr. 8504, fol. 1). Several charter initials depict Charles V in standing and holding his gloves (e.g., *Images du pouvoir royal* [as in note 14], 128, fig. 1, illustrating Paris, Archives nationales de France, AE II 401 B), and Jean de Berry appears in a similar manner in a charter initial dated 1389 (*ibid.*, 236, fig. 1, illus-

trating Paris, Archives nationales AE II 411). It is worth noting that Jean Golein's *Traité du sacre*, composed for Charles V in 1374, insisted that French kings should always be depicted as wearing their gloves because they were anointed with holy oil: "because the king of France is, unlike other kings, specially anointed on his hands, one puts gloves on the hands in paintings representing the kings"; Richard A. Jackson, "The *Traité Du Sacre* of Jean Golein," *Proceedings of the American Philosophical Society* 113:4 (1969): 305–324, here 317–318. But royal figures are not the only ones depicted as carrying, rather than wearing, gloves: the royal counselor Bureau de la Rivière stands while carrying his gloves on the "Beau Pilier" at Amiens; see C. R. Sherman, *The Portraits of Charles V* (as in note 7), 60–63.

28. For Charles as the "wise" king, see D. Byrne, "*Rex imago Dei*: Charles V of France and the *Livre des propriétés des choses,*" *Journal of Medieval History* 7:1 (1981): 97–113.

FIGURE 7. The *Vaudetar Bible* (The Hague, Museum Meermanno-Westreenianum, Ms. 10 B 23, fol. 3) (photo: Museum Meermanno).

enthroned surrounded by the four Evangelists an an-
gelic entourage—witness the opening miniature in a
Bible historiale illuminated just over a decade earlier by
the artist (or an artist closely related to) the illumina-
tor of the *Vaudetar Bible* (Fig. 8).[29] The *Vaudetar Bible*
departs from that standard iconography, however, in
placing Christ beneath a red baldachin. That balda-
chin must have been viewed as an important element
of the image's iconography, as it is referenced in the
frontispiece's distillation of the prefatory miniature.

The addition of the baldachin to the *Christ in Maj-
esty* miniature—and, more broadly, the suggestion that
the manuscript begins with an image of Christ—may
have been a subtle means of visually aligning Charles
with Christ. This could have been a coincidence, but it
is worth noting that this quasi-deification of the king
was an important component of French royal ideology
at precisely this time. The French translation of John
of Salisbury's *Policraticus*—commissioned by Charles
V and completed in 1372—stated emphatically that
"the ruler is an image of the divine." [30] This ideology
was further reflected in a seal that Charles used as his
personal signet throughout his reign (Fig. 9). A signet
was the type of seal most closely associated with the
person of the king; he wore it in the form of a ring on
his body, and personally impressed it in the wax when
using it.[31] That seal draws on the iconography of the
"Holy Face"—the features of Christ miraculously im-
pressed upon a cloth preserved as a relic in Rome and
transmitted via its various representations.[32]

But let us return to the frontispiece image itself,

FIGURE 9. Signet of Charles V (Paris, AN D 884 *bis*) (photo:
author).

and think some more about the question of patron-
age. Who indeed is the "patron" of this image? Well,
on one hand, it is undeniably Charles V himself. He
evidently commissioned the manuscript—the inscrip-
tion accompanying the frontispiece tells us that the
book was made "by order" of the king. But would he
have explicitly requested the portrait at the front of
the book? Here we should be more circumspect. Else-
where I have noted that physiognomic likenesses were
generally *not* directly requested by the person that

29. On the manuscript tradition of the *Bible historiale*, see
E. Fournié, "Les manuscrits de la *Bible historiale*. Présentation
et catalogue raisonné d'une œuvre médiévale," *L'Atelier du
Centre de recherches historiques: Revue électronique du CRH* 03.2
(2009), doi: 10.4000/acrh.1408. The tradition of commencing
the *Bible historiale* with a large image of Christ or God in maj-
esty, surrounded by angels and, at times, symbols of the Four
Evangelists was established in Paris by the second decade of
the fourteenth century; e.g., Paris, Bibliothèque nationale de
France, Ms. fr. 160 (1310–1320); Montpellier, Bibliothèque
de la Faculté de Médecine, Ms. 49 (1312–1317); and Paris,
Bibliothèque de l'Arsénal, Ms. 5059 (1317). The earliest *Bible
historiale* illuminated by the Master of the Bible of Jean de Sy
(London, British Library, Ms. Royal 17 E VII [1356–1357];
illustrated here as Fig. 8) adhered to that tradition as well.
Another, slightly later, copy of the *Bible historiale* written by

Raoulet d'Orléans and illuminated by the Master of the Bible
of Jean de Sy (among others) also followed this iconography
(Copenhagen, Kongelige Bibliotek, Ms. Thott 6 [1370–1380]).
Fournié reports that the frontispiece of a slightly earlier *Bible
historiale* (Berlin, Staatsbibliothek-Preussischer Kulturbesitz,
Cod. Philipps 1906 [1368]) is "identical" to the iconography
of the Trinity scene in the *Bible of Jean de Vaudetar*.

30. Paris, BnF Ms. fr. 24287, fol. 170ᵛ. For more on this ide-
ology, see D. Byrne, "*Rex imago dei*" (as in note 28).

31. M. Dalas, ed., *Corpus des sceaux français du Moyen Age,
II: Les Sceaux des rois et de régence* (Paris: Archives Nationales,
1991), 226, no. 146. For the use of secret seals and signets, see
R.-H. Bautier, "Le Sceau royal dans la France médiévale et le
mécanisme du scellage des actes," in *ibid.*, 15–34 (here 26–28).

32. S. Perkinson, *The Likeness of the King* (as in note 9),
292.

FIGURE 8. The Trinity in Majesty, from a *Bible historiale* (London, British Library, Ms. Royal 17 E VII, fol. 1) (© The British Library Board. All rights reserved).

they represent. In the case of André Beauneveu's celebrated tomb figure of Charles V, for instance, we still have the 1364 document commissioning the sculpture, which was requested by the king along with tombs for his father, grandfather, and grandmother. It is strikingly terse. Speaking on the part of Charles in the royal "we," the document states simply that "[w]e have commissioned our beloved André Beauneveu, our image-maker, to arrange to make the tombs that we have ordered be made for our very dear lords the kings Philip and our father, for our very dear lady the queen Jeanne de Bourgogne, may God have mercy on them, and for us."[33] One other document relating to the commission survives as well, and it too speaks in exceedingly vague terms about the project.[34] Neither document suggests in any way that the remarkable iconographic innovation visible in the tomb figure— its inclusion of a highly individualized and probably recognizable face—was requested by the king.

In fact, when we find portraits embedded within an object made in late medieval France, we usually discover that the portrait depicts the person for whom the object was made whether or not the person depicted was, strictly speaking, its "patron." In other words, patronage, at least as narrowly construed, may matter less than intended reception in determining whether or not an object will contain a portrait. Some particularly good examples of this are objects categorized as étrennes—gifts given as part of a revival of the ancient Roman custom of exchanging gifts at the New Year.[35] This custom was widespread to the point of institutionalization throughout the French aristocracy by the 1380s and 1390s, but its revival began in the first decades of that century. Because this was based on ancient Roman practices, the exchange of étrennes most often took place at the start of the Roman calendar year—on January 1st—but it could

also occur at the Christian New Year, determined by Easter. On that score, it is worth noting that Easter in 1372 fell on March 28—the very day on which the colophon tells us Jean de Vaudetar presented the *Bible historiale* to Charles, in the scene imagined for us by Jean de Bruges.[36]

Because they tended to be of precious materials, we can positively identify very few late medieval étrennes at present—most have been lost—but we can learn a great deal about them through sources like the exhaustive inventories of the collection of Duke Jean de Berry. The Duke of Berry's inventories record scores of objects given to him as gifts by members of his family as well as courtly underlings striving to make a favorable impression with their overlord. By Jean de Berry's time, such gifts consistently included references to the recipient's identity. The ducal iconography they collectively displayed was identical to that appearing scattered across the folios of manuscripts owned by the Duke. Most often, those gifts involved heraldry and para-heraldic emblems. To cite but a handful of examples: a ring of gold and gemstones carved with the Duke's coat of arms was given to the Duke by a lesser nobleman in 1409;[37] a golden container for fragrant oil in the shape of the fleur-de-lys was given to the Duke by his daughter-in-law Catherine in 1405;[38] a ring displaying a bear and a swan supporting the duke's arms was given to the Duke by his son-in-law, Jean de Bourbon, in 1407;[39] and a ring with diamonds carved into the initials "E" and "V" was offered to Jean by Louis of Anjou in the same year.[40]

The fleur-de-lys was, of course, the symbol of the French royal family, to which Jean belonged as the younger brother of Charles V; Jean de Berry made the arms his own through the addition of the "engrailed" red border. The bear and the swan, too, were associ-

33. *"No Equal in Any Land,"* 191–192, no. 5.

34. *Ibid.,* 192–193, no. 8.

35. On the étrennes, see B. Buettner, "Past Presents: New Year's Gifts at the Valois Courts, ca. 1400," *Art Bulletin* 83 (2001): 598–625, and J. Hirschbiegel, *Etrennes. Untersuchungen zum höfischen Geschenkverkehr im spätmittelalterlichen Frankreich der Zeit König Karls VI. (1380–1422)* (Munich: Oldenbourg, 2003).

36. Sterling (*La peinture médiévale* [as in note 7], 1: 188)

notes the fact that the dedication implies that the book was presented on Easter, but he did not pursue that observation.

37. Jules Guiffrey, *Inventaires de Jean, Duc de Berry (1401–1416),* 2 vols. (Paris: Ernest Leroux, 1894–1896), 1: 121 (no. 394).

38. *Ibid.,* 1: 94 (no. 316).

39. *Ibid.,* 1: 119–120 (no. 389).

40. *Ibid.,* 1: 132 (no. 442).

ated with Jean de Berry's identity, although scholars today continue to debate their precise significance. The French words for these animals may have been part of a rebus for the name of the duke's mistress, perhaps a woman named Ursine, or for one of his patron saints, St. Ursin.[41] Finally, the initials "E" and "V" may have stood in for a motto such as "en vous."[42] While the obscurity of those associations is frustrating to present-day historians, their opacity was probably intentional, as they allowed the expression of various degrees of familiarity with a public figure's identity. Every subject could be expected to recognize their lord's coat of arms, but only his closest associates would likely have been aware of the details of the various personal affiliations and histories referenced indirectly through rebuses, mottoes, or initials.

On at least two occasions, the Duke received an étrennes gift that referenced him by representing his face: in 1408, Jean de Bourbon offered him a ring displaying gemstones carved into "the likeness of the face of the duke," while four years later the duke's grandson presented him with "a gold ring on which the face of the duke is counterfeited in a cameo."[43] Like the other étrennes mentioned above, these objects, too, have been lost, but they must have been similar to this ring, which is today in the Louvre (Fig. 10).[44] That ring depicts John the Fearless, Duke of Burgundy and nephew to Jean de Berry. The expense of the materials alone gave the ring considerable value, of course, but an additional feature may have enhanced its appeal still further: late medieval texts that discuss the powers of natural substances credited its stones with apotropaic effects, promis-

FIGURE 10. Ring with the Profile of John the Fearless, France, early fifteenth century (Paris, Musée du Louvre, OA9524) (photo: RMN-Grand Palais/Art Resource, N.Y.).

ing to protect the wearer against such misfortunes as snakebites and drunkenness.[45] Those stones were fashioned into the face of the Duke, with features and costume similar to those witnessed in other depictions of him, such as one from *The Book of Marvels*, illuminated by the Mazarine Master in about 1410–1412 (Fig. 11).[46] The miniature does not rely solely on

41. R. Cazelles, *Illuminations of Heaven and Earth: The Glories of the 'Très Riches Heures du duc de Berry'* (New York: Abrams, 1988), 72; Guiffrey, *Inventaires* (as in note 37), 1: cxxx; 2: 463.

42. Or, if they were meant to be read as "V" and "E," as the first and last letters in "Ursine;" see M. Thomas, *The Grandes Heures of Jean, Duke of Berry*, trans. V. Benedict and B. Eisler (New York: George Braziller, 1971). For an explanation of the various border elements, see esp. Thomas's notes to pl. 14, and M. Meiss, *French Painting in the Time of Jean de Berry: The Late Fourteenth Century and the Patronage of the Duke* (London: Phaidon, 1967), 1: 95–97; for the latter explanation, see Cazelles, *Illuminations of Heaven and Earth* (as in note 41), 62.

43. Guiffrey, *Inventaires* (as in note 37), 1: 162 (no. 606) and 1: 163 (no. 611).

44. *Paris 1400* (as in note 12), no. 66.

45. In general, see J. Evans, *Magical Jewels of the Middle Ages and the Renaissance, particularly in England* (Oxford: Clarendon Press, 1922), 192. See also the description of the powers of those stones in lapidaries, for instance, Paris, BnF, Ms. fr. 12786 fols. 24ᵛ–31, and in the *De proprietatibus rerum*, for instance, Paris, BnF, Ms. fr. 216 fols. 229–241; for the lapidary tradition, see L. C. A. Pannier, *Les lapidaires français du moyen âge des XIIᵉ, XIIIᵉ et XIVᵉ siècles* (Geneva: Slatkine Reprints, 1973).

46. Paris, Bibliothèque nationale de France, Ms. fr. 2810, fol. 226; see F. Avril *et al.*, eds., *Das Buch des Wunder: Handschrift Français 2810, der Bibliothèque nationale de France, Paris / Marco Polo* (Luzern: Faksimile Verlag, 1995), esp. 307–324.

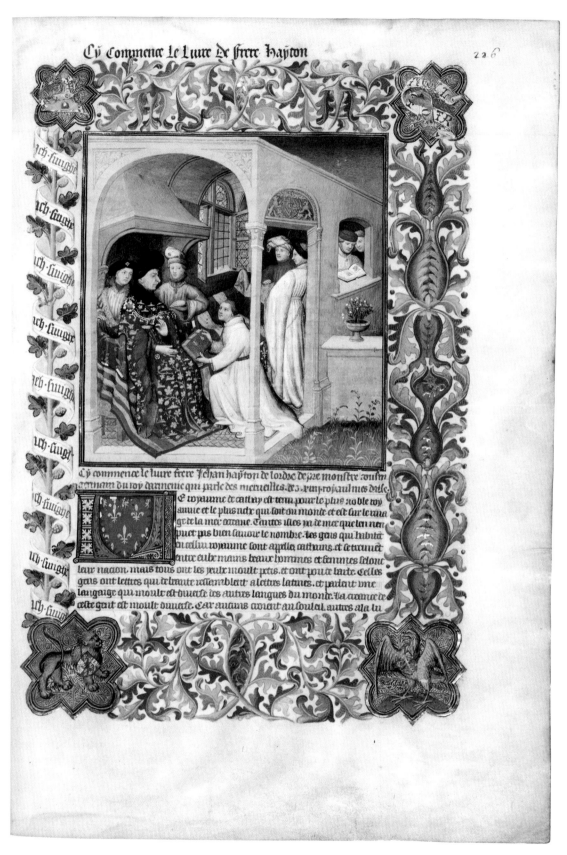

FIGURE 11. Presentation of the book to John the Fearless, from the *Book of Marvels*, Paris, *c.* 1412 (Paris, BnF, Ms. fr. 2810, fol. 226) (photo: Bibliothèque nationale de France).

facial features to identify the Duke, of course. The borders are saturated with heraldry and devices associated with John the Fearless. Within the image itself, the Duke's coat of arms appear on the tympanum over the door and on the textile covering the bench on which he sits, while an object he selected as a personal device—the carpenter's plane—appears on his costume and in stained glass roundels. The ring, too, features a similar iconography: a motto and an indented image of a plane are concealed on the interior surface of the band.

But what does all of this tell us about the frontispiece to the *Vaudetar Bible*? Well, first it should remind us that the inclusion of a recipient's signs of identity—including a physiognomic likeness—on an object was a critical element of gift-giving strategies. This in turn complicates notions of patronage for objects such as this. In the strictest sense, Charles V was the patron of this manuscript, having evidently commissioned its creation. But at the same time, Jean de Vaudetar played a critical role in the manuscript's production as well, having likely served as the person who engaged the team of scribes and artists responsible for its creation. This was an important moment in Jean de Vaudetar's career. Already following in his own father's footsteps as a goldsmith and *valet de chambre* to the king, Jean was in fact ennobled by Charles the next year. He remained an important member of Charles's inner circle, being summoned to the king's bedside as he lay dying in 1380.[47]

Raoulet d'Orléans, too, was dependent on royal favor for his livelihood. We should recall that he is likely to have been the one responsible for authoring the colophon. That colophon begins with a forty-line prayer to the Virgin; Richard and Mary Rouse note that while the speaking voice of the forty verses of prayer adopt several subject positions, including that of the King, "more than half—twenty-three—have

as their subject Raoulet d'Orléans."[48] Clearly Raoulet wanted his royal patron to bear him in mind. A decade earlier, while he was still dauphin, Charles had commissioned another copy of the *Bible historiale*,[49] with Raoulet serving as the scribe; this was among his earliest productions. It ends in a manner that offers interesting parallels to the *Vaudetar Bible*. On the facing folio—the last folio originally written on—the Master of the *Coronation Book of Charles V* painted a small miniature depicting the dauphin Charles kneeling in prayer at a *prie-dieu* emblazoned with his heraldry (Fig. 12). Charles looks toward the Virgin and Child seated opposite him; the holy figures appear to turn toward him in acknowledgement of his prayer. Beneath the image is an extended prayer taking the form of an acrostic poem; the first initials of each line combine to read "Charles ainsné fils du roy de France duc de Normandie et dalphin de Viennoys (Charles, eldest son of the king of France, duke of Normandy, and dauphin of Viennois)." With text and image, Raoulet effectively puts pious words in the dauphin's mouth, and respectfully signs the prayer with the dauphin's own name. The Rouses suggest convincingly that Raoulet must have worked closely with the illuminator to devise this clever homage to his patron.[50] If so, this may have foreshadowed Raoulet's even more ambitious collaboration in the *Vaudetar Bible* with Jean de Vaudetar and Jean de Bruges.

And indeed, Jean de Bruges was obviously yet another important agent in this commission. As best we can judge from surviving documents, he, too, was reaching a significant point in the midst of a critical phase of his career. In 1368, he had been named *pictor regis* and *valet de chambre* to the king, and in that same year the king gave him a house in northern France, near Jean's native Flanders. By 1374 he had become busy enough in his work to hire an assistant, and in 1380 he was granted a life pension by the king.[51]

47. F. Autrand, *Charles V le Sage* (Paris: Fayard, 1994), 850; C. F. O'Meara, *Monarchy and Consent* (as in note 12), 273–274 *et passim*.

48. Rouse and Rouse, *Manuscripts and their Makers* (as in note 2), 1: 276.

49. Paris, Bibliothèque nationale de France, Ms. fr. 5707. The Rouses report that a nearly illegible note on fol. 367ᵛ dates the completion of the text to 20 December 1362; a final

line of verse on fol. 368 records the date of the completion of the manuscript as 1363 (meaning, as the Rouses note, any time after Easter that year, 2 April); Rouse and Rouse, *Manuscripts and their Makers* (as in note 2), 1: 274–275.

50. *Ibid.*

51. S. Perkinson, *The Likeness of the King* (as in note 6), 208–214.

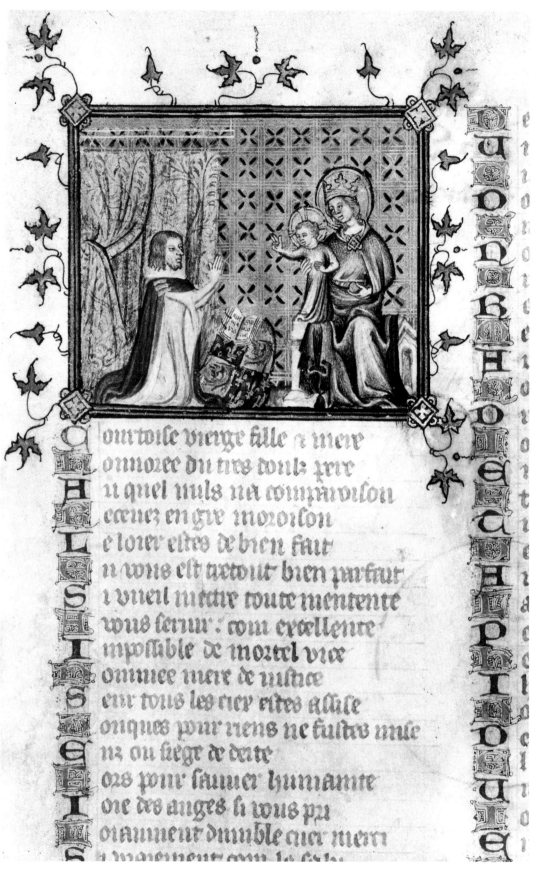

FIGURE 12. The Dauphin Charles praying to the Virgin and Child, from Augustine, *The City of God* (Paris, BnF, Ms. fr. 5707, fol. 368) (photo: Bibliothèque nationale de France).

With his house and his pension, Jean had achieved the kind of security that few of his era could hope for. To what degree was this frontispiece his initiative? It seems unlikely, after all, that the king requested this image—its scale makes it essentially unique in the history of dedication scenes in its period. Did Jean de Vaudetar request it? Perhaps—after all, the colophon calls particular attention to the marvelous nature of the images in the book and to his role in bringing them into being. He may even have been the one who brought Jean de Bruges into the project. The artist's involvement in this book was itself unusual: documents consistently refer to him as a "painter," rather than an "illuminator." But even if Jean de Vaudetar had requested the frontispiece from Jean de Bruges, the painter must have played a considerable role in its conception and execution, endowing the work with the sense of monumentality of a larger, free-standing painting, employing methods of suggesting three-dimensional space that were subtle compared to what was typically seen in manuscript illumination, and referencing a larger scale image, namely the panel depicting Charles's father John the Good in the Ste. Chapelle.

So in short, we have, in fact, four candidates who can lay some claim to the title of "patron" of this particular image. Art history has tended to think of agency as an either/or proposition, oscillating between assigning primary agency to either an artist or a patron, and seeing those two roles as fundamentally distinct. This is different than the ways that agency has traditionally been discussed by art historians. Over the course of the history of the discipline, discussions of agency have tended to oscillate

back and forth in their focus along a single track. To characterize these shifts with a very broad brush: in the early years of the discipline, scholars emphasized great artistic geniuses as the primary "authors" of major works of art. In the twentieth century, on the other hand, scholars became increasingly attuned to the role of great patrons. In certain respects, the 1960s and 1970s were the great heyday of this tendency. Although he rejected the use of the term "patron" for that of "client," which he felt better signaled the active and primary role of the person putting up the money for an artistic project, Michael Baxandall's brilliant 1972 study of *Painting and Experience in Fifteenth-Century Italy* began with a lengthy meditation on the ways that Renaissance patrons controlled even minute details of a finished work of art.[52] In a similar vein, and published in exactly the same period, Millard Meiss's monumental, multivolume investigation of *French Painting in the Time of Jean de Berry* takes the patronage of the Duke of Berry as its central organizing principle.[53] In many respects, we today remain heirs to this focus on the great patron; witness, for instance, the series of French exhibitions, culminating in the staggeringly beautiful *Paris 1400* show held in 2004 at the Louvre, which were structured around the patronage of the members of the French royal family in the fourteenth and early fifteenth centuries.[54]

But in cases like the frontispiece to the *Vaudetar Bible*, we might think of "patronage" as being less discrete, and more like a network. My thinking here is loosely informed by Alfred Gell's important study, *Art and Agency*, but also (in terms specifically of studies of portraiture) by the work of Harry Berger.[55] In the case of the *Vaudetar Bible*, we might consider patronage in

52. M. Baxandall, *Painting and Experience in Fifteenth-Century Italy: A Primer in the Social History of Pictorial Style* (Oxford: Clarendon Press, 1972), 1–27.

53. M. Meiss, *French Painting in the Time of Jean de Berry: The Late Fourteenth Century and the Patronage of the Duke*, 2 vols. (London: Phaidon, 1967); M. Meiss, *French Painting in the Time of Jean de Berry: The Boucicaut Master* (London: Phaidon, 1968); M. Meiss, *French Painting in the Time of Jean de Berry: The Limbourgs and Their Contemporaries*, 2 vols. (New York: G. Braziller, 1974).

54. In chronological order, those exhibitions were *Les Fastes*

du gothique of 1981–1982, *L'Art au temps des rois maudits* of 1998, and *Paris 1400* of 2004.

55. A. Gell, *Art and Agency: An Anthropological Theory* (Oxford; New York: Clarendon Press, 1998). In a 1994 essay, Harry Berger invoked a concept he dubbed "the fiction of the pose" to denote the complex ways in which both the creation and reception of portraits rely on active roles on the part of the artist, the sitter, and the viewer. Berger's work focused primarily on late fifteenth- and sixteenth-century Italian portraits, and his ideas cannot be easily grafted on to objects emanating from the late medieval courts of northern Europe. However, that sort

ways both simple and complex. On one hand, it was direct and straightforward, in the sense that the king evidently promised monetary support for the project and that he issued an un-ignorable royal request for the book. But patronage is also more diffuse. For Jean de Vaudetar, the king was his patron, but when Jean himself became the conduit conveying royal largesse to the team involved in creating the book, he now became a type of patron in his own right. In what seems to have been more or less his trademark move, Raoulet d'Orléans, the scribe, interjected his own versified praise of Charles into the project, also heaping praise on the others involve in its creation. Raoulet's poetic activity may have been at his own initiative, but it was obviously conditioned by what he imagined his patron would appreciate, and probably by Vaudetar's willingness to join him in conveying that pious flattery to the king. The artist Jean de Bruges, too, needed to please Charles—the person at whose pleasure he served as *pictor regis* and who paid him a substantial salary. At the same time, he may have been hoping to impress Jean de Vaudetar, given his role in this prominent project. Along those lines, it is noteworthy that the painter imagined the presentation in a particularly private setting, with Jean de Vaudetar appearing alone before the king, who wears the simple *cale* on his head rather than the more ceremonious crown.[56] Indeed, the image imagines the courtier enjoying a level of intimacy far greater than that found in slightly later presentation miniatures emanating from the same artistic circle—witness the royal officers intruding from the left on the presentation scene in the *c.* 1375–1380 manuscript containing Raoul de Presle's translation of Augustine's *City of God*, for instance (Fig. 13).[57]

In short, in the creation of the frontispiece to the *Bible of Jean de Vaudetar*, the patronage of multiple individuals—the king, Jean de Vaudetar, and even Raoulet d'Orléans—would have exerted a subtle and probably largely unspoken pressure on the individual

FIGURE 13. Raoul de Presle presenting his translation to Charles V, from Augustine, *The City of God* (Paris, BnF, Ms. fr. 22912, fol. 3) (photo: Bibliothèque nationale de France).

most of interest to art historians, Jean de Bruges. But given his own status—a status proudly established in the facing inscription—the painter may also have enjoyed a certain degree of autonomy. Rather than simply responding to the explicitly stated demands of his patron or patrons, Jean likely *imagined* their desires, trying to fulfill this commission in a manner that would surprise and delight them, that would remind them of his unflagging loyalty to them, and confirm the wisdom of their choice in commissioning his services. In sum then, patronage and other forms of agency are inextricably entwined in cases like this. Patronage can come from multiple directions, and it can take many forms, from direct payment for a project, to long-term sponsorship of an individual, to decisions made in response to, and anticipation of, a powerful person's unstated desires.

of approach might prompt us to think in more nuanced ways about how agency is never straightforward when it comes to late medieval dedication scenes like the one in the *Vaudetar Bible*. H. Berger Jr., "Fictions of the Pose: Facing the Gaze of Early Modern Portraiture," *Representations* 46 (1994): 87–120.

56. C. R. Sherman (*The Portraits of Charles V* [as in note 7], 25–29) aptly categorizes the frontispiece among the images she describes as "intimate dedication portraits."

57. Paris, Bibliothèque nationale de France, Ms. fr. 22912, fol. 3.

LUCY FREEMAN SANDLER

The Bohun Women & Manuscript Patronage in Fourteenth-Century England

IN THE second half of the fourteenth century, a group of twelve richly illuminated Psalters and Hours was produced in England for members of the Bohun family. Almost all the surviving manuscripts were illustrated by an artist named John de Teye and his associates, illuminators who were members of the Bohun household at Pleshey Castle in Essex, and worked there or in other Bohun residences as in-house artists over a period of time from 1361, or before, to 1384, or later. Some of these books were made for male members of the family, the earls of Hereford, Essex and Northampton, and others for women, Eleanor (1366–1399) and Mary (c. 1370–1394), the two daughters of the last Bohun earl, Humphrey (1342–1373), called Humphrey the seventh.[1] The production history of these Bohun books offers a wealth of material for consideration of the concept of medieval patronage, and in particular for evaluation of the roles played by the Bohun women, Eleanor, Mary, and their mother Joan Fitzalan (d. 1419), as the commissioners and recipients of the manuscripts.

In modern English usage the term patronage, meaning the financial support of causes, institutions, and individuals, has multiple connotations, some pejorative, such as political patronage, some positive, such as patronage of the Metropolitan Museum. But in the Middle Ages the definition was narrow: "patron" and "patronage," whether Latin, French, or Anglo-Norman, referred primarily to church dedications or the providers and recipients of ecclesiastical benefices; those who held the right to make appointments were the patrons, who provided the financial support of clerical beneficiaries.[2] For example, in the last third of the thirteenth century, Pierre d'Abernon, best known as the author of the manual of religious instruction called the *Lumere as lais*,[3] and probably the rector of the church of Fetcham, Surrey, called Sir John d'Abernon, who held the advowson of the church, "my patron who has the name of John d'Abernon."[4]

Since the Renaissance, however, the term patronage has been applied more broadly. As used now in relation to works of art, patronage is more than merely payment for production; the term implies financial support on a grand scale, with an eye to some public, not just private, benefit. Nevertheless, in relation to medieval illuminated manuscripts, the subject of this essay, "patronage," or "patron," in the first instance does refer simply to the identifiable individual or corporate body that paid for the production of a

1. The bibliography on the Bohun manuscripts is extensive. The chief general works are: M. R. James and E. G. Millar, *The Bohun Manuscripts* (London, 1936); L. F. Sandler, *Gothic Manuscripts 1285–1385*, A Survey of Manuscripts Illuminated in the British Isles, 5, eds. J. J. G. Alexander, 2 vols. (London, 1986), II: 133–142; and L. E. Dennison, "The Stylistic Sources, Dating and Development of the Bohun Workshop, ca. 1340–1400," (unpublished Ph.D. diss., University of London, 1988). Most recently, see J. Catto, "The Prayers of the Bohuns," in *Soldiers, Nobles and Gentlemen: Essays in Honour of Maurice Keen*, eds. P. R. Coss and C. Tyerman (Woodbridge, 2009), 112–125, and L. F. Sandler, "One Hundred and Fifty Years of the Study of the Illuminated Book in England: The Bohun Manuscripts from the Nineteenth Century to the Present," in *Gothic Art & Thought*

in the Later Medieval Period, Essays in Honor of Willibald Sauerländer, ed. C. P. Hourihane, Index of Christian Art, Occasional Papers, XII (Princeton, N.J., 2011), 243–263. See the Appendix to the present essay for a listing of all the surviving Bohun manuscripts, with chief bibliographical references for each.

2. See, for example, www.anglo-norman.net, s.v. 'patron'; also *Dictionary of Medieval Latin from British Sources* (Oxford, 1975–), s.v. 'patronus.'

3. See ed. G. Hesketh, *La lumere as lais by Pierre d'Abernon of Fetcham*, 3 vols. (London, 1996, 1998–1999, 2000).

4. "mon patrun ke Johan a nun a / De Abernun;" see Pierre d'Abernon's life of St. Richard of Chichester, ll. 1102–1103, London, BL Ms. Add. 70513, fol. 243ᵛ; quoted by Hesketh, *La lumere as lais* (as in note 3), III: 5.

book. Geoffrey Luttrell, for example, "who had me [that is, this book] made" was the patron of the well-known Luttrell Psalter.[5] Sadly, however, most other fourteenth-century English manuscripts do not reveal the names of their patrons so openly. In fact, when we associate a manuscript with a name, we do not always know whether the name refers to the patron as commissioner or as recipient, and commissioner and recipient are by no means always identical. The early fourteenth-century English manuscript known as the Ramsey Psalter, for instance, was surely made for use by someone at the Benedictine abbey of Ramsey, as we know from the calendar and the illustrations, many of which refer specifically to the abbey.[6] Among the illustrations is an *imago clipeata* (a memorial portrait in a circular frame)[7] of William of Grafham, the cellarer of the monastery (*fl.* 1303), with a memorial inscription "may Grafham be honored." [8] Although it has been suggested that Grafham was depicted as owner, or recipient, of the manuscript,[9] the location of the image and the phrasing of the inscription make it more likely that he was to be honored because he commissioned the book for another individual, probably the abbot of the time, John of Sawtry (d. 1316). Whichever Grafham was, our concept of medieval

manuscript patronage has to encompass both commissioners and recipients.

Patronage, however, is more than a matter of simple identification of these individuals, much as manuscript scholars feel a sense of accomplishment when they succeed in doing so by weighing all the evidence, documentary, textual, and pictorial. Five of the Bohun manuscripts that include prayers on behalf of "thy servant Humphrey" may serve as examples of the challenges in determining commissioners and recipients.[10] A Humphrey de Bohun was certainly the destined recipient of those Bohun Psalters now in the National Library, Vienna, Exeter College, Oxford, and the Egerton Collection of the British Library (Fig. 1). The petitions of these prayers are in the "voice" of a living supplicant, but we would have to turn to the evidence of pictorial style to decide whether the Humphrey in question was Humphrey the sixth earl of Hereford, who died in 1361, or Humphrey the seventh, who died in 1373. And the pictorial evidence suggests a variety of conclusions. The text of the Vienna Psalter was written in full and its illustrations were at least begun while the sixth earl was alive. There is little doubt that he should be considered the commissioner of the manuscript. The pictorial cycle,

5. "Dominus Galfridus louterell me fieri fecit": Luttrell Psalter, London, BL Ms. Add. 42130, fol. 206ᵛ; see, most recently, *The Luttrell Psalter: A Facsimile*, commentary by M. P. Brown (London, 2006).

6. New York, Pierpont Morgan Lib. and Mus. Ms. M. 302, and St. Paul in Lavantthal, Stiftsbibl. Cod. 58/1 (XXX/2,19); see L. F. Sandler, *The Ramsey Psalter*, commentary vol. (Graz, 1999); more accessibly, Sandler, *Gothic Manuscripts 1285–1385* (as in note 2), I: illus. 91–94, II: 47–48, no. 41.

7. See R. Winkes, *Clipeata imago: Studien zu einer römischen Bildnisform* (Bonn, 1969).

8. "Grafham honoretur": St. Paul in Lavantthal, Stiftsbibl. Cod. 58/1, fol. 16ᵛ, at the bottom of the December calendar page.

9. See *English Benedictine Libraries, The Shorter Catalogues*, Corpus of British Medieval Library Catalogues, 4, ed. R. Sharpe *et al.* (London, 1996), 359, no. 74 (the "psalterium bonum" of John of Sawtry) and 360, no. 87 (the "psalterium" of W. de Grafham). Sharpe, the editor of the Ramsey library catalogue, identified the Psalter that belonged to William de Grafham as "surely the celebrated Ramsey Psalter," evidently because it included the portrait, and rejected my earlier conclusion (L. F. Sandler, *The Peterborough Psalter in*

Brussels and other Fenland Manuscripts [London, 1974], 117) that Grafham had commissioned the manuscript for John of Sawtry.

10. Vienna, Österreichische Nationalbibl. Cod. 1826*, fols. 151–155ᵛ; Oxford, Exeter Coll. Ms. 47, fols. 118–122; London, BL Ms. Egerton 3277, fols. 160ᵛ–165ᵛ; Oxford, Bodleian Lib. Ms. Auct. D. 4.4, fols. 224–229ᵛ; Pommersfelden, Gräflich Schönbornische Bibl. Ms. 348, fols. 1ᵛ–7ᵛ; for the chief bibliography on these manuscripts, see the Appendix. The prayers in question are *memoriae*, or suffrages of the apostles and saints, viz., *Deus qui beato petro apostolo tuo colatis clavibus regni celestis animas ligandi atque solvendi potestatem tribuisti concede michi servo tuo himfridi ut intercessionis eius auxilio a peccatorum meorum nexibus absolvi merear* (God, who bestowed on thy Apostle Peter, charged with the keys of the kingdom of heaven, the power to bind and release souls, grant me thy servant Humphrey that through the aid of his intercession I may merit absolution of my deadly sins [London, BL Ms. Egerton 3277, fol. 160ᵛ]. Common components of Books of Hours from the late fourteenth century onward, in the case of the Bohun manuscripts the *memoriae* comprise a separate section at the end of the main text. The naming of the individual supplicant, as in the Bohun manuscripts, is rare.

FIGURE 1. Memoria of St. Thomas naming Humphrey. Psalter and Hours of Humphrey de Bohun, London, BL Ms. Egerton 3277, fol. 161ᵛ, detail (© The British Library Board. All rights reserved).

however, was probably completed for the seventh earl (Fig. 2). The text of the Exeter College Psalter too might have been written out while the sixth earl was alive, but the illustrations were probably begun for the seventh (Fig. 3), and were completed only after his death. In the third case, the text of the Egerton Psalter was written and the pictorial cycle executed in part during the life of the seventh earl, but again, the illustrations were completed some years after his death (Fig. 4).[11] Consequently, it would seem that at least as far as the Egerton Psalter is concerned, the prayers on behalf of "Humphrey" refer to a different Humphrey than those in the Vienna and Exeter College manuscripts.

Even more problematic are two other Bohun manu-

scripts that include the same prayers for Humphrey, because their illustrations suggest that they were made for neither the sixth nor the seventh earl.[12] The Psalter and Hours in the Bodleian Library, for example, has a full-page miniature showing a Bohun *woman*, identifiable as Mary de Bohun, in prayer before the Virgin and Child (Fig. 5). In effect, pictorial evidence here clashes with textual evidence.[13] The armorial complex of the manuscript tilts the balance, however, at least as far as the recipient is concerned, in favor of the woman, because her Bohun arms together with those of her husband are coupled on one of the main pages of the book (Fig. 6). But at the probable date of production of the manuscript, the early 1380s, the Bohun lady was still a child, so we would

11. For a discussion of the relative chronology of these three manuscripts, see L. F. Sandler, *Illuminators and Patrons in Fourteenth-Century England: The Psalter and Hours of Humphrey de Bohun and the Manuscripts of the Bohun Family* (forthcoming); the conclusions are summarized in the Appendix to the present essay, nos. 2, 3, and 4.

12. Psalter and Hours of Mary de Bohun, Oxford, Bodleian Lib. Ms. Auct. D. 4.4 (Appendix no. 7) and *Memoriae*, Pommersfelden, Gräflich Schönbornische Bibl. Ms. 348 (Appendix no. 11). The Pommersfelden volume is a fragment of a Book of Hours that includes the Bohun arms along with those of Anne of Bohemia and Richard II, who married in 1382, years after the death of Humphrey the seventh Bohun earl; see L. F. Sandler, "Lancastrian Heraldry in the Bohun Manuscripts," in *The Lancastrian Court, Proceedings of the 2001 Harlaxton Sympo-*

sium, ed. J. Stratford, Harlaxton Medieval Studies, xiii (Donington, 2003), 221–232, esp. 229–230.

13. Both James and Millar, *Bohun Manuscripts* (as in note 1), 23, and Dennison, "Stylistic Sources" (as in note 1), 11–53, 159–160, 259, concluded that the destined owner of the volume was Humphrey the seventh, and that the pictorial cycle was completed before his death in 1373; they believed that Mary de Bohun inherited the manuscript and that her portrait was a later insertion. The heraldry accompanying the biblical cycle, however, with carefully paired and juxtaposed armorials, suggests that the entire pictorial program was intended for Mary de Bohun after her marriage to the Lancastrian Henry of Bolingbroke in 1381; see Sandler, "Lancastrian Heraldry" (as in note 12), 226–227.

FIGURE 2. David and Solomon scenes, initial to Psalm 109. Psalter of Humphrey de Bohun, Vienna, Österreichische Nationalbibliothek cod. 1826*, fol. 100 (photo: Österreichische Nationalbibliothek).

FIGURE 3. Jacob and Joseph scenes, initial to Psalm 52. Psalter of Humphrey de Bohun, Oxford, Exeter College Ms. 47, fol. 32 (revised numbering) (photo: Exeter College).

FIGURE 4. David and Saul scenes, initial to Psalm 38. Psalter and Hours of Humphrey de Bohun, London, BL Ms. Egerton 3277, fol. 29ᵛ (© The British Library Board. All rights reserved).

have to look elsewhere to find the commissioner of the volume, whom I believe, in the absence of any other viable candidates, was her widowed mother, Joan Fitzalan, with whom the young bride was still living for the first several years of her married life.[14]

Beyond identification of commissioner and recipient, the study of manuscript patronage calls for an evaluation of the role of the commissioner in determining the pictorial (and textual) contents of the book, and the response of the recipient or owner to the completed work. The Bohun manuscripts offer some enlightenment on these questions. In the case of the Bodleian Psalter and Hours, Joan Fitzalan, the commissioner in question, was the daughter of the earl of Arundel, Richard Fitzalan (c. 1313–1376). She married Humphrey de Bohun, the seventh earl of Hereford, as well as Essex and Northampton, in 1359. After he died in 1373 Joan lived on as the dowager countess of Hereford, outlasting her husband and even her children, and died only in 1419, probably having reached the advanced age of about seventy. From the time of her marriage to the year of her husband's death, she lived in the Bohun family's ancestral residence at Pleshey in Essex.[15] The Bohun

14. J. H. Wylie, *History of England under Henry IV*, 4 vols. (London, 1884–1898), IV: 132, citing the Register of John of Gaunt; see *John of Gaunt's Register, 1379–1383*, E. C. Lodge and R. Somerville, eds., 2 vols., Camden Third Series, LVI–LVII (London, 1937), nos. 646 (1 Feb. 1382) and 996 (31 Jan. 1382).

15. On Joan Fitzalan, see J. C. Ward, "Joan de Bohun, Countess of Hereford, Essex and Northampton, c. 1370–1419: Family, Land and Social Networks," *Essex Archaeology and History* 32 (2001), 146–153. Various documents place Joan at Pleshey from time to time after Humphrey died in 1373 (Wylie, *His-*

tory of England under Henry IV (as in note 14), I: 103–104, III: 128), but what is known of her itinerary suggests she was often at Rochford Hall, Essex, where her younger daughter Mary married Henry of Bolingbroke in 1381; see Ward, "Joan de Bohun," 148, and *Oxford Dictionary of National Biography Online*, s.v. 'Henry IV,' entry by A. L. Brown and H. Summerson. After Humphrey de Bohun's death, Pleshey became the chief residence of Joan's elder daughter Eleanor and her husband Thomas of Woodstock; see G. E. C[ocayne], *The Complete Peerage*, 13 vols. (London, 1910–1959), s.v. 'Gloucester,' VI: 720–721.

FIGURE 5. Mary de Bohun adoring the Virgin and Child. Bohun Psalter and Hours, Oxford, Bodleian Library Ms. Auct. D. 4. 4, fol. 181ᵛ (photo: Bodleian Library).

169

FIGURE 6. Last Judgment, miniature and initial to Penitential Psalms. Bohun Psalter and Hours, Oxford, Bodleian Library Ms. Auct. D. 4. 4, fol. 169 (photo: Bodleian Library).

household there was large, and along with the domestic staff, the cooks, porters, grooms, and many others, the *familia* included clerks, a confessor who was an Augustinian friar, and, most important, the illuminator John de Teye, and perhaps another "luminour," also named John.[16] Like the Bohun confessor, John de Teye was himself a well-educated Augustinian friar.[17] So within the castle walls of Pleshey were learned clerics competent to advise the Bohun patrons on the types and forms of manuscripts needed to foster their spiritual welfare, then to conceptualize the books' pictorial programs, and finally to realize the plans in ink, pigment, and gold. As clerical advisers they were the counterparts of the "scholarly advisers" to whom we often attribute the complex pictorial programs of manuscripts illuminated by secular artists in urban settings.[18] But in this case, the Bohun clerics carried out the artistic work themselves. Because they were deeply embedded in the Bohun household, the books they planned and executed reflected and constructed the Bohun social as well as religious identity, fostering an image of high rank and devout

piety to be transmitted dynastically to the family descendants.

Now, to return to Joan Fitzalan, as the dowager countess of Hereford she may have been the force behind the production not only of the Bodleian Psalter and Hours, but five other devotional manuscripts, at least three of them intended for her younger daughter Mary de Bohun, after her marriage early in 1381 to Henry of Bolingbroke, the future Henry IV.[19] Joan was a woman to be reckoned with. In the absence of male heirs, after the death of her husband she became a great landholder in her own right, and she continued to employ officers of Humphrey's household in her own service. In the turbulent period at the end of the reign of Richard II and the beginning of that of Henry IV, Joan even held the earl of Huntingdon, John Holland, who had plotted against Henry, captive at Pleshey, and commanded his execution.[20] On a gentler note, Joan was the literary patron of Thomas Hoccleve's devotional meditation in English verse, titled "The Complaint of the Virgin before the Cross," a text sometimes illustrated.[21] And she was

16. Information on the Bohun household is derived chiefly from the will of Humphrey de Bohun, sixth earl of Hereford and Essex; see J. Nichols, *A Collection of All the Wills, Now Known to be Extant, of the Kings and Queens of England...* (London, 1780), 44–56. In his will Humphrey bequeathed ten pounds to "frere Johan de Teye nostre luminour" and 40 shillings to John "luminour" (p. 49). John de Teye was apparently still in the employ of the Bohuns in 1384, when he asked the prior-general of the Augustinian order for permission to "call and keep Fr. Henry Hood for a year, while instructing him in the art of illuminating books"; see F. Roth, *The English Austin Friars, 1249–1538,* 2 vols. (New York, 1961–1966), II: doc. 559. Whether John was resident at Pleshey during this time is uncertain from the document; since the Bohun manuscripts of the 1380s in which his work appears were probably ordered by Joan Fitzalan for her daughter Mary de Bohun, it is possible that John and his chief associate, perhaps the "johan luminour" of the will of Humphrey the sixth, both of whom worked for the two successive Bohun earls, moved with Joan to one of her other Essex residences after the death of her husband Humphrey the seventh; for this suggestion, see M. Vidas, "Representation and Reception, Women in the Copenhagen Bohun Hours Ms. Thott 547 4°," *Fund og Forskning I det Kongelige Biblioteks Samlinger* 50 (2011), 81–82, n. 6.

17. See Roth, *English Austin Friars* (as in note 16), I: 136–177.

18. The concept of the scholarly adviser on the pictorial programs of manuscripts is associated in the first instance

with Erwin Panofsky's characterization of the *Exposition des ymages qui sunt ou kalendrier et ou sautier* (Exposition of the images that are in the calendar and in the Psalter) at the beginning of the Belleville Breviary (Paris, BnF Ms. lat. 10483, fols. 2–4) as the written record of the instructions of a "Dominican theologian" for illustrations carried out by Jean Pucelle; see E. Panofsky, *Early Netherlandish Painting,* 2 vols. (Cambridge, Mass., 1953), I: 32–33; *contra,* see L. F. Sandler, "Jean Pucelle and the Lost Miniatures of the Belleville Breviary," *The Art Bulletin* 66.1 (1984), 90, arguing for Pucelle's "authorship," both textual and pictorial.

19. Psalter, Cambridge, Fitzwilliam Mus. Ms. 38-1950; Psalter and Short Office of the Cross, Baden-Baden, Lichtenthal Abbey Archive Ms. 2; Legends of the Virgin Mary, St. Margaret, and St. Mary Magdalen, Copenhagen, Kongelige Bibl. Ms. Thott 517.4°; Hours of the Virgin, Copenhagen, Kongelige Bibl. Ms. Thott 547.4°; Pommersfelden, Gräflich Schönbornische Bibl. Ms. 348. For these manuscripts, see the Appendix, nos. 6, 8, 10, and 11.

20. Ward, "Joan de Bohun" (as in note 15), 150, and n. 38, citing A. Goodman, "The Countess and the Rebels: Essex and a Crisis in English Society (1400)," *Transactions of the Essex Archaeological Society,* 3rd ser., 11 (1970), 267–279.

21. See F. J. Furnivall and I. Gollancz, eds., *Hoccleve's Works, The Minor Poems,* Early English Text Society, 61, 73, revised by J. Mitchell and A. I. Doyle (Oxford, 1970), 1–8; for an illustrated copy, see London, BL Ms. Egerton 615, *c.* 1450, fol.

called upon as a custodian, companion, escort, and caretaker of noble boys and girls, in addition to her own daughter Mary.[22] Indeed, according to Froissart, she saved Mary from being cloistered as a nun, foiling the machinations of her elder daughter Eleanor's husband, Thomas of Woodstock, the youngest son of Edward III, and instead succeeded in having Mary married to John of Gaunt's son Henry of Bolingbroke.[23] Mary was ten or eleven years old at the time of her marriage. She died in 1394, at about the age of twenty-four, soon after the birth of the last of her six children.[24]

Concern for dynastic preservation and pride in the Bohun family and its royal connections are evident in all the manuscripts ordered in the 1380s by Joan for her daughter Mary. Part of this evidence is textual, as the prayers to the apostles on behalf of Humphrey de Bohun suggest. No matter which Humphrey, the intention and the result was to insure that a memorial of the heads of the Bohun family would last throughout all time. Pictorial material in these manuscripts also served a memorial purpose, in particular, the complex armorial displays that spelled out the Bohun heritage graphically. For example, on the Penitential Psalms page of Mary de Bohun's Psalter and Hours in the Bodleian Library, the arms of England and Bohun are juxtaposed with those of Lancaster and Bohun on either side of the miniature of the Last Judgment (Fig. 6).[25] The pairing of England and Bohun refers heraldically to the first Bohun connection with the royal family, the marriage between Humphrey the fourth Bohun earl of Hereford and Elizabeth the youngest daughter of Edward I in 1302. Across the page, the pairing of Lancaster and Bohun refers to the more recent marriage of another royal Plantagenet, Henry of Bolingbroke, who used the arms of the earldom of Lancaster at this time,[26] to Mary de Bohun. The heraldic ensemble is completed at the bottom of the page with the arms of Butler as earl of Ormond, Bohun as earl of Northampton, and Courtenay as earl of Devon, representing the marital partners of the daughters of the fourth Bohun earl of Hereford and Essex, and his last surviving son, William earl of Northampton, Mary de Bohun's grandfather.[27]

Just as the Bohun artists were able to interpret the Bohun dynastic hopes through graphic armorial display, they also translated Bohun dynastic concerns into pictorial imagery. Joan Fitzalan could of course have had no hope for the continuation of the Bohun male line, since she had borne only daughters, but a

63; for the verse "Complaint" inserted in the English prose translation of Guillaume de Deguileville's *Pélerinage de l'âme*, see M. C. Seymour, *Selections from Hoccleve* (Oxford, 1981), xiv–xv. For Joan Fitzalan's literary patronage, see K. K. Jambeck, "Patterns of Women's Literary Patronage: England, 1200–ca. 1475," in *The Cultural Patronage of Medieval Women*, ed. J. H. McCash (Athens, Ga., 1996), 236–239.

22. See Wylie, *History of England under Henry IV* (as in note 14), I: 206, II: 30, n. 3, IV: 131–132.

23. This account of Mary de Bohun's marriage appears in only one edition of Froissart, printed from a manuscript copy formerly owned by T. Johnes (now destroyed); see *Chronicles of England, France and Spain by Sir John Froissart*, trans. T. Johnes, 2 vols. (London, 1857), I: 623–624.

24. For the marriage and children of Mary de Bohun, see, most recently, *Oxford Dictionary of National Biography, Online Edition*, s.v. 'Henry IV,' specifying the date of the marriage of Mary and Henry as "probably 5 February 1381." It has been widely stated that Mary bore a child as early as 1382, before she was twelve or thirteen, but this has been disproved by Ian Mortimer, *The Fears of Henry IV, The Life of England's Self-Made King* (London, 2007), Appendix III, "Henry's Children," 370–372.

25. Arms of England: quarterly France ancient (azure semy de lis or) and England ancient (gules three lions passant gardant or); Bohun, azure a bend argent between two cotises and six lions rampant or; Lancaster, gules three lions passant gardant or, a label of three points azure flory or.

26. The arms of Henry of Bolingbroke's father John of Gaunt as duke of Lancaster were quarterly France ancient (azure semy de lis or) and England (gules three lions passant gardant or), a label of three points ermine. On these armorials, see Sandler, "Lancastrian Heraldry" (as in note 12), 222–224, citing C. R. Humphery-Smith and M. G. Heenan, "The Royal Heraldry of England, Part Five," *The Coat of Arms* 7 (1962), 84

27. Butler, earls of Ormond, or a chief indented azure; Courtenay, earls of Devon, or three torteaux, a label of three points azure; Bohun, earl of Northampton, azure a bend argent between two cotises and six lions rampant or, three mullets gules. Eleanor de Bohun (d. 1363) married James Butler (c. 1305–1338) in 1327; Margaret de Bohun (d. 1391) married Hugh Courtenay (1303–1378) in 1325; William de Bohun (c. 1312–1360) was created earl of Northampton in 1337. For these earldoms, see *Handbook of British Chronology*, 3rd ed., ed. E. B. Fryde *et al.* (Cambridge, 1986), s.v. 'Ormond (Ireland),' 'Devon, Northampton.'

number of illustrations in the manuscripts made for her daughter Mary communicate the hope, if not expectation, that children would be forthcoming from the brilliant marriage Joan had engineered for her child. It was the Bohun artists who manipulated the Old Testament narratives that form the chief elements of the pictorial programs of these manuscripts to focus on episodes of marriage and birth. One case is the vignette of the wedding of Zipporah and Moses in Mary's Psalter now in Lichtenthal Abbey in Germany (Fig. 7). Unlike conventional medieval images of marriage, here the couple is shown obliquely before a priest at an altar. Zipporah, according to medieval scholars a type of the Church, and thus by analogy of the Virgin Mary,[28] is in the foreground, overlapping Moses. That the composition was purposely designed to focus on the female marriage partner, with her long streaming golden hair and little crown, is made clear if this image is compared with the historiated initial depicting the same subject in a manuscript certainly owned by a male Bohun, the Psalter illustrated for Humphrey the seventh at Exeter College, Oxford (Fig. 8). In contrast to the Lichtenthal Psalter, in the Exeter College manuscript, Zipporah is practically completely hidden by Moses, no surprise since he was, after all, the protagonist of several books of the Old Testament illustrated in great detail in this manuscript.[29] But the arrangement of the Exeter College composition underscores the purposeful innovation in the treatment of the same subject in the Psalter made for Mary de Bohun.

Joan Fitzalan's concerns about Bohun births were also translated into pictorial images. In the Lichtenthal Psalter the artist again manipulated the pictorial cycle so that three of the main illustrated pages of the manuscript focus on birth scenes: the birth of Abel on the Psalm 1 page (Fig. 9); then the birth of Esau and Jacob on the Psalm 52 page (Fig. 10); and finally, the birth of Moses (Fig. 11) on the Psalm 80 page, which has the Moses-Zipporah marriage vignette in the center of the *bas-de-page*.[30] Of course the biblical births all produced male offspring. As it happened, in what might have appeared to confirm the talismanic power of images, Mary de Bohun's first four children were also boys.[31]

But what *of* Mary? If she played no role in commissioning manuscripts, as the recipient her response to imagery created for her should be considered as part of what may be called the web of patronage. Although we have no direct knowledge of this response, a persuasive picture of how Mary experienced the textual/pictorial amalgam of her books can be constructed. Credit must be given to the skill and ingenuity of the Bohun artists. It may be that all Joan Fitzalan had to say to them was, in effect, "make a well-illuminated Psalter and Hours for my young daughter," "well-illuminated" being one of the few descriptive terms found in a detailed inventory of Bohun manuscripts that was compiled at Pleshey in 1397.[32] What the artists produced were two sorts of images: first, pictures of biblical women with which a young girl could identify, such as the marriage of Zipporah in the Lichtenthal Psalter (Fig. 7), images whose affective and instructional power was increased by putting Mary-doubles literally in the pictorial narrative; and second, images of surrogate Marys in prayer, images that served as models of pious behavior and memorials permanently re-enacting her religious devotion, such as the miniature in the Bodleian manuscipt (Fig. 5) showing Mary in prayer before the Virgin and Child, presented by her name-saint, Mary Magdalen.

28. See Sandler, *The Lichtenthal Psalter and the Manuscript Patronage of the Bohun Family* (London, 2004), 81–82, citing the explanatory text of the Moralized Bible, Oxford, Bodleian Lib. Ms. Bodley 270b, fol. 40, Paris, early thirteenth century, and London, BL Ms. Add. 18719, fol. 20ᵛ, England, late thirteenth century: *Moyses significat Christum, uxor eius ecclesiam* (Moses signifies Christ, his wife the Church).

29. Old Testament subjects of Oxford, Exeter Coll. Ms. 47 (Appendix no. 3) are listed in James and Millar, *Bohun Manuscripts* (as in note 1), 5–22, with an earlier foliation.

30. On the pictorial cycle of the Lichtenthal Psalter, see Sandler, *Lichtenthal Psalter* (as in note 28), esp. 136–142.

31. Henry, king of England (1387–1422); Thomas, duke of Clarence (1388–1421); John, duke of Bedford (1389–1435); Humphrey, duke of Gloucester (1390–1447).

32. E.g., *Item i sauter bien escript et esluminez ove claspes dargent endorrez pris xiiis, iiiid.* (Item: a Psalter well written and illuminated, with clasps of gilded silver, price 13 shillings 4 pence); see J. Dillon and W. H. St. John Hope, "Inventory of the Goods and Chattels Belonging to Thomas, Duke of Gloucester, and Seized in His Castle at Pleshy, Co. Essex 21 Richard II (1397); with Their Values, as Shown in the Escheator's Accounts," *Archaeological Journal* 54 (1897), 275–308, esp. 299.

FIGURE 7 (*enlarged*).
Marriage of Zipporah and
Moses. Bohun Psalter and
Short Office of the Cross,
Baden-Baden, Lichtenthal
Abbey Archive Ms. 2, fol.
83, detail of *bas-de-page*
(photo: L. F. Sandler).

FIGURE 8 (*enlarged*).
Marriage of Moses and
Zipporah, initial to Psalm
75. Psalter of Humphrey
de Bohun, Oxford, Exeter
College Ms. 47, fol. 49ᵛ
(revised numbering)
(photo: Exeter College).

FIGURE 9. Birth of Abel. Bohun Psalter and Short Office of the Cross, Baden-Baden, Lichtenthal Abbey Archive Ms. 2, fol. 1, detail of border (photo: L. F. Sandler).

FIGURE 10. Birth of Jacob and Esau, initial to Psalm 52. Bohun Psalter and Short Office of the Cross, Baden-Baden, Lichtenthal Abbey Archive Ms. 2, fol. 54ᵛ, detail (photo: L. F. Sandler).

FIGURE 11. Birth and Finding of Moses, initial to Psalm 80. Bohun Psalter and Short Office of the Cross, Baden-Baden, Lichtenthal Abbey Archive Ms. 2, fol. 83, detail (photo: L. F. Sandler).

Another surrogate Mary appears on the Matins page of the Bohun Hours in Copenhagen (Fig. 12).[33] Identifiable by her heraldic garment, Mary occupies the marginal area adjacent to the historiated initial. Like the Lichtenthal Psalter Zipporah, Mary here has long, streaming blond hair held in place by a thin gold band. She is in a private cabinet, kneeling at a lectern and holding an open prayerbook in her hands as she gazes across the boundary of the initial frame to the vision made present within the initial field. This is the Annunciation, with the angel in a golden shower appearing before the crowned Virgin, who is seated on a throne-like chair in a chamber-like interior. Another golden shower, the radiance of the Holy Spirit, streams toward the Virgin through the slit in the turret above. The Virgin herself has long golden hair, and rests her hand on an open book, motifs echoed in the representation of Mary de Bohun, so that the Virgin's own devotion, and desire for knowledge and learning, all implied by her hand on the book,[34] are shown by the artist to offer a model for her namesake Mary de Bohun.

Like many medieval women owners of manuscripts, most famously perhaps Jeanne d'Evreux,[35] Mary de Bohun's patronage was passive. She was the recipient of books commissioned by others, books deemed suited to her station in life, books designed for her spiritual instruction and solace, and without a doubt for her visual pleasure. But among the Bohun manuscripts associated with female patronage, there is one where patronage can be understood as active rather than passive. This is the Hours and Psalter made for, and commissioned by, Eleanor de Bohun, Joan Fitzalan's elder daughter, the third woman in the Bohun web of patronage.[36] At the end of the volume is a now-erased posthumous inscription in Anglo-Norman: "This book, which she commanded to have written, belonged to Eleanor de Bohun, duchess of Gloucester."[37] Born around 1366, Eleanor was a mature woman of at least twenty-three when the text and illustrations of this manuscript were produced, sometime between 1389 and 1397.[38] Between 1374 and 1376, before she was even ten, she had been married to Thomas of Woodstock, the youngest son of

33. See the detailed account of the iconography in Vidas "Representation and Reception, Women in the Copenhagen Bohun Hours Ms. Thott 547 4°" (as in note 16), 82–90.

34. For the association of Virgin with learning, see the widely circulated Gospel of Pseudo-Matthew, chap. 6: "… no one more learned in the wisdom of the law of God, more lowly in humility, more elegant in singing, more perfect in all virtue" (*Ante-Nicene Fathers*, 8, ed. A. Roberts *et al.* [Buffalo, N.Y., 1886], online at www.gnosis.org/library/psudomat.htm). Another version of this source specifies that Mary was "skilled in singing the songs of David," that is, the psalms; see G. Schiller, *Iconography of Christian Art*, trans. G. Seligman (Greenwich, Conn., 1971), I: 42. On the motif of the reading Virgin Mary, see, among many others, S. G. Bell, "Medieval Women Book Owners: Arbiters of Lay Piety and Ambassadors of Culture," *Signs*, Journal of Women in Culture and Society, 7 (1982), 742–768, esp. 761–763, and P. Sheingorn, "'The Wise Mother': The Image of St. Anne Teaching the Virgin Mary," *Gesta* 32 (1993), 69–80, esp. 69.

35. See the influential essay by M. Caviness, "Patron or Matron? A Capetian Bride and a *Vade Mecum* for Her Marriage Bed," *Speculum* 68 (1993), 333–362.

36. Edinburgh, National Lib. of Scotland Ms. Adv. 18.6.5 (Appendix no. 12); see L. F. Sandler, "The Last Bohun Hours and Psalter," in *Tributes to Kathleen L. Scott, English Medieval Manuscripts: Readers, Makers and Illuminators*, ed. M. V. Hennessy (London, 2008), 231–250.

37. "Cest livre feust a Alianore de bohun duchesse de Gloucestre lequel ele fist escrire;" transcribed in Burlington Fine Arts Club, London, *Exhibition of Illuminated Manuscripts* (as in Appendix no. 2), 73.

38. The manuscript includes a prayer, erased in the sixteenth century but readable (fol. 66ᵛ), on behalf of then-living Pope Boniface IX (1389–1404), hence the *terminus post quem* 1389; an invocation for Eleanor's husband Thomas of Woodstock was inserted into the litany (fol. 38ᵛ), *Ut viam famuli tui thome disponas et omnia opera eius dirigas* (That thou mayest oversee the path of thy servant Thomas and direct all his acts), wording indicating that he was alive, hence a *terminus ante* of 1397, the year Thomas was killed. In fact, the form of the supplication suggests that it might have been inserted prior to the Thomas' departure for a crusade to Prussia in October 1391, an event also preceded by the grant of an indult to Thomas and Eleanor to enter enclosed monasteries, such as the London convent of the Minoresses, where their daughter Isabel was a nun, and in whose precincts they leased a house, perhaps in order to pray for the success of Thomas' crusade; see below, note 40, and A. Goodman, *The Loyal Conspiracy: The Lords Appellant under Richard II* (London, 1971), 79–80, also L. Staley, *Languages of Power in the Age of Richard II* (University Park, Pa., 2005), 224; for the indult, see *Calendar of Entries in the Papal Registers Relating to Great Britain and Ireland, Papal Letters IV. A.D. 1362–1404*, W. H. Bliss and J. A. Twemlow, eds. (London, 1902), 394. If the litany entry was occasioned by the

FIGURE 12. Mary de Bohun in prayer, Annunciation and Miracle of the Virgin, Matins
initial page. Hours of Mary de Bohun, Copenhagen, Kongelige Bibliotek Ms. 547.4°,
fol. 1 (photo: Kongelige Bibliotek).

Edward III.[39] When she was a girl, Eleanor's mother Joan Fitzalan may well have commissioned Psalters and Hours for Eleanor, as she had for her younger daughter Mary, but they have not survived. The one book extant, the Edinburgh Hours and Psalter, was illustrated by an artist who also worked on the decoration of manuscripts owned by Eleanor's husband Thomas,[40] and this artist's sphere of activity was not limited to the Bohuns, since his hand appears again in the great Carmelite Missal begun in London during the 1390s.[41] One of Eleanor's clerks could have been the go-between with the London-based artist, her chaplain or confessor could have advised on the textual and pictorial contents,[42] but the manuscript truly seems to reflect the personal wishes of the lady herself in image and text.

What is the evidence? It is unfortunate that the original plans for profuse heraldic display, which called for the juxtaposition of as many as eight armorial shields on the opening pages of the Hours of the Virgin, the Psalter, and the Penitential Psalms, were never carried out because the spaces were left blank awaiting an armorial specialist.[43] As for the pictorial images in the manuscript, in general the program of the both Hours of the Virgin and the Psalter is conventional. The Hours of the Virgin, which are combined with the devotion known as the Short Office of the Cross, are illustrated primarily with

prospective crusade, the dates of execution of the manuscript would be narrowed to 1389–1391. I am grateful to Dr. Kenneth Dunn of the National Library of Scotland for checking the reference to Pope Boniface IX.

39. The most recent biographical reference to Eleanor dates her birth "*c. 1365*" and her marriage in the early summer of 1374; see *Oxford Dictionary of National Biography, Online Edition*, s.v. 'Thomas, duke of Gloucester,' entry by Anthony Tuck, 2008.

40. On manuscripts illuminated for Thomas of Woodstock, see J. Stratford, "*La somme le roi* (Reims, Bibl. mun., Ms. 570), the Manuscripts of Thomas of Woodstock, Duke of Gloucester, and the Scribe, John Upton," in *Le statut du scripteur au moyen age, Actes du xiie collogue scientifique du Comité international de paléographie latine (Cluny, 17–20 juillet 1998)*, ed. M.-C. Hubert et al. (Paris, 2000), 267–282. On Thomas of Woodstock as a cultural patron in general, see L. Staley, *Languages of Power in the Age of Richard II* (as in note 38), esp. 193–263, where it is proposed (213 *et passim*) that Thomas commissioned the anonymous Middle English poem *Pearl* in memory of the oblation of his daughter Isabel to the Franciscan convent (Minoresses) in London. Thomas had a residence in London, in which thirteen books were inventoried after his death; see *Calendar of Inquisitions Miscellaneous (Chancery) Preserved in the Public Record Office VI, 1392–1399* (London, 1963), 223–224, no. 372; for the possible location of the house, see E. T. Riley, *Memorials of London and London Life in the XIIIth, XIVth and XVth Centuries...* (London, 1868), 427, an account of a night attack in 1378 by men of Cornhill on Thomas' "hostel" while he was "lying in his bed," citing Corporation of the City of London, Letter-book H, fols. 94, 101. Thomas and Eleanor certainly owned a house within the precinct of the London convent of Minoresses without Aldgate, where their daughter Isabel had been an oblate since infancy; Thomas built a door from this house directly into the part of the church used by the laity; see L. Staley, *Languages of Power in the Age of Richard II* (as in note

38), 223–224, and M. Carlin, "Holy Trinity Minories: Abbey of St. Clare, 1293/4–1539," unpublished survey, Centre for Metropolitan History, Institute of Historical Research, University of London, 1987, 38–40. I am grateful to Prof. Carlin for providing me with extracts from this survey.

41. Carmelite Missal, London, BL Ms. Add. 29704-5, before 1391(?); see M. Rickert, *The Reconstructed Carmelite Missal, an English Manuscript of the Late XIV Century in the British Museum (Additional 29794-5, 44892)* (London, 1952), her hand C2.

42. Eleanor de Bohun's will names Hugh Peyntour, *chapeliein de ma franc chapell deinx le chastell de Plessy* (chaplain of my free chapel within the castle of Pleshey) as an executor; see Nichols, *Wills* (as in note 16), 184. Peyntour had been ordained as a priest in London in 1371, and was a chaplain at Pleshey as early as 1386; see *Registrum Simonis de Sudbiria diocesis londoniensis A.D. 1362–1375*, Canterbury and York Society, 38 (Oxford, 1937), 100, and F. T. Wethered, *Lands and Tythes of Hurley Priory, 1086–1535* (Reading, 1909), 43, referring to Hurley Charters and Deeds, no. 578, an acquittance of Hugh Peyntour to the prior of Hurley, in which Hugh is described as chaplain of Pleshey. Hurley Priory, Berkshire, was a cell of Westminster Abbey, which holds its charters: see L. Tanner, "The Nature and Use of the Westminster Abbey Muniments," *Transactions of the Royal Historical Society*, 4th ser., 19 (1936), 55.

43. See J. Stratford, "*La Somme le roi*" (as in note 40), 279–280, observing that the armorials included in other manuscripts made for Thomas of Woodstock, such as the *Somme le roi*, Reims, Bibl. municipale Ms. 570, were painted by heraldic specialists. The use of such specialists in the late fourteenth century is also indicated by the armorials in historical compilation datable 1386–1399, London, BL Ms. Cotton Nero D.VI; see especially fol. 56ᵛ, where on a page with a completed figural initial, the shield of John of Gaunt was added by the specialist, but the shields of the dukes of Orleans, Berry, and Bourbon were left blank (Stratford, fig. 67), probably in this case because he had no models for these "foreign" arms.

Lucy Freeman Sandler

Passion subjects, as happens very often in the fourteenth century,[44] and the Psalter is illustrated mainly with historical subjects focusing on David, also a quite common approach.[45] Yet either the particular David subjects, or the particular take on normal David subjects, is sometimes unusual, and when this happens, David, the king of Israel, is read in terms of contemporary kingship, reflecting both Eleanor's engagement with, and encouraging her reflection on, the complexities of the reign of her husband's nephew Richard II.[46] Psalm 26, for example, is illustrated with the anointing of David (Fig. 13), a purposeful choice of the older of the two common alternative subjects, the newer responding to the opening line of the psalm, "The Lord is my light and my salvation," in showing David pointing to his eye.[47] The details of the Edinburgh image are truly extraordinary. Typically, inspired by the Psalm *titulus*, "The psalm of David before he was anointed," the boy David is anointed on the head by Samuel, identified by his garments as an Old Testament priest (Fig. 14). But in the Psalter of Eleanor de Bohun, Old Testament figures are replaced by entirely contemporary actors: a youthful crowned king in contemporary dress, a nobleman indicating

the ruler's silver sword, an archbishop vested with a pallium, and another mitered figure holding a book, and the archbishop anoints not the king's head but his bared chest. As was once commented about the miniature from an illustrated English coronation order of the second quarter of the fourteenth century now at Corpus Christi College, Cambridge (Fig. 15), the scene in Eleanor de Bohun's Psalter corresponds to no single moment in the story of David's rise to kingship but is instead a glory of regality,[48] biblical, but contemporary as well. In fact, the picture is filled with details reflecting the actual coronation of Richard II in 1377.[49] In the coronation procession the appointed bearer of the royal silver sword, called "Curtana," was the brother-in-law of Eleanor de Bohun, John, duke of Lancaster.[50] After the archbishop of Canterbury unbuttoned Richard's tunic, he anointed him on the hands, chest, shoulders, elbows, and head. Next, Richard was girded with the sword that had been carried by John, and then crowned by the archbishop.[51] All the while, it was the abbot of Westminster who guided the ten-year-old ruler through the stages of the ritual, perhaps using an *ordo*, like the book represented in the picture.[52] In equating the biblical David

44. On the Short Office of the Cross, see V. Leroquais, *Les livres d'heures manuscrits de la Bibliothèque nationale*, 3 vols. (Mâcon, 1927–1943), I: xxvi; for the Latin text, see F. J. Mone, *Die lateinische Hymnen des Mittelalters*, 3 vols. (Freiburg im Breisgau, 1853), I: 106–110, no. 82; for a list of fourteenth century English examples, see Sandler, *Gothic Manuscripts* (as in note 1), II: 211. The Passion illustrations of the Short Office of the Cross follow a standard pattern, whose subjects are determined by the event described in verse in each hour of the office.

45. On the subjects of the initials at the main divisions of the Psalter, see G. Haseloff, *Die Psalterillustration im 13. Jahrhundert, Studien zur Geschichte der Buchmalerei in England, Frankreich und den Niederländen* (Kiel, 1938).

46. In the initials for Psalms 38, 52, and 97, David appears not in typical "biblical" dress but in the armor or mantle of a contemporary ruler; see Sandler, "The Last Bohun Hours and Psalter" (as in note 36), esp. 241–243, for discussion of these and the other illustrations of the Psalter.

47. As a sampling, for England, of 19 Psalters executed between 1190 and 1250, the Anointing of David appears as the illustration of Psalm 26 in 18, and David pointing to his eye, in one; see N. J. Morgan, *Early Gothic Manuscripts (I) 1190–1250*, A Survey of Manuscripts Illuminated in the British Isles, IV, pt. 1, ed. J. J. G. Alexander (London, 1982); of 23 Psalters of the first half of the fourteenth century tabulated by L. F. Sandler, *The Peterborough Psalter in Brussels and Other Fenland Manu*

scripts (London, 1974), 98–99, about half showed the Anointing of David, and half David pointing to his eye; by 1400 the balance had completely reversed, and David pointing to his eye was nearly universal; see K. L. Scott, *Later Gothic Manuscripts 1390–1400*, A Survey of Manuscripts Illuminated in the British Isles, VI, ed. J. J. G. Alexander (London, 1996), II, esp. Table 1. David pointing to his eye evidently appeared as the subject of Psalm 26 in some Parisian manuscripts as early as 1200; see Haseloff, *Die Psalterillustration im 13. Jahrhundert* (as in note 45), 24 and Table 4.

48. The phrase of J. Wickham Legg, *Three Coronation Orders*, Henry Bradshaw Society, XIX (London, 1900), xxxvi–xxxvii.

49. For the *ordo* used at the coronation of Richard II, with detailed rubrics describing the ceremony and its participants, see J. Wickham Legg, *English Coronation Records* (London, 1901), 81–130 (in Latin, with English translation), and for a contemporary narrative account of the coronation, written up by clerks of the steward of England, John of Gaunt, 164–168.

50. John of Gaunt carried the sword by right as the duke of Lancaster; see Legg, *English Coronation Records* (as in note 49), 131–132, 150. Thomas of Woodstock, as constable of England, had the right to carry the royal dove-topped rod and present it to the king after he was crowned; Legg, 146, 165.

51. See Legg, *English Coronation Records* (as in note 49), 91–96, 118–120.

52. *Ibid.*, 83, 113.

FIGURE 13. Anointing of David, initial to Psalm 26. Hours and Psalter of Eleanor de Bohun, Edinburgh, National Library of Scotland Ms. Adv. 18.6.5, fol. 78, detail (photo: National Library of Scotland).

FIGURE 14. Anointing of David, initial to Psalm 26. Vaux-Bardolf Psalter, London, Lambeth Palace Library Ms. 233, fol. 44, detail (photo: Lambeth Palace Library).

FIGURE 15. Coronation of an English King. Apocalypse and Coronation Order, Cambridge, Corpus Christi College Library Ms. 20, fol. 68 (photo: Corpus Christi College).

with the living Richard, the image proclaims Bohun fidelity to the concept of royal power sanctioned by God, echoed two hundred years later in Shakespeare's lines "Not all the water in the rough rude sea | Can wash the balm off from an anointed king; | The breath of worldly men cannot depose | The deputy elected by the Lord."[53] The imposition of such a layer of contemporary political meaning on conventional Psalter imagery in the Hours and Psalter of Eleanor de Bohun certainly causes us to see her manuscript in a patronage context quite different from that suggested by the manuscripts of Mary de Bohun.

But above all it is the textual components that stamp this manuscript so personally as commissioned by and belonging to Eleanor de Bohun. Almost all the devotional texts in the volume are voiced in the feminine gender, including both a long and a short confession, the Litany of the Virgin, a long prayer to all saints, a prayer to the guardian angel, and the prayer to be said before reciting the Psalms.[54] Other prayers identify Eleanor herself as the supplicant, for instance, *Deus propicius esto michi peccatrici famule tue Alianore* (God be gracious to me, a sinner, thy servant Eleanor).[55] Some of the rubrics for these texts are in Anglo-Norman but the texts themselves are all in Latin. While often enough in contemporary manuscripts the vernacular is used not only for rubrics but for comparable devotional texts as well,[56] the dominance of Latin in Eleanor de Bohun's book suggests that she was familiar with the official language of the church, in other words, that she was a literate woman.

Particularly striking are the prayers to be said during Mass.[57] These again are in Latin, and represent a dramatic increase in the participation of Eleanor, a lay person, to the degree that her role as participant is nearly merged into that of the celebrant. One example is the wording of Eleanor's prayer to be said when the priest has consumed the host and drunk from the chalice, introduced by the rubric *Et qant le prestre ad usez ditez ceste oresoun* (And when the priest has consumed [the host] say this prayer).[58] In the Sarum rite, at this point the priest recites *Gracias tibi ago domine* (I give thanks to thee, O Lord), a prayer that includes the phrase *hoc sacramentum salutis nostre quod sumpsi indignus peccator* (this sacrament of our salvation, which I, unworthy sinner, consumed).[59] Eleanor's prayer is almost exactly the same, except that "consumed" was replaced by "saw."[60] For her, as for all lay people at the end of the fourteenth century, actual Communion was infrequent.[61] The Eucharist

53. *Richard the Second*, Act III, scene 2, in anticipation of Richard's embarkation for Ireland. If the manuscript was produced between 1389 and 1391, as suggested above, note 38, this would have been a period of relative rapprochement between Richard and Eleanor de Bohun's husband Thomas of Woodstock, who had been one of the Lords Appellant in 1388; see *Oxford Dictionary of National Bibliography, Online Edition*, s.v. 'Thomas of Woodstock.'

54. Long confession (fols. 14–15ᵛ): *Confiteor deo celi ... ego miser infelix peccatrix.* Short confession (fol. 46ᵛ): *Confiteor tibi domine ... Deus propicius esto michi peccatrici famule tue.* Litany of the Virgin (fols. 41–42): *Kyrielyson ... intercede pro me miserrima peccatrice.* Prayer to All Saints (fols. 42–43): *O vos omnes sancti ... succurrice michi peccatrici miserrime.* Prayer to Guardian Angel (fols. 43–43ᵛ): *Credo quod sis angelus sanctus ... ut me miserrimam fragilissimam atque indignissiam.* Prayer before psalms (fol. 65): *Suscipere digneris domine deus ... quos ego indigna & peccatrix.*

55. Fol. 138ᵛ, preceded by a rubric *Require letaniam post septem psalmos penitenciales ante psalterium* (Refer back to the litany following the Seven Penitential Psalms before the Psalter), evidently intended to be added to the customary prayers following the litany (fols. 39–39ᵛ).

56. Vernacular and Latin prayers may appear in the same manuscript, and the rubrics of Latin prayers are often in the vernacular, as in some cases in Eleanor de Bohun's book. For fourteenth-century examples in Anglo-Norman, see R. J. Dean and M. B. Boulton, *Anglo-Norman Literature: A Guide to Texts and Manuscripts*, Anglo-Norman Text Society, Occasional Publications Series, 3 (London, 1999), 392–492, nos. 720–986, with bibliography, to which may be added E. Brayer, *Livres d'heures contenant des textes en français*, Centre national de la recherche scientifique, *Bulletin d'Information de l'institut de recherche et d'histoire des textes* 12 (Paris, 1964). See also N. J. Morgan, "Texts and Images of Marian Devotion in Fourteenth-Century England," in *England in the Fourteenth Century, Proceedings of the 1991 Harlaxton Symposium*, ed. N. Rogers, Harlaxton Medieval Studies, III (Stamford, 1993), 34–57.

57. Fols. 65–68ᵛ.

58. Fol. 68ᵛ.

59. Fol. 68ᵛ. For the Latin text, see J. Wickham Legg, *The Sarum Missal, Edited from Three Early Manuscripts* (Oxford, 1916), 228.

60. Fol. 68ᵛ: *hoc sacramentum salutis nostre quod vidi indigna peccatrix* (this sacrament of our salvation which I, unworthy sinner, saw).

61. M. Rubin, *Corpus Christi: The Eucharist in Late Medieval Culture* (Cambridge, 1991), esp. 3–82.

was a " 'spiritual communion,' which could be experienced through a fervent viewing of the sacrament,"[62] but in having the echo of the priest's words recorded in this manuscript, and in reciting those words over and over again, Eleanor became more than a passive auditor and viewer. And this is confirmed in her will where this manuscript, which was bequeathed to one of Eleanor's daughters, is described as a "psalter, primer [Hours of the Virgin], and other devotions with two gold clasps enameled with my arms, which I have *used a great deal*" [italics mine].[63]

* * *

Two contrasting aspects of patronage of illuminated manuscripts in the later Middle Ages are revealed by the Bohun manuscripts discussed in this essay: one,

active, focused on the commission of books and the conception and execution of their pictorial programs, and the other, passive, focused on the recipients and their reading and viewing experiences. The three Bohun women played different parts in this web of patronage: Joan Fitzalan was the commissioner of books she did not own; Mary de Bohun was the recipient of books commissioned for her; and finally Eleanor de Bohun was both commissioner and recipient and more, for her patronage extended beyond herself to her heirs. In the end, our idea of medieval manuscript patronage has to include commissioning, conceiving, executing, receiving, and bequeathing—all activities we should consider essential to our construction of the history of the book.

62. *Ibid.*, 64.

63. Nichols, *Wills* (as in note 16), 183: *Item un livre ove psautier, primer, & autres devocions, ove deux claspes d'or, enamaillez ove mes armes, quel libre jay pluis usee, ove ma benoison.* The manuscript

was bequeathed to Eleanor's daughter Joan, who died in 1400, only a year after her mother. On its later descent, see Sandler, "The Last Bohun Hours and Psalter" (as in note 36), 244–245.

APPENDIX

The list that follows includes, in rough chronological order, all the manuscripts that have been associated with Bohun ownership to date, together with the chief bibliography for each. The date ranges given here are those accepted or proposed by the author.

{1} Private owner, fragmentary Hours with Bohun arms, *c.* 1345–1350. 2 + 82 fols. (fols. 1–2, 112–193 of a fifteenth-century English Sarum Hours); 153 × 93 mm; text block 95 × 46 mm; 23 long lines.

fols. 1–2v (Matins of the Short Office of the Cross) and fols. 112–193 (prayers in Latin and Anglo-Norman, prognostications in Anglo-Norman, Litany of the Virgin and Gospel Sequences), miniature, initials with royal and Bohun arms, and foliated borders, first artist of the Vienna Psalter (Appendix, no. 2).

C. de Hamel, "A New Bohun," in *The English Medieval Book: Studies in Memory of Jeremy Griffiths*, ed. A.S.G. Edwards, V. Gillespie, and R. Hanna (London, 2000), 19–26.

{2} Psalter, Vienna, Österreichische Nationalbibliothek Cod. 1826*, begun before 1350(?) for Humphrey de Bohun, sixth earl of Hereford and Essex, completed by

1373(?) for Humphrey de Bohun, seventh earl of Hereford, Essex and Northampton.
160 fols.; 280 × 194 mm; text block 184 × 102 mm; 23 long lines.

fols. 1–6v (calendar), illustrations, John de Teye, and minor initials, associate of John de Teye, *c.* 1360–1373; fols. 7–57v, 58v, 85v (Psalms 1–67, 68, 97), initials and borders, various hands prior to John de Teye, *c.* 1350(?); fols. 51–160, initials and borders (Psalms 58–150, Canticles, Penitential Psalms, Litany and *Memoriae*), John de Teye, except as noted, *c.* 1360–1373(?).

H. J. Hermann, *Die westeuropäischen Handschriften und Inkunabeln der Gotik und der Renaissance, Beschreibendes Verzeichnis der illuminierten Handschriften in Österreich*, new series, VII, 2, *Englische und französische Handschriften des XIV. Jahrhunderts der Nationalbibliothek in Wien* (Leipzig, 1936), 17–38; M. R. James and E. G. Millar, *The Bohun Manuscripts*, Roxburghe Club, vol. 200

(London, 1936), 33–46; L. F. Sandler, *Gothic Manuscripts 1285–1385, A Survey of Manuscripts Illuminated in the British Isles*, 5, ed. J.J.G. Alexander (London, 1986), II: 147–149; L. F. Sandler, "Word Imagery in English Gothic Psalters: The Case of the Vienna Bohun Manuscript (ÖNB, cod. 1826*)," in *The Illuminated Psalter: Studies in the Content, Purpose, and Placement of its Images*, ed. F. O. Büttner (Turnhout, 2004), 281–290.

{3} Psalter, Oxford, Exeter College Ms. 47, begun *c.* 1360, possibly for Humphrey de Bohun, sixth earl of Hereford and Essex, or after 1361, for Humphrey de Bohun, seventh earl of Hereford, Essex and Northampton, completed for unknown patron in a later campaign, *c.* 1390.

127 fols.; 286 × 190 mm; text block 181 × 101 mm; 22 long lines.

(New foliation) fols. 1–6V (calendar), illustrations, later artist, *c.* 1390; fols. 7–81V (Psalms 1–113), historiated initials and borders, John de Teye, and most minor initials, associate of John de Teye, *c.* 1360–1373; fols. 82–126V (Psalms 118–150, Canticles, fragmentary litany, *Memoriae*), minor initials, associate of John de Teye, *c.* 1360–1373, historiated initials and borders, various later hands, *c.* 1390.

H. O. Coxe, *Catalogus codicum MSS. qui in collegiis aulisque Oxoniensibus hodie adservantur*, Codices Mss. collegii Exoniensis, 2 vols. (Oxford, 1852), I: 17–18; Burlington Fine Arts Club, London, *Exhibition of Illuminated Manuscripts* (London, 1908), 35–36, no. 73; M. R. James and E. G. Millar, *Bohun Manuscripts* (as in Appendix no. 2), 5–22; L. F. Sandler, *Gothic Manuscripts* (as in Appendix no. 2), II: 149–151; L. Dennison, "Oxford, Exeter College Ms. 47: The Importance of Stylistic and Codicological Analysis in Dating and Localization," in *Medieval Book Production, Assessing the Evidence*, ed. L.L. Brownrigg (Los Altos Hills, Calif., 1990), 41–60; A.G. Watson, *A Descriptive Catalogue of the Medieval Manuscripts of Exeter College, Oxford* (Oxford, 2000), 79–82.

{4} Psalter and Hours of the Virgin, London, British Library Ms. 3277, begun after 1361(?), probably for Humphrey de Bohun, seventh earl of Hereford, Essex and Northampton, completed in the 1380s in a later campaign, possibly on commission from Joan Fitzalan, countess of Hereford, widow of the seventh earl.

iii + 170 fols.; 343 × 232 mm; text block 215 × 125 mm (app.); 24 long lines.

fols. 1–6V (calendar), illustrations, follower of John de Teye's associate, 1380s(?); fols. 7–170V (Psalms, Canticles, Litany, Hours of the Virgin, Penitential Psalms and Litany, Office of the Dead, *Memoriae*, Confession of Robert Grosseteste), all initials and borders, except as noted below, and almost all verse initials and line-fillers, associate of John de Teye, *c.* 1361–1373; fols. 29V, 46V, 67, 68V, 78, 87, 98V, 114, 120V, 123, 126V, 129, 133, 142, 145V (main divisions of Psalter, Hours of the Virgin, Penitential Psalms, and Office of the Dead), large historiated initials and borders, anonymous artists over earlier drawings by John de Teye or his associate, 1380s.

British Library, *Catalogue of Additions to the Manuscripts 1936–1945* (London, 1970), 376–381; L. F. Sandler, *Gothic Manuscripts* (as in Appendix no. 2), II: 151–154; L. Dennison, "British Library, Egerton Ms. 3277: A Fourteenth-Century Psalter-Hours and the Question of Bohun Family Ownership," in *Family and Dynasty in Late Medieval England, Proceedings of the 1997 Harlaxton Symposium*, ed. R. Eales and S. Tyas, Harlaxton Medieval Studies, IX (Donington, 2003), 122–156; L.F. Sandler, "Bared: The Writing Bear in the British Library Bohun Psalter," in *Tributes to Jonathan J.G. Alexander: The Making and Meaning of Illuminated Medieval and Renaissance Manuscripts, Art & Architecture*, ed. S. L'Engle and G. B. Guest (London, 2006),269–280.

{5} London, British Library Ms. Royal 20. D.IV, Romance of Lancelot, France, *c.* 1300, two repainted miniatures with initials repainted with Bohun arms on fols. 1 and 102V, John de Teye, *c.* 1360–1380.

310 fols.; 340 × 238 mm; text block 240 × 155 mm; 2 cols., 40 lines.

G. F. Warner and J. P. Gilson, *Catalogue of Western Manuscripts in the Old Royal and King's Collections*, 4 vols. (London, 1921), II: 378; F. Wormald, "Afterthoughts on the Stockholm Exhibition," *Konsthistorisk Tidskrift* 22 (1953), 83–84; L. F. Sandler, *Gothic Manuscripts* (as in Appendix no. 2), II: 154–155; A. Stones, "A Note on the 'Maître au Menton Fuyant,'" in *"Als Ich can," Liber amicorum in Memory of Professor Dr. Maurits Smeyers*, ed. B. Cardon *et al.* (Leuven, 2002), 1263; http://www.bl.uk, Manuscripts Catalogue (revised description); http://www.bl.uk, Digitized Manuscripts.

{6} Psalter, Cambridge, Fitzwilliam Museum Ms. 38-1950, made for Mary de Bohun or Henry Bolingbroke, *c.* 1380–1394, with fifteenth-century additions for a male owner.

iii + 243 + iii fols.; 170 × 119 mm; text block 98 × 63 mm; 18 long lines.

fol. 1 (Psalm 1), miniature, historiated initial and *bas-de-page*, John de Teye; fols. 1ᵛ–217ᵛ (Psalms, Canticles, Penitential Psalms and beginning of Litany), miniatures, historiated initials, *bas-de page* illustrations, and minor initials, associate of John de Teye; fols. 218–243ᵛ (part of litany, prayers and calendar), fifteenth century.

Burlington Fine Arts Club (as in Appendix no. 3), 34–35, no. 72; G. F. W[arner]., *A Descriptive Catalogue of Fourteen Illuminated Manuscripts (Nos. XCV to CVI and 79A) Completing the Hundred in the Library of Henry Yates Thompson* (Cambridge, 1912), 45–52, no. XCIX, reprinted with slight revisions in M. R. James and E. Millar, *Bohun Manuscripts* (as in Appendix no. 2), 51–59; F. Wormald and P. M. Giles, *A Descriptive Catalogue of the Additional Illuminated Manuscripts in the Fitzwilliam Museum Acquired between 1895 and 1979 (Excluding the McClean Collection)*, 2 vols. (Cambridge, 1982), II: 431–436; L. F. Sandler, *Gothic Manuscripts* (as in Appendix no. 2), II: 159–161; L. F. Sandler, "Gone Fishing: Angling in the Fitzwilliam Bohun Psalter," in *Signs & Symbols, Proceedings of the 2006 Harlaxton Symposium*, ed. J. Cherry and A. Payne, Harlaxton Medieval Studies, XVIII (Donington, 2009), 168–179.

{7} Psalter and Hours of the Virgin, Oxford, Bodleian Library Ms. Auct. D.4.4, made for Mary de Bohun, *c.* 1380–1394, with fifteenth-century additions.

xii + 274 fols.; 168 × 115 mm; text block 98 × 61 mm; 18 long lines.

fols. iii v–xiᵛ (prayers and calendar), fifteenth century; fols. xiiᵛ, 181ᵛ, and unnumbered leaf following fol. 243 (full-page miniatures), successor of John de Teye(?); fols. 1 and 182 (Psalm 1 and Hours of the Virgin, Matins), miniatures, initials and *bas-de-page* illustrations, John de Teye; fols. 1ᵛ–274, (Psalms, Canticles, Penitential Psalms, Litany, Hours of the Virgin, *Memoriae* and prayers, Gospel Sequences, Office of the Dead), full-page miniatures, half-page miniatures, historiated initials, *bas-de-page* illustrations, and minor initials, except as noted above, associate of John de Teye.

F. Madan *et al.*, *Summary Catalogue of Western Manuscripts in the Bodleian Library at Oxford*, 7 vols. (Oxford, 1922), II: 86–87; M. R. James and E. Millar, *Bohun Manuscripts* (as in Appendix no. 2), 23–32; L. F. Sandler, *Gothic Manuscripts* (as in Appendix no. 2), II: 157–159.

{8} Baden-Baden, Lichtenthal Abbey Archive Ms. 2, Psalter and Short Office of the Cross (in Anglo-Norman), made for Mary de Bohun or Henry Bolingbroke, *c.* 1380–1394.

166 fols.; 180 × 130 mm; text block 110 × 70 mm; 20 long lines.

fols. 1–158 (Calendar, Psalms, Canticles and Litany), calendar illustrations, historiated initials, borders, and *bas-de-page* illustrations, John de Teye; fols. 160–164ᵛ (Short Office of the Cross), historiated initials and borders, assistant, over drawings by John de Teye; fol. 165 (prayer), historiated initial and border, John de Teye; almost all minor initials and borders, verse initials and line-fillers throughout, associate of John de Teye.

F. Heinzer and G. Stamm, *Die Handschriften von Lichtenthal, Die Handschriften der Badischen Landesbibliothek in Karlsruhe*, 11 (Wiesbaden, 1987), 350–352; F. Heinzer, "Un témoin inconnu de 'Bohun Manuscripts': Le ms. 2 des archives de l'abbaye de Lichtenthal," *Scriptorium* 43 (1989), 259–266; H.-P. Geh and G. Römer, eds., *Mittelalterliche Andachtsbücher Psalterien, Stundenbucher, Gebetbucher ...* (Karlsruhe, 1992), 88–90; H. Siebenmorgan, ed., *Faszination eines Klosters, 750 Jahre Zisterzinserinnen-Abtei Lichtenthal* (Karlsruhe, 1995), 260–261; L. F. Sandler, *The Lichtenthal Psalter and the Manuscript Patronage of the Bohun Family* (London, 2004); L. F. Sandler, "The Anglo-Norman Office of the Cross of the Lichtenthal Psalter," in *Cultural Performances in Medieval France, Essays in Honor of Nancy Freeman Regalado*, ed. E. Doss-Quinby, R. L. Krueger, and E. J. Burns (Cambridge, 2007), 153–162.

{9} Legends of the Virgin Mary, St. Margaret, and St. Mary Magdalen, Copenhagen, Kongelige Bibliotek Ms. Thott 517.4°, made for Mary de Bohun, *c.* 1380–1394.

38 fols.; 176 × 130 mm; text block 110 × 70 mm; 20 long lines.

fols. 1, 10ᵛ, 22ᵛ, historiated initials and borders, John de Teye; almost all minor initials and borders, associate of John de Teye.

N. C. L. Abrahams, *Description des manuscrits français du moyen âge de la Bibliothèque royale de Copenhague* (Copenhagen, 1844), 9; C. Bruun, *De illuminerede Haandskrifter fra Middelalderen I. Det Store Kongelige Bibliotek, Copenhagen* (Copenhagen, 1890), 197; E. Jorgensen, *Catalogus codicum latinorum medii aevi Bibliothecae Regiae Hafniensis* (Copenhagen, 1926), 232–233; Gyldne Bøger, *Illuminerede middelalderlige håndskrifter: I Danmark og*

Sverige (Copenhagen, 1952), no. 16; F. Wormald, "Afterthoughts" (as in Appendix no. 5) 83–84; L. F. Sandler, *Gothic Manuscripts* (as in Appendix no. 2), II: 162–163; L. F. Sandler, "Mary de Bohun's *Livret de saintes* in Copenhagen," in *Tributes to Nigel J. Morgan, Contexts of Medieval Art: Images, Objects & Ideas*, ed. J. M. Luxford and M. A. Michael (London, 2010), 65–76.

{10} Hours of the Virgin, Copenhagen, Kongelige Bibliotek Ms. Thott 547.4°, made for Mary de Bohun, *c.* 1380–1394.

15. 66 fols.; 176 × 130 mm; text block 108 × 67 mm; 20 long lines.

fols. 1–66 (Hours of the Virgin, Penitential Psalms and Litany, Office of the Dead), historiated initials, borders, and *bas-de-page* illustrations, John de Teye; almost all minor decoration, associate of John de Teye.

C. Bruun, *De illuminerede Haandskrifter* (as in Appendix no. 9), 192–196; Jorgensen, *Catalogus* (as in Appendix no. 9), 232–233; M. R. James and E. Millar, *Bohun Manuscripts* (as in Appendix no. 2), 47–52; L. F. Sandler, *Gothic Manuscripts* (as in Appendix no. 2), II: 161–162; E. Petersen, "*Illuminatio*: Texts and Illustrations of the Bible in Medieval Manuscripts in the Royal Library, Copenhagen," in *Transactions of the 15th Congress of the International Association of Bibliophiles, Copenhagen 20–26 September 1987*, ed. P. A. Christiansen (Copenhagen, 1992), 75–79; E. Petersen, ed., *Living Words and Luminous Pictures: Medieval Book Culture in Denmark* (Copenhagen, 1999), no. 20; N. Damsholt, "Women and Book Culture," in *idem, Living Words* [Essays], 113–115; M. Vidas, "Representation and Reception, Women in the Copenhagen Bohun Hours Ms. Thott 547.4°," *Fund og*

Forskning i det kongelige Biblioteks Samlinger 50 (2011), 79–128.

{11} *Memoriae* and Gospel Sequences from a Book of Hours, Pommersfelden, Gräflich Schönbornische Bibliothek Ms. 348, made for Mary de Bohun or Henry Bolingbroke, *c.* 1380–1394.

15 fols.; 170 × 122 mm; text block 120 × 75 mm; 20 long lines.

fols. 1–9, 10v–14v, historiated initials, borders, minor decoration, associate of John de Teye; fols. 9v–10 (Instruments of the Passion, male and female saints), full-page miniatures, John de Teye.

Katalog der Handschriften der Gräflich von Schönbornischen Bibliothek zu Pommersfelden, IV (typewritten copy at Monumenta Germaniae Historica, Munich); L. F. Sandler, *Gothic Manuscripts* (as in Appendix no. 2), II: 155–157; J. Plotzek, ed., *Andachtsbücher des Mittelalters aus Privatbezitz* (Cologne, 1987), no. 12.

{12} Hours of the Virgin and Psalter, Edinburgh, National Library of Scotland Ms. Adv. 18.6.5, made for Eleanor de Bohun, *c.* 1389–1397.

148 fols.; 225 × 152 mm; text block 140 × 97 mm; 2 cols., 32 lines.

Historiated initials & borders, London artist "C^2" of the Carmelite Missal (London, Ms. Add. 29704-29705).

Burlington Fine Arts Club (as in Appendix no. 3), 73–74, no. 150; L. F. Sandler, *Gothic Manuscripts* (as in Appendix no. 2), II: 163–165; L. F. Sandler, "The Last Bohun Hours and Psalter," in *Tributes to Kathleen L. Scott, English Medieval Manuscripts: Readers, Makers and Illuminators*, ed. M. V. Hennessy (London, 2008), 231–250.

ADEN KUMLER

The Patron-Function

INTRODUCTION

THE RECENT flowering of medieval patron-
age studies has recuperated the related prob-
lems of intentionality and agency for a period of art
history in which named artists are rare and textual
evidence for the aims of individual artists is scarce.
Confronted with the documentary void that so often
envelops medieval artists and *their* conception, real-
ization, and response to the monuments and objects
they made, art historians have increasingly attended
to the evidence—often vexingly terse or simply am-
biguous—for the agency and intentions of patrons.[1]

This discovery, or re-discovery, of the important
part played by patrons in the realization of many me-
dieval works of art, architecture, and material culture
follows several decades in which Vasarian or Roman-
tic conceptions of individual artistic genius have been
seriously interrogated and found wanting in relation
to medieval practices and works. As a consequence,
the turn to patronage among medievalists has brought
a new interest in how collective, collaborative, and
sometimes contested forms of agency were distributed
among a variety of historical actors in the making of
monumental and so-called "minor" works of art, alike.

Epitomized beautifully by a full-page painting from
the Toledo *Bible moralisée*, now held at the Morgan

Library, the making of art in the Middle Ages always
involved social relations (Fig. 1).[2]

Here, the Toledo *Bible moralisée* would seem to re-
count its own origins in the social, intellectual, and
aesthetic milieu of thirteenth-century Paris, a locus
in which royal interests collaborated with clerical and
artistic ambitions. In the upper register, the figure of a
queen (likely intended to evoke Blanche of Castile) ad-
dresses her male royal counterpart with an animated
gesture that suggests both her active participation in
the *Bible moralisée*'s conception and her continuing
role as a presiding, patronal genius over the scene of
production below. In that lower register, the queen's
adlocutio is echoed by a clerical figure as he makes his
point, *viva voce*, with reference to the open volume on
his desk. And finally, in a delightful *mise-en-abîme*, in
the lower right compartment of the image an artist
sits hunched over a folio upon which we can make
out the alternating roundels and text columns char-
acteristic of the *mise-en-page* of *Bibles moralisées*. The
quadripartite organization of the painting, defined by
an architectural embrasure that loosely evokes the
dense cityscape of Capetian Paris, frames the making
of this monumental work of exegesis and illumination
as embedded within, and productive of, a profoundly
relational social, intellectual, and aesthetic economy.[3]

1. The tradition and recent flowering of patronage studies
within the field of medieval art history is surveyed, with an
extensive bibliography, in Jill Caskey's excellent *vade mecum*:
J. Caskey, "Whodunnit? Patronage, the Canon, and the Prob-
lematics of Agency in Romanesque and Gothic Art," in *A Com-
panion to Medieval Art*, ed. Conrad Rudolph (Malden, Mass.;
Oxford, 2008), 193–212. For a complementary survey essay,
see also B. Brenk, "Committenza," in *Enciclopedia dell'arte me-
dievale*, ed. A. M. Romanini and M. Righetti, 12 vols. (Rome,
1994), 5: 203–218.

2. On the separated final quire of the third volume of the
Toledo *Bible moralisée*, today preserved at the Morgan Library
(Ms. M. 240), with extensive reference to prior scholarship,
see J. Lowden, *The Making of the Bibles Moralisées* (University
Park, Pa., 2000), 1: 95–137; R. Branner, *Manuscript Painting in*

Paris During the Reign of Saint Louis: A Study of Styles (Berkeley,
Calif., 1977), 47–57; H. Stahl, *Picturing Kingship: History and
Painting in the Psalter of Saint Louis* (University Park, Pa., 2008),
16–23; E. König and R. Haussherr, *Bible moralisée: Prachthand-
schriften des Hohen Mittelalters; gesammelte Schriften von Rei-
ner Haussherr* (Petersberg, 2009), 100–102. Morgan Library,
Ms. M.240 is reproduced in facsimile, with a commentary, in
H.-W. Stork, *Die Bibel Ludwigs des Heiligen: Vollständige Fak-
simile-Ausgabe im Originalformat von MS M.240 der Pierpont
Morgan Library, New York*, 2 vols., Codices selecti phototypice
impressi, 102–102* (Graz, 1995). For an online full-color surro-
gate and extensive bibliographic information, see http://corsair
.themorgan.org/cgi-bin/Pwebrecon.cgi?BBID=77422

3. I concur with Lowden's warning that this painting "can-
not, of course, be taken as a simple factual record of the making

FIGURE 1. Making a *bible moralisée* in the Toledo *Bible moralisée*, *c.* 1220s–1230s C.E.;
New York, Pierpont Morgan Library, Ms. M. 240, fol. 8ʳ (photo: The Pierpont Morgan
Library, New York).

Indeed, as art historians have increasingly come to appreciate, the making of many ambitious medieval works of art—like the *Bibles moralisées* produced in thirteenth-century Paris—defy the tidy accounts of agency and intention once favored by scholars.[4] Adding to the difficulty or fascination (depending on one's predilications) of so much of the period's art and architecture, many medieval works of art also propose accounts of their making; accounts that are highly rhetorical, even artful in their modes of address and persuasion.

To take a further example, the inscription of the proper noun "Gofridus" on a choir capital at St.-Pierre in Chauvigny would seem, in a series of chisel strokes, to range the plastic forms carved from the surface of the block under the authorial rubric of a personal name, and, by visual implication, to align the sculptor's act of manual making with the providential working of the deity's hand in salvation history (Fig. 2).[5] The epigraphic identification "Gofridus" resists reduction to a more or less neutral gesture of (self) identification. It is, instead, no less an epiphany of presence, authority, and paradoxically self-assertive homage than the carved scene of the Magi kneeling before the Virgin and Christ Child that it frames from above. The manual inscription of "Gofridus" in this block—and all that its suggestive juxtaposition with the *manus dei* might imply—set the capital apart, at least in our historiography, from other unsigned blocks.[6]

of the *Toledo Bible moralisée*"; he sees the figures of the lower half of the miniature as "representative[s]" of the "religious" advisers/designers of the project and the "craftsmen" who realized the work, but suggests that while the royal figures of the upper half of the image are likewise "representative," they must also have been "understood as individuals"; for Lowden's extended discussion of this image, see Lowden, *The Making of the Bibles Moralisées* (as in note 2), 127–132.

4. Updating Robert Branner's findings, Mary and Richard Rouse note that the making of the *Bibles moralisées* was a signal event in the history of illuminated book production in the thirteenth century and "provided recurrent employment over some thirty years for a small army of book-producers": R. H. Rouse and M. A. Rouse, *Manuscripts and Their Makers: Commercial Book Producers in Medieval Paris, 1200–1500* (Turnhout, 2000), 1: 33. Indeed, the vast quantity of innovative vignettes devised for the *Bibles moralisées*, a number frequently estimated to surpass 13,000 individual medallions, is remarkable. As Harvey Stahl summarizes, "the research and invention, planning and production, required to create these manuscripts should be counted among the most ambitious pictorial enterprises undertaken in any medium during the Middle Ages. Artistically, they represent a quantum enlargement of the pictorial repertory and an unprecedented expansion of both the range of visual interpretations and the strategies used to communicate them...": Stahl, *Picturing Kingship* (as in note 2), 16. For further discussion of the production processes employed in the making of the *Bible moralisées*, see Lowden, *The Making of the Bibles Moralisées* (as in note 2) and vol. 2: 199–209 (esp.). The scope, duration, and complexity of the production of these moralized bibles staggers the imagination, and foregrounds the inadequacy of older conceptions of more or less autonomous artistic "masters" supervising manuscript production within discrete workshops or ateliers. The discursive production of "masters" by connoisseurial art history is, of course, a paral-

lel phenomenon to the production of "patrons" by works of art explored in this essay.

5. Marie-Thérèse Camus identifies this inscription as "[l]e nom du sculpteur," (p. 64), and notes that further inscriptions identifying the carvers of sculpture are found elsewhere in Poitou: M.-T. Camus, *Sculpture romane du Poitou: Le temps des chefs-d'œuvre* (Paris, 2009), 314. For Camus's further discussion of "la personnalité puissante" of Gofridus, as manifested in his carvings, see *ibid.*, 365–369.

6. On medieval signatures, see Béatrice Fraenkel's magisterial study: B. Fraenkel, *La Signature, genèse d'un signe*, Bibliothèque des histoires (Paris, 1992). For further discussion of the inclusion of proper nouns in medieval works of art and their complex, vexed status in historical interpretation, including the often contested identification of such names as artists' "signatures," see M. Schapiro, "Script in Pictures: Semiotics of Visual Language," in *Words, Script, and Pictures: Semiotics of Visual Language* (New York, 1996), 117–126 (esp.); C. B. Kendall, *The Allegory of the Church: Romanesque Portals and their Verse Inscriptions* (Toronto; Buffalo, N.Y.; London, 1998), 171–184; J. Leclercq-Marx, "Signatures iconiques et graphiques d'orfèvres dans le haut Moyen Âge. Une première approche," *Gazette des beaux-arts*, ser. 6, 137 (2001), 1–16; R. Favreau, "Les commanditaires dans les inscriptions du haut Moyen Age occidental," in *Committenti e produzione artistico-letteraria nell'alto medioevo occidentale*, 2 vols., Settimane di studio del Centro Italiano di Studi sull'Alto Medioevo 39 (Spoleto, 1992), 681–722; P. C. Claussen, "Früher Künstlerstolz: Mittelalterliche Signaturen als Quelle der Künstsoziologie," in *Bauwerk und Bildwerk im Hochmittelalter: anschauliche Beiträge zur Kultur- und Sozialgeschichte*, ed. K. Clausberg (Giessen, 1981); R. Oursel, *Floraison de la sculpture romane*, vol. 2, Introductions à la Nuit des temps, 7 ([La Pierre-qui-Vire], 1973), 11–35; P. C. Claussen, "Künstlerinschriften," in *Ornamenta ecclesiae: Kunst und Künstler der Romanik: Katalog zur Ausstellung des Schnütgen-Museums in*

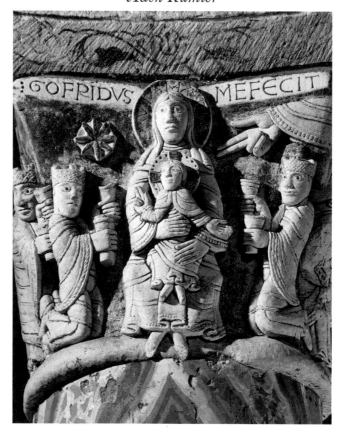

FIGURE 2. *Gofridus me fecit*: Historiated capital from St.-Pierre de Chauvigny (Poitou-Charentes), *c.* 1120–1150 C.E. (photo: Gianni Dagli Orti/The Art Archive at Art Resource, N.Y.).

Other names etched into the surfaces of medieval works of art delineate a different vision of what it means to be a work's maker. A ninth-century carved ivory plaque in the Museo Archeologico Nazionale at Cividale presents us with not one, but two statements attributing its confection to *Dux Vrsus* (Fig. 3).[7] Hedg-

ing its bets, the ivory employs both the terse perfect tense that we encountered in the Gofridus inscription at Chauvigny in the claim *Vrsus dux fecit* (Duke Ursus made [me/this]) inscribed upon the surface of the Cross immediately above Christ's head, only to further insist in an inscription below Christ's left arm on

der Josef-Haubrich-Kunsthalle, ed. A. Legner, 3 vols. (Cologne, 1985), 1: 187–230; P. A. Mariaux, "Women in the Making: Early Medieval Signatures and Artists' Portraits (9th–12th c.)," in *Reassessing the Roles of Women as "Makers" of Medieval Art and Architecture*, ed. T. Martin, 2 vols., Visualising the Middle Ages 7 (Leiden, 2012), 1: 393–427; A. Legner, "Illustres manus," in *Ornamenta ecclesiae: Kunst und Künstler der Romanik*, ed. A. Legner, 3 vols. (Cologne, 1985), 1: 187–230; A. Dietl, *Die Sprache der Signatur: Die mittelalterlichen Künstlerinschriften Italiens*, 4 vols., Italienische Forschungen, 4 (Berlin, 2009), 6. For a penetrating analysis of the influence of inscribed proper nouns upon the art historical imagination, see L. Seidel, *Legends in Limestone: Lazarus, Gislebertus, and the Cathedral of Autun* (Chicago, Ill., 1999), 1–32.

7. The ivory plaque has traditionally been identified as a pax,

but, as Adolph Goldschmidt proposed, it seems more likely it was originally employed in a book cover. The *Vrsus* named in the plaque's inscription cannot be identified with certainty; Goldschmidt suggested that the inscription naming Ursus may itself represent a second campaign of work, subsequent to the carving of the figural elements, which he argues were accomplished no later than the first quarter of the ninth century: A. Goldschmidt, *Die Elfenbeinskulpturen aus der Zeit der Karolingischen und Sächsischen Kaiser, VIII.–XI. Jahrhundert*, Denkmäler der deutschen Kunst (Berlin, 1969), 1: 82 (No. 166). I regret that I have been unable to consult M. De Faccio, "Cinque sècoli di fortuna visiva di un manufatto altomedievale: la 'pace' del duca Orso tra disegni, incisioni e fotografie," *Forum Iulii* 24 (2000), 33–51.

FIGURE 3. So-called Pax of Duke Ursus, *c.* 900 C.E. (?); Museo Archeologico Nazionale, Cividale (photo: Cameraphoto Arte, Venice/Art Resource, N.Y.).

the cross: *Vrsus dux fieri precepit* (Duke Ursus ordered [me/this] to be made). The intertwined questions of agency and intention are taken up and resolved, not once, but twice on the plaque's surface: the ivory names Ursus as the immediate, perfect-tense cause of its carved surface ("fecit") and, simultaneously, attributes to that ducal figure a mediated, but no less determinative role as the author of the ivory's making (*precipit fieri*).[8]

If the Chauvigny capital and the Cividale ivory propose two different accounts of how works of art might come to be—one seemingly focused on the artist's hand, the other suppressing the name of that hand in favor of the denomination of a patron—other works, like the Morgan *Bible moralisée* full-page painting—pursue a middle way, framing their origins and, presumably, their excellence as a collective affair, involving a triangulation between makers, patrons, and works. Laying bare the social dynamics of much, if not all medieval creation, the initial letter D of Psalm 101 in a glossed Psalter, likely produced in Reading, tells us *Iohannes me fecit | Rogerio* ("John made me | for Roger") (Fig. 4).[9] This declaration, articulated within the very form of the large decorated letter, quite literally embeds the names John and Roger in its very fabric, and so designates the artful letter as produced by,

and an enduring witness to, the calligraphic and biographic conjunction of these two names. The Psalm verse opened by this initial, *Domine exaudi orationem meam et clamor meus ad te veniat* ("Hear, O Lord, my prayer: and let my cry come to thee," Psalm 101:2), one of the seven penitential psalms, situates this two-fold attribution within a poignant, soteriological context. Calling out to the Lord, the initial would seem to speak of and for both its maker and its original recipient, further embedding their common connection to the manuscript, and to each other, within the practice of penitence, prayer, and petition.

As this heteroclite sampling of works suggests—and the essays in this volume amply demonstrate—medieval monuments and portable objects propose a heterogeneous, even contradictory, series of accounts of the relative primacy of artists or patrons, the venerated role of a charismatic founder or donor, and the agency of collectivities. Indeed, Madeline Caviness, Stephen Perkinson, Elizabeth Pastan and Stephen White, and other scholars have variously cautioned against the fallacy of substituting or conflating the agency and intention of artists, patrons, and recipients; an interpretive practice that risks reproducing the rhetorics and tropes of many medieval works of art.[10] At times, it would seem, art historical recuperation

8. On the "me fecit" and "me fieri fecit" formulae favored by medieval artists and patrons, in addition to the sources cited in note 6, see also Kendall, *The Allegory of the Church* (as in note 6), 83–84, 172; P. A. Mariaux, "Quelques hypothèses à propos de l'artiste roman," *Médiévales. Langues, Textes, Histoire* 44 (2003), 199–214.

9. Oxford, Bodleian Library, Ms. Auct. D.4.6 and the decorated initial considered here are assigned to Reading Abbey on stylistic grounds and in light of a fourteenth-century annotation referring to the building of the chapel of St. Mary, Reading (fol. 157ᵛ): J. J. G. Alexander, "Scribes as Artists: The Arabesque Initial in Twelfth-century English Manuscripts," in *Medieval Scribes, Manuscripts & Libraries: Essays Presented to N. R. Ker*, ed. M. B. Parkes (London, 1978), 87–116; A. Coates, *English Medieval Books: The Reading Abbey Collections from Foundation to Dispersal*, Oxford Historical Monographs (Oxford; New York, 1999), xx–xxi, 53–55, 58–59, 113, 152–153 (No. 47). Although the Roger named in the initial D of fol. 91ʳ has commonly been identified as the Roger who served as Reading's fifth abbot from (1158–1165 C.E.), and while the manuscript has been identified as one of two glossed Psalters inventoried at the abbey as once belonging to "Rogerii Sigar" in the so-

called Fingall Cartulary's inventory of Reading Abbey books (London, British Library, Egerton Ms. 3031, fol. 8ᵛ), Peter Kidd has noted that the Bodleian Psalter cannot be securely identified with either of the two glossed Psalters listed in the inventory and therefore its usual dating to the Abbot Roger's tenure at Reading on the basis of this external evidence is not secure: http://mssprovenance.blogspot.com/2010/12/bodleian-ms-auct-d-4-6.html. A transcription of the inventory of Reading Abbey's library in Egerton Ms. 3031, fols. 8ᵛ–10ᵛ and 12ᵛ is available in Coates, *English Medieval Books*, 25–34. In a personal communication (12/27/2012) Peter Kidd kindly observed that the litany found in Ms. Auct. D.4.6 is that of Winchester, which would suggest that either the Psalter was made for Roger before his abbacy at Reading, or else that the manuscript was not made for Reading's Abbot Roger.

10. S. Perkinson, *The Likeness of the King: A Prehistory of Portraiture in Late Medieval France* (Chicago, Ill., 2009), 189–277 (esp.); M. Caviness, "Patron or Matron? A Capetian Bride and a *Vade Mecum* for Her Marriage Bed," *Speculum* 68 (1993), 333–362; M. Caviness, "Anchoress, Abbess, and Queen: Donors and Patrons or Intercessors and Matrons?" in *The Cultural Patronage of Medieval Women*, ed. J. H. McCash (Athens, Ga.,

FIGURE 4. *Ioh(ann)es me fecit Rogerio*: Psalter with interlinear gloss, *c.* 1158–1164 c.e. (?); Oxford, Bodleian Library, Ms. Auct. D.4.6, fol. 91ʳ (photo: Bodleian Library, University of Oxford).

of intention in the name of the patron has inadver-
tently smuggled a persistent conception of *individual*
authorial agency, authority, and presence into ex-
planations of how certain, often celebrated, medi-
eval works of art came to be.[11] Implicitly or explic-
itly designating the patron as the specific cause of
monuments and portable objects alike, we have often
construed those works as indices of singular authors,
treating them as symptomatic traces of a self-fash-
ioned, lived life.[12]

In a speculative and experimental spirit, this essay
considers what might be at stake in the *inventio patroni*
or *matronae* practiced in art historical interpretation
of medieval works of art.[13] It can hardly be contested
that the social-art historical study of patronage has
had a powerful influence upon our understanding of
what it variously meant to make, to commission, to
receive, and to behold monuments and objects over
the course of the Middle Ages. In this essay, how-
ever, I propose to step back from this way of thinking
about medieval patronage, and to consider instead
the discursive elaboration and power of patronage as

a cultural-historical and epistemic function, a func-
tion operative within medieval art, but also—no less
powerfully—operative within our interpretations of
the medieval past. In other words, I propose a thought
experiment driven by the question: what would hap-
pen were we to think of patrons as the *effects*, rather
than the causes of certain works of art?

A PATRON-FUNCTION IN THE
MIDDLE AGES?

This line of speculation takes as its point of departure
the 1969 lecture Michel Foucault gave to the *Société
française de Philosophie*, published in the same year as
the essay "Qu'est-ce qu'un auteur?," a text in which
Foucault responds, in a rather devastating fashion, to
Roland Barthes's claims concerning the death of the
author.[14] The complexity and difficulty of Foucault's
lecture turned essay are well known; here, I offer only
a brief précis of the heart of Foucault's conception
of the author-function in order to appropriate that
analysis for my own ends.[15]

Foucault's examination of "the author-function"

1996), 105–153; E. C. Pastan and S. D. White, "Problematizing
Patronage: Odo of Bayeux and the Bayeux Tapestry," in *The
Bayeux Tapestry: New Interpretations*, ed. M. K. Foys, K. E. Over-
bey, and D. Terkla (Woodbridge; Rochester, N.Y., 2009), 1–24.

11. As Perkinson has noted: Perkinson, *The Likeness of the
King* (as in note 10), 25. See also the salutary prefatory re-
marks by Lindquist and Perkinson in the special issue of *Gesta*
dedicated to later medieval "artistic identity" edited by them:
Sherry C. M. Lindquist and Stephen Perkinson, "Artistic Iden-
tity in the Late Middle Ages: Foreword," *Gesta* 41, no. 1 (2002),
1–2.

12. The convergence and collaboration of connoisseurial,
symptomatic, and deductive-forensic modes of interpretation
are brilliantly explored in C. Ginzburg, "Morelli, Freud, and
Sherlock Holmes: Clues and Scientific Method," in *The Sign
of Three: Dupin, Holmes, Peirce*, ed. U. Eco and T. Sebeok, Ad-
vances in Semiotics (Bloomington, Ind., 1983), 81–118. On
"self-fashioning," see the landmark formulation of S. J. Green-
blatt, *Renaissance Self-fashioning: From More to Shakespeare* (Chi-
cago, Ill., 1980).

13. The import of the language and concepts we bring to
discussions of women as patrons in the Middle Ages is further
elucidated by Corine Schleif's contribution to the present vol-
ume. For further discussion of *matronae*, matrons, and the larger
questions surrounding the interpretation of art commissioned
by, made for, or made "against" medieval women, see the es-
says by Caviness cited in note 10.

14. M. Foucault, "Qu'est-ce qu'un auteur?" *Bulletin de la
Société française de philosophie* 63, no. 3 (1969), 73–104. English
translation cited from M. Foucault, "What Is an Author?" in *The
Foucault Reader*, ed. P. Rabinow, trans. J. V. Harari, 1st ed. (New
York, 1984), 101–120. Originally published in 1968, the Barthes
essay to which Foucault responds was reprinted as R. Barthes,
"La mort de l'auteur," in *Le bruissement de la langue*, Essais
critiques, 4 (Paris, 1984), 61–67. For further consideration of
Foucault's response to Barthes's claims concerning the author's
death, see A. Wilson, "Foucault on the 'Question of the Author':
A Critical Exegesis," *The Modern Language Review* 99, no. 2
(2004), 339–363, 340–348 (esp.); A. Wilson, "What Is a Text?"
Studies in History and Philosophy of Science 43, no. 2 (2012), 341–
358.

15. Foucault would seem to invite such appropriation when
he observes, but does not fully develop, the claim that the au-
thor-function "does not affect all discourses in the same way at
all times and in all types of civilization," and further suggests
that his analysis might form "an introduction to the histori-
cal analyses of discourse," observing: "[p]erhaps it is time to
study discourses not only in terms of their expressive value
or formal transformations, but according to their modes of
existence. The modes of circulation, valorization, attribution,
and appropriation of discourses vary with each culture and are
modified within each." Foucault, "What Is an Author?" (as in
note 14), 113, 117.

aims to excavate several fundamental characteristics of the author within what he calls "notre civilisa-tion."[16] The culture in question is discussed as a dis-cursive landscape, organized in relation to a litany of proper nouns: Beckett, Mallarmé, Flaubert, Proust, Kafka, Nietzsche, Clement of Alexandria, Diogenes Laertius, Jerome, and—not least—Freud and Marx, to give only a sampling of the authorial names con-jured in the essay. It is this classificatory scheme, and the operation of the auratic presence of the "author" within it, that Foucault subjects to a liberating, skep-tical analysis.[17]

Proceeding from the observation that the name of an author differs in signifying ways from other proper nouns, and that not all discourses are attributed to an author or granted the privileges of "authored" works, Foucault calls into question any commonsensical con-viction that an author is the equivalent or synonym of a "writer,"[18] or that all texts generated by the same "author" will have the same status within a given culture or historical moment.

> an author's name is not simply an element in a dis-course (capable of being either subject or object, of being replaced by a pronoun, etc.); it performs a cer-tain role in relation to discourse, assuring a classifi-catory function. Such a name permits one to group together a certain number of texts, to define them, to exclude certain ones, and to contrast them to oth-ers. Additionally, it establishes a relationship among texts…. As a result we could say that in a civilization

like our own there are a certain number of discourses that are endowed with the 'author-function,' while others are deprived of it. A private letter may well have a signer—it does not have an author; a contract may well have a guarantor—it does not have an au-thor. The author function is therefore characteristic of the mode of existence, circulation, and functioning of certain discourses within a society.[19]

Thus we can see that Foucault is developing not sim-ply a counter-history of what an author is or does, or what it means for a discourse or text to be received as "authored," but rather he is most interested in an "author-function" operative within culture. He argues that the author produced by this "operation" in dis-course is not an "actual" person, but rather a series of "egos" or subject-positions, discursively identified with the author, but fundamentally non-coincident with the originator of a given text and, therefore, available to other subjects as they variously encoun-ter that discourse. And a powerful claim within his larger argument points to the interpreter's share in this complex operation:

> It [the author function] results from a complex op-eration whose purpose is to construct the rational entity we call an author. Undoubtedly, this construc-tion is assigned a 'realistic' dimension as we speak of an individual's 'profundity' or 'creative' power, his intentions or the original inspiration manifested in writing. Nevertheless, these aspects of an individual, which we designate as an author (or which comprise

16. Foucault, "Qu'est-ce qu'un auteur?" (as in note 14), 84, 89.

17. Adrian Wilson offers a stimulating reading of the coun-ter-history sketched by Foucault's deft mobilization of precisely the authorial names previously invoked, to very different ends, by Barthes: Wilson, "Foucault on the 'Question of the Author'" (as in note 14), 344–348.

18. As Wilson elucidates, the lexical resonance of the French word "écriture" and its competing theorizations at the time of Foucault's lecture, and since, defines a semantic and analytic aporia within Foucault's essay, as in so many other subsequent theorizations of "text." Accordingly, the distinction, contiguity, or conflation of the figures of the writer and the author remains an unresolved crux in Foucault's 1969 lecture: *ibid.*, 349–354 (esp.). For further, sustained discussion of the vexed status of the "text" and "textuality" within Foucault's lecture and in its wake, see also Wilson, "What Is a Text?" (as in note 14).

19. Foucault, "What Is an Author?" (as in note 14), 107–108

(modified slightly). "… un nom d'auteur n'est pas simplement un élément dans un discours (qui peut être sujet ou complé-ment, qui peut être remplacé par un pronom, etc.); il exerce par rapport aux discours un certain rôle: il assure une fonction clas-sificatoire; un tel nom permet de regrouper un certain nombre de textes, de les délimiter, d'en exclure quelques-uns, de les opposer à d'autres. En outre il effectue une mise en l'apport des textes entre eux … On pourrait dire, par conséquent, qu'il y a dans une civilisation comme la nôtre un certain nombre de discours qui sont pourvus de la fonction 'auteur' tandis que d'autres en sont dépourvus. Une lettre privée peut bien avoir un signataire, elle n'a pas d'auteur; un contrat peut bien avoir un garant, il n'a pas d'auteur. Un texte anonyme que l'on lit dans la rue sur un mur aura un rédacteur, il n'aura pas un auteur. La fonction auteur est donc caractéristique du mode d'existence, de circulation et de fonctionnement de certains discours à l'in-térieur d'une société." Foucault, "Qu'est-ce qu'un auteur?" (as in note 14), 82–83.

an individual as an author) are projections, in terms always more or less psychological, of our way of handling texts: in the comparisons we make, the traits we extract as pertinent, the continuities we assign, or the exclusions we practise. In addition, all these operations vary according to the period and the form of discourse concerned. A 'philosopher' and a 'poet' are not constructed in the same manner ...[20]

The operation of the author-function, according to Foucault, not only appropriates a human agent in his or her name, but also conditions our reception of that act of appropriation in a two-fold manner. Retrojecting qualities discerned in an authored work into our conception of its named author, the author-function simultaneously, and in historically and culturally specific ways, shapes how we receive discourses attributed to such author-constructs.

Within this dynamic, the specific character or qualities of each work circulating and received under the name of an author plays a determinative part. Addressing this facticity of the text in relation to the author-function's operation, Foucault insists upon the priority and specific facture of the text as crucial to the author-function's effects:

> However, the author function is not, actually, a pure and simple reconstruction, made at second hand, from a text taken up as an inert material. The text always bears within itself a certain number of signs that refer to the author. These signs are well known to grammarians: they are personal pronouns, adverbs of time and place, and the conjugation of verbs.[21]

Without denying the historical reality of authors, philosophers, and poets, and their very real relationship to the texts they wrote and that circulate under their names, Foucault suggests that these empirical or biographical *realia* do not adequately account for how we receive, compare, contrast, and construe discourses in terms of their authors. At the same time, however, Foucault insists that the function of the author in our conception and reception of certain discourses is not simply an *a priori* fiction or a *post facto* construct, imposed, willy-nilly from without. The author-function is, instead, he argues, a referential presence within the specific grammatical, rhetorical, and literary fabric of texts. In other words, Foucault identifies precisely the most conventional of textual signs—those common grammatical and rhetorical protocols that collectively constitute a system of highly conventional discursive protocols—as crucial to the operation of the author-function.

Foucault distills his elaboration of the author-function into an inventory of four "characteristics;" it is these four characteristics that I shall appropriate for my discussion of medieval patronage:

> ... [1] the author function is tied to the juridical and institutional system that circumscribes, determines, and articulates the universe of discourses; [2] it does not operate in all discourses uniformly and in the same way at all times and in all forms of civilization; [3] it is defined not by the spontaneous attribution of a discourse to its producer, but rather by a series of specific and complex operations; [4] it does not refer purely and simply to a real individual; it can give rise simultaneously to several egos, to several subject-positions that different classes of individuals [*des classes différentes d'individus*] can come to occupy.[22]

The four characteristics of the author-function identified by Foucault insist upon the voice or presence of the author as an effect generated by the author-function within and through discourse. This authorial effect, in turn, profoundly shapes how a given discourse is received and circulates, both in its immediate historical milieu and in the contexts of subsequent interpretations.

20. Here I prefer the translation offered by Adrian Wilson: Wilson, "Foucault on the 'Question of the Author'" (as in note 14), 350.

21. *Ibid.*, 352.

22. Foucault, "What Is an Author?" (as in note 14), 113 (modified). In the original French text: "la fonction-auteur est liée au système juridique et institutionnel qui enserre, détermine, articule l'univers des discours; elle ne s'exerce pas unifor-mément et de la même façon sur tous les discours, à toutes les époques et dans toutes les formes de civilisation; elle n'est pas définie par l'attribution spontanée d'un discours à son producteur, mais par une série d'opérations spécifiques et complexes; elle ne renvoie pas purement et simplement à un individu réel, elle peut donner lieu simultanément à plusieurs ego, à plusieurs positions-sujets que des classes différentes d'individus peuvent venir occuper." Foucault, "Qu'est-ce qu'un auteur?" 88.

Working from Foucault's four-fold scheme, I propose a variant inventory, modified to better parse the related problems of patrons and patronage in the Middle Ages:

 1. the patron-function is tied to the juridical and institutional systems that circumscribe, determine, and articulate the realm of discourse/works;

 2. it does not operate in all discourses/works in the same way at all times and in all types of cultures, nor within any given culture;

 3. it is defined not by the spontaneous attribution of a work to its initiator/sponsor/commissioner/funder/donor or recipient, but rather through a series of precise and complex operations;[23]

 4. it does not refer, purely and simply, to a real individual, in so far as it gives rise simultaneously to a variety of egos and to a series of subjective positions that individuals may come to occupy.[24]

In what follows, I want to sketch how we might recognize each of these characteristics in medieval conceptions and practices of patronage and, if only by implication, why we might want to bring greater critical attention to bear upon patronage's discursive operations and effects.

PROPER NOUNS AND *PATROCINIA*

We can begin with our first variation on Foucault's theme, namely that "the patron-function is tied to the juridical and institutional systems that circum-

scribe, determine, and articulate the realm of discourse/works." For Foucault, the author-function's ties to juridical systems were laid bare by the emergence in the late eighteenth and early nineteenth centuries of a conception of the author as the originator of discourse as property. Accordingly, as Foucault observes, authors, like publishers, were legal subjects constituted in terms of certain rights and liabilities; that is, they were subjects capable of transgression through writing and, as a corollary, exposed to discipline and punishment.[25]

That the patron-function is implicated in larger juridical and institutional frameworks or structures in the Middle Ages, particularly in the early and high Middle Ages, is quite clear if we briefly consider the medieval concept of *patrocinium*. Taken over from the Roman legal tradition, *patrocinium* defined the relationship of obligation that bound a community to a patron saint and that patron saint to a community or jurisdiction in the Middle Ages.[26] Typically, *patrocinia* were centered on gravesites, or cult centers that possessed a saint's relics; while the *patrocinium* of certain saints might encompass an entire church, other *patrocinia* coincided with individual altars, consecrated in the name of the saint whose relics they enclosed. Accordingly, saints, present in their relics, must be recognized as active patrons in their own rights in the Middle Ages. Holy subjects, invested with quasi-legal authority, saints were understood to possess the churches or altars they inhabited in

23. As in much recent literature on medieval patronage, the terms employed here to designate the person for whom a work of art was made responds to our increased awareness of the range and diversity of relationships to the creation and receipt of works of art covered by the generic term "patron." As Colum Hourihane observed at the Princeton symposium, such a proliferation of terms has the virtue of pointing to the complexities of medieval patronage as a phenomenon and the divergence of scholarly perspectives upon it. In the final section of this essay, however, I employ the term "patron-devotee" to describe the situation of the painted female figure who so often appears in a posture of devotion in the manuscript compendium I discuss; in stressing this figure's status as a devotee I follow Adelaide Bennett's lead.

24. Attentive readers will recognize that I have suppressed Foucault's phrase "classes différentes d'individus" in my reworking of this passage. Suffice it to say that as so many of the works of art considered in this essay (and in many current

re-examinations of medieval patronage) were made for elite beholders, this suppression is deliberate.

25. Foucault, "What Is an Author?" (as in note 14), 108–109; Foucault, "Qu'est-ce qu'un auteur?" (as in note 14), 83–85.

26. For a point of entry into the extensive literature on medieval conceptions of *patrocinium*, with further bibliography, see H. Flachenecker, "Researching *Patrocinia* in German-speaking Lands," in *Saints of Europe: Studies Towards a Survey of Cults and Culture*, ed. G. Jones (Donington, 2003), 75–91; A. Angenendt, "Patron," in *Brepolis Medieval Encyclopaedias–Lexikon des Mittelalters Online*, ed. C. Bretscher-Gisiger and T. Meier, 10 vols. (Stuttgart, 2000), vol. 6, cols. 1806–1808; U. Köpf, "Patrocinia," in *Religion Past & Present: Encyclopedia of Theology and Religion*, ed. H. D. Betz *et al.*, 4th ed., English ed. (Leiden; Boston, Mass., 2007), 9: 620–621; A. Angenendt, "In Honore Salvatoris. Vom Sinn Und Unsinn Der Patrozinienkunde [1]," *Revue d'Histoire Ecclésiastique* 97, no. 2 (2002): 431–456; A. Angenendt, "In honore Salvatoris. Vom Sinn und Unsinn der

the form of their relics and, not unlike Foucault's paradigmatic modern authors, as possessors and patrons they were inscribed within a legal framework of rights, liabilities, obligations, discipline, and even punishment.

The relationship between the saint and the living inhabitants of his or her jurisdiction was one of patron and clients, a bond of mutual obligation with the potential for conflict, even coercion.[27] Patron saints were owed reverence, cultic service, deference, and even revenues within their *patrocinia*; in turn, however, they were held responsible for protecting their clients and their property. When a *patronus* failed to keep his client community from harm, liturgical and extra-liturgical practices of humiliation, punishment—even physical abuse—might be pursued by the saint's human dependents: benefaction and liability were two sides of the same coin in the dynamic contexts of medieval *patrocinia*.

In this respect, the saint's *patrocinium* offers a complex, but revealing point of entry into the operations of patronage in the Middle Ages, not simply as a series of discrete acts with social historical and art historical significance, nor even as a complex pattern or tradition of such acts, but also as a *function* articulated in

relation to legal structures or categories, but not limited to the discourses or protocols of the law. Analyzed as a function, we can recognize that the patron saint's *patrocinium* produced both distinction and solidarity, classifying and organizing economies of value, relationships to power and vulnerability, and the dynamic distribution and redistribution of authority among an array of shifting subject positions.

The patron-function's differentiated and differentiating operation, subtly animates the painting prefacing Purchard of Reichenau's *Carmen de Gestis Witigowonis Abbatis*, a petition-poem addressed to Reichenau's absentee abbot and internal patron, Witigowo, in the late tenth-century manuscript, now held in Karlsruhe (Fig. 5).[28] A major benefactor of his abbey, Witigowo was responsible for initiating the construction of the Mariamünster at Reichenau as well for giving a series of splendid ornaments to the Abbey.[29] He was also, however, chronically absent, so occupied with the business of Emperor Otto III's court, that, Purchard implies, he neglected the affairs of the monastery.[30]

In Purchard's *Carmen*, the personification of the Abbey of Reichenau, identified as Augia (a pointed, if obscure reference to 1 Esdras 5:38), laments the

Patrozinienkunde [11]," *Revue d'Histoire Ecclésiastique* 97, no. 3 (2002), 791–823.

27. On the coercion of saints and/or their relics, see P. J. Geary, "Humiliation of Saints," in *Living with the Dead in the Middle Ages* (Ithaca, N.Y., 1994), 95–115; P. J. Geary, "Coercion of Saints in Medieval Religious Practice," in *Living with the Dead in the Middle Ages*, 116–124; H. Platelle, "Crime et châtiment à Marchiennes: Étude sur la conception et le fonctionnement de la justice d'après les Miracles de sainte Rictrude (xiie s.)," *Sacris Erudiri* 24 (1980), 155–202; 174–175, 178–181 (esp.).

28. Karlsruhe, Badische Landesbibliothek, Aug. ccv, fol. 72[r]; on this manuscript, see A. Legner, ed., *Ornamenta ecclesiae: Kunst und Künstler der Romanik* (Cologne, 1985), 1: 247 (Cat. no. B 46/47). Sadly incomplete, the *Gesta Witigowonis* has been edited: Purchard von Reichenau, "Carmen de gestis Witigowonis," in *Poetae latini aevi Carolini 5: Die Ottonenzeit*, ed. K. Strecker, 2 vols., Monumenta Germaniae Historica. Antiquitates, 1 (Leipzig, 1937), 1: 260–279. Regrettably, I have not been able to consult Purchard von der Reichenau, *Die Taten des Abtes Witigowo von der Reichenau: (985–997): Eine zeitgenössische Biographie*, ed. W. Berschin and J. Staub, Reichenauer Texte und Bilder, 3 (Sigmaringen, 1992). For further discussion of

Purchard, Witigowo, and Reichenau as a patronal *milieu*, see E. Garrison, *Ottonian Imperial Art and Portraiture: The Artistic Patronage of Otto III and Henry II* (Farnham; Burlington, Vt., 2012), 11–13. I borrow the term and conception of "internal patron" and "internal patronage" from J. M. Luxford, *The Art and Architecture of English Benedictine Monasteries, 1300–1540: A Patronage History*, Studies in the History of Medieval Religion, 25 (Woodbridge, 2005), xi, 29–113 (esp.). See also Luxford's essay in the present volume.

29. Catalogued vividly in Purchard von Reichenau, "Carmen de gestis Witigowonis" (as in note 28), 269–270 (ll. 184–223), 271–276 (ll. 272–458).

30. As Augia remonstrates, "Non tamen hoc miror, cum sponso spreta relinquor, me vilem precii retinet quo iudice cuncti. Sed non sum vanis mulier clamosa querelis, perfectae fidei volo quin succumbere legi, pulcher apostolico quam laudat dogmate sermo dicens: 'Vir talis, qui non datur esse fidelis, debet salvari fretus muliere fideli.' ... patientia virtus me docuit verae convitia spernere queque; rebus in adversis nec abessent propsera mentis, si sponsus solum vellet sibi vivere mecum continuus, stabilis, nusquam pergendo localis." Ibid., 265 (ll. 36–42, 65–69). See also Garrison, *Ottonian Imperial Art and Portraiture* (as in note 28), 12.

FIGURE 5. Purchard of Reichenau, *Carmen de Gestis Witigowonis Abbatis, c.* 975–1000 C.E.; Karlsruhe, Badische Landesbibliothek, Cod. Aug. perg. 205, fol. 72ʳ (photo: Badische Landesbibliothek).

absence of her spouse, Witigowo, while simultaneously advertising his virtues and her attractions; this combination of lament and encomium effectively casts Witigowo as both a generous patron and a less than ideal husband. The painting prefacing the poem visually embeds the figure of Witigowo, standing on the Virgin's right, in a diagram of patronal relations. As Mary's client the Abbot was responsible for an ambitious expansion of the Church of St. Mary at Reichenau; this building campaign would seem to be evoked in the prefatory painting by the structure borne—with difficulty it would seem—by the personification of Reichenau in the bottom left corner of the image. In the poem's conceit and in its prefatory painting, however, Witigowo is also a problematic abbot-patron, his patronal generosity manifested in inverse proportion to his periods of residence and spousal *stabilitas*, according to Augia's complaint. Within the prefatory painting, the figure of Witigowo, visually set in parallel to Reichenau's bishop-founder Pirmin, would seem to cut a rather different figure from that illustrious predecessor. Positioned in the right half of the miniature, Pirmin stands with and for the diminutive monastic community ranged behind him. Witigowo, by contrast, enjoys a not entirely splendid isolation. Reichenau's patron-abbot, the image suggests, is not the *patronus* that the Abbey's *fundator* Pirmin remains.

The painting that introduces the *Carmen de Gestis Witigowonis* diagrams patronage as a kind of circuit: a nexus of both power and dependency. Indeed, I would suggest that in this painting the patron-function works in a manner analogous to the petitioning rhetoric of Purchard's poem: the longer we look, the less confident we are that the generous Witigowo is living up to the title of *Abba*. Positioned at the center of the composition, in a place of honor beside the Virgin and positioned to receive the Christ Child's blessing, Witigowo is also excluded from Pirmin and Mary's colloquy, and marginalized in relation to the monastic collectivity in the foreground. Although

Witigowo is given top billing in the inscription that stretches like an arch over the figures at the center of the composition, his patronal performance within the miniature is slightly discordant. It may not be going too far to observe that the artist has aligned the letters E G O from the absentee's Abbot's proper, patronal name with the rendering of his un-haloed head set against the red ground.[31]

Naming Witigowo, Purchard and the artist of this image would seem to engage in a pointed form of double talk, employing the visual and poetic forms associated with the encomium or the dedication image to single out a patronal figure in ways that do not always, or only, flatter. If Witigowo-the-patron is produced as an effect of Purchard's poem and its prefatory painting, it is as a profoundly polyvalent figure, at once an acknowledged patron and an errant abbot. Moreover, as Foucault observes of the author-function, this productive operation within the image is itself multiple. The painting visually describes not one but several mutually differentiated subject positions in which the roles of patron and client oscillate in subtly relational terms. The painting prefacing Purchard's poem does not propose a solution to the problem of Reichenau's patronage, so much as it forces the issue in the form of a question.

KNOWING PATRONS WHEN WE SEE THEM

But what of medieval works that do not name their patrons and do not speak to the beholder in a patronal first person? Pursuing these questions, in the remainder of this essay I want to briefly consider a phenomenon that I suspect is well known, perhaps even painfully obvious, to most medieval art historians, but may yet deserve further thought. I have in mind the purely visual recognition that often occurs when we see a figure like the kneeling woman depicted in a fourteenth-century Parisian manuscript and recognize in her form the image of a patron or owner (Fig. 6). We do this with something like a learned instinct. We know patrons or owners when we see them

31. It is hard to resist the temptation of seeing a trace of abbatial politics in the image. Witigowo was forced to abandon the abbacy of Reichenau in 997, an event evoked in a coda added by Purchard to his verse encomium following the event: Purchard von Reichenau, "Carmen de gestis Witigowonis" (as

in note 28), 278–279 (ll. 535–552). For further discussion of the dating and circumstances of this addition to the text, see *ibid.*, 260; Garrison, *Ottonian Imperial Art and Portraiture* (as in note 28), 12.

FIGURE 6. *Les quinze ioies nostre dame* in the *Legiloque* compendium, *c.* 1325–1350
C.E.; Paris, BnF, Ms. n.a.fr. 4338, fol. 134ʳ (photo: Bibliothèque nationale de France).

because we've come to know their favorite haunts in medieval stained glass windows, monumental sculpture, and manuscript pages alike, and we've learned their customary postures, their signifying scale, and the often illustrious company they keep.³² Indeed, these conventions for when, where, and how the figures of patrons and owners appear in medieval art are so well known to art historians that we often take them for granted. And it is in this connection, I suggest, that Foucault might help us to better appreciate the power of these complex, varying, precise, and yet profoundly conventional medieval protocols that ef-

fectively cast a patronal glamor over one figure in a group, assembly, or complex composition.

From time to time, we encounter a work of art that offers us a wonderful opportunity to watch the patron-function in action, not simply as manifest in more or less codified visual conventions, but rather as a kind of animating force that works through convention or the protocols of visual tradition to produce if not subjects, then legible subject positions; the manuscript that will form the focal point for the remainder of this essay, is just such a work of art (see Fig. 6).³³ Paris, BnF, Ms. n.a.fr. 4338 is a vernacular

32. In 2002 Nigel Morgan noted that these well-known conventions had not yet received sustained consideration as a coherent system of visual protocols: N. Morgan, "Patrons and Devotional Images in English Art of the International Gothic *c.* 1350–1450," in *Reading Texts and Images: Essays on Medieval and Renaissance Art and Patronage in Honour of Margaret M. Manion,* ed. B. J. Muir (Exeter, 2002), 93–122. Although his observation still holds true, in recent years a series of scholars, not least Morgan himself, have shed considerable light on the interest and import of these representational strategies. The following citations are representative of this development, rather than exhaustive: N. Morgan, "Patrons and Devotional Images"; N. Morgan, "Patrons and Their Devotions in the Historiated Initials and Full-Page Miniatures of 13th-Century English Psalters," in *The Illuminated Psalter: Studies in the Content, Purpose and Placement of Its Images,* ed. F. O. Büttner (Turnhout, 2004), 309–322; N. Morgan, "Gendered Devotions and Social Rituals: The Aspremont Psalter-'Hours' and the Image of the Patron in Late Thirteenth and Early Fourteenth-Century France," *Melbourne Art Journal* 6 (2003), 5–24; L. F. Sandler, "The Image of the Book-owner in the Fourteenth Century: Three Cases of Self-definition," in *England in the Fourteenth Century, Proceedings of the 1991 Harlaxton Symposium,* ed. N. Rogers, Harlaxton Medieval Studies, III (Stamford, 1993), 58–80; L. F. Sandler, "The Wilton Diptych and Images of Devotion in Illuminated Manuscripts," in *The Regal Image of Richard II and the Wilton Diptych,* eds. D. Gordon, L. Monnas, C. Elam (London, 1997), 137–154; J. J. G. Alexander, "Painting and Manuscript Illumination for Royal Patrons in the Later Middle Ages," in *English Court Culture in the Later Middle Ages,* eds. V. J. Scattergood, J. W. Sheborne (New York, 1983),141–162; A. Sand, "Vision, Devotion, and Difficulty in the Psalter Hours 'Of Yolande of Soissons,'" *The Art Bulletin* 87, no. 1 (2005), 6–23; K. A. Smith, "Book, Body, and the Construction of the Self in the Taymouth Hours," in *Negotiating Community and Difference in Medieval Europe: Gender, Power, Patronage, and the Authority of Religion in Latin Christendom,* Studies in the History of Christian Traditions, 142, eds. K. A. Smith, S. Wells (Leiden; Boston, Mass., 2009), 173–204; K. A. Smith, *Art, Identity, and Devotion in Four-*

teenth-Century England: Three Women and Their Books of Hours (London, 2003); K. A. Smith, "The Neville of Hornby Hours and the Design of Literate Devotion," *Art Bulletin* 81 (1999), 72–92; A. Bennett, "A Book Designed for a Noblewoman: An Illustrated *Manuel des Péchés* of the Thirteenth Century," in *Medieval Book Production: Assessing the Evidence: Proceedings of the Second Conference of The Seminar in the History of the Book to 1500, Oxford, July 1988* (Los Altos Hills, Calif., 1990), 163–181; A. Bennett, "A Woman's Power of Prayer Versus the Devil in a Book of Hours of ca. 1300," in *Image & Belief: Studies in Celebration of the Eightieth Anniversary of the Index of Christian Art,* ed. C. Hourihane, Index of Christian Art Occasional Papers, 3 (Princeton, N.J., 1999), 89–108; J. Naughton, "A Minimally-Intrusive Presence: Portraits in Illustrations for Prayers to the Virgin," in *Medieval Texts and Images: Studies of Manuscripts from the Middle Ages,* eds. M. M. Manion, B. J. Muir (Chur; Sydney; Philadelphia, Pa., 1991), 111–126. See also the contributions of Nigel Morgan, Lucy Freeman Sandler, and Adelaide Bennett in the present volume. The elegant painted heads that fill the exceptionally large initials of London, British Library, Royal Ms. 15 D II have prompted Lucy Freeman Sandler and the author to discuss strategies of visual surrogacy distinct from patronal representation: L. F. Sandler, "The *Lumere* as *Lais* and Its Readers: Pictorial Evidence from British Library Ms. Royal 15 D II," in *Thresholds of Medieval Visual Culture: Liminal Spaces,* eds. E. Gertsman and J. Stevenson, Boydell Studies in Medieval Art and Architecture (Woodbridge; Rochester, N.Y., 2012), 73–94; A. Kumler, *Translating Truth: Ambitious Images and Religious Knowledge in Late Medieval France and England* (New Haven, Conn.; London, 2011), 97–99.

33. A compendium of nineteen Middle French texts and twenty-seven images, the manuscript comprises 209 fols. (210 × 150 mm) in regular quaternion quires: (i + 1–26⁸). Folio references in my discussion will not depend on either of the erroneous foliations found in the manuscript; my fols. 1ʳ and 2ʳ are currently foliated in pencil as A and B, my fol. 3ʳ is currently foliated in pencil as roman numeral "I" in the manuscript, etc. For an annotated inventory of the manuscript's textual contents, see Mary Rouse and Richard Rouse, "French Literature

compendium of spiritually improving texts produced in Paris, likely in the 1330s, and illuminated primarily by the artist we know as Mahiet, a collaborator with Jean Pucelle on the Belleville Breviary and a much sought-after illuminator in his own right.³⁴ The volume would seem to have some connection to the comital house of Saint-Pôl for that illustrious family is referenced repeatedly in the manuscript's textual contents.³⁵ During the period before and concurrent with the production of the manuscript several members of Saint-Pôl family were notable patrons, but Ms. n.a.fr. 4338 conspicuously lacks any heraldic markers or other visual referents associating it with any member of that comital house.³⁶

And yet, a patronal presence is felt acutely in this volume, not least in its striking colophon which speaks not in the voice of a scribe but, as Richard and Mary Rouse have observed, in the voice of a patron:

Here we shall end our treatise. And giving thanks to God and to his blessed mother, and entreating those who shall hear and read it that they shall consider themselves satisfied with our little instruction, which charity and devotion thus made us prepare in order to leave behind us some thing with which our good friends, both men and women, and our lords and our ladies might occupy themselves spiritually. To whom we recommend ourselves very humbly, both in life and especially in death.³⁷

and the Counts of Saint-Pol ca. 1178–1377," *Viator* 41 (2010), 101–140, 135–139 (esp.). The volume's visual and textual program is considered at greater length in A. Kumler, "Translating Ma Dame de Saint-Pol: The Privilege and Predicament of the Devotee in the Legiloque Manuscript," in *Translating the Middle Ages*, eds. K. L. Fresco and C. D. Wright (Farnham; Burlington, Vt., 2012) 35–53. For further discussion of select aspects of the manuscript's visual and textual program, see also J. Hamburger, "Body vs. Book: The Trope of Visibility in Images of Christian-Jewish Polemic," in *Ästhetik Des Unsichtbaren: Bildtheorie und Bildgebrauch in Der Vormoderne*, eds. D. Ganz and T. Lentes, KultBild, Bd. 1, 112–145 ([Berlin], 2004), 115–116; S. Huot, "The Writer's Mirror: Watriquet De Couvin and the Development of the Author-Centred Book," in *Across Boundaries: The Book in Culture & Commerce*, eds. B. Bell, J. Bevan and P. Bennett (Winchester; New Castle, Del., 2000), 29–46, 30–32 (esp.); S. Huot, "Polytextual Reading: The Meditative Reading of Real and Metaphorical Books," in *Orality and Literacy in the Middle Ages: Essays on a Conjunction and Its Consequences in Honour of D. H. Green*, eds. M. Chinca and C. Young, Utrecht Studies in Medieval Literacy, 12 (Turnhout, 2005), 203–222, 206–209 (esp.); A.-M. Legaré, "L'Image du livre comme adjuvant mémoriel dans le Conte des trois chevaliers et des trois livres," in *Medieval Memory: Image and Text*, eds. F. Willaert, H. Braet, T. Mertens, and T. Venckeler, Textes et études du moyen âge, 27 (Turnhout, 2004), 129–143.

34. R. Rouse, "Mahiet, the Illuminator of Cambridge University Library, MS DD.5.5," in *The Cambridge Illuminations: The Conference Papers*, ed. S. Panayatova (London, 2007), 173–186; M.-T. Gousset, "Libraires d'origine Normande à Paris au xiv^e siècle," in *Manuscrits et Enluminures dans le Monde Normand (X^e–XV^e siècles): Colloque de Cerisy-la-Salle (octobre 1995): Actes*, eds. P. Bouet and M. Dosdat (Caen, 1999), 169–180; *Les Fastes Du Gothique: Le Siècle de Charles V: Galeries Nationales du Grand Palais, 9 Octobre 1981–1^er Février 1982* ([Paris], 1981), 299–300 (Cat. no. 247).

35. Invocations of the comital House of St.-Pôl occur in connection with a legendary account of the founding of the Carthusian order related twice the manuscript (within the *Nouvelletez du monde* in fols. 110^r–111^v and again in the *Trectie dou saint esperit*, fols. 175^v–177^r); the third reference to this family occurs in the rubric introducing the *Petit trectie de nostre dame* in which a count of St.-Pôl is identified as the tract's author (fol. 186^v). For further discussion, see Rouse and Rouse, "Counts of Saint-Pol" (as in note 33), 122–129, 135–139.

36. An eighteenth-century(?) annotation in the lower margin of fol. 187^r asserts that the diapered ground in the miniature painted directly above it displays the arms of Luxembourg and Châtillon: "Ces armes exprimées du Lyon de gueule et de l'Aigle d'argent sont celles de Luxembourg et de Chastillon monstrent que ce Liure et fort ancient et qu'il est escrit enuiron l'a[nnée] 1366 que Mahaut Comtesse de S. Paul espousa Guy Conte de Luxembourg selon Du Chesne." Delisle took the miniature's ground to be heraldic and identified the Count and Countess of St.-Pôl referenced in the manuscript as Mahaut de Châtillon (d. 1378 c.e.) and her husband, Guy Conte de Luxembourg (d. 1371 c.e.): L. Delisle, "Notice sur un receuil de traités de dévotion ayant appartenu à Charles V," *Bibliothèque de l'École des Chartes*, 5 (6ème ser.) (1869), 534, 536–537, 539–540. Subsequent discussions of the manuscript have not pursued this proposed armorial designation or its implications for the patronage of the manuscript. I see no reason to construe the decorated ground as genuinely heraldic. Moreover, on chronological grounds the manuscript could not have been made for Delisle's proposed *destinaire*, Mahaut de Châtillon: Rouse and Rouse, "Counts of Saint-Pol" (as in note 33) 123–124. For further discussion of Mahaut de Chatillon's and Charles de Valois' patronage of the Carthusian order, see the contribution of Sheila Bonde and Clark Maines to the present volume.

37. Ci acheuerons nostre traitie. Et redant [*sic*] graces a dieu et a sa benoite mere. Et suppliant a ceus qui laront et

Despite the intimacy of this expression of patronal goodwill and affection, the voice that speaks from the page is nameless. He, or rather, as the Rouses have argued, *she* speaks as a patron, but without offering us the proper nouns we want: a title, a baptismal name, a patronymic.[38] Further complicating matters, the female figure painted in the privileged posture of a devotee before the Virgin and Child is similarly anonymous. Unmarked by the visual language of heraldry, but given the elegant form of a woman of high station, this figure invites generic recognition only to frustrate specific denomination: she can be recognized as a patron or owner, but she cannot be hailed in her own name.

Depending on one's scholarly temperament, the female figure's namelessness proves awkward, or confusing, or potentially interesting, for this distinguished *anonyme* appears again: not once, but twice more in this manuscript (Figs. 7–8). Her first appearance in the presence of the Virgin and Child overtly emulates other images of Marian devotion featuring patrons or donors, typically found in fourteenth-century books designed for prayer (see Fig. 6).[39] The miniature's emphatic visual evocation of the pictorial *milieu* of the prayer book is a clear response to the text prefaced by the miniature: *Les quinze joies nostre dame*, a pious Marian meditation. This conventional image

of a female Marian client vested with a patronal aura, however, was *not* painted in a prayer book, but rather forms one of a series of twenty-seven illuminations executed in a compendium of didactic texts designed for moral-spiritual instruction.

Within this luxurious manuscript, the operation of the patron-function is, I suggest, very much in evidence. We can discern its influence on folio 143v, where the female figure reappears in a mirror-reversed reiteration of the posture she assumed before the Virgin and Child (Fig. 7). Set upon on a small indeterminate patch of ochre in a profoundly ambiguous space, the female figure—now clad in a pale purple surcoat and vibrant orange sleeves—kneels in the presence of the graceful figure of Christ crucified within or upon an open book, its pages inscribed in gold with the words of Pilate's *titulus* ("Ihesus nazarenus rex Iudeorum") and hung with seven seals.[40] Appearing yet again on folio 178r, the female figure gazes once more upon the crucified body of Christ, her own diminutive book nestled in the ample folds of her pink surcoat (Fig. 8). A curly haired youth sits and writes in the right half of this pictorial space, while in the tree behind him we can discern the small figure of a bird: the eponymous nightingale of the poem prefaced by this illumination, the *liuret dou Rossignolet* (Little Book of the Nightingale).[41]

liront que il se tiennent apaiez de nostre petite information. Que charite et deuotion nous a ainssi fait ordener pour lessier apres nous aucune chose en quoi se puissent espirituement occuper noz bons amis et nos bonnes amies. Et nos seigneurs et nos dames. Aus quiex et aus queles nous nous recommandons tres humblement. Et a uie et a mort especiaument (my translation, modified from that published by Mary and Richard Rouse); for further analysis of this *envoi*, see Rouse and Rouse, "Counts of Saint-Pol" (as in note 33), 124–125.

38. Mary and Richard Rouse make a convincing case for attributing the patronage of the compilation to Marie de Brabant, while cautioning that her role as commissioner/compiler need not mean she was the recipient or owner of any of the three extant exemplars of the compilation: *ibid.*, 124–129.

39. On images of Marian devotion, see N. Morgan, "Texts and Images of Marian Devotion in Fourteenth-Century England," in *England in the Fourteenth Century, Proceedings of the 1991 Harlaxton Symposium*, ed. N. Rogers, Harlaxton Medieval Studies, III (Stamford, 1993), 34–57; N. Morgan, "Texts and images of Marian Devotion in Thirteenth-Century England," in *England in the Thirteenth Century*, ed. W. M. Ormrod (Stam-

ford, 1991), 69–103; N. Morgan, "Texts and images of Marian Devotion in English Twelfth-Century Monasticism, and their Influence on the Secular Church," in *Monasteries and Society in Medieval Britain, Proceedings of the 1994 Harlaxton Symposium*, ed. B. Thompson, Harlaxton Medieval Studies, VI (Stamford, 1999), 117–136; N. Morgan, "The Coronation of the Virgin by the Trinity and Other Texts and Images of the Glorification of Mary in Fifteenth-Century England," in *England in the Fifteenth Century, Proceedings of the 1992 Harlaxton Symposium*, ed. N. Rogers, Harlaxton Medieval Studies, IV (Stamford, 1994), 223–241.

40. The image is a particularly sophisticated and daring example of a powerful medieval tradition of troping upon on the conception of Christ as Book; in its local manuscript context, the miniature collaborates with the text it prefaces, the *Livre de vie et aguillon d'amour*, to make a stunning, sophisticated contribution to this tradition; for a detailed discussion of this image and its relation to the text it prefaces, with further bibliography, see Kumler, "Translating Ma Dame de Saint-Pol" (as in note 33), 45–50.

41. For more extensive analysis of the relationship of this

FIGURE 7. *Liure de uie et aguillon d'amour et de devotion* in the *Legiloque* compendium, *c.* 1325–1350 C.E.; Paris, BnF, Ms. n.a.fr. 4338, fol. 143ᵛ (photo: Bibliothèque nationale de France).

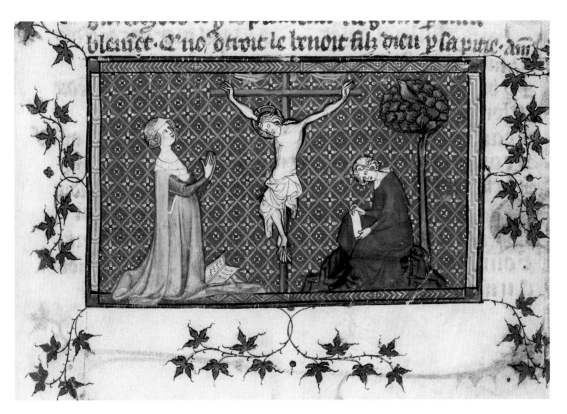

FIGURE 8. *Un petit liuret à l'essample dou rossignolet* in the *Legiloque* compendium, *c.* 1325–1350 C.E.; Paris, BnF, Ms. n.a.fr. 4338, fol. 178ʳ (photo: Bibliothèque nationale de France).

As with the first appearance of the female figure within the manuscript, the beholder of these subsequent miniatures is offered no indication of the personal identity of the devotee. She is unmarked by any heraldic sign that would assert her individuality and identity across the visual program's varied pictorial contexts. What is more, Mahiet altered the color of her garments from one image to the next, thus eschewing a favored medieval formal device for identifying recurring figures, not distinguished by other attributes or by physiognomic likeness.[42] While the illuminator has maintained several visual constants in his renderings of the female figure, notably her bunched braided coiffure and her bodily posture, he has also introduced significant variation. Not only does this leopard change her spots, as it were, but the pictorial contexts in which she appears vary, transporting her from a highly conventional supplication of the Virgin and Child, to a strange indeterminate scene that would seem, if imprecisely, to evoke the illuminated apocalypse tradition, only to situate her in a miniature landscape in which the iconography of devotional images and genre scenes of literary production and patronage merge.

Each of these miniatures responds to the literary construction and *topoi* of the text it introduces and so re-inflects the patron figure, transforming her from a Marian devotee, to a contemplator of an eschatological *corpus Christi*, to the *belle amie* addressed by a Christological verse allegory. How is it then that, encountering this repeated, yet varying figure from one painting to the next, we recognize her not only as a patron, but even as the same patron? And what are the implications of that implicit or explicit hermeneutic act of denomination that, absent any proper noun or its heraldic equivalent, is, nonetheless, prepared to find a patron in this figure?

I think we recognize this female figure as a patron on the basis of those "precise and complex operations" by which the patron-function operates within the visual arts of the Middle Ages. Taken together, these formal stratagems, iconographic tropes, and compositional protocols amount to a skillful and effective choreography of visual consistency and conventionality, as well as of signifying, even individualizing departures from established schemas. As Ms. n.a.fr. 4338 demonstrates, the patron-function's operations also work to define the patron from within the manuscript as not one, but a series of subject positions within that work. In so doing, the patron-function puts these paintings into a subjective relationship with the world beyond their pictorial spaces in a manner that cannot be readily or simply ascribed to the "facts" of the patron's embodied, living and breathing, existence. Here then, we are confronted with the fourth characteristic operation of the patron-function: namely, that "it does not refer purely and simply to a real individual, *in so far as it gives rise* simultaneously to a variety of egos and to a series of subjective positions that individuals may come to occupy."

If the existence of one real, individual fourteenth-century aristocratic woman was the *sine qua non*, in existential and economic terms, for the illuminations painted in this manuscript, our Foucauldian patron-function invites us to consider how Mahiet's polyvalent figuring of the patron not only mediates both her empirical absence and fictive presence for us today, but may also have reconfigured that presence as multiple—or as multiply other—for her in the fourteenth century.

In his analysis of the author-function, Foucault emphasized the "variety of egos" that the author-function produces; subject positions that other individuals may come to occupy through their encounters with authored discourse. In many respects, Foucault's analysis was predicated on a conception of the ego, and of

image to the verse allegory it prefaces, see Kumler, "Translating Ma Dame de Saint-Pol" (as in note 33), 50–52. For further textual consideration of the *Liuret dou Rossignolet*, see also M. Okubo, "Le rossignol et le mystère de Jésus-Christ. A propos d'un poème inédit: Le livret du rossignolet," *Reinardus: Yearbook of the International Reynard Society/Annuaire de la Société internationale renardienne*, 4, eds. B. J. Levy and P. Wackers (1991), 137–146; M. Okubo, "Le rossignol sur la croix: une fi-

gure du rossignol-Christ dans la poésie médiévale," *Reinardus: Yearbook of the International Reynard Society/Annuaire de la Société internationale renardienne* 6, eds. B. J. Levy and P. Wackers (1993), 81–93.

42. On physiognomic likeness, see the essays by Stephen Perkinson and Anne Derbes in the present volume, as well as Perkinson, *The Likeness of the King* (as in note 10).

subjectivity, that he overtly (if inconsistently) identified with the conditions of modernity.[43] By way of a conclusion, I propose that while *varietas* may indeed be a value we can find celebrated in visual and material traces left behind by the medieval patron-function, we must acknowledge that one of the powers of the patron-function in the period was also to produce subjective sameness, repetition, and conformity.[44]

Paris, BnF, Ms. n.a.fr. 4338 is one of a trio of books painted by Mahiet, likely within a decade, containing the same sequence of texts accompanied by an almost identical program of miniatures.[45] In the miniature Mahiet painted for the *Aguillon d'amour* treatise in the second exemplar of this compendium, (BnF, Ms. fr. 1136), the composition we encountered in Ms. n.a.fr. 4338 appears again, in a slightly revised formulation (Fig. 9). Again, we encounter Christ crucified against the book with seven seals, its pages in this manuscript untouched by the text of Pilate's *titulus*. And again, this startling Christological motif is venerated by a kneeling figure, her head now modestly veiled. In a third manuscript containing this compilation of texts and images (Chantilly, Bibl. du Château, Ms. 137) the schema is repeated once more (Fig. 10).

A social art-historical approach to these three manuscripts would encourage us to think about patronage in lateral terms; that is, as a mode of asserting or celebrating a kind of solidarity or shared commitment to spiritual excellence among female donors or recipients linked by a common desire for or receipt of this compilation, very likely also linked by bonds of blood or marriage.[46] There are certainly important questions yet to be asked about the role of manuscript exemplars or models—as well as favored artists—in the elaboration or affirmation of such social or kin-

ship bonds. I shall conclude the thought experiment I have pursued in this essay, however, by instead proposing that among and between these three sibling manuscripts there may be something more of the patron-function's subtle efficacy to be discerned. If the small, but signifying differences we discern in the female figures painted within each manuscript ring the changes on how the patron is produced, not as a reference to a living person beyond the material bounds of the book, but rather as an effect of specific pictorial and textual protocols, so too, from one manuscript to the next, the patron-function produces a series of subject-positions that are powerfully marked by conformity. Like a kind of visual echo chamber, the three emphatically emulative sequences of patron figures painted in these three manuscripts reveal the patron-function's power to produce *subjective* sameness. Operating within and across these volumes, the patron-function reverberates not simply between one manuscript and its beholder, but also—at least potentially—among at least three original beholders and the subtly varied, mutually imitative figures of patronal presence that inhabited and animated their illuminated books.

CONCLUSION: PATRONS AS EFFECTS

In my discussion of the repeated representation of a female devotee in each of these manuscripts, I have suggested that the efficacy of the patron-function renders otherwise anonymous and unmarked aristocratic female forms recognizable *as* representations of a patron—indeed, despite visual variation, as the *same* patron—precisely in so far as it figures the patron from *within* the work of art as a subjective, and multiple effect, exceeding the terms of any simple reference to

43. In a vexingly footnote-free passage, Foucault references four criteria for authorial attribution that he claims are set forth by Jerome in *De viris illustribus*, thus overtly gesturing toward a pre-modern chapter in the history of the author-function: Foucault, "What Is an Author?" (as in note 14), 110–111; Foucault, "Qu'est-ce qu'un auteur?" (as in note 14), 86–87. I have not been able to identify the relevant passage(s) in *De viris illustribus*, nor in any other work by Jerome, nor have other scholars who have taken up this challenge: A. S. Jacobs, "'Solomon's Salacious Song': Foucault's Author Function and the Early Christian Interpretation of the Canticum Canticorum," *Medieval Encounters* 4, no. 1 (1998), 1–23, 4 n. 15 (esp.).

44. For a brilliant investigation of medieval visual and semiotic conceptions of stereotypy, conformity, and individuality, see B. Bedos Rezak, *When Ego Was Imago: Signs of Identity in the Middle Ages* (Leiden; Boston, Mass., 2011), 209–255 *et passim*.

45. The relation and probable production sequence of the three extant exemplars of the compilation are considered at length (with discussion of Chantilly, Ms. 138, a closely related fifteenth-century manuscript) in Rouse and Rouse, "Counts of Saint-Pol" (as in note 33), 122–129. Mary and Richard Rouse attribute the illumination of Chantilly, Ms. 137 to Mahiet; I remain unconvinced by this attribution.

46. *Ibid.*, 129.

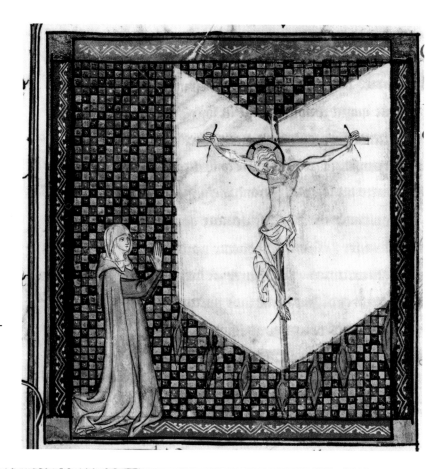

FIGURE 9. *Liure de uie et aguillon d'amour et de devotion tract* in a second manuscript of the *Legiloque* compendium, *c.* 1325–1350 C.E.; Paris, BnF, Ms. fr. 1136, fol. 100ʳ (detail) (photo: Bibliothèque nationale de France).

FIGURE 10. *Liure de uie et aguillon d'amour et de devotion tract* in a third manuscript of the *Legiloque* compendium, *c.* 1325–1350 C.E.; Chantilly, Bibliothèque du Château de Chantilly, Ms. 137, fol. 152ʳ (detail) (photo: CNRS-IRHT, © Bibliothèque et archives du château de Chantilly).

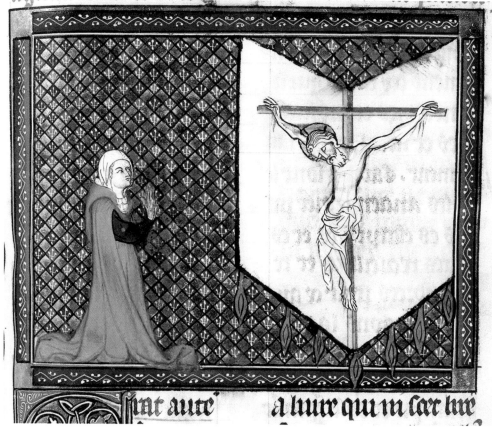

an individual existing in the world beyond the fiction of pictorial space. Entertaining the idea that certain works of medieval art may have produced patrons as *effects* does not, however, require us to throw social-historical commitments to the study of patrons and patronage out with the proverbial bathwater. The historical reality of patronage as a practice involving sums of money and materials, once living and breathing men and women, and the complex interactions and negotiations they engaged in as they commissioned, made, and received works of art and architecture is, and ought to remain, a fundamental preoccupation as we work to better understand medieval objects, monuments, and people. Nonetheless, if we also at-tend to the medieval patron as a subjective *effect* produced within, between, and among works of art and their receptions, we discover anew the medieval work of art not as a reflex of extra-artistic values, experiences, or concerns, but as powerful medium for subjectivity itself. In this light, the work of art comes into sharper focus as an efficacious, operative site in which we might yet discern the workings of the medieval patron-function as it produces and forecloses a privileged spectrum of modes of being, precisely as the effects of aesthetic experiences. These effects resonated powerfully in the Middle Ages, and, I suggest, they continue to reverberate in our perception of medieval works of art today.

* * *

This essay has benefitted from the insights, questions, critiques, and suggestions of the many colleagues gathered at the Princeton symposium convened by Colum Hourihane and the Index of Christian Art; I am grateful to those colleagues for their many contributions to my thinking. I would also like to offer my sincere thanks to my research assistant Gwendolyn Collaço who made the writing of this essay possible in countless ways and to Jacob Proctor whose comments and questions have enriched my thinking. Finally, sincere thanks are due to Colum Hourihane and his colleagues at the Index of Christian Art not only for their editorial acumen, but also for all they do to sustain lively conversation about issues central to the study of medieval art, architecture, and material culture.

INDEXES

GENERAL INDEX

(Italic numbers indicate text figures)

A

Abbotsbury Abbey (Dorset), 46
Abingdon Abbey (Berkshire/
 Oxfordshire)
 –William Ashenden, abbot of, 182
Adelheid of Burgundy, empress, 228,
 229
Ado of Vienne, St., 6
Ælflæd, queen, 67
Agnes of Champagne, 110
Agnes of Méran, 161
Alban, St., 180, 211
Alburgis, abbess of Heiningen convent,
 230–232, *231*
Alcuin of York, 153
Alexander II, pope, 11
Alfrid, Saxon king, 232
Altichiero da Verona, 131
Amalfi Cathedral
 –bronze doors of, 6, 7, 9, *10*, 11, 14,
 18, 24, *25*, 27–28, *29*
Amiens
 –Bernard of Abbeville, bishop of,
 101
 –Cathedral of, 101, 110
Anagni Cathedral, 199
André Chédeville, 100
Anglo-Saxon Chronicle, 75
Anna von Schweidnitz, 222
Anne, St., 171, 182
Antony, St., 48
Apollinaire, St., 108
Arena Chapel [Scrovegni Chapel],
 141–142, 147
Arnold von Born, 217, *218*
Ashenden, William, abbot of Abing-
 don, 182
Augsburg Cathedral, 73
Augustine, St., 152, 155, 162, 274
Autun Cathedral
 –donor capital of, 216, *217*
 –west portal inscription of, 222–225,
 224
Auxerre Cathedral, 100
 –stained glass of, depicting Saul's
 suicide, 168
Aymes, prior-general of the Carthusian
 order, 80, 85

Aynolph, John, prior and canon regu-
 lar of Holy Sepulchre, Warwick,
 184, *185*

B

Bachkovo, Mother of God Petritzoni-
 tissa monastery, 199
Baillardus (theologian), 110
Baldwin II, Latin emperor of Constan-
 tinople, 172
Baldwin, John, 159
Bamberg, Michelsberg Abbey, 213
 –Burchard, librarian of, 213–214
Barthes, Roland, 304
Barworth, Stephen, rector of Newing-
 ton parish church, 184
Basil I, Byzantine emperor, 195,
 204
Bath Abbey (Somerset), 40
Bawtre, Reginald, priest at All Saints
 North Street, York, 187
Baxandall, Michael, 50, 273
Bayeux
 –Cathedral of, 55, 60, 62, 64–65,
 71–72, 74
 –inventory of, 70–71, *71*, 72, 74
 –Louis II d'Harcourt, bishop of, 70,
 71
 –Odo of Conteville, bishop of, 59–60,
 60, 62–66, 74, 75
Bayeux Embroidery, 54–75, *57*, *58*, *60*,
 63, *65*, *69*, *75*, 222
 –and Bayeux Cathedral, 55, 60, 62,
 64–65, 70–72, 74, 75
 –and Bernard de Montfaucon, 55–
 56, 59, 70
 –and comparison to English manu-
 scripts, 60–62, *62*, *63*
 –and comparison to tapestries and
 other textiles, 66–68, 72
 –ecclesiastical use of, 70–74, 75
 –eighteenth-century drawing of, 55,
 56
 –and the Norman Conquest of Eng-
 land, 54, 55–56, 59, 66, 70, 74–75
 –and patronage by Odo of Conte-
 ville, 59–60, 62–66, 74, 75

 –and Queen Matilda, 55
 –details of:
 –Bird Slinger, 61, *62*
 –Bishop Odo of Bayeux, *60*
 –Death of King Edward the Con-
 fessor, 55–57, *58*, 58–59
 –Duke William and his men with
 Earl Harold crossing the river
 near Mont-Saint-Michel, 74, *75*
 –Duke William comes to Bayeux,
 64, *65*
 –Duke William's Messengers, *57*
 –Earl Harold departing for the
 Continent from Bosham, 64, *65*,
 69
 –Fable of the Fox and Crow, *69*,
 69–70
 –Harold makes an Oath, 64, *65*
 –Offering of the Crown to Earl
 Harold, *58*, 58–59
 –The Siege of Dol with Duke
 Conan fleeing by slip rope, 62, *63*
Beaufort, John, 177
Beauneveu, André, 258, 268
 –tomb statue of Charles V, 258, 260,
 259, 268
Beauvais Cathedral, Saint-Vincent's
 chapel of, 100
Bell, Susan, 13, 233
Belting, Hans, 50
Benedict, St., 19, 34
Benno of Osnabrück, 213
Berger, Harry, 273
Bergmann, Ulrike, 210–211
Berlin, Staatliche Museen Preussischer
 Kulturbesitz, Gemäldegalerie
 –*The Gift of Kalmthout*, 217–218,
 218
Bernaert (Bernard) van Orley, 68
Bernard of Abbeville, bishop of Amiens,
 101
Bernard of Clairvaux, St., 143
Bernardino Scardeone, 121, 127, 137,
 145
Bernstein, David, 66
Bernward of Hildesheim, 213, 232
Bertelli, Gioia, 11–12, 22
Bibles moralisées, 151, 164–165, *166*, 172

Bigote, John, priest at North Cerney, 185, *186*
Billotey, Françoise, 79
Binski, Paul, 12
Blanche of Castile, 151, 164, 165, 168, 171, 297, *298*
Blanche of France, *infanta* of Castile, 91
Blanche of Navarre, 80, 83–84, 91
Bohun family
 –Eleanor de Bohun, 275, 283, 287–289, 290, 292–293
 –Humphrey de Bohun, fourth earl of Hereford, 283
 –Humphrey de Bohun, sixth earl of Hereford, 276–277
 –Humphrey de Bohun, seventh earl of Hereford, 275, 276–277, 279, 284
 –Joan Fitzalan, countess of Hereford, 275, 279, 282–284, 287, 289, 293
 –Mary de Bohun, 275, 276, 277–279, *281*, 282, 283, 284, 287, *288*, 292, 293
 –William de Bohun, earl of Northampton, 293
Bolton family, 177
Born, Arnold von, 217, *218*
Bosham Church (West Sussex), 64, *65*, 69
Bourchier, Thomas, bishop of Worcester, 188, 189
Bourgfontaine Charterhouse, 76, 77, *77*, 78, 79–80, 81–98, *89, 92, 93, 94, 95*
 –Eustache, prior of, 85, 86, 94, 97
Bowersock, Glen, 27
Brampton, Robert and Isabel, monumental brass of, 190–191
Branner, Robert, 164
Brenk, Beat, 12, 13, 22, 152, 168, 171, 172
Broadway Manor-house (Worcestershire), 39, *39*
Bristol, St. Augustine's Abbey, 40
Brubaker, Leslie, 13
Brunyng, Robert, abbot of Sherborne, 181
Brus family, 42
Brussels Royal Palace, 68
Bruzelius, Caroline, 12
Buchthal, Hugo, 196
Budny, Mildred, 66
Bugslag, James, 168
Burchard II, bishop of Halberstadt, 213

Burchard, librarian of Michelsberg Abbey, Bamberg, 213–214
Bury St. Edmunds Abbey (Suffolk), 52, 73
Buzzacarini family
 –Anna, abbess of S. Benedetto, 121, 131, *132, 133*, 134, 144–145
 –Fina, wife of Francesco da Carrara, lord of Padua, 120–121, 123, 126–131, *126, 130, 132, 133*, 134, 140, 144, 145–146, 147, 149–150
 –tomb of, and canopy, 123, *123*, 126–127, *126*, 128, 147, 148, 149

C

Cahors Charterhouse, 86
Canterbury
 –Cathedral of, 46
 –Henry Rumworthe, archdeacon of, 184
 –St. Augustine's Abbey, 61, 62, 74, 75
 –Scolland, abbot of, 74
Carlier, Claude, 92
Carlisle Cathedral (Cumbria), 48
Carloman, son of Pepin the Short, 153
Caskey, Jill, 32, 49, 151
Catherine, St., 184
Cavalcanti
 –Mainardo, 120
 –Monna Andrea, 120
Caviness, Madeline, 13, 66, 163, 208, 209, 302
Cecilia, St., 19, *21*, 187
Celestine III, pope, 161, 163
Chamberlain, sir William, 189, *189*
Charlemagne, 153
Charlemagne Master, the, Cholet workshop, 244
Charles II, the Bald, Holy Roman Emperor, 154, 155, 158
Charles IV, the Fair, king of France, 29, 209
Charles IV, Holy Roman Emperor, 217, *218*, 222
Charles V, the Wise, king of France, 256, 257–264, *259, 261*, 266–268, 271, *272, 273, 274, 274*
 –and the *Parement de Narbonne*, 258–259, 260, *261*
 –and the Vaudetar Bible, *256, 257*,

258, 260, 263–264, 266–268, 271, 273, 274
 –biography of (Christine de Pizan), 260–263
 –image of, charter, 259, 260, *261*
 –signet of, 266, *266*
 –statue of, Musée du Louvre, 258, 260, *261*
 –tomb statue of, 258, *259*, 260, 268
Charles V, Holy Roman Emperor, 68
Charles VI, king of France, 262–263
Charles, count of Valois, 77, 78, 80–83, 84, 85, 87, 88, 90–91, 96–97, *96*
Chartres
 –Cathedral of, 99–100, 101–103, *102*, 104–118
 –canons, chapter of, 99, 101, 108, 114, 117
 –Corps-Saints altar, apse, 101
 –fire of 1194, and reconstruction, 100
 –main altar of, choir, 101
 –obit altar of, choir, 101
 –Sainte Chasse with Virgin's veil relic of, presbytery, 101
 –Saint Piat chapel of, 108
 –*Santa Camisa* of the Virgin, main altar of, presbytery, 117
 –stained glass of, 99, 100, 101–108, *102, 103, 105, 107, 108, 109*, 110–118, *111, 112, 113, 115, 116, 117, 118*
 –depicting Saul's suicide, 151, 164, 168–171, *169, 170*, 172
 –donor-canon windows:
 –Gaufridus Chardonel, 104–106, *105*, 107
 –Geoffrey, 114, 115, *115, 116*
 –Guillaume Thierry, 108–110, *109*
 –Henricus Noblet, 101–103, *103*, 106
 –Jean of Courville, 113–114, *113*
 –Nicolaus Lescene, 104, *105*, 106
 –Petrus Baillart, 110, *111*
 –Renaud of Mousson, bishop of Chartres, 110, *111*
 –Robertus de Berou, 110–112, *112*
 –Stephanus Cardinalis [Chardonel], 106–107, *107, 108*

–unidentified canons, 115–118, *116, 117, 118*
–Virgin and Child statue of, gilded silver, main altar, presbytery [not extant], 104, 106, 107
–Virgin of Notre Dame Sous Terre statue of [not extant], 104–106
–Fulbert, bishop of, 104
–Leobinus, St., bishop of, 99
–Renaud of Mousson, bishop of, 110, *111*
Chartres, Saint-Père-en-Vallée Abbey, 108, 113
Chartres, Saint-Saturnin church, 104
Chartreuse de Champmol, 3
Chauvigny, St.-Pierre church of
–choir capital with inscription, 299, 300, *300*, 302
Chédeville, André, 100
Chenu, Marie-Dominique, 27
Christine de Pizan, 260–263
Cividale del Friuli, Museo Archeologico Nazionale
–Pax of Duke Ursus (ivory plaque), 300–302, *301*
Clémence of Hungary, 91
Clement V, pope, 90
Clinton, John, 245
Clinton, Roger, 245
Clovis I, king of the Franks, 154
Collet, Thomas, 187, 188, *188*
Cologne, St. Gereon Basilica, Treasury
–arm reliquaries, 217, *218*
–enamel plaque with Arnold von Born, 217, *218*
Comyn, John, 243
Conan of Dol, duke, 62, *63*
Constans, son of Constantine, 27
Constantine I, St., 3, 4, 9, 13, 24, 27, 28, 29, 203
Constantine VII Porphyrogenitos, Byzantine emperor, 195–196, 197
–ivory, Pushkin Museum, Moscow, 195
Constantinople [Istanbul]
–Chora [Kariye Camii] monastery, 198–199, *199*
–mosaic with Theodore Metochites, 198, *199*
–Hagia Sophia, 204, *205*
–Hodegon Monastery
–Joasaph, scribe of , 200

–Patriarchal church of St. Sophia, 195, *196*
–mosaic with emperor before Christ, narthex, 195, *196*
–St. Mary Pammakaristos church [Fetiye Camii], 199
Constantius, son of Constantine, 27
Corbeil, priory of, 39
Cornwall, sir John, 180–181, *181*
Council of Trent, 114
Coverham Abbey (Yorkshire), 45–46
Curteys, William, 52
Corvey Abbey
–Saracho, abbot of, 213
Cutler, Anthony, 13, 194
Cysoing, monastery of, 161, 162

D

Dali, church of St. Demetrianos, 200–202, *201*
–donor portrait, west wall, 200–202, *201*
Daniel, St., 135
De Administrando imperio, 196
de Mély, Ferdinand, 110
Delaporte, Yves, 104, 110, 114
Demetrianos Andridiotis, 202
Derbes, Anne, 222
Dermoyen, Willem and Jan, workshop of, 68
Desiderius of Montecassino, 11, 19–22
Deslandes, Eucher, fr., 74
Despenser, Isabel, 42, 46–48, *47*
Deuchler, Florens, 162
Diebold, William, 158
Diet of Frankfurt, 153
Dietrich II, bishop of Naumburg, 225
Dodwell, C. R., 73, 158
Dominic, St., 240
Douglas, Mary, 51
Dreux family, 171
Dufrenne, Suzy, 197
Durandus, bishop of Mende, 135
Durham Cathedral, 46, 67, 73

E

Easby Abbey (Yorkshire), 45–46
East Harling (Norfolk), parish church, east window of, 189, *189*
Edith of Wessex, queen of England, 57, 58

Edmund, St., 73
Edward the Confessor, St., king of England, 42, 55–57, 58–59, *58*, 244
Edward I, king of England, 283
Edward III, king of England, 78, 83, 283, 289
Einsiedeln Abbey, 24
Eleanor de Bohun, 275, 283, 287–289, 290, 292–293
Eleanor, countess of Vermandois, 162
Elizabeth of Hungary, 237, 240
Elizabeth, St., mother of John the Baptist, *130*, 144, 147–148
–and Zachariah, 135
Emirbayer, Mustafa, 28
Enguerran de Marigny, 81, 83
Enguerrand IV of Coucy, 254
Esau de' Buondelmonti, despot of Ioannina, 200
Euphemia de Walliers, 36
Eusebius, 3, 28
Eustache, prior of Vauvert and Bourgfontaine charterhouses, 85, 86, 94, 97
Euthymios, St., 197
Evesham Abbey (Worcestershire), 39–40
–Roger Yatton, abbot of, 40
Evron, Notre Dame de l'Épine, 100

F

Faras Cathedral, 202
–panel with Bishop Marianos, 202
Farfa Abbey
–Casket (ivory), 9
–Customary, 73
Fastolf, sir John, 46
Ferdinand I and Sancha, ivory crucifix of, 3
Fetcham (Surrey), church of, 275
–John d'Abernon, sir, rector of, 275
Fetiye Camii, *see* Constantinople
Fina Buzzacarini, *see* Buzzacarini family
Fitzalan, Richard, earl of Arundel, 279
Fitzhamon, Robert, lord of Gloucester, 42
Fleck, Cathleen, 13
Flora, Holly, 4
Florence, Sta. Maria Novella, chapel of, 120
Focillon, Henri, 33

Forde, Edmund, monumental brass of
(Swainswick), 191
Foucault, Michel, 304–308, 312,
316–317
Francesco da Carrara, lord of Padua,
120, 127, 129, 131, 140, 144, 147
Francesco Novello, 144, 147, 150
Francis, St., 240
Frankfurt, Diet of, 153
Freningham family, 183
Frithestan, bishop of Winchester, 67
Froissart, Jean, 263, 283
Fulbert, bishop of Chartres, 104
Fulda Abbey
—Ratger, abbot of, 213

G

Gaignières, Roger de, 92, 96, 110
—drawing of heart tomb of Philip VI,
92, *92*
—*Exchange of a diptych between John II
and a pope* (after a panel painting in
Ste.-Chapelle), 260, *262*
Ganimberti, Raimondo, bishop of
Padua, 128
Gardner, Julian, 33
Gaucher de Châtillon d'Austreche,
246–247
Gaudenti Cavalieri, the, 222
Gaufridus Chardonel, donor-canon of
Chartres, 104–106, *105*
Gauthier, bishop of Chartres, 171
Gell, Alfred, 28, 29, 50, 194, 273
Geoffrey, donor-canon of Chartres, 114,
115, *115*, *116*
George of Antioch, 203
George, St., 203
Gerardo, archbishop of Siponto, 22,
30
Germain of Auxerre, St., 100, 104
Gerona Cathedral, 73
Gesta Guillelmi, 55
Ghuiluys de Boisleux, 253, 254
Gilbert de la Porrée, bishop of Poitiers,
27
Giotto di Bondone, 142, 147
Giustina, St., 135
Giusto de' Menabuoi, 121, 123, 142,
143, 148
—Annunciate Virgin, polyptych, 143,
143
—frescos by, *122, 123, 124, 125, 126,*

*130, 132, 133, 134, 136, 137, 138,
139, 142, 146, 148, 149*
Glastonbury Abbey (Somerset), 34, *35*
—Walter of Monington, abbot of, 34
Gloucester Abbey (13th c.), 49
Goddy, Henry and Agnes, 187, 188, *188*
Golden Legend, 134, 143
Goswin van der Weyden, 218, *219*
Grant, Lindy, 168, 171–172
Green, Mary, 187
Gregory I, the Great, St., pope, 153,
154
Gregory VII (Hildebrand), pope, 11, 14,
19, 22, 163
Gregory Palamas, 200
Grodecki, Louis, 172
Grosvenor, Robert, 45
Guest, Gerald, 173
Guibert de Nogent, 73
Guillaume Roland, bishop of Le Mans,
100
Guillaume Thierry, donor-canon of
Chartres, 108–110, *109*
Guisborough Priory (Yorkshire), 42, 46
Gundersheimer, Werner, 36
Guy of Dampierre, count of Flanders,
254
Gylbert, Robert, bishop of London, 184

H

Habington, Thomas, 187, 188
Halberstadt
—Burchard II, bishop of, 213
Halfen, Roland, 171
Hamburger, Jeffrey, 106
Hamsterley, Ralph, 190, 193
—monumental brass of (Oddingley),
190, *190*, 191, *192, 193*
Harling, Anne, 189
Harold Godwinson, earl, 57, *58*, 58–59,
64, *65*
Haseley (Warwickshire), parish church,
stained glass of, 184–185, *185*
Heiningen, Augustinian convent [for-
mer], 230–232
—figures of Hildeswied and Alburgis,
230–232, *231*
Heller, Eva Giurescu, 119, 120
Henri of Braine, archbishop of Reims,
101
Henricus Noblet, donor-canon of Char-
tres, 101–103, *103*, 106

Henry I, king of Germany, 228, *229*
Henry II, Holy Roman Emperor, 232
Henry III, king of England, 42, 243,
244
Henry IV, king of England, 163, 180,
282, 283
Henry V, king of England, 180
Henry VI, king of England, 180
Henry of Blois, bishop of Winchester,
24, 211, 212, 213, *212*
Hereford
—earls of, *see* Bonhun family
—Thomas Spofford, bishop of, 182–
183, 191
Herimann Cross (1056), 24
Herlihy, David, 66
Herman de Lerbeke, chronicler of the
bishops of Minden, 73–74
Herod, king, 147, 149
—Massacre of the Innocents, 147–149
Herveus, bishop of Troyes, 101
Heydon, sir Henry, 191–192, *192*
Higgitt, John, 243
Hildebrand (Pope Gregory VII), 11, 14,
19, 22
Hildeswied, donor of Heiningen con-
vent, 230–232, *231*
Himbleton (Worcestershire), parish
church
—stained glass of, 187–188, *188*
—William Palmer, priest of, 188
Hincmar, archbishop of Reims, 153–
154, 158
Hoccleve, Thomas, 282
Holland, John, earl of Huntingdon, 282
Holland, Margaret, 177–179
Horley (Oxfordshire), parish church,
stained glass of, 184
Hrabanus Maurus, *see* Rabanus Maurus
Humphrey de Bohun, fourth earl of
Hereford, 283
Humphrey de Bohun, seventh earl of
Hereford, 275, 276–277, 279, 284
Humphrey de Bohun, sixth earl of Her-
eford, 276–277
Humphrey, duke of Gloucester, 180
Hundred Years War, 79, 83

I

Ingeborg of Denmark, queen of France,
160, 161–162, 163
Innocent III, pope, 114, 117, 161

Investiture Controversy, 163
Ioannina
 –Thomas Preljubović, despot of, 200
Isabel Despenser, 42, 46–48, *47*
Istanbul, *see* Constantinople

J

Jacobus da Voragine, 143
Jacopo II da Carrara, 128
Jacques de Guérande, archbishop of
 Tours, 101
Jäggi, Carola, 216
Jean d'Orléans, 259
Jean de Berry, duke, 9, 66, 268–269,
 273
 –collections of, 268–269
Jean de Bourbon, 268, 269
Jean de Bruges, 257, 258, 259, 264, 268,
 271–273, 274
Jean de Neuville-Vitasse, 253, 254
Jean de Vaudetar, *256*, 257, 268, 271,
 273, 274
Jean Froissart, 263
Jean of Courville, donor-canon of Char-
 tres, 113–114, *113*
Jean Pucelle, 313
Jean XXII, pope, 85–86
Jeanne d'Évreux, queen consort of
 France, 13, 29, 209, 287
Jeanne de Bourgogne, 268
Jeanne of Châtillon, 84
Jeanne of Flanders, 254
Jenkins, Romilly, 195
Jerusalem, Church of the Holy Sepul-
 chre, 3, 4, 19, 29
Jervaulx Abbey (Yorkshire), 46
Joachim and Anna, Sts., 135
Joan Fitzalan, countess of Hereford,
 275, 279, 282–284, 287, 289, 293
Joan of Valence, 243
Joasaph, scribe of Hodegon Monastery,
 Constantinople, 200
John Chrysostom, St., 152–153
John d'Abernon, sir, rector of Fetcham,
 275
John de Brokehampton, abbot of Eve-
 sham, 39–40
John de Teye, 275, 282
John II, the Good, king of France, 91,
 96, 259, 260, *262*, 273
John of Dunster, prior of Bath Abbey,
 40

John of Gaunt, duke of Lancaster,
 283
John of Salisbury, 159, 266
John of Sawtry, abbot of Ramsey, 276
John the Baptist, St., 121, 123, 129, *130*,
 131–134, *134*, 144, 145, 147, 148
John the Evangelist, St., 48, 123, 131–
 134, *134*, 187, 241, 244
John the Fearless, Duke of Burgundy,
 269–271
 –and *The Book of Marvels*, 269–271,
 270
 –ring with profile of, Musée du
 Louvre, 269, *269*
John VI Kantakouzenos, Byzantine em-
 peror, 199–200
John VIII, pope, 158
John, duke of Bedford, 180
Jordan, Alyce, 172
Julien, St., 100

K

Kariye Camii, *see* Constantinople
King, Catherine, 119, 120, 127, 134
Kitzinger, Ernst, 12–13, 194
Knightley, Thomas, monumental brass
 of (Fawsley), 191
Kohl, Benjamin, 119
Krautheimer, Richard, 27
Kress, Anton, provost, 221

L

Ladis, Andrew, 147
Lanercost Priory (Cumbria), 46
Laon Cathedral, 73
Lateran Council, Fourth (1215), 114,
 117
 –and transubstantiation, 114, 118
Laurence, St., 183, *183*
Lawrence of Siponto, St., 22
Le Liget Charterhouse (Chemillé-sur-
 Indrois), 86
Le Mans
 –Cathedral of, 100
 –Guillaume Roland, bishop of,
 100
 –Notre Dame de la Couture, 100
Leignel, Marie-Pierre, 79
Leo Patrikios, 204
Leo VI, the Wise, Byzantine emperor,
 195

Leobinus, St., bishop of Chartres, 99
León, San Isidoro church of, 3
Lescene [Li Sesne] family, 104
Leson, Richard, 254
Liber Pontificalis, 29, 73
Lipsmeyer, Elizabeth, 216
Livre des Miracles de Notre Dame, 100
London
 –British Museum
 –Enamel plaques depicting Henry
 of Blois, 24, 210–213, *212*,
 217
 –Lothar Crystal (*c.* 860), 24
 –Robert Gylbert, bishop of, 184
 –Westminster Abbey, 42, *43*
Lorenz, St., 221
Lorin, Charles, 110
Lothar II, 154
Lothar Crystal, *see* London
Louis I, the Pious, king of the Franks,
 154
Louis II, king of the Franks, 154
Louis II d'Harcourt, bishop of Bayeux,
 70, 71
Louis VIII, king of France, 164, 165,
 171
Louis IX, St., king of France, 13, 28, 84,
 91, 151, 164, 165, 171, 172, 174
Louis X, king of France, 81, 83, 91
Louis XI, king of France, 104
Louis of Anjou, 268
Louis of France, count of Évreux, 91
Louis of Toulouse, St., 96–97, *96*
Louth Park Abbey (Lincolnshire), 40
 –Richard of Dunham, abbot of, 40
Lowden, John, 164, 165, 197
Lucy, St., 187
Luttrell, Geoffrey, 276
Luxford, Julian, 78, 84, 94

M

Macarius, St., Bishop of Jerusalem,
 28
 –letter from Contantine, 3, 4
Madrid, National Archaeological Mu-
 seum of Spain
 –ivory crucifix of Ferdinand I and
 Sancha, 3
Mahaut de Saint-Pol, 80, 81–82, 84
Mahiet (illuminator), 313, 316, 317
Mainardo Cavalcanti, 120
Marchand, Lucien, 79

Margaret Beauchamp, duchess of Somerset, 179, *179*, 180
Margaret Holland, 177–179
Margaret, St., 250, 251, *251*, *252*
Maria Angelina Komnene Doukaina, the Palaeologina, 200
Marianos, bishop of Faras, 202
Marie of Brabant, 91
Marsilio da Carrara, 128
Martha, St., 134, *134*
Martin of Tours, St., 19, 81
Martin, Therese, 13, 14, 22–24, 29
Martindale, Andrew, 13
Mary de Bohun, 275, 276, 277–279, *281*, 282, 283, 284, 287, *288*, 292, 293
Mary Magdalene, St., 48
Mathilda of Ringelheim, queen, 228, *229*
Matilda of Flanders, queen consort of England, *55*
Matthew Paris, 35, 40
Mauro, father of Panteleone, 6, 9, 11, 19, 22
Maurone Comite family of Amalfi, 6, 9
Mauss, Marcel, 13, 51
Mazarine Master, the, 269
Meditations on the Life of Christ, 131, 134, 138
Meiss, Millard, 273
Meteora, Transfiguration monastery, 200
　–icon of, The Touching of Thomas, 200
Michael, St., 139
Mische, Ann, 28
Mitchell, John, 4
Mitford, Richard, bishop of Salisbury, 181
Monreale, cloister of, 14, *15*
Montfaucon, Bernard de, 55–56, 59, 70
Mont-Saint-Michel Abbey, 74, *75*
Monte Sant'Angelo, Sanctuary of St. Michael
　–bronze doors of, 4–6, *5*, 9, 11, 13, 14, *16*, *17*, 19, *21*, 22, *23*, *24*, *26*, 27–28, 29–30, *30*
　–and St. Michael, 4–6, 19
Montecassino Abbey
　–bronze doors of, 6, 9, 19, 22
Monumens de la Monarchie française (Montfaucon), 55, 56

More, William, prior of Worcester Cathedral, 37
Morley, lord Robert, 46
Mortimer family, 42
Moscow, Pushkin Museum
　–ivory depicting Constantine VII Porphyrogenitos, 195
Mount Athos, monastery of Vatopedi, 200
Mouriki, Doula, 198
Müstair, St. John church of
　–fresco fragment with Saul's suicide, 154–155

N

Naples, *Battle of Pavia* tapestry set, 68, *69*
Naumburg
　–Cathedral of Sts. Peter and Paul
　　–figures, west choir, 225–227, *226*
　　–Dietrich II, bishop of, *225*
Nees, Lawrence, 158
Neophytos, St., 202
Nersessian, Sirapie der, 204
Nettlestead (Kent), parish church
　–stained glass of, 183, *183*
Newburgh Priory (Yorkshire), 46
Newington (Oxfordshire), parish church
　–Richard Salter, rector of, 184
　–stained glass of, 183–184, *184*
　–Stephen Barworth, rector of, 184
Niccolò da Carrara, 121
Nicholas, St., 6, 104, 106
Nicholas Cabasilas, 200
Nicholas of Myra, St., 239
Nicolaus Lescene, donor-canon of Chartres, 104, *105*, 106
Nikephoros Choumnos, 198
Nordhausen, Dom zum Heiligen Kreuz, 227–228, *227*
　–figures, 228, *227*, *229*, *230*
North Cerney (Gloucestershire), parish church
　–Crucifixion window of, 185, *186*
　–John Bigote, priest of, 185, *186*
Nuremberg
　–St. Lorenz church, west façade of, *222*, *223*
　–St. Sebald church, epitaph for Klara Münzmeister, née Löffelholz, 219–221, *220*

O

Odo of Conteville, bishop of Bayeux, earl of Kent, 59–60, *60*, 62–66, 74, 75
Odo's reliquary (at Bayeux), 64
Olson, Mancur, 51
Orley, Bernaert (Bernard) van, 68
Otto I, the Great, Holy Roman Emperor, 228, *229*
Otto II, Holy Roman Emperor, 228, *230*
Otto III, Holy Roman Emperor, 308
Otto of Bamberg, 213

P

Padua
　–Arena Chapel, 222
　–Cathedral Baptistery, 120, 121–123, 126–127, 128–129, 135, 137, 146, 150
　　–frescos of, 121–123, 127, 128–150
　　–Annunciation, 141–143, *142*, 145
　　–Apocalypse cycle, apse, 121, *124*, 135, 136–139, *138*, *139*, 141, 143, 144
　　–Christ among the Doctors, west wall, 147, 148–149, *149*
　　–Crucifixion, 131, *133*
　　–Entry into Jerusalem, 131
　　–Fina Buzzacarini presented to the Virgin and Child (donor portrait), west wall, 123, *126*, 128–129, 147, 149
　　–Gensis cycle, dome, 121, *122*, 131–135, *134*, 140–141, 143, 145
　　　–Noah cycle, dome, 135, *136*
　　　–Hospitality of Abraham, dome, 145, *146*
　　　–Jacob cycle, dome, 135–136, *137*
　　–Life of John the Baptist, esp. Birth of John the Baptist, south wall, 121, *125*, 129, *130*, 144, 145, 147
　　–Massacre of the Innocents, west wall, 147, 148, *148*
　　–Ministry cycle, 129
　　–Miracles of Christ, 131, *132*, 146

–Passion cycle, 129
–Raising of Lazarus, 131
–Salvation history cycle, west, north, and east walls, 121, 123, *123, 124, 126*, 128, 141, 147
–Way to Calvary, 131, *133*
–and Enrico Scrovegni, 222
–Palazzo di Levante, 120
–Prosdoscimo, bishop of, 135
–Raimondo Ganimberti, bishop of, 128
–S. Anthony Basilica (the Santo), S. Giacomo chapel of, 131
 –Council of King Ramiro fresco, 131
–Scrovegni Chapel, 198
Palermo
–Cappella Palatina, 12
–Maria dell'Ammiraglio, mosaic of Christ crowning Roger II, 13
Palmer, William, priest at Himbleton, 188
Pantaleon, St., 103
Pantaleone (de Maurone Comite), 6, 9–11, 13–14, 19, *20*, 22, 24, 27–28, 29, 30
Paphos, Hermitage of Saint Neophytos, 202
Parement Master, the, 259
Paris
–Archives nationales de France, signet of Charles V, 266, *266*
–Dominican church, rue Saint-Jacques, 90, 91
–Franciscan House, 90, 91
–Musée du Louvre
 –ring with profile of John the Fearless, duke of Burgundy, 269, *269*
 –statue of Charles V, 258, 260, *261*
–Saint-Jacques-aux-Pelerins, 81
–St.-Denis Cathedral, 39, 51, 91, 92, 153
 –gilt doors of, 213
 –Suger, abbot of, 9, 13, 39, 51, 213
–St.-Victor Abbey, 159
–Ste.-Chapelle, 260, 273
 –King's window depicting Saul's suicide, 151, 164, 168, 172, *173*
–Vauvert Charterhouse, 81, 84, 85, 86, 95
 –Eustache, prior of, 85, 86, 94, 97
Paris, Matthew, 35, 40

Parpulov, Georgi, 198
Paschal II, pope, silver reliquary box of, 24
Pastan, Elizabeth, 222, 302
Pastoureau, Michel, 263, 264
patrocinium, 307–310
Paul, St., 19, *20*
Paulinus of Aquileia, 153
Pepin the Short, king of the Franks, 153
Perkinson, Stephen, 302
Peter Abélard, 110
Peter Comestor, 159
Peter de Dreux, duke of Brittany, 171
Peter Lombard, 162
Peter the Martyr, 240
Peter of Riga, 165
Peter, St., in prison, 14, *17*
Petit, Joseph, 79
Petrarch, Francesco, 131, 147
Petrus Baillart, donor-canon of Chartres, 110, *111*
Philip II, Augustus, king of France, 110, 161, 162, 163
Philip III, the Bold, king of France, 91, 244
Philip IV, king of France, 81, 91
Philip VI, the Fortunate, king of France, 77, 78, 79, 80, 82–83, 84, 86, 87, 88, 90, 91–92, 96–97, *96*, 98
 –heart tomb of, 92–94, *92, 96*, 98
Philip the Bold, duke of Burgundy, 3
Philip of France, count of Poitiers, 91
Philippe Romanus, canon of Le Mans, 100
Photios I, patriarch of Constantinople, 204–205
Pierre d'Abernon, 275
Pierre of Bordeaux, archdeacon of Vendôme, 104
Pirmin, bishop of Reichenau, *309*, 310
Pleshey Castle, 275, 279–282, 284
Poeschke, Joachim, 127
Poitiers
 –Gilbert de la Porrée, bishop of, 27
Polemitas, church of St. Michael, 203–204, *203*
 –foundation inscriptions, 203–204, *203*
Poquet, abbé, 79
Prague, Muzeum hlavniho mešta Prahy
 –pilgrim's badge, 217, *218*

Pressouyre, Léon, 96
Prosdoscimo, bishop of Padua, 135
Protevangelium, 148
Pucelle, Jean, 313
Purchard of Reichenau, 308, 310
Pympe family, 183

Q

Quedlinburg Cathedral, 73

R

Rabanus Maurus, 154, 159, 165, 214, *215*
Radene, Anna, 203
Raimondo Ganimberti, bishop of Padua, 128
Ramsey Abbey (Cambridgeshire), 276
 –John of Sawtry, abbot of, 276
Raoul de Presle, 274, *274*
Raoul, canon of Senlis, 100
Raoulet d'Orléans, 257, 271, 274
Rasyphus, St., 64
Ratger, abbot of Fulda, 213
Ravenna, S. Vitale, mosaic with Christ, two angels, St. Vitale, and Bishop Ecclesius, dome of the apse, 216, *216*
Ravennus, St., 64
Reichenau
 –Abbey of, 308–310
 –Mariamünster of, 308
 –Pirmin, bishop of, *309*, 310
 –St. Mary church of, 310
Reims
 –Cathedral of, 101, 110, 155
 –Henri of Braine, archbishop of, 101
 –Hincmar, archbishop of, 153–154, 158
Remigius, St., 154
Renaud II, count of Bar, 110
Renaud of Mousson, bishop of Chartres, 110, *111*
Richard II, king of England, 282, 290, 292
Richard of Dunham, abbot of Louth Park, 40
Richard of Thidenhanger, 34
Riddagshausen Abbey, 232
Rievaulx Abbey (Yorkshire), 46
Robert of Béthune, 254

Robert of France, count of Clermont, 91

Robertus de Berou, donor-canon of Chartres, 110–112, *112*

Roger II of Sicily, 12

Romanos II, Byzantine emperor, 196, 197

Rome
 —Forum of Trajan, 3
 —Old St. Peter's Basilica, inscription from, 24–27, 29
 —Pantheon, 11
 —S. Paolo fuori le Mura, bronze doors of, 6, *8*, 9, 11, 14–19, *20*, 22
 —Sta. Cecilia, 19–22
 —Sta. Maria Maggiore, mosaics of, 14
 —Temple of Romulus/Basilica of Sts. Cosmas and Damian, 11

Ross-on-Wye (Herefordshire), parish church, east window of, 182, 191

Rough, Robert, 222

Rouse, Mary and Richard, 271, 313, 314

Rudol, bishop of Halberstadt, 213

Rumworthe, Henry, archdeacon of Canterbury, 184

S

Saalman, Howard, 127

Saint-Mihiel Abbey
 —Smaragdus, abbot of, 154, 155

Saint-Pôl family, 313

Salter, Richard, rector of Newington parish church, 184

Salisbury
 —Richard Mitford, bishop of, 181

Sandona, Mark, 222

Saracho, abbot of Corvey, 213

Sauer, Christine, 210

Sauerländer, Willibald, 168

Saul, king of the Israelites, 151–173
 —image of, fresco:
 —Müstair, St. John, 154–155
 —image of, manuscript:
 —Chantilly, Musée Condé, Ms. 9 *olim* 1695 (Ingeborg Psalter), 151, 160–163, *161*, 164, 165
 —Dijon, Bibliothèque municipale, Ms. 14 (Bible of Stephen Harding), 160
 —London, British Library, Ms.

Harley 1526–1527 (*Bible moralisée*), 151, 164, 165
 —London, British Library Ms. Harley 2803 (Worms Bible), 160
 —London, British Library, Ms. Harley 2895 (Psalter), 160
 —London, Lambeth Palace Library, Ms. 3 (Lambeth Bible), 160
 —New York, Pierpont Morgan Library, Ms. M. 240 (*Bible moralisée*), 151, 164
 —New York, Pierpont Morgan Library, Ms. M. 638 (Morgan Picture Bible), 172–173
 —Oxford, Bodleian Library, Ms. Bodley 270b (*Bible moralisée*), 151, 164, 165
 —Paris, Bibliothèque de l'Arsenal, Ms. 521 (Arsenal Bible), 173–174
 —Paris, Bibliothèque nationale de France, Ms. lat. 8846 (Great Canterbury Psalter), 160
 —Paris, Bibliothèque Nationale de France, Ms. lat. 11560 (*Bible moralisée*), 151, 164, 165
 —Paris, Bibliothèque nationale de France, Ms. lat. 16943 (*Historia scholastica*), 160
 —Rome, San Paolo fuori le mura, Ms. s.n. (San Paolo Bible), 151, 155–158, *156*, *157*, 164
 —Toledo, Cathedral Library, Mss. 1–3 (*Bible moralisée*), 151, 164, 165, *167*, 172
 —Vienna, Österreichisches Nationalbibliothek, Cod. ser. n. 2701 (Admont Bible), 160
 —Vienna, Österreichische Nationalbibliothek, Cod. Vindobonensis 1179 (*Bible moralisée*), 151, 164–165, *166*
 —Vienna, Österreichische Nationalbibliothek, Cod. Vindobonensis 2554 (*Bible moralisée*), 151, 164
 —image of, stained glass:
 —Auxerre Cathedral, northern ambulatory, 168
 —Chartres Cathedral, north transept, 151, 164, 168–171, *169*, *170*, 172
 —Paris, Ste.-Chapelle, King's window, south wall, 151, 164, 168, 172, *173*

Savonarola, Michele, 121, 137

Schade, Herbert, 158

Schaus, Margaret, 208

Schweidnitz, Anna von, 222

Scardeone, Bernardino, 121, 127, 137, 145

Scolland, abbot of St. Augustine's Abbey, 74

Scrope, St. Richard, 45, 177

Scrope family, 46

Scrovegni, Enrico, 222

Secret of Secrets (Pseudo-Aristotle), 263

Sedulius Scottus, 154

Seidel, Linda, 222

Senlis
 —Raoul, canon of, 100

Sens Cathedral, 110

Ševčenko, Ihor, 198

Sherborne Abbey (Dorset)
 —Robert Brunyng, abbot of, 181

Siena, Sta. Maria dei' Servi, 127–128

Sinai, St. Catherine's monastery, 197–198
 —icon of, Elijah fed by the Raven, 197–198
 —icon of, Moses receiving the Law, 197–198
 —icon of, Mother of God with Moses and Euthymios II, 197

Siponto
 —Gerardo, archbishop of, 22, 30

Skinner, Patricia, 9, 11

Smaragdus, abbot of Saint-Mihiel, 154, 155

Solberg, Gail, 119, 127

Souldern (Oxfordshire), parish church, monumental brass of unknown person, 191, *191*

Sparham (Norfolk), parish church, painted screen of, 192

Speyer, Historisches Museum der Pfalz, situla, 211

Spofford, Thomas, bishop of Hereford, 182–183, 191

St. Albans Cathedral (Hertfordshire), 35, 36, 40, 46

Stafford family, 183

Stenton, Sir Frank, and *The Bayeux Tapestry* volume, 59–60, 62–65

Stephan Uroš I, king of Serbia, 203

Stephan, king of England, 211, 213

Stephanus Cardinalis [Chardonel], donor-canon of Chartres, 106–107, *107*

Stephen, St., 183

Stephen II, pope, 153

Stephen, bishop of Tournai, 162

Sterling, Charles, 96

Stöber, Karen, 78

Stratford, Neal, 211, 212, 213

Stretton Sugwas (Herefordshire), chapel of Bishop of Hereford, 182

Suger, abbot of St.-Denis, 9, 13, 39, 51, 213

Sulpicius Severus, 19

T

Tewkesbury Abbey (Gloucestershire), 42, 46
 –Warwick Chantry Chapel, 42, *44,* *45*
 –William of Bristol, abbot of, 46

Theodore Apseudes, 202

Theodore Lemniotes, 203

Theodore Metochites, 198–199, *199,* 205

Theophanu, empress, 228, *230*

Theophilos Lemniotes, 203

Theotime, 204

Theotimus, 250

Thomas of Woodstock, 283, 287–289, 290

Thomas Preljubović, despot of Ioannina, 200

Thornton Abbey (Lincolnshire), 37, *38*

Tilley, Christopher, 28

Toledo Cathedral, 164

Tournai
 –Stephen, bishop of, 162

Tours
 –Cathedral of, 101
 –Jacques de Guérande, archbishop of, 101

Troyes Cathedral, 101

U

Ursin, St., 269

Ursus, duke, 300, 302

V

Val Saint-Pierre Charterhouse (Braye-en-Thiérache), 86

Valerian, St., 19, *21*

Valséry, Praemonstratensian abbey of, 86

Vasari, Giorgio, 52, 297

Vatopedi, monastery of (Mount Athos), 200

Vauvert Charterhouse, *see* Paris

Vendôme
 –Pierre of Bordeaux, archdeacon of, 104

Venice, S. Marco, mosaic, east dome, 140–141, *140*

Vita Ædwardi, 57–58, 75

Vita Constantini, 3, 4, 13, 19

W

Wace (Norman poet), 250

Walker, John, rector of Holy Trinity Goodramgate, 185–186

Walter of Monington, abbot of Glastonbury, 34

Warnke, Martin, 13

Warr, Cordelia, 119, 144, 145

Warter Priory (Yorkshire), 46

Warwick (Warwickshire), Priory of St. Sepulchre
 –John Aynolph, prior and canon regular of, 184, *185*

Warwick Chantry Chapel, *see* Tewkesbury Abbey

Watton Priory (Yorkshire), 46

Weitzmann, Kurt, 195, 196, 204

West Wickham (Kent), parish church, stained glass of, 191–192, *192*

Weybridge (Surrey), monumental brasses with skeletons, 191

Weyden, Goswin van der, 218, *219*

Wherwell (Hampshire), Benedictine nunnery of, 36

White, Stephen, 69–70, 302

Wigmore Abbey (Herefordshire), 42

William de Bohun, earl of Northampton, 293

William I, the Conqueror, duke of Normandy, king of England, 54, 55, 57, 62, 64, *65,* 74

William II, king of Sicily, 14

William of Bristol, abbot of Tewkesbury Abbey, 46

William of Grafham, 276

William of Poitiers, 55, 56

William of Termonde, 254

William of Valence, 243

Williams, Jane Welch, 114

Willys, Denis, monumental brass of (London), 191

Winchester
 –Frithestan, bishop of, 67
 –Henry of Blois, bishop of, 24, 211, 212, 213, *212*

Wingfield, sir Robert, 189, *189*

Winifred, St., 184

Witigowo, abbot of Reichenau, 308, *309,* 310

Wöltingerode, Cistercian convent of, 232

Worcester
 –Cathedral of, 37
 –William More, prior of, 37
 –Thomas Bourchier, bishop of, 188, 189
 –Anglo-Saxon cathedral of, 51

Worcestre, William, 46

Wormald, Frances, 60–61, 62, 64, 75

Wulfstan, bishop of Worcester, 51

Y

Yatton, Roger, abbot of Evesham, 40

York
 –All Saints North Street
 –Reginald Bawtre, priest of, 187
 –stained glass of, 186
 –Works of Corporal Mercy window of, 186–187, *187*
 –Holy Trinity Goodramgate, parish church, east window of, 185–186
 –John Walker, rector of, 185–186

INDEX OF MANUSCRIPTS

(Italic numbers indicate text figures)

AUTUN, Bibliothèque Municipale
–Ms. 19 *bis* (Marmoutiers Sacramentary): 214, *214*

BADEN-BADEN, Kloster Lichtenthal Archiv
–Cod. 2 (Psalter of Mary de Bohun): 284, *285*, *286*, 287

BALTIMORE, Walters Art Museum
–Ms. w. 40 (Book of Hours): 236–237, *236*
–Ms. w. 97 (Book of Hours): 240, *240*
–Ms. w. 98 (Book of Hours): 249
–Ms. w. 104 (Book of Hours): 240–241

BERKELEY, Castle Archives
–Select Roll 98 (pedigree of Bristol abbots): 40, *41*

CAEN, Archives départementales du Calvados, série G,
 Bibliothèque du chapitre cathédrale de Bayeux
–Ms. 199 (Inventory of Bayeux Cathedral): 70, *71*, *72*, 74

CAMBRAI, Médiathèque municipale
–Ms. 87 (Book of Hours): 245–247, *246*, 250, 253

CAMBRIDGE, Corpus Christi College Library
–Ms. 20 (coronation order): 290, *291*

CAMBRIDGE, Trinity College
–Ms. B.11.7 (Hours of Sir John Cornwall): 180–181, *181*

CAMBRIDGE, University Library
–Ms. DD.5.5 (Belleville Breviary): 313

CHANTILLY, Bibliothèque du Château
–Ms. 137 (*Legiloque* compendium): 317, *318*

CHANTILLY, Musée Condé
–Ms. 9 *olim* 1695 (Ingeborg Psalter): 151, 160–163, *161*,
 164, *165*
–Ms. 65 (*Très Riches Heures du Jean Duc de Berry*): 66, 67

COPENHAGEN, Kongelige Bibliotek
–Ms. 547.4° (Hours of Mary de Bohun): 287, *288*

CRACOW, Czartoryski Library
–Ms. 3466 (Psalter-Hours): 234–236, *235*, 250

DIJON, Bibliothèque municipale
–Ms. 14 (Bible of Stephen Harding): 160

EDINBURGH, National Library of Scotland
–Ms. Adv. 18.6.5 (Hours and Psalter of Eleanor de Bohun):
 287, 289–293, *291*
–Ms. 21000 (Murthly Hours): 243, *245*

ESCORIAL, Biblioteca del Real Monasterio San Lorenzo
–Ms. Ψ II.7 (Homilies of Basil the Great): 9

THE HAGUE, Rijksmuseum Meermanno-
 Westreenianum
–Ms. 10 B 23 (Vaudetar Bible): *256*, 257–258, 260, 263–268,
 265, *267*, 271–274

KARLSRUHE, Badische Landesbibliothek
–Cod. Aug. perg. 205 (*Carmen de Gestis Witigowonis Abbatis*):
 308–310, *309*

LOCATION UNKNOWN, formerly Dyson Perrins
–Ms. 34 (Psalter-Hours): 237, *238*

LOCATION UNKNOWN, formerly Pierre Berès
–(Psalter-Hours): 247, *248*, 250, *251*

LONDON, British Library
–Ms. Add. 29704-5 (Carmelite Missal): 176, 289
–Ms. Add. 36684 (Saint-Omer Hours): 242
–Ms. Add. 42130 (Luttrell Psalter): 24, 276
–Ms. Add. 74236 (Sherborne Missal): 48–49, *49*, 181–182
–Ms. Arundel 91 (Passional of St. Augustine's): 61, *61*
–Ms. Cotton Claudius B.IV (Old English Hexateuch): 61–62,
 62, *63*
–Ms. Egerton 1139 (Queen Melisende Psalter): 160
–Ms. Egerton 3277 (Psalter and Hours of Humphrey de
 Bohun): 276, 277, *277*, *279*
–Ms. Harley 1526–1527 (*Bible moralisée*): 151, 164, 165
–Ms. Harley 2803 (Worms Bible): 160
–Ms. Harley 2895 (Psalter): 160
–Ms. Royal 2 A.XVIII (Beaufort-Beauchamp Hours): 177–
 180, *179*
–Ms. Royal 2 B.I (Prayer Book): 180
–Ms. Yates Thompson 11 (Add. 39843) (*Trois Estaz de bonnes
 ames*): 106

LONDON, Lambeth Palace Library
–Ms. 233 (Vaux-Bardolf Psalter): 290, *291*
–Ms. 3 (Lambeth Bible): 160

LONDON, Victoria and Albert Museum
–Reid 83 (Reid Hours): 243, *250*

LOS ANGELES, Getty Museum
–Ms. 66 (Avranches Psalter): 162

MADRID, Bibliotheca Nacional
–Ms. Vit. 23-10 (Book of Hours): 243–245

MANCHESTER, John Rylands University Library
–Ms. lat. 117 (Psalter-Hours): 254

METZ, Bibliothèque municipale
–Ms. 1588 (Psalter-Hours): 241–242, *241*

MONTPELLIER, Bibliothèque Inter-universitaire,
 section médicine
–Ms. H. 196 (*Montpellier Chansonnier*): 243

MT. SINAI, Saint Catherine Monastery
–Ms. Sinai 339 (Homilies of Gregory of Nazianzos): 14

NEW YORK, Metropolitan Museum, Cloisters
– Ms. L. 1990.38 (Book of Hours): 237, *237*, 238–239, *239*,
 253
–Ms. 54.1.2 (Hours of Jeanne d'Évreux): 13, 209
–Ms. 1969 (Psalter and Hours of Bonne of Luxembourg):
 106

NEW YORK, Morgan Library and Museum
–Ms. Glazier 59 (Book of Hours): 250
–Ms. M. 92 (Book of Hours): 234, *235*, 250, *250*
–Ms. M. 240 (Toledo *Bible moralisée*): 151, 164, 297–299,
 298, 302
–Ms. M. 302 (Ramsey Psalter): 276
–Ms. M. 638 (Morgan Picture Bible): 172–173
–Ms. M. 730 (Psalter-Hours): 253–254
–Ms. M. 754 (Saint-Omer Hours): 242, *242*, 250–252, *252*,
 253
–Ms. M. 945 (Hours of Catherine of Cleves): 141

NUREMBERG, Germanisches Nationalmuseum
–Cod. Hs. 113264 (Kress Missal): 221, *221*

NUREMBERG, Landeskirchliches Archiv
–Cod. St. Sebald, St. Sebald 2 (Missale Bambergense): 217,
 217

NUREMBERG, Stadtbibliothek
–Cod. Solger 4.4 (Nuremberg Hours): 245

OXFORD, Bodleian Library
–Ms. Auct. D. 4.4 (Psalter and Hours of Mary de Bohun):
 276, 277–279, *280*, *281*, 282, *283*, 284

–Ms. Auct. D. 4.6 (Psalter): 302, *303*
–Ms. Bodley 270b (*Bible moralisée*): 151, 164, 165
–Ms. Digby 227 (Abingdon Missal): 182
–Ms. lat. liturg. f. 2 (York Book of Hours): 177, *178*
–Ms. Tanner 166 (Chronicle of Thornton): 37, *38*
–Ms. Top. Glouc. D. 2 (Founders' book of Tewkesbury
 Abbey): 46–48, *47*

OXFORD, Exeter College
–Ms. 47 (Psalter of Humphrey de Bohun): 276, 277, *278*,
 284, *285*

PARIS, Archives nationales de France
–Ms. J358, no. 12 (charter): 259, 260, *261*

PARIS, Bibliothèque de l'Arsenal
–Ms. 288 (Book of Hours): 245
–Ms. 521 (Arsenal Bible): 173–174

PARIS, Bibliothèque nationale de France
–Ms. Est. Rés. Oa 11(Gaignières collection): 260, *262*
–Ms. fr. 1136 (*Legiloque* compendium): 317, *318*
–Ms. fr. 2810 (*The Book of Marvels*): 269–271, *270*
–Ms. fr. 5707 (*Bible historiale*): 271, *272*
–Ms. fr. 22912 (*The City of God*): 274, *274*
–Ms. lat. 1 (First Bible of Charles the Bald): 153
–Ms. lat. 1328 (Artois Psalter-Hours): 245
–Ms. lat. 8846 (Great Canterbury Psalter): 160
–Ms. lat. 11560 (*Bible moralisée*): 151, 164, 165
–Ms. lat. 16943 (*Historia scholastica*): 160
–Ms. n.a.fr. 4338 (*Legiloque* compendium): 310, *311*, 312–
 316, *315*
–Ms. grec. 139 (Paris Psalter): 196–197
–Ms. grec. 510 (Homilies of Gregory of Nazianzus): 204
–Ms. grec. 1242 (theological writings of Emperor John VI
 Kantakouzenos): 199–200

PARIS, Bibliothèque Sainte-Geneviève
–Ms. 782 (*Grandes Chroniques de France*): 244

PARIS, Musée du Louvre
–Ms. MI 1121 (*Parement de Narbonne*): 258–259, 260, *261*

PARIS, Private Collection
–(Psalter-Hours): 237, *238*

POMMERSFELDEN, Gräflich Schönbornische
 Bibliothek
–Cod. 348 (Bohun Hours): 276

RENNES, Bibliothèque municipale
–Ms. 22 (Psalter): 179

ROME, San Paolo fuori le mura
–Ms. s.n. (San Paolo Bible): 151, 155–158, *156*, *157*, 164

SOUTHWARK, Roman Catholic Cathedral
–Ms. 7 (Book of Hours): 192–193, *192*

STOCKHOLM, Nationalmuseum
–Ms. B.1655–56 (Book of Hours): 248–249

TOLEDO, Cathedral Library
–Mss. 1–3 (*Bible moralisée*): 151, 164, 165, *167*, 172

TROYES, Bibliothèque municipale
–Ms. 1905 (Book of Hours): 250

UTRECHT, Universiteitsbibliotheek
–Cod. Bibl. Rhenotraiectinae 1, Nr. 32 (Utrecht Psalter), 60

VATICAN CITY, Biblioteca Apostolica Vaticana
–Ms. Reg. gr. 1 (Bible of Leo Patrikios): 204

–Ms. Vat. lat. 6808 (Farfa Customary [*Consuetudines farfenses*]): 73

VIENNA, Österreichisches Nationalbibliothek
–Cod. 652 (*Liber de laudibus sanctae cruces*): 214–215, *215*
–Cod. 1826* (Psalter of Humphrey de Bohun): 276–277, *278*
–Cod. 1857 (Hours of Mary of Burgundy): 221
–Cod. ser. n. 2701 (Admont Bible): 160
–Cod. Vindobonensis 1179 (*Bible moralisée*): 151, 164–165, *166*
–Cod. Vindobonensis 2554 (*Bible moralisée*): 151, 164

WORCESTER, Cathedral Library
–Register A XI: 37, *37*

YORK, Minster Library
–Ms. Add. 2 (Bolton Hours): 176–177, 180

PRINTED BY
CAPITAL OFFSET | PURITAN PRESS
HOLLIS, NEW HAMPSHIRE

BOUND BY
ACME BOOKBINDING
CHARLESTOWN, MASSACHUSETTS

DESIGNED AND COMPOSED BY
MARK ARGETSINGER
HOLYOKE
MASSACHUSETTS